13th Triennial Meeting Rio de Janeiro
22–27 September 2002

ICOM COMMITTEE FOR CONSERVATION

COMITÉ DE L'ICOM POUR LA CONSERVATION
ICOM COMITÉ PARA LA CONSERVACIÓN

PREPRINTS Volume II

EDITOR
Roy Vontobel

ASSOCIATE EDITORS
Whitehall Associates, Ottawa

PREPRINTS COMMITTEE
Jonathan Ashley-Smith
Victoria & Albert Museum
London, United Kingdom

Agnes Gräffin Ballestrem
Rijnsaterswoude, The Netherlands

Françoise Flieder
Centre de recherche sur la
conservation des documents
graphiques
Paris, France

Judith Hofenk de Graaff
Rijnsaterswoude, The Netherlands

Stephen Hackney
Tate
London, United Kingdom

Cliff McCawley
Canadian Conservation Institute
Ottawa, Canada

Edson Motta Jr
Rio de Janeiro, Brazil

Alice Boccia Paterakis
Agora Excavations
American School of Classical Studies
Athens, Greece

Caroline Villers
Courtauld Institute of Art
London, United Kingdom

Published by James & James (Science Publishers) Ltd, 35–37 William Road, London NW1 3ER, UK

A catalogue record for this book is available from the British Library

ISBN 1 902916 30 1

Printed in the UK by Hobbs the Printers

Available from:

James & James (Science Publishers) Ltd.
35–37 William Road
London NW1 3ER
United Kingdom
Fax: +44 171 387 8998
E-mail: orders@jxj.com
http://www.jxj.com/

ICOM-CC Secretariat
Isabelle Verger
c/o ICCROM
13, via San Michele
00153 Rome, Italy
Tel: + 39 06 58 55 34 10
Fax: + 39 06 58 55 33 49
E-mail: secretariat@icom-cc.org

ICOM-CC thanks the following organizations for their generous sponsorship of the Preprints: the Conselho Nacional de Desenvolvimento Científico e Tecnológico (CNPq), the Getty Conservation Institute and the International Council of Museums (ICOM).

 The Getty Conservation Institute

COVER PHOTOGRAPH

Marc Ferrez
Largo da Lapa, Santa Tereza.
Rio de Janeiro, RJ, c. 1875.
Albumen, 14.5 x 21.5 cm.
Moreira Salles Institute / Gilberto Ferrez Collection.

Marc Ferrez
Largo da Lapa, Santa Tereza.
Rio de Janeiro, RJ, c. 1875.
Albumine, 14,5 x 21,5 cm.
Institut Moreira Salles / Collection Gilberto Ferrez.

Marc Ferrez
Largo da Lapa, Santa Tereza.
Rio de Janeiro, RJ, c. 1875.
Albumen, 14.5 x 21.5 cm.
Instituto Moreira Salles / Colección Gilberto Ferrez.

Contents / Table des matières / Contenido – Volume II

Sculpture and polychromy / Sculpture et polychromie / Escultura y policromia

490 Retablo mayor de San Mateo de Lucena, Córdoba: Estudio Técnico / A. Carrassón López de Letona, T. Gómez Espinosa

496 Metodología de intervención en las portadas del Nacimiento y del Bautismo de la Catedral de Sevilla: programa de mantenimiento / C. Cirujano, F. Guerra-Librero, T. Laguna Paúl

502 Piedad de Aleijadinho en Felixlândia, Minas Gerais, Brasil / B. Coelho, M.R.E. Quites, M.N. Queiroz

507 The Montvianex Madonna: materials and techniques in 12th-century Auvergne / L.G. Kargère

513 Study and treatment of the *Madonna and Child* by Conrad Meit, particularly of partial polychromy and polished finishes / I. Leirens

520 The 'ruby' in Baroque Christ sculptures in Brazil / C.M.D. Moresi

524 Research into non-traditional gilding techniques as a substitute for traditional matte water-gilding method / M. Sawicki

533 Investigation, conservation and mounting of a fibrous plaster frieze by Charles Rennie Mackintosh / C. Stable, B. Cobo del Arco, H. Spencer

540 Redécouverte d'un modèle en terre cuite du *Sommeil* de Rodin : étude et restauration / J. Vatelot, S. Colinart, L. Degrand, A. Romain

Mural paintings, mosaics and rock art / Peinture murale, mosaïques et art rupestre / Pintura mural, mosaicos y arte rupestre

549 Chromatic degradation processes of red lead pigment / S. Aze, J-M. Vallet, O. Grauby

556 Rock art conservation in the Peruaçu valley, Minas Gerais, Brazil / H. David de Oliveira Castello Branco, L.A.C. Souza

560 Determination of the treatment and restoration needs of medieval frescos in Georgia / M. Gittins, S. Vedovello, M. Dvalishvili, N. Kuprashvili

565 Painting techniques of the Mexicas at the Great Temple of Tenochtitlan in Mexico City / D.M. Grimaldi Sierra, A. Murray, K. Spirydowicz

571 Microclimate modelling for prediction of environmental conditions within rock art shelters / I.D. MacLeod, P. Haydock

578 Weathering processes at a rock art site in Baja California, Mexico / V. Magar

582 Rock paintings conservation and pigment analysis at Cueva de las Manos and Cerro de los Indios, Santa Cruz (Patagonia), Argentina / I.N.M. Wainwright, K. Helwig, D.S. Rolandi, C. Gradin, M.M. Podestá, M. Onetto, C.A. Aschero

Graphic documents / Documents graphiques / Documentos gráficos

593 Technological study and conservation of the Gospel of the Dormition Cathedral / G.Z. Bykova, M.A. Volchkova, V.S. Petetskaya, N.L. Petrova, T.B. Rogozina

597 An investigation into the effect of iron gall ink on the discolouration of lead white / A. Derbyshire, P. Regnault, R. Kibrya, R. Withnall, G. Banik, G. Smith, K. Brown

603 Deacidification without equipment and money – dream or reality? / J. Hanus, J. Mináriková, E. Hanusová

609 Italian metal point drawings: international studies of the artistic technique / L. Montalbano, C. Frosinini, A. Duval, H. Guicharnaud, G. Casu

615 Assessment of the state of degradation of historical parchment by dynamic mechanical thermal analysis (DMTA) and Solid-state C NMR / M. Odlyha, N.S. Cohen, G.M. Foster, A. Aliev

622 Leafcasting parchment documents degraded by mould / A. Pataki, K. Forstmeyer, A. Giovannini

628 The acidity of paper. Evaluation of methods to measure the pH of paper samples / S. Saverwyns, V. Sizaire, J. Wouters

Photographic records / Documents photographiques / Documentos fotográficos

637 Desarrollo de la Preservación del Patrimonio Fotográfico en Chile / *I. Csillag*

644 Condition survey and preservation strategies at the Danish Film Archive / *J.S. Johnsen, K.B. Johansen*

651 Recent advances and future directions in the education and training of photograph conservators / *D.H. Norris, N.W. Kennedy*

658 Investigation of Jean-Louis-Marie-Eugene Durieu's toning and varnishing experiments: a non-destructive approach / *D. Stulik, H. Khanjian, A. de Tagle, A.M. Botelho*

664 An investigation into a consolidation treatment for flaking autochrome plates / *C.C. von Waldthausen, B. Lavédrine*

Ethnographic collections / Collections ethnographiques / Colecciones etnográficas

673 Pesticides and repatriation at the National Museum of the American Indian / *J.S. Johnson, J.P. Henry*

679 Common problems in archaeological and ethnographic conservation intersect with the contemporary: case studies of two African objects / *D. Moffett, S. Hornbeck, S. Mellor*

685 Renovación del enfoque de las tradiciones culturales del pasado y presente / *M.A. Paixão*

690 Into the Unknown Amazon . . . / *J. Quinton, B. Wills*

696 Real-time monitoring of dimensional change in Australian Aboriginal bark paintings during storage / *N. Smith, K. Roth*

701 A collaborative examination of the colourfastness of Amazonian featherwork: assessing the effects of exposure to light and laser radiation / *M.R. Solajic, B. Pretzel, M. Cooper, J.H. Townsend, T. Seddon, J. Ruppel, J. Ostapkowicz, T. Parker*

Wet organic and archaeological materials / Matériaux organiques et archéologiques gorgés d'eau / Materiales orgánicos arqueológicos húmedos

712 The Lactitol® conservation of wet polychrome wooden objects found in a 15th-century Aztec archaeological site in Mexico / *A. Alonso-Olvera, S. Imazu, D. Mendoza-Anaya, A. Morgos, Ma.T. Tzompantzi-Reyes*

718 The Bremen Cog Project: the conservation of a big medieval ship / *P. Hoffmann*

Textiles / Textiles / Textiles

727 Caring for a Brazilian 'humming bird': an adventure in the embroidered world of Arthur Bispo do Rosario / *L. da Silveira, T.C.T. Paula*

730 Conservation project of an early 19th-century Turkish Ghiordes rug found to have significant pesticide (DDT) contamination: the result of a successful cooperation / *C. Di Nola, C. Tonin, M.B. Songia, R. Peila, C. Vineis, R. Roggero, L.E. Brancati*

736 L'art de la fibre de nylon : Le défi d'un textile architectural contemporain / *S. Little*

741 A study of material and digital transformations: the conservation of two ancient Egyptian beaded items of dress / *C. Rogerson*

747 The conservation of a Korean painted silk banner, c. 1800: Paint analysis and support via solvent-reactivated acrylic adhesive / *M. Takami, D. Eastop*

755 The role of pressure mounting in textile conservation: recent applications of U.S. techniques / *D. Windsor, L. Hillyer, D. Eastop*

Leather and related materials / Cuir et matériaux apparentés / Cuero y materiales relacionados

764 *Meeting Between Solomon and the Queen of Sheba*: history, technology and dating of a gilt leather wall-hanging, or the contribution of a restoration process / *C. Bonnot-Diconne, N. Coural, E. Koldeweij*

770 Conservation procedure based on methodical research to remove an alkyd varnish from a gilt leather wall-hanging / *P. Hallebeek, M. de Keijzer, N. Baeschlin*

777 Evaluation de la quantité de matières grasses extractibles d'un cuir ancien /
 F. Juchauld, C. Chahine, S. Thao

785 The 16th-century leather ceremonial buckler in the Bagatti-Valsecchi mu-
 seum in Milan: a case study / M. Paris, L. Rissotto, M.C. Berardi

792 Presentation and evaluation of spot tests for identification of the tannin type
 in vegetable tanned leather / D.V. Poulsen

Natural history collections / Collections d'histoire naturelle / Colecciones de historia natural

801 The corrosion phenomena in fossilized trees: a case study of fossil forests in
 Kastoría and on the island of Lésvos, Greece / V. Lampropoulos,
 G. Panagiaris, E. Velitzelos

Stone / Pierre / Piedras

809 The Nine Muses Roman sarcophagus at Hearst Castle: Identification of the
 geological provenance and characterization of the marble during the first
 phase of conservation / T. Marinov, Z. Barov

816 Composición y alteración de la toba volcánica de la fachada de un edificio en
 el centro histórico de la ciudad de México / A.L. Suárez Pareyón

Glass, ceramics and related materials / Verre, céramique et matériaux apparentés / Cerámicas, vidrios y materiales relacionados

823 Una nueva metodología para estudios científicos en conservación y
 restauración de cerámica prehispánica / C. Christiani, C. González Tirado,
 M.E. Guevara Muñoz

829 La restauración de la cerámica olmeca de San Lorenzo Tenochtitlan,
 Veracruz, México: teoría y práctica / A. Cruz Lara, M.E. Guevara Muñoz,
 A. Cyphers

835 The conservation of enamels on metal: characterization and historical notes /
 A. Gall-Ortlik, B. Beillard

841 Restauración de esmaltes sobre plata: El Ajedrez de Carlomagno /
 I.H. Martín

Metals / Métal / Metales

851 Evaluation de la corrosion du plomb aux archives nationales de France /
 M. Dubus, M. Aucouturier, S. Colinart, J-C. Dran, M. Gunn, R. May,
 B. Moignard, J. Salomon, P. Walter, I. Colson, A-M. Laurent, M. Leroy

860 'All that glitters is not pseudogold': a study in pseudo-pseudogilding /
 G. Eggert, H. Kutzke

865 Application of corrosion data to develop conservation strategies for a historic
 building in Antarctica / J. Hughes, G. King, W. Ganther

871 In situ corrosion monitoring of the iron shipwreck City of Launceston (1865) /
 I.D. MacLeod

Resins: Characterisation and evaluation / Résines: Caractérisation et évaluation / Resinas: Caracterización y evaluación

881 An investigation of the photochemical stability of films of the urea–aldehyde
 resins Laropal® A 81 and Laropal® A 101 / E.R. de la Rie, S.Q. Lomax,
 M. Palmer, C.A. Maines

888 Durability of an epoxy resin employed in restoration of historical buildings /
 M. Frigione, M. Lettieri, A.M. Mecchi, U. Santamaria

894 Possibilities for removing epoxy resins with lasers / S. Scheerer, M. Abraham,
 O. Madden

Modern materials / Matériaux modernes / Materiales modernos

903 Analysis of materials, restoration practice, design and control of display
 conditions at the National Cinema Museum in Torino / O. Chiantore,
 D. Scalarone, A. Rava, M. Filippi, A. Pellegrino, D.P. Campagnoni

911 Ageing studies of acrylic emulsion paints / T. Learner, O. Chiantore,
 D. Scalarone

920 Making better choices for painted outdoor sculpture / A. Mack, A. Chang,
 S. Sturman

927 Deterioration and conservation of plasticized poly (vinyl chloride) objects /
 Y. Shashoua

935 Transparent Tubes by William Turnbull: the degradation of a polymethyl
 methacrylate sculpture / S. Willcocks

941 Poster session abstracts

958 Index of preprint authors / Index des auteurs des prétirages / Indice de autores de trabajos completos

959 Index of poster session authors / Index des auteurs des panneaux d'affichage / Indice de autores de posteres

960 Index of keywords / Index des mots-clés / Indice de palabras-clave

Sculpture and polychromy

Sculpture et polychromie

Escultura y policromia

Sculpture et polychromie
Sculpture and polychromy

Coordonnatrice : Myriam Serck-Dewaide

Durant la période triennale de 2000-2002, le groupe « Sculpture et polychromie » s'est agrandi de quelques dizaines de membres. Les renseignements et la bibliographie ont été fournis aux membres selon leurs demandes (par courrier électronique ou par la poste). Les communications étant devenues beaucoup plus faciles, la circulation des informations et le suivi des contacts avec les membres se sont largement améliorés. Une réunion intermédiaire s'est déroulée à Sienne en Italie les 20 et 21 avril 2001 et cela grâce à l'organisation et à l'accueil de Monsieur T.A. Hermanès, directeur du CERR (Centro Europeo di ricerca sulla Conservazione e sul Restauro di Siena, Santa Maria della Scala , Piazza del Duomo, 2 - I. 53100-Siena).

Le premier jour, consacré à une rencontre internationale, comportait 10 conférences données par des membres de notre groupe de travail et invités : Aubert Gérard (Vesoul, France) (remplacé par un collaborateur), Myriam Chataignière (Paris), Emmanuelle Mercier (IRPA, Bruxelles), Juan Carlos Bermejo-Cejudo (Maastricht), Rosaura Garcia Ramos (Vitoria), Anne Vuillemard (Strassbourg), Liliana Zambon (Paris), Chiara Piccini (Florence), Francesca Tonini (Udine) et moi-même. Les sujets traités étaient : la pratique de la désinfection à l'anoxie dynamique pour des sculptures de grandes dimensions, la sculpture égyptienne, la polychromie interne et externe des cathédrales, les retables et les interventions du XIXe siècle et enfin plusieurs interventions sur les reconstitutions et retouches suivies de discussions et de débats.

Le deuxième jour était très dense et un public nombreux a assisté à un programme de 12 conférences italiennes révélant tendances et travaux actuels en conservation, restauration et recherches en sculpture dans toute l'Italie. De fructueux contacts ont ensuite été établis.

A la fin de la période, deux bulletins bilingues auront été publiées : une en 2001 et une en 2002 (en préparation).

Anton Rager, notre collaborateur américain, n'a plus travaillé pour l'ICOM-CC après le 11 septembre; depuis, il a porté aide à ses compatriotes en participant notamment au déblaiement du World Trade Center.

Le travail des membres a été des plus passionnant. Au départ, plus de 15 sujets de recherche (abstracts) m'ont été soumis en préparation du Congrès de Rio. En fin de parcours, neuf articles et cinq posters ont été retenus.

Nous espérons des candidatures pour reprendre le poste de coordonnateur du groupe, car notre mandat s'achèvera à Rio.

Myriam Serck-Dewaide

During the three-year period of 2000 to 2002, the Sculpture and Polychromy Working Group expanded by several dozen members. Members received the bibliography and other requested information (by e-mail or regular post). Since communications have become considerably easier, information distribution and contacts with members have improved greatly. An Interim Meeting took place in Siena, Italy, 20-21 April 2001, organized and hosted by T. A. Hermanès, CERR Director (Centro Europeo di ricerca sulla Conservazione e sul Restauro di Siena/ European Research Centre for Conservation and Restoration in Siena, Santa Maria della Scala, Piazza del Duomo, 2 - I. 53100-Siena).

The first day was dedicated to an international session consisting of 10 lectures by members of our Working Group and guest speakers: Aubert Gérard (Vesoul,

France) (replaced by a colleague), Myriam Chataignière (Paris), Emmanuelle Mercier (IRPA, Bruxelles), Juan Carlos Bermejo-Cejudo (Maastricht), Rosaura Garcia Ramos (Vitoria), Anne Vuillemard (Strassbourg), Liliana Zambon (Paris), Chiara Piccini (Florence), Francesca Tonini (Udine) and myself. Topics were: disinfecting large sculptures with dynamic anoxia, Egyptian sculpture, polychromy of cathedral interiors and exteriors, altarpieces, 19th-century work, and numerous papers on reconstruction and retouching. Discussion and debate followed presentation of the papers. The second day was extremely busy and large audience attended the 12 Italian lectures covering sculpture conservation, restoration and research trends and current work throughout Italy. Many useful contacts resulted.

By the end of the triennium, we will have published two bilingual newsletters: one in 2001 and one in 2002 (in progress).

Since September 11, Anton Rager, our American colleague, no longer works for ICOM-CC. Instead, he is assisting his compatriots by participating in the World Trade Center clean-up operation in New York.

Members' work has been remarkably passionate. From the outset, I received more than 15 proposal abstracts of research topics for the Rio Triennial Meeting. In the end, we selected nine articles and five posters.

We are currently looking for candidates for the position of group coordinator, since our term ends in Rio.

Myriam Serck-Dewaide

Abstract

The cooperation between the sculptors Juan Bautista Vázquez, 'the Old Man', and Jerónimo Hernández with the painter Antonio Mohedano created a masterpiece of the Spanish mannerism. With regard to polychromy, it shows a very rich technical and ornamental repertory, thus following the last third of the 16th century's style. The Spanish Renaissance tradition meets in these travelling masters coming from Avila, in Castilla, where they worked before moving to Andalucía and having previously lived in Toledo. The role of both artists in introducing Italian mannerist innovations in Andalucía was tremendously far-reaching. The work by the IPHE in the conservation of the Lucena retabule allows us the rare opportunity to study it in cooperation with a multidisciplinary professional team. The data contained in the preserved documents have been compared with the results of the laboratory tests; the gilding and polychromy were analyzed.

Resumen

La cooperación entre los escultores Juan Bautista Vázquez, 'el viejo', y Jerónimo Hernández, junto con el pintor Antonio Mohedano, dio como fruto la creación de una obra maestra del manierismo español. Respecto a su policromía muestra un rico repertorio de los motivos y técnicas de ejecución vigentes en el estilo del último tercio del siglo XVI. La tradición del Renacimiento Español se ve representada en estos artistas viajeros procedentes de Avila, en Castilla, donde trabajaron antes de trasladarse a Toledo y Andalucía. El papel de ambos artistas como introductores de las innovaciones del manierismo italiano tuvo gran alcance en Andalucía. El trabajo desarrollado por el IPHE en la conservación del Retablo de Lucena nos brinda la oportunidad de realizar su estudio mediante la colaboración conjunta de un equipo profesional multidisciplinar. Los datos aportados por los documentos que se conservan se han comparado con los análisis de laboratorio, donde se han analizado los dorados y las policromías.

Retablo mayor de San Mateo de Lucena, Córdoba: Estudio Técnico

Ana Carrassón López de Letona, Teresa Gómez Espinosa★
Instituto del Patrimonio Histórico Español
Greco 4,
28040 Madrid, España
E-mail: acl@apdo.com, teresag.espinosa@iphe.mcu.es

Historia del retablo

El templo de San Mateo, fundado por los marqueses de Comares, data de la primera mitad del siglo XVI. La documentación de su retablo mayor nos permite conocer sus comitentes, autores y fechas de realización. El 25/10/1570 Gerónimo Hernández se compromete a ejecutar en tres años la arquitectura, ensamblaje y talla del retablo en la Notaría Apostólica de Córdoba.[1]

Dos años después, este proyecto fue sustituido por otro de mayores pretensiones, concertado en Sevilla, en el que Juan Bautista Vázquez, 'el Viejo', escultor castellano maestro de Hernández, se compromete a hacer la imaginería, aumentando el número de historias (ver Figura 1). El plazo de ejecución se estableció en dos años, durante los cuales se iría entregando la obra en cuatro fases. El precio de la arquitectura se había fijado en 1.200 ducados, el de la escultura en 1.500; los pagos se efectuarían en correspondencia con las fases estipuladas de entrega de la obra.

El retablo terminó de asentarse el 1 de diciembre de 1579. Para asentar los retablos se desplazaban oficiales especializados del taller donde se había labrado y el cliente corría con los gastos de la cabalgadura y la manutención; pero cuando el retablo tenía suficiente entidad era el maestro el que iba al lugar para dirigir las operaciones. Así lo hicieron Hernández y Vázquez permaneciendo más de un mes en Lucena y haciéndose cargo de los gastos. Finalizada la obra, Hernández rogaba al obispo que se le indemnizase por el aumento de costes que esto había supuesto. El retablo estuvo en blanco, al menos, hasta 1598, año en que se contrata la policromía. Pasaron bastantes años hasta que fue desmontado para ser policromado, algo frecuente en obras de esta envergadura, pues las policromías, abundantes en oro, suponían un elevado presupuesto.

La tasación se realizó el 26 de febrero de 1580, llevándola a cabo Juan Bautista Monegro – uno de los escasos retablistas españoles familiarizado con los preceptos palladianos – representando a Hernández y a Vázquez, y Juan de Orea, Maestro Mayor de la Alhambra, por parte de la iglesia. Resultó un precio total de 5.796 ducados, obviamente rebasaba lo estipulado en el contrato. Esta demasía suscitó el pleito que inició la fábrica al estimar excesivo el peritaje. Se zanjó el problema validando el veredicto de los peritos y ordenando que se hiciese efectivo.

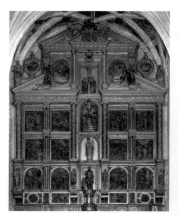

Figura 1. Retablo de San Mateo de Lucena.

★Autor a quien dirigir la correspondencia

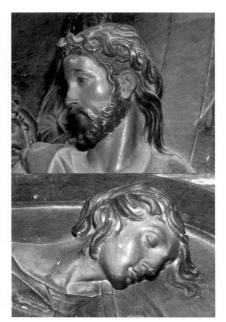

Figura 2. Ecce Homo, de Vázquez. San Juan evangelista, de Hernández.

Cuando Hernández proyecta el retablo de Lucena acusa los preceptos de tratadistas italianos como Bramante, Serlio y Palladio. Aplicó sus conocimientos e ideas innovadoras en este retablo experimentando con nuevos elementos arquitectónicos, en ocasiones puramente decorativos.

El resultado es un original y complejo conjunto manierista, donde los elementos arquitectónicos adquieren gran relieve, quedando la labor escultórica abigarrada entre aquellos.

Son muchas las novedades que aporta Hernández en el retablo de san Mateo:

- En 1572 marcaba un hito en la evolución de la arquitectura en madera sevillana: romper los frontones del monumental ático del retablo de Lucena y originar los tres tipos de frontón partido que desarrollaría la retablística andaluza: frontón roto de segmentos curvos, de segmentos rectos y de segmentos alabeados, tal como se suceden en el ático.
- Las excepcionales cajas de contorno ovalado que contienen las dos escenas pasionales al lado del Calvario.
- Incorpora en el ático la columna entorchada y en las columnas de orden gigante la variante de decorar el fuste con tallos de zarcillos espirales, modelo que preludia la columna salomónica.

Las autorías

La presencia de varias manos en la ejecución de las esculturas es algo común en estos grandes retablos (ver Figura 2). De la mano de Hernández son las imágenes de los evangelistas del banco, de gran calidad, como lo son también las figuras del ático, con variantes de estilo, pues las virtudes son las obras con referencias más directas a las estatuas de la antigüedad, mientras que los dos profetas responden al estilo de Castilla.

El resto de la imaginería es obra de Vázquez, 'el Viejo', y de su taller, así se aprecian notables diferencias de calidad entre unas y otras. Además de la mano directa de Vázquez, se pueden distinguir otras dos de inferior calidad. Las escenas situadas en el primer cuerpo son las más cuidadas y es donde se hace más evidente el estilo elegante y delicado del maestro, aunque también se encuentran relieves de excelente calidad en los cuerpos más altos.

Algunas de las figuras de bulto de la calle central han sido tan manipuladas que resulta difícil enjuiciar su primitiva calidad; es el caso de san Mateo y la Asunción. No ocurre lo mismo con el Resucitado, una figura muy notable que protagoniza una arriesgada composición. Entre los cuatro apóstoles del primer cuerpo, los pequeños son los que mejor responden a la influencia de la escuela castellana, concretamente al estilo de Berruguete; los más grandes se han concebido de acuerdo a conceptos más clásicos y resultan menos expresivos.

Antiguas restauraciones

La única restauración documentada afecta principalmente a las zonas inferior y central del retablo. Tuvo lugar en 1777 y la realizó Luis Márquez Reciente, respondiendo la repolicromía al gusto contemporáneo, en contraposición con la del siglo XVI, que es de excepcional calidad. Tal acción se justificaba de la siguiente manera: 'renobado el estofado de las Ymágenes del Retablo…por estar mui indecentes y con muchas faltas de dedos, cabezas…'.

Las figuras completamente repolicromadas son los apóstoles del primer cuerpo, san Mateo y la Asunción. En todas se detecta la policromía original subyacente, salvo en la del titular. En estas imágenes se aplicaron nuevos aparejos para ser repolicromadas y lograr los relieves cincelados. La repolicromía es tosca y su escaso mérito se ve más mermado al compararse con la de Mohedano. Sólo tiene calidad en las vestiduras de la Virgen; en la cenefa del manto el motivo principal es la rocalla; está realizada en relieve, modelado en el aparejo, y dorada al agua. Entonces debieron manipular el rostro de estas imágenes para incluir ojos postizos de vidrio, como añadirían también los orillos de encaje, de los que aún subsisten restos.

Esta restauración hizo que la policromía primitiva quedase en gran parte oculta, y en algún caso destruida. Posiblemente correspondan al mismo momento la

Figura 3. Detalle del ático. Ensamblajes.

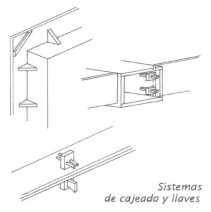

Sistemas
de cajeado y llaves

Figura 4. Ensamblajes y refuerzos.

mayoría de los repintes que afectan al conjunto de la imaginería. Hay otros, aislados y puntuales, muy oscurecidos, que pudieran corresponder a otras intervenciones.

En la zona inferior del retablo se ven alteraciones debidas a la instalación de dos baldaquinos que se pusieron sucesivamente delante del retablo. Primero fue un templete de estilo neoclásico que allí se dispuso en 1851 y se mantuvo hasta 1902, año en que se sustituyó por otro de gusto neogótico que se retiró en los años sesenta.

No podemos hablar de una intervención única en el conjunto del retablo, parece más correcto pensar en varias reparaciones acometidas en distintas ocasiones.

Materiales y construcción del retablo

De la documentación se han extraído datos de especial interés relativos a las maderas empleadas. Vázquez aceptaba: 'toda la cual dicha ymagineria me obligo de hazer e acabar y entregar a la dicha fábrica y a su mayordomo en su nombre en esta ciudad de seuilla de buena obra y madera de pino de sigura o cedro de Yndias si en esta ciudad lo oviere en esta manera'.

En el memorial de tasación del retablo consta el volumen de madera empleado: 20 pinos en la imaginería, 275 bornes – así denominaban comúnmente al roble en Andalucía – y 24 pinos en la arquitectura. El valor de un pino en Sevilla era de 7 ducados, el de un borne 1 ducado. El precio total fue de 583 ducados.

Aunque el análisis de las maderas constituyentes de esta obra aún no está concluido, se han identificado a simple vista dos tipos: conífera y roble, lo que corresponde con los datos documentales. Éste último se utilizó principalmente en la arquitectura, no obstante se encuentran también algunas esculturas y relieves de roble, así como el pino se empleó en esculturas y elementos estructurales. No se ha localizado el cedro de Indias.

El retablo mide 11.41 x 8.35 m y se adapta al testero plano de la cabecera. Asienta sobre basamento de piedra – de la sierra de Cabra – y se organiza en banco, tres cuerpos, o dos si consideramos segundo y tercero como integrantes de un solo orden gigante, divididos en cinco calles y ático. A partir del banco, se asegura al muro con ocho gruesas vigas de carga, distribuidas las cuatro primeras tras las ménsulas del banco y las cuatro siguientes bajo las grandes columnas. Tras el entablamento del tercer cuerpo, hay otros cuatro puntos de anclaje al muro actuando como tirantes, igual que las tres últimas vigas en la cornisa del ático. Doce pequeños maderos, embutidos en la fábrica, sirven de apoyo a las cajas.

La distancia entre retablo y fábrica del testero es mínima, salvo en los laterales del ático, lo que impide acceder a la zona posterior. El muro está rebajado verticalmente tras la calle central.

La gran cantidad de piezas de madera empleadas en este conjunto resulta extraordinaria en comparación con la mayoría de retablos estudiados. Los sistemas de unión y ensamblaje empleados varían según la función que cada elemento desempeña. El sistema de unión viva simplemente encolada puede aparecer reforzado por colas de milano y/o lañas de forja, numerosas en el conjunto (ver Figura 3). Con esta fórmula están construidas las historias, añadiendo barrotes. El fuste de las grandes columnas está realizado con seis piezas encoladas y reforzadas por lañas; las pequeñas están construidas con solo dos piezas.

Los relieves del banco tienen las uniones de sus tableros reforzados con colas de milano pasantes, a lo que se añaden dos barrotes y un tablero liso, insertado todo en un bastidor, fijado con clavos de forja, sistema que se repite en otros elementos estructurales.

En cajas y armazones se ha utilizado para ensamblar sus piezas perpendiculares la cola de milano, de considerable resistencia mecánica. La mayoría de estos armazones presentan en su interior, como refuerzo, calzos, ángulos y llaves (ver Figura 4).

Los relieves de los encasamentos se componen de varios tableros verticales (3/5), mientras que las historias del banco los presentan horizontales (2/3). Las cajas del primer cuerpo tienen fondo, al contrario de las de los cuerpos superiores, donde los relieves van directamente apoyados al muro. Estas cajas descansan sobre dos listones ensamblados por un extremo a cola de milano, en su entablamento, y por el otro recibidos al muro, con el refuerzo de un apoyo central empotrado en la fábrica.

Figura 5. Policromía. Detalle de estofados en la Visitación.

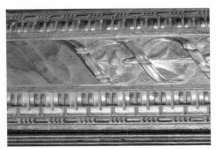

Figura 6. Ático. Veladuras sobre el oro y bol amarillo.

Figura 7. Banco. Veladuras sobre el oro.

Las esculturas de bulto también muestran numerosas uniones en su composición, utilizándose para asegurar algunas piezas espigas de madera. Las piezas van encoladas y enlenzadas, con lienzos de diferente grosor. Algunas imágenes del ático fueron talladas sin ahuecar en bloques con un fuerte torcimiento de las fibras de madera, añadiendo diversas piezas superpuestas en el frente para conseguir el volumen deseado. Las de la calle central también son macizas. Otras figuras del retablo sí están ahuecadas, como algunas del primer cuerpo.

En estas obras compuestas por gran número de dispositivos y módulos, ensamblados unos sobre otros, anclándose al muro y asegurándose cada módulo al elemento anterior y a su lateral contiguo, se crea una red de elementos interrelacionados y susceptibles de transmitir movimientos y desplazamientos de unas piezas a otras cuando se producen fallos.

Policromía

El dorado y la policromía se encargaron a Antonio Mohedano, quien lo contrató en 1598 y lo cobró en 1607, veintiocho años después de haberse finalizado el retablo. Aunque no se sabe con precisión cuando se empezó el trabajo, si se conoce la documentación de 1607 en la que se detallan las condiciones de pago al artista.[2] El trabajó ascendió a 6.500 ducados.

La policromía de Mohedano es magnífica, de gran calidad técnica y riqueza decorativa (ver Figura 5). Elogiada ya por Palomino, quien la califica de magistral, se caracteriza por las encarnaciones mates y los ricos estofados. Combina el estilo renacentista con innovaciones propias del barroco. Las encarnaciones mates corresponden al nuevo gusto naturalista que se impondría a principios del siglo XVII, pues cuando se terminó la obra escultórica aún estaban de moda las brillantes encarnaciones a pulimento. En los estofados persisten motivos decorativos propios del siglo XVI junto a decoraciones características de las obras en que ya se han impuesto las normas derivadas de la reforma trentina. Se echan en falta los grutescos renacentistas; sin duda, Mohedano, un pintor manierista, conocía aquellas obras, pero tuvo que adaptarse a la nueva doctrina, que rechazaba todo aquello que atentase contra el decoro de las imágenes sagradas.

En bibliografía antigua se llegó a decir que esta obra era de bronce, no les faltaba cierta razón, pues el dorado de la arquitectura se trató con intención de lograr un efecto broncíneo. Los oros – dorados al agua – fueron cubiertos por unas finas veladuras traslúcidas para conseguir ese efectista acabado. Se encuentran, con variedad de matices, tanto en elementos arquitectónicos como escultóricos (ver Figuras 6-7). Así puede compararse el dorado broncíneo de las virtudes del ático con el cobrizo de los relieves del banco. La utilización de veladuras sobre dorados nos ofrece una particularidad rara en otros conjuntos. Por otro lado, se puede apreciar el juego de contrastes entre el dorado mate y el bruñido; se han localizado superficies 'mateadas', sobre los dorados bruñidos, logradas a base de un fino cincelado que cubre figuras y detalles decorativos.

El estudio científico de las policromías lo ha realizado Marisa Gómez, quien tomó muestras representativas del conjunto y efectuó paralelamente los ensayos previos a la limpieza. Las técnicas de análisis empleadas en los Laboratorios del IPHE han sido las siguientes: Microscopía óptica y microanálisis, Espectrometría de IR por transformada de Fourier (FTRI), Microscopía electrónica de barrido-microanálisis por dispersión de energías de RX, cromatografía en capa fina, de gases y líquida.

Los aparejos se han realizado aplicando una capa de cola sobre la madera y después varias capas de yeso gris y cola animal, a las que se superponen las de yeso blanco y proteína, para acabar con una impregnación aislante de cola. Su espesor varía dependiendo de la zona que cubren, así en las encarnaciones el espesor es menor.

En el embolado pueden distinguirse dos colores: rojo muy intenso y amarillo tostado, éste último utilizado en zonas ocultas de la arquitectura. Los panes de oro asientan sobre estos aparejos. Las láminas de oro son de mayor espesor que lo habitual en otros retablos de la época, pero de calidad algo inferior al llevar mayor cantidad de plata.

Los estofados son más variados, complejos y de ejecución más delicada en el banco y en las historias del primer cuerpo. El repertorio de motivos esgrafiados es

Figura 8. Policromía. Paisaje estofado.

prolijo: ojeteados, escamas, líneas rectas y onduladas, rayas intermitentes, triángulos, retículas, grecas, eses, motivos vegetales entrelazados, cintas y motivos geométricos que van formando dibujos y combinaciones variadas. En las vestiduras alternan con motivos realizados a punta de pincel, fundamentalmente vegetales: flores y frutas. En los fondos de los relieves se estofan paisajes y arquitecturas.

La paleta de colores es muy rica en todo el conjunto. Se encuentran colores tornasolados en las vestiduras, con gradación cromática de tonos dentro de una misma gama, algo que sí era común en la policromía manierista. Abundan las finas veladuras, predominantemente opacas, empleadas para lograr una mayor riqueza de efectos.

Destaca la calidad de los pigmentos empleados en los estofados: albayalde, azurita natural, malaquita, bermellón, laca roja y amarillo de plomo y estaño. La mayoría de los estofados van sobre una delgada imprimación blanca, cuyo espesor no suele exceder de 5 micras. Los tonos más intensos están hechos con pigmentos puros, como los azules de azurita natural, de molienda homogénea y gran pureza, aplicada sobre imprimación blanca; o los verdes de malaquita muy pura, con grano de mayor tamaño, dispuesta directamente sobre el oro. Las capas rojas son más delgadas, ya que el bermellón es un pigmento más cubriente, y están realzadas por veladuras de laca roja. Los tonos más claros se adquieren añadiendo albayalde a los pigmentos mencionados. Ciertos matices verdes se logran mezclando azurita y amarillo de plomo y estaño; los violetas se componen de azurita, laca roja y albayalde.

Las encarnaciones mates están realizadas al óleo con aceite de linaza cocido como aglutinante. El aparejo en ellas es más fino y las imprimaciones, blancas, amarillentas o ligeramente anaranjadas, se componen de albayalde con pequeñísimas cantidades de minio, utilizado como secativo. En las carnes rosadas y rojizas el albayalde se ha mezclado con cantidades variables de bermellón y tierras. Las encarnaciones de los cristos tienen matices azulados y rosados, compuestos por albayalde, azurita y trazas de laca roja, todo sobre imprimación blanca. La preparación de los cabellos es similar a la de las encarnaciones y en un caso se ha detectado huevo como aglutinante; los pardos se obtienen mezclando tierras, negro carbón y bermellón, los grises con albayalde, negro carbón y tierras.

En los relieves de la mazonería la gran mayoría de las figuras presentan la rara particularidad de tener las encarnaciones esgrafiadas, pues en las zonas encarnadas no solían realizarse estas labores.

La repolicromía diociochesca presenta un aparejo semejante al anterior, aunque no se ha detectado la anhidrita, ni se distinguen dos tipos de yeso. El bol es de color pardo rojizo, menos homogéneo y con menor proporción de hierro y aluminio que el anteriormente descrito. El pan de oro es más fino y de calidad superior; se encuentra bruñido y al mixtión. Hay corlas rojas sobre plata – en la original se han encontrado sobre oro – realizadas con cochinilla fijada sobre alúmina. Los azules son de albayalde y azul de Prusia. El pigmento rojo es bermellón. Los aglutinantes son aceites secantes y huevo (en algunos estofados). Las encarnaciones son también mates, el rostro de la Asunción es muy claro y se compone de dos capas sucesivas, espesas, de albayalde y trazas de laca roja, aglutinados con aceite de nueces.

Se han encontrado recubrimientos posteriores de distinta índole en toda la superficie: Pardos, verdosos y blanquecinos, posiblemente consecuencia de anteriores intervenciones que han oscurecido con el tiempo, por oxidación y adhesión de polvo. Según su naturaleza, pueden clasificarse en cuatro tipos: cera de abejas (opacos, blanquecinos o grises), proteínas mezcladas con aceite no secante (probablemente huevo) y con pigmentos pardos (tierras), aceite de linaza y una resina de colofonia.

Tras el estudio del retablo y su estado de conservación se procedió a su tratamiento. Los criterios generales de intervención han estado enfocados al respeto y conservación de la obra.

Conclusión

El retablo de san Mateo es el primer exponente del manierismo en la retablística andaluza y su trascendencia en este contexto es indiscutible. El análisis de su policromía constituye una interesante aportación para el conocimiento de la obra del artista, pues la mayoría de su producción se ha perdido. Mohedano fue un

pintor renacentista que tuvo que adaptarse, con el cambio de siglo, a los nuevos postulados contrarreformistas. Siendo esta obra de gran interés en tantos aspectos, hay que destacar la importancia de que conserve las veladuras que confieren a los dorados esa apariencia broncínea, pues, aunque es técnica teóricamente conocida, es raro encontrar una obra en la que se conserven estos acabados, que suponemos se han eliminado en otros casos por desconocimiento y por la dificultad de identificarlos entre suciedades y barnices. Otra rara particularidad es la utilización de numerosas piezas de madera en la composición de arquitecturas y esculturas. Estás tuvieron que reforzarse con lañas antes de la policromía, debido al largo tiempo que permaneció en blanco.

Agradecimientos

A Marisa Gómez, del IPHE, responsable de los análisis de policromías. A Marian García y Montse Algueró, por su contribución. A Rocío Bruquetas, del IPHE, por su colaboración en el estudio técnico. Y a la empresa CORESAL por su participación en los estudios previos y por los dibujos.

Notas

1 Archivo General del Obispado de Córdoba. Sección: Provisorato. Leg. 1, 12r–15v
2 González Zubieta, 1978

Referencias

González Zubieta, R, 1978. *Vida y obra del artista andaluz Antonio Mohedano de la Gutierra*, Córdoba.
López Martínez, C, 1929, *Desde Jerónimo Hernández hasta Martínez Montañés,* Sevilla y 1932, *Desde Martínez Montañés hasta Pedro de Mena*, Sevilla.
López Salmanca, F, 1996, *Historia de Lucena* (II), Lucena.
Palomero Páramo, J M, 1981, *Gerónimo Hernández*, Sevilla, 89–92, 1983 y *El retablo sevillano del Renacimiento. Análisis y evolución (1560-1629)*, Sevilla, 261–264.
Palomino de Castro, A, 1795, *Museo Pictórico y Escala Óptica*, Madrid, II, 839.
Ramírez Luque, F, 1778, *Tardes Divertidas*, Lucena, 395–396.

Abstract

The conservation of the portal representing the Nativity and the Baptism of Christ in Sevilla's Cathedral, attributed to the architect Charles Gauter de Ruan, had as its objective the preservation of both the original parts and those historical additions which did not represent a danger to the supporting materials. A maintenance plan was developed according to a diagnosis of the monument's deterioration process, the measures adopted to stabilize it, the potential risks it will face and the possibility of controlling them. Once the incidence of each deterioration factor is assessed, regular inspections will be established to detect new damages. According to the results of these inspections, future actions will be planned to avoid the progressive deterioration of the portals.

Resumen

Las intervención en las portadas del Nacimiento y del Bautismo de la Catedral de Sevilla, del arquitecto Charles Gauter de Rúan, ha tenido como objetivo la conservación del monumento, manteniendo las adiciones históricas que no entrañaban riesgo para los soportes. Se redactó un Plan de Conservación basado en el diagnóstico de los procesos de alteración, las soluciones adoptadas para estabilizarlos, los riesgos a que está sometido, y las posibilidades de control de los mismos. Basándose en la valoración del grado de incidencia de cada uno de los factores de deterioro, se ha establecido la periodicidad con la que se deben realizar una serie de inspecciones, cuyo objetivo es el detectar la aparición de nuevos daños. Dependiendo de los resultados de estos exámenes, se plantean las intervenciones necesarias para evitar el progresivo deterioro de las portadas.

Palabras claves

Sevilla, Catedral, terracota, conservación, mantenimiento

Metodología de intervención en las portadas del Nacimiento y del Bautismo de la Catedral de Sevilla: programa de mantenimiento

Concha Cirujano
Instituto del Patrimonio Histórico Español
Calle Greco 4
28040 Madrid, España
E-mail: concha.cirujano@iphe.mcu.es

Fernando Guerra-Librero
CORESAL
Calle Donoso Cortés 90
28015 Madrid, España
Fax: + 34 91 544 2144
E-mail: conservacion.b.c.@coresal.com

Teresa Laguna Paúl
Catedral de Sevilla
Avenida de la Constitución s/n
41004 Sevilla, España
E-mail: teresalaguna@CAPROF.US.ES

Introducción

Las portadas del Nacimiento y del Bautismo de la Catedral de Sevilla son obra del Maestro Mayor Charles Gauter de Rúan, documentado en Sevilla entre 1435 y 1477. Este 'Maestre Carli' levantó la mayor parte del sector occidental de la catedral, señalando con su marca de control los lienzos de ambos ingresos. El Maestro Mayor Juan Normán terminó las cornisas altas en 1449 y quince años después Lorenzo Mercadante de Bretaña inició las esculturas de barro cocido en estas portadas, cuyo programa iconográfico es unitario, aunque se realizó en varias etapas (figura 1).

El tímpano de la portada del Nacimiento de Cristo, realizado por Mercadante, es de acusada ascendencia nórdica y queda cimentado por los evangelistas de las jambas precedidos por los santos sevillanos San Laureano y San Hermenegildo. Los dos profetas, situados en línea con el dintel de acceso, están atribuidos a Pedro Millán.

En la otra portada, las esculturas de Cristo, San Juan Bautista y un ángel conforman el bautismo, realizado a principios del siglo XVI. Las esculturas de sus jambas, muy cercanas a Mercadante, muestran los orígenes de la Iglesia hispánica de Sevilla: Santa Justa, San Fulgencio, San Leandro, San Isidoro, Santa Florentina y Santa Rufina. En el arranque de sus arquivoltas, los profetas sedentes tienen las firmas de Pedro Millán.

Figura 1. Vista general de la portada del Nacimiento

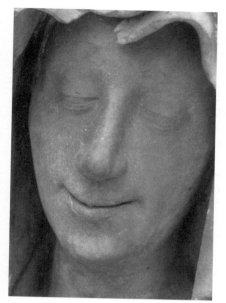

Figura 2. Acabado bruñido en el rostro de Santa Florentina

Figura 3. Marca de los palillos de modelado

Antiguas intervenciones

Apenas existen fuentes y documentación relativas a las intervenciones y restauraciones de ambas portadas de la catedral de Sevilla.

La primera referencia la hizo D. Antonio Ponz en 1786, al publicar que las esculturas habían sido restauradas y cubiertas por una protección al óleo. Sin embargo en el Archivo de la Catedral no se ha encontrado constancia o pago de esta intervención, quizás porque fue realizada como tarea ordinaria de mantenimiento.

En diciembre de 1889, Joaquín Fernández Ayarragaray efectúa unas obras que, al parecer, se ciñeron únicamente a tapar y recibir las juntas de los sillares de la parte alta del lienzo. Pocos años después, en 1914, Joaquín de la Concha Alcaide realiza una intervención en varias portadas de la catedral, remodelando los zócalos y sustituyendo las hiladas de base. También repuso piezas en las cresterías y gabletes y el escultor José Ordóñez y Rodríguez acometió la restauración de las esculturas, reintegrando distintos elementos.

Desde esta fecha y hasta finales del siglo XX, las portadas no han tenido ninguna intervención significativa. A finales de la década de 1980, diversas instituciones comenzaron a llamar la atención respecto a la degradación y deterioro medioambiental que tenían.

Estudios previos

La Consejería de Cultura y Medio Ambiente de la Junta de Andalucía, a la vista de la problemática que presentaban ambas portadas, encarga en el año 1992 al Instituto de Ciencia de Materiales de Sevilla un estudio,[1] con objeto de conocer los materiales constitutivos, técnicas de ejecución de las esculturas, estado de conservación y factores y procesos de deterioro. Se conoció así la influencia del medio ambiente y del proceso de fabricación y cocción en el estado de conservación de las figuras de terracota, además de las alteraciones que presentaba el material pétreo.

Durante el proceso de restauración se efectuaron nuevos estudios, ensayos de envejecimiento de consolidantes, y análisis de materiales utilizados en las intervenciones anteriores. Asimismo, se colocaron unas sondas para evaluar la velocidad de deposición de particulas contaminantes sobre las superficies pétreas y de terracota, de cara a redactar un plan de mantenimiento.

Materiales y tecnicas de ejecución

La piedra es una caliza biocalcarenítica extraída de las canteras del Puerto de Santa María. Para las figuras de las jambas, los profetas sedentes del arranque de las arquivoltas y los motivos escultóricos de los tímpanos, se utilizó arcilla calcárea de las proximidades de Sevilla, posiblemente de Santiponce.

Del examen de las muestras cerámicas mediante DRX, se deduce la presencia de silicatos cálcicos neoformados durante la cocción, o de fases relictas no transformadas térmicamente, lo que indica que la cerámica ha sido cocida a distintas temperaturas. Esto se traduce en distinto grado de vitrificación y coloración que, en general, se corresponden con el peor o mejor estado de conservación.

El acabado de las superficies presenta diferentes texturas asignables a otras tantas técnicas. En los rostros, la superficie es bruñida (figura 2), mientras que en los paños de las vestiduras se pueden apreciar las huellas de los palillos utilizados para el modelado (figura 3).

Las figuras se modelarían en una sola pieza, ahuecándola y dividiéndola antes de la cocción. En el momento de la colocación de las esculturas, se unirían las piezas con mortero de yeso.

De los estudios previos se desprende que la escena del Nacimiento estaba policromada. El cabello del Niño sería dorado, así como las estrellas del pesebre que se superpondrían a un fondo azul. Durante la intervención en la portada del Bautismo, se recogieron muestras de diferentes recubrimientos para su análisis. En una de estas muestras, tomadas de la figura de Jesús, cuyo aspecto era el de una capa homogénea de color negro, se pudo comprobar que el componente principal era

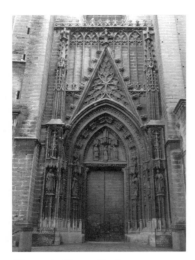

Figura 4. Desarrollo de costras negras en la portada del Bautismo

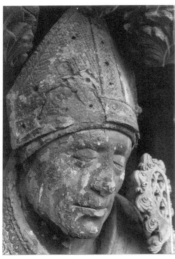

Figura 5. Formación de exfoliaciones en superficie bruñida

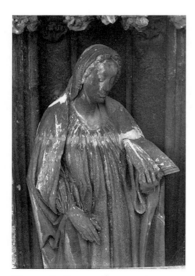

Figura 6. Escorrentías y costras negras en la figura de Santa Justa

yeso, con pequeñas proporciones de anhidrita y cuarzo. En el difractograma realizado apareció una reflexión de baja intensidad que podría atribuirse a la presencia de lanarkita, por lo que se puede pensar en restos de una capa alterada elaborada con blanco de plomo (albayalde).

En las esculturas de las jambas, no se han encontrado indicios de policromía durante la intervención, sin embargo todas conservan restos de aparejo de yeso con color ocre encima, aplicado en capas sucesivas que se extienden incluso sobre los rostros. La coexistencia de estas capas y de los restos de policromía, induce a pensar en la posibilidad de que originalmente las esculturas estuvieran total o parcialmente policromadas y que más tarde, al haberse perdido parte de la policromía, se recubrieran en un deseo de homogeneizar la tonalidad, ocultando a la vez las reposiciones y los morteros de unión de las distintas piezas.

Alteraciones

La piedra presenta como forma de alteración más acusada, la disgregación granular y el desarrollo de costras de yeso neoformado, a partir de la deposición de contaminantes ambientales (figura 4).

La terracota sufre alteraciones derivadas por un lado de su exposición al medio y por otro del proceso de elaboración. La pérdida de humedad durante el secado y cocción origina retracciones que se hacen patentes en la formación de grietas y fisuras. Además de ello, aparecen daños superficiales por el tipo de acabado y por las diferentes temperaturas a que se ven sometidas las piezas durante la cocción.

La técnica de bruñido produce un doble efecto ya que da lugar a la formación de una película superficial, con una porosidad sensiblemente inferior a la del barro sin bruñir; además las láminas de arcilla se disponen en bandas paralelas, mientras que su disposición en el resto es más heterogénea. Esta diferencia entre la capa externa y la interna da lugar a un deterioro diferencial en la zona de contacto, ocasionando exfoliaciones y desprendimientos (figura 5).

Los materiales ajenos a la obra, añadidos durante el montaje de las esculturas o en intervenciones anteriores constituyen a su vez otro factor de deterioro por su aporte de sales.

La capa de aparejo y policromía, además de una función estética, cumpliría un papel protector y su desaparición deja a la superficie cerámica expuesta a la acción de los agentes externos, más concretamente en los últimos años a la acción de los contaminantes atmosféricos y a las vibraciones, producidas por el intenso tráfico rodado que se registra en esta fachada de la catedral.

El diseño de los doseletes que protegen las figuras, favorece el lavado diferencial de las superficies, que afecta con especial intensidad a rostros, hombros y a zonas sobresalientes de los pliegues de las vestiduras. En las áreas protegidas de la acción directa del lavado por agua de lluvia tiene lugar el desarrollo de costras negras, que adquieren un notable grosor en el interior de algunos de los pliegues de los mantos (figura 6).

En el examen mediante SEM, estas costras aparecen constituidas por un acúmulo de partículas heterogéneas entre las que se identifican enrejados de cristales lenticulares de yeso de neoformación, granos de cuarzo, filosilicatos, carbonatos, partículas contaminantes (cenoesferas silicoaluminatadas, partículas oquerosas sulfatado-carbonosas), granos de polen, e incluso partículas disgregadas procedentes del propio substrato cerámico. En los microanálisis realizados sobre estas costras se detectan concentraciones anómalas de plomo y fósforo.

Criterios y metodología de intervención

La intervención se centró en la conservación del original, eliminando las gruesas costras negras que, además de contribuir al paulatino deterioro del soporte, ocultaban las superficies, desfigurando la visión de las portadas. Se mantuvieron todas las adiciones realizadas tanto en el momento del montaje, como a lo largo de las diferentes intervenciones, siempre y cuando los materiales utilizados en ellas no supusieran un peligro para la conservación del original (figura 7). Las reposiciones se limitaron a aquellos elementos que cumplían una función estructurasl o de protección.

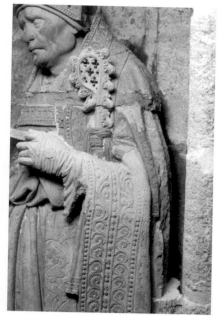

Figura 7. Reintegraciones antiguas en la figura de San Fulgencio

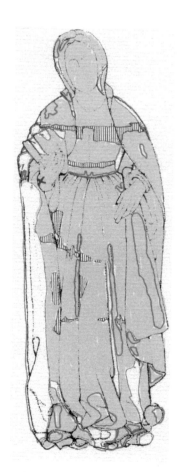

Figura 8. Cartografía de materiales

Tomando como soporte la fotogrametría, se realizaron cartografías en las que se recogieron la distribución de los materiales constitutivos, el sistema constructivo utilizado para las portadas, la localización de las alteraciones y la disposición de las diferentes capas existentes sobre la cerámica y el material pétreo (figura 8).

Con objeto de establecer los sistemas de limpieza más idóneos, garantizando la conservación de los escasos restos de policromía y de aparejo, se realizaron pruebas en zonas representativas del conjunto, lo que nos permitió conocer la naturaleza y grosor de las capas que se superponían a la superficie original, recogiéndose toda la información en fichas individualizadas.

Se efectuaron ensayos de limpieza mediante desincrustación fotónica, verificando mediante SEM su alta efectividad sobre la cerámica. Sin embargo, ante el peligro que suponía su uso en zonas que posiblemente conservaran algo de policromía, se decidió descartarlo para evitar posibles cambios cromáticos.

Se combinaron diferentes sistemas, dependiendo del grosor y composición de los depósitos de suciedad y del estado del soporte, conservando todas las capas de yeso aplicadas como protección. Los métodos empleados se recogieron un una cartografía de intervención.

Finalmente era necesario consolidar y proteger la superficie, por lo que se aplicó un éster del ácido silícico y un siloxano modificado, productos seleccionados a partir de los ensayos de envejecimiento. La intervención se completó con la instalación de un sistema electrostático que impedirá el anidamiento de aves. Los circuitos se situaron en puntos no visibles de la portada, dejando totalmente libres las esculturas.

Programa de mantenimiento

Entendemos por mantenimiento la labor cotidiana destinada a conservar sistemáticamente las condiciones necesarias del material, estructura y funcionalidad de un Bien Cultural, asegurando su supervivencia y transmisión futura. Por ese motivo, a la hora de redactar el proyecto, nos fijamos como objetivo final la elaboración de un programa de mantenimiento que permitiera detectar a tiempo los daños, evitando así la necesidad de intervenciones drásticas posteriores, ya que los factores extrínsecos que han originado el deterioro seguirán incidiendo sobre los materiales constitutivos de la obra.

A pesar de este carácter 'rutinario', toda acción de mantenimiento debe estar inserta en una planificación que englobe todos los procesos de conservación, unificando criterios y creando una normativa básica de actuación, que defina los diferentes controles e intervenciones y delimite la programación en el tiempo.

Es evidente que el instrumento primordial para garantizar la conservación de un Bien Cultural es el desarrollo sistemático de un mantenimiento, en concordancia con los objetivos que marcaron su restauración. La intervención de restauración debería ir seguida de un programa de controles periódicos que constaten la bondad de la metodología utilizada.

Un segundo objetivo es garantizar su propia continuidad, paliando el proceso de degradación natural y previendo futuras lesiones, y esto depende de que el programa de mantenimiento sea útil, eficaz y de fácil seguimiento.

En tercer lugar, el mantenimiento debe ser operativo y económico. Por tanto deberá ofrecer las siguientes características de actuación:

- continuidad de los objetivos de conservación
- economía de cada una de las tareas
- planificación a largo plazo, y revisión periódica del diagnóstico de origen
- mínima intervención, entendida como actuaciones limitadas estrictamente al mantenimiento.

Para cada Bien Cultural, los controles e intervenciones de mantenimiento, vendrán definidos por la previsión de daños que a lo largo del tiempo van a afectarle. Existen dos métodos lógicos para desarrollar esta previsión:

El primero de ellos consiste en analizar las causas, esto es, los agentes de alteración que tienen incidencia sobre el Bien Cultural. Una vez cuantificada la incidencia en relación a la gravedad de los daños que provocan, se puede obtener el índice de vulnerabilidad. Dado que cada factor de deterioro tiene asociadas unas

intervenciones y unos controles de mantenimiento imprescindibles, se puede obtener la periodicidad óptima para realizarlos.

El segundo se centraría en el análisis de la patología que sufría la obra, con objeto de hacer una previsión de posibles daños ulteriores cuantificando su intensidad a partir del estado de conservación inicial y de los procesos de restauración realizados.

Así, por ejemplo, para evaluar la incidencia que la lluvia tiene en los procesos de deterioro, se debe estudiar el régimen de precipitaciones; la composición del soporte y su fragilidad; porosidad y capacidad de alteración frente a la humedad; la forma del objeto y los sistemas de protección y por último la orientación, que tiene relación directa con la dirección e intensidad del viento y por tanto de cómo recibe el agua.

El resultado será la realización de dos tipos de intervenciones, unas asociadas directamente con los agentes de alteración y otras a la patología que le afecta. Con estos datos se puede redactar un manual de mantenimiento con un calendario de intervenciones y controles, fechas de realización y medidas de conservación preventiva a cumplimentar (ver Tabla 1).

Conclusiones

A pesar del reconocimiento general de que una intervención no tiene sentido si no va acompañada de un programa de mantenimiento, resulta excepcional que esta práctica se lleve a cabo aunque únicamente un control exhaustivo del monumento permitirá su conservación, dependiendo ésta la mayor parte de las veces de intervenciones puntuales y poco costosas.

Un programa de mantenimiento bien ejecutado, con una serie de rutinas de seguimiento y control, permite, además, obtener datos fiables sobre el comportamiento a largo plazo y en condiciones reales de los tratamientos aplicados, constituyendo una ayuda eficaz a la hora de plantear nuevas intervenciones.

Nuestra intención con este trabajo ha sido poner en evidencia la escasa vida de una restauración, cuando la obra sobre la que se interviene continúa expuesta a los mismos factores de alteración.

Las intervenciones sobre los bienes culturales son económicamente gravosas para los organismos encargados de su conservación, y constituyen en sí mismas un riesgo, que no tiene sentido asumir si posteriormente se abandona el Bien Cultural. Una buena gestión del Patrimonio debería implicar la implantación de programas de conservación preventiva y mantenimiento de los Bienes Culturales, asegurando así su supervivencia.

Agradecimientos

A la Consejería de Cultura de la Junta de Andalucía, por facilitarnos el estudio previo de las portadas. A José Vicente Navarro, geólogo del Instituto del Patrimonio Histórico Español, por su colaboración durante los trabajos de restauración.

Notas

1 Pérez Rodríguez, J L, Jiménez de Haro, M C y Justo Erbez, A et al. (1993), Estudio científico de las puertas del Bautismo y Nacimiento de la Catedral de Sevilla.

Referencias

Arquillo, F, 1990, 'El estado de conservación de las esculturas de Mercadante que decoran las portadas del Bautismo y del Nacimiento en la Catedral de Sevilla', *Revista Atrio 2*.

Baudry, M T, 1978, *La sculpture: methode et vocabulaire*, Ministére de la Culture, España.

Garcés Desmaison, M A, 1998, *La restauración como conservación, Restauración arquitectónica II*, Secretariado de Publicaciones e Intercambio Científico, Valladolid.

Gestoso y Pérez, J, 1889, *Sevilla monumental y artística*.

Gómez de Terreros, Mª V, 1996, 'Obras de Joaquín de la Concha Alcaide en la Catedral de Sevilla', *Laboratorio de Arte 9*.

Ponz, 1792, *Viage de España en que se dan noticia de las cosas más apreciables y dignas de saberse, que hay*. T. IX y XVII.

Tabla 1. Programa de mantenimiento de la portada del Nacimiento, Catedral de Sevilla

FACTORES	AGENTES DE VALORACIÓN	GRADO DE INCIDENCIA	CONTROLES DE MANTENIMIENTO ASOCIADOS	PERIODICIDAD OPTIMA DE CONTROLES	INTERVENCIONES DE MANTENIMIENTO ASOCIADAS	PERIODICIDAD OPTIMA DE LAS INTERVENCIONES
ATMOSFÉRICOS	LLUVIA	9	- Hidrofugante - Consolidación - Detección escorrentías - Detección acumulaciones de agua - Detección de patologías - Localización, cuantificación de daños	2 años	- Limpieza - Sellado de grietas y fisuras - Repaso de juntas abiertas - Hidrofugación	2 años, 3er cuerpo 6 años, 2° y 1er cuerpo
	VIENTO	6	- Cohesión del soporte - Estado del soporte - Estado de los consolidantes - Estado de los protectores - Detección erosiones y otros - Localización y cuantificación de daños	2 años	- Limpieza - Protección	6 años 1°,2° y 3er cuerpo
	TEMPERATURA	4	- Control de las temperaturas - Revisión y sellado de grietas - Revisión de uniones materiales diferentes - Localización, cuantificación de daños	6 años	- Sellado de grietas y/o fisuras abiertas - Sellado de juntas abiertas - Sellado de uniones de diferentes materiales	6 años 1°,2° y 3er cuerpo
AGUA	HUMEDAD RELATIVA	4	- Control de la Hr - Control de la insolación - Revisión de juntas - Localización, cuantificación de daños - Estado del hidrofugante	2 años	- Limpieza - Consolidación - Hidrofugación	2 años, 3er cuerpo 6 años, 2° y 1er cuerpo
	FILTRACIONES Y ESCORRENTIAS	10	- Control de la Hr - Control de las temperaturas - Control de la insolación - Estado de consolidación del material - Focos bióticos - Eflorescencias y criptoeflorescencias - Localización, cuantificación de daños - Revisión juntas, grietas y fisuras - Estado de las protecciones	2 años	- Limpieza - Desalación - Tratamiento biocida - Hidrofugación - Consolidación si es necesaria	2 años, 3er cuerpo 6 años, 2° y 1er cuerpo
QUIMICOS	PARTICULAS SALINAS	7	- Localización, cuantificación de daños - Control de emisiones contaminantes - Localización, cuantificación de daños	2 años	- Limpieza - Protección	2 años, 3er cuerpo 6 años, 2° y 1er cuerpo
	SALES SOLUBLES	10	- Controles de Hr y T - Controles de humedades - Localización, cuantificación de daños	2 años	- Limpieza - Desalación - Protección	2 años, 3er cuerpo 6 años, 2° y 1er cuerpo 6 años, 2° y 1er cuerpo
CONTRUCTIVOS	IDONEIDAD DEL MATERIAL. ELEMENTOS DE PROTECCIÓN	10	- Estabilidad de los materiales - Revisión de uniones, anclajes... - Revisión de grietas y fracturas - Localización, cuantificación de daños	2 años	- Sellado de anclajes - Consolidación del soporte - Sustitución de elementos si procede	2 años, 3er cuerpo 6 años, 2° y 1er cuerpo

Piedad de Aleijadinho en Felixlândia, Minas Gerais, Brasil

Resumé

Estudio acerca de una imagen
atribuída a Antônio Francisco Lisboa,
apodado 'Aleijadinho', considerado el
máximo artista del período colonial
del Brasil. El objeto de estudio es su
conservación-restauración, bien como
la constatación de la procedencia de
tal atribución. Imagen tallada en
madera policromada, de la segunda
mitad del siglo 18, de la ciudad de
Felixlândia, Minas Gerais, Brasil.
Aparte de su valor histórico y
artístico, posee también grande
importancia de devoción. Se
ejecutaron estudios históricos,
técnicos, iconográficos, formales y
estilísticos. La restauración le dio un
nuevo valor a la escultura,
devolviéndole sus colores originales.
Las características encontradas nos
conducen a afirmar ser una obra casi
desconocida, de gran calidad artística,
llevada a cabo por Aleijadinho.

Palabras claves

escultura, policromía, madera, siglo 18,
Aleijadinho, atribución, conservación,
restauración, Brasil

Beatriz Ramos de Vasconcelos Coelho★
Maria Regina Emery Quites
Moema Nascimento Queiroz
CECOR, Centro de Conservação e Restauração de Bens Culturais Móveis
Universidade Federal de Minas Gerais
Av. Antônio Carlos, 6627
30270-010 Pampulha, Belo Horizonte, Minas Gerais, Brasil
E-mail to: beatrizrcoelho@aol.com

Historial

En el siglo 18, en Minas Gerais, había una hacienda denominada del Bagre,
perteneciente al Padre Félix Ferreira da Rocha. En 1762 este sacerdote hace una
donación de un terreno destinado a la construcción de una capilla con la invocación
de Nuestra Señora de la Piedad. En 1948 el sitio, alejado de la zona de actuación
de Aleijadinho, se transformó en municipio, recibiendo en 1949, el nombre de
Felixlândia en homenaje al Padre Félix.

No es posible determinar la fecha de la construcción de la primitiva capilla, sin
embargo, se sabe que fue demolida y que pasó a ser otra de mayor tamaño. En 1949,
se lanzó la fundación del actual santuario de Nuestra Señora de la Piedad.

La primera referencia a la imagen de Nuestra Señora de la Piedad como obra del
Maestro Antônio Francisco Lisboa data de 1881, de acuerdo con A. Gabriel (1949) que
afirmó: 'es una tradición, ya registrada por el Canónigo Severiano de Campos Rocha,
que la hermosísima imagen de Nuestra Señora de la Piedad, Patrona de la Parroquia,
es obra del famoso Aleijadinho'.[1] Armando Anastasia (1971) relata que llegó a
Felixlândia y vio lo que consideró 'la obra maestra de Antônio Francisco Lisboa. Una
Piedad, la patrona de la parroquia, soberbia, divina, en un tamaño casi normal'.[2]
Vittório Lanari (1988), médico e investigador de la imaginaria de Minas, publicó un
artículo 'Desvelando los misterios de un genio' en el que describe cuatro esculturas que,
según él, serían de Aleijadinho, una de ellas, descrita en detalles, es Nuestra Señora de
la Piedad, de Felixlândia, 'Es una obra maestra que hombrea con los Cristos de los
Pasos de Congonhas'.[3] Márcio Jardim (1995) publica unas informaciones y una
fotografía de dicha Nuestra Señora de la Piedad.[4] No encontramos referencia a esta
escultura en ninguna otra publicación sobre Aleijadinho.

Técnica constructiva

Imagen de Nuestra Señora de la Piedad, en madera (*Cedrella* sp., Meliaceae)
policromada, que mide 112 x 97 x 54 cm, de talla entera, hueca, compuesta por
varios bloques (véase Figura 1). El principal está formado por la Virgen, gran parte
del cuerpo del Cristo y la base. Hay una tapa en la parte posterior que mide 88 cm
de altura y 48 cm de anchura, y otra tapa menor situada atrás de la cabeza de la
Virgen, fijadas con clavos. Aún existe otra, en la parte inferior, de formato
irregular y que mide 80 x 43 x 2 cm, que cierra la base de la escultura y que tiene
dos aberturas ovales de distintas medidas. Esta tapa inferior está asentada con clavos
al bloque principal y tiene un sistema de encaje dentado del lado derecho. En ella
encontramos, después de haberse removido la placa puesta a posteriori, una
inscripción de color beige 'fue encarnada en setiembre de 1886'. Dentro de la
escultura existen marcas de gubia y 17 pequeñas piezas de madera de formas
variadas y tamaños, colocados con clavos, que sirven de refuerzo para el soporte.

En la Virgen encontramos los siguientes bloques: mano derecha y dedo índice
de igual mano; parte del lado izquierdo del manto y las dos placas ya referidas. La
faz fue seccionada para la colocación de los ojos. Merced a radiografías pudimos
observar que los ojos son de vidrio, esféricos (cristal soplado), huecos, castaños

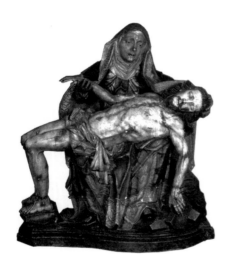

*Figure 1. Frente antes de la restauración
(Photo credit: Nadalin/Cecor)*

oscuros y con clavos para asegurar la cabeza. La abertura para la aureola es rectangular y se comunica internamente con la abertura de la boca. La lengua es una pieza separada y encajada.

El Cristo está compuesto por diferentes bloques de distintas dimensiones: cuerpo, piernas, parte de las piedras y de la base, los talones, las pantorrillas y el brazo derecho. Parte de la base se encuentra fijada al bloque principal con ganchos de metal.

En la Virgen, especialmente en el rostro, la carnación poseía un repintado rugoso y marrón. La túnica es azul y dorada, sin que parezca contemporánea de la carnación original. Las hojas de acanto del decorado son de hoja de oro no pulido, sobre masa amarilla que, a su vez, está encima del azul de la túnica, sin preparación. Esta manera de ejecución escapa de la técnica de policromía tradicional, pudiendo corresponder a la intervención referida en la inscripción de 1886. El borde de la túnica tiene relieves con hojas de oro cuya base es de agua, contorneado por un cordón de fibra vegetal, también dorado.

El manto es azul externamente y rosa en su interior, con bordes en relieve tanto del lado interno como externo. En tales relieves la doradura también se aplicó con hoja de oro a base de agua. Los zapatos son negros con relieves dorados.

El Cristo tiene la cabellera marrón oscura. El *perizonium* era beige, con bordes en ocre, habiendo sido dorado anteriormente, conforme resquicios encontrados.

En la parte inferior de la escultura hay una representación de piedras, agua o vegetación, y base de formato irregular. En la representación del agua o vegetación encontramos hoja de plata cubierta con laca verde, en resinato de cobre. Las piedras tienen un color gris azulado y la banda horizontal de la base se halla marmolizada en tonos rojizos.

Análisis formal

La composición es estática, simétrica, y el movimiento aparece sólo en los pliegues debajo del mentón, en el perizonium y en el cabello del Cristo. Predominan la diagonal del cuerpo del Cristo y la vertical que va de la cabeza a los pies de la Virgen. No hay drama en el rostro de la Virgen, que demuestra tristeza conformada y perplejidad. Ella está sentada, con las rodillas alejadas, la izquierda suavemente levantada con el pie apoyado sobre una piedra. La cabeza está cubierta con un tocado y un manto sin ver los cabellos y las orejas, y casi no se percibe, bajo la indumentaria, el cuerpo. El rostro es joven, oval, sin arrugas, con los ojos entreabiertos y mirando hacia abajo. La mirada y la boca entreabierta, bien como la depresión en forma de U que acompaña a la unión de las ceja con la nariz le dan expresividad a la Virgen. Las cejas caen en ligera diagonal. El párpado superior es bastante curvo y lagrimal bien definido. La nariz y las pestañas se unen a través de una arista en forma de Y. La nariz es afilada, con alas pronunciadas y proyección redondeada. La depresión nasal-labial es acentuada, formando un óvalo. La boca, pequeña y carnosa, está entreabierta, percibiéndose la lengua. El labio superior forma una M, con líneas curvas pronunciadas y abiertas. La depresión bajo el labio es fuerte, con el mentón en montículo y suave papada.

Las manos son pequeñas con dedos rollizos y falangetas más finas que las falanges y las falanginas. Las uñas son cortas, poseyendo implantación redondeada y extremidades rectas. Los nódulos de los dedos se notan muy claramente, estando el pulgar derecho en completa oposición a los otros dedos, mientras que en la mano izquierda el pulgar está casi paralelo a los demás dedos.

La Virgen lleva una túnica larga, azul, sujeta en la cintura. Los dobleces son definidos y redondeados. Como elemento decorativo, grandes hojas de acanto, duras y sin detalles, distribuidas en fajas verticales y paralelas. Tiene una barra inferior, con relieves desarrollados, en forma de ramos y flores, contorneada, en el área superior, por festón en fibra natural.

Un manto azul de forro rozado, cubre la cabeza y cae hasta el piso. Este manto tiene contornos en forma de relieve, tanto en la parte interior como exterior, con dibujo en forma de medias flores. Debajo del manto, se observa el tocado que describe, en lo más alto de la frente, dos curvas pronunciadas y unidas, formando una punta descendente. El tocado cuenta, debajo del mentón, muchos dobleces movidos y en arista, contrastando con el resto de la vestimenta. Los zapatos son negros, cerrados, con puntas finas idénticas, una flor estilizada dorada en relieve. La parte de atrás del manto es una placa azul, sin dobleces ni relieve (véase Figura 2).

Figure 2. Parte de atrás antes de la restauración (Photo credit: Nadalin/Cecor)

El Cristo, acostado sobre el regazo de su Madre, está con la cabeza horizontal y ligeramente hacia abajo. El rostro es triangular, con ojos cerrados y boca entreabierta. La nariz y las cejas se unen a través de aristas formando una Y. Los pómulos son salientes y el pelo dividido al medio, estriado, con mechas voluminosas y en movimiento. En la parte superior de la frente, dos mechas pequeñas y horizontales, en forma de S espejada. La barba tiene estrías transversales al rostro y los bigotes empiezan cerca de las ventanas de la nariz, dividida en finas mechas sinuosas. Hay algo de desproporción entre la cabeza, el tórax y las piernas del Cristo. En el tórax, se destacan las tetillas salientes, marcas de las costillas, una fuerte depresión ovalada debajo del esternón y el ombligo en forma de una gota en un círculo.

El brazo izquierdo baja verticalmente con la mano apoyándose en las piedras, y el derecho apoyándose en la mano de su Madre. Se ven las venas en ambos brazos. Las manos del Cristo son pequeñas, los dedos largos, las uñas cortas con implantaciones redondeadas y extremidades rectas. Los nódulos de los dedos están bien demarcados, especialmente en la articulación de los huesos en la mano izquierda. El pulgar derecho no está puesto de manera opuesta a los demás dedos y el izquierdo está casi paralelo a los demás dedos. Los muslos siguen la misma inclinación del cuerpo y las rodillas forman un ángulo recto. La anatomía de las piernas se marca muy bien, pudiéndose ver una depresión seguida de una saliencia, ya descrita por Lanari en 1988. Los pies se apoyan únicamente en ángulo recto sobre una piedra, son pequeños, sus huesos están muy bien marcados y la piel forma curvas alrededor de la perforación, que tiene una forma estrellada. Tal como en los brazos, las venas pueden verse. El dedo grande es menor que el segundo, habiendo una separación grande entre ellos, de forma rectangular.

El Cristo está sólo con el *perizonium,* que tiene muchos dobleces movidos y aristas, no pudiendo verse el tipo de sujeción.

La Virgen está sentada sobre piedras, angulosas y con muchas facetas, bajo las cuales salen, debajo de la cabeza del Cristo, unas estrías anchas y movidas, recordando el formato de una gran cabellera, y representando vegetación o agua. Debajo de las piedras hay una base de forma horizontal irregular, con curvas y rectas, pintadas de rojo marmóreo en la parte frontal.

Análisis estilístico

Los estudios muestran que las características técnicas encontradas son muy parecidas a las de San Juan de la Cruz y de San Simón Stock de la iglesia de Nuestra Señora del Carmen de Sabará, que cuentan con un documento probatorio de que la autoría le pertenece a Aleijadinho.[5] Son huecas, con placas que cierran las aberturas en la parte posterior. En el interior encontramos también piezas de madera de distintos tamaños como refuerzo; los ojos son esféricos, hechos con la técnica del vidrio soplado; los rostros están fijados a la cabeza con clavos.

En cuanto a la policromía de Nuestra Señora de la Piedad, la carnación es de excelente calidad, sin embargo, el vestuario es pobre en materiales y técnicas. El relieve del manto, superior al de la túnica, se asemeja a algunos encontrados en San Simón Stock, San Juan de la Cruz y en una Nuestra Señora de la Merced atribuida a Aleijadinho. No encontramos una explicación para las diferencias de calidad y de diseño de los relieves de la túnica y del manto. Podrían haber sido ejecutados por dos personas y en épocas diferentes. Un detalle interesante es que no fue usado ni punzón ni esgrafiado comunes en la policromia del siglo 18 y del inicio del siglo 19 en Minas Gerais.

Parece poco probable que la inscripción en la base inferior 'fue encarnada en setiembre de 1886', sea referente al policromado original, pues así la escultura habría quedado un siglo sin policroma. Consideramos que ésta podría ser la fecha del repintado.

Las características formales y estilísticas corresponden a las conocidas como de Aleijadinho. Pero había un detalle diferente: la barba contorneaba el rostro, sin ninguna separación, contrariando el estilo del artista que representa las barbas terminadas en dos espirales separadas, dejando libre el mentón (véase Figuras 3 y 4). Durante la restauración, se verificó que la barba se unía a través de un agregado hecho con yeso pintado. Este agregado se removió, habiendo quedado el rostro del Cristo con todas las características del maestro.

Hicimos comparaciones con los Cristos de los Pasos del Santuario del Buen Jesús de Matosinhos, en Congonhas, Minas Gerais, y con San Simón Stock y San Juan de la Cruz, de Sabará, todos comprobadamente de autoría de Aleijadinho. No tienen expresión dramática, incluso cuando en el Huerto de los Olivos, en la Flagelación o en la Coronación con espinas. Los cabellos de los Cristos de Congonhas son estriados, distribuidos en mechas sinuosas terminadas en volutas, con dos mechas horizontales, pequeñas y en curvas espejadas sobre la frente. En la Piedad, las formas del rostro, manos, piernas, pies y tórax, corresponden a las usadas por el Aleijadinho. Encontramos en el Cristo de la Piedad de Felixlândia, las saliencias infra-rotulianas, descritas por Lanari e idénticas a las de otras esculturas de los Pasos de Congonhas, en que aparecen las rodillas de los personajes. Pero, lo que más impresiona a quien estudia esa imagen, es la fuerza que emana en la representación de la Madre con su Hijo muerto en los brazos, que ningún discípulo o falsificador sería capaz de conseguir.

Si se compara con otra Nuestra Señora de la Piedad, también atribuida a Aleijadinho, podremos considerar que hay muchas semejanzas, como la composición general, la forma gestual y de la indumentaria. La de Felixlândia, empero, sería una obra posterior, más madura y más expresiva, aparte de tener una mejor solución anatómica en el Cristo, sin la fuerte desproporción entre tórax, cabeza y piernas.

Estado de conservación

Una capa oscura cubría toda la policromía, alterando su aspecto e impidiendo que se viese la carnación original de estupenda calidad (véase Figura 6). Había grietas principalmente en el repintado de las carnaciones y en los relieves del manto, bien como pérdidas en la región de las carnaciones. La túnica y el manto de la Virgen no tenían vestigios de policromía subyacente. La escultura tenía una enorme rajadura vertical en la región torácica de la Virgen, interrumpida en la altura del cuerpo del Cristo. Esa hendidura continuaba en la túnica, bajando de forma irregular hasta la base de la escultura y otra hendidura del lado derecho, cerca del zapato. Encontramos en la placa inferior y en la representación de las piedras, pequeñas áreas atacadas por insectos.

En el interior de la escultura había telas de araña, polvo, huevos, excrementos de insectos, manchas de humedad y de pintura blanca. La mano derecha del Cristo tenía fracturado el dedo anular y perdido el dedo meñique.

Fue observado el repintado en la carnación del Cristo, de la Virgen y en la base. Los hematomas y las heridas en relieve también eran intervenciones, con formas salientes y anaranjadas. Una intervención en madera revestía la base original de la escultura, fijada con clavos, laterales quebradas y una hendidura horizontal en la parte frontal.

Se encontraron cuatro ganchos de metal fijando las separaciones entre los bloques en la parte inferior de la escultura, quizá una intervención.

La escultura fue abierta para verificar las condiciones de conservación de la parte interna de la pieza, habiendo sido encontrados, además de los problemas ya descritos, 57 notas escritas, sin fecha y enrolladas o dobladas, dirigidas a la Piedad, pidiendo o agradeciendo gracias. Considerando la ortografía y el color del papel, eran recientes (véase Figura 5).

Tratamiento realizado

Se ejecutó la remoción del barniz oscurecido con Jabón de Resina en algunas áreas y Toluol+Dimetil Formamida (75:25) en otras. Luego de algunas prospecciones, se tomó la decisión de remover el repintado que cubría toda la pintura original en la carnación, tanto de la Virgen María como del Cristo, lo que se hizo con decapantes industriales y A4 (véase Figura 7).

Los criterios para esta decisión fueron: el repintado era de mala calidad, de aspecto tosco e irregular, con una fuerte red de grietas bastante oscurecida. Incluso luego del limpiado había, debajo del repintado, una policromía de muy buena calidad y en buenas condiciones de conservación; la remoción podría hacerse sin comprometer la policromía original; la excelente calidad de la escultura, cuya apreciación se perjudicaba en función de la mala calidad del repintado.

Después de esa etapa, se desinfectó la madera con Dragnet y se consolidó el soporte con aserrín, PVA y agua (1:1). Luego vino la complementación en las regiones de pérdidas y fisuras, salvo en la rajadura que existía en la parte frontal

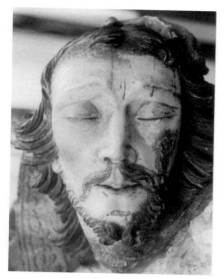

Figure 3. Barba con la intervención en el centro (Photo credit: B. Coelho)

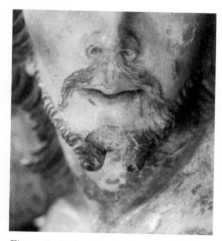

Figure 4. Barba después de remoción de la intervención (Photo credit: B. Coelho)

Figure 5. Area inferior de la base con los billetes (Photo credit: B. Coelho)

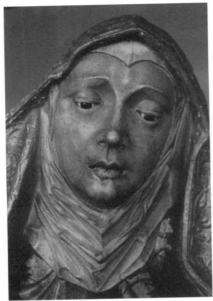

Figure 6. Rostro antes de la limpieza
(Photo credit: B. Coelho)

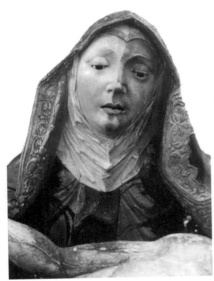

Figure 7. Rostro durante la limpieza
(Photo credit: B. Coelho)

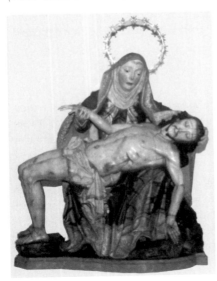

Figure 8. Después de la restauración
(Photo credit: B. Coelho)

de la escultura. En la parte interna de la escultura se hizo la limpieza y se aplicó un producto protector de madera, Osmocolor®. La reintegración cromática fue ejecutada con Maimeri y White Spirit, tratamiento ilusionista en algunas áreas y trazados o puntillismo en otras.

El resplandor, en estaño, estaba oscurecido, habiéndose realizado el soldado necesario. La limpieza se llevó a cabo aplicándose una capa de barniz que retrasa la oxidación del material. En toda la pieza fue aplicado barniz fosco Maimeri. Se procedió a la remoción de las notas escritas, las que se limpiaron, aplanaron y posteriormente colocaron en una caja de plástico fija en la parte interna de la escultura.

Aspectos sociales y religiosos

La imagen de Nuestra Señora de la Piedad de Felixlândia, aparte de su enorme valor histórico y artístico, tiene gran importancia para la devoción. Durante la restauración, en el CECOR, personas de la comunidad vinieron a visitarla para ver los trabajos de restauración y rezar delante de la imagen. Cuando se devolvió a la ciudad, presenciamos una fiesta de gran conmoción popular: una procesión de automóviles y motocicletas, recorriendo calles totalmente adornadas, casas y calles repletas de banderitas, ventanas cubiertas con manteles decorados y flores y fieles arrodillados por las calles en reverencia a su paso. El párroco hacía oraciones, acompañado por fuegos artificiales y músicas sacras. La fiesta terminó con una gran misa solemne, celebrada por dos obispos.

Conclusiones

La restauración rescató elementos originales característicos del estilo del maestro Aleijadinho. Revalorizó la imagen, permitiendo la apreciación de la belleza de la carnación original y la distinción entre la coloración del Cristo muerto y de su Madre, bien como del verdadero colorido de las piedras y de la base (véase Figura 8).

Por todos los argumentos ya relatados, estamos totalmente de acuerdo con Anastasia y Lanari: se trata de una obra casi desconocida, pero de gran valor religioso, histórico, estético e de profunda fuerza expresiva, cuya autoría le pertenece a Antônio Francisco Lisboa, el Aleijadinho.

Agradecimientos

Sr. Secretario de Cultura Del Estado de Minas Gerais, Dr. Ângelo Oswaldo Santos; BDMG Cultural; Instituto Estadual do Patrimônio Histórico e Artístico de Minas Gerais; Padre Ricardo da Costa, párroco de Felixlândia; restauradores Denise Camilo, Edmilson Marques, Bethânia Veloso y Simone Campos; químicos Luiz Antônio Souza, Claudina Maria Moresi; botánico Geraldo Zenid; joyero Marcos Kieffer; fotógrafo Cláudio Nadalim.

Referencias bibliográficas

Anastasia, Armando, 1971, *A descoberta de um novo Aleijadinho*, Belo Horizonte, Estado de Minas, Brasil.
Coelho, Beatriz, 1992, IIC (ed.), 'A contribution to the study of Aleijadinho, the most important sculptor of colonial Brazil' en *Conservation of Iberian and Latin America Cultural Heritage*, London.
Gabriel, A, 1949, *A Voz de Felixlândia*, Felixlândia, Brasil.
Lanari, Vittório, 1988, Desvendando os mistérios de um gênio, Belo Horizonte, Estado de Minas, Brasil.
Jardim, Márcio, 1995, *O Aleijadinho: uma síntese histórica*, ed. Stellarum, Belo Horizonte, Estado de Minas, Brasil.

Materiales

Jabón de resina, Richard Wolbers, Ácido Abiético 4 g, Triethanolamina 5 ml, Triton X 100 1 ml, HPM celulosa 1.3 g, agua 100 ml
A4, agua 1p. acetona, 1p. alcohol 1p. amoníaco 1p.
Dragnet 384 CE, Permetrina 38.4% e inertes 61.6%, FMC do Brasil
Osmocolor® ST, Montana®, Química
Vernice Finale Opaca, Maimeri, Itália

Abstract

The recent conservation of The Cloisters' *Montvianex Madonna* (1967.153) has provided an ideal opportunity for close examination of a French 12th-century wooden polychromed Virgin and Child from Auvergne. Investigation of the support and paint layers substantiated by scientific data has divulged several provocative technical discoveries, such as the presence of a relic in the sculpture, a multitude of tin appliqué relief on the figures' colourful garments, and the simulation of variegated stones on the throne. All embellishments are important to our understanding of French Roman-esque aesthetics. During the course of this examination, comparisons are drawn to other Sedes Sapientiae believed to originate from the same workshop.

Keywords

sculpture, wood, polychromy, 12th century, French, tin appliqué relief

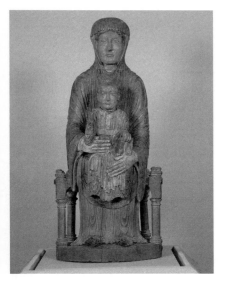

Figure 1. The Montvianex Madonna *(Acc. 1967.153), overall front, The Cloisters [Photo L. Kargère]*

The *Montvianex Madonna:* materials and techniques in 12th-century Auvergne

Lucretia G. Kargère
The Cloisters
Fort Tryon Park
New York, New York 10040, U.S.A.
Fax: 212-795-3640
E-mail: lucretia.kargere@metmuseum.org

Introduction

Sculptures of the Virgin and Child from Auvergne constitute one of the largest groups of 12th-century wooden polychromed cult figures surviving in France. The region was an important centre of wood carving production in Romanesque France. To date, no concerted technical examination has been performed on these sculptures. Ilene Forsyth (1972) initiated a comprehensive art historical study of the French Sedes Sapientiae, but some questions remain unanswered. She identifies the presence of workshops in the region. However, lacking scientific evidence, the particular technical profile of each workshop has not been defined. It is not known whether materials and techniques differ from atelier to atelier within this region, and from other centres in France. Could the discovery of common working methods support their classification?

In an attempt to meet the lack of documentation, this paper intends to detail the activity of one workshop based on the scientific examination of The Cloisters' *Montvianex Madonna* (see Figure 1).[1] The recent conservation of this sculpture in New York has allowed the sequential examination of its methods of carving, assembly and polychromy, with the identification of the 12th-century inorganic pigments, organic colorants, metal leaves and binding media.[2]

To broaden this study, comparisons will be drawn to the Metropolitan Museum's *Morgan Madonna*, believed to have been carved by the same hand (Forsyth 1972, Little 1987),[3] and observations made to other examples of the region. Closest parallels are found in Notre-Dame de Claviers in Moussages (Cantal), Notre-Dame d'Heume l'Eglise (Puy-de-Dôme), Notre-Dame d'Aubusson (Puy-de-Dôme) and Notre Dame de Parentignat (Ardèche region, private collection). However, the *Montvianex Madonna* will remain the main focus, since the results of this investigation have divulged unexpected techniques of construction and polychromy. These include the astonishing presence of a multitude of tin relief appliqué decorations, which will be discussed in the closing stages of this article.

Support

Many of the methods of carving and assembling wood observed on the *Montvianex Madonna* are common to the region's production, but details particular to this group support the notion of a distinct workshop. The sculpture conforms to the familiarly compact size of Auvergne Sedes Sapientiae, measuring 68.6 cm in height. It is carved out of good-quality walnut, apparently frequently employed for such sculptures. The *Morgan Madonna* is similarly carved in walnut and measures 78.7 cm. It should be noted however, that analysis has identified other hardwoods in the region, including lindenwood,[4] pearwood,[5] and poplar.[6]

As has been observed, Auvergne sculptures are often constructed of a number of wooden pieces (Forsyth 1972). The technique trusts that a sculpture will not crack if composed of many smaller blocks of selective quality wood. In this way, the cult figures could be carved in the round without hollowing the reverse and could be seen from all sides, an important feature for sculptures paraded through

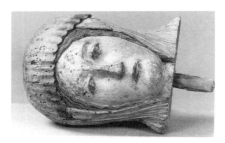

Figure 2. The Morgan Madonna *(Acc. 16.32.194), detail head, The Metropolitan Museum of Art [Photo L. Kargère]*

Figure 3. The Montvianex Madonna, *detail slit on upper colonette, throne [Photo L. Kargère]*

Figure 4. The Morgan Madonna, *detail carving of the Child's hair [Photo L. Kargère]*

villages on liturgical feast days. The method has proven durable since both The Cloisters and the Metropolitan Museum sculptures reveal surprisingly few losses and limited splitting,[7] despite the presence of the log's pith in the sculptures' main block, an element known to cause cracking.[8]

The central piece of wood, encompassing both the Virgin and Child's body, is completed by the addition of separately carved heads, a characteristic also found on most figural sculptures in the region.[9] In this atelier, a single large tenon inserted in a corresponding mortise maintains the head of the Virgin to its body, a feature clearly revealed on the *Morgan Madonna* (see Figure 2). Similarly, the Child's right forearm and left hand are separately carved and added to the main body with a small mortise and tenon joint. The Child's two feet, gravity prone, are inserted under his tunic and are maintained by small cross-dowels.

The construction and carving of the *Montvianex Madonna*'s throne, specifically, distinguishes this atelier's practices. Five peripheral colonettes are wedged in the base's perimeter and maintained by 10 cm dowels. Carved out of single elongated pieces (37cm in height), the shafts are octagonal on the lower tier, round on the upper, and are topped with simple foliate capitals and a round finishing knob.[10] Moreover, the examination of The Cloisters' example has divulged the former existence of a high back, significantly altering the sculpture's present appearance. Symbolic of Church's authority, this seat once included four panels inserted in the slits, visible on the sole remaining upper colonette[11] (see Figure 3). All joints on the throne were further secured with strips of plain-weave linen.

Finally, scrutiny of the sculpture's wood surface has revealed a careful finish, without use of rasps, scrapers or abrasives. The tool marks are remarkable in their fineness on visible areas of the sculpture (mostly between 0.5 cm and 1 cm wide cutting edges), a feature epitomized by the carving of the Child's hair, modelled with a millimetre-wide V-shaped chisel, in a radiating star fashion. Analogous tools were used to model the *Morgan Madonna* (see Figure 4).

Function

The perfection brought to bear on the carving of The Cloisters' example reflects upon its function as a cult figure. Such sculptures sometimes act as reliquaries, with subtly hidden cavities, hard to interpret and difficult to access without damaging the support. (Iconoclasme 2001). Ilene Forsyth (1972) had reservations about the presence of a relic under the small round wooden plug visible on the *Montvianex Madonna*'s proper left shoulder. However, more recently at the Metropolitan Museum, X-ray radiography has exposed a cylindrical cavity concealing radio-opaque flakes (see Figure 5). The *Morgan Madonna* displays similar evidence of a rectangular cavity on her left shoulder, skilfully disguised by a wooden plug. However, in this case, no indication of a relic was detected.

Polychromy

Technical analysis of the *Montvianex Madonna*'s paint layers has revealed an original polychromy in a remarkable state of preservation, despite the delicacy of its execution. The sculpture's treatment at The Cloisters consisted mainly in consolidating the paint layers, clearing the wood of an oxidized oil stain[12] and carefully removing islands of overpaints.

The six repainting campaigns documented during this treatment are too fragmentary to merit a detailed description. Of interest, however, are the traces of a black layer observed directly over the original flesh tones (Bréhier 1933), a first partial overpainting campaign presently analyzed as a carbon black mixed in a protein mixture, probably glue and egg. Found under a repainting campaign including the pigments azurite, orpiment and vermilion, and using a painting medium usually associated to earlier painting techniques, the black layer could date to the 13th or 14th centuries. This places the *Montvianex Madonna* as an exceptionally early example of a Black Virgin in France, a cult phenomenon described at length by Sophie Cassagnes-Brouquet (2001).

The 12th-century palette is composed of calcium carbonate, lead white, carbon black, natural ultramarine, vermilion, red ochre, orpiment, red lake (probably

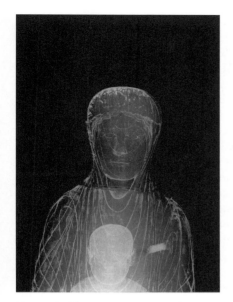

Figure 5. The Montvianex Madonna, *X-ray radiography [Michele Marincola]*

Figure 6. The Montvianex Madonna, *reconstruction of original polychromy [Photo L. Kargère]*

Figure 7. The Montvianex Madonna, *microphotography of tin relief decoration, Child's mantle [Photo L. Kargère]*

madder lake), copper resinate and tin leaf. A layering of two if not three fine strata of paint covers all surfaces of the sculpture after the preparation layer. Media analysis has divulged the simultaneous use of a proteinaceous binding-medium containing egg for most layers of paint, a drying oil medium for the flesh tones and for specific varnishes, and a casein/egg mixture for relief decorations (see Figure 6).

A localized ground layer of calcium carbonate is found in the passage of folds between the Virgin's head and her body, bordering the joint of the Child's proper right forearm, and on the sculpture's base surrounding the columns. This thicker substrate clearly constitutes a final step to insure invisible seams across joints prior to painting.

The main preparation, in an egg binder, is an exceptionally thin lead white layer (10–30 μm), consistent with the fineness of the carving, and with whitening the support and evening out any remaining variations in wood grain or tool marks on the sculpture's overall surface.

The Virgin's paenula (a mantle with a hole to pass the head) is dark blue. The distinctive blue is a thin layer of lapis lazuli darkened by the presence of a grey underlayer of charcoal, blended in lead white.[13] The Virgin's mantle is further patterned with 1.2 cm lozenge shapes formed with lacquered tin leaf aiming for the appearance of gold. The tin decorations, today visible only in traces, were once located on each fold of her garment, and applied on the grey underlayer before the lapis lazuli layer was applied. The translucent yellow glaze on top of the metal leaf contains no colouring agent and was analyzed as essentially a boiled oil, probably a linseed oil. This corresponds to recipes found in a number of early manuscripts prescribing the use of oil to produce a gold colour, including Theophilius and Heraclius (Wiik Svein 1995). Gold bands, which are 1.7 cm wide and made out of the same lacquered tin-leaf, further delimit the mantle's lower borders and frame the Virgin's head. The blue paenula covers a deep brilliant red robe, composed of a layer of vermilion red (30° μm) intensified by an organic red glaze (madder?), a sequence of colours recalled in the lining of her mantle.

The reverse of the Virgin's mantle is a darker purple red composed of the same organic red glaze applied over a brick red underlayer of fine ground red ochre pigments. The red seems to depict a very fine veil, which does not conform to the sculpture's elliptical folds; the cloth falls straight down from the back of the Virgin's head to her feet. A band of lacquered tin borders the veil's lateral sides and bottom portion (1 cm in width), while two triangular pleats are folded over on either of its lower corners.

The same red is found on the Child's himation (a cloth draped vertically over the shoulder and about the body). On the Child Christ, the colour solicits associations to the Roman Emperor, usually dressed in an imperial purple–red mantle. This section of drapery is further adorned with small, square, similarly lacquered tin leaves (0.6 cm x 0.6 cm) shaped in relief with ringed dots (see Figure 7). The filler of the relief decorations consists of calcium carbonate bulked with egg and casein proteins, varying in thickness between 120-200 μm to 1 mm, depending on the area. Although it could not be determined by media analysis whether the binders were actually mixed together to form an emulsion, the spongy aspect of the filler indicates the egg was used to soften the casein-calcium carbonate mix, which is known to otherwise form a very hard paste (Reclam 1997). The varnish imitating gold on the tin remains the same oil. The decorations are literally covering the Child's mantle, set on practically each fold, at various angles, in depth or crests, and even behind immediate view on his shoulders; they are applied over the red ochre underlayer, prior to the application of the red glaze. The T-shape collar, lateral borders and lower hem of Christ's himation are also decorated with the lacquered tin leaf. A thin carbon black line further underscores this collar. The Child's tunic is now light green, but was once covered by a dark green copper resinate glaze, and its lining consisted of the layering of an organic red glaze over a vermilion underlayer.

Counterpart to its construction, the Virgin's throne is an extraordinary seat painted to imitate rich stones of coloured marble. First, the rounded cushion is pink (lake red with lead white) further decorated with a row of eleven encircled white quatrefoils (about 1.5 cm in diameter) framed by white and black vertical bands. The cushion sits on the throne's deck, which is painted an opaque black with red

Figure 8. The Montvianex Madonna, *close up of porphyry imitation, reverse of base [Photo L. Kargère]*

veins and spots, possibly imitating a type of red and black jasper. The peripheral shafts take on more weight when imagined painted in vertical bands of green, red and black, in imitation of marbles or precious hardstones.

The sculpture's base is equally decorated to imitate the ornate varieties of marble finishes found on the floors of late antique or medieval church interiors. The reverse of the base is covered with a dark red (a red glaze over a red ochre underlayer) embellished with radiating flecks of orange red paint (vermilion) and intermittent speckles of yellow orange (orpiment mixed with vermilion). This polychromy seems to imitate a type of red porphyry (see Figure 8). The base's front may imitate either a serpentine marble or green porphyry, with veins of dark copper resinate green covering a very light green underlayer. The narrowness of the base's front could be justified by the presence of an additional socle continuing the green marble design, now lost.[14] Otherwise, medieval documents indicate that such cult sculptures were often placed on an altar or on a prepared column, such as the Clermont-Ferrand Majesty, which was mounted on a marble column with a socle of jasper (Forsyth 1972). The Montvianex's base would thus have been completed by its method of display.

Fine and smooth in finish, the flesh exhibits light pink tones, composed of a mixture of red lake particles with red ochre inclusions in a lead white matrix. In this case, the paint is mixed with oil, possibly linseed oil that may have been partially heat-modified. Anticipating this layer is the presence of an unpigmented oil layer, which purpose was evidently to seal the tempera-based preparation layer. The flesh layers are clearly applied sequentially after the drapery. The Virgin's eyes display a black pupil surrounded by a blue iris (lapis lazuli in a matrix of lead white) ringed with black, followed by the white of the eye. A black line also underscores the eye's overall shape. There are visible traces of a brown line defining the Child's eyebrows; no traces remain on those of the Virgin. The Virgin's lips are deep brilliant red. The hair of both figures was originally warm brown.

Discussion of the use of tin

The amount and varied application of tin found on the *Montvianex Madonna* calls for discussion. Tin foil was a common material in the 12th century, mostly imported from Devon and Cornwall in England, and in this respect, its finding is not surprising (Darrah 1998, Lynn 1997).

More remarkable is the discovery of a lacquered tin leaf applied over individual raised decorations on the *Montvianex Madonna*. In fact, the raised geometric designs represent the earliest recorded 'tin appliqué relief' on sculptures in the West. The continuous relief visible on the throne and sleeves of the *Morgan Madonna* is also composed of lacquered tin on a calcium carbonate base. The technique could be specific to this workshop, or it could have been disseminated through the region and is not yet documented. The method of fabrication on The Cloisters' example eludes the standard classification of pastiglia, pressmass or appliqué relief brocades (Serck Dewaide 1990). Close conformation of the tin decorations to the volumes of the sculpture indicate they were applied when the filler of the relief was still relatively moist. In view of the apparent repetitive nature of the design and the evenness of the tin's surface, it seems moulds were used to create them *en bloc*. Hypothetically, paraphrasing a technique described by Cennino Cennini (1933), a mould could have been lined with the tin, filled with a stiff paste and impressed with a wooden mallet. Once the tin conformed to the mould design, the impression was filled with the calcium carbonate mixture. When partially dry, the relief would be removed from the mould, cut in small squares and applied over the fresh paint. The casein and egg mixture would have surely provided sufficient adhesive strength. Finally, it seems reasonable to argue that the tin decorations were toned or glazed only after they were secured to the sculpture.

The technical origins of these decorations in Auvergne must be investigated. It can be argued that the metalwork technology is simply a local tradition. The first documented Sedes Sapientiae in the region was commissioned in AD 946 to a goldsmith, named Adelelmus, for the Clermont-Ferrand cathedral. This sculpture is recorded as having a wooden core covered in metal foil, a technique still found in the 11th and 12th centuries, although more infrequently (*Orcival Madonna*).

On the *Montvianex Madonna*, the metallic decorative details are clearly conceived as a cheaper substitution for such cult figures, and their fabrication could derive from repoussé metalwork. The decorations also recall the manufacture of coins, seals, pilgrim's badges and tokens in the second half of the 12th century in France, which are comparable in size and were made in moulds with pure tin or pewter (Labrot 2000).

Finally, the impressive amount of decorations found on the Auvergne Virgin and Child resume Mojmir Frinta's (1981) intention to link the use of appliqué relief decorations on Western works of art, to their presence on icons in the Byzantine Empire. It is known that Bishop Ademar of Le Puy in Auvergne headed east to Constantinople in 1097, and that monasteries in France maintained direct contact with their counterparts in Byzantium and the Holy Land in the 11th and 12th centuries (Wixom 1997). Since the technical influence of the Byzantine world on 12th-century France surpasses the scope of this paper, suffice it to say that the Auvergne Sedes Sapientiae have always been associated in style with the Byzantine Theotokos, and the polychromy revealed today on the Auvergne sculptures fosters comparisons with the splendours of the east. However, in view of the strong metal working tradition established in the region, it is more reasonable to regard the tin appliqué relief decorations as the skills of a local workshop, which was inspired, perhaps, from afar.

Conclusion

The sumptuous effects created by the simulation of precious materials, the use of metal decorations, marble surfaces and layering of colours demonstrate the importance of Auvergne wooden polychromed cult figures. Empowered with modern analytical means, this investigation has revealed techniques heretofore not documented for 12th-century sculptures in the West. Much remains to be done in our understanding of this region's production. Although the close examination of the related sculpture housed in remote chapels of the mountainous region would further our understanding of this workshop's practices, it is more realistic to call for a systematic examination of the sculptures in museums. This study should properly be extended to crucifixes, which are only alluded to in this paper.

Acknowledgements

My thanks to colleagues at the Sherman Fairchild Center for Objects Conservation for helping me with this study. Mark T. Wypyski, Associate Research Scientist, carried out the SEM-EDS analysis of the paint layers, and Pete Dandridge, Conservator, generously shared his cross-sections and treatment report of the *Morgan Madonna* sculpture. I would like to acknowledge also Richard Newman, Research Scientist at the Museum of Fine Arts, Boston, for the media analysis. Foremost, I am greatly indebted to Michele Marincola, Conservator, at The Cloisters, who provided many helpful suggestions for the improvement of this paper and who was immensely supportive throughout this project.

Notes

1 Purchased in 1967, the sculpture is traditionally provenanced to the Chapel of Saint-Victor in Montvianex, in the Puy-de-Dôme not far from Clermont Ferrand (Bréhier 1933).
2 Examination techniques: binocular microscopy, cross-section and dispersed pigments analysis under polarized light microscopy, X-ray diffraction, SEM-EDS analysis, FTIR microscopy and gas chromatography/mass spectrometry, and/or high performance liquid chromatography.
3 The *Morgan Madonna* (Acc. 16.32.194) was restored in 1987 by Pete Dandridge, Conservator at the Sherman Fairchild Center for Objects Conservation at The Metropolitan Museum of Art. The cross-sections taken for the treatment were re-examined for the present publication.
4 Auzon Crucifix, Haute-Loire
5 Musée de Cluny Crucifix (Cl.2149)
6 The Cloisters' *Lavaudieu Corpus* (25.120.221), The Louvre *Doucet Head* (RF 1662)
7 For the *Montvianex Madonna*, the Child is missing both feet and his proper left hand and book are a modern replacement. Most of the upper tier colonnettes on the throne are missing, and an entire column on the sculpture's reverse has been sawn off.

8 The presence of the pith has caused a loss on the back of the base on the sculpture's proper right; it is now replaced by a modern piece of wood.

9 The author has personally observed twelve Crucifixes from the region. All have separately carved heads.

10 Similar shafts are noticeable on Notre Dame de Parentignat and Notre Dame d'Aubusson. The thrones on Notre Dame d'Heume l'Eglise and Notre Dame de Claviers appear to be restorations. Although a single-tier throne, the *Morgan Madonna* exhibits similar details in carving and joining.

11 These wooden panels are still in place on Notre Dame D'Aubusson.

12 Soluble in Solvent no.13 Toluene:DMF, 75:25 (Masschelein-Kleiner 1981).

13 The grey underlayer appears light blue with an unaided eye, an optical effect known as Raleigh scattering, whereby white pigments scatter the short wavelengths of light effectively, whereas carbon black pigments absorb uniformly across the spectrum. Since blue light does not penetrate deeply into the paint film, a light blue reflection is formed (Brill 1980).

14 A socle, possibly original, is visible on Notre Dame de Parentignat.

References

Bréhier, L, 1933, 'Notes sur les Statues de Vierges Romanes, Notre Dame de Montvianex et la question des Vierges Noires', *Revue d'Auvergne* XLVII, 193–198.

Brill, T, 1980, *Light, its interaction with Art and Antiquities*, New York, Plenum Press.

Cassagnes-Brouquet, S, 2000, *Vierges Noires*, edition du Rouergue, Rodez.

Cennini, Cennino d'Andrea, 1954 (1st ed. 1933), *The Craftsman's Handbook*, trans. by P V Thompson Jr, New York, Chap.128, p.78.

Darrah, J A, 1998, *White and golden tin foil in applied relief decoration: 1240-1530, Looking through paintings: the study of painting techniques and materials in support of art historical research*, London, Archetype Publications, 49–79.

Forsyth, I H, 1972, *The Throne of Wisdom, Wood sculpture of the Madonna in Romanesque France*, Princeton, Princeton University Press.

Frinta, M, 1981, 'Raised Gilded Ornament of the Cypriot Icons, and the Occurrence of the Technique in the West', *Gesta* 20/2, 334–347.

Hooper, P, 1995, 'Pilgrim tokens', *Journal of the Pewter Society*, 22–28.

Iconoclasme, vie et mort de l'image médievale, 2001, Catalogue de l'exposition, Musée de l'œuvre Notre-Dame, Musée de Strasbourg, Somogy Ed., No. 8.

Labrot, J, 2000, 'Les moules à méreaux et la fonte du plomb, une activité artisanale médiévale', *Moyen Age*, March-April, 12–15.

Little, C, 1987, 'Romanesque sculptures in North American Collections', *Gesta* XXCI/2, 153–155.

Lynn, J, 1997, 'Two Thirteenth Century Panels from the Painted Chamber, Westminster Palace', *Zeitschrift für Kunsttechnologie und Konservierung* 11, 15–27.

Masschelein-Kleiner, L, 1981, 'Les Solvants' (IRPA, cours de conservation), Bruxelles, IRPA.

Reclam, P, 1997, *Reclams Handbuch der kunstlerischen Techniken*, Band 2., Stuttgart, 24, 55-6.

Serck Dewaide, M, 1990, 'Relief decoration on sculptures and paintings from the thirteenth to the sixteenth century: technology and treatment', *Cleaning, Retouching and Coatings,* IIC Conference, Brussels, 36–40.

Wiik Svein, A, 1995, 'Likneskjusmio: medieval polychrome technique in Iceland', *Zeitschrift für Kunsttechnologie und Konservierung* 9/2, 327–336.

Wixom, W D, 1997, *Byzantine Art and the Latin West: Catalogue of an exhibition, The Glory of Byzantium*, The Metropolitan Museum of Art, New York, 438.

Abstract

Traces of pigment and surface finishes on the *Madonna and Child* by Conrad Meit are studied, described and analysed in this paper. These findings have been completed with archival records and observations made on other sculptures by Meit. Based on this research, a reconstruction proposal of the original aspect of the sculpture has been made. The consequences of these findings on the choice of the conservation/ restauration treatment is discussed.

Keywords

marble, Renaissance, Conrad Meit, polychromy, gilding, polished finishes

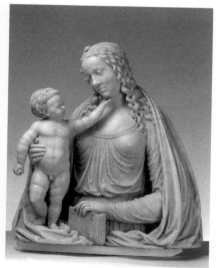

Figure 1. Madonna and Child *after treatment*

Study and treatment of the *Madonna and Child* by Conrad Meit, particularly of partial polychromy and polished finishes

Isabelle Leirens
Head of Stone Conservation Workshop
Royal Institute for Cultural Heritage (IRPA-KIK)
Parc du Cinquantenaire, 1
1000 Brussels, Belgium
isabelle.leirens@kikirpa.be
www.kikirpa.be

Introduction

The production of sculpture in the Renaissance is characterized by the use of marble, alabaster and fine-grained wood. Little is known, however, regarding polished and coloured finishes.

Archival records concerning works executed by Meit refer to the use of polychromy and partial polychromy on his sculptures, but most of his works have disappeared, been destroyed or survived in a severely modified state. Only some of his sculpture shows partial remains and most works give a distorted view of their original appearance.

The *Madonna and Child* (Figure 1) from the Saint Michael's Cathedral in Brussels has only recently been securely attributed to Conrad Meit.[1] The work was executed around 1525, while Meit was working at the Court of Margaret of Austria in Mechlin. All trace of the sculpture was lost until it reappeared in the Brussels Cathedral in the 17th century, where it has remained until today.

A cursory examination of this sculpture, made from white Carrara Statuary marble, showed clear traces of paint. Closer study of the surface revealed subtle polished finishes, further traces of paint and remains of gilding. The aim of the study was to identify these original polishes and polychrome finishes to facilitate the selection of an appropriate conservation treatment whilst at the same time enhancing the understanding of the sculpted production of Meit and the Renaissance. The sculpture was examined with the binocular microscope and ultraviolet light. Laboratory analyses were carried out and traces of original finishes were compared with other traces of finishes subsisting on sculptures by Meit or known through descriptions in the archives.[2] Using this information, a description and schematic reconstruction of the original appearance of the *Madonna and Child* is proposed.[3]

Carving the sculpture and the marble finish

The stone and toolmarks

Both the *Madonna and the Child* are carved in the same block of Carrara statuary marble.[4] Tool marks are clearly visible at the back, but almost no traces are visible on the front. At the back, toolmarks suggest the use of a flat chisel and a large toothed chisel. At the front, the only visible toolmarks are localized in the hair; these betray the stage by stage progression of the execution of the hair. The outline of the locks of hair is first rough-hewed with a large flat chisel. A drill is then used to hollow the deeper holes in the curls. Next, a fine-toothed chisel (gradina) is used to refine the waves in the curls of hair. The tooth-marks and angles left in the marble are removed first with a chisel and the surface is finally completely polished.

The marble polishing technique

Close examination of the entire surface of the sculpture shows evidence of the subtle effects of contrasting mat and polished areas (Figures 2a and 2b) that contribute to an impression of physical presence of the *Madonna and Child*.

a

b

Figures 2a and 2b. Details of the matte and satin-like finishes of the marble surface, of nose and drapery

Polishing techniques on marbles are difficult to identify. Treatises of the period[5] generally describe the use of fine abrasive grains that become progressively smaller until the chosen polishing level is achieved. The abrasive grains which are mentioned are pumice-stone, Tripoli powder, emery and 'potée d'étain'. When a higher polishing level has to be achieved, the use of leather, wisps of straw or burnt straw is recommended.

On the *Madonna and Child,* a clear alternation between a fine matte polished surface in the deeper parts and a satin-like polish on the upper parts of folds (Figures 2a and 2b) is observed. The matte polishes have been obtained with coarse abrasive powders. For the fine satin-like polish, various forms of analysis were carried out to try to identify the techniques responsible for the surface effects. Two very small samples in the fine polished parts of the mantle were taken for two types of analyses.[6] One sample showed the presence of calcite only and another sample indicated the presence of a fat matter, probably an oil. It is not known where the oil originated from or when it was applied. We would exclude the use of oil as an original finish, because the application of oil, on a surface gives an even appearance, totally inappropriate for this sculpture with intentionally polished and unpolished zones. However, its presence might be due to two other reasons: it may derive from the mordant of the gilded motifs in the mantle from where the sample was taken or it may be attributable to a subsequent conservation treatment; it is known that oil was used as protective layer on sculptures through the centuries.[7]

The pumice, Tripoli and emery powders mentioned in the treatises are normally traceable by the presence of silicium in the analysis, but no other mineral than calcite was identified in our analysis. This does not mean that those have not been partly used, but rather that the finer finishing polish has been achieved with calcite and possibly other materials which could not be traced, such as the use of leather.

Was the sculpture protected after treatment? The analysis also indicated that the sculpture was not covered with a protective layer, such as a wax. This is unusual, as marble sculpture is often protected with a layer of wax after conservation treatment.

The painted finishes

Study of the remains of pigment

Detailed examination of the *Madonna and Child* with a binocular and ultraviolet light revealed traces of polychromy and gilding. Some of this material was still in

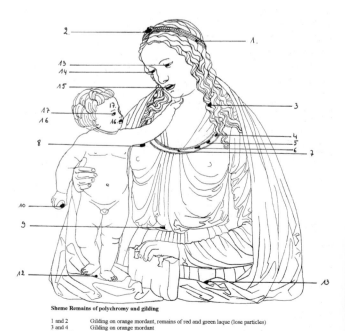

Figure 3. Diagram with the locality of the remains of polychromy and gilding

Sheme Remains of polychromy and gilding

1 and 2	Gilding on orange mordant, remains of red and green laque (lose particles)
3 and 4	Gilding on orange mordant
5,6 and 7	Azurite with leadwhite
8 and 9	Red laque
10	Red and green apple
11 and 12	Orange mordant spots
13,14 and 17	Azurite and leadwhite
15 and 16	Vermilion and red laque

its proper place, but loose unidentified fragments were also observed, due to washing of the sculpture. The correctly located traces are approximately 1 mm² to 1 cm² in size and their positions noted on a diagram (Figure 3); loose remains are listed separately.

Minute samples of about 50F each were analysed by Dr. Janka Sanyova using SEM-EDX in the laboratory of the IRPA-KIK. Three different interventions were identified, the original partial polychromy, an overpaint and a later patina layer.

The original finish is composed of gold leaf, azurite, lead white, vermilion, red earth and a red lake with an aluminium/calcium-containing substrate. Irregular remains of gilding were observed in the hair and small round spots of a mordant were found in the mantle. Traces of azurite mixed with lead white are visible in the eyes of the Madonna and on the collar of her dress. Her lips were executed in two layers, the first an opaque vermilion mixed with red earth, the second a translucent red lake. The same red lake was found without an underlayer on the Madonna's robe. A green pigment and vermilion were used to paint the apple. Loose remains of translucent green and red pigments were observed in the hair close to her crown. These may be original and form part of the finish of the crown, but this could not be proven.

The first layer of overpaint was only observed on the remains of original finish in the robe and probably followed the original design. The red/purple colour is composed of a red earth containing titanium and gypsum.

Carbon black is identified in the eyes of the Madonna, and appears to alter their original orientation. This black pigment may correspond to an obscuring layer of paint observed in a black and white photograph of 1954 covering the eyes of the Madonna, her robe and accentuating her nipples. Large brushstrokes were visible in some places in this layer and suggest the application of a patina. Layers of this type were commonly applied from the 19th century onwards.

Remains of polychromy in other work by Conrad Meit

The most important works by Meit are the monumental tombs of Margaret of Austria, Philibert of Savoy and Margaret of Bourbon in the Church of St. Nicholas of Tolentino in Brou-en-Bresse. This project is well documented, but neither archival nor literary sources mention the use of polychromy. On the other hand, smaller sculptures by Meit show clear traces of partial and complete polychromy, which are described in studies and in archives. One sculpture from Meit, unfortunately lost, is documented in the archives as being completely polychromed.[8] This is a portrait of Philibert de Savoy, executed in wood, that took Meit a year to execute. Other completely polychrome portraits, but in terracotta, are attributed to Meit by some art historians, such as the bust of Charles V from the Gruuthuse Museum in Bruges. Since doubts remain about the attribution of these sculptures to Meit, they will not be discussed in this study.[9]

Many small sculptures, mainly portraits and nudes, carved in alabaster, pearwood and boxwood show traces of polychromy and are described in the literature. *Judith with the head of Holofernes* (Bayerische Nationalmuseum, Munich), signed by Conrad Meit,[10] shows well-conserved gilding and partial polychromy. In this work the hair is gilded, the lips painted in red and the eyes painted in a naturalistic manner. Another work attributed to Conrad Meit, *Adam and Eve* (Gotha, Schlossmuseum) shows traces of paint applied in a highly refined manner, well preserved on eyes, lips, apples, cheeks and bases[11] on both figures. Another pair of sculptures, *Adam and Eve* (Vienna, Kunsthistorischmuseum), also in boxwood, show only a few traces of partial polychromy, in the same places as the previously mentioned pair. In the Vienna examples, Eve shows no traces of original finish, but Adam has remains of paint on his eyes, lips, ear and apple.[12] Of the two miniature portraits of *Margaret* and *Philibert* ordered in 1518, 'deux visaiges a nostre semblance',[13] the pearwood surface shows traces of partial polychromy in the eyes of *Margaret* (Munich, Bayerische Nationalmuseum). The corresponding portrait of *Philibert* has disappeared, but another portrait of *Philibert* (Berlin, Stichtung Preussischer Kulturbesitz)[14] is sculpted in boxwood and shows traces of gilding on the hat's tassel and zone of colour between the hat and net.

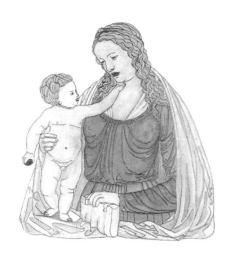

Figure 4. Reconstruction of the original partial polychromy

There is no scientific analysis to confirm whether the remains described on these sculptures are original, but a similar pattern in the application of the gilding and paint can be observed on all of them. The traces on the *Madonna and Child* correspond to the same pattern. This suggests that the traces observed on all the sculptures are original or at the very least overpainted following the design of the original, partially polychromed appearance.

Reconstruction of the original appearance

A reconstruction of the original coloured appearance of the *Madonna and Child* can be proposed based on the localization, description and identification of the remains of its polychromy and descriptions of other sculptures by Meit.

The most straightforward parts to reconstruct were the lips and eyes, where there were sufficient traces of original paint. Traces of gilding suggest the hair was probably completely gilded, as in the sculpture of *Judith* and remains of polychromy show that the fringe of the robe was painted light blue and bordered by a row of white pearls on both sides.

For the robe and mantle, the remains of polychromy can be interpreted in various ways. Spots of mordant in the mantle suggest the application of motifs consisting of small circles, but the shape of the motif is not known. Mechlin alabaster reliefs from the 15th and 16th centuries show more than one example of motifs formed by small gilded spots. For the reconstruction, certain motifs have been selected from this type of production to illustrate the overall appearance of the sculpture.

On the robe, the traces of polychromy are not extensive enough to determine whether they belong to individual motifs or form part of a complete paint layer. Remaining traces of polychromy are about 5 mm² in size and irregular in shape. It would seem unlikely that the sensuously carved robe would have been interrupted by the presence of over-decorative motifs. It would be more logical to imagine a fine transparent finish closer to the sensual conception of the sculpture (Figure 4).

Who executed the painted finishes on Meit's sculptures?

It is not possible to confirm whether or not Conrad Meit polychromed his sculptures himself. However, some descriptions in the archives imply that he commissioned another artist to apply the polychromy, such as in the case of the lost polychrome wooden portrait of *Philibert de Savoy*. Clearly, this sculpture was made by Conrad Meit, as the archives mention a payment to him 'pour avoir *fait* une ymaige de bois', nonetheless, the same archival source also mentions that Meit '*fait poindre* et coulorer la dicte ymaige'. This source distinguishes between Meit's execution of the wooden sculpture and the application of the polychromy by someone else, although it is clear from the financial arrangements that Meit held responsibility for the final result.

Interestingly, the archives mention Margaret of Austria paying painter Bernard van Orley for the polychromy of a sculpture during the same period as Meit's activity: 'Et pour avoir coulouré une grande ymaige de bois à la remenbrance de nostre Dame de pitié tenant le crucifix devant elle et icelle avoir revestue de couleurs, et draperie de fin or'.[15] This could suggest that van Orley painted sculptures at the Court on a regular basis; alternatively, it might have been an exceptional commission. Notwithstanding the lack of precision regarding Orley's involvement, this text and the previously cited example related to Meit reveal a certain level of collaboration between sculptors and painters at the Court of Margaret of Austria.

Conservation/restoration treatment

Condition before treatment

The sculpture had quite a confused appearance before treatment. Successive irregular cleanings in the past accentuated the whiteness of the upper, more

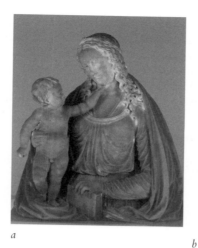

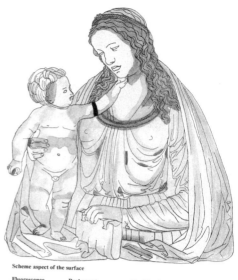

a *b*

Figure 5a and 5b. Ultraviolet reflectography and interpretation

Scheme aspect of the surface

Fluorescence	Real aspect	Identification
White fluorescent	Brown, sticky, dusty	Soap
Darkblue	Grey	Greysich aquous patina
Black	Dark grey	Glue
Whitish	White	Marble surface, ancient cleaning

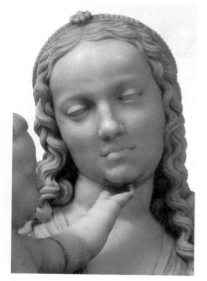

a

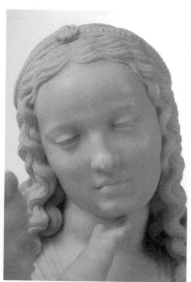

b

Figure 6a and 6b. Detail of the Madonna before and after treatment

accessible parts of the folds and the darkness of the inaccessible deeper areas. Besides this, the greyish patina had been washed off from some areas, such as the face and the bust of the Madonna as well as the face and the belly of the Child but not from the lateral parts. In addition, residues of old cleaning materials had caused the formation of a yellowish sticky matter to which dust had become ingrained. Other remains of protection layers and patinas artificially darkened some parts. Therefore, surface cleaning was a main priority, to remove past accretions and re-establish the subtle contrasts between the polished and unpolished and dark and light zones.

Ultraviolet fluorescence photography helped locate a variety of accretions on the marble surface (Figures 5a and 5b). Remains of a glue, the irregular 19th-century patina and soap were identified. The traces of glue were due to a former restoration of the arm of the Child during which glue spots dropped on some places. A considerable amount of soap remained in the hair of the Madonna and is clearly visible on the ultraviolet fluorescence photograph.

Treatment

The previous cleaning residues were first removed as well as the glue drops The soap residues were removed with demineralized water and the glue drops eliminated mechanically. Second, local cleaning was carried out to re-establish the balance between dark and light areas. For this stage, it was critical to select the suitable abrasive powder to retain the contrast between the polished and unpolished areas as the overall equilibrium of the sculpture is dependant on the interplay of surface effects (Figures 1, 6a and 6b). Abrasive powders were chosen with a hardness lower than that of Carrara marble, which is 8 Mohs on the Mohs scale. The selected powder was diatomaceous earth, whose hardness is of 6.5 Mohs, which was used with demineralized water.

Even if the sculpture was originally not covered with a finishing layer, it was important to assess the need for a protective coating after restoration. As there are no major sources of dust in the Treasury of Saint Michael's Cathedral, Brussels, the decision was taken to place the sculpture on exhibition with no extra protective layer for a year, after which time the situation would be reassessed; a year on, no significant dust deposits had accumulated, and no other observation justified the need to cover the sculpture with a protective layer.

Conclusion

The study of traces of pigment and surface finishes on the *Madonna and Child* by Conrad Meit reveals important information on its original polychromy and

gilding. Furthermore, comparison of the results with other sculptures by Meit enhances the present understanding of marble surface finishes and partial polychromy in Renaissance sculpture. The study also underlines the importance of careful observation prior to conservation/restoration treatment, even on apparently monochrome sculptures and the need to evaluate the application of a protection layer to preserve the original subtle polishing effects.

Acknowledgement

My special thanks to Christina Currie for her editing.

Notes

1 van Ypersele de Strihou, A, 2000, p. 110-114.
2 Main sources of information: J. Duverger, 1934. p. 125, and C. Lowenthal. Duverger has uncovered important evidence through his archival research in the Rijksarchief in Brussels, Stadsarchief in Antwerp, Stadsarchief in Mechlin, Staatsarchiv in Vienna and the Archives départementales du Nord in Lille. Lowenthal has precisely described the remains of polychromy on sculpture attributed to Meit.
3 As the attribution of certain works by Conrad Meit remains questionable, only sculptures described in the archives as by Meit or firmly attributed to him in the literature are discussed.
4 Analysis and identification kindly made by Dr. Lorenzo Lazzarini, Instituto Universitario di Architectura di Venezia.
5 Cellini (1967), p. 136; Vasari (1960), pp. 25-62; Felibien (1699), p. 227.
6 Two very small samples in the fine polished parts of the mantle were taken for two types of analysis: Micro-XRD (GADDS, Siemens) and FTIR (Nicolet 5DXC, by KBr technique). One sample showed the presence of calcium carbonate but no other mineral. The IR-spectra of the second sample indicated the presence of a methyl and carbonyl group that could be an organic fat matter. An extraction from the second sample with cyclohexanone was also carried out and analyzed with FTIR (Nicolet 5DXC, by KBr technique). This identified the fat matter as a probable oil. A more precise identification could have been given with GCMS. As there was no certainty on the origin of the fat, GCMS was not undertaken. I would like to thank to Dr. Bernard from the Université Libre de Bruxelles, with whom Dr. J. Sanyova collaborated for the Micro-XRD analysis.
7 Rossi-Manaresi, 1971, p. 81-95.
8 Duverger, J, 1934, p. 84: XXXV: 1526, 3 Mei: 'pour avoir fait une ymaige de bois de la représentacion de feu Monseigneur le duc de Savoye? Auquel ouvraige il a vacqué environ ung an. Et a aussi fait poindre et coulorer la dicte ymaige ainsi qu'il appartenait'.
9 Lowenthal, 1976, p. 84-86.
10 Lowenthal, 1976, p. 179: *Judith with the head of Holofernes,* Munich Bayerische Nationalmuseum, Signed 'Conrat.Meit.von.Worms', alabaster, partially polychrome and gilded, 29.7 cm, the hand and the sword are replaced and show traces of restoration.
11 Lowenthal, 1976, p.181-182: *Adam and Eve,* Gotha, Schlossmuseum, Boxwood, 36.5 and 33.7 cm.
12 Lowenthal, 1976, p.181: *Adam and Eve,* Vienna, Vienna Kunsthistorischesmuseum, attributed to Conrat Meit, boxwood, 25.5 and 24 cm.
13 Lowenthal, 1976, p.180 and 87: *Margaret,* Munich, Bayerische Nationalmuseum, pearwood, 7.4 cm, ill. 46 / Philibert: disappeared.
14 Lowenthal, 1976, p.180: *Philibert,* Berlin, Stichtung Preussischer Kulturbesitz, boxwood, 1.6 cm, ill. 47, 48.
15 Duverger, 1934, p.74: XVI. 1520, 21 April.

Bibliography

de Borchgrave d'Altena, J, 1954, 'A propos d'une Madonne de Conrad Meyt', *Revue d'Archéologie et d'Histoire de l'Art* XXIII.

Cellini, B, *The treatises of Benvenuto Cellini on goldsmithing and sculpture,* translated from the Italian by C R Ashbee, Dover Publications, New York, 1967.

Didier, R, 1980, 'Une sculpture de Conrad Meit, La Vierge d'Egmond à saint-Amand-les Eaux', *Acris Erudiri* XXIV.

Duverger, J, 1934. 'Conrat Meijt', Mémoires de l' Académie royale de Belgique, Tome V. Bruxelles.

Felibien, A, 1699, *Des principes de l'architecturen de la sculpture et des autres arts qui en dépendent,* 3rd ed., Paris, chez la Venve & J. B. Coignard.

Lowenthal, C, 1976, 'Conrat Meit', Ph.D. thesis, New York University.

Rossi-Manaresi, R, 'On the treatment of stone sculpture in the past', *The treatment of stone. Proceedings of the meeting, Bologna, October 1-3, 1971 (Rapporti della Soprintedenza alle Gallerie di Bologna, N 14, 1971)*, Bologna, Centro per la Conservazione delle scultura all'aperto, 1971.

van Ypersele de Strihou, A, 2000, *Le trésor de la Cathédrale des Saints Michel et Gudule à Bruxelles*, Bruxelles.

Vasari, G, 1960, *Vasari on technique. Being the introduction to the three arts of design, architecture, sculpture and painting, prefixed to the lives of the most excellent painters, sculptors and architects*, New York, Dover Publications.

Abstract

The production of polychrome sculptures in Brazil during the 18th and 19th centuries was very important. The blood of some Brazilian Christ sculptures was represented with red pigments, red lakes or both, but the drop of the blood was a shiny and transparent red material, known as 'ruby'. In popular tradition and the descriptions of art magazines, these drops are called 'ruby' or 'red resin'. Samples of ten Baroque and Rococo Christs (nine sculptures and one painting) from the museums and churches of Minas Gerais were examined with a scanning electron microscope equipped with am X-ray energy dispersive spectrometer (SEM-EDS). Scientific methodology confirmed the use of orpiment, the yellow sulfide of arsenic (As_2S_3), based on the description of an ancient recipe in a Portuguese manual. This paper also discusses the fabrication of the 'rubies', contributing to the knowledge of our cultural heritage.

Keywords

Baroque/Rococo, Christ, drops of blood, ruby, orpiment, Minas Gerais, Brazil

The 'ruby' in Baroque Christ sculptures in Brazil

Claudina Maria Dutra Moresi
Centro de Conservação e Restauração de Bens Culturais Móveis (Cecor)
Escola de Belas Artes (EBA) da Universidade Federal de Minas Gerais (UFMG)
Av. Antônio Carlos, 6627, Campus Pampulha
31270-901 Belo Horizonte, Minas Gerais, Brasil
Fax: + 55 21 31 34995375
E-mail: claudina@dedalus.lcc.ufmg.br

Introduction

By the end of the 17th century, with the discovery of gold in Brazil, a new region known as Minas Gerais (General Mines) emerged. During the colonial period, the greatest artistic manifestation was religious in character. Executed by Portuguese and Brazilians, the sculptures, painting of church ceilings and other paintings are today an important part of Brazilian cultural heritage. Brazilian artists learned the art technique under the Portuguese masters, using manuals that existed at that time and working in studios. The sculptors carved the wood and the polychromist was responsible for the painting. The painter Manuel da Costa Ataíde (1762-1830) painted easel and wood paintings, ceilings, and executed polychrome carnations. He made the carnations of the sculptor Antônio Francisco Lisboa (1738-1814), known as Aleijadinho (the cripple). Both were famous native artists from the Baroque / Rococo period in Brazil (Oliveira 2001). According to previous studies of the technique and materials used in polychrome sculptures from Minas Gerais (Moresi 1995), the polychrome carnations were executed with oil paint using white lead and vermilion in many paint layers. The ground layer was usually of gypsum or chalk (or both) and animal glue. In some sculptures kaolin was used to replace the gypsum, an imported material. Tabatinga is the popular name of this white earth, common in Minas Gerais region. The layer sizing, an animal glue over the wood support, and the impermeabilization layer, also an animal glue, applied over the white preparation were also used.

Kühn (1986) describes the way the three-dimensional ornaments were applied in European wood polychrome sculptures before the 19th century: 'Drops of blood, tears and the edges of wounds were rendered three-dimensionally by embedding seeds, wool, string and other things on the ground'. This technique differs from the surface finish of Brazilian polychrome sculptures, because the blood drops and the running were applied over the carnation layer, the original layer that resembles the skin. The blood of the Christ wound was represented by painting it with red pigments or red lakes, but the drop of blood was a shiny and transparent red material (see Figure 1). In the popular tradition and even in the art magazines, such drops were called 'rubies' or 'red resin' by scholars and Baroque art admirers.

Cennini (Thompson 1954) quoted the use of vermilion in his description of how to paint wounds. 'To paint a wounded man, or rather a wound, take straight vermilion; get it laid in wherever you want to do blood. Then take a little fine lacquer, well-tempered in the usual way, and shade all over this blood, either drops or wounds, or whatever it happens to be'.

In Brazil, the sculpted representation of Jesus Christ expressed a wide diversity of iconography, such as Crucified Christ, Dead Christ, Senhor dos Passos (Christ, on one knee, carrying the Cross), Our Lady of Piety, and others. Samples of ten Baroque and Rococo Christs (nine sculptures and one painting) from museums and churches of Minas Gerais were examined. The results were disputed, with the information obtained in research of primary documents related to the making, technique and materials of the works studied, and also with the descriptions found in the art books and records from that time. A study to copy those fake rubies in the laboratory began.

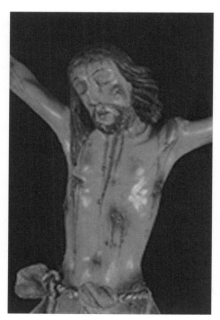

Figure 1. 'Ruby' of the 'Crucifixo', 18th century, from the Church Nossa Senhora da Conceição, Sabará, Minas Gerais. Photo: Cecor/Cláudio Nadalin

Methodology

Blood running from two Nossa Senhora do Carmo's church crucifixes in Sabará, Minas Gerais, was used as samples and studied through High Performance Liquid Chromatograph (HPLC) and diode array detection as described in a previous article (Moresi and Wouters 1997).

One sample from one of those crucifixes was examined using the stereomicroscope. After it was analyzed through HPLC and diode array detection to verify the presence of dyestuffs, which are characteristic of red lakes. The results obtained in these analyses and literature information led to the study of blood drops samples of the ten Christs studied, by scanning electron microscope equipped with X-ray energy dispersive spectrometer (SEM-EDS). This technique identifies the chemical elements in the samples and allows semi-quantitative analyses in a relative percentage of the present constituents.

Some preliminary experiments were performed to copy the blood drops used in the Christ wounds based on ancient recipes (Segredos 1794) and literature information.

Results

In the two blood-running samples analyzed, carminic acid was found. Carminic acid is the main constituent of American Cochineal lake (*Dactylopius coccus*). In all the artworks studied (see Table 1), the SEM-EDS analyses of the red drops that copy the blood show the presence of arsenic (As) and sulfur (S) in their composition, chemical elements characteristic of the orpiment (As_2S_3). An ancient recipe from a Portuguese manual (Segredos 1794) explains in detail the fabrication of the drops of blood to be used in Crucifix wound, stating the use of orpiment, the yellow sulfide of arsenic: 'To make blood drops to be placed on the crucifixes wounds *put orpiment in one of those coin glasses that has little difference in terms of height and diameter, cover it and leave a small hole in order not to crack, place it in bain Marie until the orpiment melts and lifts due to the vapor, it will run back around the core of the glass; take it out of the fire and let it cool off , break the glass to get the so called blood drops. The bigger and the more round the realm of the glass the better the blood drops will come out*'.

Carlos Del Negro (1955), writer and mineira art and architecture researcher of the colonial period, describes some materials used by the master Ataíde in the Chapel of São Francisco de Assis in Ouro Preto. According to this author, the 'burnt ialde' (ialde queimado) means the yellow ialde, orpiment (As_2S_3), having a vibrant yellow colour, specific weight 3.46, when heated it easily melts into a red liquid (melting point 300°C); it solidifies by cooling into a red dough of density 2.76'. One of the Christs analyzed, very likely to have been made by Ataíde, comes

Table 1. *Chemical elements found in the blood drops from the Minas Gerais work of arts dated back to the colonial period. Results in relative percentage of the constituents analyzed by SEM-EDS.*

No.	Title of the art work - Author	Origin	Results (%)
I	Bom Jesus do Matosinhos - master Piranga, attributed	Chapel of Bom Jesus do Matosinhos, Piranga	As (30), S (70)
2	Crucifixo I - Anonymous	Church of Nossa Senhora Carmo, Sabará	As (21-25), S (78-75)
3	Crucifixo 2 - Anonymous	Church of Nossa Senhora Carmo, Sabará	As (30), S (70)
4	Cristo Crucificado - mater Piranga, attributed	Chapel of São Francisco de Assis, Mariana	As (62), S (38)
5	Cristo Crucificado da Agonia - Anonimous	Chapel of São Francisco de Paula, Mariana	As (63), S (37)
6	Senhor dos Passos - Anonimous	Church of Santo Antônio, Santa Bárbara	As (54), S (46)
7	Cristo Morto - Anonimous	Church of Santo Antônio, Santa Bárbara	As (62), S (38)
8	Nossa Senhora da Piedade - Anonimous	Museum of Arte Sacra, Mariana	As (48), S (52)
9	Cristo Crucificad - Anonimous	Chapel of São Francisco de Assis, Ouro Preto	As (32-34), S (58-55)
I0	Crucificação - master Ataíde, attributed	Chapel of São Francisco de Assis, Ouro Preto	As (40-47), S (60-53)

As: arsenic S: Sulfur

Figure 2. Sample of the drop of the blood under the stereo-microscope, magnifying 25. Photo: Cecor/Claudina Moresi

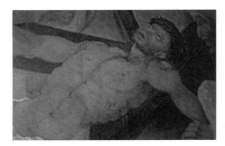

Figure 3. Detail of the 'Crucificação', easel painting attributed to master Ataíde, which is visible the blood drained off ending with a drop, the fake 'ruby'. Photo: Cecor/ Claudina Moresi

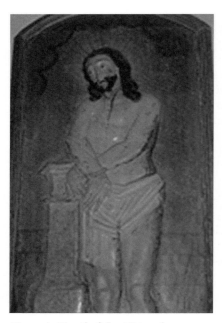

Figure 4. Detail of the 'Cristo da Coluna', painting on carved wood that is part of the scenes of the life of Christ, Chapel 'Bom Jesus do Matosinhos' in Ouro Preto. Presence of blood running and blood drops. Photo: Cecor/Claudina Moresi

from this chapel. According to the Del Negro description, we conclude that the 'burnt ialde' corresponds to the blood drops that were brought from Europe, because it is stated in document dated 1801, regarding the material used by Ataíde in the chapel of São Francisco de Assis, in Ouro Preto (Trindade 1951).

According to the literature (Sinkankas 1974), when heated in a closed glass tube, the orpiment, of a golden color, sublimates, cools it off right after, and you have a red substance with a resin shine. The orpiment, when heated in an open tube, turns to white arsenic trioxide (As_2O_3) (Pascal 1932).

The experiments that took place in the laboratory to copy the blood drops, required the manufacturing of glass tubes, 3 cm long with a round bottom of 0.5 cm diameter. It was transferred to the glass tube a small amount of ground and crushed orpiment using a grade. It created the vacuum and the tube was sealed. The tube was heated to the sublimation of the orpiment, leading to a yellow-orange and dark red-coloured substance forming bubbles in the little drops that were seen. The temperature and the heating must be controlled, because the blood drops that were examined in the stereo-microscope showed a transparent red substance, apparently homogeneous and with no bubbles (see Figure 2).

The results of the analysis of the work of arts by SEM-EDS, a semi-quantitative method, shows variations in the concentration of arsenic and sulfur and a lack of other chemical elements in a small quantity (see Table 1). Natural orpiment is always accompanied by its associated mineral realgar, the red bisulfide of arsenic (As_2S_2). Others associated minerals are calcite ($CaCO_3$), barite ($BaSO_4$) and stibnite (Sb_2S_3). These results, along with the literature (Pascal 1932, Gettens 1966), leads us to suppose that there were variations in the methods used to obtain the little red drops. Orpiment and realgar were used as pigments until the 19th century, but now these are considered too toxic for use. The orpiment was used in its natural form and since the Late Middle Ages it also was artificially made. The artificial orpiment was obtained by precipitation and sublimation. In the precipitation process, some hydrogen sulfide (H_2S) is passed through a hydrochloric solution of arsenic trioxide and the sublimation process is added to sulfur with arsenic trioxide. The realgar was made artificially in a way similar to the sublimation process of orpiment, by melting together sulfur with an excess of arsenic or arsenic oxide. The samples of little blood drops will be examined by FTIR microspectroscopy to verify the presence of characteristic pics of oxides of arsenic. And a comparative study will be done with reference material (mineral and artificial orpiment) and blood drops prepared in the laboratory. The toxicity of the arsenic compounds makes the execution of the experiments more difficult as well as the analytical materials characterization.

The realgar is known as the arsenic red and arsenic ruby. The name realgar seems to designate equally the artificial compounds of arsenic and sulfur rich in arsenic and used as dyestuffs and known as sandarac (Pascal 1932, Gettens 1966). Therefore, we suppose that the popular name 'ruby' or 'red resin' comes from those artificial compounds of arsenic.

Confirming the realism and the dramatization of the Baroque, those blood drops are found in many sizes placed on the sculpture carnations (see Figure 1). These little blood drops are stable substances, preserving the red colour. Exceptionally, these little blood drops were used on oil on easel painting named the crucifixion, 'A Crucificação' (see Figure 3), attributed to the master Manoel da Costa Ataíde (1762-1830). This painting, originally located in the Chapel Mor, is part of the scenes of Christ's life, 'Cenas da Vida de Cristo', along with another painting attributed to Ataíde, 'A Santa Ceia', and a series of paintings on carved wood (see Figure 4), located in the Chapel Mor and Sacristy, and finally with the image in wood of Senhor Bom Jesus do Matosinhos in the main altar. In the sculptures and in the paintings on wood, blood drops are found. Most likely the blood drops were used to dramatize the Baroque.

Conclusion

The characterization of the original materials of the artwork through the analytical techniques, related to them by their historic context, allows us to better understand the origin, fabrication and application of those materials, supplying us with

information about their evolution and stability. The masters and the artists of the Minas Gerais Baroque knew the work of the arts and used manuals. In the running blood, the presence of American Cochineal lake is noted.

In the case of the 'rubies', the Christ wounds, the analysis confirmed the use orpiment, through the presence of the chemical elements arsenic and sulfur, according to the description in the Portuguese manual of that time, differing from the popular tradition that stated that it was the precious gem ruby or the red resin. The manuals and ancient paper stated the realgar as arsenic red and arsenic ruby. These little blood drops are stable, showing transparent red colour. No reference about the use of this material in European or Hispanic-American sculptures were found. The results achieved in this research are important for the art historians, restorers and researchers of Baroque art contributing to the knowledge of our cultural heritage.

Acknowledgements

This work has been supported by Fundação de Amparo à Pesquisa do Estado de Minas Gerais - FAPEMIG, Conselho Nacional de Desenvolvimento Científico e Tecnológico - CNPq. Thanks to Professor Dagoberto Brandão, 'Escola de Engenharia-UFMG' for the SEM-EDS analysis. Special thanks to Romário Oliveira for the confection of the glass tubes and their sealing at Hialotécnica do Departamento de Química do ICEx-UFMG and the polychrome sculpture restorer Regina Quites, Cecor-EBA-UFMG, for valuable suggestions. The sample of mineral orpiment was supplied by Jan Wouters's team at the Institut Royal du Patrimoine Artistique, Belgium. Thanks to Dr Wouters for the HPLC analysis.

References

Del Negro, C, 1955, *Teto da nave da Igreja de São Francisco de Assis de Ouro Preto*. Arquivos da Escola Nacional de Belas Artes, Rio de Janeiro, Universidade do Brasil, 32–46.

Gettens, R J and Stout, G L, 1966, *Painting materials: a short encyclopaedia*, New York, Dover Publications, 135, 152.

Kühn, H, translated by Alexandra Tone, 1986, *Conservation and restoration of works of art and antiquities*, London, Butterworths, 22–24.

Moresi, C M D, 1995, La escultura policromada del Periodo Colonial en Minas Gerais, Brasil, *Tecnologia y Conservación*, Imprimatura 11, 13–20.

Moresi, C M D, 1999, Avaliação química do potencial de espécies nativas de Relbunium (Garança Americana) como fornecedoras de corantes e pigmentos e sua aplicação ao estudo de obras de arte, Belo Horizonte, Universidade Federal de Minas Gerais, 150–154 (Tese, Doutorado em Química).

Moresi, C M D and Wouters, J, 1997, 'HPLC analysis of extracts, dyeing and lakes prepared with 21 species of Relbunium', *Dyes in History and archaeology* 15, 85–97.

Oliveira, M A R, 2001, Os passos do Aleijadinho e suas restaurações, Imagem Brasileira 1, 81–91.

Pascal, P, 1932, *Traité de chimie minérale*, Paris, Masson et Cie, 529–647.

Segredos necessarios para os officios, artes, e manufacturas, e para muitos objetos sobre a economia domestica, 1794, Lisboa, Offic. de Simão Thadeo Ferreira, t.2 Cap. I, Modo de moer, e destemperar as tintas, 41.

Sinkankas, J, 1974, *Gemstone and mineral data book*, New York, Collier Macmillan, 204.

Trindade, C R, 1951, São Francisco de Ouro Preto, crônica narrada pelos documentos da ordem, Rio de Janeiro, ministério da Educação e Saúde, 403–5 (publicação da Diretoria do Patrimônio Histórico e Artístico Nacional; 17).

Thompson, D V, 1954, *Il libro dell'arte, The Craftsman's Handbook of Cennino d'Andrea Cennini*, New York, Dover Publications, 95.

Abstract

This paper reports on the current stage of experiments in alternative in-gilding techniques, undertaken as PhD research, with the University of Western Sydney Nepean. Initial tests included RhoplexAC33, RhoplexN580, PlextolB500, Liquitex Matte Medium, ParaloidB-72, PVA-AYAF, Regalrez1094 and Aquazol500. At the second stage, materials that attained the best results were further investigated with regard to their concentration in the solutions and methods of activating dried films. The most promising results were achieved using acrylic dispersion PlextolB500.

Keywords

non-traditional gilding, gilded wood, synthetic polymers, restoration

Research into non-traditional gilding techniques as a substitute for traditional matte water-gilding method

Malgorzata Sawicki
Art Gallery of New South Wales
Art Gallery Road
Sydney NSW 2000, Australia
Fax: +61 2 9221 6226
E-mail: margarets@ag.nsw.gov.au

Introduction

Compensation of losses in conservation treatment of gilded objects usually involves traditional gilding methods, bringing to question the prospect of reversibility of such action, as in many cases potential removal of new in-gilding is impossible without damaging the original substrate. A variation of the chromatic abstraction technique called 'gold selection', which was developed in the 1960s, has also been questioned in recent years because this restoration is often visually disruptive for the viewer (Dunkerton 2001).

Non-traditional gilding techniques, as an alternative to traditional methods, were introduced into gilded object conservation in the 1980s. However, little research has been done in this field, and few articles in professional conservation literature have been published. Consequently, conservators do not have sufficient information for assessment. This project aims to partly fill this gap in studies of non-traditional in-gilding techniques related to matte water-gilding. The purpose of this research is to select stable synthetic polymers and reversible methods to successfully compensate losses in original matte water-gilded surfaces, thereby achieving a consensus with professional standards and conservation principles.

Historical background

It has been noted in conservation literature that the losses of a traditional gilded surface can be successfully compensated using synthetic resins, including those which are stable and extensively used in other conservation fields, such as acrylic resin ParaloidB72 (for burnished water-gilding) and acrylic emulsions RhoplexAC33/N580 (for oil-gilding) (Thornton 1991). In addition, acrylic emulsions, Hyplar and Liquitex are recommended for high-gloss water-gilding. Also, it has been observed that losses in aged-burnished water-gilded surfaces can be in-gilded by laying gold leaf on an already polished surface or by using a bole foundation compound with a synthetic binder, such as polyvinyl alcohol (Thornton 1991).

Matte water-gilded surfaces have been the most difficult to compensate, as most acrylic emulsions or resins produce a glossy appearance. Some success has been achieved using acrylic emulsions such as Liquitex matte acrylic mediums and varnishes (Moyer and Hanlon 1996, Sawicki 2000). However, little is known about their ageing properties. It has also been noted in conservation literature that discolouration of Liquitex Acrylic Matte Medium occurs over a relatively brief period of time under ordinary environmental conditions (Hamm et al. 1993).

First stage of experiments

The project initially involved the selection of stable synthetic materials, which were used successfully in other conservation fields, and testing of their suitability for gilding. The initial selection of materials was carried out according to the characteristic properties of the polymers and was made on the basis of technical

Figure 1. Preparation of samples. Approximately half of each sample was matt-water gilded using traditional technique, while the other part was left in gesso for foundation of watercolours – with or without isolation layer – and gilded using one of the selected materials

and conservation literature. The materials considered for testing included those, which:

- had previously been mentioned in conservation literature for use as a substitute for traditional oil- and water-gilding
- had been successful in consolidation of matt paint or
- had been used with good results as a varnish or retouching media.

The following materials were selected for the project (see Tables 1 and 2):

- acrylic dispersions: RhoplexAC33/N580, 1:1; PlextolB500, 1:1 with water/ ethanol, 4:1; Liquitex Matte Medium (included for comparison)
- acrylic resin ParaloidB72: 5% in diethylbenzene (DEB) (w/v); 10% in xylene (w/v); 20% in toluene (w/v)
- poly(vinyl acetate) resin AYAF: 5% in methylated spirit (w/v)
- hydrogenated hydrocarbon resin Regalrez1094: 25% (w/v) in white spirit with Kraton1650G and Tinuvin292
- poly(2-ethyl-2-oxazoline) Aquazol500: 20% (w/v) in water/ethanol 10:1; 10% (w/v) in water/ethanol 10:1.

Extended discussions regarding the selection criteria and properties of particular materials are included in my research paper (Sawicki 1999).

Preparation of samples

Blocks of radiata pinewood of approximately 200 x 100 x 15 mm were coated on one side with traditional gesso (calcium carbonate mixed with 5% solution of rabbit skin glue, w/v) and then prepared as for traditional matte water-gilding. Approximately half of each sample was covered with traditional bole with a gelatine binder, and then double gilded in a traditional manner. The other part of each sample was left in white gesso for gilding using one of the selected materials (see Figure 1). Each polymer was tested on five samples (A, B, C, D, E) prepared in the following manner, using watercolours to imitate bole, and with or without isolation layers:

- A: gesso/ watercolours/ polymer solution
- B: gesso/ polymer solution mixed with watercolours or pigments
- C: gesso/ polymer as sealer/ polymer mixed with watercolours or pigments
- D: gesso/ 10% ParaloidB-72 in xylene (w/v) as isolation film/ watercolours/ polymer solution
- E: gesso/ 10% ParaloidB-72 in xylene (w/v) as isolation film/ polymer mixed with watercolours or pigments.

Gold leaf application technique was determined by the properties of the polymers and included laying the gold leaf on the surface:

- retaining tack (RhoplexAC33/N580)
- activated by exhalation (PlextolB500, Liquitex Matte Medium, Aquazol500)
- activated by wetting it with solvent or a mixture of solvents (all B72 and Regalrez1094 films were activated with a mixture of Shellsol®A/ShellsolT, 88.5%:11.5% – ratio of petroleum benzine – and ethanol, 75:25%, while AYAF was wetted with ethanol/diacetone alcohol, 2:1).

In the course of the conducted tests, applied polymers overlapped a narrow part of the traditional gilding allowing for reversibility tests. The performance of the selected polymers was evaluated for their working abilities (brushability), adhesion of gold leaf, appearance of the gilded surface, appearance of the gilded surface after application of traditional protective layer (ormolu: 5% rabbit skin glue + 10% of diluted seedlac or shellac) and removability of dried film (see Tables 2 and 3). A detailed report outlining results is included in my research paper (Sawicki 1999).

Table 1. List of materials selected for testing including basic relevant information.[1]

Polymers name	Chemical classification	Molecular weights[2] Mn	Mw	Tg in °C	D/I[3]	Viscosity grade[4]
Paraloid®B-72	Copolymer of ethyl methacrylate (EMA) and methyl acrylate (MA)	11,397	65,128	40	in DEB 11.5 in toluene 9.5	29
Rhoplex®AC33 (Primal®AC33 in Europe)	66%PEA/ 33% PMA/ 1% acrylic acid[5] dispersion at 42% (w/w) concentration[6]			5 16		medium to high
Rholpex®N580 (Primal®N580 in Europe)	N-butylacrylate homopolymer, dispersion at 54-56 % (w/w) concentration					low
Plextol®B500[6]	PEA/MMA/EMA dispersion at 50% (w/w) concentration			10 <29		low[7]
PVA AYAF	Poly(vinyl) acetate resin	51,370	113,000	24		80
Regalrez®1094	100% hydrogenated oligomers of styrene and alpha-methyl styrene	630	900	33[8] 43,8[9]		
Aquazol®500[10]	Poly(2-Ethyl-2-Oxazoline)		300,000	55		
Liquitex® Matte Medium[6]	EA-MMA-EMA dispersion at 38 % (w/w) concentration					

1 Unless specified differently chemical and physical properties parameters taken from Samet, W (ed) 1998.
2 Mw – weight average molecular weight; Mn – number average molecular weight; Tg – glass transition temperature.
3 Distinctness-of-image gloss (D/I) of 20% resins concentration solutions (w/v) applied over substrate with lowest gloss. Gloss measurements values taken from: De la Rie, E R, 1987. Research on picture varnishes: Status of the project at the Metropolitan Museum of Art. In Grimstad, K (ed), *Preprints of the 8th triennial meeting of the ICOM Committee for Conservation.* Paris, ICOM, 791D796.
4 Viscosity grade in centipoises of a solution of the resin in toluene at 70°F (21°C) and a concentration of resin of 20% by weight, according to: Feller, R L, Stolow, N and Jones E H, 1985, 126D127.
5 Data from: Stringari, C and Pratt E, 1993, 'The identification and characterisation of acrylic emulsion paint media', in *Symposium '91: saving the twentieth century; the degradation and conservation of modern materials: abstracts.* Ottawa:CCI, 411D440.
6 Data from De Witte, E, Florquin, S and Goessens-Landrie, M, 1984, 'Influence of the modification of dispersions on film properties', in Brommelle, N S, Pye E M, Smith, G and Thomson G, *Adhesives and Consolidants,* London: IIC, 32D35.
7 Data from: Howells, R, Burnstock, A, Hedley, G and Hackney, S, 1984, 'Polymer dispersions artificially aged', in Brommelle, N S, Pye, E M, Smith, G and Thomson, G, 36D43.
8 Hercules, Technical Information Sheet.
9 Data from: De La Rie, E R, and Mcglinchey, W, 1990, 'New synthetic resins for picture varnishes', in *Cleaning, retouching and coatings: technology and practice for easel paintings and polychrome sculpture.* Preprints of the contributions to the Brussels Congress, 3-7 September 1990. London: IIC,168D173.
10 All data from: Wolbers, R C, McGinn, M, and Duerbeck, D, 1998, 'Poly (2-ethyl-2-oxazoline: A new conservation consolidant', in Dorgee, V and Howlett, F C, *Painted wood: history and conservation.* Proceedings of a symposium organised by the Wooden Artefacts Group of the AIC and the Foundation of the AIC, held at the Colonial Williamsburg Foundation, Williamsburg, Virginia, 11-14 November 1994. Los Angeles: The Getty Conservation Institute, 514D527.

Table 2. Evaporation rates, boiling point, solubility parameters and fractional solubility parameters of selected solvents

Solvent	Toxicity[1]	Boiling point in °C[2]	Evaporation rate[3]	Solubility parameters[4]	Fractional solubility parameters[5] 100fd	100fp	100fh
White spirits	1	152-196	0.19	7.6	90	4	6
Diethyl benzene		184.9[6]		8.7			
Xylene	2	138.0	0.75	8.8	83	5	12
Toluene	2	110.0	2.3	8.9	80	7	13
1-methoxypropan -2-ol[7]	2	117-125	0.75	9.5			
Diacetone alcohol	2	150-172[8]	0.15[9]	9.2	45	24	31
Propan-2-ol	1	82.0	2.2	11.5	40	16	44
Ethanol	1	78.0	2.4)	12.7	36	18	46
Methanol	3	65.0	4.1	14.5	30	22	48
Water		100.0	0.27	23.2	18	28	54

1 Classification according to Phenix, A, 1993, 50, 22.
2 *Unless marked differently data obtained from: Horie, C V, 1987. Materials for Conservation. Organic Consolidants, Adhesives and Coatings, Butterworths & Co. Appendix 2.1.*
3 Unless marked differently data obtained from: Horie, C V et al, 1987, Appendix 2.1. Evaporation rate measured by evaporating the solvent from a 10% solution of tritolyl phosphate (Shell Chemicals Ltd. 1977a; ASTM D 3539-76) relative to n-butyl acetate (=1). Values in brackets were measured by evaporation of the solvent from filter paper.
4 Solubility parameters values obtained from: Stolow, N, 1985, Appendix F.
5 Data obtained from: Phenix, A, 1992, 49, 24.
6 Stolow, N, 1985, Appendix F.
7 Phenix, A, 1992, 50, 39.
8 Phenix, A, 1992, 49, 25.
9 Phenix, A, 1992, 49, 25.

Table 3. Test of removability of polymers from the surface gilded with traditional matt water-gilding technique, using solvents of increasing polarity.

Materials included in the first stage of experiments	ShellsolA/ ShellsolT® (1:4,5)	Toluene	Xylene	Xylene /acetone (1:1)	Acetone	Ethanol	Methylated spirit
5% Paraloid®B-72 in DEB (w/v)	−	+	+	+	+	+	+
20% Paraloid®B-72 in toluene (w/v)	−	+	+	+	+	+	+
10% Paraloid®B-72 in xylene (w/v)	−	+	+	+	+	+	+
Rhoplex®AC33/N 580 (1:1)	+	+	+	+	+	+	
Plextol®B 500 (1:1 with water/ethanol [4:1})	−	+	+	+	+	+	+
5% PVA AYAF in methylated spirit (w/v)	− +	+	+	+	+	+	+
25% Regalrez®1094 in white spirit (w/v) with Kratonâ1650G and Tinuvin®292.	+	+	+	+	+	+	+
10% Aquazol® 500 (w/v) in water/ethanol, 10:1	−	−	−	− +	+	+	+
Liquitex® Matte Medium	−	+	+	+	+	+	+

The removability tests were performed two-to-four weeks after gilding. They were carried out with cotton swabs dipped in various solvents of increasing polarity and applied to the surface of approximately 0.5–1 cm². Reactions between the solvent, the polymer and the gilded surface were observed under stereomicroscope. Prior solvent application ormolu protective coating was removed with saliva in the tested areas. The selected solvents are often used for the removal of overpainting from original gilding. Although, theoretically they are harmless for the water-gilded surfaces, it has been observed in a number of treatments that prolonged application of solvents, particularly polar and/or strongly hydrogen bonded solvents such as acetone and ethanol, and repeating movement of cotton swabs on the surface can abrade or remove original gilding. As the duration of solvent application is critical, it was accepted in the removability tests that each operation should not exceed 30 seconds:

− unsuccessful result: film was not removed during 30 seconds of solvent application
+ film was successfully removed during 30 seconds of solvent application

Figure 2. Final results of the first stage of experiments including all materials. Marks in the middle of each sample were left after removability tests

Summary of results (see Figure 2)

From the seven resins included in the testing only Regalrez1094 should be excluded from further experiments due to its lack of adhesion properties.

Overall, in all experiments, the worst results were achieved using 5% ParaloidB-72 in DEB. Resin concentration in the solution was too low, while the long evaporation rate of DEB caused deep penetration of B-72 into the foundation layer leaving the surface with little binder and therefore causing poor adhesion of gold leaf. B-72 in toluene or xylene performed much better, with B-72 in xylene achieving the smoothest surface texture due to lower viscosity of the applied solution and lower evaporation rate allowing for better levelling. Generally, the samples with watercolour foundation (A and D) formed a surface of smoother texture, but no significant difference was observed regarding the adhesion of gold leaf between samples with, or without an isolation layer. All samples with B-72 in xylene showed slight problems with gold leaf adhesion indicating that 10% concentration of resin was too low.

Promising results were achieved from tests with Aquazol500 as gold leaf adhered well to all surfaces, with sample D achieving the smoothest texture and lowest level of gloss.[1] During the application of ormolu, however, Aquazol500 showed exceptionally high hygroscopicity resulting in blistering and consequent removal of gilding.

Polyvinyl acetate resin AYAF showed low sheen and even texture of the surface on sample D. Nevertheless, even this sample had problems with adhesion, indicating that 5% solution was too weak. Methylated spirit also dried too rapidly to allow good levelling of forming film.[2]

Although a mixture of RhoplexesAC-33/N-580 achieved satisfactory results, they gave solutions of a high viscosity, which, with quick drying time, prevented proper levelling of forming film.

Surprisingly, Liquitex Matte Medium achieved even worse results. The undiluted dispersion formed solutions of high viscosity, which did not allow for easy application, while diluted mixtures lost their adhesion properties and required the application of multiple layers in order to attract gold leaf. An additional disadvantage of this material was its high water-sensitivity, which caused blistering of gold leaf after application of a protective coating.

Figure 3. First stage of experiments – samples that achieved the best results

Figure 4. The second stage of experiments with B-72 in xylene in concentrations 10% w/v (sample A's), 12,5% w/v (sample B's), and 15% w/v (sample C's), activated with a mixture of ShellsolA/ ShellsolT® (1:4) and propan-2-ol, in subsequent ratios of 25%, 35%, 50% v/v of alcohol content

Figure 5. Final results of the second stage of experiments including all samples

In comparison, diluted PlextolB500 produced very workable liquids, which mixed well with watercolours and formed a low sheen surface of smooth texture. Gold leaf adhered well to all samples, and it retained low sheen appearance after the application of ormolu.[3] From the seven resins included in the testing program acrylic dispersion PlextolB500 was the most promising (see Figure 3).

Second stage of experiments

During initial tests, it was recognized that further intricate studies of the selected materials are required to achieve greater confidence in them. At the next stage, materials that attained the best results in previous tests were further investigated with regard to their concentration in the solutions and methods of activation of dried films. Tests included Paraloid B72, PVA-AYAF and Plextol B500.

ParaloidB72

Previous tests indicated that the performance of B-72 film for the purpose of gilding could be determined by the selection of solvent, resin concentration and solvents chosen for re-activation. Solvents with a very slow evaporation rate can drive the resin off the surface (B-72 in DEB), while a high viscosity solution in solvents with a high evaporation rate, can influence the levelling of the applied film and result in brush marks being apparent on the gilded surface (B-72 in toluene).

Alan Phenix (1992) suggested glycol ethers as better solvents for this resin, and also as suitable replacements for toluene or xylene (see Table 2). Further experiments included B-72 solutions in 1-methoxypropan-2-ol (propylene glycol monomethyl ether), in addition to further testing of B-72 in xylene. Phenix (1992, 1993), analyzing the solubility behaviours of B-72 using varied solubility parameter systems, noted that solvents for B-72 should fit between 40 and 87 of the Teas fd parameter. Those outside these boundaries can be classified as non-solvent. Propan-2-ol has a Teas fd value of 40, and theoretically should have a slightly better effect on B-72 than ethanol with an fd value of 36. Softening the film could also be improved by increasing the aromatic content in the Shellsol®A/ShellsolT mixture, to the highest-level value of low aromatic white spirits (20%) (Stolow 1985).

Samples were prepared in a similar manner as sample D in previous experiments. Three solutions of ParaloidB-72 in xylene at concentrations of 10%, 12.5% and 15% w/v were applied twice on the prepared surface of samples A, B and C. In this manner, all sample A's were covered with a 10% solution of B-72, all sample B's were coated with a 12.5 % B-72 solution, while all sample C's were prepared with a film of 15% B-72 in xylene. Dried films were then activated with solvent mixtures of varied ratios of Shellsol®A/ShellsolT (1:4) to propan-2-ol, as follows: 25%, 35%, 50% v/v of alcohol content.

Similarly, three solutions of B-72 in 1-methoxypropan-2-ol in concentrations of 15%, 17.5%, 20% w/v were applied twice to three samples, subsequently named samples A, B and C. The dry film was activated in a similar manner to the test conducted with B-72 in xylene.

SUMMARY OF RESULTS

Solutions of B-72 in 1-methoxypropan-2-ol had a slightly lower viscosity than similar concentration solutions of this resin in xylene, allowing easier brush application. Changes in the film activation mixture, however, showed little effect. The activation of B72 coatings created some problems (Figure 4). It has been noticed in conservation literature that the activation of B-72 film is difficult, as excessive solvent spray results in the adhesive becoming fluid and as a consequence it can migrate off the surface (Phenix 1984). In current experiments a mixture of solvents used for the activation of dry film did not have enough power to dissolve the resin, but only softened it. Nevertheless, both solvents selected for B-72 (xylene and glycol ether) have a rather low evaporation rate allowing good levelling of formed film, but presumably also causing the resin to partially migrate off the surface during drying. Tests showed that the concentration of resin in both solvents must be at least 15%, and more than one application is required for attraction of gold leaf.

Figure 6. The second stage of experiments with PVA-AYAF in ethanol/diacetone alcohol (2:1), in concentration of 10% w/v (sample A's), 15% w/v (sample B's), and 20% w/v (sample C's), activated with a mixture of water/ethanol in the subsequent proportions 2:1, 1:1, and 1:2

Figure 7. The second stage of experiments with Plextol® B500 including all tests, and the best samples from the first stage

Figure 8. The second stage of experiments with Plextol® B500. Sample A2, which achieved the best results in regard to surface texture and low sheen appearance

In both sets of tests, the smoothest texture was achieved with sample A, with B72 in glycol ether solvent activated with a mixture consisting of 25% propanol (Figure 5). A higher proportion of propanol in the activation mixture caused better adhesion, but it also resulted in greater 'sinking' effects, worse wrinkles on the surface and worse appearance of the joining line between both types of gilding.

PVA-AYAF

Previous tests indicated that the performance of PVA-AYAF resin films could be improved with higher resin concentration in solvents with lower evaporation rates. Depending on the application method, various solvents are recommended for AYAF (Schniewind and Kronkright 1984, Hansen et al. 1993, Hansen and Volent 1994, Samet 1998). A mixture of ethanol/diacetone alcohol (2:1) was chosen for further experiments, despite the fact that a slower rate of drying would simultaneously cause a surface with a higher gloss (Feller et al. 1985).

The film activation mixture aimed to test the sensitivity of a fresh film of AYAF to water (Samet 1998). Although a greater content of ethanol in water could cause rapid attraction of the gold leaf resulting in the formation of a rough surface, it could also reduce the glossy appearance of the film and help to soften the polymer resulting in better adhesion of the gold leaf.

Nine samples were prepared in a similar manner as sample D in previous tests. Three solutions of AYAF in ethanol/diacetone alcohol (2:1) were prepared in concentrations: 10%, 15% and 20% of resin contents. Each solution was applied once on three samples, and after drying, the film was reactivated with a mixture of water/ethanol mixed in the proportions 2:1, 1:1, 1:2, prior to the application of gold leaf.

SUMMARY OF RESULTS

The experiments showed that the activation mixture of water/ethanol 2:1 provided sufficient adhesion for the attraction of gold leaf. A decrease in the quality of the surface with regard to its texture was proportional to the increase of ethanol content in the activation mixture. Films formed with higher resin concentration solutions activated with a mixture with low ethanol content (sample C), showed positive results, which should encourage further research on this material (see Figure 6).

Plextol B500

Further tests with Plextol B500 intended to investigate the flexibility of its adhesion properties for gilding.[4] Additionally, in order to create the characteristic effect of overlapping leaves, film activation method was included, which involved wetting the surface, similar to traditional water-gilding technique. Propan-2-ol contents in the water aimed to soften the dry film, and to act as a surfactant.

All samples were prepared in a similar manner as sample D in previous experiments. Three concentrations of Plextol B500 solutions (2:1, 1:1, 1:2 with water/ethanol 4:1) were mixed with watercolours, and applied twice on four samples. Dry films were subsequently activated with exhalation, and water with 10% propan-2-ol, 25% propan-2-ol, or 1:1 mixture of water and propan-2-ol.

SUMMARY OF RESULTS

Experiments with Plextol B500 brought again very promising results. All samples showed very good adhesion of gold leaf with one application, and no difference was noted in the adhesion of gold leaf and the appearance of the gilded surface, between samples with film formed with low and high concentrations of Plextol B500. Even the most diluted solutions provided sufficient attraction of gold leaf.

Gilding with an activation mixture consisting of 10% propan-2-ol attained the smoothest texture of the surface. Results showed that the addition of propan-2-ol in the wetting mixture assisted breaking of the surface tension of water, rather than aiding the softening of dry film of Plextol B500.

However, all surfaces that were gilded with a water/propanol mixture showed a greater level of gloss than parts gilded with the traditional method. Compared to

Table 4. Additional test of performance of Plextol®B500, one coat, double gilded, activated with water with 25% of propan-2-ol.

Type of foundation	Evaluation of performance during application	Surface appearance prior to application of gold leaf	Surface appearance after application of gold leaf	Surface appearance after application of protective layer
A1. L1. 10% B72 in xylene(w/v) L2 watercolours L3. One coat of Plextol®B500 in water/ethanol (4:1), 2:1, plus watercolour paint	No apparent problems	E	GS After second layer E	E
B1. L1. 10% B72 in xylene(w/v) L2. watercolours L3. One coat of Plextol®B500 in water/ethanol (4:1), 1:1, plus watercolour paint	No apparent problems	E	GS After second layer E	E
C1. L1. 10% B72 in xylene(w/v) L2. watercolours L3. One coat of Plextol®B500 in water/ethanol (4:1), 1:2, plus watercolour paint	No apparent problems	E	GS After second layer E	E

Table 5. Additional test of performance of Plextol® B500, one coating, activated with mixed methods

Type of foundation	Evaluation of performance during application	Surface appearance prior to application of gold leaf	Surface appearance after application of gold leaf	Surface appearance after application of protective layer
A2. L1. 10% B72 in xylene(w/v) L2. watercolours L3. one coat of Plextol® B500 in water/ethanol (4:1), 2:1, plus watercolour paint - for first gold leaf layer activated with exhalation - second coat of gold leaf applied with 1° exhalation, 2° water/propan-2-ol (25%)	No apparent problems	E	E After second layer 1° PA 2° E	E
A3. L1. 10% B72 in xylene(w/v) L2. watercolours L3. One coat of Plextol® B500 in water/ethanol (4:1), 2:1, plus watercolour paint - double gilding, foundation activated with water with 25% of propan-2-ol	No apparent problems	E	GS, After second layer: E	E
A4. L1. 10% B72 in xylene(w/v) L2. watercolours L3. One coat of Plextol® B500 in water/ethanol (4:1), 2:1, plus watercolour paint -for first coat activated with water /propan-2-ol (25%) - second activated with water With 10% of propan-2-ol	No apparent problems	E	GS After second layer: E	E

E - excellent, identical in appearance to traditional mat water gilding
GA - good matt appearance, but gold leaf does not adhere to the entire surface, small losses apparent
GB - good matt appearance but brush strokes slightly apparent/or surface uneven
GO - good matt, but oil gilding appearance remains
GS - good although surface slightly shiny
GSB - good although surface slightly shiny and brush strokes slightly apparent
RB - reasonable matt, but brush strokes apparent/or surface uneven
RR - reasonable matt, but surface rough
ROR - reasonable matt, but oil gilding appearance remains and surface is rough
RS - reasonable, but surface evidently shiny
RSB - reasonable, but surface evidently shiny and brush strokes apparent/or surface rough
PB - poor, brush strokes very apparent
PS - poor, surface too shiny
PSB - poor, surface too shiny and brush strokes apparent
PA - poor, gold leaf does not adhere
POA - poor, gold leaf does not adhere properly and oil gilding appearance remains
PR - poor, surface very rough

previous tests, the difference in appearance of the surface could be the result of variations in the activation method. Exhalation caused a blooming effect of acrylic foundation, and gold leaf applied over such a surface retains a matt appearance, as the film, which gains little moisture, dries rather quickly. In the second method of application, the dry film was wetted significantly with water/propanol solution, which takes a longer time to evaporate, again allowing for the formation of a shiny surface. In order to reduce the level of gloss of the gilded surface it was decided to conduct additional tests that would involve only one coat of PlextolB500 as a foundation layer, and a double gilding technique with mixed methods of film activation.

The foundation for three samples was prepared as for previous tests with one layer of PlextolB500: water/ethanol mixture (with watercolours added) in concentrations 2:1 (A1), 1:1 (B1) and 1:2 (C1). Dry film was activated with a mixture of water with 25% propan-2ol. After drying, the surface was gilded again, wetting the surface with the same solution (see Table 4).

For the third test, three samples, A2, A3, A4, were prepared as for previous tests with one layer of a 2:1 mixture of PlextolB500: water/ethanol, mixed with watercolours. Sample A2 was first gilded by activating the acrylic film by exhalation. After drying, the surface was gilded again by activating the surface (1) with exhalation and (2) with a mixture consisting of 25% propan-2-ol. Sample A3 was double gilded by wetting the surface with a mixture of 25% propan-2-ol content. Sample A4 was double gilded, firstly wetting the film with a mixture of water with 25% of propan-2-ol, and secondly with a mixture of water with 10% of propan-2-ol (see Table 5).

Results were excellent (Figure 7). The surface of all samples achieved a smooth texture with low sheen appearance. Sample A2 was characterized with the lowest level of gloss, similar to the part gilded with traditional technique (see Figure 8).

Conclusions

Conducted experiments show that losses in matte water-gilded surfaces can be successfully compensated using stable synthetic polymers, although additional tests would certainly contribute to a better understanding of these materials in relation to gilding. Excellent results with an acrylic dispersion of PlextolB500 indicate that this material offers great flexibility in terms of solution concentration and diverse application methods, as well as a safe working environment. Applied as a very thin layer over a matte surface, and then double gilded, activating it with combination of exhalation and a low-alcohol water mixture, Plextol®B500 can facilitate a perfect replication of original matt water-gilded surface. Further experiments including accelerating ageing tests and case studies are in progress.

Acknowledgements

The author would like to thank Dr Richard Thomas, University of Western Sydney Nepean, for his encouragement in conducting these experiments, and to Alan Lloyd, Head of Conservation Department, Art Gallery of New South Wales, for his support for this project.

Notes

1 Side tests of burnishing with agate also gave promising results.
2 The advantage of PVA-AYAF is its good burnishing abilities, proven in several side tests.
3 The surface gilded with PlextolB500 could also be burnished with agate. Additional tests with a mixture of PlextolB500/PlextolD360 gave very promising results for compensation of losses in oil-gilded surfaces.
4 It has been observed in conservation literature that dilution of Plextol B500 up to 20% of the stock still gave an adequate bond for the consolidation of flaking paint in oil paintings on glass. Lower concentrations, however, did not provide sufficient adhesion between the glass and the paint layers (Dudek 1996).

References

Dudek, G, 1996, 'Conservation of pub paintings: oil paintings on glass', *AICCM Bulletin* 21(2), 18D25.

Dunkerton, J, 2001, 'The restoration of gilding on panel paintings' in *Gilding: Approaches to treatment. A joint conference of English Heritage and the UKIC 27-28, September 2000*, English Heritage, 39D47.

Feller, R L, Stolow, N and Jones, E H, 1985, *On picture varnishes and their solvents*, rev. ed., Washington D.C., National Gallery of Art.

Hamm, J, Gavett, B, Golden, M, Hayes, J, Kelly, C, Messinger, J, Contompasis, M, Suffield, B and CCI, 1993, 'The discoloration of acrylic dispersion media', *Symposium '91: saving the twentieth century; the degradation and conservation of modern materials: abstracts*, Ottawa, CCI, 381D392.

Hansen, E F and Volent, P, 1994, 'Solvent sensitivity testing of objects for treatment in a vapor-saturated atmosphere', JAIC33(3), 315D316.

Hansen, E F, Lowinger, R and Sadoff, E, 1993, 'Consolidation of porous paint in a vapor-saturated atmosphere: a technique for minimising changes in the appearance of powdering, matte paint', JAIC32, 1D14.

Moyer, C and Hanlon, G, 1996, 'Conservation of the Darnault Mirror: an acrylic emulsion compensation system', JAIC35, 185D196.

Phenix, A, 1984, 'Lining without heat or moisture', in *Preprints of the 7th Triennial Meeting of the ICOM Committee for Conservation*, Paris, ICOM.

Phenix, A, 1992, 'Solubility of Paraloid B-72', *Conservation News* 48, 49 (21D23, 23D25).

Phenix, A, 1993, 'Solubility of Paraloid B-72', *Conservation News* 50 (39D40)

Samet, W (ed.), 1998, ' Varnishes and surface coatings', *Painting Conservation Catalogue*, Volume 1, Paintings Specialty Group of the AIC, Washington D.C., AIC, 137D151.

Sawicki, M, 1999, 'Research into non-traditional gilding techniques as a substitute for traditional mat water-gilding', research project, University of Western Sydney Nepean, Australia.

Sawicki, M, 2000, 'The visit of the Queen of Sheba to King Solomon by Edward Poynter, 1884-1890. The frame revisited', *AICCM Bulletin*, 25(21D32).

Schniewind, A P and Kronkright, D P, 1984, 'Strength evaluation of deteriorated wood treated with consolidants' in Brommelle, N S, Pye, E M, Smith, P and Thomson, G (eds.), *Adhesives and consolidants. Preprints of the contributions to the IIC Paris Congress, 2-8 September 1984*, London, IIC, 146D151.

Stolow, N, 1985, 'Physical, chemical and toxicological properties of solvents and liquids for conservation of paintings and works of art' in Feller, R, Stolow, N and Jones, E H, *On picture varnishes and their solvents*, rev. ed., Washington D.C., National Gallery of Art.

Thornton, J, 1991, 'The use of non-traditional gilding methods and materials in conservation' in Bigelow, D, Cornu, E, Landrey, G J and Van Horne, C (eds.), *Gilded wood: conservation and history*, Madison (Connecticut), Sound View Press, 217D228.

Materials

RhoplexAC33 (water dispersion of copolymer of ethyl methacrylate, EA, and methyl acrylate, MA), Rohm and Hass Company, Philadelphia, Pennsylvania 19105, U.S.A.

RhoplexN580 (water dispersion of N-butylacrylate homopolymer), Rohm and Hass Company, Philadelphia, Pennsylvania 19105, U.S.A.

Liquitex Matte Medium (water dispersion of copolymer of ethyl acrylate, EA, methyl methacrylate, MMA, and ethyl methacrylate, EMA), Binney and Smith, Easton, Pennsylvania 1-8044-0431 U.S.A.

Regalrez1094 (hydrogenated hydrocarbon resin), Hercules Resins Group, Hercules Plaza, Wilmington, Deleware 19894, U.S.A

ParaloidB72 (copolymer of ethyl methacrylate, EMA, and methyl acrylate, MA)

Rohm and Hass Company, Philadelphia, Pennsylvania 19105, U.S.A.

PlextolB500 (water dispersion of copolymer of ethyl acrylate, EA, methyl methacrylate, MMA, and ethyl methacrylate, EMA), Rohm GmbH Chemische Fabrik, Postfach 4242, 6100 Darmstadt 1, Germany

Aquazol500 (poly(2-ethyl-2-oxazoline)), Polymer Chemistry Innovations Inc., 1691 West College Avenue, State College, Pennsylvania 16801, U.S.A.

PVA-AYAF (poly(vinyl acetate) resin), Union Carbide Corporation, Old Ridgebury Road, Danbury, Connecticut 06817, U.S.A.

Abstract

This paper describes the conservation of two fibrous plaster panels in the National Museums of Scotland (NMS). The panels were part of two wall friezes, designed by Charles Rennie Mackintosh for the Front Saloon of the Willow Tea-rooms, opened in Glasgow in November 1903. The panels were removed from the tearooms in the late 1970s. Some have since been exhibited in museums and galleries, although there has been controversy about the authenticity of several restored panels and their appearance as an all-white design. Paint analysis was carried out to establish the original appearance, to interpret the history of the panels and to guide the removal of the overpaints. This also helped establish the authenticity of a third panel in the NMS collection. A mounting system was devised to enable the display of the two panels as a frieze in the Museum of Scotland.

Keywords

Charles Rennie Mackintosh, conservation, fibrous plaster, paint analysis, mounting, display

Investigation, conservation and mounting of a fibrous plaster frieze by Charles Rennie Mackintosh

Charles Stable★, Belén Cobo del Arco and Helen Spencer
National Museums of Scotland
Chambers Street
Edinburgh EH1 IJF, Scotland
United Kingdom
Fax: +44(0)1312474306
E-mail: c.stable@nms.ac.uk, b.cobo@nms.ac.uk, h.spencer@nms.ac.uk

Introduction

In 1997 the National Museums of Scotland acquired two plaster panels designed by Charles Rennie Mackintosh. The panels formed part of a frieze of eight ornamental plaster panels made in 1903 for the interior of the Willow Tea-rooms in Sauchiehall Street, Glasgow.

These two panels had been removed in 1978 from the tearooms as part of a building refurbishment and given to the Charles Rennie Mackintosh Society.

The plaster panels were based on a repeating stylized willow tree design. A scale drawing in pencil and watercolour held in the Hunterian Art Gallery proves Mackintosh's authorship of the design. The Willow Tea-rooms frieze has always been described as being monochrome (Howarth 1952, Bilcliff 1979). However the watercolour has a more colourful and elaborate design. During conservation it was discovered that the panels were in fact bi-chrome.

The plaster panels measured 164cm x 182cm and were made in two halves. They were in a very poor preservation state; their appearance and physical integrity was seriously compromised. The aim of the conservation was to improve their appearance and to make them structurally sound for display. The conservation of the panels needed to take into consideration the fact that they had not been previously restored and they were two of the last three unrestored originals.

A thorough collaborative investigation was necessary to gain a better understanding of the frieze, particularly its original appearance, colour scheme and manufacturing process.

The National Museums of Scotland had previously purchased another panel, this one restored, from the Willow Tea-rooms. Its authenticity had been questioned by some experts, and by comparing the new panels with the authenticated panels it was hoped to prove its authenticity.

Manufacturing process

Eight panels were originally made by M'Gilvray & Ferris, 120 West Regent Street, Glasgow following CR Mackintosh's design.

The low-relief plaster panels are fibrous plaster casts. Fibrous plaster was a relatively recent technique in the early 20th century. Millar (1905) regarded fibrous plaster as a technique with great possibilities. On the other hand Bankart (1908) regarded the technique as a cheap replacement for proper solid plaster panels, using a mixture of unsympathetic materials. In spite of all the potential problems this technique was widely used, as it was a quick, cheap way of creating large, light, plaster panels.

Modelling

Clay and wood were generally used to create the model from which moulds could be taken. It was the opinion of traditional plasterers (Grandinson and Son 2000) that the panel model was most likely modelled in clay.

*Author to whom correspondence should be addressed

Figure 1. Photograph of plaster frieze in situ above dining room fireplace in the Willow Tea-rooms, circa 1905. Note darker areas suggesting colour in centre of the design. Reproduced with the kind permission of Hunterian Art Gallery, University of Glasgow, Mackintosh collection.

Figure 2. One of the two pair of panels in condition as originally received by NMS before conservation.

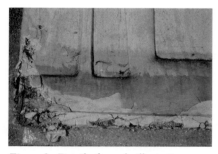

Figure 3. Detail of panels illustrating damage to the plaster, Hessian and timber laths before conservation.

In the early 20th-century gelatine or glue would have been used to produce moulds. A solid plaster cast or master would have been made in order to take further moulds. The master would have traditionally remained with the plasterers. No other original or moulds would have been kept, as they were perishable.

Casting

The casting of fibrous plaster is done in two stages. First a thin layer of plaster is poured into the gelatine mould, into which Hessian scrim and wooden laths are placed. Before the first plaster is set, a second layer of plaster with size (animal glue) is poured in (Millar 1905). This two-stage process can cause problems both during casting and during the life of the panels. During conservation it was found that the two coats of plaster had become detached, particularly in areas where the scrim had disintegrated.

Original appearance

An integral part of the conservation of the Willow Tea-rooms panels was to establish the original appearance of the frieze. A detailed examination and analysis of the paint layers was undertaken, as well as an examination of contemporary records.

Although there are no photographs taken specifically of the panels, the frieze features in several photographs of the Willow Tea-rooms on its opening (see Figure 1). It is clear from the photographs that the panels formed two continuous friezes integrated on the walls. Closer investigation of the photographs confirmed the bichrome scheme revealed during conservation.

Condition of the panels

The panels were received in a poor condition with their appearance and physical integrity seriously compromised (see Figures 2 and 3). Even though Mackintosh employed a reputable firm, regarded at the time as good specialists in fibrous plaster (Millar 1905), the plaster panels appeared to be poorly manufactured. Fibrous plaster panels cannot be removed from their supporting wall without causing major structural damage to the plaster. The building had also undergone several major refurbishments that probably damaged the panels before they were finally removed in 1978. Away from the rigid support of the wall the panels were flexible and prone to further structural damage. Storage in a damp environment accelerated their deterioration. Some of the problems that the panels were displaying were also related to the casting process and the mixture of materials used.

- Approximately 35% of the paint surfaces had become detached and lost, exposing the plaster substrate. The remaining paint was severely distorted, cracked and curled. Lifting paint was taking plaster with it. The thickness of the paint also obscured plasterwork detail.
- The plaster was physically damaged with cracks, chips and losses. In areas this damage was so severe that the substructure was revealed. The edges were in a particularly poor state.
- Iron screw fixings present had corroded causing staining of the plaster and splitting of wood.
- The Hessian scrim had partially disintegrated, weakening the plaster. Mould had developed. Some framing laths were broken or split and portions were missing.

Analysis

Methods of analysis

Initial analytical work was carried out on one of the Willow Tea-room panels (Townsend 1996). This answered some questions about the panels and served as a tool to plan the conservation of the paint layers. As conservation work progressed, further questions were raised and further analysis was designed to answer more specific questions about the individual paint layers.

A full range of analyses was carried out (see Table 1).

Figure 4. The sequence of paint layers on the plaster panels (refer to Table 2).

Summary of results

Results from the different analyses were combined to produce an overall picture of the sequence of the layers. This is represented in Figure 4 and Table 2.

PLASTER

The plaster was identified as gypsum and tested positive for protein, likely to be the gelatine that was used to make the mould. On top of the plaster a layer of Barium sulphate, mixed with animal glue, was used to smooth and prepare the surface.

Table 1. Methods of Analysis Used

Method of Analysis	Carried out by	Analysis
Polarizing light microscopy	Charles Stable NMS	Pigment analysis
Scanning Electron Microscopy (SEM-EDX)	Helen Spencer & Paul Wilthew NMS	Elemental analysis and visual analysis of layers
X-ray Diffraction (XRD)	Peter Davison NMS	Pigment analysis
Fourier Transform Infra Red (FTIR)	Anita Quye & Michelle Fung NMS	Binder analysis
Gas Chromatography Mass Spectroscopy (GC-MS)	Brian Singer (University of Northumbria)	Binder Analysis

Table 2: Results of Cross-section Analysis

Layer	Colour	Fillers	Pigment identification	Binder identification	Comments
Plaster	Off white	Gypsum (Calcium sulphate)			Animal protein probably gelatin - used to make mould
Filler	Creamy white	Barytes (Barium Sulphate)		Proteinaceous of animal origin	
1	white				
2	White		Calcium Carbonate	Proteinaceous of animal origin	Pure chalk, no fillers
3	Green	Barium Sulphate, Zinc Oxide	Calcium Carbonate Emerald Green (Copper aceto-arsenate). Prussian Blue (Ferric Ferrocyanide)	Identified as anumal glue Proteinaceous of animal origin	Pure chalk, no fillers
4	White		Calcium Carbonate	Proteinaceous of animal origin	Pure chalk, no fillers
5	Green	Barium Sulphate, Zinc Oxide	Emerald Green, Prussian Blue	Proteinaceous of animal origin	
6	White		Calcium Carbonate	Proteinaceous of animal origin	Pure chalk, no fillers
7	Green	Barium Sulphate, Zinc Oxide	Emerald Green, Prussian Blue	Proteinaceous of animal origin	
8	White		Calcium Carbonate	Proteinaceous of animal origin	Pure chalk, no fillers
9	Green	Barium Sulphate, Zinc Oxide	Emerald Green, Prussian Blue	Proteinaceous of animal origin	
10	White	Barium Sulphate, Zinc Oxide	Calcium Carbonate, lead white (Lead Carbonate)		
11	Green	Barium Sulphate, Zinc Oxide	Emerald Green	Animal glue	Analysed by GC-MS) Final layer exposed during conservation
12	White	Barium Sulphate, Zinc Oxide	Calcium Carbonate, lead white		
13				Animal glue layer	Discrete varnish layer – no pigment visible. Analysed by GC-MS)
14	White	Barium Sulphate, Zinc Oxide	Calcium Carbonate, lead white		
15	Green		Emerald Green	Linseed oil + pine resin	Pure pigment layer with linseed oil binder. Analysed by GC-MS
16	White	Barium Sulphate, Zinc Oxide	Lead white	Linseed oil + pine resin	
17	Green	Barium Sulphate, Zinc Oxide	Emerald Green Sparse ultramarine	Unidentified oil medium	
18	White	Mixed fillers elements present -Ba, Si, Ca, S	Lead white, zinc white (Zinc Oxide)	Unidentified oil medium	
19	White	Mixed fillers elements present Ba, Si, Ca, S	Lead white, zinc white, unidentified organic pink pigment	Unidentified oil medium	Pink pigment added to counteract the colour of the previous layer
20	White	Mixed fillers elements present Al, Si, S, K Ca	Lead white, zinc white	Long oil alkyd	Identified as post WW2 paint (Townsend, 1996)
21	White	Mixed fillers elements present Al, Si, S, K Ca	Lead white, zinc white	Long oil alkyd	
22	White	Mixed fillers elements present Al, Si, S, K Ca	Lead white, zinc white and sparse Prussian Blue	Long oil alkyd	Blue pigment added to counteract the colour of the previous layer
23	White	Mixed fillers elements present Al, Si, S, K Ca s	Lead white, zinc white	Long oil alkyd	
24	White	Mixed fillers elements present Al, Si, S, K Ca	Titanium dioxide and zinc white	Modern emulsion	
25	White	Mixed fillers elements present Al, Si, S, K Ca	Titanium dioxide and zinc white	Modern emulsion	

Figure 5. Back scattered electron image of paint layers 14,15 and 16. The copperaceto-arsenate particles are clearly visible in layer 15.

PAINTS

The table clearly shows the complex sequence of repainting and illustrates the evolution of paint through the century. The green was repainted seven times (see Figure 5) and the paint formulation evolved confirming that the bi–chrome colour scheme was intentional and lasted for a number of years. It is thought that the green colour scheme may have lasted until the tearoom was closed and the premises changed to a shop in the early 1930s. The paint analyses support this hypothesis.

The paint analyses are useful for authenticating other panels from the tearoom. The third panel owned by NMS had previously been restored and most of the paint layers had been stripped. However underneath the current white paint, samples of emerald green pigment were located, confirming the authenticity of this panel.

Treatment proposal

A decision was made to remove the over-paints. These over-paints were considered to misrepresent Mackintosh's original vision of the panels and to be responsible for some of the deterioration of the surface. The paint also impeded access for essential consolidation treatment of the plaster substrate. Although this direction of treatment was recognized to be more interventionist, it was felt the approach was necessary for the long-term preservation of the panels.

The proposal was to surface clean the panels and to remove the over-paints using the paint section samples as a guide to reach a stable paint finish reflective of the original colour scheme.

Consolidation and structural repair was required to impart strength to the plaster, Hessian and timber. It was necessary to gain access to both front and rear faces of the panel for this operation.

A mounting system had also to be devised to provide structural strength and rigidity and reunite the frieze for display.

Treatment

CLEANING AND PAINT REMOVAL

Initially the panels were dry brushed and vacuumed to remove soiling likely to cause surface staining with further aqueous or solvent cleaning.

A strategy for removing the different paint layers was developed. The paint analyses could not be completed before the conservation work began, so they were not available for determining suitable solvents. In retrospect the analyses were useful in explaining the behaviour of each paint layer. Solvents were tested on both the paint layers and the Hessian scrim, as it was feared that this would stain the plaster.

The top emulsion layers were found to have poor adhesion and could be separated easily from the remaining paint by mechanical removal with scalpels.

This revealed better-attached paint layers. An application of 1:1 Stoddard solvent and acetone was most successful in softening these layers. The solvent was applied with cotton wool poultices placed over spider tissue to prevent cotton fibres from becoming attached to the paint. Aluminium foil was placed over the poultice to provide a vapour barrier. Scalpels were used to remove the softened paint. The removal process was carried out by systematically working outwards from the areas where the presence of colour was suspected. This treatment was used for all layers until reaching the earliest layers that indicated the bi-chromatic paint scheme.

Problems were encountered in differentiating and physically separating these layers due to the thinness and similarity in behaviour of solvents to the paint. While soluble in Stoddard solvent/ acetone, the solvent action was too aggressive and penetrated too deeply causing two or three layers to soften simultaneously. Tests carried out with combinations of solvents along with gelling agents to find a more controllable method to remove each layer proved unsuccessful (Margaritoff 1967, Hook 1988, Goldberg 1989, Flaharty 1989, Burnstock and Kieslich 1996, Wollbrink 1993).

Introduction of high humidity proved effective in swelling the paint layers enough to facilitate mechanical removal and this method was subsequently used. To reduce the potential risk of water damage a Gor-Tex(membrane was used as a barrier between cotton wool poultices and the panel surface, allowing movement of water vapour but preventing direct water contact.

After successful removal of the paint layers, all the corroded screw fittings were removed.

Consolidation and structural repair

Scale replicas of the panels were produced and deliberately broken to test the effectiveness of different consolidants. The replicas also became beneficial for trials of the mounting methods later on.

The consolidants tested had been recommended for conserving decorative plasterwork in buildings (Phillips 1980, 1987). These included acrylic emulsions, PVA, and acrylic co-polymers. Paraloid B72 was selected as the most suitable for the following reasons:

- good cohesion of plaster material
- good stability
- non-water based resin-negating risks of swelling of organic materials
- good vehicle for carrying gap-filling agents particularly micro-balloons.

A 50:50 Acetone and Industrial Methylated Spirits combination was used. The addition of IMS reduces the evaporation rate allowing greater penetration of the consolidant. It also provides better setting qualities when micro-balloons were applied.

The Paraloid B72 was injected via hypodermic syringes. The concentration of consolidant being increased after each application, initially a 7%w/v solution was used followed by 15% w/v and 25% w/v solutions. Micro-balloons were added to the consolidant in later applications. The micro-balloons provided the consolidant with gap-filling properties, cohering the more fragmentary areas. The proportions of resin to micro-balloons were mixed until suitable consistencies were achieved, ranging from thin suspensions to thick pastes used to gap-fill large lacunae (Hatchfield 1986).

Structural repair and replacement of severely damaged or missing timbers was necessary. PVA adhesive was chosen for additional strength. A 50% v/v solution of Mowlith DMC2 in water was used to adhere new timber and also to consolidate existing splits.

In carrying out the repairs, access to both sides of the panels was required. After initial consolidation from the front, each individual panel was reversed. A support was manufactured by facing broad strips of Phillyseal R epoxy putty over the front, with cling film being used as a barrier. A framework of steel square tube was laid over the epoxy strips, levelled and secured. This effectively sandwiched the panel between the steel frame and the 18 mm marine ply stretcher beneath. Ratchet straps were used to hold the sandwich and the panels were then inverted. The back of the panels was cleaned and the consolidation process continued.

Gaps and minor areas of exposed plaster were touched in with Cryla acrylic colours.

The paint removal had revealed a deteriorated surface, dramatically changed from its prime in the early 1900s. The base colour of each section was variegated and the appearance of the entire frieze was unacceptable for display. This posed ethical and aesthetic dilemmas to find the appropriate treatment. In consultation with curatorial staff it was decided that minimal cosmetic retouching was most appropriate rather than recoating the whole surface to recreate the original finish.

Some major areas of the panels were visually distracting due to discolouration. Treating these areas was problematic, as retouching the surface would have been interventionist and difficult to reverse on such a large area. A new approach was devised; PEL acid-free tissue sheets were toned with acrylic colours. The sheets were cut and tacked flat to the surface with Paraloid B72. The toned tissue effectively subdued the more distracting areas of deteriorated paint and was also completely reversible. Most of surface finishing was carried out prior to installation but final work was carried out once installation was complete with the correct gallery lighting.

Mounting

To enable the panels to be placed on display vertically, a rigid support had to be introduced as consolidation, structural repairs and gap-filling could not completely provide the necessary strength.

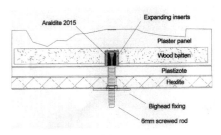

Figure 6. Detail of fixing system for Hexlite support.

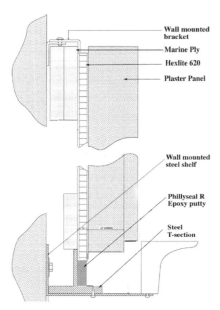

Figure 7. Detail of wall mounting arrangement for the frieze.

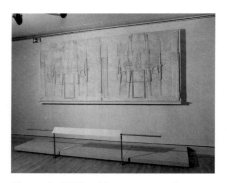

Figure 8. Willow Tea-rooms panels on display after conservation.

The support had to take into account the following criteria:

- reversibility
- successfully reuniting each half of the frieze
- minimal physical strain on the panels
- light weight to allow easier handling
- allow visual access of the reverse.

The panels had originally been fixed in situ with screws via the timber framing laths from the front of the panel. The holes were subsequently filled with plaster before painting. It was therefore decided that the timber laths could be used to carry fixings directly to attach a rigid sheet support.

We chose 14mm Hexlite 620 as the support structure due to its strength and lightness. Sheets cut to the size of each panel were secured to the reverse using flanged expansion inserts as an anchoring system (see Figure 6).

To provide fixing points, 23 12-mm holes were drilled into the laths at equal intervals so as to evenly distribute any stresses.

A barrier coating of Paraloid B72 was applied before injecting the Araldite 2015 toughened epoxy adhesive. The Araldite was left to set then drilled to create to an 8-mm hole. The inserts, which possess a knurled exterior, could be simply pushed in. A steel rod was threaded into the inserts, which expand and grips the hole.

Corresponding slotted holes were created in the Hexlite. The sheet was fitted and Plastazote used as a protective interface between the board and the plaster. To allow visual access to the back of the panels and the hidden construction techniques, viewing windows were cut in the Hexlite and glazed with Perspex.

The Hexlite and panel were secured with Bighead nuts and the steel rod cut long enough to attach the metalwork used to reunite the halves of each panel.

Installation and finishing

A steel T-section was constructed to join and support the bottom edge of each pair of panels. A thin bed of Phillyseal R was used between the Hexlite and the T-section to level the sections and fix them in the correct position. Lengths of 18-mm marine ply were bolted to the top edges to brace the joined sections. These prefabricated fittings were removed to transport the panels to the display gallery as individual sections and the whole frieze was reassembled in situ (see Figure 7 and Figure 8). After installation the gaps between the panels were filled with Paraloid B-72 and microballons and retouched with Cryla acrylic colours.

Conclusions

The analysis of the paint cross-sections proved that a bi-chrome scheme had been applied to the panels, supporting what had been suggested by photographic evidence from 1905. This colour scheme was repeated seven times over many years indicating that it was an intentional part of the design rather than 'experimentation'. The cross-sections also show the transitional changes in paint technology in the early 20th century, moving away from traditional techniques toward using modern mediums.

The analysis also provided further evidence with which to compare and confirm the authenticity of the third restored panel in the NMS collections.

The process of conservation presented a number of ethical and practical problems, in terms of deciding whether or not to remove the over-paints, and how the panels could be mounted. The conservation work could be perceived as being highly interventionist. Surviving over-paints were completely removed but this was felt justified as they were causing damage to the plaster and perpetuated the false conception of the original finish. Dowel holes were drilled in original timbers to provide anchor points for mount fixings but this distributed the load and was the best approach to deal with an object with such poor structural integrity.

Acknowledgements

We are extremely grateful for the funding provided by Putnam Investments in honour of AJC Smith (NMS Trustee), which made the investigation, conservation and display of the panels possible. We would also like to thank our colleagues at NMS, in particular Hugh Cheape, curator of Scottish culture, NMS, for providing invaluable knowledge of the Mackintosh collections and for his continued enthusiasm and support, and the Development Office for their successful fundraising efforts. We thank Joyce Townsend (Tate) and Brian Singer (University of Northumbria) for helping in the analysis.

References

Bankart, G P, 1908, *The art of the plasterer*, London.

Billcliff, R, 1979, *Charles Rennie Mackintosh, the complete furniture, drawings and interior designs*, Guilford.

Burnstock, A and Kieslich, T, 1996, 'A study of the clearance of solvent gels used for varnish removal from paintings' in J Bridgland (ed), *Preprints of the 11th Triennial Meeting of the ICOM Committee for Conservation*, Edinburgh, ICOM, 253–262.

Flaharty, D, 1989, 'Ornamental plaster restoration', *Fine Home Building* 5, 38–42.

Goldberg, L, 1989, 'A fresh face for Samuel Gompers: Methyl cellulose poultice cleaning', *Journal of the American Institute for Conservation* 28, 19–29.

Grandinson & Son, Traditional Plasterers, Innerleithen Road, Peebles, Scotland, EH45 8BA, 2000, personal communication.

Hatchfield, P, 1986, 'A note on a fill material for water sensitive objects', *Journal of the American Institute for Conservation* 25, 93–96.

Hook, J, 1988, 'The use of immiscible solvent combinations for the cleaning of paintings', *Journal of the American Institute for Conservation* 27, 100–104.

Howarth, T, 1952, *Charles Rennie Mackintosh and the modern movement*, Glasgow.

Margaritoff, T, 1967, 'A new method for removing successive layers of paint', *Studies in Conservation* 12, (4), 140–146.

Millar, W, 1905, *Plastering plain and decorative*, 3rd ed., London.

Philips, M W, 1980, 'Adhesives for the reattachment of loose plaster', *APT* XII(2),37-63.

Philips, M W, 1987, 'Alkali-soluble acrylic consolidants for plaster: A preliminary investigation', *Studies in Conservation* 32, 145–152.

Singer, B, 2001, 'Investigation of Paint samples for National Museums of Scotland', external report for NMS.

Townsend, J, 1996, 'Analysis of paint on the Charles Rennie Mackintosh panels from the Willow Tea-rooms', Glasgow, external report for NMS.

Wollbrink, T, 1993, 'The composition of proprietary paint strippers', *Journal of the American Institute for Conservation* 32, 43–57.

Materials Suppliers

Expansion inserts, GM Steel threaded rod, RS Components, PO Box 99

Corby, Northants NN17 7RS, United Kingdom, Tel: +44(0)1536 201201

Bighead® Fastners, Bighead Bonding Fastners Ltd., Units 15/16 Elliot Rd,

West Howe Industrial Estate, Bournemouth, Dorset, BH11 8LZ, United Kingdom, Tel: +44 (0)1202574601

Hexlite 620, Aeropia Ltd, Aeropia House, Newton Rd, Crawley, West Sussex RH10 2TY, United Kingdom, Tel: +44(0)1293459500

PhillySeal® R, ITW Philadelphia resins, 130 Commerce Drive, Montgomeryville Pennsylvania 18936, U.S.A., Tel: + 1 (215) 855-8450

Cryla Acrylic colours, Daler-Rowney Ltd, Bracknell, Bertshire

RG12 8ST, United Kingdom, Tel: +44(0)1344424621

Microballons, GRP Materials Suppliers Ltd., Eagle Technology Park, Queensway, Rochdale, Lancarshire OL11 1TQ, United Kingdom, Tel: +44(0)1706630151

Araldite ® 2015, Ciba Specialist Chemical Corporation, Polymers Division,

Doxford, Cambridge, CB2 4QA, United Kingdom, Tel: +44(0)1233832121

Plastazote, Zoteforms Ltd., 675 Mitcham Rd., Croydon, Surrey, CR9 3AL, United Kingdom, Tel: +44(0)206843622

PEL-Tissue, Gor-Tex® ,Paraloid B-72, Preservation Equipment Ltd., Vinces Road, Diss, Norfolk, IP 22 4HQ, United Kingdom, Tel: +44(0)1379 647400

Résumé

Les différentes étapes de réalisation de ce modèle en matériaux composites (terre cuite, plâtre, cires) sont révélées grâce aux observations, aux examens radiographiques et aux analyses de laboratoire réunis lors de sa restauration.

Une attention plus particulière est portée à l'identification des pâtes à modeler par spectrométrie infrarouge et chromatographie en phase gazeuse, montrant une diversité de composition des matériaux caractéristique de l'évolution de la chimie au milieu du XIXe siècle. Les différentes phases de la délicate opération de restauration et le choix de l'aspect final de l'œuvre sont décrits.

Mots-clés

analyse, cire, plâtre, restauration, Rodin, sculpture, terre cuite, XIXe

Redécouverte d'un modèle en terre cuite du *Sommeil de* Rodin : étude et restauration

Jennifer Vatelot
78, avenue du Général Patton
77000 Melun, France

Sylvie Colinart ★ et Laure Degrand
Centre de Recherche et de Restauration des Musées de France (C2RMF)
LRMF – UMR 171 du CNRS
6, rue des Pyramides
75041 Paris cedex 01, France
Courriel : sylvie.colinart@culture.fr

Antoinette Romain
Musée Rodin
77, rue de Varenne
75007 Paris, France

Le modèle en terre cuite du *Sommeil* (Inv. : S 1829), conservé dans les collections du musée Rodin depuis la donation des œuvres de l'artiste à l'Etat en 1916, est une étude préparatoire à la réalisation de trois plâtres (musée Rodin, Inv. : S1822, S1864, 2128) et de deux marbres portant le même titre (musée Rodin, Inv. : S1004 et collection privée).

Cette sculpture en matériaux composites, associant terre cuite, plâtre, pâtes à modeler et papier, n'a jamais été conçue pour être une pièce achevée et esthétiquement plaisante. Le peu d'intérêt que l'on a longtemps porté aux œuvres servant d'étude préparatoire et l'aspect visuel très particulier de ce modèle, dû à son caractère hétérogène puis à son empoussièrement, sont probablement à l'origine de son oubli dans les réserves du musée jusqu'à une période relativement récente à partir de laquelle sa restauration a été envisagée.

Cet article présente les informations recueillies lors des diverses observations, examens radiographiques et analyses de laboratoire effectués en vue de sa restauration[1, 2]. Ces informations permettent de retracer les différentes étapes du processus de création et de découvrir les matériaux utilisés par l'artiste, avec une attention plus particulière portée aux pâtes à modeler[3]. Les différentes phases de la délicate opération de restauration sont décrites (Vatelot, 2000).

Les différentes étapes de création

Modelée en ronde bosse grandeur nature vers 1889-1894, la sculpture représente une jeune fille endormie, la tête penchée sur son bras droit. La main gauche est glissée sous le menton, des fruits reposent sur sa poitrine et une guirlande de verdure lui sert de vêtement (voir la figure 1). Le *Sommeil* appartient à la série des bustes allégoriques, réalisés pour la plupart à partir de visages féminins. L'identité du modèle est ici inconnue mais on peut imaginer que l'artiste fut séduit par la perfection que la détente du repos donne aux traits du visage.

L'observation minutieuse de ce modèle, en grande partie recouvert de poussière, révèle les matériaux hétérogènes qui le constituent. Ils sont caractéristiques des différentes étapes de création. Multiples et complexes, elles peuvent être regroupées en deux principales phases :

- modelage et cuisson de la terre aboutissant à la réalisation d'un moule mixte, puis tirage de trois épreuves en plâtre;
- modifications des formes avec différents matériaux en vue d'une mise au point, puis taille de deux marbres (Barbier 1987) à partir du modèle de mise au point.

Pour Rodin, toute sculpture commence par être un modelage en terre ou un autre matériau plastique que l'artiste fait mouler dès qu'il est satisfait, ces œuvres se

Figure 1. Le Sommeil *avant restauration.*
© *IFROA*

★ Auteur auquel la correspondance doit être adressée

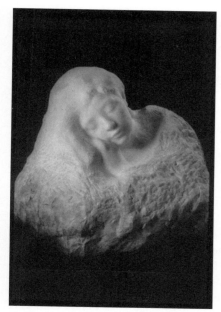

Figure 2. Marbre du Sommeil *(musée Rodin, Inv. : S1004)*

conservant mal. Dans le cas du *Sommeil*, Rodin souhaite garder la terre originale et il la fait donc cuire après avoir procédé à son évidement. Mais Rodin n'hésite pas à « revenir » sur la forme ou la composition de ses œuvres. C'est ainsi qu'avant la cuisson, les deux bras, un morceau de la guirlande sur l'épaule gauche, une partie de la guirlande au bas du dos et une partie de la chevelure sont retirés.

Dès ce stade, cette œuvre revêt un aspect « non achevé » qui laisse présager des modifications ultérieures de formes. Une fois cuite, la terre est moulée au moyen d'une technique mixte : moule souple en gélatine avec chape de plâtre pour la face, et moule à bon creux en plâtre pour le dos[4]. Les trois épreuves en plâtre sont obtenues à partir de ce moule. Cependant, contrairement à ses méthodes de travail habituelles, Rodin, qui utilise volontiers des plâtres pour poursuivre son processus de création (Romain, 2001), est revenu inexplicablement à ce modèle en terre cuite pour la mise au point préalable à l'exécution des deux marbres.

L'utilisation de matériaux composites n'est pas, non plus, un fait rare chez cet artiste. Au gré de son inspiration et en vue de la mise au point pour la taille du marbre (voir la figure 2), il opère des modifications de volume en ajoutant divers matériaux. Ainsi, Rodin reprend la terre cuite et en modifie l'aspect et la composition : le buste est noyé sous une coque de plâtre, et le volume des cheveux est modifié au moyen de ce même matériau. Une fois le plâtre posé, les cheveux, les paupières, le nez, les lèvres, le cou, la main gauche et la partie supérieure de la draperie sont repris avec des pâtes à modeler de couleur différentes.

En premier lieu, une pâte jaune est utilisée, posée en boulettes ou reprenant soigneusement un volume. Elle sert à réparer les épaufrures et les cassures de la terre cuite. Elle ferme la bouche et les orifices du nez, et atténue le relief des paupières. Elle est aussi présente sur les cheveux, en couche épaisse directement en contact avec la terre cuite. Elle est principalement constituée[5] de cire d'abeille mélangée à une paraffine et à un peu de corps gras (voir la figure 3). Des petits grains d'amidon, ovoïdes et translucides, sont présents en grande quantité dans la pâte. La forme et la taille des grains paraissent caractéristiques d'un ajout de fécule (Jane *et al.*, 1994). Un peu d'oxyde de fer jaune et de silice constituent la charge minérale de cette pâte.

Deux autres pâtes à modeler, l'une grise, l'autre gris rosé, sont posées en larges plaques travaillées au couteau, sur le sommet de la tête. Si la « cire » grise n'est décelable qu'à cet emplacement, la pâte à modeler gris rosé est visible sur le cou, en une couche plus fine, vraisemblablement pour aplanir la surface. Elle obture aussi la zone de creux entre la coque de plâtre et la terre cuite. Ces pâtes sont en majorité constituées d'un sel d'acide gras identifié en spectrométrie infrarouge par la présence de bandes de vibrations à 1551 cm^{-1} et 1530 cm^{-1} attribuables à la fonction carboxylate (voir la figure 4). L'analyse par chromatographie en phase gazeuse de ces pâtes, avec et sans acidification[6], apporte des précisions sur la composition de la phase organique. Il s'agit d'un savon très riche en sel d'acide gras mono-insaturé à 18 atomes de carbone, vraisemblablement de l'acide oléique ($C_{18:1}$), car cet acide gras est largement prédominant dans les huiles et les graisses (*Handbook of Chemistry and Phyics*, 1992). Du soufre y a été ajouté ; il confère à ces pâtes une odeur particulière. Le soufre paraît jouer, ici, le rôle de charge mais son emploi est peut

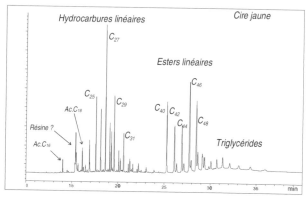

Figure 3. Chromatogramme de la cire jaune.

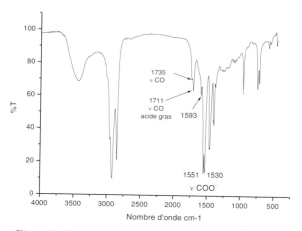

Figure 4. Spectre IRTF de la partie organique des cires grises.

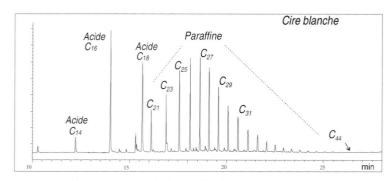

Figure 5. Chromatogramme de la cire blanche.

être dû à ses propriétés de fongicide et d'antiseptique. Quelques rares analyses (Colinart *et al.*, 1987, cat. 51, cat. 109) et recettes de pâtes à modeler mentionnent l'ajout de soufre, sans toutefois en expliquer le rôle. La pâte obtenue est parfois désignée sous l'appellation de Plastiline (Heuman, 1999). Un peu de sulfate de baryum et de blanc de zinc sont également décelés. Du noir de carbone donne le ton gris de toutes ces pâtes. Dans la cire gris rosé, c'est un peu d'oxyde de fer qui apporte sa contribution rouge. La charge minérale dans ces pâtes représente environ 80 % de la masse totale.

L'apparition de tels matériaux émane très probablement des procédés de saponification des corps gras issus des travaux de Chevreul sur la production de stéarine (premier brevet n° 4323, 5 janvier 1825). Les premiers protocoles de saponification mettaient en jeu de la soude, produisant donc des sels d'acides gras sodiques, des savons. Dans les pâtes étudiées ici, les analyses élémentaires ne décèlent pas de sodium, seulement le baryum et le zinc de la charge.

Enfin, une matière cireuse blanche a été employée uniquement pour recouvrir une partie de la main gauche, sa couleur devant s'accorder avec celle du plâtre. Dans ce cas, un mélange de paraffine, de stéarine (acide palmitique $C_{16:0}$ + acide stéarique $C_{18:0}$) et de carbonate de calcium a donné naissance à cette pâte à modeler (voir la figure 5).

En même temps que l'application de ces différentes « cires », le modèle est préparé pour la mise au point avec des clous en fer et en cuivre : les trois points de basement, les points secondaires et les points justes sont mis en place. Il semblerait que certaines modifications aient été apportées lors d'une deuxième campagne de mise au point : reprise du point de basement supérieur et de certains points justes.

Tous ces ajouts de matériaux différents modifient l'aspect de la sculpture et lui confèrent une esthétique étrange, très différente du travail habituel de l'artiste.

Etat de conservation

Jusqu'aux environs de 1982, l'œuvre n'avait pas été conservée dans de bonnes conditions. Les matériaux constitutifs ont été soumis à des variations de température et d'humidité relative importantes et, en l'absence de toute protection, une épaisse couche de poussière s'est déposée sur la sculpture.

La sculpture a également été détériorée à la suite de manipulations lors de l'installation des nouvelles réserves du musée Rodin en 1981-1982 : la coque de plâtre a été fissurée et certains morceaux de pâtes à modeler et de plâtre ont été perdus.

Ces facteurs externes ne sont pas seuls à l'origine de la détérioration de l'œuvre. Certaines altérations ont été provoquées par la nature même des matériaux ou par leur incompatibilité entre eux.

La terre cuite est parcourue d'un réseau de fissures et de microfissures qui se sont formées lors du séchage de la glaise car celle-ci n'était, en fait, pas adaptée à la cuisson : elle ne contient pas assez de dégraissants. De petits éclats ont également été provoqués par l'ajout de chaux et de plâtre dans la pâte fraîche.

Pour le plâtre, matériau surtout sensible à l'humidité, les altérations sont principalement le résultat de son interaction avec les pâtes à modeler qui l'ont taché. Sur les matériaux souples comme le papier ou la filasse, le plâtre, posé en fine couche, s'est fendillé.

Le papier journal, quant à lui, se dégrade irrémédiablement.

Quelques petits clous de cuivre utilisés comme points secondaires se sont oxydés au contact des acides libres présents dans les pâtes à modeler.

Ces pâtes montrent des altérations liées au vieillissement des produits hétérogènes qui les constituent (Regert *et al.*, 2001). La pâte jaune, fortement chargée en amidon, est pulvérulente et se désagrège. Lors de variations de température importantes, les matières grasses, ajoutées à la cire pour la rendre plus malléable, ont tendance à migrer vers la surface et vers l'interface terre cuite - cire. Ces migrations ont pour conséquences un léger suintement de la pâte en surface, avec lequel la poussière se mêle pour former une croûte, et l'apparition d'auréoles sur la terre cuite. Enfin, la faible porosité de la terre cuite et les changements de dimensions de la cire dus aux variations climatiques ont provoqué des fissures et des soulèvements.

Les pâtes à modeler grises présentent surtout des problèmes d'adhérence liés aux changements de dimension et probablement au soufre qui est retrouvé sous forme de petits cristaux (~50μm) à l'interface terre cuite - pâte à modeler.

La pâte blanche adhère très mal à la terre cuite. Elle est cassante.

La restauration

Les principales phases de traitement se sont articulées autour du nettoyage et parfois du refixage simultané des différents matériaux, de leur consolidation, en particulier de la structure de plâtre, et du collage de certains éléments en plâtre et en pâte à modeler détachés de la sculpture.

Le nettoyage

Dans un premier temps, un nettoyage léger, au moyen d'un pinceau doux, pour respecter les surfaces fragiles, et d'un aspirateur, a été entrepris pour éliminer la poussière. A ce stade, la sculpture perdait le charme et l'homogénéité que lui conférait son voile de poussière et tous les matériaux conservaient encore un aspect « sale ».

Il a donc été décidé d'effectuer un nettoyage plus poussé, en particulier pour les pâtes à modeler très encrassées.

La mise au point du protocole de nettoyage s'est appuyée sur une recherche bibliographique et sur des tests préliminaires sous loupe binoculaire.

Le choix de chaque produit à utiliser s'est fait en tenant compte des critères habituels de réversibilité. La présence des multiples matériaux a restreint l'éventail de produits utilisables.

Ainsi, le nettoyage du plâtre a été parfait en employant un gel constitué de 12 % d'attapulgite, de 3 % de carboxyméthylcellulose de sodium, de 3 % de poudre de cellulose, de 82 % d'eau et de quelques gouttes de glycérine (Laporte et Lorenzen, 1989). Posé de façon uniforme, le gel est retiré après séchage, entraînant avec lui les salissures. Trois applications ont été effectuées, cependant le plâtre conserve un *léger* aspect gris.

Pour la terre cuite, les zones non fragilisées ou éloignées des pâtes à modeler ont été nettoyées avec le même gel. Le visage et les mains, sur lesquels sont visibles des repères tracés au crayon, ont été traités à la salive. Au préalable, les points ont été protégés avec un vernis à base de PARALOÏD® B72 à 5 % en masse dans l'éthanol.

Dans le cas des pâtes à modeler, le nettoyage de chacune d'elles a été étudié séparément puisqu'elles n'ont pas la même composition. Au cours du vieillissement, les poussières se sont incrustées sur la surface rendue plus ou moins poisseuse. Pour les retirer, il faut utiliser des solvants provoquant un léger amollissement de la surface sans pour autant dissoudre la pâte.

La documentation révèle que seuls quelques produits semblent convenir au nettoyage des cires d'abeille comme celle composant la pâte jaune : solutions aqueuses additionnées de tensio-actifs, FORANE 11 (trichlorofluorométhane), FORANE 113 (trichlorotrifluoroéthane), éthanol, acétone (Besnainou, 1984 ; Chicoineau, 1988).

Les solutions aqueuses n'ont pas été retenues en raison de la présence d'amidon en grande quantité. Les produits FORANE n'ont pu être testés car, trop nocifs, ils

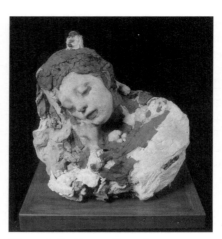

Figure 6. Le Sommeil, *après* restauration. © *IFROA*

ne sont plus commercialisés. L'acétone provoque un ramollissement trop important de la surface. L'éthanol, quant à lui, permet de retirer la couche de salissures tout en respectant la surface. Après l'essai de trois méthodes d'application de ce solvant (bâtonnet de coton, compresse médicale stérile et gel de KLUCEL G à 6 % en masse dans ce solvant), le choix s'est porté sur un nettoyage avec compresses et bâtonnets.

Le nettoyage des pâtes à modeler grises et gris rosé, toutes les deux à base d'oléate, était assez délicat. De plus, il n'existe aucune documentation sur le nettoyage de matériaux similaires. Parmi les solvants testés précédemment, les solutions aqueuses n'ont pas été retenues à cause du caractère partiellement hydrophile de la pâte. Les tests préliminaires ont montré que l'éthanol avait très peu d'effets mais que l'acétone, plus polaire, retirait la couche noirâtre. Les trois mêmes méthodes d'application, testées pour la pâte jaune, ont été reprises.

Les différents essais ont conduit à travailler avec un gel formé à partir d'un mélange de 50 % d'acétone et de 50 % d'éthanol en volume avec 6 % en masse de KLUCEL G®.

Pour la pâte blanche, l'acétone et l'éthanol sont cités dans la littérature comme étant les mieux adaptés au nettoyage des cires de paraffine et de stéarine. Ces deux solvants, non acides, peuvent être utilisés en présence de la charge à base de carbonate de calcium. Après les tests préliminaires, l'acétone paraît avoir une meilleure efficacité. Le peu de surface concernée par cette matière cireuse blanche ainsi que la présence de la cire jaune pulvérulente sur une partie de celle-ci, excluent l'utilisation de compresses ou de gel. Le nettoyage a donc été effectué sous loupe binoculaire avec un bâtonnet.

Ainsi, les pâtes à modeler ont, en partie, retrouvé leurs couleurs. L'aspect de surface des pâtes grise, gris rosé et blanche est assez homogène. Celui de la pâte jaune est plus hétérogène car elle conserve des taches sombres par endroits. Cependant, l'aspect final est jugé satisfaisant (voir la figure 6).

Quant au papier journal, trop fragile, il a simplement été dépoussiéré et, pour certains clous, la corrosion a été dégagée au scalpel.

La consolidation

Les pâtes à modeler ont une mauvaise tenue sur la terre cuite et le plâtre. L'adhésif choisi pour les stabiliser est un polybutyral de vinyle de la gamme des PIOLOFORM® B. Deux produits ont été sélectionnés pour leur viscosité en fonction du degré de consolidation souhaité :

- le PIOLOFORM® BL18 à 10 % en masse dans l'éthanol est employé pour le refixage de la pâte jaune et les collages des parties soulevées car, en raison de sa faible viscosité, il s'infiltre facilement dans les fissures.
- le PIOLOFORM® BM18 à 15 % en masse dans l'éthanol, plus visqueux et dont le pouvoir collant est meilleur. Cette résine a été utilisée pour le collage des morceaux de pâte à modeler plus importants. Cette même résine, chargée de silice micronisée (3 % en masse), a été utilisée pour la coque de plâtre qui a été collée en deux points au reste de la structure. Certains éléments de plâtre, désolidarisés de la terre cuite, ont été également collés avec ce même adhésif, non chargé.

Conclusion

Cette œuvre porte les traces du travail et des tâtonnements de Rodin. Elle montre le désintérêt de l'artiste pour la pérennité de son travail car cet assemblage n'a pas été conçu pour être solide.

Les matériaux cireux identifiés caractérisent à eux seuls la nature des pâtes à modeler disponibles dès la deuxième moitié du XIXe siècle. Présents sur une même œuvre, ils en font un exemple fort intéressant, où la traditionnelle cire d'abeille côtoie les « nouvelles cires » issues des avancées de la chimie de l'époque.

Leur effet de polychromie ne semble pas avoir été voulu par l'artiste. Les différents ajouts de matériaux ont uniquement contribué à modifier les volumes et à aplanir les surfaces. Le résultat est une œuvre esthétiquement étrange, très différente du travail habituel de Rodin.

Grâce à l'étude et à la restauration de ce modèle, une première étape du génie créateur de Rodin est redécouverte. Aujourd'hui, ce modèle est réintégré dans l'espace d'exposition du musée Rodin de Paris, au côté de son marbre.

Remerciements à : Marie BERDUCOU, directrice de l'IFROA ; Agnès CASCIO, restauratrice et responsable de la section sculpture de l'école de Beaux-Arts de Tours ; Juliette LEVY, restauratrice et responsable de la section sculpture de L'IFROA, Ghislain Vanheste, photographe de L'IFROA.

Renvois

1 La restauration a été effectuée par J. Vatelot dans le cadre d'un mémoire de fin d'études de l'Institut Français de Formation des Restaurateurs d'Œuvres d'Art (IFROA), spécialisation sculpture, septembre 2000.

2 Analyses réalisées au C2RMF : tests microchimiques, coupes transversales étudiées en microscopie électronique à balayage (MEB-EDS), spectrométrie infrarouge à transformée de Fourier (IRTF), chromatographie en phase gazeuse (CPG), analyses par faisceau d'ions (PIXE : *particle-induced X-ray emission*, PIGE : *particle-induced gamma emission*).

3 Le terme « pâte à modeler » désigne des matériaux plastiques à base de cires.

4 L'absence de couture sur la face des tirages en plâtre et les petits fragments de gélatine retrouvés dans les creux ont permis de confirmer l'utilisation de gélatine. Le réseau de coutures au dos de l'œuvre est typique d'un moule à bon creux.

5 Les constituants cireux et les additifs organiques, à l'exception de l'amidon, sont étudiés après mise en solution dans du dichlorométhane et filtration de la charge. L'identification par IRTF est effectuée par micropastille de KBr sur un spectromètre Perkin Elmer Spectrum 2000. La CPG est réalisée sur un appareil HP 6890 avec les conditions suivantes : colonne Varian CP Sil 5 CB low bleeding, 15 m, diamètre int. 0,32 mm, épaisseur phase 0,1 μm + 1 m précolonne, Injection on-column, injecteur : mode track oven, détecteur : 350 °C, flux programmé He : 2 mL à 6 mL/min, 50 °C pendant 1 min, 10 °C/min jusqu'à 350 °C, 10 °C à 350 °C. Préparation de l'échantillon : BSTFA.

6 L'identification du sel d'acide gras par CPG a été réalisée après acidification par de l'acide chlorhydrique (3N), permettant d'identifier l'acide gras.

Références bibliographiques

CRC Handbook of Chemistry and Physics, 73ᵉ édition, CRC Press, 1992-1993, p. 7-29.

BARBIER, N. *Marbres de Rodin*, Collection du musée, Paris, musée Rodin, 1987.

BESNAINOU, D. *Cires et cires*, mémoire de fin d'études de l'IFROA, 1984.

CHICOINEAU, L. « Le nettoyage des objets en cire », in : *Conservation et restauration des biens culturels*, numéro 1, décembre 1989, p. 22-25.

COLINART, S., F. DRILHON et G. SCHERF.. *Sculptures en cire de l'ancienne Egypte à l'art abstrait*, notes et documents des musées de France sous la direction de J.R. Gaborit et de J. Ligot, RMN, Paris, 1987.

HEUMAN, J. *Materiel Matters, the conservation of modern sculpture*, Tate Gallery, Londres, 1999.

JANE, J.-L., T. KASEMSUWAN, S. LEAS, A. IL, H. ZOBEL, D. IL et J.F. ROBYT. « Anthology of Starch Granule Morphology by Scanning Electron Microscopy », *Starch/Stärke*, 1994, vol. 46, n° 4, p. 121-129.

LAPORTE, B., et A. LORENZEN. *Restauration de deux plâtres monumentaux de François Sicard*, mémoire de l'Ecole de Beaux-Arts de Tours, 1989.

REGERT, M., S. COLINART, L. DEGRAND et O. DECAVALLAS. « Chemical Alteration and Use of Beeswax through Time: Accelerated Ageing Tests and Analysis of Archaeological Samples from Various Environmental Contexts », *Archaeometry*, 43, 4, 2001, 549–569.

ROMAIN, A. *L'exposition de l'Alma*, musée du Luxembourg, catalogue d'exposition sous la direction d'A. Romain, Paris, Réunion des musées nationaux, 2001.

VATELOT, J. *Etude et restauration du modèle de mise au point du* Sommeil *d'Auguste Rodin*, musée Rodin, Meudon, mémoire de fin d'études de l'IFROA, 2000.

Fournisseurs

Paraloid, Rohm and Haas Company, Corporate Headquarters, 100 Independence Mall West, Philadelphie, (Pennsylvanie) 19106-2399, Etats-Unis.

Klucel, Aqualon, filiale de Hercules Incorporated, Hercules Incorporated, Hercules Plaza, 1313 North Market Street, Wilmington (Delaware) 19894-0001, Etats-Unis.

Wacker Polymer Systems, GmbH and Co. KG, Johannes Hess Str 24, Postfach 1560, D-84 489 Burghausen, Allemagne.

Mural paintings, mosaics and rock art

Peinture murale, mosaïques et art rupestre

Pintura mural, mosaicos y arte rupestre

Mural paintings, mosaics and rock art

Coordinator: Isabelle Brajer
Assistant Coordinator: Valerie Magar

The three disciplines that presently make up the Mural Paintings, Mosaics and Rock Art Working Group were united recently; until 1996, Rock Art existed independently. During the initial period after this merging, little activity took place. In 1999, an initiative was taken to rebuild membership and revive interest in group activities. Five newsletters have been published since the last Triennial Meeting. The newsletter serves as a communication tool, informing members of ongoing conservation and restoration projects, of research projects and of new publications. Summaries of seminars and conferences of interest to group members are also included. The goal of the newsletter – promoting the exchange of experience and information – will hopefully result in the establishment of common research projects leading to an interim meeting in the near future.

Isabelle Brajer

Chromatic degradation processes of red lead pigment

Abstract

Red lead was frequently employed as a pigment in paintings, especially in medieval wall-paintings. In unfavourable environmental conditions, a strong blackening of the pictorial layer occurs due to the instability of the pigment. In order to establish the causes and processes of this alteration, two kinds of aged samples were studied. Naturally aged samples were taken from an experimental wall-painting, executed in 1977 in a sheltered outer environment. Moreover, accelerated ageing tests were led on samples with an analogous preparation, using a climatic chamber. The samples were characterized using optical and electron microscopes (SEM and HRTEM), XRD, FTIR and EDS. The naturally aged sample had a darkened surface, due to the formation of plattnerite (black PbO_2) and gypsum ($CaSO_4.2H_2O$). However, the artificial ageing test did not induce a mineralogical nor chromatic change of the pigment. A redox reaction process in aqueous environment is proposed to explain the oxidation of the pigment (Pb_3O_4 + PbO) to plattnerite.

Keywords

experimental wall-painting, artificial ageing, natural ageing, pigment oxidation, minium, red lead, plattnerite

Sébastien Aze[*] and Jean-Marc Vallet

Laboratoire du Centre Interrégional de Conservation et Restauration du Patrimoine
21 rue Guibal
F-13003 Marseille, France
Fax: +33 4 91 08 88 64
E-mail: saze@caramail.com

Olivier Grauby

Centre de Recherche sur le Mécanismes de Croissance Cristalline
Campus de Luminy
Marseille, France

Introduction

Minium, also called red lead, is an inorganic compound (Pb_3O_4) that has been manufactured and employed as a pigment since antiquity. It was frequently used in mediaeval wall-paintings (Domenech-Carbó et al. 2000, Edwards 1999), on polychromatic sculptures (Cam and Fan 2000), for making woodblock prints (Walsh et al. 1997) and occasionally on easel paintings.

The alteration phenomenon of this pigment, already described by Cennino Cennini in 1437, can be seen in many artworks where minium was employed by the artist or by restorers. The pigment's instability generally induces the blackening of the pictorial layer, which is especially strong on wall-paintings (Fitzhugh 1985). The transformation of minium to plattnerite (PbO_2) or galena (PbS) was described in several studies (i.e. Carlyle and Townsend 1990, Hwang et al. 1993, Petushkova and Lyalikova 1986). However, the mechanisms of these alterations are still misunderstood. In order to propose a non-invasive and specific method for the conservation of the relevant artworks, experimentally aged samples were studied.

Experiment

Two complementary experimental approaches were chosen to characterize the chromatic alterations of minium. On the one hand, the study of natural ageing was possible through the analysis of an experimental mural; on the other hand, artificial ageing tests were carried out on experimental wall-paintings, using a climatic chamber.

The study of natural ageing process of minium-containing paintings was carried out on a sample taken from an experimental wall-painting executed in a sheltered outdoor environment in 1977, for the Laboratoire de Recherche des Monuments Historiques (Paris). Applied with several painting techniques,[1] different pigments[2] were used to make this wall-painting, in order to study their stability. However, this study only deals with red lead, applied with various lime techniques. The experimental wall-painting was created by covering a limestone support with mortar and limewash, and the minium was applied with water. A 3 cm × 3 cm sample was taken from the bottom of the wall in 1999. Moreover, artificial ageing tests were carried out in other test areas, using a climatic chamber. These test areas consisted of prismatic calcareous supports (10 cm × 10 cm × 3 cm), on which the main classical wall-painting techniques were reproduced using commercial minium pigment. In particular, a test area with the same technique as the naturally aged wall-painting was studied as a reference. The pigment was mixed with slaked lime and water, then applied on a dry lime mortar. When dry, the samples were put into a Vötsch VT4034 climatic chamber, controlled by Simpati software (version 1.24).

*Author to whom correspondence should be addressed

Figure 1. Temperature and relative humidity variations during an eight-hour accelerated ageing cycle adopted to re-create the natural ageing of minium

The artificial ageing protocol, based on temperature and high relative humidity (RH) variations in presence of oxygen, was chosen to reproduce the climatic changes in the Cathedral of Aix-en-Provence, so that could be considered as characteristic of Mediterranean weather (Vallet, unpublished data). It consists of a sequence of 350 cycles of eight hours, each one corresponding to a series of different drastic conditions such as: humidity (RH of 85% and18°C); low temperature (RH of 0% and –10°C); humid heat (RH of 60% and 30°C); and dry heat (RH of 25% and 45°C; Figure 1).

For the study of the pictorial surface, the samples were examined with a reflected light microscope (Olympus BX60, ×50, ×100, ×200, ×500). Thin cross-sections (30 μm) were made from paint samples and observed with transmitted light. The samples were imbedded in epoxy resin, then cut and polished with alumina powder.

A crystallographic characterization was carried out, both on solid and powder samples, using a Philips X'Pert Pro diffractometer. X-ray diffractograms between 10° and 70° (2θ) were collected in steps of 0.02° (2θ) with an integration time of 2 s, using Cu-Kα radiation (wavelength 0.154056 nm). The crystal identification was realised both with the PCPDFWIN software (2.02 version), using the JCPDF-ICDD database, and by comparison with experimental diffractograms obtained from either laboratory-grade products or commercial pigments.[3]

In addition, both the pure substances and micro paint samples were analyzed with a Fourier transform infrared spectrometer (Perkin Elmer Spectrum 2000). For each sample, a 13 mm KBr die was made with a 1/150 ratio. Spectra were collected in transmission mode between 4000 and 400 cm[-1] with 4 cm[-1] steps. Spectroscopic characterization was carried out by comparison with bibliographic references (McDevitt and Baun 1964, White 1971) or experimental data.

In order to locate the compounds identified by XRD and FTIR, cross-sections and raw samples were studied with a JEOL 6320F scanning electron microscope combined with an energy dispersive X-ray fluorescence spectrometer. Further analyses were performed on thin cross-sections using a JEOL 2000FX high-resolution transmission electron microscope.

Results

Natural ageing

After five years of natural ageing, a significant chromatic change on the experimental wall-painting was reported (Dangas 1982). It was described then as a deep blackening of the pictorial layer. Indeed, the surface of the sample taken from this painting had turned from the original orange-reddish to black. When the surface was scraped, the colour of the powder was closer to red-brownish. Microscopic observations showed the presence of white crystals in the depressions created by the brush strokes, whereas some of the protuberances were a reddish colour.

Cross-sections show a stratigraphy of four layers (Figure 2), which can be described as follows, from the support to the surface:

• a white layer corresponding to the lime mortar

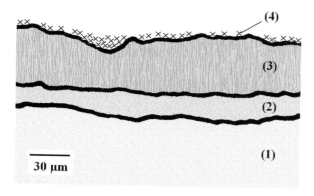

Figure 2. Stratigraphy of a naturally aged sample, deducted from optical microscopic observations of a cross-section

Figure 3. X-ray diffractogram of a naturally aged sample, showing the presence of plattnerite (P), minium (Mi), gypsum (G), massicot (Ma) and calcite (C)

- a well defined reddish layer (10 to 20 μm)
- an heterogeneous dark layer consisting of brown and black grains (30 to 80 μm)
- a discontinuous superficial white layer (1 to 5 μm).

The global crystallographic analysis of the surface (Figure 3) shows the presence of plattnerite (black lead (IV) oxide, PbO_2), gypsum ($CaSO_4.2H_2O$), red lead (Pb_3O_4), massicot (PbO-orthorhombic) and calcite ($CaCO_3$) (Table 1).

IRTF analysis of superficial micro-samples (Figure 4) confirms the presence of gypsum, calcite and minium. The main bands obtained from the pure references are present in the naturally aged sample absorption spectrum (Table 2). Furthermore, a similar spectrum was obtained with a mixture of pure substances, which was composed of 0.5 mg calcium carbonate (calcite), 0.4 mg calcium sulphate (gypsum), 0.1 mg minium and 0.1 mg plattnerite. On the naturally aged sample spectrum, three weak additional bands could be attributed to a small amount of lead sulphate (anglesite $PbSO_4$), if we refer to White (1971). Since lead (IV) oxide has

Table 1. Intense X-ray diffraction peaks (d-spacing, Å) obtained for the naturally aged massive sample and some reference substances (minium, massicot, plattnerite: experimental data; gypsum and calcite: data from JCPDS-ICDD database, resp. N. 33-0311 and 85-1108)

AGED SAMPLE	Minium	Massicot	Plattnerite	Gypsum	Calcite
7.621				7.630	
6.271	6.237	5.893			
4.302				4.283	
3.825				3.799	
3.463			3.449		3.847
3.375	3.384				
3.126	3.118				
3.070		3.067		3.065	
2.901		2.946		2.873	3.029
2.800	2.789			2.789	
2.696		2.744		2.685	
2.643	2.639				
2.583	2.568				
2.498				2.495	2.490
2.459			2.451		
2.260	2.265	2.377	2.409		2.280
2.228				2.219	
2.085		2.008		2.086	2.090
1.969	1.968				
1.913	1.919				1.907
1.890	1.889			1.900	
1.860			1.854	1.879	1.870
		1.850	1.835	1.811	
		1.797		1.778	
1.754	1.758	1.724	1.739		
		1.640	1.679	1.621	1.601
1.557		1.534	1.555		
1.515		1.514	1.513		1.522
1.472		1.474	1.475		1.437
1.382			1.389		
1.150			1.267		1.151

Figure 4. Fourier-Transform Infrared spectra of a naturally-aged sample (higher, continuous line) compared with a mixture of pure substances: minium 0.1 mg, plattnerite 0.1 mg, calcite 0.5 mg, gypsum 0.5 mg (lower, dotted line)

Table 2. Infrared absorption bands (wave numbers, cm^{-1}) of a naturally aged sample and of a mixture of substances (minium 0.1 mg, plattnerite 0.1 mg, calcite 0.5 mg, gypsum 0.5 mg), compared with pure substances absorption bands

AGED SAMPLE	Mixture	Minium	Gypsum	Massicot	Calcite
3544	3546		3549		
3408	3403		3404		
2510	2516				
1795	1798				
1683	1686		1681		
1621	1621		1618		
1541	-				1549
1440	1436				1432
					1415
1385	-				
1195	-				
1140	1143		1142		
1125	1117		1131-1118		1088
1004	-		1006-1000		
875	876				879
758	-				714
712	713				
669	669		669		684
658	-	650			
644	-				
602	603		602		
530	531	525	492	500	
448	449	445			
410	-		413		
		380		377	387
		320		300	

no absorption band in the 700–250 cm^{-1} region (McDevitt and Baun 1963), its presence could not be validated by this method.

Gypsum crystals were spotted by SEM/EDS, both inside the black layer and in the surface hollows, but not in the reddish layer. The superficial gypsum crystals displayed an irregular morphology and some varied sizes (1 to 10 μm); the crystals within the black layer were more regular, stick-shaped, and from 0.5 to 1 μm long. Plattnerite crystals were also visible. They were prismatic with straight outlines and acute angles. Their length was quite variable, from 1 to 5 μm, but globally higher than the minium crystals from the red layer.

Artificial ageing test

At the end of the artificial ageing test no colour change appeared on minium samples. Furthermore, no transformation of the minium pigment was detected by XRD or FTIR. Trilead tetroxyde (Pb_3O_4) and massicot (orthorhombic PbO) were found both in the aged and non-aged samples, just as in the pure commercial and laboratory-grade minium. The mineral brucite [$Mg(OH)_2$] was also detected as a component of the mortar. It was identified by XRD and IRTF in the slaked lime

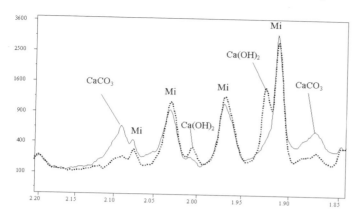

Figure 5. X-ray diffractogram of a non-aged sample (dotted line) and artificially aged sample (continuous line), showing the evolution and concentration of calcite (CaCO₃) and slaked lime (Ca(OH)₂)

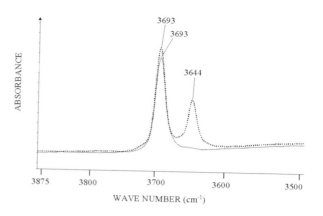

Figure 6. Fourier-Transform Infrared spectra of a non-aged sample (dotted line) and artificially aged sample (continuous line), OH- stretching frequency range (3600–3700 cm⁻¹)

that was employed for making the samples. Nevertheless, the analyses carried out in identical experimental conditions displayed a chemical modification of the samples during the ageing test. Both XRD (Figure 5) and FTIR (Figure 6) analyses showed that the amount of slaked lime (Ca(OH)$_2$) decreased, while the amount of calcium carbonate (CaCO$_3$, calcite) increased.

Discussion

The blackening of the paint layer was described for the first time after a five-year ageing period. Micro-samples and cross-sections microscopic analyses showed that this alteration was caused by the formation of a superficially deteriorated layer, which was composed of plattnerite (PbO$_2$), gypsum (CaSO$_4$.2H$_2$O), massicot (orthorhombic PbO), minium (Pb$_3$O$_4$) and anglesite (PbSO$_4$).

Both minium and massicot seemed to be residues in the original paint layer. Observations of the stratigraphy showed that the lower part of the pictorial layer was still intact. Crystallographic and molecular analyses revealed that it is composed of minium and massicot, just as both pure pigment and laboratory-grade red lead are.

Plattnerite and anglesite appeared superficially during the natural ageing period. They can consequently be considered to be characteristic of the main alteration phases, since they develop from the minium pigment. Besides, no gypsum was used to make the experimental wall-painting, and its deposit on the sample is considered to be unlikely. Hence, it appears to be another alteration phase.

The formation of plattnerite corresponds to the oxidation of lead (II) atoms to the (IV) valence state. The lead (II) atoms can originate from trilead tetroxide (Pb$_3$O$_4$), the formula of which was written by Terpstra et al. (1996) as (Pb$^{(II)}$O)$_2$(Pb$^{(IV)}$O$_2$). Moreover, red lead always contains amounts of lead monoxide, in variable proportions depending on the manufacturing process (Blair 1998), which could be degraded according to a similar process. Lead monoxides (litharge and massicot) are formed on pure lead in ambient atmospheric conditions. Nevertheless, they tend to be transformed into more stable forms, depending on the environment (Graedel 1994). Thermodynamic data suggest that both lead monoxides and trilead tetroxide may react with air and oxidize into plattnerite. The free energies of oxidation of litharge (reaction 1), massicot (reaction 2) and Pb$_3$O$_4$ (reaction 3) are, respectively, about -27.4 kJ/mol, -25.4 kJ/mol and -46.8 kJ/mol (data taken from the Alberta University Chemistry Data Tables, given at 25°C, under standard atmospheric pressure).

(1) tetra-PbO + 1/2 O$_2$ = PbO$_2$
(2) ortho-PbO + 1/2 O$_2$ = PbO$_2$
(3) Pb$_3$O$_4$ + O$_2$ = 3 PbO$_2$

These data, nevertheless, do not take into account either kinetic factors or influences of real environments. As written by Graedel (1994), plattnerite can be formed spontaneously only in highly basic conditions. Indeed, the +IV valence state of lead is stable in certain conditions, characterized by a high potential and a low acidity. These conditions are usually not satisfied in normal atmospheric ambiences. A low acidity, however, could be reached because of the strong alkalinity of the slaked lime from the mortar and pictorial layer. This argument could explain the special fragility of minium-containing frescoes (Fitzhugh 1985), and, for instance, the quick degradation of minium on the experimental wall-painting. Furthermore, formation of plattnerite seems more important in the depressions on the surface, which suggests that condensation plays a significant role. Actually, the degradation of red lead pigment seems more likely through an aqueous redox process rather than a direct transformation of crystalline matter.

The presence of gypsum ($CaSO_4.2H_2O$) and anglesite ($PbSO_4$) in the pictorial layer reveals a high concentration of sulphate forms during the natural ageing. As written by Marani et al. (1994), this condition is necessary for the formation of lead sulphates, like anglesite or lanarkite ($PbSO_4.PbO$).

Two origins of the gypsum are envisaged: on the one hand, sulphur dioxide (SO_2), which is a common atmospheric pollutant, can have reacted with the raw materials (Pb_3O_4/PbO) and $Ca(OH)_2/CaCO_3$), to form, respectively, anglesite and gypsum; on the other hand, sulphate ions can have been brought from the ground by capillary action. This phenomenon, which is responsible for many damages on frescoes, was described by Rosch and Schwarz in 1993.

The results of the artificial ageing test rest in the acceleration of the carbonation process of slaked lime from the samples. Indeed, no calcium hydroxide remained in the samples after the accelerated ageing test. Therefore, the protocol has actually produced an ageing effect.

According to the XRD and IRTF analyses, no transformation of minium pigment was induced by humidity and temperature variations inside the climatic chamber. The conditions were obviously not sufficient to induce the formation of plattnerite. Among the possible explanations, one can note that the medium alkalinity decreased significantly because of the above-mentioned phenomenon. On the other hand, an additional parameter, such as light, may have been necessary to induce the transformation.

Conclusion

The study of a naturally aged experimental wall-painting allowed us to establish a set of complementary analytic methods. Both the nature and structure of the alteration could be determined.

The blackening of the pictorial layer appeared after five years and was caused by the transformation of the pigment into plattnerite (black PbO_2). Microscopic observations, with optical and electronic microscopes, showed that this phase appeared on the surface, especially in the hollows of the pictorial surface. It was deduced that the oxidation process was influenced by the condensation and required a local dissolution of the pigment crystals.

The ageing simulation test did not induce any transformation of minium pigment in the experimental paint samples. Relative humidity and temperature variations, however, had an ageing effect on the fresh lime coat. This shows that a further parameter is necessary to cause minium oxidation.

Notes

1 Four different techniques were reproduced on the wall along vertical bands (10 cm ´ 200 cm). In the first technique, the pigments were applied directly on the fresh mortar, as in the fresco technique. In the second technique, a fresh whitewash was applied to wet mortar before the pigments were applied. In the third technique, the dry mortar was moistened before applying the limewash. Finally, a secco painting was created by mixing an organic binder (rabbit skin glue) with the pigments, which were applied to a re-wet limewash. For each technique, two kinds of lime were used, hydrated lime and slaked lime putty, as both of these limes were traditionally used.

2 Four classical ancient pigments were studied: yellow ochre, red ochre, green earth and minium.

3　Laboratory-grade reference compounds were supplied by Prolabo: for minium: lead (II, IV) oxide, 70% Pb_3O_4 and 30% PbO; for massicot: lead (II) oxide, 98% PbO; for plattnerite: lead (IV) oxide Normapur, 98% PbO_2. Commercial pigments (minium, litharge, massicot) were supplied by the Laverdure Company (Paris).

References

Blair, T L, 1998, 'Lead oxide technology – past, present, and future' *Journal of Power Sources* 73, 47–55.

Cam, D and Fan, J, 2000, 'Antique Chinese Paintings studied by LM, SEM and Microanalysis' *European Microscopy and Analysis*, 19–20.

Carlyle, L and Townsend, J H, 1990, 'An investigation of lead sulphide darkening of nineteenth century painting material', UKIC and the Tate Gallery: Dirt and pictures separated Conference, 40–43.

Dangas, I, 1982, 'Différentes altérations susceptibles d'affecter les peintures murales– Tests et relevés sur murs expérimentaux au CSTB (Champs-sur-Marne)', Internal report for the Laboratoire de Recherche des Monuments Historiques (Paris).

Domenech-Carbó, A, Domenech-Carbó, M T, Moya-Moreno, M, Gimeno-Adelantado, J V and Bosch-Reig, F, 2000, 'Identification of inorganic pigments from paintings and polychromed sculptures immobilized into polymer film electrodes by stripping differencial pulse voltammetry' *Analytica Chemica Acta* 407, 275–289.

Edwards, H G M, Farwell, D W, Newton, E M and Perez, F R, 1999, 'Minium- FT-Raman non-destructive analysis applied to an historical controversy' *The Analyst* 124, 1323–1326.

Fitzhugh, E W, 1985, 'Red lead and minium' in *Artists' Pigments: A Handbook of their History and Characteristics, Vol. 1*, National Gallery of Arts Ed., Oxford University Press, 109–139.

Graedel, T E, 1994, 'Chemical Mechanisms for the Atmospheric Corrosion of Lead' *Journal of the Electrochemical Society* 141(4), 922–927.

Hwang, I, Inaba, M and Sugisita, R, 1993, 'Discoloration of Lead Containing Pigments in Paintings' *Scientific Papers on Japanese Antiques and Art Crafts* 38, 10–19.

Marani, D, Macchi, G and Pagano, M, 1994, 'Lead precipitation of sulphate and carbonate: testing of thermodynamic predictions' *Wat. Res.* 29(4), 1085–1092.

McDevitt, N and Baun, W L, 1963, 'Infrared absorption study of metal oxides in the low frequency region (700-240 cm-1)' *Spectrochemica Acta* 20, 799–808.

Petushkova, J P and Lyalikova, N N, 1986, 'Microbiological degradation of lead-containing pigments in mural paintings' *Studies in Conservation* 31, 65–69.

Rosch, H and Schwarz, H J, 1993, 'Damage to frescoes caused by sulphate-bearing salts: where does the sulphur come from?' *Studies in Conservation* 38, 224–230.

Terpstra, H J, de Groot, R A and Haas, C, 1996, 'The electronic structure of the mixed valence compound Pb3O4' *Journal of Physics and Chemistry of Solids* 58, 561–566.

Walsh, J, Berrie, B and Palmer, M, 1997, 'The Connoisseurship Problem of Discoloured Lead Pigments in Japanese Woodblock Prints', London: IPC Conference Papers, 118–124.

White, W B, 1971, 'The infrared spectra of minerals' in V C Farmer (ed.), *Mineralogical Society Monograph*.

Abstract

The Peruaçu valley presents an exceptional concentration of speleological and archaeological sites with rock art. The rock art, executed in cave entrances and in rock shelters, is undergoing progressive degradation, as observable through time, mainly during the last 15 years. The purpose of this study was to collect and document data related to the deterioration processes, in order to contribute to a better understanding of the decay processes and, in the future, to the formulation of the site management policies. For this study, the Janelão North shelter was selected, and minute samples were collected for identification of pigments and predominant degradation products. The main alterations observed were fading of paintings, flaking of the rock surface and pictorial layer, lixiviation, exfoliation and erosion of the superficial layer, salt efflorescence and deposits, humidity stains, microorganic growth, animal activity (presence of nests and excrement) and dust.

Keywords

conservation, archaeology, rock art, prehistory, rock shelter

Rock art conservation in the Peruaçu valley, Minas Gerais, Brazil

Helena David de Oliveira Castello Branco★
Rua Dr. Juvenal dos Santos
12/201 – 30380-530
Belo Horizonte, M.G., Brazil
E-mail: hpdavid@brcom.com.br

Luiz Antônio Cruz Souza
Campus Pampulha
Belo Horizonte, M.G., Brazil

Introduction

A large concentration of speleological and archaeological sites of scientific and cultural importance is found in the Peruaçu valley region. The entrances of the caves and the rock shelters are unique for the presence and great diversity of rock art displaying exceptional expressiveness (Prous 1992). The valley is located in the north of Minas Gerais State, 620 km from the capital, Belo Horizonte, on the left bank of the São Francisco River (Figure 1). The National Park Cavernas do Peruaçu was created in 1999, but its total area of 56,800 hectares is not yet incorporated into the park's regular facilities. Archaeological research established the presence of people in the area over the last 12,000 years (Prous and Baeta 2001), but so far no evidence has been found to correlate the archaeological findings and the date of the paintings.

The purpose of this study was to collect and document data related to the rock art deterioration processes, in order to contribute to a better understanding of these processes and, in the future, enable the formulation of site management policies. In the beginning of the project we were faced with the task of finding a representative area, which would also be indicative of the conditions on several sites. By comparing degradation patterns and types of alterations, and studying the ease of access and the direct impact of visitation to various sites, as well as the substantial variety of prehistoric manifestations, we decided to focus the work on the Janelão North shelter. It is located on the left bank of the Peruaçu River, close to the Janelão cave entrance (Figure 2), which is one of the main attractions in the park. Its geographical position is 15° 06.84'S and 44° 14.56'W, with an altitude of 600 m to 700 m. The shelter is of extreme importance for the park, because it is very close to the trail that leads to the cave.

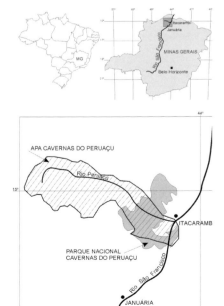

Figure 1. The location of Parque Nacional Cavernas do Peruaçu

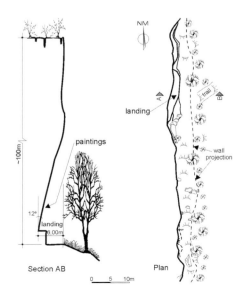

Figure 2. The Janelão Cave entrance (right). Photo: Helena David

★Author to whom correspondence should be addressed

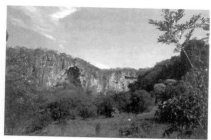

Figure 3. Section and plan of the Janelão North shelter

Figure 4. Partial view of the Janelão North shelter panels. Photo: Helena David

Table 1. Results of pigments found in Janelão North Shelter

Colour	Material	Formula	Chemical Name
Black	Vegetable Coal	C	Amorphous Carbon
	Manganese	MnO_2	Manganese Oxide
Red	Hematite	Fe_2O_3	Iron Oxide
Yellow	Goethite	$Fe_2O_3.H_2O$	Hydrated Iron Oxide
White	Calcite	$CaCO_3$	Calcium Carbonate
	China clay	$Al_2O_3.2SiO_2.2H_2O$	Hydrated Aluminium Silicate

The study of the Janelão North shelter included the following steps:

- condition survey with graphic and photographic documentation
- tests of water absorption of the support using the Karsten tube method (Amoroso and Fassina 1983, Wendler and Snethlage 1988)
- collection of samples using a magnifying glass (10´) and micro-surgical tools, according to the methodology developed by McCrone (1982)
- execution of dispersions and cross sections- micro-photmical tests for iron confirmed the PLM results and those by RAMAN spectroscopy, indicating that heating of magnetite produced hematite.

The presence of china clay (hydrated aluminium silicate – $Al_2O_3.2SiO_2.2H_2O$) detected in two samples, suggests that both the clay and the red pigment originated from the same quarry material. Goethite (hydrated iron oxide – $Fe_2O_3.H_2O$) was found in samples of yellow pigments. The PLM and FTIR analysis of white pigments pointed to the presence of calcium carbonate ($CaCO_3$). In one sample, the RAMAN spectrum suggests a combination of calcite with other minerals, like magnetite or dolomite. See Table 1 for the pigments identified in the shelter.

Binding media

It was not possible to detect the presence of substances that could act as binding media in the analyses carried out in this study. However, it is possible that the pigments were mixed with the hard water (calcium carbonate containing water) from the Peruaçu River, and that the carbonate in it acted as a binder. This possibility is confirmed by the fact that most of the samples analyzed contain calcium carbonate. Analyses of the water of Peruaçu River show a tendency for it to be hard, probably due to the contact of its gutter with the limestone (GBPE/FNMA 1999).

According to MacLeod (2000), exhaustive examinations of pigments at Australian archaeological sites did not provide evidence of organic binding media or fixatives used in the preparation of prehistoric paints. Some researchers concluded that the use of water rich in calcium carbonate assures a good cohesion of pigments after drying, contributing to the preservation of the paint layer (Wainwright 1995). There is also the possibility that binders have deteriorated and disappeared with time (Brunet et al. 1985).

Examination of some details of the white and yellow paintings with a magnifying glass (10´) revealed a film with the characteristic bubbles of a dried emulsion media (easily observable in dried modern acrylic and vinylic paintings), a phenomenon that has not been recorded previously in literature related to binding media for prehistoric rock art. Probably, some sort of 'emulsified' material had been used, which led to the appearance of the paint layer as we described. More detailed analysis of these findings need to be performed in the future, but nevertheless, since this is a unique observation, we decided to include it here.

Degradation materials

The analyses of samples of patina in the Janelão North shelter suggest that it is basically made of iron oxide and calcium carbonate. Also identified (by XRD and FTIR) is calcium oxalate (CaC_2O_4), probably a result of biological activity.

The particulate material collected in the rock depressions probably came from soil brought by trampling or the wind. It was identified by micro-chemical tests as iron oxide, bi-hydrated calcium sulphate, calcium carbonate and calcium

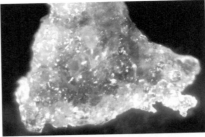

Minute sample - Magnify 100x

Cross section - Magnify 100x

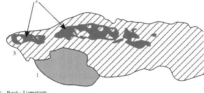

1 - Rock - Limestone
2 - Red pigment layer - Hematite
3 - Calcite layer

Figure 5. Minute sample and cross-section of a red paint layer encapsulated by Calcite. Photo: Helena David

oxalate. The presence of bi-hydrated calcium sulphate can indicate that this material was probably dispersed in the air. It was not possible to identify its origin. Since the area has low indices of air pollution, the presence of sulfur is attributed to the occurrence of recent fires.

In the examination of the cross-sections by stereo-microscopy and EDS, it is possible to distinguish a fine layer of white material on the painting. This layer consists of calcium compounds and is present even in areas where the paint layer appears to be in good condition. In a large part of the samples, the veil appears to be composed of bihydrated calcium oxalate (whewellite), calcium carbonate (calcite and aragonite) and bihydrated calcium sulphate (gypsum). In some cases these materials appear to be enveloping the pictorial layer (Figure 5 and Figure 6).

In analyses of the degradation products, as well as in the analyses of pigments and patina, the presence of bihydrated calcium oxalate and calcium carbonate is constant, and the latter appears in the form of calcite and, rarely, aragonite. Bihydrated calcium sulphate is one of the most common salts present in efflorescence on limestone and it is often found when the atmosphere contains air pollutants. The presence of calcium oxalate suggests a great biological activity on the rock surface.

Samples of white micro-organisms (Figure 7) were identified as lichens, of the crust-forming type, with hypha intertwined in green algae, and with the medulla stuck directly to the substratum. This lichen was identified as *Aspicilia,* possibly of the species *calcarea,* mentioned by J. Russ et al. (1999). It has a spongy appearance and circular forms, the growth seems to be radial, and it can provoke the scaling and delamination of the pictorial layer. This lichen can also be responsible for the production of the bihydrated calcium oxalate crust (whewellite). The concomitant presence of calcium oxalate and this type of lichens is significant because it indicates that early processes of rock degradation mainly take place by lichen transforming the calcium carbonate originally in the substrate.

Conclusion

This study is the first characterization of constituent materials and degradation processes of rock art for an archaeological site in the state of Minas Gerais. Calcium oxalate has been identified for the first time at an archaeological site in Brazil. The use of different analytical techniques allowed the identification of materials used by prehistoric man in the making Janelão North shelter panels, verifying the use of pigments based on iron and manganese oxides, vegetable coal, calcium carbonate and china clay. These results match other studies of rock art and show that the pigments used in the Peruaçu valley are the same ones used at sites in other parts of the world.

In relation to degradation materials, the identification of salts and microorganisms contributes to the understanding of the degradation processes and to the development of conservation strategies in general, without going into specific details regarding intervention processes at the present stage. The pictorial layers, in most of the cases, are covered with a fine layer composed of calcium, which may

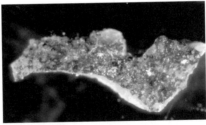

Minute sample - Magnify 100x

Cross section - Magnify 100x

1 - Rock - Limestone
2 - Fragmented layer of black painting - Vegetable coal
3 - Thin white layer - Calcium Carbonate, Calcium Sulfate and Calcium Oxalate

Figure 6. Minute sample and cross section of a black paint layer covered by a fine white layer. Photo: Helena David

Figure 7. Lichen sample examined by stereo-microscope (65′). Photo: Helena David

have contributed to their preservation. However, the same calcium compounds can be nutrients for microorganisms, especially lichens that may, in turn, be responsible for the formation of calcium oxalate. The acids produced by the microorganisms may also contribute to deterioration of the limestone, which is demonstrated by the great variety or diversity of the present deposits on the painted surfaces.

The presence of bihydrated calcium sulphate in a large part of the analyzed samples indicates that dispersed sulfur exists in atmosphere or in the wall, probably originating from fire.

This work is based on the premise that it is not possible to preserve cultural heritage without the previous knowledge of materials and alterations. The study has accomplished the first step in the conservation of rock art in the Peruaçu valley and in the state of Minas Gerais. The next steps should establish priorities and well defined approaches of intervention. This will possibly include the removal of alteration deposits (salts, dust and other substances), testing of methods for the interruption of microorganic growth on areas with paintings and engravings, testing of methods for the consolidation of the rock surface and paintings. In addition, because this is a well-visited site with easy access, it is important to develop methods to control visitation by limiting access, the extent of trails, possibly making catwalks and didactic signs explaining the importance and fragility of the site.

This study is the result of interaction with professionals of several areas, including conservation, archaeology, chemistry, physics, geology, biology, microbiology and speleology. This interaction was of fundamental importance to obtaining good results. This confirms that interdisciplinary cooperation is the key to the comprehension of conservation problems of cultural properties.

Acknowledgements

The authors thank Fundação O Boticário de Proteção à Natureza (FBPN) for project financing, Coordenação de Aperfeiçoamento de Pessoal de Nível Superior (CAPES) for master degree scholarship, Centro de Conservação e Restauração de Bens Culturais Móveis (CECOR) for facilities, equipment, support and friendship of its teachers and employees, Grupo Bambuí de Pesquisas Espeleológicas (GBPE) for support and partnership, and all people who helped us in this research, especially to Prof. Beatriz Coelho and Prof. Dr. Andre Prous.

Bibliography

Amoroso, G G and Fassina, V, 1983, *Stone decay and conservation*, Amsterdam, Elsevier Science Publishers, 453.

Brunet, J, Vidal, P and Vouvé, J, 1985, *Conservation de l'art rupestre: deux études, glossaire illustré*, Paris, UNESCO, 232.

Brunet, J and Vouvé, J, 1997, *La Conservation des grottes ornées*, Paris, CNRS Editions, 264.

GBPE/FNMA, 1999, *Levantamento espeleológico da APA cavernas do Peruaçu: Subsídios para o plano de manejo*, Relatório Final Grupo Bambuí de Pesquisas Espeleológicas/Fundo Nacional do Meio Ambiente, Belo Horizonte, 134.

MacLeod, I, 2000, 'Rock art conservation and management: the past, present and future options' *Reviews in Conservation – IIC* (1), 32–45.

McCrone, W C, 1982, 'The microscopical identification of artist's pigments' *Journal of the International Institute for Conservation, Canadian Group* 7 (1&2), 11–34.

Prous, A, 1992, *Arqueologia brasileira*, Brasília, Editora Universidade de Brasília, 605.

Prous, A, 1997, 'Síntese da arqueologia de vale do rio Peruaçu' in M G Januária, *Arqueologia do vale do rio Peruaçu*, Relatório Final UFMG/MHNJB/FNMA, Belo Horizonte, 105–129.

Prous, A and Baeta, A M, 2001, 'Arte rupestre no vale do rio Peruaçu. Aspectos gerais' *O Carste* 13 (3), 152–158.

Russ, J, Kaluarachchi, W D, Drummond, L and Edwards, H G M, 1999, 'The nature of a whewellite-rich rock crust associated with pictographs in southwestern Texas' *Studies in Conservation* 44, 91–103.

Wainwright, I N M, 1995, 'Conservación y registro de pinturas rupestres y petroglifos en Canadá' *Administración y conservación de sitios de arte rupestre*, Contribuciones al estudio del arte rupestre sudamericano, La Paz: SIARB 4, 52–67.

Wendler, E and Snethlage, R, 1988, 'Durability of hydrophobing treatments on natural stone buildings' in *The engineering geology of ancient works, monuments and historic sites*, Proceedings of the International Symposium. Athens, 945–951.

Abstract

Diagnostic studies by an Italian/
Georgian team of the wall-paintings
in the Church of St. Nicholas in
Kintsvisi and the Church of the
Virgin in Timotesubani (from the
12th and 13th centuries) in southeast
Georgia revealed the existence in
both buildings of a strong pink
coloration on the paint, of severe salt
efflorescence and of dangerous
flaking of the paint layer, all of which
are problems common to many other
monuments in the area. On-site
inspection and laboratory analyses
traced the salts as largely due to water
infiltration caused by poor drainage
and the use of inappropriate materials.
The pink colour was traced to severe
microbiological infestation. On the
basis of these findings, the team drew
up a preventive conservation emer-
gency treatment, which was success-
fully implemented in collaboration
between Italian and Georgian conser-
vators and specialists. The treatment
involved rectifying drainage problems,
improving the microclimate, re-
adhering the paint and treating the
church with biocide.

Keywords

wall-paintings, water infiltration, salts,
microbiological infestation, diagnostic
study, preventive conservation

Determination of the treatment and restoration needs of medieval frescos in Georgia

Mark Gittins and Sabina Vedovello
CBC Conservazione Beni Culturali
Viale Manzoni, 26
00185 Roma, Italy
Fax +39 0677 200500
E-mail: cbccoop@tin.it

Maka Dvalishvili* and Nana Kuprashvili
GACC
3 Rustaveli Avenue
Georgian State Museum
Tbilisi 380007, Republic of Georgia
Fax: 995 32 955685
E-mail: maka@iacgaa.ge

Introduction

Microbiological damages and microclimatic factors have become a critical
problem in the conservation of Georgian mural paintings in recent years. Most
paintings are in very poor condition and suffer from similar problems, the chief
of which are the presence of a strong pink coloured layer on the paint surfaces, salt
efflorescence and severe detachment of the paint layer. A research project to look
into these problems at the churches at Kintsvisi and Timotesubani in Georgia was
implemented by members of the Italian company CBC Conservazione Beni
Culturali (Rome) and the GACC Georgian Arts & Culture Center, with the
international collaboration of Italian and Georgian conservators and specialists and
with funding by the World Bank/Italian Trust Fund, the Open Society Georgian
Foundation and the World Monument Fund/S. Kress Foundation.

A project for an emergency treatment for the preventive conservation of the
Kintsvisi paintings was drawn up by the Italian consultants and implemented by
Georgian specialists and conservators from the Centre for the Research and Restora-
tion of Old Georgian Wall Paintings and was funded by the Fund for the Preservation
of Cultural Heritage of Georgia and the World Bank/Italian Trust Fund.

Two groups of paintings were chosen as pilot sites for diagnostic studies,
determination of methodology and execution of emergency treatment; these were
the paintings in St. Nicholas at Kintsvisi and in the Church of the Holy Virgin at
Timotesubani. Both churches are located in southeast Georgia and dated to the end
of the 12th century and beginning of the 13th century. The sites were chosen for
four reasons. First, they have similar conservation problems (which they also share
with many other churches in the area). Second, they are located in roughly the
same area and exposed to comparable climatic conditions. Third, analogous
artistic techniques were employed in both churches. And fourth, they are both of
very great artistic importance.

General conservation background

Due to the politics of the Soviet era, many of the churches in Georgia, including
those discussed here, were prevented from being used as places of worship and
consequently suffered serious maintenance problems. From the 1960s to the 1980s,
the State Department for the Protection of the Monuments tried various measures
to remedy the perilous condition of the buildings and their paintings. But in the
1990s, the political and economic turmoil and collapse of infrastructure that
followed the disintegration of the Soviet Union meant that conservation and
preservation activities were halted due to lack of resources, leading as well to
isolation from the international conservation profession.

*Author to whom correspondence should be addressed

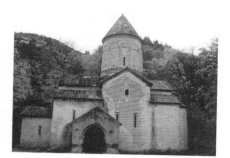

Figure 1. The Church of the Holy Virgin at Timotesubani, Georgia, 12th to 13th century. View from the south. (Photo: Nana Kuprashvili)

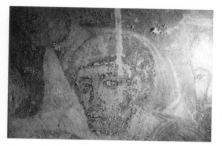

Figure 2. Detail of the wall-painting in the apse of St. Nicholaus Church in Kintsvisi, Georgia, 12th to 13th centuries. The photo, taken in raking light, shows the extensive flaking of the paint layer. (Photo: Nana Kuprashvili)

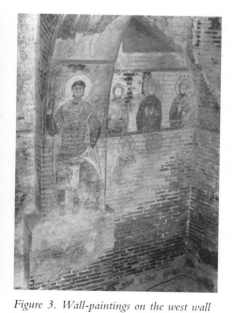

Figure 3. Wall-paintings on the west wall in the northwest bay in the church at Timotesubani. The pink discoloration is found on extensive areas of the plaster, paint and exposed wall. (Photo: Nana Kuprashvili)

Technical description

The two churches are large brick structures with stone slab roofs (Figure 1), although St. Nicholas at Kintsvisi was covered by galvanized iron in the 1960s. The interiors of both churches (well over 1000m²) were originally almost entirely decorated with paintings executed in a combination of *buon fresco* with extensive secco work, probably with casein as a binder. The paint was applied to a lime/sand/straw *intonaco,* which, in turn was applied over a fairly thick lime/sand *arriccio.* The palette employed in both cases was fairly restricted but, especially notably in the case of the Kintsvisi paintings, was the prodigious use of lapis lazuli in the backgrounds.

Aims of the project

The objective of the international program was to provide a condition report and to draw up a treatment project aimed at stabilizing the condition of the paintings.

The project had four specific aims: identifying the types of damage; localizing the sources of deterioration; determining methods for remedying the worst of the damage; and establishing ways to eliminate as far as possible the sources of deterioration. This latter point was felt to be of the utmost importance, as all too often, and not by any means solely in countries such as Georgia, where resources are so limited, conservation is restricted to hasty remedial treatment of symptoms, rather than any serious attempt to deal with underlying causes.

Condition of the paintings

The paintings at Kintsvisi and Timotesubani were found to be in poor condition, with the most obvious symptoms being staining and detachment of the plaster, flaking and powdering of the paint (Figure 2), salt efflorescence and a pink coloration over extensive areas of the plaster, paint and exposed wall (Figure 3).

Causes identified

Water infiltration

The most obvious and immediate cause of damage was due to water infiltration. Although infiltration was not as severe as in the past, due to remedial work carried out in the 1960s and 1970s,[1] it was still a severe problem. Direct observation, core-sampling and mapping of salt efflorescence showed that the sources of damp were located both in the upper part of the church and in the ground. Further, the team determined that there was no underground water-table causing rising damp and that water was entering through the walls and rising from the foundations of the buildings due to the lack of gutters and drain-pipes (Figure 4). Rainwater flowed over external surfaces, infiltrating the walls, before being discharged on the narrow, cracked and broken pavements surrounding the buildings. Thus, water was allowed to enter the foundations, but was prevented from evaporating (Figure 5). The team also found that, as the buildings were both on sloping terrain, excess surface water from rainfall was flowing downhill, further saturating the foundations and adding to the rising damp (Figure 6).

Salts

Significant quantities of nitrates and, in several samples, sulfates, were found. The nitrates were probably due to a variety of organic materials (bird and bat excrement and decaying organic material from cavities within the walls). The sulfates were almost certainly due to cement and gypsum repairs from earlier interventions.

Microbiological infestation

One of the most pressing problems facing the team was the identification and treatment of the pink coloration, so prevalent not only in these churches, but also

Figure 4. Twisted and broken gutters are seen at the northwest corner of the church at Kintsvisi. (Photo: Nana Kuprashvili)

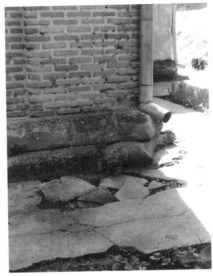

Figure 5. The drainpipe discharges rain water directly onto the concrete pavement at the southwest corner of the narthex at the church in Kintsvisi. (Photo: Nana Kuprashvili)

Figure 6. The sloping terrain along the north wall of the church at Timotesubani. (Photo: Nana Kuprashvili)

in many other sites throughout Georgia. Apart from being highly disturbing visually, many Georgian specialists feared that this unknown agent might be causing physical damage to the paintings. The coloration had been gradually increasing for a number of years, as confirmed by colour photographs of the paintings at Kintsvisi taken in the 1980s, which showed that the phenomenon had already been present at that time, though at a barely perceptible level.

In 1996, two Russian scientists had conducted a series of tests, including work on microflora in the church, but had not been able to draw any definitive conclusions (Dneprovskaya 1996). The recruiting of Italian specialists was a second attempt to resolve the problem. When the team started the investigation at Kintsvisi, it was felt that several factors contributed to the likelihood that the pink coloration was biological in nature. These were:

- high relative humidity (over 70%)
- the concentration of pink in the lower, damper areas of the churches
- the slow but steady increase of the phenomena
- the fact that the church was open at most for a few hours a day, thus limiting air movement
- the presence of possible nutrients in the binders of the paintings (casein), in materials used in previous restorations (casein and egg as fixatives, bread crumbs and wine as cleaning agents), and bat and bird excrement
- the habitual touching and kissing of the painted figures of saints by visitors to the church, which would provide an effective transmission mechanism for spores (an hypothesis supported by examination of the pink material under a magnifying glass, which showed it to be powdery in nature, as well as having a soft, slightly spongy consistency).

An unpainted area of plaster was experimentally tested with Metatin N58-10/101, a broad-spectrum biocide effective against algae, fungi and bacteria. The biocide was applied twice at a concentration of 4% in water, using a hand spray, with eight days between applications. Although no results were discernible at the end of the 15-day period, this was not surprising, as biological agents are often slow to show effect. Indeed, the follow-up investigation four months later found the test area to be completely free of pink.

During this experimental intervention, samples were taken of the contaminant and the underlying plaster, and these were subjected to intensive analysis to determine whether biological agents or some other factor was causing the coloration, and to identify the micro-organism if the cause proved to be biological. The procedure used in the analyses and the results may be summarized as follows.[2]

Four samples were examined for biological activity and proved to have an unusually high total bacterial load for wall-paintings. On the other hand, the total fungal load of the samples, while high, was generally within the normal parameters. None of the fungi and actinomycetes found in the cultures were red or pink and thus could not have accounted for the observed colour.

To test whether a non-biological agent in or on the plaster caused the pink, two samples were examined by XRD. However, none of the crystalline forms detected were red or pink. On the other hand, both whewellite and weddellite were found, indicating the possible presence of proteins.

Enzyme immune assays were then employed on the four samples to test whether suitable nutrients existed for bacterial activity. The samples were tested for a variety of protein binders, with positive results being obtained for cow-milk casein in all four cases and egg-yolk in one of the samples, proving that there existed suitable organic nutrients for bacteria.

SEM microimaging was then employed to examine the structure and composition of the pink material, with the aim of locating possible bacterial forms, revealing large numbers of spherical forms (Figure 7). Further analyses involving selective microbiological cultures and biochemical testing, together with the observed form of the bacteria, which led to the conclusion that the infestation was due to *Micrococcus roseus*, fairly commonly found in the soil and in water, and capable of producing a more or less intensive pink colour.[3] The results of these

Figure 7. Unmounted sample, secondary electron SEM photomicrograph, 10,000'. Cluster of spherical bacteria with a diameter of about 2μ, within a fracture of pink layer.

Figure 8. View to the west wall in the church at Kintsvisi. (Photo: Nana Kuprashvili)

analyses, together with the positive result in the zone subjected to biocide treatment, confirmed the microbiological origin of the pink colouring.

The treatment program

Notwithstanding generous support from the international sponsors listed at the beginning of this paper, the treatment program was only fully implemented for the church of St. Nicholas at Kintsvisi, due to limitations in available resources. Priority in the treatment project was given to preventive conservation, aimed at stopping further deterioration in the paintings, rather than an aesthetic restoration.

Water infiltration and rising damp

The guttering and drainpipes were repaired and replaced, the pavement around the church was repaired and its drainage was improved, and a simple cement trench was dug uphill of the building to divert the flow of surface water away from the structure. Local volunteers and a small religious community nearby will ensure the drains remain free of vegetation and litter. The microclimate of both churches is currently being monitored with thermo hygrometers.

Flaking and powdering paint, serious detachments in the plaster

The paint layer in imminent danger of loss was consolidated with Primal AC 33. Severely detached plaster was re-adhered using hydraulic lime, where necessary.

Salts

Cement and gypsum fillings were removed and replaced with lime and sand fillings. It is believed the reduction of water infiltration and rising damp described above will limit, if not totally halt, the ongoing damage due to salts. It was decided to avoid more invasive interventions until the microclimate stabilizes.

Microbiological treatment

During the course of the treatment of the paint and plaster, all areas of the church were treated twice with Metatin N58 10/101. A further final application was carried out while the scaffolding was being removed.

It is important to note that that all biocide treatments should be repeated after an interval of time, as a single treatment may not eliminate the usually much more resistant spore forms of the organisms, which instead must be killed after they begin to germinate. It should also be noted that in heavily contaminated situations all tools used (brushes, scalpels, spatulas, etc.) for other tasks should be disinfected regularly.

By the time the work on the church was finished, the paintings were completely free of the colouring associated with the bacterial infestation (Figure 8). To help avoid further outbreaks, bird and bat excrement was removed and the aeration of the church has been increased slightly (increasing it too radically is likely to increase salt efflorescence). Moreover, local volunteers are monitoring the church's condition. The measures taken to reduce water infiltration and rising damp will also help to reduce the risk of further outbreaks.

Conclusion

The project can be considered a success for several reasons. First, it succeeded in identifying a series of problems that are creating risks, not just for the works examined, but for a large number of other highly significant works of art in the Republic of Georgia. Second, it also identified the causes of these problems and was able to provide solutions and a methodology of preventive conservation, which will we believe is transferable to many other monuments in the area. Finally, less tangibly but perhaps most importantly in the long run, it re-established fruitful contact between conservation experts in Georgia and the international conservation community at large.

Acknowledgements

In addition to the foundations and institutions named in the introduction, many professionals from different fields were involved in this project, and the authors are grateful for their participation: Eka Privalova (Georgian State Department for Protection of Monuments), Ipollito Massari (for humidity measurements and microclimate evaluation), Vito Meggiolaro (for microbiological and other scientific analyses), Mzia Janjalia (State Institute of Art History), Guram Cheishvili (Georgian State Department for the Protection of Monuments, for restoration), Lado Gurgenidze (Centre for the Research and Restoration of Old Georgian Wall Paintings), Gaioz Grigolia (an engineer-architect with the Academy of Art, Georgia), Darejan Mgebrishvili (Georgian State Department for the Protection of Monuments, for hydrological analyses) and Givi Gavardashvili (Institute of Water Ecology, for humidity studies).

Notes

1 Areas that had suffered extensive damage in the past were quite dry, and the borders of salt efflorescence and water stains had moved quite significantly from previous positions.
2 For a detailed discussion of the step-by-step process of the analyses, see V. Meggiolaro, et al. (1998).
3 This bacteria, together with three other species of bacteria and 16 species of fungi and one of actinomycetes, had earlier been detected in samples taken from the paintings at Kintsvisi by two Russian biologists, but they had failed to connect these findings with the pink coloration found on the paintings (Dneprovskyaya and Lebedeva 1996).

Bibliography

Caneva, G, Nugari, M P and Salvadori, O, 1996, *Biology in the conservation of works of art*, Rome, ICCROM.

Dneprovskaya, M B and Lebedeva, B V, 1996, 'The reasons for the destruction of the dye layer of the Kintsvisi frescos – Technical report' Scientific research and Project Institute of Restoration 'Saqrestavracia', Tbilisi. Unpublished.

Gittins, M, Martellotti, G, Nerger, S and Paparatti, E, 2000, 'Poster: The Conservation of Roman wall decoration in Nero's Golden House, Rome', IIC Congress, Melbourne 2000, Summaries of the posters.

Massari, I, 1997, Report on the structural problems and moisture in the church of St. Nicholas at Kintsvisi, Unpublished report to the World Bank.

Massari, I, 2000, Report on the Church of the Mother of God, Timutesubani, Georgia, Unpublished report to the GACC.

Meggiolaro, V, Pressi, G and Vedovello, S, 1998, 'Degrado biologico delle pitture murali della chiesa di San Nicola a Kintsvisi Repubblica della Georgia' *Restauro & conservazione* 29, 81–86.

Sorlini, C, Monte Sila, M and Ranalli, G, 1996, 'Le indagini microbiologiche condotte sulle alterazione rosa degli affreschi' in G Testa (ed.) *La Cappella Nova o di S. Brizio nel duomo di Orvieto*, Milan, Rizzoli, 411–13.

Materials

Metatin N-58 10/101 (R) (a mixture of tributyl-tin naphtenate and benzyl ammonium chloride), Acima Chemical.
Primal AC 33 (R), Rohm & Haas

Painting techniques of the Mexicas at the Great Temple of Tenochtitlan in Mexico City

Dulce María Grimaldi Sierra★
Coordinación Nacional de Conservación del Patrimonio Cultural
Exconvento de Churubusco
Xicoténcatl y General Anaya s/n
CP 04120, México D.F., México
Fax: +52 55 5688-4519
E-mail: grimaldidm@mailcity.com

Alison Murray and Krysia Spirydowicz
Queens University
Kingston, Ontario, Canada

Abstract

A research project was undertaken to determine the painting techniques used by the Mexicas in their creation of wall-paintings at the Great Temple of Tenochtitlan in Mexico City. Fifty-four samples, from wall-paintings in various pre-Hispanic buildings, were analyzed by means of several techniques. Replicas were also fabricated so that the characteristics of various painting techniques could be observed and compared with the historic samples. The results showed that the pigments from most of the wall-paintings on mud plaster had been applied over wet mud, probably using limewater or lime milk. In the case of the wall-paintings on lime plaster, several painting techniques were used, including painting *fresco*. Future research is needed to determine whether an organic binder was used in several wall-paintings.

Keywords

Great Temple, Tenochtitlan, painting techniques, Mexica paintings, pre-Hispanic paintings, wall-paintings

Introduction

The objective of this research, carried out as part of a master's degree in art conservation at Queen's University, Canada, was to identify the painting techniques used for the earth-based and lime-based wall-paintings at the Great Temple of Tenochtitlan, in Mexico City. This project is part of continuing research started in 1978 by conservators and archaeologists who work at this archaeological site.

The wall-paintings at Tenochtitlan were created by the Mexicas, who founded the city in 1325 and were defeated by the Spaniards in 1521. Located in the ceremonial precinct, the paintings decorated temples, altars, shrines and the main pyramid called the Great Temple. This temple was rebuilt at least seven different times, which we've called construction stages I–VII, and one of its facades was enlarged on five extra occasions, namely during construction stages IIa, IIb, IIc, IVa and IVb (López Luján 1993). Among several chronological sequences that have been suggested, archaeologist Matos Moctezuma has tentatively dated the construction stages based on the glyphs carved on excavated buildings at the archaeological site (Table 1).

During an archaeological project started in 1978 to excavate the ruins of the Sacred Precinct of Tenochtitlan, the foundations of the Great Temple and parts of 14 other buildings were uncovered (López Luján 1993) (Figure 1). Today, wall-paintings on mud plaster and on lime plaster can be seen on Tlaloc Shrine (construction stage II), Huitzilopochtli Shrine (construction stage II), Eagles' House (construction stage IVb), North and South Red Temples (construction stage VI), Structure M (construction stage VI) and Structure N (construction stage VI).

Although sometimes badly deteriorated, human figures, abstract patterns and geometric motifs can be observed on the wall-paintings (Figure 2). There had been no attempt to imitate nature; rather, the representations are symbolic. The figures and motifs have a painted or incised outline, but there is no preparatory drawing. Some human figures are similar to those from the Borgia Codex, with the arms and legs creating an impression of movement. Other figures, such as those from the North and South Red Temples, are similar to the ones observed in Teotihuacan, where representations of hanging strips of paper and bows seem to decorate the walls (Solis 1995).

Figure 1. The Great Temple archaeological site

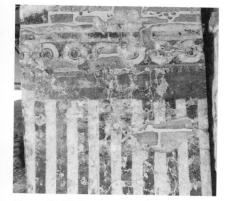

Figure 2. Wall-painting on lime plaster at the Tlaloc Shrine

Table 1. Chronology of the construction stages of the Great Temple of Tenochtitlan (Matos 1988)

Construction stages	period (AD)
Stage I	1325
Stage II	1375-1395, 1396-1417, 1417-1426
Stage III	1427-1440
Stage IV	1440-1469
Stage IVb	1469-1481
Stage V	1481-1486
Stage VI	1486-1502
Stage VII (arrival of Spaniards)	1502-1520, 1520, 1520-1525

★Author to whom correspondence should be addressed

Previous research

The plastering materials and the pigments used at Tenochtitlan have been studied extensively for decades by conservators, archaeologists and chemists at the archaeological site. According to Franco (1990), the wall-paintings on mud plaster were executed on a wall support constructed with irregular stones cemented with mud. This was covered by a thick and coarse mud plaster with sand aggregates that had a levelling function, and then by a thinner mud plaster with a small quantity of sand aggregates. The coarse plaster contained fragments of quartz, feldspars, hornblende, volcanic rocks, biogenic rocks, hematite, clays, and calcium carbonate (Flores Diaz 1981). The fine plaster had a similar composition and included albite and halloysite (Vázquez del Mercado 1998).

The wall-paintings on lime plaster were executed on a similar wall support made of stones cemented with mud and covered first by a layer of coarse lime plaster made of lime and sand, and then by a thin lime plaster made of lime and clay (Franco 1990). The lime plaster contained aggregates of quartz, hornblende, feldspars and clays (Flores Diaz 1981).

The pigments used by the Mexicas in the wall-paintings at Tenochtitlan have already been identified as follows: the red colour is hematite; the yellow is limonite or geothite; the orange is a mixture of hematite and limonite or geothite; the blue is Maya blue; and the white is calcium carbonate or kaolin (Huerta 1979, Ortega 1979, Flores Diaz 1981, Franco 1990, Reyes Valerio 1993, Xelhuantzi 1997, Vázquez del Mercado 1998). The black has been described as carbon black and as lamp black, sometimes mixed with clay (Huerta 1980, Flores Diaz 1981, Franco 1990). The pigments in the paint layers are mixed with crystals of quartz, hornblende, feldspars and calcite (Flores Diaz 1981, Xelhuantzi 1997).

Analytical methodology

Complementary methods of analysis were chosen to study the painting techniques. After on-site observation, samples were taken from all the wall-paintings. One part of each sample was prepared as a cross-section and observed under the optical microscope.[1] On the basis of the resulting observations, selected samples were analyzed by a variety of analytic techniques in order to identify matter that could provide evidence of the use of a specific painting technique. Samples were observed under the scanning electron microscope (SEM) and their elemental composition identified with the aid of energy dispersive spectroscopy (EDS).[2] Parts of the same sample or other samples were analyzed with X-ray diffraction (XRD) in order to identify the crystallographic components.[3]

Finally, samples were analyzed with techniques that help to detect organic matter: Fourier transform infrared spectroscopy (FTIR),[4] gas chromatography/mass spectrometry (GC/MS)[5] and high pressure liquid chromatography (HPLC).[6] At the same time, replicas were prepared in blue and red, as these colours are the ones more frequently observed on the wall-paintings. Blue pigment, reproduced according to Maya blue recipes,[7] and synthetic hematite were used to coat the surface of the replicas made with mud plaster and lime plaster. Various painting techniques were used to apply the pigments.[8] Cross-sections of samples taken from the replicas were observed under the optical microscope, and compared with those of the historical samples.

Study of the painting techniques on mud plaster

Most of the wall-paintings on mud plaster had similar stratigraphy, independent of the location or the period in which the buildings were constructed. Such stratigraphy showed an unbroken interface between paint layer, 16–120μ ca., and plaster layer, 40–160μ ca (Figure 3). The study of samples taken from replicas showed that this phenomenon required the pigments to be applied to wet mud where the pigment particles could not penetrate, because the crystalline platelets of the clay and the water had formed a compact layer where no shrinkage had taken place. These results are consistent with those of the painting technique identified for the wall-paintings on mud plaster from the Eagles' House (construction stage IV) at the same archaeological site (Vázquez del Mercado 1998). In a few samples a different stratigraphy was observed as particles of pigments penetrated into plaster cracks. This

Figure 3. Stratigraphy of a sample taken from a wall-painting on mud plaster, where yellow and red paint layers with an unbroken interface between paint and plaster layer can be observed (25′)

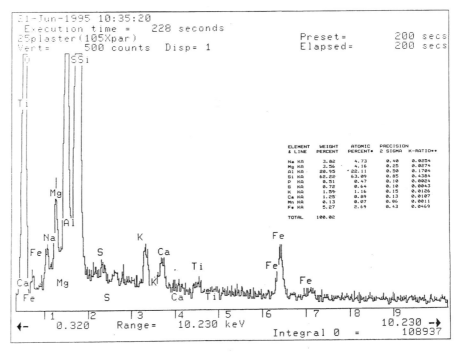

Figure 4. EDS spectrum of mud plaster from sample 25 with a low calcium content

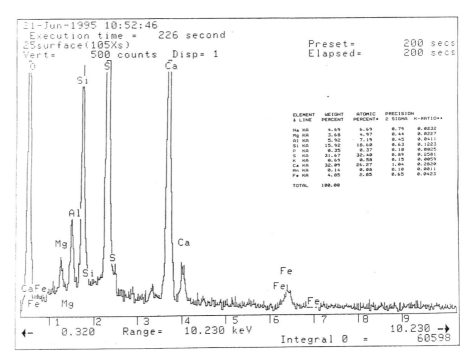

Figure 5. EDS spectrum of paint layer from sample 25 with a higher calcium content than the mud plaster

suggested that a different painting technique had been used, in which the colour was applied after the mud plaster had already dried and cracks had formed.

In several samples, EDS analysis found a higher content of calcium in the paint layer than in the mud plaster, suggesting that the colours could have been applied with limewater or lime milk as the medium (Figure 4 and Figure 5). The identification of considerable amounts of calcite in the blue pigment in the XRD and FTIR analyses also proved that there was calcium in the paint layers. The GC/MS analysis demonstrated that monosaccharides: glucose, galactose, xylose and mannose, were present in the analyzed samples in both the paint layer and the mud plaster, which suggested the use of an organic binder; however, no specific compound was successfully identified when the samples were compared with reference materials.

Study of the painting techniques on lime plaster

Different painting techniques were employed in the making of the wall-paintings on lime plaster, as was demonstrated by the different stratigraphies of the samples (Figure 6 and Figure 7). When compared with samples taken from the replicas, it was observed that one such technique was *fresco*. Paintings that seem to have been created with this technique showed a thin or medium-thick paint layer, 8–65μ ca., with pigment and plaster particles mixed in the border of both layers, probably a result of some physical process that happened during the application of the pigments. The paint and plaster layers were strongly adhered.

Figure 6. Stratigraphy of a sample taken from three superimposed wall-paintings on lime plaster, where pigment particles from the thin paint layers and plaster particles get mixed in the border of both layers (25')

Visual observations on-site also suggested the use of a *fresco* technique as no paint re-touching or glazes were observed. The use of a *fresco* technique would explain why the wall-paintings were resistant to degradation, even in the adverse environmental conditions of the Great Temple Archaeological Site. The technique was not the classical *buon fresco*, as practiced in Renaissance Italy, as some elements, such as *pontate* and *giornatas*, were missing, which perhaps suggests that the painting was done quickly, before the plaster dried. This was also suggested by the presence of plaster and paint drippings.

In other samples a *secco* painting technique seems to have been used. The stratigraphy of such samples showed a thick paint layer, 32–400μ ca., a clear interface between the paint and plaster layers, frequent detachment of the paint layer from the plaster because of poor bonding, a polished plaster layer, and, finally, the presence of monosaccharides.

Figure 7. Stratigraphy of a sample taken from a wall-painting on lime plaster, where a clear interface between the thick paint layer and the plaster layer can be observed (25')

The detected monosaccharides were found to be mainly glucose and smaller amounts of galactose, xylose and mannose. Comparison of the results with reference material revealed no similarities, even with gums and mucilages used as binders during pre-Hispanic times. As only trace amounts of amino acids were detected with HPLC analysis, there was not enough evidence to show that proteinaceous materials had been used as well. The results of the FTIR analysis showed no similarity with the spectra of reference material commonly used as binder.

Some samples showed small peaks at 2950, 2850, and 1729 cm⁻¹, probably due to the presence of hydrocarbon groups and esters or acid carbonyls (Figure 8). These compounds could be explained by the presence of organic matter; however, they could also be due to application of conservation materials to the wall-paintings. Franco (1990) described conservation treatments that used methyl methacrylate, polyvinyl acetal and polyvinyl alcohol on several wall-paintings of the Great Temple of Tenochtitlan, which have spectra with peaks at 2950, 2850, and 1729 cm⁻¹. A sample that had not been treated with these conservation materials did not show a spectrum with such peaks, suggesting that these materials caused the absorption. Therefore, a conclusive identification of an organic binder was unsuccessful, probably due to contamination with materials from earlier treatments and organic matter from pre-Hispanic times up to the present day.

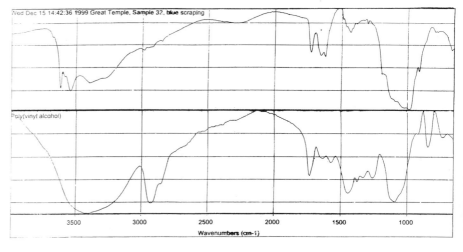

Figure 8. FTIR spectra of blue pigment from sample 32 and from poly(vinyl alcohol) where peaks at 2950, 2850, and 1729 cm⁻¹ can be observed

According to Sahagún (1999), the ritual activities that took place in the buildings at the Great Temple of Tenochtitlan involved food and other organic material. Even today, Mexico City's population is a ready source of contamination as the archaeological site is surrounded by the inhabitants of this city with highly polluted air and ground water.

Conclusions

The analysis of a large number of samples from the wall-paintings at the Great Temple of Tenochtitlan allowed a comparison to be made of the painting techniques used over the period of the Mexican Empire. The results demonstrate that the Mexicas had one painting technique when using a mud plaster, where the pigments were applied to wet mud in most cases. In only a small number of samples were the pigments applied over dry mud, which suggests that this technique was not often used and could even have come about by accident. The use of limewater or lime milk and an organic binder is suggested by the results from the analyses, but no precise identification was possible.

The characteristics of the samples of wall-paintings on lime plaster showed that the buildings were painted by means of several techniques. According to the observations and analyses, a *fresco* technique was possibly used for the exterior sides of the columns of the Tlaloc Shrine, construction stage II. In a later construction stage, number VI, a *secco* technique could have been used at the North Red Temple and at the South Red Temple, on which *fresco* wall-paintings were then superimposed. Also in construction stage VI, a *secco* technique was employed for the wall-paintings on Structure M.

This would mean that in the earlier times (1375–1427) of the period of the Mexica Empire the preferred technique was *fresco*. Later (1486–1502), different techniques were employed. A *secco* technique was initially used, and then the Mexicas turned again to a *fresco* technique. Changes might have taken place while artists searched for improvements to the painting technique, but it could also be that individual techniques were adapted to suit particular circumstances at each building. It is not possible to know the painting technique of the rest of the construction stages, as no wall-paintings from these periods could be analyzed.

It is possible that an organic binder, that has since degraded, had been used in the wall-paintings on both mud plaster and on lime plaster. However, this binder has become almost impossible to identify because the materials are probably a mixture of decayed original organic material and contamination.

Acknowledgements

We would especially like to thank the following people: Dr. H. F. Gus Shurvell for his supervision. Alan Grant, Geology Department at Queen's University, for the XRD analyses. Joy M. Moyle and John Stewart, Analytical Section, Historic Resource Conservation Branch at the Canadian Heritage, Parks Canada, in Ottawa, for the SEM/EDS analyses. Michelle Derrick and Dr. Richard Newman, Museum of Fine Arts in Boston, for the FTIR, GC/MS, and HPLC analyses. We would also like to thank INAH (Instituto Nacional de Antropología e Historia), the Canadian government and Natural Sciences Engineering and Research Council for the funding.

Notes

1 Optical microscopy was performed using a Nikon Microscope S-Kt. Thick cross-sections were observed with reflected light.

2 The SEM/EDS analysis was made using an Amray 1810 Scanning Electron Microscope with a KEVEX Quantex Version VI Energy Dispersive Spectroscope. The SEM was run at an excitation energy of 20kV, at a working distance of 21 mm, for 200 seconds. The preferred magnification was 105´. The samples were coated with carbon or gold. Selected areas were analyzed by EDS and three readings were taken to obtain an average value. The analysis was carried out in spot or partial field mode.

3 For the XRD analyses, two techniques were used depending upon the amount of material available. The samples with a small amount of material were analyzed with a Gandolfi Camera of 114.2 mm diameter. The analysis was run for 18 hours. The working parameters were 40kV and 20mA, in a cobalt atmosphere. Samples with more material were analyzed

with a Powder Diffractometer Phillips 1010. The analysis was run for one hour using the same working parameters used for the Gandolfi Camera. The resulting patterns were compared with reference patterns from the X-Plot™ for Windows, version 1.29.

4 The FTIR analysis was carried out using a Nicolet 510P FTIR Spectrometer coupled with a NIC-plan Infrared Microscope. The size of aperture for the analyses was 30 X 30μ. The spectra were the sum of 100 scans collected between 4000–650cm⁻¹ at a resolution of 4 wavenumbers. The sample was placed in a diamond anvil cell and pressed.

5 Gas chromatography coupled with mass spectrometry was used for carbohydrate analysis; two methods were used. The first method involved methanolysis, followed by silylation. The derivatives analyzed by this method were methyl glycoside TMS derivatives. The second method involved direct preparation of oxime/TMS derivatives from a sample, without any preliminary breakdown step. The GC/MS used a Hewlett Packard GC/MS system, which consisted of a 5980A capillary gas chromatograph with split/splitless injection port and 5971A mass selective detector and helium carrier gas. A Supelco PTE-5ms column was used (30m, 0.25mm ID, 0.25μl film thickness). The injection port T was 275°C; injections were carried out in split mode with a split ratio of about 20:1. The initial oven temperature was 150°C, which was raised by 2°C/minute to 200°C, then raised to 300°C by 20°/minute and held for 10 minutes for a total running time of 40 minutes. The MS transfer line temperature was 280°C. Depending on samples size and type, one or more runs of each sample was carried out.

6 The HPLC analysis used a Picotag Work Station™ (Waters Associates). The samples were hydrolyzed in an acid vapor, derivatized with *iso*-triocyanatobenzene, and analyzed using reversed phase HPLC. The analysis was carried out following the Picotag method that allows the identification of proteinaceous materials from samples in the microgram range.

7 Synthetic Maya blue pigment was prepared with indigo from the Forbes Collection and a mixture of sepiolite $((Mg,Fe)4Si_6O_{15}(OH)_2 \cdot 6H_2O)$ and palygorskite $(Mg_5(Si,Al)8O_{20}(OH)_2 \cdot 8H_2O)$ (indigo 14%, sepiolite 29%, and palygorskite 57% by weight). The preparation followed those procedures described by Littmann (1980, 1982) and Reyes-Valerio (1993). Indigo, sepiolite and palygorskite were mixed with water, thoroughly shaken, and left to settle for 12 hours. The water was then decanted and the residue dried on filter paper, placing it on a hot plate at 70°C for 80 minutes. The dry pigment was removed from the filter paper and stored.

8 The replicas on mud plaster were painted with synthetic Maya blue or synthetic hematite. Two different techniques were used: one on wet mud without any binder and the other on dry mud, using Nopal mucilage extracted from cacti of the *Opuntia* genus as the binder. The mud was taken from the plaster of the historic samples. The replicas on lime plaster were painted with synthetic Maya blue or synthetic hematite and applied with two different techniques: *fresco* and *secco*, using Nopal mucilage. The use of Nopal mucilage and gum as binders for the pre-Hispanic wall-paintings at Cacaxtla has already been studied (Magaloni 1994).

References

Flores Díaz, A, 1981, *Informe del análisis de muestras de pigmentos del Templo de Tláloc*. Departamento de Prehistoria. México: INAH.

Franco Brizuela, M L, 1990, *Conservación del Templo Mayor de Tenochtitlan*. México: INAH.

Huerta, A, 1979. *Informe pintura mural sobre muro, sección I, cala B, cuadro 36-37, lado norte y fichas de análisis de laboratorio, Templo de Tláloc*. Departamento de Restauración del Patrimonio Cultural. México: INAH.

Huerta, A, 1980, *Informe del análisis de las pinturas murales del Templo Mayor*. México: INAH

Littmann, E R, 1980, 'Maya Blue: a New Perspective' *American Antiquity* 45(1) 87–100.

Littmann, E R, 1982, 'Maya Blue: Further Perspectives and the Possible Use of Indigo as the Colorant' *American Antiquity* 47(2) 404–408.

López Luján, L, 1993, *Las ofrendas del Templo Mayor de Tenochtitlan*. México: INAH

Magaloni, D I, 1994, *Metodología para el análisis de la técnica pictórica mural prehispánica: el Templo Rojo de Cacaxtla*. México: INAH.

Matos Moctezuma, E, 1988, *The Great Temple of the Aztecs. Treasures of Tenochtitlan*, London, Thames and Hudson.

Ortega, J, 1979, *Informe petrográfico-mineralógico de cuatro muestras de pigmentos*. Laboratorio de Geología. México: INAH.

Reyes-Valerio, C, 1993, *De Bonampak al Templo Mayor: El Azul Maya en Mesoamérica*. México: Siglo Veintiuno Ediciones.

Sahagún, B, 1999, *Historia General de las Cosas de Nueva España México*: Editorial Porrúa.

Solís, F, 1995, 'Pintura mural en el Altiplano central' *Arqueología Mexicana* III (16) 30–35.

Vázquez del Mercado, X, 1998, Technique de Fabrication de la Peinture Murale sur Terre Crue: La Maison des Aigles de L'Enceinte Sacree de Tenochtitlan. Master´s degree thesis, Pre-Columbian Archaeology Research Center, Paris University.

Xelhuantzi, S, 1997, *Estudio difractométrico en muestras de pigmentos de los Templos Rojo Norte y Rojo Sur del Templo Mayor* (Tenochtitlan), D.F. Subdirección de Laboratorios y Apoyo Académico. México: INAH.

Abstract

Surface temperatures for calcareous and sandstone rock art shelters have been modelled for the West Kimberley region of Western Australia during both wet and dry seasons. The best correlations between the surface and predicted values were for still air conditions. The model correctly predicts the timing but not the magnitude of dips and bumps in the surface temperatures when drying or moisture bearing winds affect the sites.

Keywords

Aboriginal rock art, microclimate, modelling, Kimberley, Western Australia

Microclimate modelling for prediction of environmental conditions within rock art shelters

Ian D. MacLeod[*] and Philip Haydock
Department of Materials Conservation
Western Australian Museum
Cliff Street
Fremantle, Western Australia 6160
Fax: +61 8 94318489
E-mail: ian.macleod@museum.wa.gov.au, phaydock@cyllene.uwa.edu.au
Web site: www.museum.wa.gov.au

Introduction

Conservators working on rock art sites need some way of ensuring that observations made during an inspection, or recorded during treatment, will relate to the long-term conditions that will prevail when their work is done. The first step involves monitoring the microclimate of the shelters, since this provides an understanding of how moisture moves across the painted images and through the rock substrates. Since most of the sites are more than 2300 km from the laboratory, limited budgets are not conducive to regular site inspections, so measurements were done during the characteristic seasons. Microclimate modelling was developed to check that the limited data obtained during seasonal visits was generally applicable. Since poor adhesion and cohesion is a major factor in determining the survival rate of the images, an understanding of the impact of heating, cooling and moisture on the rock substrate was essential. Lyons developed a computer model, based on surface energy balance, that enables prediction of the heating and cooling rates of various surfaces (Lyons 1986). Previous work at the granitic Walga Rock site had shown that the Lyons model needed local climate data to reproduce the temperature profiles (Lyons and Haydock 1987) and this data was obtained from data loggers in a meteorological screen close to the rock art shelters.

The new model was tested for the wet and dry seasons at representative locations in the West Kimberley region of Western Australia. The analysis of the rock painting pigments, bacteria and other biological agents involved in rock weathering was conducted in the presence of, and with the specific approval of, Aboriginal owners (Clarke 1976, Clarke1978, Ford et al. 1994, MacLeod et al. 1995). The region has hot humid summers and heavy periodic rains originating from the monsoon trough to the north and tropical low-pressure systems (Elliot 1991). Winters are generally rainless with a dry southeasterly airflow giving mild to warm and dry conditions. The Bunuba calcareous sites in the southwest (Napier Ranges) are much drier than the Wunambal-Ngarinyin sandstone sites in the north (Mitchell Plateau) because they are much closer to the coast and more subject to the extremes of monsoons and of cyclonic rainfall.

Experimental

Data loggers recorded microclimate data, which were downloaded to a laptop computer. More than eight thermocouple wire sensors provided rock face temperatures. In addition, relative humidity sensors were placed at representative points within the shelters. Each thermocouple sensor was 'pinned' to the rock surface by tensioned poles that had been trimmed to a chisel point after being cut from small trees. This supported the four relative humidity sensors, which were taped 3 to 5 cm from the rock face. The local microclimate was logged in a meteorological screen up to 100 m from the site, one metre above ground level. This location was chosen to avoid large rocks and to avoid the effects of long-wave

[*]Author to whom correspondence should be addressed

radiation emission. All the loggers were calibrated and programmed to record data at 15-minute intervals over three to seven days.

Equipment

Data in the shelters were recorded using a Datataker DT100F, which had 19 channels for type K thermocouples, with an accuracy of $\pm\,0.1°C$, and four channels for the Vaisala HMW 20U relative humidity sensors, with an accuracy of $\pm\,2\%$. A storage capacity of 30K equated to 7700 data points or 80 days of readings at 15-minute intervals. The internal Ni-Cd batteries, which provided 12 days of power was supplemented by a solar panel that trickle-charged a sealed lead–acid battery. The meteorological screen data were recorded with either A.C.R. XT-102s or an ACR Smart Reader SR-002.

Description of the model

Although the model only produces temperature profiles, it is possible to use the associated relative humidity data to provide an understanding of the differences between the surface and modelled data. The absolute humidity, or water vapour pressure, provides an insight into the overall moisture regime of a rock art shelter and the nearby external environment.

The model was initially developed to predict ground surface temperatures, but has been modified to predict vertical rock face temperatures. This modification used concepts based on surface energy balance involving both daytime heating and night-time cooling, which is controlled by the amount of sky that each point on the rock face can see (Lyons and Edwards 1982, Haydock and MacLeod 1996). This 'sky view factor' is a measure of the effective area that receives the incoming radiation and 'rejects' the outgoing radiation. The original model presented the mathematical bases for the determination of these factors in horizontal direction and was modified to include vertical components (Steyn and Lyons 1985). The model assumes that the site corresponds to an 'infinite canyon', meaning that there are no ends to the shelter. While this is demonstrably not true, it does not void the model's applicability.

Daytime heating

Modelling the sky-global irradiance assumes cloudless conditions and the direct irradiance is dependant on transmissions due to water vapour absorption, ψ_{wa}, aerosol absorption, ψ_{da}, water vapour scattering, ψ_{ws}, Rayleigh scattering, ψ_{rs}, and aerosol scattering, ψ_{ds} and their product, as defined in equation 1,

$$I = I_o \cos z \; \psi_{wa} \psi_{da} \psi_{ws} \psi_{rs} \psi_{ds} \tag{1}$$

The solar constant is I_o (taken as 1353 Wm^{-2}) and z is the zenith distance. Estimation of the diffuse irradiance (D) assumes that the absorption of the direct beam occurs before scattering and that half of the scattered irradiance, without further absorption, reaches the earth as the diffuse component. The values of the diffuse irradiance are calculated according to the equation 2,

$$D = I_0 \cos z \psi_{wa} \psi_{da} \frac{(1 - \psi_{ws}\psi_{rs}\psi_{ds})}{z} \tag{2}$$

Clear global sky irradiance can be calculated from equation 3.

$$H_{cs} = I_0 \cos z \psi_{wa} \psi_{da} \frac{(1 + \psi_{ws}\psi_{rs}\psi_{ds})}{z} \tag{3}$$

Detailed derivation of the equations are found in the original papers by Davies and Lyons (Davies 1975, Lyons and Edwards 1982).

Night-time cooling

The energy flux assesses the loss of energy due to cooling in the night, which, in the absence of advection, gives the surface energy balance as

$$Q^* = (Q_H + Q_E + Q_R) \tag{4}$$

where Q^* is the net all-wave radiative flux density, Q_H and Q_E are the sensible and latent heat flux densities respectively, and Q_R is the surface heat flux density due to a net change of heat storage within the underlying rock. Under calm conditions, which prevail in the night, the sensible (Q_H) and latent heat fluxes (Q_E) may be neglected, and Q^* is reduced to L^*, the net long-wave radiative flux density, i.e.,

$$L^* = (Q_R) \tag{5}$$

Calculation of the long-wave radiation emitted by the rock surface is given by equation 6,

$$L_O = \zeta \sigma T_g^{\,4} \tag{6}$$

where ζ is the surface emissivity, σ is the Stefan–Boltzmann constant and T_g is the rock temperature. Estimation of the incoming long wave radiation for clear skies is made using equation 7,

$$L_i = 5.16 \times 10^{-13} T^6 \tag{7}$$

where T is the absolute air temperature at some reference height in the shelter. Thus the net long-wave radiative flux density is given by equation 8,

$$L^* = (5.16 \times 10^{-13} T^6 \psi_s) - (\zeta \sigma T_r^{\,4}) \tag{8}$$

and ψ_s is the all important sky view factor.

The surface heat flux and its dependence on rock face temperature can be computed by the force restore rate equation 9,

$$\frac{\partial T_r}{\partial t} = \frac{2}{c} Q_r - \Omega(T_r - T_\alpha) \tag{9}$$

where Ω is the earth's angular frequency ($7.27 \times 10^{-5} s^{-1}$), T_α is the deep rock temperature and c is given by

$$c = \frac{(2\rho_\gamma \, c_\gamma \, \lambda_\gamma)^\zeta}{\Omega} \tag{10}$$

and ρ_r is the rock density, c_r is the specific heat for rock and λ_r is the rock heat conductivity (Deardorff 1978). The product $(\rho_r c_r \lambda_r)^{\frac{1}{2}}$ represents the thermal inertia of the rock, and maybe considered as the resistance of the rock to a change in temperature. The deep rock temperature would be estimated from an integral formulation based on the penetration depth of the annual thermal-wave,

$$\frac{\partial T_d}{\partial t} = \frac{Q_R}{c_d} \tag{11}$$

where $c_d = (2\pi.365)^{\frac{1}{2}} c$. The rock surface temperature can be calculated by the substitution of equations 5 and 8 into 9 and solving the two differential equations 9 and 11 numerically. The model does not set out to address the various specific weathering situations along the rock face, but rather moves to assess general trends within the shelter. From the indication of these trends, the patterns and processes of weathering are better understood.

Application of the model to Kimberley rock painting sites

Data from four sites from both wet and dry seasons used the simple surface energy budget to model the rock surface temperature (Lyons and Haydock 1987). The ambient air temperature is not assumed to be constant, and the flux of the incoming long-wave radiation is allowed to vary. The maximum rock surface temperature and mean deep rock temperature recorded the previous day were used to initialize the model, as this gave better results. A typical 24-hour period was chosen to be

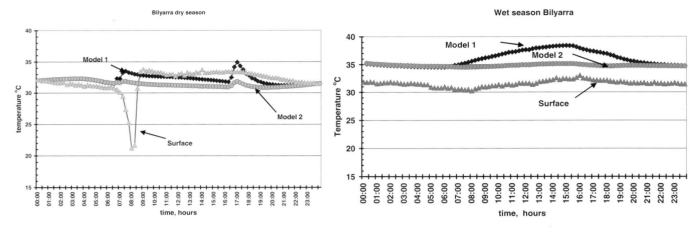

Figure 1. Bilyarra dry season, surface rock and modelled temperatures

Figure 2. Bilyarra wet season, surface rock and modelled temperatures

representative of the days over which observations were made at the painting sites. The modelling results are presented both with and without consideration of the sensible and latent heat fluxes according to the standard parameterization (Oke et al. 1981).

Calcareous sites in the Napier Range

BILYARRA

The shelter was formed by undercut weathering into a bedding layer of quartzose micaceous calcarenite that had been formed in a high-energy beach or tidal environment, with the substrate coming from weathered granitic sources that have been cemented together with calcite (MacArthur and Wright 1967). The site orientation is 20^0 (almost NNE) and is 120 m long with an overhang width that varies between 5 m and 15 m. The shelter has a complex shape with three separate levels and a variable ceiling height of between 5 m and 7 m. The surface and modelled temperatures for June 24, 1990, (Figure 1) show that while the surface temperature can swing by 13°C in less than an hour, the model does not predict such marked swings. The underlying cause of the rapid changes is probably due to a combination of incident sunlight causing local wind eddies, which causes a rapid loss of water from the surface, and direct incident sunlight. Model 1, which assumes no sensible or latent heat flux, reaches its maximum two hours earlier than the surface. The size of the calculated afternoon sharp rise around 17:00 was greater with Model 1 than Model 2, which were both higher than the surface temperature. The model has correctly predicted the cooling of the rock in the morning and the maximum temperature that it reached with the morning sun. Previous work has shown that changes in the rock surface temperatures can be directly attributable to water adsorption, and evaporation can be detected in the dry season (Haydock and MacLeod 1996).

Because of equipment breakdown during part of the wet-season measurements at this site, the initialization temperatures for the wet season modelling are out by approximately 3°C. Thus it was not possible to directly compare the absolute values of the calculated and observed temperatures for February 13, 1992 (Figure 2). Despite this problem, the temperature-versus-time profile of the surface data lies closest to Model 1, but has some contribution from latent and sensible heat fluxes (Model 2) since the cooling and heating rates lie between the values of both models. The 3°C surface diurnal variation is similar to that predicted by the Model 1 system and the predicted maximum occurs very close to the surface value. Generally, the surface temperature profiles for the first eight hours are more intense than the modelled curves. The absence of the rapid 'evaporative' cooling observed in the dry season is due to the much higher ambient moisture levels prevailing during the wet season.

BARRALUMMA II

This ground level shelter lies within a 25-m long overhang that is 5 m wide and 2.5 m high, on the northern outside edge of the Napier Range. The paintings are

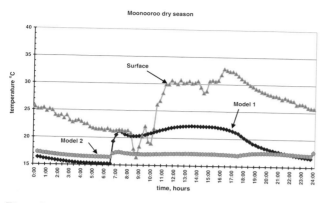

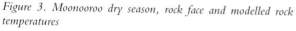

Figure 3. Moonooroo dry season, rock face and modelled rock temperatures

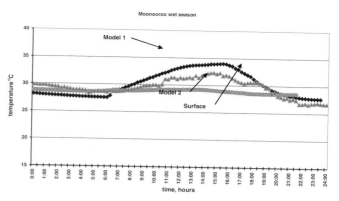

Figure 4. Moonooroo wet season, rock face and modelled rock temperatures

mainly on the ceiling area. The model failed to mirror the observed conditions, with the predicted dry season diurnal temperature range being 8°C less than the observed value. The wet season model agreed with the diurnal range, but did not perform well for the rates of cooling and heating. The failure is probably due to the relatively shallow nature of the rock shelter and the direct impact of the sun on the dry surface.

Modelling for sandstone sites in the Mitchell Plateau

Both sites consist of intensely metamorphosed quartz sandstone where individual sand grains have been deformed and forced together. Void spaces are negligible and some secondary silica overgrowths have additionally bound the grains. Traces of iron normally present in the parent rock display some secondary silicification on the weathered surface. Weathering is generally in the form of granular disintegration on the upward facing surfaces and sheet exfoliation, leading to the leaching of silica.

MOONOOROO

Moonooroo consists of an outcrop of low-lying quartzite boulders scattered in piles over about a hectare near the King Edward River. The paintings are scattered in small shelters throughout the outcrops formed by block weathering. The modelled site was on one side of a rock that was 5 m high, 12 m long and 6 m wide, which was oriented 345°, or roughly NNW. The still air model for the dry season data for July 27, 1990 provides the best fit as it predicts the observed sudden rise of rock face temperature in the morning, but two hours too soon, and the long heating cycle over the day and evening cooling gradient mirror much of the rock face behaviour (Figure 3). It fails to depict the direct heating from the sunlight later in the afternoon, which is due to the northwesterly orientation of the shelter. While the minimum for Model 1 and the surface temperatures are coincident at 16°C, the maximum rock temperature at 32° was 10 degrees hotter than predicted by the model. The modelled data provide a much better fit in the wet season on March 14, 1992, which reasonably matches the heating and cooling gradients and the minimum and maximum temperature times, with the surface-cooling rate being faster than the model (Figure 4). The actual diurnal range of more than 6 degrees is essentially identical to the model. Data from succeeding days show a trend to lower night values as the overall temperature cooled down, i.e., the microclimate is dynamic, whereas the model uses data from the preceding day.

YALGI

The shelter formed by block weathering is oriented 30° or roughly NNE and lies at the base of a rugged outcrop, adjacent to a low sandstone cliff that runs parallel to a large creek. The images cover an area 4 m wide, 7 m long and 1.5 m to 2.5 m high, and the soils within the shelter are generally sandy and stony (MacArthur and Wright 1967). The dry season surface and modelled data for July 31, 1990, show the surface temperature fell 7°C from 03:30 to 09:30 before it rapidly rose to just above the approximate night temperature in less than an hour. This

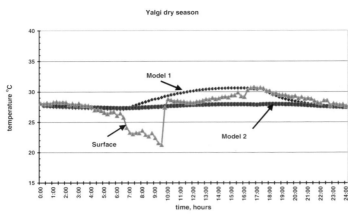

Figure 5. *Yalgi dry season rock face and modelled rock temperatures*

Figure 6. *Yalgi wet season, rock face and modelled rock temperatures*

temperature drop was due to a cold dry south-easterly wind cooling the rock surface (sensible heat flux).

The surface temperature indicates direct sunlight hitting the rock, but the model indicates the heating should have started as a long generous curve from around sunrise at 06:30 (Figure 5). The calculated and surface maxima are coincident, and there is agreement regarding late afternoon heating around 17:00. The surface temperatures in the wet season, for March 9, 1992, lie between Model 1 and Model 2, and while Model 2 predicts the double dipping of the surface curve there is no synchronization of the times or the magnitude of the dips (Figure 6). Scheme two better represents the heating of the rock face, but it does not predict the sudden heating at 07:30. Scheme one results match the surface data of the cooling rock face prior to 06:00. It is likely that cooling dry winds caused the second temperature drop at 20:00 as the relative humidity also suddenly dipped during this the same period. The temperature recovery results from the thermal mass and deep rock temperature. Only the first six hours of the model provided matching temperature profiles, but the sudden cooling conditions in the evening could not have been predicted.

Conclusion

The normally good correlation between the surface and Model 1 temperatures shows that the shelters generally have little turbulent mixing of the air. The finite size of the caves and their non-ground level bases ensures that the predicted temperature ranges for all caves are smaller than observed values. Lower temperature ranges also result if the rock density is greater than the real value and if they have different heat capacities than standard specimens. However, custodial issues prevented access to suitable weathered host rock for relevant analyses.

Since the model showed the 'sky view factor' is very important for vertical surface elements, significant improvement in the model could be made using photographic techniques to get more accurate values of this factor (Lyons and Haydock 1987, Haydock and MacLeod 1996). The model does not have the ability to predict the temperatures when the microenvironment is highly variable. Rapid rises and dips in the rock temperatures are either due to the impact of direct sunlight on the surface or to localized winds causing evaporation of moisture from rock fissures.

The model successfully predicted the temperature rises of the sun striking the rock face. Allowance for the natural shapes and curves and dipping ceilings would also improve the model. Since the blanketing effects of clouds that impede long-wave cooling and reduce the direct ultraviolet radiation cannot be modelled, the system works best for the clear and open skies that predominate in Western Australia. The combination of recorded and calculated microclimate data, using the modified Lyons model, enables prediction of the microclimate of the shelters over an extended period of time.

Acknowledgements

We wish to thank the Western Australian Heritage Council for funding, the National Gallery of Australia for equipment and assistance from Bruce Ford, members of the Junjuwa Community Incorporated and the Gulingi Nangga Aboriginal Corporation and the Department of Conservation and Land Management rangers from the Windjana Gorge National Park for assistance during our field work. Thanks are due to Tom Lyons and Inge Savage for modelling the data.

References

Clarke, J D, 1976, 'Two Aboriginal rock art pigments from Western Australia: their properties, use and durability', *Studies in Conservation*, 21, 134–142.

Clarke, J D, 1978, 'Deterioration Analysis of Rock Art Sites' in C. Pearson (ed.), *Conservation of Rock Art*, 54–63.

Davies, J A, 1975, 'Estimating Global Solar Radiation', *Boundary Layer Meteorology*. 9, 33–52.

Deardorff, J W, 1978, 'Efficient prediction of ground surface temperature and moisture, with inclusion of a layer of vegetation', *Journal of Geophysical Research* 83, 1889–1903.

Elliot, D, (Bureau of Meteorology), personal communication, April 1991.

Ford, B, MacLeod, I D and Haydock, P, 1994, 'Rock art pigments from the Kimberley region of Western Australia: identification of the minerals and conversion mechanisms', *Studies in Conservation* 39, 57–69.

Haydock, P and MacLeod I D, 1996, 'Microclimate modelling in the West Kimberley: a report on the analysis of microclimate data', unpublished report to the Australian Institute for Aboriginal and Torres Strait Islander Studies, Perth, 1–70.

Lyons, T J, 1986, 'Model: predication of surface temperature', unpublished report, Murdoch University, School of Environmental and Life Sciences, Murdoch, Western Australia, 6150.

Lyons, T J and Edwards, P R, 1982, 'Estimating Global Irradiance for Western Australia, Part I' in *Archives for Meteorology, Geophysics and Bioclimatology*, B30, 357–369.

Lyons, T J and Haydock, P, 1987, 'Surface energy budget model of a cave', *Theoretical and Applied Climatology* 38, 8–14.

MacArthur, W M and Wright, M J, 1967, *Atlas of Australian Soils: Explanatory Data for Sheet 9 – Kimberley Area*, collated by Northcote K.H. C.S.I.R.O. and Melbourne Uni. Press Melbourne (Soil classification Qb34 and soil classification JK14).

MacLeod, I D, Haydock, P, Tulloch, D and Ford, B, 1995, 'Effects of microbiological activity on the conservation of aboriginal rock art', *AICCM Bulletin* 21(1), 3–10.

Oke, T R, Kalanda, B D, Steyn, D G, 1981, 'Parameterization of heat storage in urban areas', *Urban Ecology* 5, 45–54.

Steyn, D G, and Lyons, T J, 1985, 'Comments on "The determination of view factors in urban canyons"', *Climate and Applied Meteorology* 24, 383–385.

Abstract

Different weathering processes have been found at the Cueva del Ratón, one of the hundreds of painted shelters located in the Sierra de San Francisco in Baja California, one of the most arid areas in Mexico. Although the paintings of nearby shelters are about 3000 years old, their state of preservation is quite surprising, considering the open-air conditions. There are, however, some conservation problems, essentially linked with the action of water or humidity. The presence of silica-rich layers associated with the rock art figures is discussed, since their role in the conservation of the site has been both beneficial and damaging. The presence of manganese oxide-rich layers is also mentioned. These layers do not cause a physical or chemical damage, but they do obliterate the figures they cover. A monitoring of the micro-climatic conditions of the shelter is proposed, in order to fully understand the role of humidity and temperature in the weathering processes.

Keywords

Baja California, rock art, weathering, silica-rich layers, manganese oxide layers, monitoring

Weathering processes at a rock art site in Baja California, Mexico

Valerie Magar

Coordinación Nacional de Restauración del Patrimonio Cultural, INAH
Ex-convento de Churubusco
Xicotencatl y General Anaya s/n
San Diego Churubusco, CP 04120
México D.F., México
Fax: +52 56 88 45 19
E-mail: vmagar@avantel.net

Introduction

More than 200 painted rock shelters have been located within the mountain range of the Sierra de San Francisco, one of the most arid regions of Baja California and Mexico (Figure 1). The sites are usually spectacular, with larger-than-life-size figures located high on the ceilings and cliffs. Due to the significance of this rock art, the whole area was added to the UNESCO World Heritage List.

Within the past few years, several research projects have been carried out to gain more knowledge about this mysterious region, the archaeology of which is still only partially understood. The projects also aimed at analyzing the alteration problems of this area, in order to define the most suitable conservation and management proposals.

One site in particular, the Cueva del Ratón, was chosen for a conservation project, which was initially launched in 1994 by the Getty Conservation Institute, the Instituto Nacional de Antropología e Historia (INAH), and Amisud, a non-governmental organization (Stanley Prince 1995). When this project ended, earlier than expected, most of the information gathered during its three years was taken up by a new project, in which several new objectives were established, forming the basis for a doctoral research project. This paper presents some of the results of that research.

The Cueva del Ratón

The site of El Ratón is located on a cliff formed by several layers of tuff (Figure 2). The shelter formed by the erosion of one of those layers, is called unit I in this paper. The layer above it, called unit II, now forms a ceiling in the deepest parts of the shelter, in the southern part of the site, while it slowly turns into an almost vertical wall towards the northern part. One can find more than 200 painted figures along the site, representing a few abstract figures, but mostly humans and animals, such as deer, bighorn sheep and mountain lions. Four colours were used

Figure 1. Location of the Sierra de San Francisco

Figure 2. View of the shelter and the cliff

Figure 3. Schematic view of the shelter. In black, we can see the painted areas. The diagonal lines show the back wall.

Figure 4. Cross-section of a sample. The stratigraphy shows the rock surface, covered by a thick silica-rich layer, and red pigment on top (10').

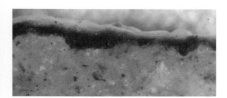

Figure 5. Cross-section of a sample. The stratigraphy shows the rock surface, and extremely fine silica-rich layer, red and black paint, and again a silica-rich layer (22').

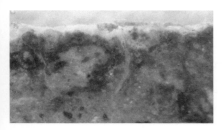

Figure 6. Cross-section showing silica flowing through the joints on the rock. On the surface, there is a silica-rich layer, and red pigment (23').

to create these paintings: red and black (which are widely used), white (usually found as an outline for the figures), and less commonly, yellow. Dating analyses were carried out for this shelter (Fullola et al. 1994), but unfortunately they later proved to be unreliable. Other dating has been carried out more recently on nearby shelters, giving a reading of roughly 1000 BC (Gutiérrez and Hyland 1997).

Weathering of the rock art

The configuration of the site offers protection to most of the figures, but some of them are exposed to direct sunlight and water runoff whenever it rains. The site is, therefore, characterized by an uneven weathering throughout its different areas (Figure 3).

The main threat for the rock art seems to be related to the behaviour of the rock wall, since the paint itself is in quite good condition. Only the white sometimes seems to have flaking problems, in a very similar way to white paints from other sites around the world. This is basically caused by the larger particle size of white materials, which are more difficult to bond with the rock wall. At the Cueva del Ratón, however, this seems to be a minor problem.

This cannot be said about the stability of the rock wall, which is a greater threat, presenting four main problems. Two of them are linked to the presence of soluble salts, which create losses in the form of granular disintegration and flaking. These processes are found in different parts of the shelter. Granular disintegration tends to occur towards the central part of the site (areas D1 and D2), in a place where the shelter is not very deep, but where the painted areas are still protected from water runoff. The damage caused to the rock art is quite apparent. Flaking, on another hand, occurs in the southern and deepest part of the shelter; it seems to be a very slow process, and is not as visible, but it certainly constitutes a threat that should be kept in mind.

Silica rich layers

The third kind of problem is found throughout the whole shelter. It is associated with the presence of silica-rich layers, formed at the rock surface. These layers have been forming for a long time, and the paintings were actually applied over them (Figure 4). In some areas of the shelter, the processes causing the formation of these layers was still active after the paintings were made, and some are, therefore, partially covered by new layers (Figure 5).

These silica-rich layers usually appear stratified, and their colour varies from white to opaque yellow. Sometimes, translucent layers are also present, although they are scarcer. Their thickness varies considerably in different samples, between 65 and 665 μm. Between the whitish layers, there are sometimes black layers, much thinner (less than 30 μm), which could contain organic material, although it was not possible to verify this.

The stratification suggests that the formation of these layers is cyclical, depending on the different conditions prevailing at different periods. Similar layers have been found in other sites, related to rock art (Dolanski 1978, Wainwright and Taylor 1978, Watchman 1990, 1996), and basically two hypotheses were proposed for their formation: the precipitation of solutions coming from within the rock, or the deposition of solutions flowing over the surface.

Cross-sections of samples taken at the Cueva del Ratón showed evidence that solutions are migrating through the joins and cracks of the rock, towards the surface (Figure 6). In this case, specific elements from the rock are being transported towards the surface. They are essentially composed of silica, although other elements are usually also associated, such as aluminum or compounds such as gypsum or calcium oxalates.

The phenomenon itself is quite interesting and surprising in such an arid environment as the one in the Sierra de San Francisco, with less than 100 mm of rain per year. It is well known that silica is not a very soluble element. But the presence of these silica-rich layers is also important in terms of conservation, because their role towards the paintings is not always the same.

Figure 7. View of area D3, with large losses caused by the detachment of the hardened surface. Over the scale, it is still possible to perceive part of the figure, formed by the head of a deer.

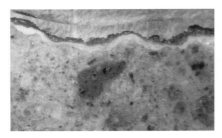

Figure 8. Cross-section of a sample. The stratigraphy shows the rock surface, silica-rich layers, and, on top, the manganese-rich layer.

In most cases, the amorphous silica layers seem to be protecting the paintings, as several authors have described of rock art sites elsewhere. In these cases, they act as a protective coating, actually bonding the paint firmly to the rock and isolating it from the environment. This is essentially the case for the well-protected areas of the shelter.

For other areas, the presence of these silica rich layers seems to be causing important problems. At a microscopic level, there are examples where the silica layer seems to be transporting pigment particles towards the surface, and in other cases it divides one paint layer into two separate layers. There are also serious problems, very apparent on the site, concerning the stability of the rock surface. It seems that the formation of these superficial and very hard silica-rich layers causes the impoverishment of the inner core of the rock and after some time, it can no longer support the hardened surface. The latter is eventually detached, and falls, leaving an extremely friable area exposed. This area tends to deteriorate faster, with granular disintegration. This process is found on the northern area of the shelter, on places that do not receive shelter (Figure 7).

Black manganese-rich layers

On the southernmost area of the shelter, there is another kind of problem. The rock art is almost completely obliterated by a black layer that covers it almost entirely. Analyses showed the presence of manganese oxide-rich layers, with a thickness of less than 65 µm, which seems very similar to the desert varnish one finds on exposed rocks in arid environments (see Figure 8). Its appearance suggests it to be a deposit situated on top of the silica-rich layer. Its location in a specific area of the shelter is not well understood, although it seems, again, to be related to differences in humidity and temperature levels.

The role of humidity

These different types of alteration are evidently related to the presence of humidity and its movements and actions within the site. Unfortunately, during this research, we could not count on the essential monitoring of the microclimatic conditions, which are found throughout the shelter. There is an important need to fully understand the processes involved in the different weathering phenomena, which have been described, before any attempt for conservation can be made.

The role of different sources of humidity must, therefore, be understood and monitored to thoroughly understand the mechanisms involved in the weathering of the rock art. As mentioned earlier, many of the phenomena described require certain amounts of humidity and the scarce rains that reach this region do not seem to be enough. There is an undeniable role played by rain in the formation of the shelter, since water can penetrate into it, and it tends to erode the lower part of the back wall in the deepest area of the shelter.

However, another source of humidity had to be found. Capillary water could easily be discarded, as it was not apparent. However, another factor is fog, which is created by the junction of the hot desert air with the coldwater currents from the Pacific Ocean. Their important role in sustaining the growth of vegetation is well known. However, neither their action on the rock surface nor their composition has been monitored. It is very probable that they form real aerosols, which should be very reactive.

Future proposals and final considerations

In the near future, a complete yet practical monitoring system for the shelter will be developed, in order to get a complete view of the prevailing conditions throughout the year. The analysis of the data will certainly provide new evidence, which should permit a better understanding of the complex weathering processes that affect the site of El Ratón. Only then will we be able to propose adequate treatments, which will probably deal with controlling the different types of humidity affecting the site.

Acknowledgements

I would like to thank the Getty Consevation Institute for granting me access to the information retrieved during the 1994-1996 conservation project. My deepest gratitude also goes to the Instituto de Geología and the Instituto de Investigaciones en Materiales from the Universidad Nacional Autónoma de México, for their support to carry our the chemical analyses.

References

Dolanski, J, 1978, 'Silcrete skins. Their significance in rock art weathering', *Conservation of rock art, Proceedings of the International Workshop on the Conservation of rock art, Perth, September 1977,* C Pearson (ed.), Institute for the Conservation of Cultural Material, Sydney, 32–35.

Fullola, J M, del Castillo, V, Petit, M A and Rubio, A, 1994, *Premières datations de l'art rupestre de Basse Californie (Mexique),* I.N.O.R.A. (9), Foix, France, 1–4.

Gutiérrez, M L and Hyland, J, 1997, *Informe técnico final del proyecto Arte Rupestre de Baja California Sur.* Proyectos Especiales de Arqueología 1993-1994, Instituto Nacional de Antropología e Historia, Fondo Nacional Arqueológico, México.

Stanley Prince, N, 1995, *Conservación de pintura rupestre en Baja California, México, Informe de las dos primeras campañas, 1994-1995,* The Getty Conservation Institute, Los Angeles.

Wainwright, I and Taylor, J, 1978, 'On the occurrence of a parallel pigment layer phenomenon in the cross-sectional structure of samples from two rock painting sites in Canada', *Conservation of Rock Art, Proceedings of the International Workshop on the Conservation of Rock Art,* C Pearson (ed.) Institute for the Conservation of Cultural Material, Sydney, 29–31.

Watchman, A, 1990, 'What are silica skins and how are they important rock art conservation?' *Australian Aboriginal Studies* (1) 21–29.

Watchman, A, 1996, 'Properties and Dating of Silica Skins associated with Rock Art', PhD dissertation, University of Canberra, Australia.

Abstract

A collaborative project, Documentación y Preservación del Arte Rupestre Argentino, was initiated by the Instituto Nacional de Antropología y Pensamiento Latinoamericano in 1994. This paper describes the project generally and then focuses on analyses of samples from two rock painting sites in Patagonia, Argentina: Cueva de las Manos (which is a World Heritage Site) and Cerro de los Indios. Representative microsamples were removed from rock paintings and substrate rock to investigate pigments, substrate preparation, mineral accretions and other physical aspects of the sites. Analyses were done using light microscopy, X-ray microanalysis (scanning electron microscopy), X-ray microdiffraction and Fourier transform infrared spectroscopy. Pigments identified were red earth (haematite; α-Fe$_2$O$_3$), yellow earth (goethite; α-FeOOH), manganese oxide black (pyrolusite; β-MnO$_2$), green earth (celadonite or glauconite), maghemite (γ-Fe$_2$O$_3$) as well as gypsum, kaolin, quartz and other minor ancillary minerals. Coloured material excavated at an archaeological site at Cerro de los Indios was also analyzed for comparison.

Keywords

archaeology, rock paintings, Argentina, pigments, earth pigments, oxalates, pyrolusite, maghemite

Rock paintings conservation and pigment analysis at Cueva de las Manos and Cerro de los Indios, Santa Cruz (Patagonia), Argentina

Ian N.M. Wainwright[*]
Analytical Research Laboratory
Canadian Conservation Institute
Department of Canadian Heritage
1030 Innes Road
Ottawa, Ontario K1A 0M5, Canada
Fax: +1 (613) 998-3721
E-mail: ian_wainwright@pch.gc.ca

Kate Helwig
Canadian Conservation Institute
Ottawa Ontario, Canada

Diana S. Rolandi
Instituto Nacional de Antropología y Pensamiento Latinoamericano
Buenos Aires, Argentina

Carlos Gradin
Consejo Nacional de Investigaciones Científicas y Técnica (CONICET)
Buenos Aires, Argentina

M. Mercedes Podestá
Instituto Nacional de Antropología y Pensamiento Latinoamericano
Buenos Aires, Argentina

María Onetto
Instituto Nacional de Antropología y Pensamiento Latinoamericano
Buenos Aires, Argentina

Carlos A. Aschero
Instituto de Arqueología, Universidad Nacional de Tucuman
San Miguel de Tucumán, Argentina

Introduction

A collaborative rock art conservation research project to study selected rock art sites in Argentina was initiated in 1994 by the Instituto Nacional de Antropología y Pensamiento Latinoamericano (Ministerio de Cultura y Educación, Argentina) and the Canadian Conservation Institute (CCI, Department of Canadian Heritage) as part of a wider project, Documentación y Preservación del Arte Rupestre Argentino (Conservation and Recording of Rock Art in Argentina). The goals of this comprehensive cultural resource management project include investigation of pigments, binding media and technique; investigation of mechanisms of deterioration of the rock paintings; and development of conservation, recording and cultural resource management strategies (Rolandi et al. 1998). Rock paintings and petroglyphs at the Cueva de las Manos and Cerro de los Indios sites were examined by a study team in March 1995 and microscopic samples were taken for analysis by light microscopy, X-ray microanalysis (scanning electron microscopy), X-ray microdiffraction and Fourier transform infrared spectroscopy.

Figure 1. Approach to the Cueva de las Manos rock paintings site.
Photo: Ian N.M. Wainwright, CCI

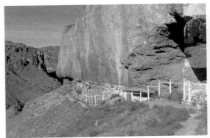

Figure 2. Cueva de las Manos. Path leading to caves and paintings.
Photo: Ian N.M. Wainwright, CCI

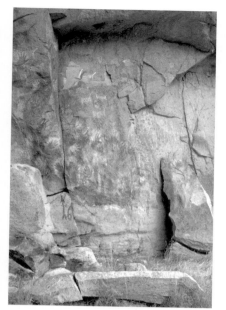

Figure 3. Cueva de las Manos. Rock paintings, hand stencils.
Photo: Ian N.M. Wainwright, CCI

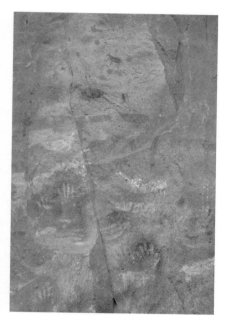

Figure 4. Cueva de las Manos. Black, white, yellow and red earth paintings.
Photo: Ian N.M. Wainwright, CCI

The sites are located in the province of Santa Cruz (Patagonia area) and the rock paintings are an expression of a hunting and gathering culture that occupied the region from at least 9000 years ago to the end of the prehispanic period. Cueva de las Manos consists of a 600 m complex of rock paintings beside and within caves in a cliff in the side of a rift valley through which the Rio Pinturas flows (Figure 1 and Figure 2). Scientific research in the region was carried out by Gradin and collaborators and archaeological investigations are now coordinated by Aguerre (Gradin and Aguerre 1994). The site is located between Perito Moreno and Bajo Caracoles and is reached by a paved road constructed in 1987. The second site visited, Cerro de los Indios, is located just outside the village of Lago Posadas (Instituto Geográfico Militar Carta Topográfica HOJA 4772-IV, 1983). Annual rainfall in the area is less than 2 cm.

Cueva de las Manos is a national historic monument and, in 1999, was designated a World Heritage Site. In the past, the site was reached by foot from a road on the other side of the canyon. There is a small building for staff and visitors at the approach to the site area and a small designated area for overnight camping. The site gets its name from the many multi-coloured stencilled depictions of individual hands, often superimposed (Figure 3 and Figure 4). Other important elements are hunting scenes with guanacos (Figure 5). Local structural geological change in the past (faulting, falling rock) defines the overall character of the site, which is essentially stable at present. The site has been enclosed with chain link fencing to control visitor access. Although the fence can be climbed quite easily, it has reduced damage by visitors (Figure 6). The most important factor affecting the long-term preservation of Cueva de las Manos is increased visitation which has resulted from improved access, increasing numbers of Argentinean and international visitors, as well as increased interest in eco-tourism and rock art. Graffiti is present but is moderate compared with other sites worldwide. An inventory of graffiti and other damage caused by visitors was completed by the study team. Graffiti and other forms of vandalism are the most significant threat to the sites at this time.

Experts in photography, chemical analysis, surveying and geology have also contributed to the overall project. A detailed topographical plan of the site has been drawn and the Universidad Nacional de Tucumán is doing geological monitoring. An ongoing comprehensive documentation of the sites is crucial to the project and includes surveying, photography and visual observation. A database of photographs, videos and other documentation is being compiled, as is educational material about the site and the archaeology and natural history of the region (Instituto Nacional de Antropología y Pensamiento Latinoamericano 1999). Graffiti at the sites was documented and data on visitation statistics and visitor impact is being recorded.

Sampling and analytical methods

Samples were removed from the rock paintings using a tungsten carbide tool. Sample locations were recorded photographically and a visual colour notation was made with Munsell Soil Color Charts. Samples taken were microscopic and locations were selected to be as unobtrusive as possible. Samples were also taken

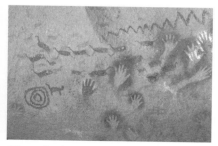

Figure 5. Cueva de las Manos. Hunting scene, guanacos.
Photo: Ian N.M. Wainwright, CCI

Figure 6. Cueva de las Manos. Protective fence.
Photo: Ian N.M. Wainwright, CCI

from a green coloured rock adjacent to the rock paintings. Artefacts were examined under low-power magnification using a stereomicroscope. Important features were documented with photomacrography using a 35 mm Contax 137 MA Quartz camera mounted on a Zeiss OpMi-1 stereomicroscope.

Several artefacts excavated by one of the authors (Carlos A. Aschero) from a site adjacent to the rock paintings at Cerro de los Indios, Santa Cruz, Argentina were also examined as part of this study. Analysis of these pigments and painted rock fragments was carried out in order to document the site and also to provide a reference for a study of the materials used in the rock paintings themselves. Both pigments and painted rock fragments were found at various levels of the excavation. The small red and yellow rocks, referred to as pigments, were probably brought to the cliff by the artists as potential colouring materials. The painted rock fragments consist of pigment that appears to have been deliberately applied to a rock surface.

None of the coloured rocks showed obvious signs of use, although minor surface abrasions were visible on certain of them. When the artefacts were broken open for sampling, the colour appeared to be relatively homogeneous from the exterior to the interior of the fragments, with the exception of one of the red fragments from layer 3e, square $KIII_4$, which had a red exterior crust and a white interior.

In two of the three painted rock fragments (the red-brown paint from layer 4a, square GII and the yellow paint from layer 6 (2°), square BB4c) the pigment had a powdery appearance and was not tightly bound to the rock surface. The third fragment, from 3c (base), square $KIII_1$, had a smoother appearance and the paint was more firmly adhered to the substrate. Striations, possibly related to the application of the paint to the rock, were visible on the surface of this sample.

In order to obtain samples from the painted rock fragments while retaining the surface features of the paint, small scrapings of paint were removed from the artefacts using a scalpel under low-power magnification. To obtain samples of the pigment materials, fragments were broken off the coloured rocks and were ground using a mortar and pestle. This type of sampling was employed because a surface scraping would not necessarily give an accurate indication of the minerals present throughout the interior of the coloured rock.

X-ray microanalysis

A Hitachi S-530 scanning electron microscope incorporating a Tracor X-ray detector and a Noran Voyager X-ray energy spectrometer was used to obtain a qualitative determination of the chemical elements present in the samples. Using this technique, elemental analysis of volumes down to a few cubic micrometers can be obtained for chemical elements from sodium (Na) to uranium (U) in the periodic table with a sensitivity of about 1%. Analysis was carried out using an accelerating voltage of 20 kV and a working distance of approximately 20 mm. The chemical elements detected were categorized as major, minor or trace, based on relative peak heights, with no corrections for atomic number, absorption or fluorescence matrix effects.

X-ray diffraction

In order to determine the crystalline components present, particles of pigment and other materials were removed from the fragments and analyzed by X-ray diffraction (XRD) using a Rigaku instrument equipped with a 12 kW rotating anode generator with a cobalt anode, operated at 45 kV and 160 mA. Samples were mounted with silicone grease on a glass fibre and placed in a sample holder on a goniometer head for analysis by microdiffractometry. The detector, which has an angular range of $2\theta = 3°$ to $147°$, is a position-sensitive proportional counter with a position analysis device and is interfaced to a multichannel analyzer and a computer. Counting time was 7200 seconds. The mineral phases were identified by computerized searching of X-ray powder diffraction patterns from the International Centre for Diffraction Data PDF-2 database (sets 1–45, 1995) using Micro Powder Diffraction Search Match (μ-PDSM) developed by Fein-Marquart Associates.

Fourier transform infrared spectroscopy

In addition to X-ray diffraction, the samples were analyzed using Fourier transform infrared spectroscopy (FTIR). Infrared spectroscopy is often useful for the identification of minerals and can complement results obtained by XRD. Also, organic constituents present in the samples can be identified by FTIR. FTIR spectra were collected using a Michelson MB100 spectrometer equipped with a 2 mm diameter wide band mercury cadmium telluride (MCT) detector and a microbeam compartment, which provided a 1.13 mm beam size at the focus. Samples were mounted in a low-pressure diamond anvil microsample cell for analysis. Spectra were acquired from 4000 to 400 cm^{-1}, by coadding 200 interferograms.

Analytical results

The materials identified by X-ray diffraction (XRD) and Fourier transform infrared spectroscopy (FTIR) are listed in Tables 1, 2 and 3, where the results of the two techniques have been combined. The results of the qualitative elemental analysis by X-ray microanalysis (SEM) are also provided in the table.

Pigments and other materials identified at Cueva de las Manos (Table 1) were red earth (haematite; α-Fe$_2$O$_3$), yellow earth (goethite; α-FeOOH), manganese oxide black (pyrolusite; β-MnO$_2$) and green earth (celadonite or glauconite). Green earth was also found on rocks located outside the cave, suggesting that the source of green earth pigment used was local. In addition, gypsum, kaolin, quartz and calcium oxalate were found admixed with the pigments. For three samples it was possible to identify the calcium oxalate as whewellite (CaC$_2$O$_4$·H$_2$O) by X-ray diffraction.

Extremely small sample size made identification of some of the samples from the Cerro de los Indios rock paintings difficult. The pigments and other materials identified (Table 2) were yellow earth (goethite; α-FeOOH), manganese oxide black (pyrolusite; β-MnO$_2$), green earth (celadonite or glauconite) and maghemite (γ-Fe$_2$O$_3$). Red earth (haematite; α-Fe$_2$O$_3$) was probably used based on the presence of iron in red samples. However, the sample or particle size may have been too small to allow identification by XRD. In addition, gypsum and quartz were found, as were a number of minor ancillary materials, such as a possible trace of a dioctahedral mica. One sample contained trona (a sodium hydrogen carbonate hydrate).

The results for the archaeological pigments and painted rock fragments (Table 3) indicate that the red pigments and paints are all coloured by red earth (haematite; α-Fe$_2$O$_3$). Accessory minerals identified with haematite in the samples include quartz, potassium feldspar, mica, calcite, fluorite, siderite and barite. The yellow paint and pigment samples were found to be coloured by yellow earth (goethite; α-FeOOH). Kaolin and quartz were identified as accessory minerals with goethite. Protein, likely present as a binding medium for the pigment, was identified in one of the red painted rock fragments.

Discussion

Samples from Cueva de las Manos and Cerro de los Indios

RED EARTH AND YELLOW EARTH PIGMENTS

Earth pigments, which consist of a range of iron oxide and iron oxyhydroxide minerals, have been widely reported in the literature. Haematite (α-Fe$_2$O$_3$; Wainwright 1995), lepidocrocite (γ-FeOOH), maghemite (γ-Fe$_2$O$_3$), akaganeite (β-FeOOH; Zolensky 1982), and goethite (α-FeOOH; Scott and Hyder 1993) have been reported in Aboriginal rock paintings. Maghemite (γ-Fe$_2$O$_3$), an iron oxide mineral that has been found to be commonly associated with haematite in pigment samples from other archaeological sites in Santa Cruz, Argentina (Barbosa and Gradin 1987, Aschero 1985, Iniguez and Gradin 1977), was identified at Cerro de los Indios, but not at Cueva de las Manos. Accessory minerals often associated with earth pigments, such as kaolin and quartz, were also identified.

Table 1. Analyses of Pigments and Related Materials from *Cueva de las Manos*

Sample		Combined results of analysis by XRD and FTIR	Elemental analysis (SEM) **major**, minor, and (trace) elements
2	pale red	gypsum, quartz, kaolin, trace calcium oxalate*	**Fe, Si**, Ca, K, Al, Ti/Ba, (Mn, S)
3	brownish-yellow	goethite, gypsum, quartz, trace kaolin, calcium oxalate hydrate (whewellite structure)	**Fe, Ca**, Si, S, (Al)
5	green	green earth gypsum, quartz, trace calcium oxalate	**Fe, Si, K**, Al, Ca, Ti, (Mg, S)
6	red (with black particles)	haematite, quartz, kaolin, unidentified phase, trace calcium oxalate*	**Fe, Si, Ca, Al**, S, (Ti) black particle: **Mn**, Fe, Ca, S, (Al, Si)
7	black	manganese dioxide (pyrolusite), gypsum, unidentified phase	**Mn, Ca**, S, Fe, Si, (Al, P, K, Ti?, Zn?)
10	intense red	haematite, gypsum, quartz, trace kaolin, calcium oxalate hydrate (whewellite structure)	**Ca, Fe, Si**, S, Al, (K, Ti?)
11	reddish-yellow	gypsum, quartz, calcium oxalate hydrate (whewellite structure)	**Ca, Fe**, S, Si, (Al, Ti)
20	loose white powder	gypsum, possible trace quartz, possible trace kaolin group clay	**Ca, S**, Si, (Al, Fe)
43	green rock outside cave	green earth, quartz, silicates, possibly potassium feldspar	**Si**, Al, Fe, K, (Ca, Cl?, Ti?, Mn?)

*It was not possible to determine the state of hydration of the calcium oxalate from the infrared spectra. However, in cases where calcium oxalate was identified by XRD, it was found to have the whewellite structure ($CaC_2O_4 \cdot H_2O$)

Table 2. Analyses of Pigments and Related Materials from *Cerro de los Indios*

Sample		Combined results of analysis by XRD and FTIR	Elemental analysis (SEM) **major**, minor, and (trace) elements
21	purple	quartz, unidentified phase	**Fe, Si**, Al, K, (S, Na, Ti?)
23	pure red	gypsum, quartz, unidentified phase	**Si**, Al, K, Fe, S, Ca
25	black	manganese dioxide (pyrolusite), quartz, silicates	**Mn**, Si, Ca, Fe (Al, P, S, K, Zn?)
26	green	green earth, gypsum, quartz, minor unidentified phase	**Fe, Ca, S**, Si, K, (Al)
22A	strong brown	unidentified	yellow fragment: **Si**, Al, K, Fe (Ca, Ti, Mg)
22B	loose yellow pigment spheres	unidentified	**S, P, Cl**, (Si)
30	red brown	maghemite, quartz	**Fe**, Si, (Al, P, S, K, Mn?)
31	white accretion	sodium hydrogen carbonate hydrate (trona), probably sulfate, minor unidentified phase	**S**, Na
49	porous green stone near paintings	quartz, possible trace dioctahedral mica	**Si**, K, Al, (Ca, Ti, Fe)

Table 3. Materials Identified in Red and Yellow Paint and Pigment Samples from Excavation at *Cerro de los Indios*

Sample		Combined results of analysis by XRD and FTIR	Elemental analysis (SEM) **major**, minor, and (trace) elements
1a	**4a, Sq: GII** deep red-brown paint applied to rock surface	haematite, quartz, fluorite	**Fe**, Si, K, Ca, Mn, (Al, S, Cl)
4	**3c(base) Sq: KIII₁** mid-red paint applied to rock surface	haematite, quartz, orthoclase feldspar, possible trace dioctahedral mica, protein	**Fe, Si**, Al, P, S, Cl, K, Ca, (Mg, Ti or Ba)
1b	**4a, Sq:GII** pigment; red rock fragment	haematite, quartz, siderite, barite	**Fe**, Ba, S, Si, (Al, K, Ca)
3a	**3e, Sq:KIII₄** pigment; fragment has a red exterior crust and a white interior	red surface: haematite, quartz, dioctahedral mica, possible trace orthoclase feldspar white interior: quartz, orthoclase feldspar, dioctahedral mica	red surface: **Al, Si, Fe, K**, Ca, (S, Cl)
3b	**3e, Sq:KIII₄** pigment; red rock fragment	haematite, quartz, orthoclase feldspar, possible trace dioctahedral mica	**Si**, Al, K, Fe
3c	**3e, Sq:KIII₄** pigment; red rock fragment	haematite, calcite, possible trace quartz	**Ca, Fe**, (possible trace Si)
3d	**3e, Sq:KIII₄** pigment; red rock fragment	haematite, quartz, orthoclase feldspar, trace dioctahedral mica	**Si**, Al, K, Fe
3	**3e, Sq:KIII₄** pigment; red rock fragment	haematite, quartz, orthoclase feldspar, trace dioctahedral mica	**Si**, Al, K, Ca, Fe
5a	**6(2°), Sq:BB4c** pigment; red rock fragment	haematite, quartz, trace dioctahedral mica	**Fe**, Si, Al, K
5b	**6(2°), Sq: BB4c** yellow paint applied to rock	goethite	**Fe**, Al, Si, (Cl, Ca, Mn)
2	**3a(cumbre), Sq:I4₄** pigment; yellow rock fragment	goethite, quartz, kaolin-group clay (kaolinite or halloysite)	**Fe**, Al, Si , (K, Ca, Ti, S?, P?)

GREEN EARTH: CELADONITE OR GLAUCONITE

Green earth is a naturally occurring mineral of widespread origin. To the extent that we have been able to analyze comparative standard materials, we can only state with certainty that it is one of two closely related minerals, glauconite or celadonite. Pigments composed of either of these two minerals have traditionally been referred to as green earth. Until recently, glauconite and celadonite have been described from the point of view of their mode of origin: glauconite (from the Greek *glaukos*, meaning bluish green or grey) is used to designate the iron-rich, green pelletal micas of marine origin; celadonite (from the French *celadon*, meaning sea-green or willow-green) is used to designate the non-marine occurrences such as vesicle-fillings and veins in basalts or alteration products of volcanic rocks.

CALCIUM OXALATES

The presence of calcium oxalates was usually determined from the infrared spectra. It is not possible to distinguish which hydrates of calcium oxalate were present by infrared spectroscopy. However, in cases where calcium oxalate was identified by X-ray diffraction, it was found to have the whewellite structure, $CaC_2O_4 \cdot H_2O$. Calcium oxalate exists in a number of hydration states, primarily weddellite ($CaC_2O_4 \cdot 2H_2O$), and whewellite ($CaC_2O_4 \cdot H_2O$) with other hydrated forms up to $CaC_2O_4 \cdot 3H_2O$.

The mechanism of incorporation of the oxalates into the paint layer has not been determined, but a number of possibilities exist (Moffatt et al. 1985, Wiedemann and Bayer 1989, Russ et al. 1999). Calcium oxalates may have been present in the paint layer as original constituents. Alternatively, the oxalates may be of micro-biological origin. The formation of oxalates by microorganisms, such as lichens and fungi, is well documented (Saiz-Jimenez 1989). These oxalates, usually whewellite and weddellite, are produced by the reaction of calcium carbonate with the oxalic acid produced by lichens.

Excavated archaeological red and yellow paint and pigment samples

PIGMENTS AND ACCESSORY MINERALS

Because the excavated samples were larger, a more detailed analysis of pigments and accessory minerals was undertaken. Yellow earth (goethite; α-FeOOH) was found to be the colorant for the archaeological samples of yellow paint reported here. Goethite has been found to be a common yellow colouring material in other sites in Santa Cruz (Barbosa and Gradin 1987, Aschero 1985). In addition to goethite, the yellow pigmenting material sometimes contained a kaolin-group mineral (either kaolinite or halloysite). Kaolin is commonly associated with goethite in sedimentary deposits (Onoratini 1985).

All of the samples of red pigmenting material excavated at the site adjacent to Cerro de los Indios were found to be coloured by red earth (haematite; α-Fe$_2$O$_3$).

Silicates of both the dioctahedral mica and orthoclase feldspar group were identified in some of the red pigment samples. Since the X-ray diffraction patterns are very similar for certain compounds within these two groups (for example, illite and muscovite in the mica group and orthoclase, sanidine and microcline in the orthoclase feldspar group) a more specific identification was not possible. Although all the samples were found to be coloured by haematite, they differed in the accessory minerals that were identified. Accessory minerals such as kaolin, quartz, feldspars and mica were found in many of the samples.

An examination of the accessory minerals present in the samples is important for several reasons. First, the presence of certain minerals may sometimes indicate a specific geological source for the pigment material. Second, documenting the accessory minerals in a large number of samples from different sites may allow patterns of use for specific mineral mixtures to be recognized.

Many of the accessory minerals identified in the excavated samples from Cerro de los Indios have been previously identified in samples from other sites in Santa Cruz. Quartz, feldspar and mica have been found in numerous samples of red pigmenting material from the excavation at Alero Cárdenas. Barite was also identified with haematite in one of the samples from this excavation (Barbosa and Gradin 1987). Calcite has been previously identified with haematite in a pigmenting material from Cerro Casa de Piedra-5 in Santa Cruz (Aschero 1985).

ORGANIC COMPONENT

An organic component was identified in one of the archaeological painted rock fragment samples using Fourier transform infrared spectroscopy. Protein, likely present as a binding medium for the pigment, was identified in the mid-red paint applied to a rock surface (3c base, sq:KIII$_1$). The presence of a proteinaceous binding medium may be responsible for the fact that this paint was smoother and more firmly adhered to the rock surface than to the other painted rock fragments.

Conclusions

Analysis of microscopic paint samples from Cueva de las Manos and Cerro de los Indios by X-ray diffraction and scanning electron microscopy/X-ray microanalysis showed the pigments used for the rock paintings.

At Cueva de las Manos, pigments and ancillary minerals found include gypsum, kaolin, quartz, red earth (haematite; α-Fe$_2$O$_3$), yellow earth (goethite; α-FeOOH), manganese oxide black (pyrolusite; β-MnO$_2$) and green earth (celadonite or glauconite). Calcium oxalate hydrate (whewellite structure) was found in some samples. All of these materials are photochemically stable. Alteration of gypsum (conversion to hemi-hydrate and hydration pressure) is a factor to be considered for long-term deterioration. However, the generally dry conditions at the site are not favourable for this mechanism occurring.

At Cerro do los Indios, quartz, gypsum, manganese oxide black (pyrolusite; β-MnO$_2$), maghemite (γ-Fe$_2$O$_3$) and green earth (celadonite or glauconite) were found. Archaeological samples excavated from a site adjacent to Cerro de los Indios showed the presence of haematite (α-Fe$_2$O$_3$) and goethite (α-FeOOH) in combination with accessory minerals. Protein was detected in one of the excavated samples. Infrared spectroscopy uncovered no evidence that an organic vehicle was used in the paints.

Acknowledgements

This paper is based in part on a lecture presented at Symposium 6 (New Studies of Rock Art in South America) of the International Rock Art Congress, 5 April 1997, Cochabamba, Bolivia. The authors wish to acknowledge the substantial support of this research by the Fundación Antorchas, Argentina and UNESCO.

References

Aschero, C A, 1985, 'Notas sobre el uso de pigmentos minerales en el sitio CCP-5, Prov. de Santa Cruz, Argentina' in C Del Aldunate, R J Bereguer and V R Castro (eds.), *Estudios en Arte Rupestre. Primeras Jornadas de Arte y Arqueología. El Arte Rupestre en Chile, Santiago 16-19 August 1983*, Museo Chileno de Arte Precolombino, 13–24.

Barbosa, C E and Gradin, C J, 1986–1987, 'Estudio composicional por difracción de rayos X de los pigmentos provenientes de la excavación del Alero Cárdenas (Provincia de Santa Cruz)', *Relaciones de la Sociedad Argentina de Antropología*, XVII/1, 143–171.

Gradin, C A and Aguerre, A M, 1994, 'Contribución a la Arqueología del Río Pinturas (Provincia de Santa Cruz)'. Búsqueda de Ayllu, Argentina.

Iñiguez, A M and Gradin, C J, 1977, 'Análisis mineralógico por difracciones de rayos X de muestras de pinturas de la Cueva de Las Manos, Estancia Alto Río Pinturas', *Relaciones de la Sociedad Argentina de Antropología* 11, 121–128.

Instituto Nacional de Antropología y Pensamiento Latinoamericano, 1999, *Arte y Pasaje en Cueva de las Manos*. Secretaría de Cultura de la Presidencia de la Nación, Buenos Aires.

Moffatt, E A, Adair, N T and Young, G S, 1985, 'The occurrence of oxalates on three Chinese wall paintings' in P A England and L van Zelst (eds.), *Application of Science in Examination of Works of Art. Proceedings of the Seminar, 7-9 September 1983*, Boston, Museum of Fine Arts, 234–238.

Onoratini, G, 1985, 'Diversité minérale et origine des matériaux colorants utilisés dès le paléolithique supérieur en Provence', *Bull. Mus. Nat. Marseille* 45, 7–114.

Rolandi de Perrot, D, Gradin, C J, Aschero, C A, Podestá, M M, Onetto, M, Sánchez Proaño, M, Wainwright, I N M and Helwig, K, 1998, 'Documentación y preservación del arte rupestre Argentino. Primeros resultados obtenidos en la Patagonia Centro-Meridional.' *Chungara*, 28 (1-2), 7–31. [January/December 1996 (printed 1998), *Revista Chungara, Revista del Departamento de Arqueología y Museología, Universidad de Tarapacá, Arica, Chile, ISSN 0716-1182*]

Russ, J, Kaluarachchi, W D, Drummond, L and Edwards, H G M, 1999, 'The nature of whewellite-rich rock crust associated with pictographs in Southwestern Texas', *Studies in Conservation* 44 (2), 91–103.

Saiz-Jimenez, C, 1989, 'Biogenic vs. anthropogenic oxalic acid in the environment', *Oxalate films: Origin and Significance in the Conservation of Works of Art. Proceedings, Milan, 25-26 October 1989*, Milan, Centro CNR Gino Bozza, 207–214.

Scott, D A, and Hyder, W D, 1993, 'A study of some Californian Indian rock art pigments', *Studies in Conservation* 38, 155–173.

Wainwright, I N M, 1995, 'Conservación y registro de pinturas rupestres y petroglifos en Canadá' in M Strecker and F Taboada Téllez (eds.) *Administración y Conservación de Sitios de Arte Rupestre, Contribuciones al Estudio del Arte Rupestre Sudamericano*, no. 4. La Paz, Bolivia, Sociedad de Investigación del Arte Rupestre de Bolivia, 52–82.

Wiedemann, H G, and Bayer, G, 1989, 'Formation of whewellite and weddelite by displacement reactions in Oxalate Films: Origin and Significance' in *The Conservation of Works of Art. Proceedings, 25-26 October 1989*, Milan, Centro CNR Gino Bozza, 127–135.

Zolensky, M, 1982, 'Analysis of pigments from prehistoric pictographs, Seminole Canyon State Historical Park' in S Turpin (ed.), *Seminole Canyon: The Art and the Archaeology*, Texas Archeological Survey and The University of Texas at Austin, Texas, 279–284.

Graphic documents

Documents graphiques

Documentos gráficos

Graphic documents

Coordinator: Jan Wouters
Assistant Coordinators: Dianne Van der Reyden, Gerhard Banik

This ICOM-CC Triennial Meeting, organized in Rio de Janeiro, represents a major challenge for the Graphic Documents Working Group, because of the near-to-coincidental planning of an IIC meeting in Baltimore, Maryland (U.S.A.), on the major subjects of study covered by our group: scientific investigation and conservation of paper and parchment. Despite this ill-coordinated planning of events, it is encouraging to see that Working Group members have nonetheless managed to produce high-level contributions for ICOM-CC in the form of oral presentations, papers and posters. It is hoped that the organizing of the Triennial in Rio de Janeiro may pave the way for our colleagues in Latin America to interact more with their colleagues from other parts of the world and provide a solid basis for keeping these interactions alive in the future.

The Graphic Documents Working Group presently has 80 active members, only 24 of whom are registered ICOM members. This discrepancy underscores the need for further efforts by the Directory Board of ICOM-CC, and by Working Group Coordinators, to enhance interest in ICOM membership.

During the past triennial period, two newsletters were produced, dated 9 March 2000 and 7 March 2001.

An Interim Meeting, organized by the late Rikhard Hördal and Istvan Kecskemeti, was held from 7–10 March 2001 at the EVTEK Institute of Art and Design in Vantaa-Helsinki, Finland. The meeting was attended by about 100 people, including scientists, restorers, historians and students. Over the three days, 21 lectures were given. Abstracts of the lectures were distributed at the meeting and were available on the Institute's Internet Web page. There was ample time for discussions. Many people from the Baltic region expressed interest in the activities of the Working Group and several of them registered as members.

The growing importance of the ICOM-CC Working Group on Graphic Documents, as a forum for specialists and students in the field to meet, learn and exchange experiences, was clearly demonstrated in the past three years by the increasing number of collaborative initiatives in which several Working Group members took part, and even played a leading role, and which were subsidized by international organizations.

Jan Wouters

Abstract

The conservation of the Dormition Cathedral Gospel (dating from the end of the 14th/beginning of the 15th centuries) involved unbinding, paint consolidation, parchment flattening and rebinding, executed in such a way that the configuration of the book block as a whole could be preserved but the Codex made available for study and display.

The painting was consolidated with water/alcohol solutions of vinyl-acetate-ethylene copolymer. To preserve the pattern of golden tooling on the edges, the parchment was flattened using a particular moistening and pressing method, applied to still-folded bi-folios and whole quires. While reconstructing the text-block sewing, we eliminated previous repairs that had brought about stiff deformations and damage of the book spine.

Keywords

conservation, parchment, manuscript, miniature, text block, binding, tooled edge

Technological study and conservation of the Gospel of the Dormition Cathedral

G Z Bykova, M A Volchkova, V S Petetskaya, N L Petrova★ and T B Rogozina
The Grabar Art Conservation Centre
60/2, B Ordynka Street
117109 Moscow, Russia
Fax: +7 095 959 12 81
E-mail: grabar@sovintel.ru

Background

The Gospel of the Dormition Cathedral (Moscow, the Kremlin Museums, Armory Chamber, inv. N 11056) is one of the best-known masterpieces of codices of Moscow, dating from the end of the 14th/beginning of the 15th centuries (see Figure 1). Its most obvious characteristics are its golden cover, a binding with ornamental golden tooling, eight miniatures, five ornamental headpieces, 440 polychromic initials (ornamental and zoomorphic) and golden rubrics, placing the manuscript among the *chef-d'œuvres* of old Russian art. At the same time, it is one of the most venerated relics of the Orthodox Church. For a number of centuries the Codex was opened by Russian metropolitans and patriarchs only on the occasion of the most solemn services.

During its history, the introduction of new decorative elements has changed the Gospel's outer appearance. The stylistic features of these changes has allowed the codicologists to date them as belonging to the time of the manuscript's last binding – the 17th century. On that occasion, silk flyleaves in paper frames were put in front of the miniatures and the edges of the book block trimmed and decorated with ornamental golden tooling. The wooden boards were covered with a crimson silk velvet onto which was put the golden cover. The edges of the manuscript were covered with pearl veils.

In 1994 a committee was formed, consisting of manuscript curators, conservators, paleographers, historians and art-historians, to discuss the general condition of the Codex and the steps necessary for future conservation. It was agreed that flaking paint, deformations of the parchment sheets and the immobility of the glued spine were such that the Codex could not be opened for study or display without seriously threatening further its condition. It was decided therefore to take up all necessary steps for long-term conservation and to profit by seizing this opportunity to study the painting technology and stuctural codicological features of the Codex.

Figure 1. General view of the manuscript before conservation

Technological studies

The manuscript comprises 45 quires, those with miniatures containing 12 folios, all others 8. The miniatures and flyleaves were inserted in the quires on separate sheets.

The lining comprises two columns made by pressing a sharp tool onto each bi-folio pair. This method, combining folios with 'direct' and 'reflected' lines, is typical of old Russian manuscripts. However, for this manuscript the horizontal 'direct' and vertical 'reflected' lines were made from different sides of each pair of bi-folios. This particular type of lining, formerly unknown in Russian researches, was revealed for the first time during restoration of an old Russian codex.

The miniatures were painted according to the old Russian icon painting technique. Blue paint consisted of a lower layer containing azurite, overpainted with ultramarine. This feature was found to be very different from the blue paint

★Author to whom correspondence should be addressed

used in the Khitrovo Gospel (Russian State Library, f.304, III, 3/M.8657), which has close historic ties to the Dormitian Cathedral Gospel. In the former, only ultramarine was used. This difference, together with the more virtuously executed miniatures of the Khitrovo Gospel, suggests that different artists were involved.

Conservation treatment

General considerations

In 1994 the committee, representing an enlarged body of the Moscow Kremlin Scientific Conservation Board, decided on the plan for conservation of the Codex. This involved unbinding, consolidation of paint, flattening of parchment sheets and rebinding. Any intervention was to be executed in such a way that the outer appearance of the manuscript remained unchanged

Dismantling of the binding

When the green silk endsheets were removed from the inside of the wooden boards, book-binding parchment support strips appeared, bearing Latin texts. These strips were glued over the binding spine and onto the oak boards, covering the sewing fastening holes in the boards (see Figure 2). The text block was separated therefore by cutting off the sewing threads in the spine of each quire, leaving intact all overlying layers (parchment strips, glue, threads) in the binding spine. In this way all specific features of the binding design could be studied. It could be established that in the last binding, silk threads were used for sewing and cords for binding. Obviously, the taut-pulled silk threads had brought about the destruction of parchment at the stitched points. Coupled with the gluing method, the sewing disabled the manuscript such that it could not open freely.

The cords had been fastened with wood pegging, a technique typical of manuscript sewing on cords, reflecting the last binding intervention. As well the holes for cords, the quire folds also had cuttings typical of the previously applied Byzantine sewing stitch. The holes in the boards had been glued up further with paper fragments bearing printed Cyrillic letters.

The texts found on parchment strips and paper fragments were paleographically attributed to the end of the 16th and the beginning of the 17th centuries, respectively.

Consolidation of damaged paint

The miniature paintings showed different kinds of destruction: local off-peeling, swelling, flaking, exfoliation, cracking and irreplaceable losses. Some destructions had been caused by wax droplets. The miniatures' background, painted with powder gold and slightly polished, showed exfoliation and in part had lost its smooth top layer. The boundary between golden ground and paint layer exposed damages and losses because of looser adhesion of pigments to the gold than to the parchment surface. Important losses and exfoliations were noted on miniature frames, caused by the thick multilayered paint on those areas.

The profile of initials was set out using powder gold. After that the inside space was filled up with a ground of powder gold and a paste-paint layer which partially overlapped the gilded areas of the images. In these cases, main destructions comrised exfoliations of the paint layer where it made contact with the gold. Extensive areas occurred where golden paint showed losses and swellings (see Figures 3 and 4).

Specific destructions were seen also in golden rubrics in the text. These were painted first with cinnabar in small amounts of gum arabic and thereafter covered with powder gold. The low amount of binder caused the cinnabar layer to exfoliate and to be lost as dust, causing the colouring of adjacent areas of parchment. Because there was no binding medium between the powder gold and cinnabar, destruction of the golden layer on letters had taken place.

All consolidations of paint structures which were at risk were performed using a water/alcohol solution of vinyl–acetate–ethylene copolymer (3%, w/v in

Figure 2. Fragment of the manuscript before conservation, displaying the parchment supporting strips with Latin text and the silk threads which caused destruction of the parchment folds

Figure 3. Fragment of an initial before conservation

Figure 4. Fragment of an initial (see Figure 3) after conservation

Figure 5. General view of the miniature before conservation

Figure 6. General view of the miniature (see Figure 5) after conservation

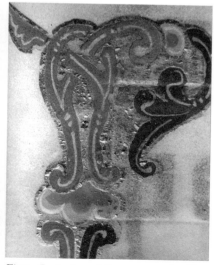

Figure 7. A view of the ornamental golden tooling before conservation

alcohol/ water, 2/1, v/v). Such treatment was accomplished by applying the solution locally, under the paint layer at the spots where destructions had been detected. The process was controlled through a binocular microscope. This methodology for painting consolidation has been used in our institute for more than 30 years. The copolymer does not cause any visual changes in the painting and has sufficient adhesive power and elasticity. Consolidations may be efficiently and quickly performed in a layer-wise manner. For instance, to consolidate a paint layer on a golden ground, the powder gold itself was first consolidated by fixing it onto the parchment to prevent exfoliation. The flaked paint could then be fixed on the consolidated ground.

After having consolidated the paint layer, all remaining surface impurities, such as particles of powder gold, wax droplets and soot, were removed by careful rolling of cotton pads moistened with mixtures of alcohol and petroleum ether (boiling range 80–120°C) at different volumetric ratios; this procedure was carried out under microscope.

Elimination of parchment deformations

It seemed likely that the former rebinding had been executed on a book block containing already deformed parchment sheets. Together with the lack of freedom in movement caused by spine gluing, this had caused further deformations over time. Particular attention had to be paid to the elimination of deformations in the parchment sheets (see Figures 5 and 6) without altering their dimensions and their positioning in the book block profile, so that the pattern of the golden tooling on the edges and the thickness of the book could be preserved. For these reasons, the glue of the spine was removed by a dry mechanical method, controlled under the microscope.

Deformations of the parchment folios were eliminated by moistening the individual bi-folios in their folded condition, that is, without flattening or risking deformation of the individual spine profiles. To this end, moist blotter paper was put into the folded bi-folios, at room temperature. When the parchment was considered sufficiently soft and elastic, the moist blotter was replaced by a dry one. This procedure could be adapted to the particular condition of each bi-folio of a quire.

The quire was then wrapped in cloth and placed in a press in such a way as to prevent the folds from being exposed to any pressure. By applying this methodology, we minimized the risk of altering the configuration of an individual quire and, hence, the reconstructed book block. The finished treatment showed that we had indeed been able to preserve the configuration of the polychromic edge patterns (see Figures 7 and 8).

The flyleaves with silk insertions, which had been applied to protect the miniatures, were damaged severely. The silk was glued in between a double paper passe-partout, the edges of which had been tooled, so we decided to smooth out the deformations of the flyleaves without any dismantling. First, impurities in the silk were removed with perchloroethylene and paper dirt was gummed away with rubber crumbs. After the silk dyestuff had been checked for resistance to water, the silk fabric was dampened slightly and deformations were then flattened out using a small flat iron heated to 50°C. The flyleaves were wrapped in felts, slightly pressed and replaced in the book block.

Reconstruction of the manuscript binding

It was necessary to replace those features of the last rebinding which had resulted in poor conservation, e.g. the use of silk threads for sewing and a heavily glued back. Thus, the silk sewing was replaced with flax threads, avoiding taut tightening. Parchment strips and paper fragments with text records were taken away and mounted upon separate sheets of archive cardboard, strictly in accordance with their arrangement in the original binding. In lieu of parchment strips, flax supports were placed over the binding spine to reinforce it. These flax supports were sewn with thin threads to the cords without any gluing. The spine itself was made a hollow-back, but gave the impression of a glued back book block when

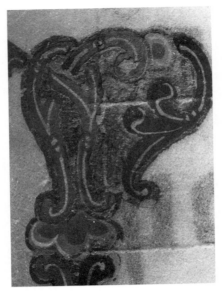

Figure 8. A view of the ornamental golden tooling (see Figure 7) after conservation

closed. The sewing cords were fixed in the board perforations using the original wooden pegs.

In this condition, the manuscript could be opened again easily without any extra load on the spine.

Conclusion

The conservation of the Dormitian Cathedral Gospel consisted of unbinding, paint consolidation, conservation of the flyleaves and rebinding. The challenge was to radically change the binding and to eliminate parchment sheet deformations without altering dimensions and profiles in such a way that the edge tooling and book-block trimming would be changed. This was accomplished by the introduction of a particular bi-folio and quire moistening and flattening system and by paying attention to preserving boards and sewing type of the manuscript, yet radically changing the construction of the binding (by the elimination of spine gluing). Our interventions made it possible to improve the future conservation of the Gospel and to allow again its opening without damage to the paint or the binding; thus the Codex was made available again for study and display.

Acknowledgements

The authors wish to thank the following for their help: Professor Olga A Knyazevskaya (Russian Academy of Science), Dr Vladimir N Malov (Russian Academy of Science), Dr Alexandra A Guseva (The Russian State Library) and Dr Vilena N Kireeva (State Scientific Research Institute for Restoration).

References

Bykova, G Z, 1990, 'Srednevekovaya givopis na pergamente (tehnika, sohrannost, restavratsiya), Issledovaniya, konservatsiya, restavratsiya srednevekovyh pamyatnikov', Moskva, *Ekspress informatsiya* 2, 25–32.

Bykova, G Z, 1993, 'Medieval painting on parchment: technique, preservation and restoration', *Restaurator*, 14, 188–197.

Fedoseeva, T S, 1999, *Materialy dlia restavratsii givopisi i predmetov prikladnogo iskusstva*, Moskva, 57–58, 83–84.

Garikova, Z F, Golikov, V P and Okunkov, V S, 1990, 'Analiz prostranstvennogo raspredeleniya restavratsionnyh polimernyh materialov v pergamrnte s pomoschyu fluorestsentnyh zondov', *Issledovaniya, konservatsiya, restavratsiya srednevekovyh pamyatnikov*, Moskva, Ekspress informatsiya 2, 36–43.

Petrova, N L, 1998, 'Initsialy litsevogo Evangeliya Uspenskogo sobora Moskovskogo Kremlia. Rezultaty issledovaniy v protsesse restavratsii', *Tesisy dokladov megdunarodnoy konferentsii Iskusstvo rukopisnoi knigi*, St Petersburg, 25.

Materials

CEV (vinyl–acetate–ethylene copolymer), Plastpolymer company, 32 Polustrovskiy prospekt, St Petersburg, 195108, Russia

Abstract

This paper will describe a recently observed phenomenon in a manuscript from the 16th century wirtten by Wenzel Jamnitzer, a German goldsmith.

It has been observed that, within the book, large areas of the lead white pigment have blackened. However, areas of the lead white which correspond directly to iron gall ink inscriptions on the reverse of the same sheet are not blackened. Effectively a ghost image of the inscriptions can be seen running through the otherwise discoloured lead white pigment. This paper will present the results of the analysis of the various pigments, using Raman microscopy and X-ray fluorescence. The analysis confirms the presence of lead white and other pigments including the little-known pigment, mosaic gold (tin disulfide). *In situ* identification of blackened lead white, i.e. lead sulfide was obtained for the first time. We also suggest mechanisms for the ghost image effect and offer observations as to the possible source of the lead white discolouration.

Keywords

iron gall ink, lead white, Raman microscopy, mosaic gold

An investigation into the effect of iron gall ink on the discolouration of lead white

Alan Derbyshire,* Pascale Regnault and Richard Kibrya
Conservation Department
Victoria and Albert Museum
South Kensington
London SW7 2RL, United Kingdom

Robert Withnall
Department of Chemical and Life Sciences
University of Greenwich
Wellington Street
Woolwich
London SE18 6PF, United Kingdom

Gerhard Banik
Staatliche Akademie Der Bildende Künste
Stuttgart
Höhenstrasse 16
D-70736 Fellbach, Germany

Greg Smith and Katherine Brown
University College London
20 Gordon Street
London WC1H 0AJ, United Kingdom

Introduction

The main object under examination is volume one (of two volumes) of a treatise written by the German goldsmith Wenzel Jamnitzer (1508–85) of Nuremberg. This illustrated manuscript was written, in German, in 1585. It is a treatise on scientific instruments with details of their use for the goldsmith. It also describes how they can be used in astronomy and geometry to help reproduce scaled objects and calculate distances and altitudes. Figure 1 shows the illustrated title page. The title reads:

> Ein gar Kunstlicher und wolgetzierter Schreibtisch sampt allerhant Kunstlischen Silbern und vergulten newerfunden Instrumenten so darin zufinden. Zum gebrauch der Geometrischen und Astronomischen auch andern schonen und nutzlichen Kunsten. Alles durch Wentzel Jamitzer Burger und Goldscmidt in Nurmberg auffs new verfertigt. Der Erst Theil, Anno Domini M.D.LXXXV.

There are some seventeen other illustrations, in watercolour, throughout the volume. Gold and silver have also been used – as paint – to highlight some of the illustrations.

Figure 1. Title page of the manuscript by Wenzel Jamnitzer, dated 1585

*Author to whom correspondence should be addressed

The treatise is written in what appears to be an iron gall ink on off-white laid paper. The ink is dark brown in colour and can be seen to be discolouring the paper on which it is written and adjacent pages. This is typical of iron gall ink. Under UV radiation a characteristic yellowish fluorescence can be seen around the ink and the affected paper.

The paper is watermarked with the arms of Nuremberg, similar to watermarks of the period 1580 – 1591.

Condition

The manuscript is in what would be classed in conservation as a 'fair' condition, i.e. there are signs of previous damage or deterioration but it now appears to be stable. There is abrasion to the binding and the edges of the pages. There are foxing blemishes throughout the volume which are particularly visible under UV radiation. As already indicated, there is some yellow/brown discolouration of the paper wherever there is direct or indirect contact with the iron gall ink.

There are also what appear to be large areas of discolouration of lead white pigment and tarnishing of the silver paint.

Observed effect of the iron gall ink on the discoloured lead white areas

It was during routine examination of the manuscript prior to display that a curious effect was observed. The blackening of lead white pigment was extensive throughout the volume. However, areas of lead white which had iron gall ink on the verso of the same sheet were not discoloured, leading to a ghost image of the ink running through the otherwise blackened lead white. This effect can be seen in Figure 2.

As a result of this observation it was decided to analyse the various pigments in order to increase our knowledge of the materials used with a view to trying to explain this curious phenomenon.

Pigment analysis using Raman microscopy and X-ray fluorescence (XRF)

It was decided to use non-destructive instrumental analysis to try to determine which pigments were present. The two methods available to us were Raman microscopy and XRF.

Raman analysis was carried out using a Labram Raman spectrometer (Jobin Yvon, Ltd.). The pigments were excited using the 632.8 nm light emission from a helium-neon laser and the laser power at the sample was typically equal to a few milliwatts. The incident light was focused on the sample using an Olympus BX40 microscope fitted with a 50x achromatic objective, which also collected the back-scattered Raman and Rayleigh radiation. The Rayleigh radiation was blocked by a super-notch filter, and the Raman light dispersed by an 1800 g/mm grating and

Figure 2. Ghost image effect from folio 49 verso of the Jamnitzer manuscript

detected by means of a peltier-cooled CCD chip. Pigments were identified by comparison of their Raman spectra with those of the literature.

The X-ray parameters for analysis were 100 seconds livetime, 50 kV, 0.2 mA, no filter, airpath environment with a rhodium x-ray source.

Results of the pigment analysis

The blue pigment ultramarine was identified, from its Raman spectrum, on the title page and at other locations. Vermilion was identified as the red pigment in a number of the illustrations from both its Raman spectrum and the presence of mercury indicated from XRF analysis. The red initial letters throughout the manuscript are vermilion. Red lead was also identified on a number of the illustrations from its Raman spectrum and XRF analysis which confirmed the presence of lead.

Yellow ochre and the rare yellow pigment, mosaic gold (tin disulfide, SnS_2) were both identified from their Raman spectra. XRF also confirmed the presence of tin in the case of mosaic gold. The latter was the pigment used for the bells on folio 40, recto.

Metallic gold and silver cannot be detected by Raman but were both detected with XRF analysis as highlights. Most areas of silver paint have discoloured due to oxidation.

Areas of the white pigment from several different locations on the manuscript gave Raman spectra for lead white which was backed up by XRF analysis showing lead to be a major constituent.

Analysis of materials involved in the ink/discoloured white reaction

The assumption on initial observation of the manuscript was that there had been a reaction between iron gall ink and the lead white pigment. It was necessary to confirm this by analysis. After the above general analysis of the various pigments, the Raman and XRF investigations therefore focused on trying to identify the ink, the discoloured white and the ghost image areas.

Confirmation of the presence of iron gall ink

Several of the black ink initials gave Raman spectra characteristic of amorphous carbon. However the results of all the XRF analysis indicated that iron was a major constituent. Carbon would not be detected by XRF and although Raman spectra for iron gall ink have been obtained (Vandenabeele, forthcoming) this is not easy and, in this case, bands due to amorphous carbon would probably dominate any spectra. The combined Raman and XRF results therefore suggest an iron gall ink with added carbon black. This is consistent with the earlier observations under visible and UV radiation.

Confirmation of the nature of the discoloured white pigment

Discolouration of lead white is a well known effect although the conditions which bring it about are not necessarily completely understood (Daniels and Thickett 1992). The discolouration of lead white to black lead sulfide, PbS, is known to occur in the presence of hydrogen sulfide. However it is hard to imagine the extensive discolouration seen throughout a closed book like the Jamnitzer manuscript occurring due to atmospheric pollution alone. It is worth noting, however, that there is considerable evidence of microbiological activity (foxing blemishes which fluoresce under UV) throughout the manuscript. Perhaps there is a connection between microbiological activity and the blackening of lead white in a watercolour medium. This area needs further research but has been previously reported on wall paintings (Petushkova and Lyalikova 1986).

The other known discolouration product from lead white which also has been reported on wall paintings is lead dioxide, PbO_2 (Giovannoni et al. 1990). This can be dark brown in appearance. Lead dioxide can be formed from the oxidation of lead white under basic conditions. It was therefore necessary to ascertain if the discolouration was PbS or PbO_2.

Analysis of discoloured lead white can be very difficult especially when sampling is not an option. XRF analysis showed the presence of lead but, of course, not the nature of the specific compound. Although Raman microscopy is a highly sensitive, compound specific, non-destructive tool that can be readily used for *in situ* analysis there are problems obtaining good spectra for both PbS and PbO$_2$. Both of these compounds are poor Raman scatterers and both are extremely sensitive to even moderate laser radiation. The result is that often they can be decomposed by the laser, leading to the formation of other lead species and hence spurious spectra. However modern Raman microscopes can now use low power excitation even when analysing weakly scattering samples. In the case of the Jamnitzer manuscript it has been possible, for the first time, to obtain, *in situ*, a spectrum for PbS confirming the nature of the discoloured pigment seen throughout the book. For comparison, reference spectra were also obtained from the natural mineral, galena (PbS) and from a mock up made by painting out lead white in a gum Arabic medium and exposing it to hydrogen sulfide. All three sources of PbS gave similar spectra. Further indication that the spectrum obtained from the blackened area of the Jamnitzer was indeed that of PbS was obtained by deliberately raising the laser power. PbS is known to degrade to lead sulfate with a modest increase in laser power. A spectrum for lead sulfate was indeed obtained as a result of this procedure. From an ethical point of view it should be noted that only a microscopic grain of discoloured lead white had been affected by this procedure.

The blackened areas were also found to give spectra for lead white, indicating that on a microscopic level not all of the lead white had been discoloured.

Discussion and analysis of the ghost image areas

The visual evidence suggested that the iron gall ink is directly affecting the way the areas of lead white pigment are discoloured. Figure 3 shows a detail of one of the ghost image areas. It shows very clearly the direct correlation between iron gall ink writing on one side of the folio and the non-discolouration of the lead white pigment on the other side of the page. Wherever there is no iron gall ink the lead white has discoloured to lead sulfide as confirmed by the analysis described above.

It is interesting to note, however, that where there is a correspondence between discoloured lead white and iron gall ink on the recto of the same sheet or on the facing sheet (i.e. direct contact) there appears to be no effect. The lead white remains blackened. This suggests that the effect of the iron gall ink on the lead white is better able to act via the paper than by direct contact with the ink itself. This may suggest that the effect is initiated at the moment of painting the illustrations or of writing with the ink (whichever came first), i.e. while the paper is moist.

There may be a number of possible explanations for what we are seeing. However it is likely that a simple acid–base reaction is taking place as in the following equation:

$$2PbCO_3 \text{ x } Pb(OH)_2 + 6H+ > 3Pb_2+ + 2CO_2 + 4H_2O$$

Figure 3. Detail of ghost image area

An acid-base reaction of this type is likely to occur in a watercolour as it would be facilitated by the protic medium. This would also explain why no negative image of the handwriting has been observed when the discoloured lead white and iron gall ink are on facing pages which are separated by an air interface. If the medium was not a vehicle for this reaction, a chemical change would be expected when the two pages came into contact.

Previous research has shown that sulfuric acid from the iron gall ink can leach (Neevel 1999) through the paper. This acid from the iron gall ink could then be reacting with the lead white to form the relatively stable, white substance, lead sulfate. If this were the case then degradation of the lead white to black lead sulfide could only occur away from the inked lines. We would then expect to find lead sulfate in the ghost image areas.

Analysis of the ghost image area seems to suggest that the explanation is not as simple as this. The results from the Raman analysis of several of the ghost image areas gave very few positive identifications. Basic lead carbonate and lead sulfate are both very good Raman scatterers and the presence of either or both would be relatively easy to detect by Raman microscopy. Lead sulfate was not found, which seems to preclude the idea that major lead sulfate was formed in the reaction between iron gall ink and lead white. Some lead white was identified – but very little. Also, traces of calcium sulfate were identified. It seems likely that the calcium sulfate had been added to the lead white by the artist, presumably as a filler (traces of calcium sulfate were also identified in the discoloured areas of mainly lead sulfide). The main identification from the ghost image areas was cellulose.

Other examples of the effect

Since initial observation of the ghost image effect on the Jamnitzer manuscript a survey of other manuscripts in the museum's collection has been carried out. Out of some 150 books that were examined only two other examples were found, both in 15th-century Books of Hours. However there are some notable differences. Both of these are illuminated in watercolour on vellum rather than paper. In both cases, out of numerous illustrations, only the first illuminated page of each book has been affected. It is interesting that – unlike with the Jamnitzer manuscript – there was no sign of microbiological activity under visible or UV examination. It could be that, in these cases, the mechanism of lead sulfide formation is due to atmospheric pollution. Hence only the first illuminated page in each book, which may have been exposed on display more frequently, have been affected.

Raman analysis of the ghost image areas on the two Books of Hours gave relatively weak spectra for lead white. Again lead sulfate was not detected. The implication is that – as with the Jamnitzer – there is a reduction in the amount of lead white remaining in the ghost image areas compared to the blackened areas. However the question remains as to why this remaining lead white has not been converted to lead sulfide. One possible answer could be that the initial basic lead carbonate has been largely neutralized by acid from the iron gall ink. What remains would be lead carbonate rather than basic lead carbonate, which may be less readily converted to lead sulfide and therefore remains unaffected (Carlyle and Townsend 1990).

Conclusion

The effect described here seems relatively rare judging by the results of the survey and from the questioning of other conservators. Analysis of the ghost image areas has highlighted conservators' general surprise at the seemingly haphazard nature of the blackening of lead white pigment. More research is required to confirm the likelihood of this discolouration being caused by microbiological activity as well as atmospheric pollution.

The ghost image effect itself seems likely to be an acid-base reaction, which emphasizes the nature of iron gall ink degradation. However it has not been possible to detect the specific chemical nature of the ghost image areas using Raman microscopy. Current research is underway to create the phenomenon artificially by preparing mock-ups on test papers which carry on one side iron gall

ink writing and on the other side a coat of lead white bound in gum Arabic. In order to enforce a migration of reactive products from the ink through the paper web to the lead white, the test papers are aged in stacks with cyclical variations of humidity within the paper stack. The experiment will be realized in an enclosed system with external temperature changes.

Acknowledgements

The authors would like to thank their colleagues for discussion of the problem outlined here.

References

Daniels, V, Thickett, D, 1992, *The Reversion of Blackened Lead White on Paper*, Institute of Paper Conservation conference papers, Manchester.

Carlyle, L and Townsend, J H, 1990, 'An investigation of lead sulphide darkening of 19th century painting materials', *Dirt and Pictures Separated Conference Papers*, UKIC and Tate Gallery.

Giovannoni, S, Matteini, M and Moles, A, 1990, 'Studies of developments concerning the problem of altered lead pigments in wall paintings', *Studies in Conservation*, 35, 21–25.

Neevel, J G and Mensch, C T J, 'The behaviour of iron and sulphuric acid during iron-gall ink corrosion' in J Bridgland (ed.), *Preprints of the 12th Triennial Meeting of the ICOM Conservation Committee*, Lyon, International Council of Museums.

Petushkova, J P and Lyalikova, N N, 1986, 'Microbiological degradation of lead containing pigments in mural paintings', *Studies in Conservation*, 31, 65–69.

Vandenabeele, P and Moens, L, forthcoming, 'Art investigation by means of Ramen spectroscopy', *Asian Chemistry Letters*, 2002.

Abstract

Sheets of acidic and alkaline papers were conditioned in 92% relative humidity, put into stack of inter-leaved alkaline/acidic sheets, wrapped in a plastic bag, put between two boards and pressed. Four different paper samples changed their original pH from 4.4–5.4 to 6.2–6.4 after 3–5 days of contact. Original and treated newspaper and writing papers were aged at 103°C up to 32 days and some mechanical properties were tested. Values of folding endurance, tearing resistance, tensile strength and elongation are significantly higher for deacidified writing paper after accelerated ageing compared to original samples. Differences between acidic and deacidified newspaper after accelerated ageing were not significant, although deacidified paper presents slightly higher values for all tested properties. Despite pH after deacidification failing to reach value 7, the method can be considered a 'first aid' measure for archives and libraries with very limited technical and financial resources.

Keywords

acidic paper, deacidification, pH readings, accelerated ageing, paper ageing, mechanical properties

Deacidification without equipment and money – dream or reality?

Jozef Hanus★ and Jarmila Mináriková
Slovak National Archives
Drotárska 42
817 01 Bratislava, Slovak Republic
Fax: +421 2 6280 1247
E-mail: hanus@snarchiv.sk

Emília Hanusová
University Library
Michalská 1
814 17 Bratislava, Slovak Republic

Introduction

Problems of acidic degradation of paper documents and books in archives and libraries are well known to experts and public alike. Many professional publications and studies point to the fact that deterioration of mechanical properties of paper in the course of ageing is caused primarily by acidity which has been introduced into paper since 1850 by the use of technology during production processes (Kantrowitz et al. 1940, Barrow and Sproull 1959, Virginia State Library 1959, Wilson 1969, Winger and Smith 1970). A dominant factor in this process is acidic sizing with rosins and alum, which was used for the first time by Illig in Germany in 1807 and in principle has continued in use until nowadays. A key stage in the sizing process is the reaction of rosin acids with aluminium ions under the creation of non-soluble aluminium resinates and their retention and fixation on the surface of fibres and other components of paper. As aluminium is an amphoteric element, it can create different anionic and cationic forms depending on pH. There exists a close dependency between the state of aluminium ions in solution and absorption on pulps (Entin et al. 1972). In order to reach the optimal sizing process and maximal retention of sizing agent it is necessary to keep pH readings around 4.8 (Kucera et al. 1982) during the process of paper-making. In practical paper production pH reading very often varies within the range of 4.3–5. However, such acidity values are not suitable from the point of ageing resistance of paper.

The Slovak National Archives keeps approximately 30,000 shelving metres of archival documents, of which about 20,000 to 25,000 shelving metres are written on paper produced after 1850, i.e. potentially on acidic paper. The additional 7 regional and 36 district archives keep about 120,000 shelving metres of archival documents. It is supposed that about 85,000 to 90,000 shelving metres of these are also on acidic paper (Hanus et al. 2001). The proportion of total amount of documents to those on acidic paper is more or less similar to that for many other world archives.

The situation in libraries shows that of a total of 3.8 million book volumes kept in the Slovak National Library in Martin, about 2.5 million are from the period 1850 onwards. In other Slovak libraries of a total of 46.2 million volumes about 44.5 millions date from the same period, i.e. they are potentially acidic. For this reason the Slovak National Library, the Slovak National Archives, the Slovak Technical University and the Slovak Academy of Science got together to create a National Preservation Programme (Bukovský et al. 2001).

Deterioration of acidic paper documents and books represents one of the most significant problems of preservation in archives and libraries. In view of the fact that enormous quantities of acidic materials require treatment, mass deacidification methods and processes are used which necessitate sophisticated technology and financial resources. Many publications and studies concerning different methods and processes of deacidification have been published (Porck 1996).

★Author to whom correspondence should be addressed

Previous research followed changes in the mechanical properties of an acidic writing paper through a stack of 50 and 250 sheets artificially aged in archival boxes (Hanus et al. 1996). Statistical evaluation confirmed a higher ageing rate inside the stack of paper compared to that for the top and bottom sheets. These results support theory that close contact between paper sheets can in some way influence their behaviour and changes in mechanical and chemical properties. It is already known that migration of materials can occur between sheets of paper in contact over long periods of time (Barrow 1953, Kozak and Spatz 1990), and in particular the migration of free acid has been observed.

A simple method for the deacidification of papers and books is also presented in the work of Middleton et al. (1996). It consists of placing the sheets to be deacidified in intimate contact with alkaline paper containing calcium carbonate. However, deacidification only proceeds at a useful rate if the sheets are initially conditioned at a high relative humidity (RH) and this humidity is maintained while the sheets are held together under applied pressure. At 97% RH and 350 kP (50 psi) deacidification often can be completed in less than a day. Other factors, such as the roughness and the electrolyte content of the sheets in contact, are also important in determining the treatment time.

On the basis of the above, we decided to test Middleton's method under conditions which exist in the majority of our archives and libraries, i.e. without any special technical and personnel requirements.

Materials and methods

Tested acidic papers:

- writing wood-pulp-free acidic paper, pH = 4.4
- newspaper wood-pulp acidic paper, pH = 5.4
- wood-pulp-free book paper (a book from 1947), pH = 4.4
- acidic blotting paper prepared by immersing in 0.005 M HCl, pH = 4.4
- alkaline offset paper, pH = 9.3, with alkaline reserve 15–17% $CaCO_3$.

Deacidification method

Sheets of acidic and alkaline papers were conditioned in a chamber with 92% RH created by a saturated solution of copper sulphate for 48 hours. Conditioned samples of papers were put into an alkaline/acidic/alkaline stack, wrapped in a plastic bag in order to retain as much humidity as possible and placed between two wooden boards. One stack of paper was pressed in a hand book-binding press, the other was held together under a pressure of 7 kPa which represents 43.7 kg per A4 format sheet of paper.

As a contact period we took the time from the beginning of pressing until the moment of stack dismounting. The sheets were air-dried and pH was measured using a cold extraction method.

pH measurement

pH readings were measured using a cold extraction method in compliance with the ISO 6588 on pH-meter Radelkis by a combined electrode.

Accelerated ageing

Samples of original and deacidified papers were artificially aged according to ISO 5630/1 in a laboratory oven WSU 100 (WEB MLW Labortechnik, Ilmenau, Germany) at 105°C during a period of 6, 18 and 32 days. After accelerated ageing before each measurement the samples were conditioned at 23°C and 50% RH according to ISO 187.

Folding endurance

The folding endurance of paper defined by Schopper was determined in accordance with ISO 5626 on the Doppelfalzgerät DFP equipment (WEB

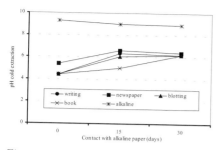

Figure 1. pH changes of tested papers in plastic bag loaded by pressure 7 kPa (43,7 kg/A4)

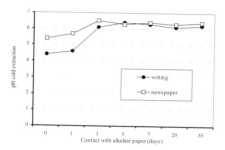

Figure 2. pH changes of newspaper and writing papers in plastic bag loaded in hand made press

Werkstoffprüfmaschinen, Leipzig) for both machine direction (MD) and cross direction (CD). It is expressed as the number of double folds at a standard jaw tension of 7.7 N.

Tearing resistance

Tearing resistance test was performed using an Elmendorf Testing Machine in compliance with ISO 1974 on samples cut in MD and CD and is expressed in mN.

Tensile strength

Instron model 1011 was used to measure tensile strength according to ISO 1924-1 in MD and is expressed in terms of tensile breaking load (kN/m), elongation (%) and tensile strength index (Nm/g).

Results and discussion

In the first stage of our tests we measured changes of pH values of acidic samples in contact with alkaline paper. The results are presented in the following figures. Figure 1 shows results measured within the stack of alkaline and acidic papers which were put into a plastic bag, placed between two wooden boards and loaded under the pressure of 7 kPa. pH was measured using the cold extraction method after 15 and 30 days of contact between the papers.

From measured results it clearly follows that after 30-day contact between tested acidic and alkaline papers, conditioned to 92% RH, the final pH readings for acidic papers stabilized at value 6.2 for writing, book and filter papers and at 6.4 for newspaper. This means that the process caused a shift of pH from acidic to nearly neutral medium. However, the shift up to the alkaline medium and creation of alkaline reserve was not observed in tested samples.

In order to obtain more information on deacidification, we monitored changes of acidity in newspaper and writing papers interleaved by alkaline paper, conditioned for 3 days at 92% RH, wrapped in a plastic bag and pressed between two wooden boards in a hand book-binding press. Readings were taken at frequent intervals. The pH readings obtained by cold extraction method were evaluated after 1, 3, 5, 7, 20 and 30 days of contact with alkaline paper (see Figure 2).

Measured results show that the acidity of both papers decreased and pH readings increased to the level 6.2–6.4. This level was reached after approximately after 3–5 days and remained stable for both newspaper and writing papers.

The same procedure under the same conditions was repeated and papers loaded in a hydraulic press. Changes in pH for newspaper and writing papers were determined after 5 and 7 days of contact with alkaline paper. The obtained results were the same as those presented for the previous test for contact over 30 days (see Figure 2).

In the next test the samples of writing wood-free paper were immersed in water, then water was drained off. The wet paper was interleaved with alkaline paper and

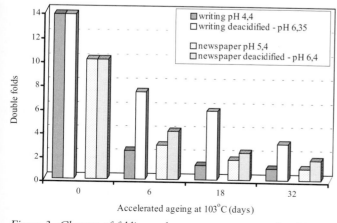

Figure 3. Changes of folding endurance – newspaper and writing papers (MD)

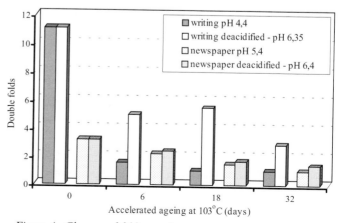

Figure 4. Changes of folding endurance - newspaper and writing papers (CD)

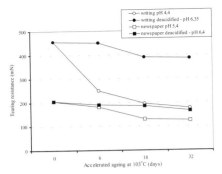

Figure 5. Changes of tearing resistance (MD)

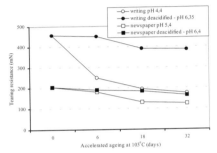

Figure 6. Changes of tearing resistance (CD)

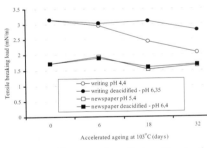

Figure 7. Changes of tensile breaking load - acidic and deacidified newspaper and writing papers (MD)

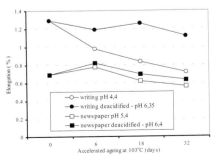

Figure 8. Changes of elongation - acidic and deacidified newspaper and writing papers (MD)

pressed between two wooden boards in a book-binding press. pH of acidic paper was measured after 5-day contact of both papers. Acidic paper increased its original pH readings from 4.4 to 6.3.

The above-mentioned tests demonstrate that the same effect may be achieved either by conditioning of acidic writing paper at 92% RH followed by close contact with alkaline paper or by its immersion in water, draining off, and again followed by contact with alkaline paper. pH values were stabilized within the range 6.2–6.4 after 3–5 days of contact with alkaline paper.

Ageing resistance of acidic and deacidified papers

In order to follow the changes in ageing resistance the samples of acidic and deacidified newspaper and writing papers were artificially aged by dry heat. Changes in some mechanical properties were evaluated after 6, 18 and 32 days of accelerated ageing.

Changes in folding endurance for newspaper and writing papers are presented in Figure 3 for MD and in Figure 4 for CD. Measured results demonstrate that deacidified writing paper (pH 6.35) preserved a significantly higher value of folding endurance comparing to original acidic paper (pH 4.4) in the course of all monitored time intervals both for MD and CD. Despite relatively low original values of double folds, the differences after 6, 18 and even 32 days of accelerated ageing show very clearly higher mechanical strength and flexibility for deacidified writing paper. On the basis of these results it can be stated that the method used for neutralization is suitable for this type of paper.

The original acidic and deacidified newspaper did not show such significant difference for folding endurance after accelerated ageing since the original value of double folds was very low (see Figures 3 and 4).

Very distinct positive effects for the neutralization process on writing paper is manifested by changes in tearing resistance. The results show that in the case of deacidified paper its original value of tearing resistance decreased from 450 mN (MD) after 32 days accelerated ageing to 385 mN (see Figure 5). This means that even after long-term ageing the deacidified writing paper retained 84.6% of its original tearing resistance while the same acidic paper without deacidification retained only 38.5% of its tearing resistance after the same period. The results show a very similar situation for CD tearing resistance changes (see Figure 6). On the basis of tearing resistance of newspaper paper, it can be claimed again that, although tearing resistance values for deacidified paper were higher than for acidic paper, the differences were not as significant as for writing paper (see Figures 5 and 6).

Despite the fact that changes in tensile strength are considered not as sensitive to paper ageing as for example changes in folding endurance or tearing resistance, this mechanical property of paper is very often used in evaluation of paper ageing resistance (Hanus 1986). Changes in tensile strength were followed in our tests and are expressed in terms of tensile breaking load (see Figure 7), elongation (see Figure 8) and tensile strength index (see Figure 9). The effect of deacidification is again more significant for writing paper. The ageing resistance of deacidified paper is around 25–30% higher for all three measured parameters after 32 days accelerated ageing at 103°C compared to original acidic paper.

As in previous cases, the differences in tensile strength parameters for deacidified and acidic newspaper paper after accelerated ageing were not as clear as for writing paper. Changes in pH for acidic and deacidified writing paper and newspaper after accelerated ageing at 103°C are presented in Table 1. Despite the serious fall in pH after the first six days of ageing, the deacidification treatment will probably extend

Table 1. pH (cold extraction) of acidic and deacidified writing and newspaper after accelerated ageing at 103°C

Ageing (days)	Writing paper		Newspaper paper	
	acidic	deacidified	acidic	deacidified
0	4.40	6.35	5.40	6.40
6	3.80	4.70	4.25	4.70
18	3.90	4.85	4.15	4.60
32	4.05	4.80	4.05	4.40

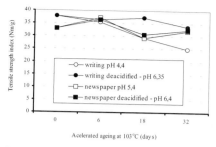

Figure 9. Changes of tensile strength index – acidic and deacidified newspaper and writing papers (MD)

the lifetime of the paper in terms of acid-lability. After 32 days of ageing, the pH of deacidified papers is still considerably higher – especially for writing paper – than for non-deacidified after 6 days of ageing.

Conclusion

The goal of our work was to examine a simple neutralization method for paper acidity by ion migration which becomes evident under the conditions of high RH (92%) and close and tight contact between alkaline and acidic papers.

The four types of acidic papers tested in our work represent large quantities of different papers present in archives, libraries and some other institutions. From the point of their low longevity, weak ageing resistance and self-destructiveness due to the inherent acidity resulting from production processes, these types of paper cause the most serious problems in archives and libraries all over the world.

In tested samples the close contact method of deacidification under the above-mentioned conditions caused a decrease of acidity and rise in pH readings from original values of 4.4 and 5.4 to pH 6.2–6.4 and stabilization of pH at this level. These values were reached within 3 to 5 days. Prolongation of contact between alkaline and acidic papers up to 30 days did not bring any further increase in pH values, and neither the level of full neutralization of acidity was reached nor creation of alkaline reserve set up.

On the other hand, it must be pointed out that using this simple method the tested samples of acidic paper with the rather high acidity of pH 4.4 (and thus quite unsuitable for books and documents) were changed to paper with a cold extraction pH value which was only very mildly acidic and close to a neutral value (pH 6.4). Despite the fact that no paper reached a pH value over 7 – and thus we cannot speak about a complete deacidification of tested samples – the final pH values are acceptable also from the point of view of long-term paper ageing resistance.

In order to follow the changes in ageing resistance of treated papers, the samples of acidic and deacidified newspaper and writing papers were artificially aged by dry heat. Measured results clearly show that deacidified writing paper (pH 6.35) preserved a significantly higher value of folding endurance compared after the ageing to original acidic paper (pH 4.4) both for MD and CD. The same positive influence is reflected also in tearing resistance and the tensile strength of treated writing paper after accelerated ageing.

On the basis of these results we can recommend the suitability of such treatment for this type of acidic paper.

However, despite there being a slight improvement in mechanical properties of treated newspaper, differences between acidic and deacidified samples after accelerated ageing were not as significant as for writing paper.

The method outlined here is very simple and does not require any special equipment or qualified staff, or incur extra financial costs. It can serve as a 'first aid' treatment for some types of acidic writing paper and result in significant improvement of ageing resistance.

References

Barrow, W J, 1953, 'Migration of impurities in paper', *Archivum*, (3), 105.

Barrow, W J and Sproull, R C, 1959, 'Permanence in book papers' *Science*, 129 (3356), 1075.

Bukovský, V, Katušlák, D and Hanus, J, 2001, *Program ochrany papierových informácií v SR. Bunièina a papier – technológie, vlastnosti, ivotné prostredie*, Zborník z medzinárodnej konferencie, Bratislava, 11–12 September, 2001, 179.

Entin, B I, Puzyrev, S A and Burkov, K A, 1972, 'Vzaimodejstvije soedinenii alzuminija s cellulozoj' *Bum. prom.* 10, 8.

Hanus, J, 1986, *Štúdium starnutia papiera zhéadiska ochrany archívnych dokumentov. Kandidátska dizertaèná práca*, Bratislava, CHTF SVŠT.

Hanus, J, Komorníková, M and Mináriková, J, 1996, 'Changes in some mechanical properties of paper during ageing in an archival box', in Bridgland, J (ed.), *Preprints of the 11th Triennial Meeting of the ICOM Conservation Committee*, Edinburgh, International Council of Museums, 1–6 September, 510–516.

Hanus, J, Mináriková, J and Hanusová, E, 2001, 'Deacidification without equipment and money – dream or reality?', in *ICOM-CC Interim Meeting, Working Group on Graphic Documents*, 7–10 March, EVTEK Institute of Arts and Design.

Kantrowitz, M S, Spencer, E W and Simmons, R H, 1940, *Permanence and Durability of Paper, An Annotated Bibliography of the Technical Literature from 1885 A.D. to 1939 A.D*, Washington, Government Printing Office.

Kozak, J J and Spatz, R E, 1990, *TAPPI Paper Preservation Symposium Proceedings*, Atlanta, TAPPI Press, 129.

Kuèera, J, Krkoška, P and Matton, P, 1982, 'Niektoré moznosti ovplyvnenia podmienok glejenia papiera', *Papír a celulóza*, 37 (6), 99.

Middleton, S R, Scallan, A M, Zou Xuejun and Page, D H, 1996, 'A method for the deacidification of papers and books', in *Tappi* 79 (11), 187–195.

Porck, Henk, J, 1996, *Mass Deacidification, An Update of Possibilities and Limitations*, Amsterdam, European Commission on Preservation and Access, and Washington, Commission on Preservation and Access.

Virginia State Library, 1959, *Deterioration of Book Stock, Causes and Remedies; Two Studies on the Permanence of Book Paper*, conducted by W. J. Barrow, edited by Randolph W Church, Richmond, Virginia State Library Publications, No. 10.

Wilson, W K, 1969, 'Reflections on the stability of paper', *Restaurator*, 1 (2), 79.

Winger, H W and Smith, R D, 1970, *Deterioration and Preservation of Library Materials*, Chicago, University of Chicago Press.

Abstract

This research concerns one of the oldest and most precious drawing techniques: metal point drawing on prepared ground. Little specific knowledge on this technique exists, although it was one of the most popular forms of graphic expression of the late Middle Ages and early Renaissance.

This project originates from a necessity to learn about the materials and the techniques used for this type of drawing and their behaviour over time with regard to preventive and active conservation. In 1997 a group of scientists and conservators started a systematic analysis of some four-teenth- to sixteenth century Italian drawings, using modern diagnostics and working directly on the originals as well as on prepared test samples.

We present here the first steps of this vast research: analysis of the metal point line using PIXE (Particle Induced X-ray Emission) and practical application of the antique recipes of Cennino Cennini to create the test samples.

Keywords

early Renaissance, metal point drawing, PIXE analysis, antique recipes, pigments, prepared grounds, conservation issues

Italian metal point drawings: international studies of the artistic technique

Letizia Montalbano★ and Cecilia Frosinini
Opificio delle Pietre Dure
Fortezza Da Basso
Via F. Strozzi 1
50100 Florence, Italy
Fax: +39 055 4625448
E-mail: dip.disegni.opd@virgilio.it, restauro@fol.it

Alain Duval and Hélène Guicharnaud
C2RMF
6 rue des Pyramides
75041 Paris cedex 01, France
Fax: +33 1 47 033246
E-mail: alain.duval@culture.gouv.fr, helene.guicharnaud@culture.gouv.fr

Giuseppe Casu
Dipartimento di Fisica e INFN
Università degli Studi di Firenze
Largo E. Fermi 2
Arcetri, 50100 Firenze, Italy
Fax: +39 055 229330
E-mail: casu@fi.infn.it

Introduction

The subject, up to now only analysed in depth by Joseph Meder,[1] is vast and complex and precludes the examination of very precious drawings, all of which are conserved in the most important private and public collections. The main problem today lies in the identification of this technique and, consequently, in the treatment of such delicate works of art using appropriate methods.

Up to now many works judged to be metal point have been errors: historians have frequently confused the metal stylus with graphite or black chalk, and the prepared papers with tinted or coloured papers. As for the metal points themselves, only silver was taken into account, resulting in the omission of other metals and alloys even when mentioned in the ancient bibliography.

Our first step therefore was to analyse and recognize the constituent materials and their characteristics. To detect the metals used in the styluses, we applied PIXE analysis (Particle Induced X-ray Emission). For the preparations and metal styluses, we recreated the antique recipes and made various test samples.

Study of the metal point drawing technique

The complexity of this field led us to distinguish between various working stages. First was a history of the metal point technique, including the reconstruction of the antique draughtsmanship. Second was an analysis of the metals and the original preparations, followed by the identification of conservation problems.

Due to the fragility of the drawings, non-invasive technical analysis was used on the originals: infrared reflectography, X-ray emissiography and radiography, PIXE and X-ray fluorescence. To study the deterioration of the materials however, invasive technical analysis was carried out on the test samples: infrared spectrometry, artificial ageing and the timing of metal oxidation.

History of the metal point technique

The fifteenth century marked the establishment of metal point drawing as an autonomous graphic medium, a step up from the secondary role which had characterized it during previous centuries.

★Author to whom correspondence should be addressed

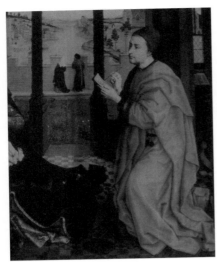

Figure 1. Rogier Van der Weyden, St Luke painting the Virgin *(detail)* *[Boston, Museum of Fine Art]*

While the technique came to be appreciated by the artists of that time, mainly in the area of Tuscany and the Lombard–Venetian region, it was soon abandoned, in the early sixteenth century, for more ready drawing techniques.

Before entering in detail into this extraordinary field, it is necessary to define what is meant by metal point drawing on prepared ground.

- For *metal point*, the use of a most antique tool, the stylus, previously used for writing, to create miniatures and for drawing (Montalbano 1996) (see Figure 1), and for the stylus itself, the use of lead (in tin alloy) and silver and, occasionally (according to some sources), gold and copper. Then, once drawn, cancellation from the sheet only of the marks left by the lead; removal of the other metals would necessitate a re-preparation of the ground, thus making this type of drawing one of the most difficult to execute.

- For *prepared ground* the surface of a sheet of paper or parchment, brushed with a composite material, most frequently coloured, of the same density as a tempera.

Besides making the sheet stronger for drawing on with hard metal points, this preparation also served as a final background and therefore had a precise artistic value.

The antique preparations used in the study were made by mixing one or more pigments with an inert charge (generally powdered burnt bone) and an organic glue, made from scraps of animal skin.

The historical and practical reconstruction of this practice suffers from the lapse of centuries. The bibliographical sources available are in fact scarce and fragmentary, up to and through the entire fourteenth century. It is only later that we start to find recipes and practical applications of the metal stylus and its use in drawing.

The most complete source is *Il Libro dell'Arte* by Cennino Cennini. The text indicates with precision the pigments used for the preparations and the alloys used to forge the metal stylus. Cennini also talks about paper (as folio) in general, *bambagina* and *pecorina* being at that time the supports most used when drawing. Because most of the metal point drawings that survive today are on paper, our studies concentrated primarily on this type of support.

Reconstruction of Cennino Cennini's antique recipes

Cennini considers metal point drawing, which he calls 'drawing on tinted paper', very important for the apprenticeship of the painter, dedicating to it eleven chapters of his book, of which chapters 15, 16 and 18 through 22 cover the pigments, and chapters 8 and 10 through 12 the metal styluses.

The preparations

The colours proposed by Cennini are green (tinta verde), violet (morella o ver pagonazza), indigo (tinta indaca), pink (color rossigno o squasi color di pesco), fleshtone (incarnato) and grey (tinta berrettina o ver bigia).

To prepare the tempera mixture we used the same pigments as mentioned in his recipes:

green paper: verdigris, cinnabar, yellow ochre, lead white
violet paper: lead white and red jasper or hematite[2]
indigo paper: indigo and lead white
pink paper: sinopia, verdigris and lead white
fleshtone paper: cinnabar and lead white
grey paper: lead white, lamp black and sinopia
inert charge: bone white[3]

For the quantities, we read Cennini's measures as follows: the broad-bean = 1/2 tsp; the walnut = 1 tsp; the ounce = 30 g approx.

Only for the green and the grey paper did Cennini talk about bone white mixed with the tempera, which served as an inert charge, as a brightener and as a thickener.

The glue used in the tempera mixture is the one described in chapter 16 of Cennini's book. We used a refined skin glue in a 1/14 water solution. To achieve the consistency of a tempera, we mixed approximately 200 ml with the pigments.

The pigments, first tested using FTIR, were then ground to very fine powder and mixed with the skin glue, obtaining the right density to permit homogeneous coats.

Samples of 16th-century hand-made Western (60 g in weight) and Japanese Atsu Shi (62 g) papers were prepared (60 g is the average weight of most of the original drawings' supports).

The prepared tint was then laid down many times onto the paper surface, using wide flat brushes in both vertical and horizontal directions, leaving each coat to dry so as to avoid damaging the delicate surface.

As reported by Cennini, five or six coats were necessary to achieve optimal results, after which the completely dry test samples were burnished with an agate to make the surface slightly shiny.

CONSIDERATIONS

Already at this first stage we were able to understand some of the pigments' characteristics, such as the greater solubility of the cinnabar, lead white, lamp black and verdigris, as compared to sinopia and indigo. Red jasper was, in contrast, virtually insoluble, resulting in a non-homogeneous preparatory layer on which it was quite impossible to draw. This led us to think of a probable error in interpretation of the term 'lapis amatita', which in this case was not jasper but red hematite, which is more soluble and similar to cinnabar.

It is a little premature to form conclusions as to why some tints were used more frequently than others. Nevertheless, studying the originals, it is clear that the pink colour, with all its varieties from violet to peach, was the favourite from the second half of the fifteenth century onwards. We surmise that the choice of the pink tints was not only a question of taste, but also because technically it was more successful.

Seeing that some originals had very special pink tones, we replaced cinnabar and sinopia with various lakes, obtaining very particular but not improbable colourings. Lakes, as we shall see later, have been found in analysis of the preparations using PIXE. We also found that they are easily blended and make excellent preparations. It is possible therefore that they were in fact in use at this time.

Other considerations can be made after the practical procedures adopted, which helped us to interpret some of the physical damages typical of these drawings. Too much water (an increase of 15–20 ml on the original recipe) added to the glue gives a weak and imperfect preparation that will eventually pulverise. Vice versa, decreasing the water in the glue (by 15–20 ml) gives an excessively hard preparation that in time will crack and fall off the paper support. Finally, over-mixing the tempera creates air bubbles which, on the paper surface, will result in little craters, weak points and defects

If we examine the original drawings, in the light of the test-sample manufacture carried out, we see a strict correspondence between technique and damage. Many of the preparations are badly made – too rigid or too soft and weak, with superficial faults such as craters and impurities. Such faults, throughout the centuries, have resulted in actual damage, mainly at the expense of the metal line which, unable to find a perfect adherence to the support, has been lost.

The metal points

Cennini talks about metal points in chapters 8, 10, 11 and 12 of his book. He cites lead and silver styluses, describing how to use them and for what type of drawing they serve best.

In chapter 8 he also mentions brass, but only as a tool, and with a silver point. Lead, a relatively soft metal, seems to have been used primarily for sketches, drawn over with ink, rather than for finished drawings. A lead point behaves more like a pencil is similar to graphite and does not overly mark the preparation; the metal line tends to blur with time.

Silver leaves a more precious-looking line, and was much used in Italy together with brushstrokes of 'biacca' (lead white) (see Figure 2). Harder than lead, it clearly marks the preparation, creating a trace with slight shading effects.

Figure 2. Benozzo Gozzoli, Dioscuri di Monte Cavallo *[London, British Museum, inv. Pp 1–18]*

Figure 3. Filippino Lippi, Study for the Virgin Mary and Child *[Lille, Musée des Beaux-Arts, inv. Pl 78]*

All of these metals leave on the ground a very similar grey mark that oxidizes over time, as the originals show, leaving a brown-black colour.

After making our own styluses – for the silver: little pointed silver 900 bars, for the lead: two parts lead to one part tin, following Cennini's recipes – we drew on the test samples.

CONSIDERATIONS

The metal point as a tool is easy to use, although the silver, if too pointed, tends to scratch the preparation and therefore does not leave a strong enough mark. This is one of the reasons why, when examining the original drawings, we find some of them virtually illegible. To this we may add Cennini's annotation in chapter 17: on too shiny surfaces, the metal point line does not stand out and is barely visible.

Visually the two metal point lines differ slightly, not so much in colour (all are the same grey) but in tonality, and in the type of mark – the silver is quite linear, the lead softer.

We are still not sure how much time expires before the metal starts to oxidize. Meder talks about a month, but in our case the drawings executed six months ago still have no visible tone changes.

Further chemical analyses on the test samples will be carried out, looking specifically at metal oxidation.

Drawing analysis

Diagnostic surveys have been carried out on original drawings belonging to the Musée des Beaux-Arts, Lille, Musée Condè Chantilly and Castello Sforzesco, Milan.

We shall here examine PIXE analysis of the Lille collection.

In 1998 the Centre de Recherche et de Restauration des Musées de France (C2RMF) began to research metal point drawings by Pisanello, exposing them to PIXE. This study was soon extended to other collections.

The fifteen Lille drawings analysed were collected by J B Wicar (1762–1834) in Italy. Unfortunately there is no exact trace on the provenance of these drawings, and this makes it difficult to explain some of the damage incurred, e.g. the retouching of inv. Pl 230 with ink, probably in order to render the metal lines more visible and to simulate a better conservation state.

The drawings examined (listed below) were all judged to be drawn using a silver point, except for one which was executed using lead on unprepared paper.

- Sandro Botticelli (Pl 77), silver point on prepared paper
- Filippino Lippi (Pl 78, Pl 232, Pl 288, Pl 289, Pl 290), silver point on prepared paper (see Figure 3)
- Workshop of Filippino Lippi (Pl 80 front, Pl 80 back, Pl 81, Pl 82, Pl 230, Pl 233, Pl 304, Pl 306), silver point on prepared paper (see Figure 4)
- Filippino Lippi (Pl 79), lead point on unprepared paper.

The silver point drawings

All the sheets were covered with a preparation layer made of bone white and pigments, as indicated by Cennini. The pigments were identified using elemental analysis and microscope observation as follows: lead white, ochre, cinnabar and red lake are the pigments used for the reddish or brownish layers (Pl 78, Pl 288, Pl 289, Pl 232, Pl 306, Pl 233, Pl 230, Pl 304, Pl 81 and Pl 82). The grey and blue layers are coloured using either carbon black or small dark blue grains which probably derive from organic indigo (Pl 77, Pl 290, Pl 80f and Pl 80b).

The silver point lines contain a small amount of copper (between 0 and 8%) and zinc (between 0 and 3%). Furthermore, all the silver lines contain mercury, which was probably not in the metal points. The presence of this element in all the silver point and lead point drawings analysed in Paris and in Florence is most likely due to a later contamination (Duval 1999).

Figure 4. Filippino Lippi, Study of a Naked Man with Raised Arm *[Lille, Musée des Beaux-Arts, inv. Pl 230]*

Figure 5. Zavattari Workshop, Allegories of Hunt and Justice *[Milan, Castello Sforzesco, inv. 6946B–2666]*

The lead point drawing

As indicated by Cennini, lead point drawings do not need a preparation layer. Furthermore, he recommends making a stylus using two parts lead to one part tin.[4] The composition of the lines of the drawing (Pl 79) is a lead:tin alloy; the ratio of lead to tin is approximately 1.6, which is close to the value indicated by Cennini.

A case of retouching: Pl 230

The sheet contains two drawings: a sketch on the left and a standing man on the right (see Figure 4).

The lines of the latter are darker than the lines of the sketch. PIXE analysis reveals, in addition to silver, a higher content of copper and zinc, a small quantity of nickel, and perhaps iron. The presence of iron, however, is doubtful, because its high content in the preparation makes it difficult to assess its presence in the lines. Examination by microscope shows that the original silver point lines have been covered with ink, probably to increase legibility. It is not possible to say when this retouching was done – whether it was carried out by the artist himself, as was often the case, or later by another (Tordella 1999). However, due to the high content of zinc and the presence of nickel in the ink, the latter assumption is more probable.

Considerations

Overall the results of the PIXE analysis tell us that the ground is made of white bone powder coloured with various pigments. As for the metals used, in one case the metal point line shows the use of a lead–tin stylus of similar composition to the one described in Cennini's recipe. In the other cases, the metal used for the stylus is silver containing a variable amount of copper. Mercury has also been found in all the metal point lines, and the presence of this metal is now under discussion: is it an effect of contamination or was it included in the alloy?

Conservation

After having analysed the techniques and the constituent materials we conclude with a general vision on the conservation status of these particular drawings.

We have seen that the actual nature of the materials can be a direct cause of deterioration. However, much of the damage has been incurred over time.

First, the metal point drawings are works by great Renaissance artists, and because of their unique importance, even though conserved and collected since ancient times, they have been exhibited too frequently, and therefore have been mishandled, resulting in damage.

The oldest drawings were made to transmit iconographical models and served as work tools, and thus much damage was incurred in the same period as the work itself: for example, retouching of the metal lines, erasure of part of the ground, the re-use of previously existing drawings and the gluing together of various sheets.

Other drawings suffer from damages typical of a collecting, such as dismembered sketchbooks, leaves which have been cut out (see Figure 5), relined and retouched drawings and leaves pasted onto new collectors books.

The drawings studied here have also been restored or retouched on various occasions over time, most often using inadequate methods and with no respect for their complex physical and technical nature.

Separate research is fundamental to study of this area.

Conclusions

This research, in itself complex, is based primarily on drawing examples that we can analyse and conserve.

Up to now we have been able to study the technique of execution, looking in particular at the grounds, and the damage that these may cause. Some examples have been simulated in the laboratory.

PIXE analysis has clarified many doubts regarding the composition of the styluses used in metal point drawing. Many questions remain however: for example, the presence of mercury in all the silver point drawings analysed. Only a systematic analysis of drawings from different collections will clarify this point.

Acknowledgements

Thanks go to the following: Università degli Studi di Firenze, Dipartimento di Fisica e INFN (Pier Andrea Mandò, Franco Lucarelli); Centre de Recherche et de Restauration des Musées de France (Odile Guillon); Musée des Beaux-Arts de Lille (Barbara Brejon de Lavergnée, Odile Liesse); Opificio delle Pietre Dure e Laboratori di restauro (Roberto Bellucci, Simona Calza, Diane Kunzelman, Maria Rizzi e le allieve, Angela Susini, Manuela Vernaglia, Chiara Rigacci and Melissa Gianferrari).

Notes

1 Meder J, 1919, *Die Handzeichnungen. Irhe Technik und Entwicklung*, Vienna , 72–100.
2 Opinions differ as to the composition of violet paper. See *De Arte Illuminandi*, revised by F Brunello, 1992, Neri Pozza, 119.
3 Cennini, C, chap. 7.
4 Cennini, C, chap. 11.

References

Cennini, C, late 14th century, *'Il Libro dell'Arte' The Craftsman's Handbook*, revised by Daniel V Thompson, Dover, 1960.

Duval, A, 1999, *PIXE analysis of Metal Point Drawings*, 6th International Conference on Non-destructive Testing, Micro-analytical Methods and Environmental Evaluation for Study and Conservation of Works of Art, 17–20 May, Rome, Italy, 1007–1022

Merrifield, M, 1849, *Original Treatises dating from XII Centuries on the Art of Painting in Oil Miniature*, London (rev. ed., New York 1967), 275–277.

Montalbano, L, 1996, 'Il disegno a punta metallica. Storia di una tecnica ormai dimenticata', in *OPD Restauro*, Florence, Centro Di ed, n.8, 241–254.

Tordella, P G, 1999, 'Il disegno tra conservazione e "renovazione" nelle fonti e nella pratica artistica tra quattro e settecento', *Conservazione dei materiali librari archivistici e grafici*, vol. 2, Umberto Allemandi & C, 181–200.

Materials

The pigments: sinopia (red ochre), n.008; indigo genuine, n.108; lamp black, n.998; yellow ochre, n.0784; lead white, n.0210; hematite, n.1100; red jasper, n.2100; cinnabar, n.0050; verdigris, n.0320, Zecchi Belle Arti e Restauro, Via dello Studio19/r, Florence, Italy, Tel: +39 055 211470.

Bone white, n.2400, sold by Zecchi.

Japanese papers, Code 641–171, Japico Drissler-Italy, Via Mascagni 902, 00199 Rome, Italy, Tel:+39 068 610116.

Colle de Peau en Grain, n.350400, Lefranc & Burgeois, Paris, France. Sold by Zecchi.

Abstract

DMTA and solid-state ^{13}C NMR techniques were used to measure historical parchment samples which were studied in the project MAP (MicroAnalysis of Parchment; contract no. SMT4-CT94-0514) in collaboration with the School of Conservation in Copenhagen. DMTA (dynamic mechanical thermal analysis) was used in both thermal scan and creep modes. Thermal scans provided information on the transitions associated with the collagen polymer. Micro-thermal analysis was also used to obtain information on the topography and thermal conductivity of sample areas of 100 μm. Localized heating enabled measurements of softening transitions in the sample. This behaviour is influenced by the chemical composition of parchment. ^{13}C NMR provided information on the carbon atoms associated with the polypeptide chains of the collagen in parchment. The behaviour of samples immersed in water and measured in DMTA creep mode was used to track the shrinkage behaviour of the parchment samples. The different but complementary techniques provided a means for characterizing the physicochemical state of parchment samples.

Keywords

parchment, dynamic mechanical thermal analysis, solid-state NMR spectroscopy

Assessment of the state of degradation of historical parchment by dynamic mechanical thermal analysis (DMTA) and Solid-state ^{13}C NMR

Marianne Odlyha★ and Neil S Cohen
School of Biological and Chemical Sciences
Gordon House
Birkbeck College, University of London
29 Gordon Square
London WC1H 0PP, United Kingdom
Fax: +44 (020) 7679 7464
Web site: www.bbk.ac.uk/bcs/
E-mail: m.odlyha@bbk.ac.uk

Gary M Foster
Department of Engineering & Computer Science
University of Exeter
Exeter EX4 4QF, United Kingdom

Abil Aliev
Chemistry Department
University College London
20 Gordon Street
London WC1H OAJ, United Kingdom

Introduction

Parchment, whether in the form of bookbindings or manuscripts, is of considerable interest. It is necessary therefore to have an understanding of the chemical composition and the physicochemical state of historical collagen to allow for improved preservation and conservation treatment. Unaged parchment contains collagen. Its structure has been described in terms of three individual protein strands in the α-helix conformation. These are rigidly held by strong hydrogen-bonding interaction between the hydroxyl of the hydroxyproline and the amino hydrogens of adjacent glycine units. Upon ageing, collagen loses its well-ordered triple helical conformation to form random coils which then constitute gelatin (Fraga and Williams 1985). The parchment samples described in this paper are based on animal hide, of calf and sheep origin. Only three from the set studied in the MAP (MicroAnalysis of Parchment) project have been selected and their physical appearance and characteristics are described in Table 1. The remainder are discussed elsewhere, together with the additional techniques used for their complete characterization (Larsen, in press).

Method

The aim of this paper is to demonstrate the type of information that can be obtained using dynamic mechanical thermal analysis (DMTA) and solid-state NMR spectroscopy. The interpretation of data is based on what is generally accepted about the primary structure of collagen and gelatin. The primary structure is defined as the sequence of the amino acid residues in its polypeptide chains

Table 1. Description of modern and historic parchments

Parchment	Thickness (mm)*	Description
NP7	0.16	Unaged calf parchment obtained from Z H De Groot, Rotterdam, the Netherlands. Beige, soft, thin, flexible, smooth, speckled underside
HP31	0.29	Aged but not dated bookbinding board, calf, partly horned, from the Royal Library, Denmark. Pale yellow/brown upper side, fibrous appearance, slightly translucent
HP28	0.24	Aged, sheep, not dated bookbinding back from the Royal Library, Denmark. Yellow/brown upper side, pale underside, flexible

*thickness measured before removal of any backing/coating layers

★Author to whom correspondence should be addressed

(Rachamandran and Reddi 1976). In terms of primary structure this sequence has been described as a block co-polymer containing imino acids (proline and hydroxy-proline) with glycine at every third position, i.e -(Gly-A-B)x-(Gly-Pro-HyPro)y-. The presence and size of the imino acid residues will have some effect on the mechanical properties since they restrict rotation and lead to a certain rigidity in the blocks containing them, thus the structure can be considered in terms of soft and hard blocks depending on whether glycine or proline occurs every third position.

DMTA

DMTA measures the mechanical properties of materials under a sinusoidal mechanical stress and relates these to the internal motions of polymer molecules or their hard and soft segments. Previous measurements have been made on primed canvas (Odlyha 1998) and leather (Odlyha et al. 1999), and this paper reports measurements performed for the first time on parchment samples. Materials which show both elastic (hard), viscous (soft) and time-dependent behaviour are referred to as viscoelastic. DMTA measures characterizes the viscoelastic nature of the material by the nature of the observed transitions. These in turn provide valuable markers for the physicochemical state of the material. Previous work on dehydrated gelatin using thermomechanical analysis has demonstrated that two transitions were observed (Fraga and Williams 1985) and the interpretation of the observed thermal properties was based on known aspects of the primary structure of gelatin. The transitions are referred to as glass transitions. Below the glass transition temperature the co-operative molecular motion along the chain is frozen, causing the material to respond to stress like an elastic solid. As the temperature is increased some motion commences in the flexible side chains and this causes the modulus of the sample to fall. The modulus continues to decrease as the sample approaches its glass transition temperature, T_g, at which point the main polymer chain is set in motion and the sample changes from the glassy to the rubbery state. Thus the transitions correspond to molecular motions of the material during its heating. Information on the viscoelastic properties of parchment samples may provide a means of determining the actual state of the collagen block co-polymer in the parchment samples and give an insight into the extent of cross-linking and the degree of crystallinity in the samples.

The effect on the mechanical properties of heating the sample while immersed in water is also explored. The hydrothermal stability of collagen fibres is a particularly good measure of the strength or quality of skin, leather and parchment materials and the degree of their deterioration. The hydrothermal stability is characterized by shrinkage of the material when heated in water at a defined temperature. This parameter has been measured using thermomicroscopy and differential scanning calorimetry (Larsen 2000, Chahine 2000). In this paper DMTA in creep mode is used to measure shrinkage under uniaxial loading. This was made possible by the modification of Mark 3 Rheometric Scientific DMTA (Foster et al. 1997) to study the effect of wetting and drying. Recently effects of dehydrothermal treatment of collagen have been studied and have been shown to alter molecular packing in collagen upon water removal (Wess and Orgel 2000).

Solid-state ^{13}C NMR

NMR is a non-destructive technique that can yield information on the chemical environment and mobility of the nuclei in a system (Harris 1993). It has been used previously to study organic compounds in non-metallic historical seals (Cassar et al. 1983). In this project solid-state ^{13}C NMR was used to study parchment samples as received to determine the state of deterioration through analysis of changes in the chemical environment of the carbon atoms of the collagen polymer.

Experimental

DMTA (thermal scan and creep)

Samples (20 mm x 10 mm) were clamped in the tensile mode and measured between –130° and 120°C at 3°C/min, at a frequency of 1 Hz and a force of 4

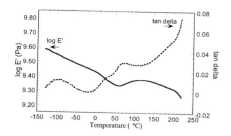

Figure 1. DMTA curves (log E' and tan delta) of unaged parchment NP7 as a function of temperature

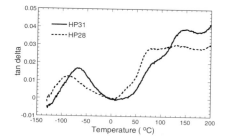

Figure 2. DMTA curves (tan delta) of aged parchments HP28 and HP31 as a function of temperature

N. A second heating of the parchment samples was performed after removal of the physically adsorbed moisture. For creep measurements the sample was clamped and immersed in a beaker of water, at a distance from the main DMTA measuring head. Water was pumped and continuously circulated through the beaker by means of a water bath which enabled controlled heating to be performed. The sample was also mounted in the tensile mode and a small (0.1 N) static force applied along the length of the sample. This enabled any expansion or contraction of the sample during immersion or drying to be measured. A low static force was used so that the shrinkage would not be overwhelmed by the applied force. The experiment commenced with the sample in air, to give a starting baseline. After 10 minutes, the sample was immersed in water, at a temperature of 30°C. Subsequently the temperature of the water bath was increased in 5°C steps every 10 minutes, until a maximum temperature of 85°C was reached. The sample was then removed from the water bath and left to dry at room temperature.

Solid-state ^{13}C NMR

Fourier transform high-resolution solid-state NMR spectra were obtained under conditions of magic angle spinning (MAS) with cross-polarization and then with power dipolar decoupling. CPMAS and single-pulse MAS/Decoupling ^{13}C NMR spectra were recorded at 75.5 MHz (7.05 T) on a Bruker MSL300 spectrometer using a standard Bruker magic angle spinning (MAS) probe with double-bearing rotation mechanism. The samples were fitted into the cylindrical zirconia rotor (external diameter: 7 mm) and then spun at MAS frequency 4.5–7 kHz (with stability better than c.2 Hz). All spectra were recorded at ambient probe temperature. The ^{13}C chemical shifts are given relative to tetramethylsilane.

Micro-Thermal Analyser

Some preliminary work was performed using Micro-Thermal Analysis (μTA). This technique combines the capability of an atomic force microscope for surface imaging with the capability of performing thermal analysis on small areas of the sample (100 μm). Preliminary measurements were made on sample HP28 which was prepared in thin cross-section (Wouters et al., in press)

Results

DMTA

Figure 1 displays the typical DMTA response of unaged parchment. Two curves are shown: log E' (modulus or stiffness of the sample)and tan delta (measure of viscoelasticity: tan delta for completely elastic body will be zero). The peak below room temperature can be linked to side chain motion. Its intensity is related to the free moisture content of the sample and this has also been observed previously in cellulosic materials where intensity of the peak increased on exposure to environments of high relative humidity (Odlyha 1998). The shoulder peak at 25°C occurs also on the first heating but with increased intensity. Its intensity appears to be dependent on the residual physically adsorbed moisture. The peak at 65°C can be interpreted as the temperature at which motion of the main collagen polymer backbone occurs.

Figure 2 displays the tan delta curves for aged parchment samples (HP28 and HP31). The peak below room temperature is again present. The peak in the region of 70°C is also present, together with an additional peak in the region of 140°C. Transitions at these temperatures have been reported in gelatin (Fraga and Williams 1985). It is thus possible to say that some of the collagen in the aged parchments has converted to gelatin. The presence of the peak at higher temperatures indicates that the aged samples must contain more rigid blocks containing proline and hydroxyproline along with glycine than the unaged sample.

Information from solid-state ^{13}C NMR suggests an increase in hydroxyproline upon ageing. A more detailed discussion is given below.

HP28, topography

HP28, thermal conductivity at 70°C

Figure 3. HP28: left-hand side shows the topography of the surface and the right-hand side shows the corresponding thermal conductivity image

Thermomechanical measurements are also possible on localized areas of the sample. Figure 3 (left-hand side) shows the surface topography of sample HP28. The lighter areas represent the higher areas of the sample, the darker areas the lower areas. In micro-thermal analysis (μTA), the silicon or silicon nitride probes used in atomic force microscopy are replaced by a thermal probe capable of acting both as a temperature sensor and as a heater. With this arrangement thermomechanical analysis can be performed on a micron scale at selected locations marked by the numbers in Figure 3. The right-hand side of Figure 3 shows the thermal conductivity image: areas that are lighter are more conductive than the darker areas. Figure 4 provides the results of thermomechanical measurements on selected marked locations of the sample area (1, 3, 4 and 5). Locations 1 and 3 reveal transitions at temperatures seen in HP28 by DMTA whereas location 4 (highly thermal conducting) reveals no transition. The fact that transitions at the micro scale can be related to transitions at the macro scale (DMTA) provides the possibility of studying archival samples.

DMTA *creep*

Curves for NP7 and HP28 are shown in Figures 5 and 6 respectively. The graphs were plotted as per cent displacement (y-axis) against time (x-axis), with the temperature profile superimposed (y2-axis). The stepwise increase in temperature from 30°C to 85°C between 0 and 130 minutes can be seen in Figure 5. On initial immersion in water the displacement trace of unaged sample NP7 shows a slight blip, but there is little overall change in the sample dimensions. By comparison, historic parchment HP28 showed a 3% expansion in length (positive displacement) as water is absorbed during initial immersion, indicating that the sample had softened and could be stretched more readily once it has been wetted.

Figure 5 shows that there was no change in NP7 until a temperature of 65°C at which point the sample started to shrink rapidly. The main shrinkage (i.e. the largest single change in displacement) was complete at 70°C. The measurements were repeated five times and the same amount of shrinkage and temperature range over which shrinkage occurred were recorded. There was then a sharp decrease from 85°C to 18°C as the sample was removed from water. As surface water evaporates from the thermocouple and dries there is a return from 18°C to room temperature (24°C). Most of the shrinkage of NP7 was complete by 80°C. The sample was removed from the water at 85°C, at which point there was a significant partial recovery in sample dimension (10% expansion), although the final dry sample was still 18% shorter than in its original state. Furthermore, on completion of the experiment the rectangular piece of parchment was seen to have bowed (concave) edges, providing physical evidence that shrinkage had occurred.

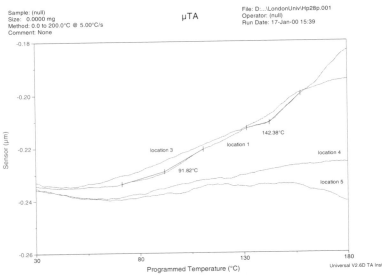

Figure 4. Local thermal analysis experiments (μTMA) at the locations indicated. At location 1 two transitions around 90°C and 140°C are detected with low thermal conductivity

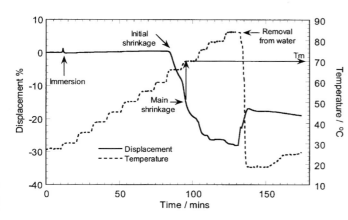

Figure 5. Per cent displacement on heating plotted as a function of time for unaged parchment NP7. Temperature is calculated as shown in (a)

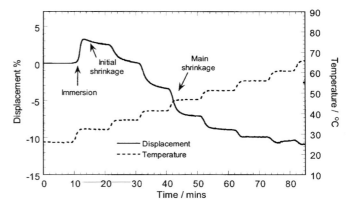

Figure 6. Per cent displacement on heating plotted as a function of time for naturally aged parchment HP28

At the other extreme, the aged sample HP28 (see Figure 6) showed signs of shrinkage immediately upon immersion in water at 30°C. The shrinkage steps were also much more even in magnitude and distributed over a wider temperature range than those seen in the unaged parchment, where most of the shrinkage occurred over a 10°C temperature interval.

From the data shown in the figures, the following parameters could be measured:

- *Per cent displacement change (expansion or contraction) on initial immersion in water:* enables determination of the extent of wetability of each parchment sample.
- *Temperature of initial shrinkage, T_i:* the temperature step at which the measured displacement begins to decrease.
- *Temperature of main shrinkage, T_m:* the temperature step during which the largest per cent shrinkage occurs.
- *Temperature range of shrinkage, (T_m-T_i):* the difference between the initial shrinkage temperature and the main shrinkage temperature (T_m-T_i). This range was used in preference to the whole shrinkage range since it was not possible to define accurately a final shrinkage temperature T_f. A larger temperature range T_m-T_i can be taken as an indicator of degraded collagen and thus a more aged parchment.
- *Main shrinkage (%):* the amount of shrinkage that occurs within 10°C (2 temperature steps) of the main shrinkage temperature.
- *Total shrinkage (%):* the total overall displacement change that occurs in the sample.
- *Amount (%) of shrinkage at T_m as a fraction of the total shrinkage (ratio, R):* R = Main shrinkage / Total shrinkage. In unaged parchment samples most of the shrinkage occurs within a narrow temperature region (i.e. at or close to T_m) and so this value will be high. In more aged samples the shrinkage is spread over a wider temperature range and this value will thus be lower.
- *Recovery on drying:* the displacement change on removal from water and drying in air.

The results of these measurements are summarized in Table 2 for the modern and historic parchment samples. As expected, the shrinkage ratio, R, is much higher for the modern parchment NP7 (0.67) than for historic parchment HP28 (0.47).

Table 2. Summary of displacement (%) on immersion in water and then (%) shrinkage on heating on drying

Parchment	Change on immersion	Temp. of initial shrinkage	Temp. of main shrinkage	T_m-T_i $\alpha(T)$	Main shrinkage	Total shrinkage	Shrinkage ratio	Recovery on drying
	%	T_i (C)	T_m (C)	C	%	%	R	%
NP7	-1.0	65	70	5	20	30	0.67	10
HP28	3.2	30	45	15	7	15*	0.47	×

Note: *approximate estimate as sample split towards end of experiment; actual value is therefore slightly higher

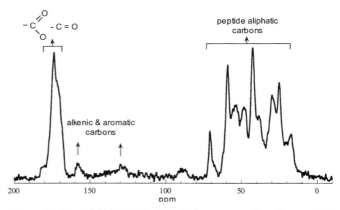

Figure 7. Typical ^{13}C NMR CPMAS spectrum of parchment NP7

Solid-state ^{13}C NMR

STANDARD MATERIAL: TYPICAL CPMAS SPECTRUM OF COLLAGEN

Figure 7 shows the ^{13}C CPMAS spectrum of a modern parchment NP7. Its features are similar to those of a rabbit–skin glue film (10% by weight) previously tested in our laboratory and also to published work on the canine Achilles tendon (see Fyfe 1983). The spectral peaks may be assigned to functional groups of the component amino acid residues (Fyfe 1983). The peak at 71 ppm was allocated to C-4 of hydroxyproline. Its neighbouring peak at 60 ppm contains contributions from the C-2 of both proline and hydroxyproline. The sharp peak at 43 ppm was attributed to the C-2 of glycine.

To enable comparison between spectra, peak fitting procedures were used to enable calculation of area ratios. This procedure is described in detail elsewhere (Larsen 2001). Calculation of the area ratios of the peaks at 60 and 71 ppm against sample type shows that NP7 has the highest ratio and HP28 the lowest. The numerator represents the state of the chemical environment of the C-2 of both proline and hydroxyproline and of the denominator, the chemical environment of the C-4 of hydroxyproline. NP7 represents the intact collagen state in the non-degraded parchment. A change or decrease in this ratio indicates a change in one or other or both components, i.e. a decrease in proline, an increase in hydroxyproline, or both. Similarly calculation of area ratios of the peaks at 43 and 71 ppm shows that NP7 has the highest ratio and HP28 the lowest. This again suggests an increase in levels of hydroxyproline which would account for the difference in mechanical behaviour of the samples.

Conclusions

Samples have been characterized according to their viscoelastic response and some evidence for gelatinatization has been found. DMTA creep mode measurements revealed a low shrinkage temperature for the aged parchment and sensitivity to water. The possibility of obtaining similar information at the micro level has also been demonstrated. Data obtained by the various techniques can be linked in the following way. NMR provided information on the amino and imino acid residues, and variations in their calculated ratios have been measured in unaged and naturally aged samples. These differences correspond with differences measured in glass transition temperatures by DMTA and in shrinkage behaviour, measured by DMTA in creep mode immersed in water.

Acknowledgements

We would like to thank Dr René Larsen (School of Conservation, Copenhagen, Denmark) for supplying the parchment samples and Johan Claeys (Royal Institute for Cultural Heritage, Laboratory for Materials and Techniques, Brussels, Belgium) for preparing the cross-section for micro-thermal analysis. This work was supported by the European Commission (Standards, Measurement and Testing SMT4-CT94-0514). We would also like to thank Dr R Ibbett (ACORDIS Textiles) for assistance with funding the modification of the DMTA.

References

Cassar, M, Robbins, G V, Fletton, R A and Alstin, A, 1983, 'Organic components in historical non-metallic seals identified using C-13 NMR spectroscopy', *Nature*, 303, 238–239.

Chahine, C, 2000, 'Changes in hydrothermal stability of leather and parchment: a DSC study', *Thermochimica Acta*, 365(1–2), 101–111.

Foster, G M, Ibbett, R and Odlyha, M, 1997, *Internal Report*, Birkbeck College, London and Courtaulds Textiles, Coventry, UK.

Fraga, A N and Williams, R J J, 1985, 'Thermal properties of gelatin films', *Polymer* 26, 113–118.

Fyfe, A C, 1983, *Solid-state NMR for Chemists*, Guelph, Canada, CFC Press.

Harris, R K, 1993, *Chemistry in Britain*, 601–604.

Larsen, R, 2000, 'Experiments and observations in the study of environmental impact on historical vegetable tanned leathers', *Thermochimica Acta*, 365(1–2), 85–101.

Larsen, R (ed.), in press, *Micromethods for the Analysis of Parchments*, EU Standards Measurement and Testing SMT4-CT96-2106, School of Conservation, Copenhagen.

Odlyha, M, 1998, *Characterisation of Cultural Materials by Measurement of their Physicochemical Properties*, PhD thesis, Birkbeck College.

Odlyha, M, Foster, G M, Cohen, N S and Larsen, R, 1999, 'Evaluation of deterioration effects in leather samples by monitoring their drying profiles and changes in their moisture content', in J Bridgland (ed.), *Preprints of the 12th Triennial Meeting of the ICOM Conservation Committee*, Lyon, International Council on Museums, vol 2, 702–708.

Ramachandran, G N and Reddi, A H, 1976, *Biochemistry of Collagen*, New York, Plenum Press, 1–40.

Wess, T J and Orgel, J P, 2000, 'Changes in collagen structure: drying, dehydrothermal treatment and relation to long term deterioration', *Thermochimica Acta*, 365(1–2), 119–129.

Wouter, J, Claeys, J, Lamens, K and van Bos, M, in press, 'Evaluation of methods for the micro-analysis of materials added to parchment', in Larsen, R (ed.), *Micro Analysis of Parchment*, MAP project, School of Conservation, Copenhagen.

Leafcasting parchment documents degraded by mould

Abstract

This article discusses the treatment of heavily mould-degraded parchment documents. One possible conservation treatment is to leafcast the parchment. Two special techniques are described in detail and compared. A technique introduced by Wouters is followed by a method applied by Giovannini. The characteristics of these two leafcasting methods in terms of surface texture, shrinkage and tension behaviour and applicability when confronted with the above-described type of objects are compared. Some critical effects are described and a case study is given.

Keywords

parchment, mould, leafcasting, suction table, Hide Powder, liquid fill preparation, strengthening, filling

Andrea Pataki★
Staatliche Akademie der Bildenden Künste Stuttgart
Höhenstrasse 16
70736 Fellbach, Germany
Fax:+ 49 711 586453
E-mail: andrea.pataki@sabk.de

Kerstin Forstmeyer
Institut für Erhaltung von Archiv- und Bibliotheksgut
Schillerplatz 11
71638 Ludwigsburg, Germany
Fax:+ 49 7141 186699
E-mail: kerstin.forstmeyer@acormail.de

Andrea Giovannini
Via Mescolcina 1
6500 Bellinzona, Switzerland
E-mail: giovannini@adhoc.ch

Introduction

Of the great variety of conservation treatments available for parchment, leafcasting has been used for several years. Wouters (2000, 78–81) gives a detailed chronological overview of the existing and newly developed methods of filling losses in parchment objects. Through the continuous optimization of these various conservation methods, a diversity of treatments is available. The conservator can choose a parchment fill material either of milled parchment, of derivates of protein fibres, or a mixture of protein and cellulose fibres. Cellulose ethers, animal glues or other binding agents are available as additives (Wouters 2000, 84).

We present here two different methods of leafcasting parchment which have been used repeatedly in our respective laboratories with good success. The two leafcasting techniques can both be used in the treatment of one particular type of damage, namely losses of heavily mould-degraded parchment documents. We describe both methods and provide a comparative evaluation of the treatment results achieved using them.

The first method of leafcasting parchment to be discussed was developed by Wouters, Peckstadt and Watteeuw (Wouters et al. 1992, 67–77, Wouters et al. 1995, 5–22). The second was introduced by Giovannini and drawn from a recipe by Beöthy-Kozocsa et al. (1990, 113). Giovannini adapted this method for his particular needs using those materials available to him. Following our discussion of the treatment techniques, we then present a case study.

Description of the two leafcasting methods

The first method, developed by Wouters, Peckstadt and Watteeuw, will be referred to here as 'reconstituted parchment'. This is a new term. The technique by Giovannini will be described as liquid fill preparation.

Reconstituted parchment

Several years ago, during the conservation project of the Codex Eyckensis, an 8th-century parchment manuscript, a new method for leafcasting parchment was developed to fill the extensive losses of the parchment pages (Peckstadt et al. 1996, 541). Treatment entails the following. First 'Hide Powder', a dry powder of protein fibres, is swollen in water and beaten in a special blender with a cooling

★Author to whom correspondence should be addressed

device. It is then treated with formaldehyde[1] to increase bonding between the protein fibres, which results in a higher opacity of the formed sheet of the proteinaceous layer – the so-called reconstituted parchment. During the preparation procedure methylhydroxyethylcellulose (Tylose®) is added as a dispersion aid and calcium carbonate, precipited, also added to further enhance the opacity of the reconstituted parchment. This watery suspension is applied using a dropper bottle with slight overlap along the edges of the loss. The parchment, relaxed in a Gore-Tex® sandwich prior to leafcasting, is placed on a suction table to flush the liquid of the suspension and consolidate the reconstituted parchment layer. After drying under a slight weight, encouraged by exchanging the blotters several times, the leafcasting is complete.

Note that Wouters' reconstituted parchment can be prepared according to two different recipes, producing either an opaque or a translucent reconstituted parchment. Here we discuss the former, opaque, reconstituted parchment.

Liquid fill preparation

In adapting a recipe from Beöthy-Kozocsa et al. (1990, 113), Giovannini developed a method of leafcasting parchment that presents both as an alternative and a supplement to Wouters' method. The method is as yet unpublished. At the Budapest University Library the idea of leafcasting was pursued when conservators were faced with the task of treating a collection of 15th-century manuscripts that were heavily damaged by mould. The result of this project was the development of a leafcasting suspension consisting of milled limed leather, different Japanese fibres, a cellulose ether (Tylose®), alcohols and parchment glue. Three different methods of creating a fill were developed, the suspension could be applied to the loss on a suction table, a fill could be prefabricated by leafcasting it with the aid of a template and bonding it to the loss-edges in a damp condition or the prefabricated fill could be allowed to dry and is then glued to the loss (Beöthy-Kozocsa et al. 1990, 113–114). Giovannini changed the components by replacing the limed leather with milled genuine parchment, the parchment size with isinglass and the Japanese fibres with rag paper fibres.[2] He keeps the suspension in small dropper bottles and applies it in small drops to the parchment loss while it rests on a suction table. As for Wouters' treatment, the parchment object is kept in a relaxed or even humidified condition by spraying it beforehand with a water/alcohol solution.

Characteristics of the leafcasting materials: their possibilities and limitations

Purity and ease of preparation

Although Wouters' system is very pure, consisting only of protein fibres plus a dispersing aid (0.3% Tylose®) and an additive similar to a filler (0.28% calcium carbonate), the preparation procedure demands a complex range of laboratory tools and devices and takes up considerable time. In comparison the liquid fill preparation is easier to produce, but contains several constituents with diverse characteristics and ageing properties. Wouters' main aims behind the limited use of materials for suspension are to keep the procedure as close as possible to the original parchment, i.e. to use only protein fibres, and to keep the procedure as simple as possible when looking at the ageing properties of the reconstituted parchment. Therefore, he uses only one main component, i.e. protein fibres, for parchment to treat. Other additives may always alter the ageing properties.

Working technique

The leafcasting procedure for both techniques is similar. In either case, the parchment is relaxed in a Gore-Tex® sandwich or is lightly dampened by spraying it with a water/alcohol solution before placing it on a suction table. A suction table surfaced with a porous, translucent polyethylen plate with a transmitted light source is most convenient for observing the building-up process of the filling material. As supporting material a sheet of Hollytex® with a very close and dense structure is

Figure 1. One-layer application of the liquid fill preparation (left) and reconstituted parchment (right); the transmitted light helps to distinguish between the cloudy and open impression on the left side and the smooth and homogenous impression on the right side

Figure 2. The raked light helps to distinguish between the fibrous and paper-like surface texture on the left side (liquid fill preparation) and the dense and smooth surface texture on the right side (reconstituted parchment)

recommended. Bondina® or Reemay® for example are not applicable as a supporting material because the porosity of the non-woven material prevents easy detachment of the reconstituted parchment. Very fine screens such as Scrynel® will not work here either.

An aspect which has not yet been discussed concerns working procedures. Wouters et al. (1995, 17) apply the fill in the region of the loss plus the area of the overlap. This demarcation of the working area is achieved using a Melinex® template cut in the size of the loss plus 3–5 mm for the overlap. The template is placed beneath the parchment object and creates a suction only in the area of the loss and its borders. Other parts of the object are not fixed on the suction table by means of suction. The application is suitable for single located losses.

Giovannini places the parchment object on the suction table without a template and applies the liquid fill preparation on the loss area. Since no area is masked off, he is able to fill individual located losses but also to apply thin layers of fill preparation as a kind of a coating not dependent on the area of loss. This technique may be described as an 'overleafcasting' and is suitable for a fragile or a perforated parchment.

Surface texture

The reconstituted parchment has a very homogeneous and smooth texture but is also slightly napped like a genuine pumiced parchment (see Figure 1). It reacts to changing relative humidity by slightly expanding or shrinking when incorporated as a filling material.

The liquid fill preparation has quite a different surface texture because of the presence of cellulose fibres. The surface is more fluffy with visible fibrous veins and has a more open character (see Figure 2).

The reconstituted parchment consists of protein fibres solely and some additives in comparison to the liquid fill preparation, which consists of protein and paper fibres and relatively high amounts of binding agents. The paper fibres in the liquid fill preparation act as a filler that determines and distinguishes the mechanical properties of both leafcast infills. The shrinkage and the tension behaviour as well as the tensile and tearing resistance of the dried suspension are affected due to the different ingredients. These differences also affect the possible thickness that may be achieved and the strengthening ability.

Shrinkage and tension behaviour

Based upon earlier investigations by Wouters et al. (1995, 10), the reconstituted parchment fill may shrink much as approximately 5% after drying. This has to be kept in mind when choosing this method for the treatment of fragile objects sensitive to any form of tension. The fill material applied with an overlap to the original may shrink significantly, resulting in a break at the contact zone between the overlapping reconstituted parchment margins and (a probably fragile) original parchment. This tension ability is due also to the dense and compact character of the reconstituted parchment which consists exclusively of protein fibres.

Through empirical observation it became clear that shrinkage is less with the liquid fill preparation. The presence of the paper fibres as filler is the reason for this. Again, the paper fibres influence the sheet formation and create a more open fill material with less tension.

To create as low a tension as possible it is advisable after leafcasting to place filter paper after the leafcasting on the object to further reduce the moisture and to realize a uniform drying process.

Tensile and tear resistance

Schrempf (2001, 198) carried out a whole range of tests by means of analytical instruments and measurements to compare the different leafcasting methods. He compared the two above-described methods and observed a relatively higher tensile and tearing strength for the reconstituted parchment. Results of his tests confirm visual observations and tension behaviour.

Figure 3. Parchment document under transmitted light [State Archive Stuttgart, U 44 2408]; the document is heavily degraded by mould resulting in perforation and losses throughout the parchment and staining

Figure 4. Detail of a heavily mould-degraded parchment; the right side is fibrous without any bonding between the protein fibres

Figure 5. Detail of the degraded parchment document [State Archive Stuttgart, U 44 2408] after leafcasting; lower left corner, verso, losses and staining are visible

Thickness and strengthening characteristics

The thickness of the reconstituted parchment can be calculated and reproduced exactly because of the very precise calculation system (Wouters et al. 1995, 14). The thicknesses range from approximately 0.06 mm (a one-layer application of the suspension) to approximately 0.25 mm. The liquid infill preparation creates thicknesses ranging from approximately 0.1 mm (a one-layer application of suspension) to approximately 0.2 mm. Although the given numbers seem comparable, it is easier to build up a 0.2-mm sheet of reconstituted parchment than to do so using liquid fill preparation. This is because of the dense character of the Wouters' suspension. The liquid fill preparation is more suitable for leafcasting areas of scattered losses with lower thicknesses due to the inclusion of paper fibres. This aspect has proven useful for such tasks as the overall stabilization of a weakened parchment.

Water removal during treatment

Because of the very dense character of the suspension of the reconstituted parchment, a suction table with a high air-flow is needed to keep the moisture exposed to the parchment for as short a time as possible. The thicker the desired layer, the longer the time treatment on the suction table. In practice this means that a loss of approximately 5.5 cm x 5.5 cm with a thickness of 0.2 mm is more or less the maximum size of a fill. The time factor seems an important consideration because the collageneous substrate generally changes its mechanical properties spontaneously. The parchment swells and contracts upon direct contact with water in an uncontrolled way. The less dense suspension of the liquid fill preparation means time on the suction table is shorter as the liquid is flushed away faster.

Case study and discussion

The State Archive in Stuttgart owns a collection of 16th-century folded parchment documents (the 'Urfehden', U 44) that previously had been stored in a damp location and subsequently damaged by mould. Due to the folded condition, the mould-degraded areas of parchment lie adjacent to each other, creating mirror images throughout the sheets. The parchment is colourfully stained ranging from reddish and greenish to greyish tonality.

A healthy parchment consists of tensious layers of protein fibres that form a very dense, taut and compact parchment. Parchment degraded by mould is often perforated with very small losses that are closely scattered and surrounded by extremely degraded areas as in the case study (see Figure 3). Unless the entire sheet is uniformly damaged, degraded areas are located directly adjacent to areas that are in much better condition.

The surface texture of the damaged parchments is open, short-fibred and comparable to paper (see Figure 4). Often, these objects should only handled with an overall support.

A common practice when treating such objects is to line them on the verso with thin Japanese paper. This is a very speedy, and in many cases satisfactory, treatment. However, from a mechanical and aesthetic point of view, there are alternatives. The parchment may be stiffened using a film of adhesive and a layer of paper. Leafcasting in this situation takes into consideration the addition of a strengthening material similar in material and texture to the original.

The parchment document serving as a case study (Figure 5) was humidified in a Gore-Tex® sandwich and placed on a suction table. It was leafcast using Giovannini's liquid fill preparation without a Melinex® template. The losses were filled with the suspension, and as well, the heavily degraded areas were coated with a layer of the suspension. After leafcasting, but while still on the suction table layers of filter paper were placed over the entire object to further reduce the existing moisture. After 20 minutes of blotting the object was placed between blotters and boards under light weight. The blotters were exchanged three times in the first two hours. The sandwich was then left to dry for several days.

Figure 6. Detail of the degraded parchment document [State Archive Stuttgart, U 44 2408] after leafcasting; lower left corner, verso, partially leafcast with the liquid fill preparation

Figure 7. Detail of the degraded parchment document [State Archive Stuttgart, U 44 2408]; verso, the right side is 'overleafcast' with the liquid fill preparation coating the degraded area; the fibrous texture matches the original texture at the left side

The parchment gained mechanical stability after the leafcasting and can now be handled again (see Figure 6). Unfortunately, the colour impression changed slightly, one of the drawbacks of leafcasting mould-degraded parchment.

Effects of leafcasting mould-degraded parchment

Working technique

When placing an object without a Melinex® template on a suction table, the suspension liquid can migrate under the object as a result of the air-flow of the suction. This means that the suspension liquid is not restricted to an isolated area of loss. In this case however we are dealing with a more overall treatment in comparison to use of a Melinex® template for a single loss. Mould-degraded parchment documents often need this kind of surface treatment as well as fill of losses because of the porous and overall destabilization of the parchment.

Surface texture

The different surface textures of the reconstituted parchment and the liquid fill preparation are described above. The liquid fill preparation is more suitable than the reconstituted parchment as its surface is very similar to the surface of a mould-degraded parchment (see Figure 7). In both cases the surface is open, fibrous and fluffy.

Change of colour impression

A parchment which is heavily degraded by mould has a distinctive open and fluffy surface structure. The degraded parchment fibres are not held any more within the parchment but are slightly loose and detached from their formerly strong bonding. After treatment with the liquid, the surface is compressed and smoother, therefore the colour impression shifts to slightly darker tones. This must be taken into account when treating mould-damaged parchments aqueously on the suction table.

Migration of water-soluble components

Some of the coloured components of mould stains are water-soluble and are able to migrate during leafcasting. The object undergoing treatment should be sprayed from time to time and blotted using filter paper to absorb these fugitive substances.

Additional variation and outlook

The surface texture of the reconstituted parchment seems less compatible than the liquid fill preparation for heavily mould-degraded parchments. To change the very smooth surface and to lower the tension behaviour it is possible to add some cellulose fibres which act as a filler. To do so mix 200 ml translucent suspension from the reconstituted parchment with 0.5 g eucalyptus fibres swollen in 100 ml water to create a similar suspension. No additives are needed to leafcast this variation of the reconstituted parchment.

Although the mixture has been applied already on an object, further tests and observations needed to be performed.

Conclusion

The treatment of parchment documents degraded by mould is tricky. The parchment is generally very fragile, with perforations and scattered losses. Genuine parchment is often adjacent to degraded areas. One solution is to leafcast such objects. Two methods of leafcasting were presented here, both of which seem to be suitable in such cases. With respect to surface texture, shrinkage and tension of the leafcast sheet, the liquid fill preparation seems the better alternative. The reconstituted parchment may show higher tensions that need to be considered before using the method. However, this restriction can be overcome by addition of cellulose fibres to the suspension.

The drawbacks with leafcasting are that the infill may create tensions, the colour impression of the parchment may be altered after treatment and water-soluble components are liable to migrate during the process. Having these aspects in mind it is important that the conservator treating these objects is familiar with the leafcasting procedures and have some experience in this field.

Acknowledgement

For fruitful discussions and editing of the text we would like to thank Prof. Irene Brückle, Buffalo, and Prof. Dr Gerhard Banik, Stuttgart.

Notes

1 After swelling and blending the suspension, 40 ml formaldehyde (opaque reconstituted parchment) is added for 1000 ml preparation suspension. After 24 hours the suspension is rinsed to wash out the surplus formaldehyde. The formaldehyde can be described as a tanning agent that creates bonding between the protein fibres which results in a higher opacity of the reconstituted parchment.

2 Recipe from Giovannini for leafcasting parchment. Take 4 g rag paper fibres, 4 g milled parchment, 400 ml demineralized water, mix the ingredients and let them swell for 24 hours. Mix in a blender with a cooling device five times for 10 seconds (if such a blender is not available, place the containers for mixing to cool in a freezer), add 150 ml ethanol and 50 ml 2-propanol and 20 ml Tylose® (5% in demineralized water). Finally, slowly add 20 ml isinglass (app 20%), warmed up, and leave the mixture for 24 hours in the refrigerator before mixing again in a blender for 2 seconds. The mixture is supposed to be uniform, without any lumps. If this state is not reached, blend again or add some water.

References

Beöthy-Kozocsa, I, Sipos-Richter, T and Szlabey, G, 1990, 'Parchment codex restoration using parchment and cellulose fibre pulp', *Restaurator*, 11, 95–109.

Peckstadt, A, Watteeuw, L and Wouters, J, 1996, 'The conservation of parchment manuscripts: two case studies', in Bridgland, J (ed.) *Preprints of the 11th Triennal Meeting of the ICOM Conservation Committee*, Edinburgh, International Council of Museums, 539–544.

Schrempf, J, 2001, 'Anfasern von Pergament', *Kölner Beiträge zur Restaurierung und Konservierung von Kunst- und Kulturgut*, 12, 157–224.

Wouters, J, 2000, 'The repair of parchment: filling', *Reviews in Conservation*, 1, 77–86.

Wouters, J, Peckstadt, A and Watteeuw, L, 1995, 'Leafcasting with dermal tissue preparations: a new method for repairing fragile parchment and its application to the Codex Eyckensis', *The Paper Conservator*, 19, 5–22.

Wouters, J, Gancedo, G, Peckstadt, A and Watteeuw, L, 1992, 'The conservation of the Codex Eyckensis: the evolution of the project and the assessment of materials and adhesives for the repair of parchment', *The Paper Conservator*, 16, 67–77.

Materials

The materials and description for the preparation of the reconstituted parchment can be found in Wouters et al. (1995, 5–22).

The materials for the liquid filled preparation may be obtained from Andrea Giovannini.

Several non-woven supporting tissues: Hollytex®, Anton Glaser, Theodor Heusstrasse 34, 70174 Stuttgart, Germany, Artikel Nr: 3265; Polyestervlies, Gaby Kleindorfer, Asterstrasse 8, 84186 Vilsheim, Artikel Nr: 37265; Freudenberg Vliesstoffe KG, Filter Division, 69465 Weinheim, Artikel Nr: 2413, Viledon (Polyester); Suction table, Belo Restaurierungsgeräte, Ernst-Häußlerstrasse 16, 79585 Steinen, Germany

Abstract

It is well known that paper is not stable in time. There are several causes of paper decay, but acidification is by far the main reason. In general the pH is used to express paper acidity. The determination of the pH of paper, a solid material, is a difficult task. Several methods exist, nine of which were evaluated in this study. All methods are destructive and can cause serious damage to the paper investigated. To limit the damage a micro-extraction method was developed that only requires about 40 µg paper for one pH measurement.

A different way to express the acidity of a paper sample is the alkaline reserve, a parameter that is often used when analyzing paper with a pH higher than seven. Its determination is quite time- and product-consuming and labour-intensive. This work tested if the pH can be an indicator for the alkaline reserve.

Keywords

acidity/pH of paper, comparison of pH determining methods, micro-destructive sampling, alkali reserve

The acidity of paper. Evaluation of methods to measure the pH of paper samples

Steven Saverwyns★, Valérie Sizaire and Jan Wouters
Royal Institute for Cultural Heritage
Jubelpark 1
B-1000 Brussels
Belgium
Fax: + 32 (0)2 732 01 05
E-mail: steven.saverwyns@kikirpa.be, valerie.sizaire@kikirpa.be, jan.wouters@kikirpa.be
Web site: www.kikirpa.be

Introduction

Of all writing and drawing materials that people have employed down the ages, like waxed boards, leaves, bronze, silk, and clay tablets, paper is the most widely used around the world and has become one of the most important bearers of our history and culture.

Unfortunately, as with organic materials in general, paper is susceptible to several decay processes that may lead to irreversible losses in relatively short times (McCrady 1996, Havermans 1997, Bégin 1999, Bukovsky 2000). One of the most important factors that accelerate the decay of paper is acidity, usually expressed by the pH of an aqueous extract of the paper. Acidic papers yield extracts with a low pH, and hence with a high proton concentration. Those papers can become brittle and, in some extreme cases, pulverize. At the molecular level this means that the long cellulose chains present in a strong or 'healthy' paper, are broken down by hydrolysis in the presence of water bound to the paper (Whitmore 1994, El-Saied 1998, Neevel 1999, Dupont 2000). The speed of this hydrolytic reaction increases significantly when the proton concentration in the molecular environment of cellulose is high.

By definition, the pH is measured in solutions, making the pH determination of paper, a solid material, a difficult task. In most cases this problem is dealt with by taking a certain amount of paper and adding water, so that a fixed ratio paper/water is obtained, followed by measuring the pH of the aqueous extract. To assure that the pH values found are reproducible, the procedure of taking the sample and measuring the pH is described in standards. Unfortunately for the conservation community, these standards stem from the paper industry, requiring between 1 and 2 grams of paper. Besides the methods described in standards other possibilities exist to determine the pH of paper, and many of those are frequently used by conservators.

The goal of this research was to compare existing methods for the pH determination of paper, and to develop a micro-destructive method allowing conservators to use an extraction technique warranting accurate pH readings.

Materials and methods

pH determination tests

Nine different methods for the determination of the pH of paper were evaluated: two cold extractions, two hot extractions, four different indicators (Abbey pen, pHydrion pencil, bleeding and non-bleeding indicator paper) and a surface electrode.

EXTRACTIONS
Two standards, ISO 6588 (1981) and ASTM D 778 (1998), both describing a hot and a cold extraction, were examined.

For the ISO cold extraction 2 g of paper is cut in pieces with maximum dimensions of 0.5 x 0.5 cm. 100 mL distilled water is added and the mixture is left to stand for one hour, but should at least be shaken once. The pH is measured in the extract, after removal of the paper shred, using a conventional pH electrode (in this work: Hamilton Minitrode).

★Author to whom correspondence should be addressed

The ISO hot extraction is analogous to the cold extraction except that the extraction is performed using boiling distilled water. After rapid cooling of the extract, and removal of the shred, the pH is measured.

The ASTM cold extraction method consists of the extraction of a 1 g test specimen in 70 mL of cold distilled water (25 ±5°C) for one hour, and determination of pH without filtration using a commercial pH meter.

The same procedure is followed for the ASTM hot extraction except that the test specimen is boiled for one hour. After cooling down of the extract the pH is measured. For both the ASTM methods, pure N_2 was passed through the solutions until the pH is measured to prevent absorption of CO_2.

INDICATORS

All indicator tests are based on the development of pH-dependent hues and a scale of reference colours. The simplest example is the Abbey pen. A line is drawn on a dry paper. If the line colours yellow, the paper is acidic (or has a pH below 7); if the colour remains purple, the paper is neutral or alkaline. The other indicator tests allow determination of a pH value, rather than indicate if a paper is acidic or not. For the bleeding and non-bleeding indicator strips as well as for the pHydrion pencil the paper needs to be wetted, which can leave stains on the paper. Also the indicators themselves leave stains, with the exception of the non-bleeding ones.

SURFACE ELECTRODE

This test was performed according to the Tappi 'T 529 om-99' standard (1999): a flat combination electrode is immersed in a drop of water on the surface of the paper sample. The paper sample is backed with a non-absorbing, resilient material such as gum rubber. After about ten minutes' immersion time the pH can be read on the pH meter.

Preparation of test papers

Before the different methods can be tested on their accuracy, and compared to each other, papers with known pH are necessary. The easiest way to obtain such papers is to treat neutral papers with buffers with known pH. For the preparation of acidic and neutral papers citric acid was used, for alkaline papers trishydroxymethylaminomethane (or 'tris'), both in a concentration of 250 mmol/L. The pH of the buffers was adjusted to the desired value with a sodium hydroxide solution. Pure cellulose paper (Whatman, chromatography paper 1 CHR, 25 x 25 cm) was used. A sheet was placed in a small tank and the buffer was added. The tank was shaken gently, and after five minutes the paper was removed. It was placed between two Hollytex sheets and left to dry for 24 hours. The first hour it was turned over every 15 minutes to prevent migration of the buffer.

During any extraction step the pH will change as a consequence of dilution. The factor of dilution must be taken into account to correct expected pH readings and to make proper evaluations of accuracy. This factor was determined using neutral Whatman paper treated with a phosphate solution according to the buffering procedure previously described. This was followed by an extraction as described in the ISO standard. With the aid of an absorbance spectrophotometer the phosphate concentration was determined in the original phosphate solution and in the extract. From these results the dilution factor was calculated to be 30. This implies that the pH of the paper extracts needs to be compared with the pH of the 30-fold diluted buffer solutions.

Refinement of the Tappi 'T 529 om-99' standard

The Tappi 'T 529 om-99' standard does not describe how much water needs to be added to the paper before the surface electrode is placed on the paper, nor are the dimensions of the paper sample mentioned. Moreover, the diffusion of the water cannot be accounted for. However, it seemed reasonable to us to measure surface pHs at known paper/liquid ratios. To this end surface pHs were measured on cut paper samples (buffered at pH 3.64) of known dimensions (either 1.1 x 1.1 cm or 2.3 x 2.3 cm) and using 50 µL of water in each case. pH readings differed significantly and only in the

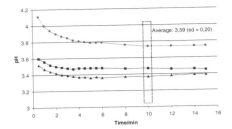

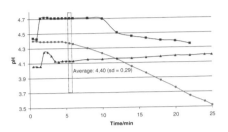

Figure 1. pH measurements with a surface electrode. pH readings as a function of time for a buffered paper with dimensions of 1.1 x 1.1 cm (a) and 2.3 x 2.3 cm (b). The rectangle selects readings used for calculations of means and deviations.

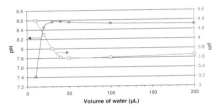

Figure 2. pH measurements with a surface electrode. pH readings as a function of the volume of water added to the paper for an alkaline (×) and an acidic (□) paper.

case of the smaller samples were accurate pH-values found (see Figure 1a and b). The higher pH for the larger sample can be explained by the fact that the pH-determining components are highly water soluble, and that the papers easily absorb the water. This results in a migration of the buffer components to the edges of the paper sample. When the paper sample exceeds the dimensions of the electrode surface, the buffer concentration underneath the electrode will be lower than expected, and in the case of acidic papers a higher pH will be found.

The amount of water added also influenced the pH measured. This is illustrated in Figure 2. When only 10 or 20 µL of water was added to a paper sample (dimensions 1.1 x 1.1 cm), too high or too low a pH was found, for an acidic or an alkaline paper respectively. Volumes larger than 50 µL on the other hand resulted in small deviations, probably due to dilution effects. From these results it was concluded that a volume of 40 µL is desired to obtain accurate pH values.

These results indicate that small alterations to the Tappi standard are advisable. According to the dimensions of the paper sample, or the volume of the water droplet, in practice the paper wettability, results can vary widely.

Results and discussion

Comparative studies

ACCURACY TESTS WITH REFERENCE PAPERS

To test the accuracy of the different pH methods previously described, papers (coded W1, W2, W3 and W4) buffered at 4 different pH values were used: 3.40, 4.94, 6.48 and 8.50 respectively. These pH values were corrected for dilutions as described in 'Materials and methods' (above). From Table 1 it is clear that all extraction methods lead to accurate pH values. Results found with the surface electrode must be compared with the pH values of the non-diluted buffers since in this case almost no dilution effects occur when measuring the pH. Therefore we must conclude that also with the surface electrode acceptable results are obtained (when measured under controlled conditions of paper dimensions and volume of water added). Also the pH values of the indicators need to be compared to the values of the non-diluted buffer solutions. Predictions with the Abbey pen were correct, but offer very limited information concerning the true pH. The pH values found with the pHydrion pencil and with the indicator papers can in some cases diverge from the buffer pH with more than 0.5 pH unit, illustrating that these tests are not very accurate and only lead to a rough estimation of the pH. Besides this, the interpretation of the colour of the indicators is liable to errors. These results agree with earlier studies (Brandis 1993).

In general it can be concluded that only the extraction techniques and the surface electrode lead in all cases to accurate results. The errors on the measurements, which are a measure of the precision, are significantly higher with the surface electrode as compared to extracts. Therefore extraction techniques should be preferred.

TESTS WITH AGED PAPERS

Once the accuracy and the precision of the different methods were established using the buffered papers, some natural and artificially aged papers were also analyzed (see Table 2). No conclusions concerning the accuracy could be drawn (since the 'true' pH values are not known). When we focus on the extraction techniques, it is clear that for the acidic papers in almost all cases the hot extractions cause lower pH values than the cold extractions, and higher pH values for alkaline

Table 1. pH-values obtained with the different methods for buffered papers with known pH. The standard deviation (calculated for n = 2 measurements) is given in brackets

Paper code[*]	pH buffer	pH[**] expected	Extractions				Surface-electrode	Indicators			
			ISO		ASTM			Abbey	pHydrion	Non-bleeding	Bleeding
			Cold	Hot	Cold	Hot					
W 1	3.40	3.64	3.65 (0.01)	3.65 (0.00)	3.67 (0,00)	3.67 (0,01)	3.59 (0,20)	< 7	3	3.6	3 – 3.5
W 2	4.94	5.46	5.46 (0.00)	5.46 (0.01)	5.46 (0.01)	5.51 (0.01)	4.98 (0.16)	< 7	3 – 4	5.5	5.5
W 3	6.48	7.04	7.06 (0.01)	7.06 (0.01)	7.08 (0.01)	7.12 (0.01)	6.27 (0.06)	> 7	6	6.8	6.5 – 7
W 4	8.50	8.42	8.46 (0.01)	8.46 (0.03)	8.46 (0.00)	8.43 (0.00)	8.35 (0.06)	> 7	9	8.7	9

[*] 'W' indicates Whatman paper
[**] pH of the 30-fold diluted buffer solution

Table 2. pH-values obtained with the different methods for aged papers. The standard deviation (calculated for n = 2 measurements) is given in brackets

Paper code#	Extractions				Surface-electrode	Indicators			
	ISO		ASTM			Abbey	PHydrion Non-bleeding		Bleeding
	Cold	Hot	Cold	Hot					
B1927	4.20 (0.05)	3.98 (0.01)	4.20 (0.01)	4.07 (0.02)	3.47 (0.06)	< 7	3	3 – 4	4.5
B1929	3.94 (0.02)	3.87 (0.04)	3.90 (0.01)	3.93 (0.06)	3.27 (0.05)	< 7	2 – 3	4.5	4 – 4.5
B1932	4.14 (0.00)	4.08 (0.03)	4.11 (0.02)	4.09 (0.09)	3.87 (0.11)	< 7	3	3.5 – 4	4
B1955	4.14 (0.01)	3.97 (0.01)	4.17 (0.01)	4.05 (0.00)	3.62 (0.09)	< 7	2 – 3	4	4
B1966	4.34 (0.03)	3.96 (0.01)	4.42 (0.01)	4.09 (0.02)	3.78 (0.02)	< 7	3 – 4	4 – 4.4	3.5 – 4
B1966 EQ	6.73 (0.01)	5.86 (0.04)	6.77 (0.07)	6.01 (0.06)	6.63 (0.16)	< 7	5 – 6	5	6
NP1947	5.91 (0.20)	5.58 (0.04)	5.96 (0.04)	5.50 (0.14)	5.40 (0.14)	< 7	3	5	5
NP1957	3.93 (–)	3.68 (–)	3.77 (–)	3.77 (–)	3.24 (0.07)	< 7	3 – 4	3 – 4	3.5 – 4
A1	4.54 (0.01)	4.23 (0.01)	4.73 (0.01)	4.26 (0.00)	3.92 (0.02)	< 7	3 – 4	4	5
A2	4.30 (0.01)	4.00 (0.01)	4.42 (0.01)	4.04 (0.01)	3.56 (0.05)	< 7	3	4.4	5
A3	5.45 (0.03)	5.05 (0.03)	5.42 (0.07)	5.07 (0.03)	4.77 (0.01)	< 7	4 – 5	5	5.5
AL	9.05 (0.04)	9.76 (0.17)	9.55 (0.04)	9.69 (0.01)	7.98 (0.17)	> 7	5	6.5	6 - 6.5

'B' indicates a book, 'NP' a newspaper, 'A' an artificially aged paper and 'AL' an alkaline paper. The number indicates the year of print (except for the papers indicated A1, A2 and A3)

Table 3. Comparison of pH-values obtained with the classic cold extraction method and with the new miniaturized extraction method. The standard deviation is mentioned in brackets (n = 2, except for NP1957, where n = 1)

Paper code	Classic extraction	Micro extraction
W1	3.65 (0.01)	3.68 (0.01)
W2	5.46 (0.01)	5.43 (0.04)
W3	7.06 (0.01)	6.98 (0.05)
W4	8.46 (0.01)	8.26 (0.08)
B1927	4.20 (0.05)	4.18 (0.07)
B1929	3.94 (0.02)	3.74 (0.06)
B1932	4.14 (0.00)	4.03 (0.05)
B1955	4.14 (0.01)	4.15 (0.18)
B1966	4.34 (0.00)	4.46 (0.02)
B1966EQ	6.73 (0.01)	6.68 (0.05)
NP1947	5.91 (0.20)	5.32 (0.21)
NP1957	3.93 (–)	3.87 (–)
A1	4.54 (0.01)	4.71 (0.06)
A2	4.30 (0.01)	4.71 (0.13)
A3	5.45 (0.03)	5.67 (0.02)
AL	9.05 (0.04)	7.77 (0.02)

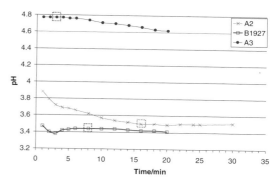

Figure 3. Stabilization curves, showing the change in pH as a function of time, of some selected aged papers, when measuring with the surface electrode. The squares indicate the best moment for pH readings.

papers. The reason is the more efficient extraction of pH-determining compounds in the case of hot extractions. Differences between the cold extractions as a group and between the hot extractions as a group are acceptable. The difference of 0.5 pH unit between the cold extractions for the alkaline paper can be attributed to the absorbance of CO_2, leading to a lower pH value, when the extract is not flushed with N_2, as is the case when using the ISO standard.

pH values obtained with the surface electrode are always lower than the values of the cold extraction, again ascribed to the fact that little dilution occurs. Besides the worse precision obtained with the surface electrode, an additional disadvantage was noticed. The time to obtain a stable pH reading depends strongly on the paper sample as is illustrated in Figure 3. Some papers (for example, sample A2) do not easily absorb the water, resulting in long stabilization times. Others absorb the water readily, resulting in quick responses, but after some time the wetted paper dries out and the signal starts drifting (for example, sample A3). This implies that the pH needs to be followed as a function of time to know when a stable pH reading can be done. This is very time-consuming and labour-intensive.

For the indicators some problems in interpreting the colour developed occurred when the paper samples were already coloured (for example, yellow due to ageing effects). The Abbey pen still allows the prediction of an acidic pH or not, while for the other indicators again, deviating values from the ones measured with the extraction techniques are obtained.

Miniaturization of the ISO-cold extraction standard

Although the extractions lead to excellent results, the methods cannot be used on precious papers since they require too much sample to be taken. In order to make

Figure 4. Schematic presentation of a sheet of a book showing the places the samples were taken for pH determination either with the miniaturized method (nos 1–10) or with the classic ISO extraction method (Strip 1–Strip 3).

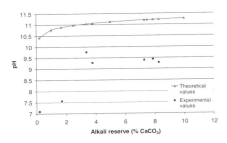

Figure 5. pH as a function of the alkali reserve for different conservation cardboards. The expected theoretical pH, calculated using the alkali reserve, is also shown.

Table 4. pH of paper as a function of the distance from the edge of a sheet, illustrating the high area specificity of the method. For three paper strips, all of which enclose several microdrill positions, the pH determined using the classic ISO extraction method is also given

Number	Distance to edge (mm)	pH
1	1.0	3.40
2	3.5	3.40
3	5.5	3.56
4	8.0	3.79
5	10.5	3.83
6	13.0	3.88
7	15.5	3.99
8	20.5	4.20
9	25.5	4.21
10	30.5	4.22
Strip 1	1 – 10	3.61
Strip 2	10 – 20	3.93
Strip 3	20 – 30	4.20

Table 5. pH-value and alkali reserve of some selected cardboards used for the production of conservation boxes. Results are the average value of two measurements. The standard deviation is given in brackets

Number of cardboard	pH (standard deviation)	Alkali reserve (in % $CaCO_3$) (standard deviation)
1	9.39 (0.01)	7.33 (0.85)
2	7.09 (0.03)	0.19 (0.03)
3	9.27 (0.07)	3.76 (0.04)
4	9.43 (0.01)	7.93 (0.06)
5	9.28 (0.08)	8.29 (0.21)
6	7.56 (0.04)	1.75 (0.01)
7	9.76 (0.03)	3.42 (0.01)
8	9.45 (0.01)	5.02 (0.20)

the extractions more accessible to the conservation community, a miniaturization procedure was worked out. The samples were taken using a so-called microdrill technique (Puchinger 2001, Wouters 2001), and weighed only about 40µg. This is a reduction in the amount of paper by a factor of 50,000. A volume of water, with respect to the ratio paper/water mentioned in the ISO standard, was added and the pH of the extract measured using a micro pH-electrode. Again the accuracy and the precision were tested using the buffered papers (W1–W4) and even on this scale results were excellent (Table 3). Only the alkaline paper shows a small deviating result.

Also for some aged papers the pH was determined, and compared with the pH obtained from the classic large-scale ISO extractions (Table 3). For most papers there was a good agreement between the classic pH extraction and the micro extraction. Again for the alkaline paper bad results were obtained. Also some acidic papers showed differences between both extraction methods. A possible explanation for this is the heterogeneity of the paper, since only a few tens of micrograms are sampled. On the other hand such heterogeneity may be deliberately shown by the micro pH measurement to reveal the diffusion of acidity for instance. Such an opportunity was shown by measuring the pH as a function of the distance from the edge of a sheet of paper (see Table 4 and Figure 4). At the same time three strips of paper were sampled that covered the range of the microdrill sampling positions and their pH determined using the classic extraction method. Since the strips enclose several microdrills, it is expected that the pH values of the strips are situated in between the pH values of the microdrills taken at the edges of a certain strip. Results in Table 4 indicate that this is indeed the case. This does not only explain why in some cases divergent results are obtained using the microdrill technique, but also shows the high area specificity of the new miniaturized method. Moreover it is an indication of the accuracy of the miniaturized pH determination method.

Unfortunately the method remains micro-destructive. Current research work focuses on the development of a new non-destructive pH measurement.

pH versus alkali reserve

Most pH measurements focus on the acidic pH range, because especially a low pH can be harmful to paper. Sometimes – for example, after deacidification or in a new material of conservation-quality – a paper is given a so-called alkali reserve. According to the ISO 10716 standard (1994), this is a 'compound such as calcium carbonate, that neutralizes acid that might be generated as a result of natural ageing or from atmospheric pollution'. The possible correlation between pH and alkali reserve was investigated. If so, then the time- and material-consuming and labour-intensive way of determining the alkali reserve could be avoided. For that purpose the alkali reserve of some archive boxes was determined following the directives given in the ISO 10716 standard, and their pH according to the ISO 6588 standard (see also Sizaire, in preparation). Results are shown in Table 5 and Figure 5. Apparently, none or low alkaline reserve caused around neutral pH, reserves over 3% caused pHs over 9. In all cases, however, the pH was lower than the theoretically expected value, due to the low solubility of $CaCO_3$. From the graph it can also be deduced that no correlation between pH and alkali reserve exists: both an alkali reserve of 3.4% and 8.3% give rise to a pH higher than 9. It can be concluded that the pH can only be used to predict if an alkali reserve is present or not, but not to determine its magnitude, implying that the pH of an alkaline paper only gives limited information about the condition of the paper.

Conclusion

Of the nine investigated methods only the extraction methods lead to accurate pH-values. Also the surface electrode can give accurate results when used under controlled conditions of paper dimensions and volume of water added. These parameters, however, are not stipulated in the Tappi standard. The indicator tests only give a rough idea of the pH of the paper.

Because the extraction techniques are not intended for use by the conservation community, a micro-extraction method for the measurement of the pH of paper was developed. The accuracy of the method was excellent, and an additional advantage of high area specificity was obtained, while only about 40 μg of paper is necessary for a pH measurement.

Finally it was illustrated that the pH can only indicate if an alkali reserve is present, but no conclusions about the magnitude of the alkali reserve can be drawn.

Acknowledgements

We are grateful to Gerhard Banik and Ulrike Binder from the Staatlich Akademie der Bildenden Künste (Fellbach, Germany) as well as to José Luiz Pedersoli Júnior from the Instituut Collectie Nederland (Amsterdam, The Netherlands) for the kind donation of some of the papers investigated.

References

ASTM D 778–97. 'Standard Test Methods for Hydrogen Ion Concentration (pH) of paper Extracts (Hot-Extraction and Cold-Extraction Procedures)', American Society for Testing and Materials, 1998.

Bégin, P, Deschâtelets, S, Grattan, D W, Gurnagul, N, Iraci, J, Kaminska, E, Woods, D and Zou, X.,1999, 'The effect of air pollutants on paper stability', *Restaurator: international journal for the preservation of library and archival material*, 20 (1), 1–21.

Brandis L, 1993, 'A comparison of methods used for measuring the pH of paper', *Bulletin*, 18 (3–4), 7–17.

Bukovsky, V, 2000, 'The natural ageing of paper after exposure to daylight', *Restaurator: international journal for the preservation of library and archival material*, 21 (4), 229–37.

Dupont, A-L and Tétreault, J, 2000, 'Cellulose degradation in an acetic acid environment', *Studies in conservation*, 45 (3), 201–210.

El-Saied, H, Basta, A H and Abdou, M M, 1998, 'Permanence of paper 1: problems and permanency of alum-rosin sized paper sheets from wood pulp', *Restaurator: international journal for the preservation of library and archival material*, 19 (3), 155–171.

Havermans, J B G A and Dufour, J, 1997, 'Photo oxidation of paper documents: a literature review', *Restaurator: international journal for the preservation of library and archival material*, 18 (3), 103–114.

ISO 6588, 'Paper, board and pulps – Determination of pH of aqueous extracts', International Standard Organization, 1981, Reference number ISO 3588–1981 (E).

ISO 10716, 'Paper and board – Determination of alkali reserve, International Standard Organization, 1994, Reference number ISO 10716:1994 (E).

McCrady, E, 1996, 'Effects of metal on paper: a literature review', Alkaline paper advocate, 9 (1), 8–9.

Neevel, J G and Mensch, C T J, 1999, 'The behaviour of iron and sulphuric acid during iron-gall ink corrosion' in *Preprints of the 12th Triennial meeting of the ICOM Committee for conservation, Lyon*, Vol. 2, 528–33.

Puchinger, L and Stachelberger, H, 2001 (in print), 'A new "Micro Sampling Technique" for parchment' in Larsen, R (ed.), *Handbook in the Micro Analysis of Parchments*, 23–33.

Sizaire, V, Vanden Berghe, I, Saverwyns, S, Smets, L and Wouters, J, 'Boxes for storage of museum objects: discussion of norms and materials available', in preparation.

'Tappi 'T 529 om-99', Surface pH measurement of paper', Tappi,1999.

Whitmore, P M and Bogaard, J, 1994, 'Determination of the cellulose scission route in the hydrolytic and oxidative degradation of paper', *Restaurator: international journal for the preservation of library and archival material*, 15 (1), 26–45.

Wouters, J, Claeys, J, Lamens, K and Van Bos M, 2001 (in print), 'Evaluation of methods for the Micro-analysis of Materials Added to Parchment' in Larsen, R (ed.), *Handbook in the Micro Analysis of Parchments*, 35–69.

Materials

Hamilton Minitrode pH-electrode, bleeding indicator strips, non-bleeding indicator strips, pHydrion pencil, citric acid, tris(hydroxymethtl)aminomethane, sodium hydroxide, Whatman paper:
Merck Eurolab
Geldenaakse baan 464
B-3001 Leuven
Belgium
Tel:+32 (0)16 38 50 11

Nitrogen (N_2)
L'Air Liquide
Atealaan 27
B-2270 Herenthout
Belgium
Tel: +32 (0)14 24 68 68

Abbey pen
Atlantis France
Rue Des Petits Champs 26
75002 Paris
France
Tel: +33 (0)1 42 96 53 85

Phosphoric acid
Acros Organics
Janssen Pharmaceuticalaan 3A
B-2440 Geel
Belgium
Tel: +32 (0)14 57 52 11

Orion Micro pH electrode
Ankersmid
Drie Eikenstraat 90
B-2650 Edegem
Belgium
Tel: +32 (0)3 230 64 48

Surface electrode
Metrohm Belgium
Coremanstraat 34b1
B-2600 Berchem
Belgium
Tel: +32 (0)3 281 33 31

Photographic records

Documents photographiques

Documentos fotográficos

Photographic records

Coordinator: Susie Clark
Assistant Coordinator: Nora Kennedy

The ICOM-CC Photographic Records Working Group is relatively new, and this last triennial period has been a time for consolidation of initial achievements. The group now has a membership of 62 with a wide geographical spread, including members in New Zealand, North and South America, Europe, Africa and Israel. Membership numbers continue to rise. The first part of the triennium involved necessary administration, such as updating membership information, establishing a format for newsletters and arranging the Interim Meeting.

In 2001, three newsletters were produced and distributed by e-mail. Given the wide geographical spread of members and the fact that the Coordinator is currently self-employed, the distribution of the newsletter by e-mail seemed the most viable option. However, in 2002, a printed newsletter is due to be produced that will focus on the research of Working Group members.

A very successful Interim Meeting was held at Centre de Recherches sur la Conservation des Documents Graphiques in Paris, 27–28 September 2001. It was organized in Paris by Martine Gillet, Bertrand Lavédrine and their colleagues, who deserve many thanks for their endeavours. The first day of the meeting consisted of visits to the Maison Européenne de la Photographie (Atelier de Restauration et Conservation des Photographies de la Ville de Paris), Atelier de restauration des photographies (Bibliothèque Nationale de France) and the Centre de Recherches sur la Conservation des Documents Graphiques. The second day consisted of presentations covering areas such as the analysis and identification of processes, environmental effects on film base material, treatment of digital prints, conservation of autochromes and the training of photographic conservators. Time was also allowed for discussion of research projects currently being undertaken by Working Group members. The discussion was very lively and useful, with many members participating. It could have continued much longer had time permitted. It was encouraging to see the Working Group providing a valuable forum for the exchange of ideas and information.

This triennium has also seen the development of more intermediate levels of training and experience, between college or university and long-term employment. One particularly significant development is the Mellon Fellowship programme, and a number of the first batch of Fellows were present at the Interim Meeting to elaborate on their research. Programmes such as these are beginning to have a significant impact on photograph conservation and the dedication of the Fellows to their subject was clear to all.

Photographic conservation has been a small field compared to other areas of conservation. However, as the value of photographs in society is increasingly recognized, the importance of photographic conservation is increasingly appreciated. Given the relatively small numbers of photographic conservators in any one country, an active international forum for the exchange of ideas and information between conservators provides a valuable role. This is also so because of additional new developments in the field in response to the development of digital technology. It is to be hoped that the next triennium will actively develop the role of the Working Group and that it will flourish.

Susie Clark

Resumen

El objetivo de este artículo es dar a conocer el trabajo en preservación de fotografía que se ha desarrollado en Chile desde el año 1980 y que en la actualidad realiza el Centro Nacional del Patrimonio Fotográfico (CNPF), corporación cultural sin fines de lucro dedicada a la preservación del patrimonio fotográfico, incluyendo la gestión integral de los proyectos desarrollados. Del mismo modo, intenta difundir esta experiencia en el resto de Latinoamérica y discutir las problemáticas en el área de la conservación del patrimonio cultural que tienen en común nuestros países. El equipo del CNPF trabaja en la preservación de la fotografía. Por ello sus tareas se dirigen hacia la creación de sistemas de trabajo cooperativo, con instituciones estatales y privadas, tanto en el ámbito nacional como internacional, en función de la conservación, la investigación y la difusión, del patrimonio fotográfico. Muchos años de experiencia nos han permitido establecer una metodología de trabajo estandarizada y viable, esto último debido a que fue adaptada a la realidad de los países latinoamericanos, en los cuales el presupuesto de inversión en cultura es limitado.

Palabras claves

preservación, conservación, investigación, difusión, estándar

Desarrollo de la Preservación del Patrimonio Fotográfico en Chile

Ilonka Csillag
Ejército 233, 2 piso
Santiago, Chile
Fax: + 56 2-676-2815
E-mail: cenfoto@udp.cl

La experiencia en conservación de fotografía en Chile comenzó en el año 1980 en el Museo Histórico Nacional con la iniciativa de preservar la fotografía chilena. Campañas públicas y donaciones familiares e institucionales y aportes de privados, permitieron que se formara el Archivo Fotográfico del Museo, el cual se constituye hoy en una de las colecciones fotográficas más relevantes de Chile. Con aproximadamente 100,000 fotografías correspondientes en su mayoría al siglo XIX y principios del XX haciendo un recorrido por Chile, su sociedad y su historia.

A medida que la colección aumentaba, se desarrolló una metodología de tratamiento de estabilización para colecciones fotográficas. Esta metodología fue evolucionando para transformarse en un modelo estándar que define el almacenamiento por formatos en sobres libres de ácido, y en solo cuatro diferentes tipos de muebles (ver figura 1). Los depósitos también fueron reacondicionados con soluciones sencillas que permiten mantener una atmósfera estable.

Esta metodología fue creada a partir de la revisión y análisis en terreno de distintas instituciones culturales en Estados Unidos y Europa, la cual fue adaptada a la realidad nacional durante la década de los ochenta. El Centro Nacional del Patrimonio Fotográfico (CNPF)[1] ha desarrollado y perfeccionado la metodología y la aplicación de sistemas de acondicionamiento que serán descritas a continuación.

El almacenaje en cajas por colección, sistema utilizado en la mayoría de los archivos estudiados, era una solución inalcanzable para las instituciones chilenas, por lo tanto, se optó por dividir las colecciones por formato y disponerlas en forma vertical dentro de muebles metálicos, utilizando separadores rígidos adosados a las paredes de los muebles, para evitar deformaciones y presión excesiva entre los materiales, optimizando además el espacio. Esta decisión respondió a la necesidad de adaptarse a los recursos económicos, disponibilidad de materiales en el mercado y la capacidad del personal encargado (ver figura 2).

Hoy en día, existen varios archivos que han adoptado esta modalidad y por ello podemos decir que esta metodología de trabajo, que se basa en la adopción de estas medidas simples de conservación preventiva y al uso del material y mobiliario antes descrito, ha creado un efecto multiplicador en las personas dedicadas a esta labor, las cuales se han capacitado por medio de cursos y pasantías que les permitieron adquirir un mayor grado de especialización en el tema de la conservación de materiales fotográficos.

También ello ha acrecentado el interés por el patrimonio fotográfico y su conservación, generándose iniciativas dentro de instituciones de distinta índole de conservación de colecciones, así como la necesidad de capacitación específica en la conservación de fotografía de las personas encargadas de los archivos.

Muchos de los proyectos se han desarrollado en conjunto con la Dirección de Bibliotecas, Archivos y Museos, la institución gubernamental que custodia más del 50% de las colecciones patrimoniales en Chile. Algunos de estos archivos son: el Archivo Fotográfico de la Sala Medina (Biblioteca Nacional), el Museo Fuerte Niebla en Valdivia, el Museo Histórico Militar, el Museo Regional de Magallanes, el Museo Regional de Copiapó, el Museo Gabriela Mistral de Vicuña, el Museo Van de Maele de Valdivia, la Sección de Antropología del Museo Nacional de Historia Natural, el Convento Santo Domingo, the Mackay School de Viña Mar, el Archivo Fotográfico de Ministerio de Relaciones Exteriores, entre otros.

Figura 1. Depósito del Archivo Fotográfico en el Museo Histórico Nacional de Chile.

Figura 2. Depósito de la colección fotográfica de la Sala Medina en la Biblioteca Nacional de Chile (se pueden aprecian los diferentes formatos de muebles y sobres).

Figura 3. Seminario Taller de capacitación dirigido a encargados de archivos fotográficos, Conservación de Colecciones Fotográficas Patrimoniales, realizado por los profesionales españoles Angel Fuentes y Celia Martínez en el laboratorio del Archivo Siglo XX, año 1999.

El CNPF se ha establecido como un centro especializado que coordina actividades relativas a la fotografía en sus distintos ámbitos: formación de una biblioteca especializada, organización de seminarios de capacitación a lo largo de todo el país, intercambio de experiencias con otros países. Asimismo, mantiene comunicación con aquellas personas que han participado en proyectos de conservación y se han capacitado a través de una lista de interés e información que funciona en Internet (ver figura 3).

Algunas de las actividades realizadas en los últimos dos años son:

- Publicación de un manual titulado *Conservación: Fotografía Patrimonial* de Ilonka Csillag, Santiago, 2000.
- Realización de un Catastro Nacional de Colecciones Fotográficas Patrimoniales: diagnóstico de 98 archivos fotográficos chilenos realizado en conjunto con la Biblioteca Nacional y financiado por la Fundación Andrew Mellon y SQM, 1999.
- Edición del libro *Historia De La Fotografía En Chile: Rescate De Huellas En La Luz*, 6 síntesis de investigaciones sobre fotografía chilena, Alexander, A, Alvarado, M, Berestovoy, K, Díaz, A, Granese, J L y Marinello, J D, Santiago, 2000.
- Edición del libro *Historia de la fotografía: Fotógrafos en Chile durante el siglo XIX*, de Hernán Rodríguez Villegas, Santiago, 2001.
- Seminarios y talleres dirigidos a encargados de las colecciones fotográficas, dictados por especialistas extranjeros de España y USA. El último curso, *Taller de conservación de álbumes fotográficos*, se realizó en septiembre del 2001, en Santiago de Chile, en la Universidad Diego Portales, con quien el CNPF ha firmado un convenio de cooperación mutua.
- Conservación y documentación de la colección fotográfica del Convento Recoleta Domínica.

Catastro nacional de colecciones fotográficas patrimoniales

La existencia de millones de fotografías en Chile, la necesidad de conocer su condición actual y los requerimientos para asegurar su preservación, nos llevó a realizar un Catastro Nacional de Colecciones Fotográficas Patrimoniales, realizado con el apoyo de Andrew Mellon Foundation y en conjunto con la Biblioteca Nacional de Chile, el cual constituye un diagnóstico del estado de conservación general de las colecciones fotográficas nacionales, reunido en una base de datos automatizada, con el propósito de establecer un plan nacional de preservación de colecciones fotográficas patrimoniales a corto, mediano y largo plazo.

Para la realización de este diagnóstico se visitaron cada una de las 93 colecciones que fueron consideradas para este catastro a lo largo de Chile. En cada una de ellas

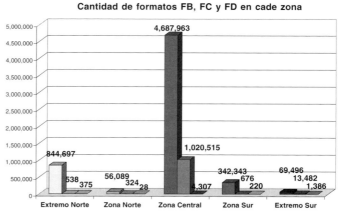

Figura 4. Gráfico que muestra los diferentes formatos de fotografías pertenecientes a las colecciones fotográficas catastradas y según la clasificación asignada por el CNPF. Información obtenida a través del Catastro Nacional de Colecciones Fotográficas Patrimoniales realizado con el apoyo de Andrew Mellon y en conjunto con la Biblioteca Nacional de Chile (CNPF 2000)

se realizó una entrevista personal al encargado del archivo; un estudio del clima de los lugares de depósito de las colecciones (se tomaron registros de temperatura y humedad relativa); el registro de las áreas del almacenamiento, depósitos, acceso a las colecciones, servicios, políticas de exhibición y préstamo. Al mismo tiempo, se desarrolló una base de datos automatizada con toda la información, que ha permitido consultar, interpretar y actualizar los datos.

Las conclusiones fundamentales extraídas del proceso de diagnóstico revelan la existencia de aproximadamente 16 millones de fotografías distribuidas en colecciones de tipo documental, artístico, histórico y de prensa.

Uno de los objetivos de la realización de este catastro era poder determinar la cantidad de material fotográfico por conservar. La ficha del catastro reúne la información relativa al formato de depósito de cada imagen. Por ejemplo, el formato FB corresponde a un sobre de 13 x 18.5 cm en donde se guardan todas las fotografías de hasta ese formato (ver figura 4).

Así podemos observar que existen más de cinco millones de fotografías que pueden ser guardadas en el formato FB. De allí se desprende que requerimos la misma cantidad de sobres para conservar todas las fotografías catastradas de ese formato si es que se decidiera conservarlas todas. Del mismo modo se necesitan diez mil muebles tarjeteros dobles para almacenar los sobres. Lo mismo puede ser calculado con los otros formatos. En la actualidad es posible saber casi con exactitud que recursos se necesitarían para preservar las colecciones fotográficas chilenas (ver figura 4).

Asimismo, la información relativa al tipo de colecciones muestra que los archivos catastrados reúnen una mayor cantidad de material negativo y copias en papel del siglo XX que del siglo XIX. Por lo anterior, los contenidos de los programas de capacitación deben poner énfasis en la problemática de conservación de este tipo de materiales.

A partir de esta información se establecieron prioridades de acción en el ámbito nacional, donde la capacitación se consideró un aspecto fundamental a enfrentar. El catastro se consideró como una herramienta esencial para conocer la realidad nacional y es la base para establecer prioridades en los planteamientos de los proyectos futuros.

Criterios y metodología de trabajo con las colecciones fotográficas patrimoniales

El concepto de preservación de colecciones que ha desarrollado el CNPF, considera acciones de conservación, investigación y difusión de cada una de las colecciones abordadas, además de realizar un trabajo en conjunto con las instituciones que custodian las colecciones fotográficas, para que los resultados sean sustentables a largo plazo.

La metodología de trabajo consiste en aplicar un modelo estándar para cada una de las etapas, que sean acordes con los recursos humanos y materiales de las instituciones chilenas. Estas etapas han sido definidas por el desarrollo de actividades que se enmarcan en las etapas de conservación (conservación preventiva, organización, depósito, mobiliario, acondicionamiento), investigación (histórica y estética, documentación) y difusión (acceso, publicación).

Conservación preventiva

En términos de conservación preventiva se han establecido criterios básicos basados también en estándares de conservación que han sido estudiados y definidos a nivel internacional y adaptado a la realidad de Chile, tomando en cuenta las diferentes tipologías de objetos fotográficos, según sus diferencias morfológicas y sus necesidades particulares de conservación.

Organización

Al iniciar el estudio de una colección, es primordial hacer un diagnóstico de ella, ya que por medio de éste se puede identificar los tipos de materiales, las necesidades de la colección y las prioridades de la institución, lo que orienta sobre los mecanismos necesarios para la creación de sistemas de conservación.

Figura 5. Muebles metálicos tarjeteros dobles, formato FB (sobres para fotografías de hasta 13 x 18.5 cm) con base y ruedas con frenos.

Figura 6. Muestra de un caja para álbum fotográfico fabricada en Chile.

Depósito

Se recomienda establecer depósitos o espacios separados para el almacenaje de negativos y positivos, material blanco/negro y color.

Los valores recomendados para la conservación de las fotografías sobre papel, son de un 40% HR y 18 °C.[2] Estos índices pueden mantenerse utilizando un depósito sencillo completamente aislado del exterior con dos puertas de acceso y un equipo deshumidificador que regule ambos factores.

Muchas veces estos índices son difíciles de mantener dadas las condiciones adversas de los edificios y la falta de recursos; no obstante, es de gran importancia poner énfasis en lograr una estabilidad climática que minimice los cambios medio ambientales bruscos, los cuales desencadenan los procesos de deterioro con mayor rapidez.

Para la iluminación del depósito es recomendable utilizar luces que no emitan radiación ultravioleta. Si no existe alternativa para la utilización de tubos fluorescentes, entonces deben ser filtrados. Es recomendable el uso de un temporizador que apague automáticamente las luces después de un tiempo predeterminado.

El depósito debe contar con sistemas de registro climático, seguridad y control contra robos, incendios e inundaciones, aspectos que también forman parte del plan de emergencias que cada institución debe desarrollar.

Selección de mobiliario

Los muebles que han sido seleccionados como los más recomendables, dentro de los ya existentes en el mercado nacional, son de metal esmaltado horneado a más de 180 °C, con ruedas y frenos para mejorar el aseo de los depósitos y con una base a 30 cm del suelo para mejorar la respuesta en caso de desastres como, por ejemplo, en inundaciones (ver figura 5).

Acondicionamiento

A diferencia con otros archivos extranjeros de que han adoptado la utilización de materiales tales como poliéster y polipropileno para el acondicionamiento de materiales fotográficos, el CNPF recomienda la utilización de contenedores de papel.

La razón para no utilizar en los materiales positivos el poliéster, se debe a que en la gran mayoría de los depósitos no existen atmósferas totalmente controladas y como consecuencia de ello, hay un riesgo potencial de condensación interna y depósito de partículas en suspensión.

Los sobres y carpetas que se recomiendan para el almacenaje de fotografías son fabricados en Chile, con papel libre de ácido, adheridos con metilcelulosa, que pueden ser adquiridos en el mercado nacional. Los sobres y carpetas pueden ser fabricados por los conservadores o técnicos que trabajan en las bibliotecas o archivos. Las fotografías de estuche y álbumes, son almacenadas en cajas y estuches fabricados a medida con los mismos materiales (ver figura 6).

Se han establecido formatos estándares para acondicionamiento de colecciones basado en el uso de 3 tamaños de sobres de papel, que corresponden a cuatro tipos de muebles existentes en el mercado que se adaptaron a las pautas básicas de conservación. A cada formato se le asignó un código de ubicación acorde al tipo de mueble. Este sistema presenta un significativo ahorro de recursos ya que no considera formatos especiales. Los formatos usados son:

- El formato FB que mide 13.5 x 18.5 cm, fabricado para el mueble tipo fichero en el cual se guardan todas las imágenes de hasta ese formato.
- El formato FC cuyas medidas son 27 x 34 cm, para el mueble tipo kardex que se guardan en carpetas colgantes con sostenedores de plástico (10 sobres por carpeta).
- El formato FD para los formatos superiores a 27 x 34 cm, se almacenan en planeras dentro de carpetas (ver figura 7).
- Álbumes que son almacenados en muebles tipo storage.

Figura 7. Planera para el almacenaje de formatos FD y mayores.

Figura 8. *Portada del libro* Fotógrafos en Chile durante el siglo XIX, *del autor Hernán Rodríguez Villegas, publicado por el CNPF en Diciembre del año 2001.*

Cada fotografía es numerada individualmente en forma correlativa, anteponiendo el código de formato (Fb, Fc, ó Fd). Se utiliza para ello lápiz grafito.

Sistemas de catalogación y acceso

El principal objetivo es evitar la consulta directa de la imagen original. El CNPF diseñó una base de datos automatizada que contiene las imágenes y la información técnica e histórica de cada fotografía. Este sistema permite un acceso más amigable y la necesidad de consultar los originales se reduce ostensiblemente.

Se ha considerado la incorporación de la documentación de las colecciones fotográficas a un sistema de catalogación llamado SUR, creado por el Centro de Documentación de Bienes Patrimoniales de Chile, dependiente de la Dirección de Bibliotecas, Archivos y Museos, elaborado con apoyo de The Getty Research Institute. Este sistema está siendo probado con colecciones museables de diferentes características y será trasladado a una plataforma universal de manera de facilitar el acceso. Por el momento se ha elaborado una base de datos simple en donde se puede acceder a las colecciones y luego, una vez probado SUR, cada archivo fotográfico podrá trasladar la información a ese sistema.

Con relación a la digitalización como un modo de acceso, está en proceso de estudio con el propósito de establecer una norma a nivel nacional que asegure la permanencia y continuidad en el tiempo de la modalidad de trabajo seleccionada, considerando las diferencias cualitativas y cuantitativas de los recursos materiales y humanos existentes en los archivos a lo largo de Chile.

Capacitación

El CNPF ha organizado y dictado numerosos seminarios, cursos y charlas sobre conservación de fotografía a lo largo de Chile, dirigidas principalmente a los responsables de archivos fotográficos. A estas actividades han sido invitados docentes extranjeros, como Ángel Fuentes (España), Celia Martínez (España) y Grant Romer (Estados Unidos), quienes han abordado temas específicos de conservación en distintos niveles.

Como un apoyo fundamental a la capacitación, el CNPF publicó en el año 2000 la sexta versión del libro titulado *Conservación: Fotografía Patrimonial*, que reúne en 126 páginas toda la información básica necesaria para enfrentar la conservación de una colección fotográfica. Este libro es distribuido gratuitamente.

Difusión

El apoyo a las investigaciones relevantes es una tarea primordial para el CNPF, por lo que ha coeditado investigaciones en conjunto con diversos autores y empresas editoras, como una manera de aportar al desarrollo de la historia de la fotografía chilena.

En el año 2000, se publicó el libro *Rescate de Huellas en la Luz*, el cual reúne seis síntesis de investigadores que abordan el tema histórico y estético de la fotografía en Chile en distintas épocas, desde la llegada del daguerrotipo a los inicios del fotoperiodismo y la producción de fotografía contemporánea, usando procesos históricos, como daguerrotipos.

Otro ejemplo es la publicación, en diciembre del 2001, del libro *Historia de la Fotografía: Fotógrafos en Chile durante el siglo XIX,* de Hernán Rodríguez Villegas. Esta publicación rescata estudios, vida y obra de los fotógrafos que pasaron o vivieron en Chile durante el siglo XIX, y constituye una pieza fundamental para nuevas investigaciones de fotografía chilena (ver figura 8).

Futuros proyectos del Centro Nacional del Património

Según la estrategia de acción planteada a partir de los resultados del catastro, se está desarrollando una próxima etapa que contempla dos años de actividades en torno a los temas de conservación e investigación de colecciones y capacitación de encargados de archivos.

Este proyecto está dirigido a establecer un programa de conservación para nueve colecciones fotográficas pertenecientes a instituciones públicas y privadas

del sur, centro y norte del país, resultando un total de 200,000 fotografías debidamente conservadas y documentadas.

Cada una de las colecciones contempladas bajo este futuro programa de conservación, fueron seleccionadas por su gran significado cultural, histórico, documental y estético, a nivel regional y nacional, además de considerar su estado actual de conservación, que en la mayoría de los casos presentan un alto riesgo de deterioro. Se conservarán las siguientes colecciones:

- Colección Alberto D'Agostini en el Museo Saleciano Maggiorino Borgatello, Punta Arenas
- Museo Regional de Magallanes, Punta Arenas
- Instituto de la Patagonia, Punta Arenas
- Universidad de Concepción
- Museo de Historia Natural de Concepción.
- Colección Odber Heffer en la Universidad Diego Portales, Santiago
- Museo Pedagógico de Chile, Santiago
- Museo regional de La Serena
- Museo regional de Copiapó

Paralelamente se realizará actividades de capacitación, tanto para los encargados de las colecciones como para personas interesadas en profundizar sobre temas específicos, como por ejemplo, el curso regional de conservación de negativos flexibles y placas de vidrio que se realizará en la ciudad de Punta Arenas y el de Conservación de Álbumes Fotográficos que se realizó en Santiago en septiembre del año 2001. Por otra parte, durante la primera etapa de conservación, se capacitará *in situ* al personal encargado de cada una de estas colecciones en los temas de conservación preventiva, identificación de procesos fotográficos y conservación directa de materiales fotográficos.

En el ámbito de la investigación histórica de la fotografía, se trabajará en el estudio de la colección del fotógrafo D'Agostini, un sacerdote salesiano que vivió en Punta Arenas, cuya colección es de importante valor histórico debido a que contiene imágenes inéditas de las culturas nativas extintas (Selk'nam, Kaweshkar y Yámana) además de la fauna, flora y geografía continental de principios de siglo. El resultado será difundido en una publicación que presentará su trayectoria como fotógrafo, además de un análisis histórico y estético de las imágenes.

Otro importante proyecto que está en gestación es la realización de una investigación histórica y estética de todos los daguerrotipos, ambrotipos y ferrotipos pertenecientes a colecciones públicas y privadas a lo largo de Chile, cuya publicación está programada para el año 2003.

Conclusión

Desde que se iniciara el trabajo de conservación de fotografía en 1980 en el Museo Histórico Nacional, el Centro Nacional del Patrimonio Fotográfico ha desarrollado en Chile un sistema de conservación adaptado a la realidad nacional sustentable en el tiempo y, de la misma manera, ha centrado sus esfuerzos en la gestión de proyectos, generando alianzas estratégicas con instancias públicas y privadas.

El trabajo desarrollado en estos años ha permitido poner en valor la fotografía en Chile. Cuenta de ello nos dan los más de ocho libros relativos a la fotografía en Chile que fueron publicados el año 2001.

La conservación preventiva ha sido un tema prioritario en todas las actividades de capacitación realizadas por el CNPF, y en la actualidad más de 30 personas están trabajando directamente con colecciones fotográficas a lo largo de Chile. Seis ediciones de un manual de conservación de fotografía se han publicado y distribuido gratuitamente desde 1993.

Más de 20 colecciones fotográficas chilenas han sido preservadas y son ellas un conjunto patrimonial de primera importancia para nuestro país.

Una lista de trabajo funciona desde 1999 y en ella se han inscrito 70 personas. Esta lista recibe información relativa a la conservación, historia y estética de la fotografía.

Agradecimientos

El Centro Nacional del Patrimonio Fotográfico agradece a todas aquellas instituciones y empresas, tanto nacionales como internacionales, que han colaborado en el rescate del patrimonio fotográfico chileno a lo largo de todos estos años. Ellos son Fundación Andes, Dirección de Bibliotecas, Archivos y Museos (DIBAM), Empresa Minera SQM, Lan Chile, Kodak Chile, Universidad Diego Portales y Centro Cultural de España (en Chile), y Fundación Andrew Mellon (U.S.A.), Conservación y Acceso a Archivos Patrimoniales (España) e International Museum of Photography and Film at The George Eastman House (U.S.A.).

Notas

1 El Centro Nacional del Patrimonio Fotográfico (CNPF) está ubicado en Ejército 233, 2 piso. Santiago de Chile. Fono: (56/2) 676 2269. El equipo estable del CNPF se conforma por: Ilonka Csillag, Directora, fotógrafa y conservadora de fotografía; Roberto Aguirre y Soledad Abarca, ambos conservadores de fotografía; Karen Berestovoy, fotógrafa e historiadora del arte; Margarita Alvarado, diseñadora y Licenciada en Estética y Macarena Urzúa y Andrea Purcell, ambas licenciadas en Literatura y Estética.

2 Reilly (1986) recomienda en su libro *Care and Identification of 19th-Century Photographic Prints* valores de humedad relativa entre un 30-40% y 18°C de temperatura, estos valores son los *parámetros* ideales que se ha intentado lograr, pero aproximarse a estos parámetros en forma rigurosa es casi imposible para la mayoría de las instituciones en Chile, por ello en el libro Conservación Fotografía Patrimonial (página 54) se recomienda que la humedad relativa no exceda un 40% (+/-2%) y la temperatura 18°C (+/-2°C).

Referencias

Alexander, Abel et al. *Historia de la fotografía en Chile: Rescate de huellas en la luz*, Ed. Centro Nacional del Patrimonio Fotográfico, Santiago, 2000.

Centro Nacional del Patrimonio Fotográfico, Biblioteca Nacional. *Informe Final Proyecto Preservación de Colecciones Fotográficas Patrimoniales*, Santiago 2000.

Csillag, Ilonka. *Conservación de Fotografía Patrimonial*. Ed. Centro Nacional del Patrimonio Fotográfico. sexta edición, Santiago, 2000.

Reilly, J, *Care and Identification of 19th-century Photographic Prints*, Rochester, New York, Eastman Kodak, 1986.

Abstract

A strategic plan for the preservation of motion picture films stored at the Danish Film Archive was formulated. The plan was based on a condition survey combined with analysis of the storage climate, and was produced in co-operation with the IPI. The condition survey demonstrated that the oldest part of the film collection, that on cellulose nitrate supports, suffered most from chemical decay and physical damage. Analysis of the storage climate predicted a life expectancy of 75 years for fresh film but less than 15 years for films already decaying. In 2000 new storage facilities for part of the collection were constructed, increasing life expectancy to 500 years for fresh films and to 200 years for decaying films. Conclusions drawn from the survey indicated that creating a storage environment of -5°C and 30% RH would increase the life expectancy of decaying films from 10 to 500 years.

Keywords

motion picture films, condition assessment, storage, climate, life expectancy, preservation plan

Condition survey and preservation strategies at the Danish Film Archive

Jesper Stub Johnsen* and Karin Bonde Johansen
Danish Film Institute/Film Archive
Naverland 13
2600 Glostrup, Denmark
Fax: +45 33 74 36 21
Web site: www.dfi.dk
E-mail: jesperj@dfi.dk

Introduction

A voluntary agreement between the Danish Ministry of Culture and the Danish Film Institute (DFI) resulted in a commitment by the Archive to carry out a condition survey of its film collection between 1999 and 2002. This survey would provide a working paper to be used in prioritizing preservation needs at the Archive and would form the basis for a future preservation programme.

Background

The Danish Film Archive contains approximately 30,000 motion picture titles, covering the period from very early film production in Denmark (1897) until the most recent Danish as well as foreign titles. All types of materials from black and white silent motion picture film on cellulose nitrate film bases to colour films on cellulose acetate and polyester film (PE) supports are present in the archive. Since 1962 the films have been stored in an old military fortification, which was divided into seven vaults for cellulose nitrate and thirteen vaults for cellulose acetate materials. The vaults were designed to maintain a climate of 12°C and 50% relative humidity (RH). However, the temperature was forced down to 5–7°C, resulting in a change in RH from 60% to 100%. Eight other locations without air conditioning have also been used for storage due to a lack of climatised storage space.

In January 2000 the Film Archive established a new storage room with a climate of 5°C, 35% RH. Preservation materials and several prints (projection motion picture films) were moved to this cold storage room. The new archive holds approximately one third of the DFI's film collection.

The survey

In 1999 a collection survey programme was set up to assess the condition of the film collection. The collection was divided into five groups, each representing a different kinds of material and stability problems. The collection categories are described in Table 1.

Methodology

Based on a statistical random sampling technique described by Drott (1969) 164 film reels[1] were examined from each group. (The reduced sample size from the

Table 1. Collection categories, sample size and results of the condition assessment survey

Collection	Base	No. of titles	Sample size	Confidence (%)	Tolerance (%)	condition category (%)					Sum (%)
						1	2	3	4	5	
National Museum	CN	940	96	95	±10	9	36	40	14	1	100
Archive collection	CN	4000	164	80	±5	4	35	55	5	1	100
Shorts and documentaries	CA	3900	164	80	±5	10	49	40	1	0	100
Preservation materials	CA	6564	164	80	±5	28	66	6	0	0	100
Prints for screening	CA	15,000	164	80	±5	4	53	41	2	0	100

*Author to whom correspondence should be addressed

National Museum is due to the statistical requirement that a maximum of 10% of the total collection is examined.) Typical observations are given in Table 2. The decay criteria were established using previous studies on degradation of photographic materials (Kodak H-23 1992, 30–61, Read and Meyer 2000, 83–104, Johnsen 1997, 51–72). The results of the observations are divided into five different condition categories corresponding to actual conservation needs.

The acidity of film bases is measured using the Alizarin Red Heat Test (ARH) (SMPTE 1950) for cellulose nitrate and A-D strips for cellulose acetate film bases (A-D strips 1998). All cellulose nitrate and cellulose acetate materials in the survey were tested using the relevant acid base detection test.

Using the ARH test (sometimes called the punch-test), a small sample of the cellulose nitrate base, approximate diameter 6 mm, is punched out of the reels. The sample is placed in a test tube together with filter paper prepared with an alizarin red indicator paper then is heated to 134°C. The state of deterioration is measured as the time taken once the sample has reached the desired temperature for the test paper to change colour from red to yellow due to the degradation products released. One hour or longer without a reaction means that the material will last for at least two years before duplication is necessary, while a reaction of >10 mins means that the film material should be copied and destroyed immediately (SMPTE 1950).

The A-D strips have been used on nearly 500 cellulose acetate film samples. Initially blue, they change from green to yellow depending on the concentration of free acetic acid released from the cellulose acetate film base.

The storage climate, expressed in temperature (T) and relative humidity (RH) of the film collections, was monitored for more than one year using TinyTag dataloggers. In January 2001 the DFI awarded the Image Permanence Institute (IPI) a contract for the purpose of helping to set preservation goals for the collection. This contract included an analysis of the measured storage climate using Climate Notebook Software and expressing the results using Time-Weighted Preservation Index (TWPI).

TWPI is a tool used to interpret the effect of the storage environment, and reflects temperature and RH cycles over the year. TWPI does not take into account any existing deterioration and thus life expectancy may be less for some films than that for fresh film. (Life expectancy should be understood as the number of years required for development of noticeable deterioration of fresh films, but total deterioration is not essential (Reilly et al., 1995).)

The analyses also include a calculation of the Mold Risk Factor for the individual storage sites. The Mold Risk Factor indicates the probability and severity of mould growth on susceptible materials (Bigourdan and Santoro 2001, 20–21).

Results

The overall results divided into percentages for each condition category for each group of films are given in Table 1. In the case of a film reel with more than one problem relating to stability, category is allocated based on the worst type of decay or damage according to criteria listed in Table 2.

Only a relatively small percentage of films in each group were placed in category 1, reflecting the there are few films in very good technical condition and without any problems of chemical stability: when film material has been used a few times there will in most cases be technical damage that will place it in the next condition category. From category 3 onwards the chemical signs of decay are inevitable. This might include fading of colours in colour films, yellowing, brittleness or the acidification of film bases. More than 250 cellulose nitrate film samples were tested in the survey, but only 2% of films from the Archive collection reacted to the ARH test compared with 14% of the, mostly older, films stored at the National Museum (see Figure 1). This suggests that the extant cellulose nitrate films should generally be in relatively good condition.

The results of testing with A-D strips are shown in Figure 2. For Shorts and documentaries, 34% of the films had reached an A-D of level 1.0, while only 1% had reached the autocatalytic point (A-D level 1.5). Prints had the highest amount of film with a slight indication of vinegar syndrome (A-D level 0.5), but only 8% had reached a level of 1.0. Almost 60% of the preservation materials displayed minor signs of vinegar syndrome, but only 1% had reached and A-D level of 1.0.

Table 2. Criteria used to evaluate the condition of cellulose nitrate and cellulose acetate film

Condition	Condition definition	A-D level	ARH	Shrinkage (%)	Decay criteria physical damages	chemical damages	humidity-related damages
I	good condition	0	>2 h.	<0.7	none to a few perforation damages	none	none
2	fair condition	0.5	I–2 h	0.7–1.0	2–10 damaged perforations, tears, curling, twisting	minor silver mirror	ferrotyping, mould on the surface of the reel, mite infestation
3	materials degrading, duplication is advisable	I.0	30–60 mins	I.0–2.0	> 10 damaged perforations, many tears, distinct twisting	silver mirror, brittleness, yellowing of base, colour shift/fading in colour films	blotches, mould on emulsion
4	material is in critical condition and should be copied immediately	2–3	<30 mins	>2.0	unable to project film	fading, bleaching and discolouration of images, distinct base decomposition, distinct brittleness	images destroyed by mould
5	current condition may be beyond restoration	3	<30 mins	>2.0	film partly or completely fragmented	base dissolved and/or sticky	meaningful images destroyed by mould

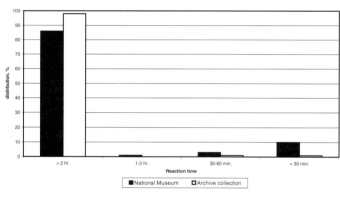

Figure 1. *Results of Alizarin Red Heat Test of cellulose nitrate film samples*

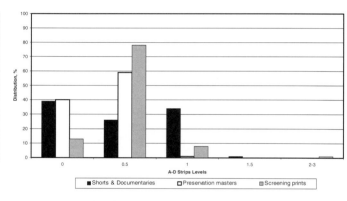

Figure 2. *Results of testing cellulose acetate film samples with A-D strips*

Figure 3 shows the storage climate expressed as TWPI in years. The TWPI shows the quality of the storage environment and indicates the number of years before fresh films will start to show significant degradation. In the old fortification cellulose nitrate film is stored in seven vaults with a TWPI varying from 101 to 147 years. Films in the climatised vaults for cellulose acetate materials have an expected lifetime of 77–150 years. Due to the lack of space for many years a series of storage vaults without climatisation were also used. The climate in these places has a TWPI of 62–89 years. In comparison, films stored in the newly constructed archive have a TWPI of 518 years.

Also in Figure 3, storage vaults with a Mold Risk Factor of +1 are indicated. Contrary to expectations there is no relation between the risk of mould growth and whether the vaults are air-conditioned or not. Even in many of the vaults with air conditioning average RH is so high as to actively promote biological attack.

Figure 3. *Environmental assessment of the storage facilities at the Film Archive. The bars indicate the final TWPI in years. The TWPI bar >500 years is from the new archive vault built in 1999. The black bars indicate vaults with climate control and a Mold Risk Factor of 0. The grey bars indicate storage locations without climate control and a Mold Risk Factor of 0. The white bars indicate storage locations with climate control and a Mold Risk Factor of +1 (indicating high risk of mould growth on the film materials). The bars with chessboard pattern indicate storage locations without climate control and a Mold Risk Factor of +1.*

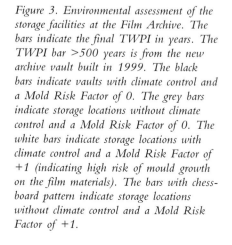

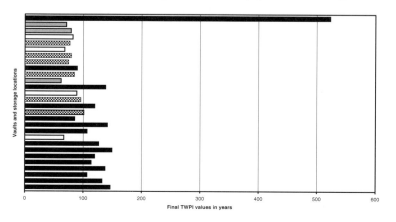

Discussion

Looking at Table 1 it can be seen that for cellulose nitrate films, 15% of the collection from the National Museum needs some type of immediate conservation treatment (categories 4 and 5), while for the Archive Collection the proportion is 6%. This corresponds to 142 film titles (±5%) and 240 film titles (±5%) respectively. The main types of damage observed in for categories 3, 4 and 5 of the cellulose nitrate collections were base discoloration (20%), brittleness (20%) and base dissolution (4%).[2]

In the Shorts and documentaries collection 41% of the films show ongoing degradation (categories 3 and 4). The predominant types of damage are colour fading in colour films (44%), mould growth (13%), blotches (16%) and twisting (28%); 34% have an acid content equal with A–D level 1.0.

Fortunately the preservation materials had the best overall condition. Only 6% fell into category 3, which corresponds to 394 film titles (±5%). However 60% or 3,938 film titles (±5%) have a slight indication of free acetic acid (A–D level 0.5).

In the print collection, 43% were assessed as category 3, 4 or 5, reflecting the large proportion of physical damage to these films. Almost 80% of the prints had an acidity level equal with to A–D level 0.5, indicating the start of chemical decay in the film base.

The aim of film conservation treatment may be to stabilize the film and protect it from further decay (e.g. improve the storage environment). It may also be to improve appearance (restoration and/or reconstruction) and/or to meet a specific user function (e.g. to make the film printable or screenable again). All films will of course benefit from improved storage conditions in terms of slowing down the rate of decay. However, for films in condition categories 4 and 5 improved storage alone does not help. Restoration treatments are needed to make possible the use of such material for its intended purpose.

Films in condition category 3 show clear signs of decay, particularly decay caused by chemical or biological activity, but such films are not necessarily unusable. The tradition for many years has been to prioritize these films for duplication in order to retain content. However, films in this category will benefit most from a better storage environment. By improving the storage environment the rate of decay will be reduced, which in turn will reduce the need for duplication (and the costs) or, more precisely, will spread the costs of duplication over a greater number of years. This will also allow the Archive to better prioritize the duplication and restoration programme. Furthermore, the possibilities for adding value to the collection will increase. Instead of focusing only on fighting the acute stability problems by increasing the number of second or third generation duplicates, work preserving the original materials can be combined with, e.g., intellectual work on identification, history and content.

The results given in Figure 2 reveal that nearly two thirds of the Shorts and documentaries collection and the preservation materials show definite signs of chemical base deterioration (A–D level of 0.5 or more) while close to 90% of the prints shows signs of vinegar syndrome. However, only a very small part of the cellulose acetate film collections has reached or is above the autocatalytic point (A–D level of 1.5). This means that there are significant signs of decaying film bases in the majority of the collection but the level is not alarming and the rate of decay can effectively be slowed down significantly if the storage environment is improved.

Comparison of duplication and improvement of the storage climate

IPI's model for calculating the life expectancy of cellulose acetate film collections (Reilly 1993) allows us to calculate the expected lifetime at different storage climates for fresh as well as decaying film to be calculated (see Table 3).

Assuming that all degrading films (films falling into condition categories 3, 4 and 5, including films on cellulose nitrate supports[4]) are stored in the old fortification, it can be seen from Table 3 that there are only 10 years left to duplicate this material. In Table 4 this result is recalculated to attain the number of titles that need to be duplicated each year over the next 10 years for each group of film. Altogether this

Table 3. Life expectancy (LE) for film collections under different storage conditions[3]

Life expectancy	Old fortification	Storage conditions New storage	New storage
	9°C, 81% RH	5°C, 30% RH	-5°C, 30% RH
Fresh film	75 years	500 years	1000 years
Degrading film	10 years	200 years	500 years

Table 4. Duplication needs for different storage conditions in number of titles per year[5]

Collection	Old fortification (no. of titles/year)	5°C, 30% RH (no. of titles/year)	-5°C, 30% RH (no. of titles/year)
National Museum	52	3	1
Archive collection	244	12	5
Shorts & documentaries	160	8	3
Preservation masters	40	2	1
Prints for screening	645	33	13
Total	1141	58	23

Table 5. Yearly preservation costs (in million DKK) for different preservation environments[6]

Description	Old fortification (no. of titles/year)	5°C, 30% RH (no. of titles/year)	-5°C, 30% RH (no. of titles/year)
Duplication	55.5	2.9	1.2
Storage	0.4	0.3	0.4
Preservation costs total	55.9	3.2	1.6

will amount to 1141 titles. Table 5 shows budget estimates for duplication and the power necessary to maintain the cold but humid climate in the old fortification. It can be seen that the total budget needs for preserving the film collections are nearly DKK56 million every year for 10 years.[7]

Tables 3–5 compare the fortification and other constant storage climates at 5°C or –5°C both at 30% RH. By creating a constant storage climate for all collection categories at –5°C the yearly budget needs for duplication are reduced dramatically from nearly DKK56 million to DKK1.6 million each year.

It should be noted that, however, the numbers are based on pure mathematical calculations. It will never be realistic or reasonable in practice to duplicate nearly 1200 film titles every year for 10 years. The print collection accounts for the vast majority of the duplication needs and in practice only a few new prints will be made for Danish film titles and no foreign titles will be duplicated. In this situation, the economic and practical advantages of improving the storage climate are clear.

Preservation strategy

The environmental conditions indicated in Figure 4 have been chosen for the strategic preservation plan. This is based on the results from condition survey, storage climate analysis and the relevant ISO standards (ISO 10356, 18911, 18923), combined with observations and recommendations offered by the IPI and practical considerations.

At the moment (January 2002), the Danish Film Archive has established a cold storage room at 5°C, 30% RH for the print collection. Plans for extending the storage facilities for preservation masters, shorts and documentaries as well as special storage facilities for cellulose acetate films attacked by the vinegar syndrome have been designed and approved by the Ministry of Culture and the necessary budget has also been approved. At the same time the Ministry of Culture has established a working group with the aim of designing new storage facilities for the entire cellulose nitrate film collection.

Conclusion

A condition assessment survey of film collections made it possible to increase knowledge of our entire film collection, to obtain an idea of the nature of any deterioration, and consequently to focus on collections with special conservation needs. The survey revealed that the cellulose nitrate collection was in the worst

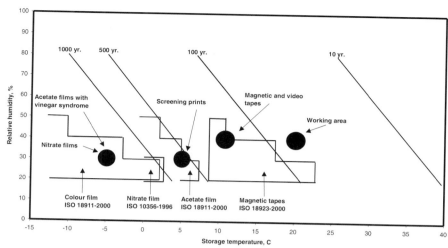

Figure 4. The influence of temperature (T) and relative humidity (RH) on the chemical stability of imaging materials and magnetic tapes. The diagonal lines indicate life expectancy at 10, 100, 500 and 1000 years when a material is constantly stored at combinations of T and RH along the lines. Also shown are the contours of the recommended storage climate mentioned for colour, cellulose nitrate and cellulose acetate films and magnetic tapes according to the relevant ISO-standards. The circles indicate the preservation strategy aimed at by the DFI when planning new archive facilities. Note: although cellulose nitrate and cellulose acetate films will be stored in the same climate, they will however be stored in separate locations.

condition. The collection from the National Museum will need a thorough examination in order to locate the films with ongoing deterioration.

The study also demonstrated the advantage of cold storage compared to duplication. By establishing a constant storage climate at -5°C the life span of already deteriorated films will increase, on average, from 10 to 500 years. Cold storage is also much more cost effective than duplication, and duplication alone provides an unrealistic approach to solving the preservation problems of a large film collection as it requires many man-hours and a large budget. Construction of a cold storage facility at -5°C will reduce the duplication needs of the Danish Film Archive from 1140 titles per year to 23 titles. Storage pays!

The consequences of ignoring the need for a proper storage environment are severe and include lost information, lost value and lost cultural heritage.

Acknowledgements

We wish to thank our colleagues at the Danish Film Archive for help and assistance with this project. A special thank to Jean-Louis Bigourdan, Research Scientist at IPI, for analysis and recommendations, and Susie Clark, co-ordinator of ICOM–CC Working Group on Photographic Records, for her help with the manuscript.

Notes

1 Only one reel per film title assuming it is representative of the overall condition of that film title. A normal feature film consists of five to six reels.
2 These observations are not shown in any of the tables included here.
3 Life expectancy ratings based on IPI's degradation model for cellulose acetate film (Reilly 1993). Old fortification estimate based on actual measured climate and IPI's model.
4 The rate of decay may differ between cellulose acetate and cellulose nitrate supports. Variations between the rates of decay in different cellulose nitrate films are believed to be much greater than those for cellulose acetate. However, the discussion here is based on the model for cellulose acetate decay and assumes that cellulose nitrate decays at the same rate (Adelstein 2001).
5 Based on IPI's degradation model for cellulose acetate film (Reilly 1993), assuming that the same model is valid for cellulose nitrate film. The number of titles to be duplicated is calculated using the condition survey results given in Table 1, categories 3, 4 and 5. In the old fortification there are 10 years left to copy the decaying films but storing the titles at 5oC, 30% RH will increase this to 200 years (see Table 3).
6 Only expenditure for power consumption to run the air-conditioning equipment in Denmark is calculated for storage. Expenditure for duplication is calculated from actual

laboratory prices per metre of motion picture film: DKK50,000 per title for cellulose nitrate film (National Museum and Archive Collection), DKK15,000 for shorts and documentaries, DKK150,000 for preservation masters and DKK50,000 for a screening print.

7 The budget needs for duplication are based not only on simple laboratory costs but also take into account the varying lengths of the film titles and the materials DFI normally requires during a duplication programme for preservation.

References

A-D strips, 1998, *User's Guide for A-D Strips. Film Base Deterioration Monitors*, Rochester, NY, Image Permanence Institute, Rochester Institute of Technology, version 1.6.

Adelstein, P Z, 2001, *Optimimizing Nitrate Film Storage, Preserve – then show*, 60th Anniversary Seminar of DFI/Film Archive, 11–13 November, Copenhagen, Denmark.

Bigourdan, J-L and Santoro, K, 2001, 'Strategic preservation plan for motion-picture film collections – condition evaluation, environmental assessment, recommendations for a new archive', *Report to The Danish Film Institute*, Film Archive, 17 August.

Drott, C M, 1969, 'Random sampling: a tool for library research', *College & Research Libraries*, March, 119–125.

ISO 10356, 1996, *Cinematography – Storage and Handling of Nitrate-base Motion-picture Films*, Geneva, International Organization for Standardization.

ISO 18911, 2000a, *Photography – Processed Safety Films – Storage Practices*, Geneva, International Organization for Standardization.

ISO 18923, 2000b, *Imaging Materials – Polyester-Base Magnetic Tape – Storage Practices*, Geneva, International Organization for Standardization.

Johnsen, J S, 1997, *Conservation Management and Archival Survival of Photographic Collections*, Ph.D. Dissertation, Göteborg University, Institute of Conservation, Acta Universitatis Gothoburgensis, Göteborg Studies in Conservation, 5.

Kodak H-23, 1992, *The Book of Film Care*, Rochester, NY, Eastman Kodak Company.

Read, P and Meyer, M-P, 2000, *Restoration of Motion Picture Film*, Oxford, Butterworth-Heinemann.

Reilly, J M, 1993, *IPI Storage Guide for Acetate Film*, Rochester, NY, Image Permanence Institute, Rochester Institute of Technology.

Reilly, J M, Nishimura, D W and Zinn, E, 1995, *New Tools for Preservation. Assessing Long-term Environmental Effects on Library and Archives Collections*, Washington, DC, The Commission on Preservation and Access.

SMPTE, 1950, Film decomposition test, *Journal of the SMPTE* 54, 381–383.

Recent advances and future directions in the education and training of photograph conservators

Debra Hess Norris★
Chair, Art Conservation Department
303 Old College
University of Delaware
Newark, DE 19716, U.S.A.
Fax: +1 302 831 4330
E-mail: dhnorris@udel.edu

Nora W. Kennedy
Sherman Fairchild Conservator of Photographs
Metropolitan Museum of Art
1000 Fifth Avenue,
New York, NY 10028, U.S.A.
Fax: +1 212 570 3811
E-mail: nora.kennedy@metmuseum.org

Abstract

Tradition is a strong teacher, but in a field in which a notable lack of tradition exists stepping out of the mould is always possible. Photograph conservation is currently undergoing an examination of its unconventional roots and new ways are being devised to invigorate its growth within the larger field of conservation. Changing attitudes about treatment, scientific input, the immensity and challenges of collections care, and emerging technologies are all aspects that have contributed to this evolution. New initiatives in education and training are emerging as a response to the changing needs of photograph conservation professionals.

Keywords

photograph conservation, education, training, graduate study

History and evolution

The field of photograph conservation evolved from a confluence of the photographic and conservation professions. The complex history of the development of photographic processes reflects not only an interest in faster, easier and more colourful systems, but also an abiding desire to create more stable processes that would withstand the ravages of time.

From photography's inception, both amateur and professional practitioners have utilized chemical processes to 'revive' faded and discoloured images and to repair physically damaged any support materials. The intention seems primarily to have been to restore an image rather than to promote its stability into the future. Knowledge arising from, and an appreciation of, the inventor's intentions in creating more stable processes, coupled with the photographer/restorer's methods, eventually have combined with existing practices in paper conservation to produce the first photograph conservators.

Thirty years ago, the accepted course of study for a photograph conservator included apprenticeship or graduate school training in paper conservation supplemented by the study of photographic science, photographic history and the practice of photography. Photograph conservators did not strictly specialize, and many worked with a variety of related materials such as prints, drawings and even books. Now, occasionally, photograph conservators even specialize within photography, e.g. on cased images or contemporary materials. Valuable input from other conservation disciplines, including objects, paintings and textiles, supports our understanding of the variety of materials involved in creating photographs. In the 1980s the concept of preventive conservation, including collections care, storage, exhibition parameters and emergency response, became a serious part of the photograph conservator's training.

The establishment of formal training

In 1976 the Winterthur/University of Delaware Program in Art Conservation (WUDPAC) established training in photograph conservation under the leadership of José Orraca. WUDPAC was the first graduate conservation training programme in the world to offer photograph conservation as a major specialty. Since 1976, WUDPAC has trained nearly 20 conservators, where previously there had been only five practising conservators in the United States. Within the past 15 years, additional international graduate and undergraduate education and training programmes at such institutions as Buffalo State College and New York University, *Ecole National du Patrimoine: Institut du Formation des Restaurateurs d'Oeuvres d'Art*, *Université Paris-Sorbonne* and the Royal Danish Academy of Fine Arts have begun to offer photograph conservation as an area of study. Graduates from these

★Author to whom correspondence should be addressed

programmes have had a significant impact on the preservation of our international photographic heritage. They work with extensive photograph collections, including those at the Library of Congress, the Museums of the City of Paris, the Harry Ransom Humanities Research Center, the Austrian National Library, the Victoria & Albert Museum, the Metropolitan Museum of Art and the Museum of Modern Art, as well as establish prosperous and respected private practices. Their studies have deepened our understanding of waxed paper negatives, albumen print degradation, consolidation and loss compensation methodologies, silver image oxidation and other specific topics.

However, there exists a need for additional formally trained conservators of photography. In the past six months, six temporary and permanent new positions have been announced in the United States alone. All require graduate-level photograph conservation studies. To date, three positions remain open.

Defining the ideal training

Opinions about what constitutes the ideal education in photograph conservation continue to vary considerably. Differences in final image materials, binder layers and primary supports, coupled with a wide range of finishing procedures, the challenge of inherently unstable media and the enormous quantities of photographs within collections, dictate the need for specific skills, preservation tactics and methodologies. In a 1996 survey, 50 photograph conservators and allied professionals agreed that knowledge of photographic history, preventive conservation and treatment practice are mandatory, coupled with strong hand skills, ethical decision-making and critical thinking. However, there was little agreement on the areas of photographic chemistry and connoisseurship. Dissension and differences in opinion were often attributable to training history and employment. Conservators in private practice promoted the importance of hand skills, whereas those in cultural institutions considered connoisseurship studies equally vital. The re-creation of historic processes, densitometry, sensitometry, duplication procedures and conservation history were rated 'less essential' by both conservators and allied professionals, although they were still viewed as important (Kennedy 1996).

As with all conservation disciplines, educators agree that photograph conservation graduates should demonstrate an appropriate balance of caution and courage, compromise and excellence, flexibility and humility, versatility, innovation, a deep respect for the knowledge and experience of others, the ability to work as part of a team, a commitment to continuing professional development, and the attitudes and motivation necessary to work both skilfully and ethically. We must prepare our graduates for performing well in the workplace. They must become professionally active and serve as effective advocates and respected practitioners on a day-to-day basis.

Modifications in photograph conservation education and training

Over the past 10 years, photograph conservation education has been modified by conservation educators to meet changing attitudes, philosophies and practices within the field. Advancements are described below.

Preventive conservation

Photograph conservators are responsible for large holdings. The Library of Congress alone has a collection of 12 million photographic images. Focused and increased study on the broader issues of environmental control, proper storage and housing of materials, staff and user education, emergency response and collection assessment is therefore mandatory. Photograph conservation permits access to highly effective preservation assessment tools that serve as essential teaching resources, e.g. environmental guides for acetate film and contemporary colour collections and acid-base indicator strips to determine the condition of amateur and professional motion picture film.[1] Our collective experience of emergency response procedures for the safe and efficient recovery of photographic collections has increased exponentially (Norris 1996, 1998). Disaster drills incorporated into conservation curricula provide future practitioners with opportunities to salvage water-soaked photographic materials. Short-term internships or on-site visits

require students to assess photograph collections in urgent need of preservation and to apply preventive conservation concepts. In so doing, students gain an awareness of the significant challenges that await their expertise and learn to prioritize and to work towards practical preservation goals. Such experiential learning opportunities must be emphasized and expanded upon.

Conservation science

Educators continue to emphasize conservation science within conservation education and training programmes. Some programmes require students to conduct comprehensive technical studies designed to ensure that each student has the ability to identify, formulate, design, conduct, interpret and write up a limited scientific research project. Many of these studies have contributed to our understanding of photographic materials and treatment procedures, including the relationship between toning and image colour in matte collodion photographs, coating materials and techniques used on 19th- and 20th-century photographs, parameters for X-ray fluorescence analysis of photographs, surface cleaning of degraded silver gelatin emulsions, tarnish reduction on daguerreotype plates and the effect of immersion on gum dichromate prints. The ICOM-CC Photographic Materials Working Group does provide an international forum for the dissemination of information within the field.

These smaller research projects in no way supplant the overriding need for more fundamental research into materials characterization. Photographic conservation is currently unable to address complex preservation and conservation challenges which require sufficient understanding of the long-term repercussions relating to the materials and their interactions. This ignorance is due in part to the array of materials used historically in photography, coupled with the new commercial products that appear regularly on the market and are untested by conservation standards. Although numerous surveys and meetings have been conducted over the years in an attempt to establish research priorities,[2] the meeting with the most practical outcome was that hosted by the Getty Conservation Institute and the Image Permanence Institute in Rochester, New York, in August 1999. Twenty-four conservators, scientists and curators convened to identify research priorities in photograph preservation and to pinpoint two to three feasible projects that would significantly advance knowledge in the field. Eight scientists from the three major photograph conservation research institutes worldwide commented on the practicality and level of scientific confidence possible for the proposed research initiatives. The results indicated a need for non-destructive materials characterization research focused on photographic print processes from the 19th and early 20th centuries, and safe exhibition guidelines, based on comprehensive monitoring programmes and light exposure research.

In coming years, individuals and institutions capable of contributing minor and major research projects should emphasize materials characterization. The importance of forensic-based investigations in photograph conservation has emerged. Market values for photographs are rising and the number of fakes appearing on the market has increased dramatically. Recently, the presence of optical brightening agents (OBAs), in combination with the identification of chemical-processed hard wood fibres, has revealed a large group of vintage Lewis Hine photographs to be posthumous reprints from the original negatives (Blumenthal 2001). Materials characterization research will advance our knowledge of photographic process identification and help to distinguish the distinctive working methods of specific photographers. It will reveal the presence and composition of early metallic toners, historic coatings and other finishing methods, binder additives and vintage primary supports. Ultimately, this research will also result in the development of new and safer conservation treatment strategies. Through short-term and targeted research projects, graduate and postgraduate students will continue to contribute to these important efforts.

Conservation treatment practice

As our scientific and art-historical understanding of photographic materials has increased, photograph conservation treatment has become more refined and

significantly less intrusive. Fifteen years ago, photograph conservators routinely unmounted, refixed and washed aged albumen prints to remove residual chemicals and to minimize discolouration. It is now understood that such interventions may promote yellowing and cause the aged egg-white binder layers to crack irreversibly. There is no chemical proof that refixing an aged silver image improves the image or extends its life. Today, platinum prints are bathed (only when necessary) on blotters or with suction-vacuum tables to protect their fragile surfaces. Organic solvent treatments are used sparingly for contemporary silver gelatin materials, as their deleterious effects on binder layers and paper-based additives such as optical brighteners are now better understood. Silver mirrored surfaces are lightly waxed or left untreated, as more aggressive treatments in the past have proven detrimental.

Teachers of photograph conservation must present a thorough overview of conservation treatment practice and methodology in a wide variety of materials, including cellulosics, metals, pigments, dyes, glass, plastics and proteinacious materials. Historic processes should be re-created and expendable vintage materials collected for experimental trials focused on the careful evaluation of various treatment procedures. Re-creations can be used for teaching but will not provide the individual with the experience of treating vintage materials. Careful choice of experimental samples is essential and often limits experimentation to the most common processes, where large groups of repetitive imagery proliferate. Testing can be conservative and teaching materials need not be destroyed. However, students must be encouraged to experiment, to take risks and to 'think outside the box'. When surface cleaning aged albumen or collodion prints, the efficacy of sulphur-free vinyl erasers may be compared by students with the use of soft brushes or aqueous solutions, and the ease of application, control, gloss/surface modification and degree of dirt reduction considered. Chemical treatments are not used in general practice, but students should be encouraged to undertake chemical treatment experiments and thus to become aware of their advantages and disadvantages. Uninformed disapproval of procedures will not promote confidence or respect in the public eye.

Cultural and institutional context

In prescribing photograph conservation and preservation measures, the photographer's intent and the photograph's research value must be understood. Given the changing view on photography, such cultural designation may be complicated. For example, documentary photographs may be 'promoted' to fine art status with the passage of time. With the 'discovery' of their makers, nineteenth-century albumen prints of Egyptian scenes that have served for decades as active research tools may be removed from filing cabinets in order to be matted and consigned to restricted access (examples are Bonfils, Sebah and du Camp). To foster an understanding of cultural context, students specializing in photograph conservation must continue to take seminars in photographic history, as well as independent studies in which historic processes are duplicated using traditional techniques. In addition, they must learn about the sociological context in which the photograph was produced and explore how these factors have changed the way in which the artefact is perceived. A certain amount of foresight and open-mindedness is essential when predicting what may be of lasting value. Dialogue with photographers, commercial mounters, retouchers and printers should be encouraged, and efforts should be made to secure additional funding for student research travel so that objects and collections can be examined first hand.

Electronic media and documentation procedures

Videotapes are shedding, disks are crashing, digital prints are fading, formats are evolving…. The challenge of effectively preserving electronic media and other new technologies is of primary concern. Photograph conservators are frequently responsible, often simply by default, for the care of these materials, including the conservation of hard copies and the long-term care of digital data. They must oversee permanence issues in the procurement of hardware and software and advise on digitization protocol for historic photographic collections. Since 1998, lectures

and workshops that focus on the evolution of electronic media, electronic imaging, information migration and permanence have been incorporated into many photograph conservation curricula, including a specialization in new technologies recently offered in the Copenhagen programme. Digital imaging systems are being used increasingly in the field for assessment and condition reports. Conservation professionals of all disciplines must have first-hand experience of these emerging technologies.

Management and advocacy

Effective management techniques are critical to ensure the success of complex preservation activities within cultural institutions. Since 1995, issues of management and marketing have been incorporated into the WUDPAC curriculum. The bottom line is that students must be exposed, whenever possible, to issues surrounding budgets and resource management. A major international conference of university, business and government leaders was recently convened in Canada to develop strategies to meet the challenges of the global marketplace. These leaders discussed how to equip graduates for professional success and identified the primary they believed essential:

> Repeated emphasis was given to communication and organization skills, team work and language facility. But there was another area of consensus that spoke to something more elusive, something intangible. This was the realm of attributes and values, a collection of qualities more to be inculcated than taught; comfort with ambiguity, intellectual resilience and a willingness to fail and learn from failure; a heightened sense of ethics, historical perspective, and a sensitivity to cultural differences; critical thinking and problem-solving abilities; an understanding of how 'knowledge' is created, and the imperative of challenging absolutes. (Leggett 1999)

In time, these skills and attributes may distinguish the exceptional leader from the merely competent.

As we change and modify our photograph conservation curriculum, we must accept that there is simply too much knowledge to teach aspiring conservators during a three- or four-year period. Professional graduate education is not about teaching exhaustive knowledge of the profession; it is about teaching students how to learn. Curriculum reform and enhancement are expensive. External funding is vital. Recently, three graduate conservation programmes in North America worked together to raise well over $7 million in endowment support from federal agencies, foundations, corporations and private individuals.

Innovative educational initiatives supported by The Andrew W. Mellon Foundation

From 1994 to 1997, The Andrew W. Mellon Foundation engaged in a study of current and future priorities in fine art conservation, identifying urgent needs in photograph conservation and the relative scarcity of training opportunities. While institutions throughout the United States and abroad have invested heavily in collecting photographs, many have been slow to address issues relating to their preservation or the importance of establishing positions of responsibility dedicated to their care. Such institutions have traditionally placed their holdings in departments of 'prints and photographs', assigning their preservation to those working in paper conservation. A growing recognition that the skills required for photograph conservation are distinct from (yet complementary to) those in paper conservation has resulted in the establishment of two pivotal initiatives, both funded by the Mellon Foundation.

Advanced Residency Programme in Photograph Conservation

In 1999 George Eastman House, in collaboration with the Image Permanence Institute of Rochester, New York, established a two-year Advanced Residency Programme in Photograph Conservation. The programme was modelled after medical residency programmes through which Fellows may pursue topics that are

not addressed in-depth elsewhere. This approach is unique in conservation education. Rochester provides an ideal location, offering a high concentration of resources for teaching and research in photograph conservation. The educational context of this advanced programme focuses on three broad topics: imaging technology and technical history, presented in intensive course work throughout the first year, conservation treatment, taught in supervised sessions during both years, and research methods, supervised by the scientific staff at the Image Permanence Institute during both years. In addition, each Fellow is required to complete a research project directed towards developing improved characterization methodologies, the building of meaningful databases and the creation of teaching resources. Admission requirements include a degree from a recognized American graduate programme in conservation (or equivalent international experience) and a demonstrated commitment to photograph conservation. To date, six Mellon Fellows have completed their studies, and eight have begun the second, two-year cycle.

Workshops

The second Mellon Foundation initiative involves the creation of a series of biannual intensive week-long workshops that offer the opportunity for collaborative study and exchange between leaders in the larger field and young professionals committed to photographic preservation. As of August 2001, there have been seven collaborative workshops. The workshops have brought together a variety of related professionals, including curators, historians, artists, scientists and conservators, from all areas of specialization. Professionals from the commercial arena, including retouchers, mounters and printers, have also been invited to share their perspectives. Rather than the usual sacrosanct focus on preservation for all time, conservators are exposed to the art of selectively scraping away part of an emulsion, the local imbibition of dyes and selective bleaching away of image material, methods used with great skill and astonishing results by photo retouchers. Clearly, while not directly applicable to conservation treatment, such techniques are essential in broadening a student's understanding of the photographic medium.

Collaborative teaching and continuing professional development initiatives

In the United States, graduate programmes in conservation have collaborated on educational projects such as the design of pilot courses and the sharing of faculty and guest lecturers. All students majoring or minoring in photograph conservation participate in intensive intra-programme workshops, known informally as the 'Shoestring Workshops' because of their lack of funding. Students from four North American graduate conservation programmes gather in one location for two or more days of intensive treatment experience. Emphasis is on hands-on work rather than documentation, thus prioritizing experience. Teachers provide introductions and demonstrations, but students also demonstrate techniques particular to their training. Exchange takes place in an informal, friendly setting, and laying the groundwork for future collegial relations and treatment-focused research opportunities.

As the size of the Photographic Materials Group of the American Institute for Conservation has grown, conservators have sought a more intimate meeting format in which uninhibited sharing and discussion of experience and conservation treatment techniques may take place. In 1991, a small group of photograph conservators gathered at Winterthur to share treatment philosophies and procedures. All participants were required to present or demonstrate processes such that all were equally open to comments and criticism. This forum, which has grown to include a changing cast of 24 conservators, has since been hosted annually at the Orraca Studio in Kent, Connecticut. One courageous colleague summarized a group of treatments completed on cased images some fifteen years prior. The conservator stated that in today's climate, with the benefit of hindsight, there were a number of treatments he would have avoided or done differently. This type of presentation provokes active discussion in which individuals may disagree, and is illuminating in viewing changing attitudes in the field as well as in areas still

requiring further research. The chemical treatment of photographs, a controversial subject at best, was chosen as the topic of experimentation in 1998. Most participants came away from the sessions with their attitudes towards chemical treatment reinforced. However, others appreciated the potential viability of some techniques, which would benefit from further investigation and consideration, e.g. the use of iodide/alcohol which could be applied locally and with greater control.

All of these efforts to evaluate, revise and expand our educational options require energy, perseverance and hard work. Communication and collaboration within the field, as well as in the greater sphere of related professionals, facilitate and enrich any efforts. Some of the most significant changes require external sources of funding and considerable effort and planning. Other grassroots movements can be initiated by an individual or a small group with little financial backing. Even minor efforts can result in a large return, particularly when results are shared with the wider community. All should be encouraged to act, be it for the improvement of a limited sphere or for the betterment of the field as a whole.

Graduate and postgraduate educational programmes continue to be evaluated and modified by conservation educators in order to accommodate the changing needs of the field. Photograph conservation educators must continue to collaborate actively, sharing resources, teaching joint seminars, encouraging research, supporting publications and working towards establishing agreement on the minimum knowledge, skills and abilities required of all practising photograph conservators.

Notes

1 Reilly, James M, 1993, *IPI Storage Guide for Acetate Film*, Rochester, NY, Image Permanence Institute, Rochester Institute of Technology.
 Reilly, James M, 1995, *User's Guide for A-D Strips. Film Base Deterioration Monitors*, Rochester, NY, Image Permanence Institute, Rochester Institute of Technology.
 Reilly, James M, 1998, *Storage Guide for Color Photographic Materials*, Albany, NY, The University of the State of New York.
2 Various surveys and meetings investigating research priorities have taken place and some have resulted in the reports and publications listed below:
 National Conservation Advisory Council, 1979, Report of the Study Committee on Scientific Support for Conservation of Cultural Property, Washington, DC, Smithsonian Institution.
 National Institute for Conservation, 1984, *Proposed Priorities for Scientific Research in Support of Museum Conservation*, unpublished report on file with the NIC, Washington, DC.
 AIC Task Force on Conservation Research, 1989–91, unpublished report, American Institute for Conservation.
 McCabe, Constance, 1988, Draft of photographic materials research agenda: summary of the meeting (of the Fading Committee) of December 16, 1988. Published as Appendix 2 in Hansen and Reedy, 1994 (see below).
 Hansen, Eric F, and Reedy, Chandra L, 1994, *Research Priorities in Art and Architectural Conservation: A Report of an AIC Membership Survey*, Washington, DC, American Institute for Conservation.
 Norris, Debbie Hess, 1995, Current research needs in the conservation treatment of deteriorated photograph print materials, in *Research Techniques in Photographic Conservation*, Denmark, Royal Danish Academy of Fine Arts, 101–105.
 Derrick, Michelle, 1996, *Report for the National Center for Preservation Technology and Training (NCPTT) on funding priorities in materials conservation*, NCPTT, National Park Service.
 Getty Conservation Institute meeting, 2000, *Coordinated Research Possibilities for Photograph Conservation*, Rochester, NY, Image Permanence Institute, Rochester Institute of Technology.

References

Blumenthal, Ralph, 2001, The F.B.I. investigates complaints about Lewis Hine prints, *New York Times* August 16.

Kennedy, Nora, 1996, *The Coming of Age of Photograph Conservation*, Preprints of the 11th triennial meeting of the ICOM Committee for Conservation, Paris, International Council of Museums, 591–596.

Leggett, Bill, 1999, The case for a broadly based education, *Queen's Alumna Review* March/April.

Norris, Debbie Hess, 1996, *Air-drying of Water-soaked Photographic Materials: Observations and Recommendations*, Preprints of the 11th triennial meeting of the ICOM Committee for Conservation, Paris, International Council of Museums, 601–608.

Norris, Debra Hess, 1998, *Disaster Recovery: Salvaging Photograph Collections*, Philadelphia, Conservation Center for Art and Historic Artifacts.

Abstract

A collaborative research project was established to conduct an analytical study of Durieu's Album, part of the George Eastman House collection. Two non-destructive analytical methodologies, XRF and FTIR, were used to investigate Durieu's early (~1855) toning and varnishing experiments. The album contains 119 photographs, 72 of which are toned with platinum, 23 with gold and 17 toned using a combination of both metals. Five photographs were left untoned. Three types of varnishes based on shellac, beeswax and albumen or gelatin were also identified on some of the photographs in the album. The character of so-called 'image transfers' found on some of the album pages was also investigated analytically. The results obtained in the study are discussed here in relation to the development of early photographic processes and artists' techniques.

Keywords

non-destructive analysis, XRF, FTIR, toning, coating, image transfer, identification of photographs

Investigation of Jean-Louis-Marie-Eugene Durieu's toning and varnishing experiments: a non-destructive approach

Dusan Stulik,★ Herant Khanjian and Alberto de Tagle
Getty Conservation Institute
Suite 700, 1200 Getty Center Drive
Los Angeles, CA 90049 U.S.A.
Fax: ++1 310 440 7784
E-mail: dstulik@getty.edu, hkhanjian@getty.edu, atagle@getty.edu

Alexandra M. Botelho
Advanced Residency Program in Photographic Conservation
George Eastman House
900 East Avenue,
Rochester, NY 14607 U.S.A.
E-mail: ambotelho@earthlink.net

Introduction

Conservators, curators and conservation scientists met in August 1999 at George Eastman House (GEH) in Rochester to discuss the future research needs of photographic conservation. While in Rochester, participants visited the conservation laboratories of GEH and examined the research projects of Andrew W. Mellon Fellows working there. The Durieu Album from the GEH collection was the subject of historical and conservation research by Mellon Fellow Alexandra M. Botelho. A discussion ensued as to the character and cause of the 'image transfers' apparent on a number of verso pages facing photographs in the album. It was noted that some image transfers showed many details of photographs on adjacent pages, while others showed only a shape or shadow of the corresponding photographs.

Several explanations were forwarded for these observed image transfers, ranging from the presence of platinum to the effect of the organic coatings, but a single uniform opinion could not be agreed upon. The Getty Conservation Institute (GCI) scientists proposed expanding the existing study of the Durieu Album by including detailed analytical data on the composition of the image layer and the surface coating of the photographs. This extended analytical study of the album was conducted both at GEH, where several test salt print images were prepared, toned with gold and platinum, and coated with layers of various organic coating materials and varnishes, and at the GCI, where analytical and microphotographic studies of the images in the album were conducted during two separate working visits by Alexandra Botelho.

Historical background

The album examined is an important example of early French photography on paper and dates from the mid-1850s. It is attributed to French photographer Jean-Louis-Marie-Eugene Durieu (1800–74), and is part of the Gabriel Cromer Collection (reg. no. 79:0079: 1–119) at GEH. Cromer's annotations indicate that this was one of Durieu's personal albums. The album moved with a major part of the Cromer Collection to Rochester when it was acquired by the Eastman Kodak Company in 1939. Both the Cromer Collection and the Durieu Album were eventually donated to the Photographic Collection of GEH in 1972 (Botelho 2001).

Durieu was a lawyer and a government official by profession. His importance in the history of photography is accredited to his involvement in the organization of a photographic movement in France in the mid-19th century. As General Director of Administration of Cults and member of the Commission des Monuments Historiques, Durieu enlisted photographers of the Société Héliographique in creating a pictorial record of endangered historical monuments throughout France. He was also a founding member of both Société Héliographique and Société Française de Photographie (SFP), serving as president for the latter from

★Author to whom correspondence should be addressed

1855–8. He published several important articles in the *Bulletin de la Société Française de Photographie* which helped establish him as an important photographic critic, involved both in various topics of discussion on photographic practice and the promotion of photography as fine art.

Durieu began his photographic career by first learning the Daguerreotype process in 1842, then switching to the Calotype in 1848, followed by other photographic processes in the 1850s (Guillemont 1996). He is known most for his collaboration with the French painter Eugene Delacroix, a mutually beneficial relationship described in Delacroix's diary (Newhall 1952) which produced a number of photographic studies of male and female nudes to be used as studies for future paintings. Another album by Durieu, which originally belonged to Delacroix, may be found in the collection of the Bibliothèque Nationale de France (BNF).

Durieu's Album

The album is of rectangular landscape format with photographs mounted on one side of each page only. Altogether, there are 115 mounted photographs. Four loose photographs (numbers 116–119) belong to the same registrar number but it is not known if these were a part of the album or if they were added at some later period.

The photographs in the album can be classified as portraits, nudes and semi-nudes, landscape views and photographic reproductions of graphic prints and drawings by Rembrandt and Watteau. The photographs in the album are in varying states of preservation, ranging from well preserved to exhibiting advanced stages of image fading. The tonalities of the photographs range from light yellow-brown on highly faded photographs to dark purple-brown and dark olive green on well-preserved photographs. One photograph in the album is dark blue and was identified as the cyanotype print. The other photograph in the album with an unusual color tonality is pinkish; we were not able to determine which process was used to create it.

The experiments

XRF analysis

All the prints in the GEH Durieu Album were analysed using a free-standing Kevex 075 XRF (X-ray fluorescence) spectrometer. The spectrometer is equipped with a secondary target that allows the fine-tuning of analytical conditions. Most analyses were performed using mixed strontium–barium (Sr/Ba) as the secondary target, which provides good sensitivity for both low and high atomic number elements. In some cases, Molybdenum (Mo) and Gadolinium (Gd) secondary targets were used to verify findings obtained using the Sr/Ba target.

The operating conditions of the X-ray tube were 55 kV and 3.24 mA. The secondary target head of the X-ray tube was equipped with a 1-mm diameter collimator. Due to relatively low X-ray count rates from a relatively thin image layer of the analysed photographs, and in order to obtain the good X-ray counting statistics needed for future quantitative interpretation of analytical results, the experimental counting time was extended to 600 dead time corrected seconds.

The four unmounted photographs (numbers 116–119) were also analysed using the Kevex Omicron scanning micro XRF spectrometer. The spectrometer used a single element Mo primary target, operating parameters 50 kV and 1 mA using the 100-μm (diameter) collimator. The analysis was conducted under vacuum (<500 Torr) to improve sensitivity for analysis of low X-ray energy elements (Na–Ti).

FTIR analysis

The organic components of the image layer as well as any surface coatings applied to the surface of the photographs were analysed using the Nicolet 'Nic-Plan' FTIR (Fourier Transform Infrared) microscope. Both reflectance and ATR (Attenuated Total Reflectance) techniques were performed on test samples, unmounted photographs and photographs in the album, using ATR and 15x Reflechromat FTIR objectives. The obtained spectra were the variable sums of 200–2000 scans at a resolution of 4 cm^{-1}. The number of scans was varied to ensure good spectral

Figure 1a. Portrait of a man sitting. Durieu Album (GEH reg. no. 79:0079:0035)

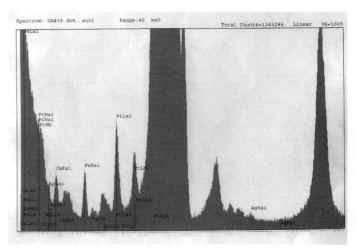

Figure 1b. XRF spectrum of a sitting man (no. 0035). Two major spectral peaks of platinum indicate the use of platinum as a toning element

resolution. The background spectra in reflectance measurements were obtained using the gold mirror attached to the 2.5-mm diameter aperture of the reflection objective. Resultant spectra were collected in reflectance format. Kramer–Kroning transformation was applied to provide absorbance spectra that were interpreted using several commercial and custom spectral libraries.

Results and discussion

XRF analysis

XRF analysis focused on identification of image-forming and toning elements, which could be responsible for the great range of tonalities and various states of preservation of the photographs in the album.

Figure 1a, portrait of a man sitting (no. 0035), shows pronounced fading. The extent of fading can be judged from dark areas of retouching, which could indicate the original tonality of the photograph. The XRF spectrum (Figure 1b) recorded at the darkest portion of the photograph showed the presence of silver as an image-forming element and the presence of platinum as a toning element. The spectrum also showed the presence of iron and calcium. Both elements are present in the paper of the album and their presence was expected also in the paper of the photograph.

Figure 2a is a photograph of a man standing (no. 0085), posing with a tall hat in one hand and a letter in the other. The photograph exhibits no visible fading and its dark purple-brown tonality indicates the presence of gold toning. This was confirmed by XRF analysis. The spectrum recorded from the dark coat of the man (Figure 2b) shows the presence of silver as an image-forming element and a relatively high concentration of gold used as a toning element. Analysis also showed the presence of calcium, iron, nickel and lead. Calcium and iron could again be assigned to both the paper of the photograph and the paper of the album. Lead was found in a number of photographs in the album. The exact source of lead and its form needs further investigation. Lead could be present in the paper of the photographs or may have been introduced during toning.

Figure 2a. Full figure portrait of a standing man. Durieu Album (GEH reg. no. 70:0079:0085)

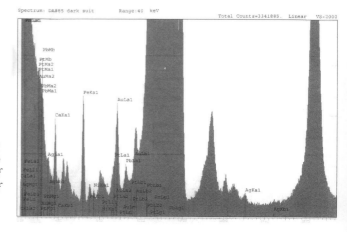

Figure 2b. XRF spectrum of a standing man (no. 0085). Two major spectral peaks of gold indicate the use of gold as a toning element

Figure 3a. Reclining nude woman. Durieu Album (GEH reg. no. 79:0079:0042)

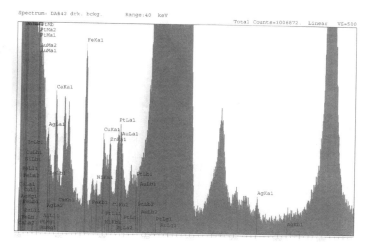

Figure 3b. XRF spectrum of reclining woman (no. 0042). The presence of spectral peaks for both platinum and gold indicates the use of combination toning

Figure 3a shows the photograph of a reclining nude woman posing on a bed draped in fabric (no. 0042). The purple-brown tonality of the photograph exhibits only moderate fading. The XRF spectrum recorded in the dark background of the photograph (Figure 3b) again shows the presence of silver as the image-forming element. In this photograph both platinum and gold are present as toning elements.

As well as these elements, calcium, iron, nickel, copper and zinc were all detected in this photograph. Calcium and iron may be assigned to the paper base of the photograph and to the paper page of the album. It is only possible to speculate when attempting to explain the presence of nickel, copper and zinc. All three elements were detected in a number of other photographs in the album. Zinc may be present in the form of zinc oxide as a paper additive or an impurity. Nickel and copper were usually present together. There is a possibility that these elements are present in the paper of the photographs or that their presence may be assigned to the paper manufacturing process or an impurity in the silver.

Analysis of all 119 photographs in the Durieu Album showed that 72 photographs were platinum toned, 23 gold toned and 17 photographs toned with both platinum and gold. Only 5 photographs were left untoned.

FTIR analysis

Besides a broad range of tonalities in the photographs from the album, the photographs also show a variety of surface treatments. Some photographs exhibit a matte surface typical of salt prints. Others exhibit a slight surface sheen. Some show clearly the presence of surface varnish.

Three major types of surface treatments could be identified in the album based on results of FTIR analysis.

The photomicrograph of the photograph of a woman in a white robe (no. 0077) reveals the presence of a thick glossy, yellow coating with a number of bubbles present in the coating layer. The FTIR spectrum (Figure 4) of the surface coating matched closely with a reference spectrum of shellac due to the presence of carbon–hydrogen stretching bands at 2931 and 2857 cm⁻¹, as well as the carbonyl doublet at 1734 and 1718 cm⁻¹, which can be assigned to the ester and carboxyl groups (IRUG 2000). Additional carbon–oxygen bands at 1240, 1160 and 1040 cm⁻¹ also match well.

The photograph of a man sitting (no. 0035; Figure 1a) exhibits an even, thin, slightly glossy coating. The FTIR spectrum of the coating (Figure 5) exhibits amid I and amid II bands at 1650 and 1550 cm⁻¹, indicating the presence of a proteinaceous coating such as albumen or gelatin.

The photograph of a lady standing (no. 006) has an even thinner coating that exhibits a slight sheen combined with a pronounced whitish bloom. The FTIR spectra of the coating (Figure 6) closely matched a reference spectra for beeswax. The presence of carbon–hydrogen stretching bands at 2920 and 2855 cm⁻¹ in combination with the carbonyl ester group spectral band at 1739 cm⁻¹ confirmed the match (IRUG 2000).

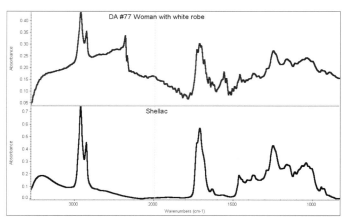

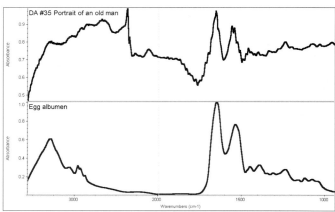

Figure 4. FTIR spectrum of organic coating on the photograph of a woman in a white robe (no. 0077)

Figure 5. FTIR spectrum of organic coating on the photograph of a sitting man (see Figure 1a)

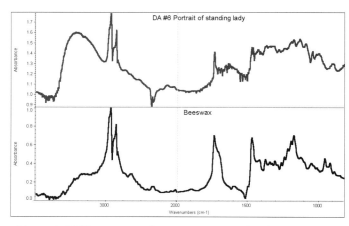

Figure 6. FTIR spectrum of organic coating on the photograph of a standing lady (no. 006)

Figure 7a. So-called 'image transfer' from the Durieu Album. Album page facing the platinum toned photograph (see Figure 1a)

Figure 7b. Detailed photomicrograph of the 'image transfer' (see Figure 7a) at 40x magnification.

We analysed 71 photographs in the album using FTIR to study various types of surface coatings. Five photographs were found to have shellac varnish, five to have wax varnish or coating, and for nineteen photographs a proteinaceous coating was clearly identified. In addition, eleven photographs contained a binary mixture of organic components that was difficult to identify due to low concentrations. The remaining organic coatings could not be identified clearly due to low or non-detectable amounts that resulted in noisy spectra.

Study of image transfers

Both optical microscopy and XRF were used to study the image transfers found on a number of pages in the album which faced photographs containing platinum. Figure 7a shows the image transfer found on an album page facing the photograph of the seated man (no. 0035; Figure 1a). The shape of the photograph is clearly visible and some features of the image, such as the man's coat and collar, can be distinguished in the image transfer. XRF analysis of the image transfer did not reveal the presence of platinum, which could be attributed to material transfer from the photograph to the surface of the page. The photomicrograph of the image transfer at 40x (Figure 7b) demonstrates that the image transfer does not consist of uniform fields of different tonalities, but rather consists of clusters of dark brown paper fibres slightly above the surface of the paper. The area density of these clusters and their number could be related to the tonality of the photograph, thus causing the image transfer.

Conclusions

The analytical study of the GEH album by Jean-Louis-Marie-Eugene Durieu makes a significant contribution to historical and art-historical studies. The album

seems to have the character of a personal or experimental notebook. Not possessing any surviving primary sources of information on processes used to create the photographs in the album, such analytical studies provide important insights into Durieu's experimentations.

Finding platinum toning in the album was very surprising. A detailed investigation of historical sources and analysis of other photographs created during the same time period would help understand how the use of platinum as a toning agent developed over time. The earliest use of platinum toning was described by De Caranza (1856). The photochemical properties of platinum and early experiments in the photochemistry of platinum were conducted by Herschel in 1831, but no application to photographs was made at that time (Schaaf 1992). The use of platinum as an image-forming element to create platinum prints was patented by Willis (1873). It is possible that early platinum toning experiments are related to experimentation precipitated by conclusions of 'the Fading Committee' in England in 1855, which outlined the beneficial effects of toning on the stability of silver-based photographs (Henneman 1855). Durieu was president of the SFP at that time and we can assume that his position gave him greater access to the experiments of fellow photographers. The collection of Durieu's photographs at the SFP contains some photographs identical to photographs in the GEH album and shows a similar range of 'experimental' tonalities and coatings.

Two types of surface varnishes were clearly identified as the coatings used on several photographs in the album. One type of varnish identified is based on shellac, the other on beeswax. A proteinaceous coating was also identified on a number of photographs. Analysis was limited to the use of non-destructive analytical methods. Samples for cross-section analyses were not available at that time. Such studies, if carried out in the future, would be very helpful in determining whether proteinaceous material was used as a sizing prior to sensitization, as surface coating or as an image layer. Employing micro-sampling and GC–MS (gas chromatography–mass spectrometry) would provide more information on the composition of multi-component varnishes.

Most FTIR analyses in this study were based on the use of reflective IR measurements. The experimental set-up at that time did not allow the use of ATR analysis on the photographs mounted permanently in the album. Future ATR analysis would provide an opportunity to analyse thinner coatings than the present reflective method allows. The study also provided some information on so-called 'image transfers'. XRF analysis showed that there is no transfer of material between a platinum-containing photograph and the adjacent page. More research is needed to describe the mechanism of image-transfer formation, but based on knowledge of the chemistry of platinum and its catalytic effects (Harley 1973), it is reasonable to assume that image transfer is caused by a catalytic action of platinum on cellulose fibres in direct contact with the platinum-containing photographic image.

Some image transfers did not show any image details; only the shapes of the photographs were 'transferred.' This can be attributed to the presence of organic coatings on some of the photographs in the album. The exact nature and mechanism of formation of these transfers, as well as the chemical mechanism of platinum-induced image transfers, will be a topic for future experiments and investigations.

References

Botelho, A M, August 2001, *Final Report*, A W Mellon Fellowship Program, Rochester, NY, GEH.

De Caranza, April 15, 1856, *Bulletin de la Société Française de Photographie*.

Guillemont, M (ed), 1996, *Dictionnaire de la Photo*, Paris, Larousse.

Infrared and Raman Users Group (IRUG) Spectral database, 2000 edition.

Harley, F R, 1973, *The Chemistry of Platinum and Palladium*, New York, Wiley & Sons.

Henneman, N, 1855, *Photographic Journal*, 3, 43.

Newhall, B, 1952, *Magazine of Art*, November, 300–303.

Schaaf, L J, 1992, *Out of the Shadows-Herschel, Talbot & the Invention of Photography*, New Haven, Yale University Press, 31–32.

Willis, W, June 5, 1873, British Patent No. 2011.

Abstract

Historic autochrome plates that do not have a final varnish layer or cover glass often exhibit flaking or lifting edges. In some cases, larger areas of delamination of the emulsion can be observed. A common stabilizing treatment for uncovered plates, which allows for safe handling and storage, is to seal the autochrome using a cover glass. However, plates that exhibit severe delamination cannot be safely sealed without prior stabilization of the fragile and brittle emulsion. This paper presents technical information on the manufacture of the autochrome plate and describes testing performed to find a treatment to consolidate flaking/ delaminating emulsions. Reproduced components of the autochrome screen and historic autochrome plates were used for testing and examination was performed using tools such as the stereomicroscope and the scanning electron microscope.

Keywords

photography, colour, autochrome, conservation treatment, consolidation, solvent vapour

An investigation into a consolidation treatment for flaking autochrome plates

Clara C. von Waldthausen★
Palmstraat 28–3
1015 HS Amsterdam
The Netherlands
Fax: +31 20 423 63 75
E-mail: c.waldthausen@planet.nl

Bertrand Lavédrine
Centre de recherches sur la conservation des documents graphiques
36, rue Geoffroy Saint-Hilaire
75005 Paris
France
Fax: +33 1 47 07 62 95
E-mail: lavedrin@mnhn.fr

Introduction

Chemical and physical composition of autochromes

The autochrome process was the first successful commercial colour process. Developed by the Lumière brothers in Lyon, France, it was used extensively between 1907 and 1935. It is a direct positive, transparent colour process on glass and can be viewed by transmitted light or projection. The complex structure is the source of the autochrome's fragile nature. An autochrome plate is composed of a superimposition, on a glass plate, of a minimum of four layers with very different chemical and physical properties. At least two hydrophobic varnishes alternate with hydrophilic layers adhering to a glass support (see Figure 1). In 1931 the glass support was replaced by cellulose nitrate and was Filmcolor. This exhibited problems of flaking similar to those discussed here (Bellone and Fellot 1981).

A review of the Lumière family archives and other private and public collections resulted in the discovery of technical notes concerning the manufacture of autochrome plates, as well as details of some of the technical problems associated with production of the plates. The notes were written either by Louis Lumière or by M. Perrigot, a technician working in the Lumière factory (Lavédrine and Gandolfo 1994). The glass support of the autochrome was carefully cleaned and coated with a first layer of varnish. A mixture of dyed potato starch (blue/violet, green, orange/red) was then dusted onto the varnished glass support leaving a monolayer of grains adhering to it. Voids between the grains were filled using charcoal black powder to avoid the penetration of extraneous white light.

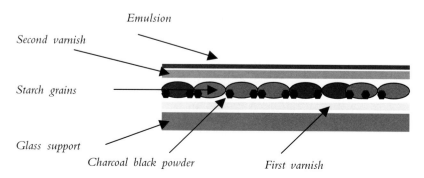

Figure 1. Structure of an autochrome plate

★Author to whom correspondence should be addressed

Figure 2. SEM image exhibiting the surface of a historic autochrome screen at 350x magnification

Figure 3. SEM image exhibiting the surface of a reproduction autochrome screen at 350x magnification

The glass support covered with varnish, starch and charcoal powder is also referred to as the autochrome screen, and is the colour component of the image after processing. Unfortunately, an unpressed autochrome screen absorbs more than 90% of the light passing through it. Also, despite a careful selection of starch grains of between 14 and 16 μm in diameter, their irregular size and shape resulted in light diffusion. To even out the surface of the screen, the Lumière brothers designed a power press. The press flattened the starch grains, thus decreasing light absorption and light diffusion. Observations using the scanning electron microscope (SEM) show a more regular surface for a pressed screen than for an unpressed screen (see Figures 2 and 3). The last of nine Lumière presses used for the production of autochrome plates has recently been restored and is currently located at in the Centre de Recherches sur la Conservation des Document Graphiques (CRCDG), Paris, France.

Once pressed, the screen was protected from water by a second varnish. Dyed starch is very sensitive to water, and without protection the dyes would have quickly migrated during the coating of the emulsion as well as during the processing of the plate. The second varnish layer increased the transparency of the screen by filling in the remaining voids and evening out the surface. The refractive index of the varnish had to be of the same order as that of the other layers of the starch screen to allow the same deflection of light by penetrating light rays in the various layers during exposure. Furthermore, the varnish had to be thin enough to avoid parallax problems that could occur if the starch grains were too far from the emulsion layer, and it had to be resistant to heat so as not to soften during projection. At the very least, the solvent used to prepare the second varnish should not dissolve the first varnish. Aromatic solvents were thus excluded and a solution of resin dammar in ethyl acetate was used. The total thickness of the three layers after drying was less than 15 μm. To complete the manufacture of the process, the autochrome screen was coated with a panchromatic, gelatin bromide emulsion. After drying, the plate was cut into different formats and packaged, four plates to a box.

Exposure and processing of the autochrome plate was performed according to the Lumière brothers' instructions included in each box. After processing the plate was allowed to dry completely and the application of a final varnish was recommended. The instructions indicate that the varnish increased the transparency and brightness of the image, ensuring better preservation and protecting the image from abrasion. Thover (1924) mentions that it is necessary to dry the plate perfectly to avoid retention of humidity in the emulsion, and thus a decrease in optimum conservation.

The Lumière brothers recommended that the final varnish be composed of a 20% solution of resin dammar in benzene. Photographers did not always apply this final varnish, perhaps in an attempt to shorten the production time or perhaps because of problems that may have been associated with its use, e.g. yellowing and the formation of orange redox spots. Problems associated with plates left

Figure 4. Detail of an autochrome plate. Frilling is visible along the upper edge

Figure 5. Detail of an autochrome plate. Delamination is visible in the upper right corner. Green spots are a result of dye migration due to contact with water

unvarnished are silver mirroring, abrading of the emulsion and sometimes the screen and, most importantly, flaking or delamination of the emulsion layer and/or of the screen.

Flaking/delamination

Considering the varied structure of the autochrome plate and the difference in composition of the layers, it is unsurprising that flaking or delamination occurs. Flaking appears to have two sources. The first is the chemical processing of the plate: the gelatin swelled in aqueous and alkaline developing solutions and often separated from the varnish at the edges, causing the gelatin edges to frill (see Figure 4). From letters and notes found in the Lumière family archives it is apparent that flaking occurred often, and that to avoid detachment of the gelatin emulsion from the screen the brothers recommended keeping the temperature of the processing solution lower than 18°C, as can be read in the instructions: '... if the temperature is too high, and also if the difference in temperature of the fixing and washing baths is too great, flaking and even a partial dissolving of the emulsion layer can result' (Anon).

The literature does not mention delamination between the starch layer and those varnishes in contact with it. Without doubt, the irregularity of the grain surface anchors the varnish layers to it. The Lumière archives do, however, indicate a separation between the glass and the entire autochrome block: varnish, screen, varnish and emulsion. Between 1929 and 1930 the company tried to adapt the nature and the preparation of the glass plate and the gelatin to prevent this problem.

The second source of flaking or delamination occurs due to a combination of factors that affect the autochrome after production. These include the weak adhesion of the emulsion to the screen, natural ageing of the layers and environmental changes. Many unsealed autochrome plates that are not coated with a final varnish exhibit flaking or delamination at the edges (see Figure 5). This physical damage to the autochrome plate poses a problem for storage and handling. The delaminated emulsion or block is generally dry and brittle and small areas can easily be lost during handling or other physical manipulation. Severe flaking or delamination cannot be stabilized solely by placing a cover glass onto the autochrome and sealing it. Any pressure, friction or slippage of the cover glass during sealing can result in the brittle emulsion or block breaking off and being lost. Instead the flaking must be stabilized. Research was thus undertaken to find a method of stabilization to make sealing of a flaking/delaminating autochrome plate possible.

Studying the deterioration of the autochrome plate

Prior to researching the stabilization of delaminating autochrome emulsions and/or screens, the characteristics of delamination/flaking in historic autochromes were studied. The major source for this research was the autochrome collection at the Institut de Paléontologie Humaine, Paris, France. This institute houses 100 autochrome plates of cave drawings from southern France and northern Spain. Judging from the expiration date on the covers of the original Lumière factory boxes in which the autochromes are housed, the photographs were taken between 1910 and 1917. None of the 100 images were sealed with a cover glass and only 52 plates of the plates were covered with a final varnish.

Many autochrome plates at the Institut exhibit signs of delamination of the edges of the emulsion due to poor adhesion of the emulsion during processing. The expanded edges of the emulsion reattached themselves to the glass support after drying and application of the final varnish, but the emulsion remains distorted in these areas (see Figure 4). Also, numerous unvarnished plates exhibit minor, active flaking of the emulsion at the edges. Others exhibit severe delamination of the emulsion, and three plates exhibit delamination of the autochrome block from the glass support. In many cases the emulsion is not lost but is lifted from the plate at angles of 20 to 60 degrees. In larger areas of delamination the emulsion curls back and the outer edges form a tight roll. When the autochrome block is partially delaminated from the glass support, slight lifting results; generally the block is too thick and rigid to curl.

Observations of historic plates under magnification

For further investigation and testing, four historic plates from the study collection of the CRCDG were examined. Several techniques were used for evaluation: visual examination, examination using a stereobinocular microscope and SEM. Two of the four historic plates used for testing do not have a final varnish and cover glass and exhibit delamination of emulsion. The remaining two plates are historic autochrome screens without emulsion. One screen is stable while the other exhibits severe cracking, delamination and flaking from the glass support.

Unexpectedly, observations during the examination using a stereomicroscope revealed a small crazing pattern in the historic autochrome screens. This crazing was not observed during visual examination, under magnification using transmitted light or during examination using the SEM. The crazing can be seen in the untreated portion of Figure 6, showing as a white random pattern surrounding groupings of coloured starch grains.

Figure 6. Photomicrograph of a historic autochrome plate. Solvent treatment was performed on the right half. Crazing is visible as a white random pattern surrounding groupings of coloured starch grains. Dark background. Magnification 25x

Conservation treatment options for consolidation

When determining various treatment options to stabilize flaking or delaminating emulsions, the following possibilities were considered: consolidation using an adhesive, consolidation using direct solvent application to regenerate adhesion of the varnish and consolidation using the action of solvent vapour to regenerate adhesion of the varnish.

The use of an adhesive to consolidate the emulsion or block was quickly eliminated. Water-soluble adhesives such as methyl cellulose (and other cellulose derivatives) or gelatin dry clear but swell the gelatin emulsion (due to water absorption), causing expansion and stress in the emulsion during and after drying. The migration of water through interstices in the varnish causes dye migration. This was proven during laboratory tests performed in order to study the sensitivity of various dyes to solvents, and can also be seen in historic autochromes, demonstrating as circular green spots throughout the image or as green areas along the edge of the autochrome plate (see Figure 5).

The use of non-water-solvent-based adhesives was also ruled out. Whilst these would not cause the emulsion to swell and expand, they could cause partial dissolving of varnish components that are solvent-sensitive. Solvent-based adhesives such as the acrylates (Paraloid B72) dry and become hard and brittle. Environmental changes can cause the various layers of the autochrome to act differently to the foreign adhesive, causing stress within the block.

The use of solvents (without adhesive) to regenerate adhesion of the emulsion or of the varnish was considered. Water was ruled out for the reasons mentioned above. The use of solvent vapour was explored because it may produce the desired adhesion without dissolving components and causing component migration in the varnish. Tests were performed to locate the appropriate techniques that would not initiate dye migration and would provide adhesion without dissolving compounds in either of the two varnishes.

Testing the action of direct solvent contact

For testing purposes the components of the autochrome screen were reproduced in the laboratory: potato starch grains 10–20 μm in diameter were separated from the rest, historic dyes used in the manufacture of the autochrome plate were mixed (red/orange, green, blue/violet), the first and second varnishes prepared, and potato starch particles dyed in one of the three dying solutions, the particles individually separated from one another and proportions of the coloured particles mixed together. Reproduction screens were made using these components. Procedures were taken from prior research performed on the autochrome process by Lavédrine (1993).

The components mentioned above and the reproduction screens were tested for sensitivity to solvent contact. Testing concluded that aside from water, ethanol produced the strongest dye migration and did not swell the varnish to produce adhesion. The non-polar solvents toluene and xylene caused solubility and

Table 1. Results indicating the solubility of the autochrome dyes to direct and indirect solvent contact

Testing	Distilled water	Ethanol 95%	Acetone 99%	Ethyl-acetate	Toluene	Xylene
Direct solvent contact with dyed starch particles placed onto Whatman paper	x	x	x	0	0	0
Direct solvent contact with dyed starch particles in solvent solution	x	x	x	x	0	0
Indirect contact of dyed starch particles with solvent vapour chamber	x	x	x	x	0	0

Note: x=soluble, 0=insoluble

Table 2. Results indicating the solubility of the components of the autochrome varnishes to direct and indirect solvent contact

Testing	Distilled water	Ethanol 95%	Acetone 99%	Ethyl-acetate	Toluene	Xylene
Indirect and direct solvent contact to the first varnish coated on Whatman paper	0	0	x	0	x	x
Indirect and direct solvent contact to the second varnish coated on Whatman paper	0	0	x	x	x	x

Note: x=soluble, 0=insoluble

Figure 7. Photomicrograph of a historic autochrome plate. Solvent vapour treatment was performed on the right half. White background. Magnification 40x

Figure 8. Photomicrograph of a historic autochrome plate. Upper circular portion exhibits the circular mark correlating to the edges of the chamber, visible after solvent vapour treatment. Dark background. Magnification 6x

migration of one or more compounds in the first and second varnishes. Acetone and ethyl-acetone caused both dye migration and dissolved varnish components.

Results

Testing concluded that due to the instability of the dyes to polar solvents and the solubility of the varnish to direct contact of non-polar solvents, the use of direct solvent contact is not recommended (see Tables 1 and 2). The non-polar solvents did not cause dye migration and were examined further using solvent vapour.

Testing the action of solvent vapour

Solvent vapour action was tested on reproduction screens using xylene and toluene. Both solvents produced adhesion in the varnishes. Although further experimentation was not conducted to determine which component of the autochrome block was affected, testing illustrates that caoutchouc, resin dammar and cellulose nitrate are all affected by xylene and toluene.

For further investigation a solvent chamber was made using Whatman Filter Paper wetted with 2 ml toluene propped into a 5 cm x 2 cm glass test tube. The solvent chamber was placed on a delaminated and cracked area of the historic autochrome screen for 5 minutes. Exposure time was determined by visual examination – when the delaminated areas of the screen had relaxed and settled into position the solvent chamber was lifted. The amount of time needed for treatment appears to be in direct correlation to the concentration of solvent in the solvent chamber. Delaminated sections were then gently pressed using silicon-coated polyester film and a Teflon® spatula.

Discussion of the effects of solvent vapour action

As a result of treatment using toluene, treated areas of historic and reproduction screens appear to have an increased colour saturation and a greater transparency (see Figures 6–8). There was no dye migration or change in colour (of the individual starch grains) of the treated area when compared visually with neighbouring untreated regions of the screen or when viewed under magnification. Examination under the stereomicroscope showed an even surface without crazing in the treated area of the historic screens. In neighbouring non-solvent treated areas the crazing is visible as a white random pattern surrounding starch particles and is the result of greater light refraction in these areas, the starch grains appearing smaller and lighter in colour than those in treated areas (see Figures 6 and 7). Due to the difference in light refraction between the treated and untreated areas, a circular mark correlating to the edges of the chamber appeared to be left behind on the screen after solvent vapour treatment had been performed (see Figure 8). Examination under the stereomicroscope and the SEM did not show an

indentation or other physical difference in this area when compared with neighbouring untreated areas. The optical change in the treated area may be due to the swelling and reformation of the varnish as a result of the solvent vapour, causing the crazing in the varnish to lessen, producing a more even surface and changing the refractive index on the surface of the screen.

Conclusion

Solvent vapour treatment appears to be a useful treatment in the consolidation of autochrome plates. Consolidation was achieved using toluene for vapour treatment. Testing indicates that direct contact with toluene does not cause dye migration. No change was witnessed in the starch grains, either visually or under magnification, after solvent vapour treatment and an overall increase in colour saturation was noted. The increase in colour saturation and darkening of the colours of the screen appears to be due to the merging of the cracks and consolidation of the varnish after vapour treatment. This also causes light refraction to diminish and results in an optical illusion whereby starch grains appear larger.

No visual evidence could be found to indicate that the change in colour saturation is characteristic of damage or deterioration of the dyes or the varnishes after vapour treatment. Although a difference in colour saturation and texture of the varnish was perceived, this difference can be attributed to reformation of the varnish, which changes its refractive index. Because of the difference in colour saturation it is recommended that solvent vapour treatment not be performed locally but on the entire plate using a larger solvent chamber. After consolidation, the emulsion or block of the autochrome can be sealed safely using a cover glass, making possible safe handling and storage of the plate.

Beneficial future research would include a detailed examination of the deterioration processes of autochrome varnishes, thus enabling greater understanding of the principles of varnish reformation. Artificial ageing tests would establish whether there is a difference in ageing characteristics between treated and untreated regions of the plate.

Acknowledgements

This research was made possible through the financial support of the Prins Bernard Cultuur Fonds of the Netherlands. The authors would like to thank Lyzanne Gann, Martine Gillet and Chantal Garnier for their help in the evaluation of the treatment and their invaluable contributions. A thank you is also extended to the Institut de Paléontologie Humaine, in Paris, France; in particular to Professor de Lumley and Mr Hurel.

References

Anon, *Mode d'emploi des plaques autochromes*, Lyon, Imprimerie J. Boulud.

Bellone, R and Fellot L, 1981, *Histoire Mondiale de la photographie en couleurs des origines à notre jour*, Paris, Hachette Réalités.

Lavédrine, B, 1993, *Les Autochromes. Approche historique et technologique du procédé Étude des problèmes liés à sa conservation. Les documents graphiques et photographiques: analyse et conservation*, Paris, Archives Nationales, 28–129.

Lavédrine, B and Gandolfo J-P, 1994, Autochromes: from the principle to the prototype, *Journal of History of Photography* 18(2), 120–128.

Thover, J, 1924, *La photographie des couleurs*, Paris, Gaston Doin éditeur.

Ethnographic collections

Collections ethnographiques

Colecciones etnográficas

Ethnographic collections

Coordinator: Marian Kaminitz
Assistant Coordinator: Jessica Johnson
Newsletter Editor: Margot M. Wright

During the first half of the triennial period, the Ethnographic Working Group's activities were focused on the very practical aspects of getting our newsletter and membership online. This was accomplished, and newsletters 20, 21 and 22 were sent out through our listserv (icom-cc-ethno@yahoogroups.com). The listserv group is now 88 members strong. The newsletters were published through the wonderful editorship of Margot Wright and guest editor Jessica Johnson.

As we come to the close of the triennial period, the programme set in Lyons has been successfully addressed by Working Group colleagues throughout the world. We have addressed toxicity of pesticides and residues on objects being repatriated. This issue has specifically occurred in museums in the United States due to federal legislation and has physical and spiritual ramifications for those handling these returned items.

Worldwide, conservators are increasingly involved with interactions between originating cultures and their cultural materials held in museum collections. These interactions have included cultural collaborations with communities and indigenous artists – such as exhibitions and conservation treatments – to present ethnographic works, to identify materials and deterioration products, and to determine treatment protocols.

Work continues to evolve and develop in these areas of interest.

Marian Kaminitz

Abstract

The use of pesticides has been a common practice by museums to control insect infestations of ethnographic collections. In the United States, the advent of repatriation legislation mandating the re-introduction of certain culturally sensitive items to their Native American cultures of origin has created a volatile situation for both the tribal and museum communities. Ritual and ceremonial use of repatriated objects contaminated with pesticides may pose serious health hazards for the recipients of these items, presenting a legal and ethical dilemma for museums. This paper discusses the Smithsonian Institution's National Museum of the American Indian's approach to recognizing and addressing the concerns of its Native American constituency, and understanding and resolving the issues related to contaminated cultural collections under its stewardship.

Keywords

American Indian, arsenic, contamination, cultural risk, culturally sensitive materials, health hazard, NAGPRA, Native American, pesticide, repatriation

Pesticides and repatriation at the National Museum of the American Indian

Jessica S. Johnson★
Senior Objects Conservator

James Pepper Henry
Repatriation Program Manager
National Museum of the American Indian
Smithsonian Institution
4220 Silver Hill Road
Suitland, Maryland 20746-2863, U.S.A.

Repatriation legislation

In November 1989, the National Museum of the American Indian (NMAI) was established through Public Law 101-185. Known as the *NMAI Act,* this historic legislation effectively transferred the collections of the Heye Foundation to the Smithsonian Institution. Furthermore, it set the framework for developing the new museum infrastructure and provided a process for inventorying, identifying and returning American Indian and Native Hawaiian human remains and funerary objects throughout the Smithsonian Institution.

This legislation was the first federal law to require repatriation of indigenous human remains by a federally funded institution to recognized lineal descendants. The argument supporting this mandate evolved from other federal policies and human rights legislation, including the *American Indian Religious Freedom Act of 1978,* created specifically to remedy government-sponsored injustices towards the American Indian population over the past two centuries.

Realizing the inherent need to extend this policy to all museums and institutions receiving federal funds for their operations and programs, the *Native American Graves Protection and Repatriation Act* (NAGPRA) became law in 1990. NAGPRA expanded on repatriation provisions of the *NMAI Act* to include sacred and ceremonial items and objects of cultural patrimony. Additionally, it provided regulations for protection of American Indian gravesites and consultation processes between recognized Native governments and institutions to reach consensus regarding these issues.

NMAI and repatriation

The NMAI has adopted and taken steps beyond the expanded repatriation provisions of the NAGPRA legislation and its subsequent amendments. The museum's mission recognizes its special responsibility to protect, support and enhance the development, maintenance and perpetuation of Native culture and community. This is accomplished through direct consultation, collaboration and cooperation with contemporary Native peoples throughout the Western Hemisphere who are culturally affiliated with the museum's diverse ethnographic and archaeological collections. Where the provisions of NAGPRA are limited to federally recognized Native governments, the NMAI has taken an inclusive approach to repatriation, acknowledging the 'spirit' of the legislation, and voluntarily extending these provisions to all of its indigenous constituents in North, Central and South America.

To some, this may seem to be a drastic approach; however, the NMAI believes repatriation and the respectful disposition of one's ancestors to be a basic human right. The museum understands that it cannot foster trust and a long-term collaborative relationship with its primary constituency if there is no equilibrium, both inter-tribally and between the tribal communities and the general non-native population. With this understanding, the NMAI has mandated the repatriation of all human remains and associated funerary objects in its possession to their culturally

★Author to whom correspondence should be addressed

identified lineal descendants, regardless of geography and socio-political borders. It has also established guidelines to facilitate international repatriations of human remains and associated funerary objects, as well as ceremonial objects and objects of cultural patrimony.

Identifying the museum's role

One stark contrast between the NMAI and science-oriented museums that manage archaeological and ethnographic collections is that the NMAI defines itself to be merely the steward of the collections and not the 'owner'. The NMAI approaches the management of its collections as a partnership with its Native constituency. The museum's challenge is to establish a balance between institutional practices of caring for culturally sensitive collections (human remains, associated and unassociated funerary objects, sacred and ceremonial objects and objects of cultural patrimony as defined by NAGPRA) and concerns of Native communities culturally affiliated with these items. Acknowledging and striving to understand the fundamental differences in the world-view perceptions of the various Native communities as contrasted with the role of the conventional museum is the critical factor in attaining this goal. This ideology must be a common denominator between the museum and the tribal communities in order for this approach to be successful.

The NMAI openly acknowledges that many of the items in its collections are unconscionably alienated from their original cultural contexts. Previous acquisition methods have been less than honourable, and in several instances have been deplorable. The infamy of this legacy remains prevalent in the long memory of the affected tribal communities.

It is important to the NMAI that its Native constituency realize the museum is forthcoming and sincere about its mixed acquisition history and past usage and interpretation of culturally sensitive collections, so that the museum can alleviate Native Americans' inherent and justified mistrust of government sponsored institutions and agencies. Through immediate disclosure, the museum hopes to begin to build trust and, eventually, equitable and long-term partnerships.

Understanding cultural risk

Understanding the beliefs and concerns of its constituent cultures is an evolutionary process for the NMAI. To fully appreciate the vast assortment of items within the collections, there must be a comprehension of the contexts from which they originate. Through direct consultation with various tribal communities, the NMAI is made aware of certain non-tangible consequences of managing, or mismanaging, culturally sensitive materials that are removed from their original cultural support structure.

Many tribal communities and Native individuals believe that objects have a life force power or living spirit that can affect human beings in a positive, negative or passive way. If these objects are purposefully or inadvertently abused or misused, they may bring harm to the individual responsible for the infraction or to persons closely associated with the individual. This concept is referred to as cultural risk.

Certain types of culturally sensitive items are the responsibility of an individual or society that has been indoctrinated to care for these items. If an item is improperly alienated without the knowledge or permission of those charged with its care, the item may be 'unbalanced' or at unrest. Only someone with the proper training and knowledge can pacify or 'retire' such an item. The NMAI recognizes that its staff members do not have this kind of expertise, as it can only be attained through a life-long absorption into a specific community.

The NMAI is actively pursuing ways to minimize cultural risk to staff working directly with collections by implementing handling guidelines for culturally sensitive items, based on the recommendations of the concerned tribal community. The NMAI has coined the phrase 'traditional care' for this particular collections management practice, even though this term is somewhat of a misnomer as it is not the intention of individual staff members to be 'traditional', but rather to be respectful of all collections. The museum encourages and sponsors recognized tribal traditional leaders to visit the collections facility and consult with staff members

concerning the long-term management of sensitive collections and to provide advice for minimizing cultural risk factors.

Complication of contaminants

Ideally, culturally sensitive collections falling within the provisions of repatriation legislation and museum policy will eventually be claimed and returned to their affiliated tribal communities where they can be properly cared for and used for their intended purpose. The museum assumes that objects claimed and repatriated as ceremonial items and items of cultural patrimony will return to ceremonial use by initiated individuals or societies.

Repatriation of items intended for ceremonial use is complicated because many of these items may be contaminated through the application of a variety of substances used to control pest infestations. The use of pesticides was a common preservation technique employed by major museums (Goldberg 1996). Only recently has the museum community begun to realize the potential health hazards that pesticide residues may pose to humans.

Some members of the larger Native community have voiced concerns over the lack of disclosure of the museum community's use of pesticides. In extreme cases, these individuals see the past application of pesticides as an overt act to sabotage tribal repatriation efforts or as a conspiracy to bring harm to tribal communities similar to the smallpox-tainted blanket incidents of the 19th century (Thornton 1987). Others view the use of pesticides as a poisoning of the object itself. In April 2000 at the Contaminated Cultural Material in Museum Collections Workshop sponsored by the Arizona State Museum at the University of Arizona, Tucson, an elder of the Tohono O'odham Nation explained that insect infestation of an object was part of that object's normal lifecycle and, through the application of pesticides, the object's lifecycle had been artificially sustained, adding to the cultural risk factor of the item.

Until recently, many museums and institutions managing ethnographic collections have not given serious consideration to the ramifications of contaminated cultural materials from both legal and ethical standpoints. Section 10.10(e) of the 1996 NAGPRA Final Regulations requires museums and federal agencies to disclose 'any presently known treatment of human remains, funerary objects, sacred objects or objects of cultural patrimony with pesticides, preservatives or other substances that present a potential health hazard to the objects or the persons handling the objects'. It is unfortunate that the phrase 'presently known treatment' is interpreted by many museums as an excuse to not investigate previous applications of these substances or to not test for the presence of hazardous persistent substances such as arsenic, mercury and lead. Ignorance of this issue by an institution can create a false sense of security among recipients of the repatriated object, which may have serious consequences.

Micah Loma'omvaya, EPA Coordinator for the Hopi Tribe, describes a stark example of what can go wrong when a museum does not disclose or thoroughly investigate its own history of pesticide use, and further fails to conduct simple qualitative testing methods to detect the presence of common but hazardous substances, before repatriating a ceremonial item to a Native community (Loma'omvaya 2001). In the spring of 2000, dangerously high levels of arsenic were found on at least two of three Hopi items tested (Seifert et al. 2000), prompting the Chairman of the Hopi Tribe to establish a moratorium on the physical repatriation of sacred and ceremonial items.

In addition to the physical contamination of these objects, there is also a cultural risk factor of metaphysical contamination. Loma'omvaya explains that Hopi ceremonial objects are considered living entities of the Hopi, who treat them with community respect and prescribed care. Loma'omvaya writes, 'We must also understand the sad response when the same Katsina priest is told that these "friends" may be contaminated with pesticides that actually poison rather than promote good health and happiness in the ceremonies conducted with them' (Loma'omvaya 2001).

NMAI and pesticides

Aside from any potential liability issues, the NMAI understands that it has an ethical obligation to research and evaluate its past pesticide use history; to inform and to

educate its employees and the tribal constituency concerning the potential health risks of exposure to contaminated items; and to provide literature that articulates these hazards and that describes methods to minimize exposure. The NMAI is also collaborating with other institutions and agencies to investigate non-destructive techniques for the neutralization and removal of toxic residues from culturally sensitive materials. This proactive approach is a conscious effort by the museum to be forthright and to minimize any technical and financial burden to the repatriating tribal communities.

Investigating the museum's history of pesticide use is a challenge. In general, most museums have not been diligent in keeping records of chemical treatments of collections. The NMAI faces such a dilemma. The museum has completed a historical review of its documentation on pesticide use in collections, including reviews of old purchase orders and correspondence, interviews with past conservators and curators, and careful examination of old photographs (Pool 2001). Through this investigation, NMAI has found that organic fumigants, including naphthalene and dichlorvos, were used widely in the collections. There is little evidence of extensive use of such heavy metals as arsenic or mercury. However, this does not mean that collections were not treated with other pesticides before acquisition or while on loan to other institutions.

A lack of records should never be an indicator that an object has not been chemically treated. The NMAI assumes that all items in the collection have been treated or exposed to pesticides at some point. It is the protocol of the museum to recommend testing for the presence of certain pesticide residues on all items considered for repatriation. The NMAI Conservation Lab has the ability to conduct relatively inexpensive, non-destructive, in-house qualitative testing for persistent hazardous substances including arsenic and lead; lead was not used as a pesticide, but appears to originate from environmental contamination. Quantitative analysis requires samples to be sent to a specialized off-site laboratory. However, results from non-destructive quantitative analysis do not provide actual levels of contamination of an entire object, and the results are presented as qualitative.

Health and safety concerns for staff members working directly with collections led to the development of a general survey for the detection of heavy metals using a rented portable x-ray fluorescence unit. This analysis provided a map of the relative concentrations of lead, arsenic and mercury in previous storage areas. Blood and urinalysis testing on individuals was also carried out. This research shows that while heavy metals (lead, mercury and arsenic) are in collections areas and on artefacts, no hazardous exposures to personnel are occurring, assuming all safety precautions are being used. To date, no hazardous exposure levels have been documented.

Through consultation, it is important for both the museum and the concerned tribal community to understand the ramifications of sampling and testing an object and the interpretation of testing results in order for the tribe to make an informed decision about the object's ultimate disposition. The decision to conduct testing, and to what extent to test, resides with the tribal community requesting repatriation, as there are cultural risk factors to consider. Some tribal communities may view the sampling of an object as invasive and therefore culturally inappropriate. Others request participation in the actual testing process to prepare the object for sampling and to offset any disturbances through its handling, minimizing cultural risk factors. In all scenarios, the tribe is informed of the potential health risks of using and storing the item and is provided with handling guidelines that they may or may not chose to follow.

The NMAI works closely with the Smithsonian's Office of Environmental Management and Safety to develop comprehensive handling guidelines concerning objects that may have been treated with pesticides and other hazardous substances. These guidelines will eventually be distributed to all of the museum's tribal constituents and to various institutions and agencies managing ethnographic collections. Additionally, new methodologies for testing and identification of pesticides are being investigated and results of these efforts will be presented at the conference in Brazil. Regional workshops to educate the tribal communities about this issue are being coordinated by the NMAI Repatriation, Conservation and Community Services offices.

Shepherdstown contaminated-collection symposium

The NMAI also supports the development of collaborations between Native Americans and professionals who are interested in different aspects of the pesticide residue dilemma. In April 2001, a symposium titled 'Contaminated Collections: Preservation, Access and Use' was hosted by the Society for the Preservation of Natural History Collections (SPNHC), the NMAI and the National Park Service. The symposium was funded primarily under a grant from the National Center for Preservation Technology and Training.

This gathering followed two previous efforts to address this issue. The first was the Contaminated Cultural Material in Museum Collections Workshop held for Arizona tribal groups in April 2000. This workshop is documented in *Old Poisons, New Problems: Information and Resource Guide for Contaminated Cultural Materials in Museum Collections* (2001). The second was a working conference held at San Francisco State University in September 2000 titled The Contamination of Museum Materials and the Repatriation Process for Native California. Those proceedings are published in the journal of the Society for Preservation of Natural History Collections, *Collection Forum*, Volume 16, Nos. 1 and 2, Summer 2001.

The Shepherdstown symposium was published in *Collection Forum*, as Volume 17. The papers were also printed with a different cover and about 500 copies were made available to Native American museums and individuals. All the papers published in *Collection Forum* volumes 16 and 17 are available on the SPNHC Website (www.spnhc.org/). The publication of these three conferences makes available a wealth of basic information for museums, tribes, public health officials and scientists who are working toward an understanding and resolution of these issues in different areas of the world.

The Shepherdstown symposium brought together individuals who had been actively working on various aspects of the problem. Participants were pre-selected based on their individual experiences and expertise, specifically for the purpose of creating a think tank to effectively address the symposium objectives. The symposium format started with selected presentations and papers. Twelve speakers collectively addressed topics of testing; tribal perspectives and training; regulatory, legal, and ethical issues; exposure and risk; and mitigation and decontamination. Over the course of two days the participants met in small groups, after each topic presentation, to roughly define issues and develop recommendations.

The main objectives identified in the Executive Summary were to:

- establish a national agenda with regional, local and tribal flexibility based on clear short- and long-term objectives
- develop and promote cross-cultural communication for understanding that leads to mutual respect
- ensure that communication of technical information includes presentation and interpretation of data that helps to explain uncertainty and allows for informed decision-making
- provide information and knowledge support about databases, testing procedures, health assessment/exposure, and research and development
- develop and validate hazard control and decontamination
- develop a code of ethics regarding collections-based hazards for institutions that hold public trust collections.

Conclusion

The National Museum of the American Indian supports the continuation of ceremonial and ritual life among Native American people, fosters and supports the study by indigenous communities of their own traditions, and endeavours to forge consensus among the museum and the Native American constituency while accounting for and balancing the interests of each. To carry out this mission, there must be continuous dialogue between the museum and the Native American community to assure that all viewpoints and beliefs are considered. Disclosure of past collections management practices, including the use of chemical pesticides, is essential in mitigating potential health hazards and cultural risk factors affecting the museum staff and Native American constituency.

Acknowledgements

Thanks to our colleagues Alyce Sadongei, Nancy Odegaard, Marian Kaminitz, Leslie Williamson, Catherine Hawks, Marilen A. Pool, Scott Carroll, Kathy Makos, Micah Loma'omvaya, Stephanie Makseyn-Kelley, Gerald McMaster, Nancy Oswald, Dorene Red Cloud and Terry Snowball.

References

Goldberg, L, 1996, 'A history of pest control measures in the anthropology collections, National Museum of Natural History, Smithsonian Institution' in *Journal of the American Institute for Conservation* 35(1), 23–43.

Loma'omvaya, M, 2001, 'NAGPRA Artifact Repatriation and Pesticides Contamination: The Hopi Experience' in *Collection Forum* 17:1–2.

Meister, B, 1997, *Mending the Circle: Understanding and Implementing NAGPRA and the Official Smithsonian and other Repatriation Policies*, New York, American Indian Ritual Object Repatriation Foundation.

Nason, J D, 2001, 'Poisoned Heritage: Curatorial Assessment and Implications of Pesticide Residues in Anthropological Collections' in *Collection Forum* 17:1–2.

National Museum of the American Indian Act (NMAI Act), 1989, Public Law 101-185.

National Museum of the American Indian (NMAI), 2001, Repatriation Policies and Procedures.

Native American Graves Protection and Repatriation Act (NAGPRA), Final Regulations, 1996.43 CFR 10.Section 10.10(e).

Odegaard, N, Carroll, S and Zimmt, W S, 2000, *Material Characterization Tests for Objects of Art and Archaeology*, London, Archetype Publications.

Odegaard, N, Pool, M and Sadongei, A (eds), 2001, *Old Poisons, New Problems: Information and Resource Guide for Contaminated Cultural Materials in Museum Collections*, Tucson, Arizona, Arizona State Museum, University of Arizona.

Odegaard, N and Sadongei, A, 2001, 'The Issue of Pesticides on Native American Cultural Objects: A Report on Conservation and Education Activities at the University of Arizona' in *Collection Forum* 16:1–2, 12–18.

Pool, M, 2001, *Pesticide Use History at the National Museum of the American Indian*, Unpublished report on file in the Conservation Department, National Museum of the American Indian.

Seifert, S A, Boyer, L V, Odegaard, N, Smith, D R and Dongoske, K E, 2000, 'Arsenic Contamination of Museum Artifacts Repatriated to a Native American Tribe' *Journal of the American Medical Association* 2383(20), May 24/31, 1–3.

Thornton, R, 1987, *American Indian Holocaust and Survival: A Population History Since 1492*, Norman, University of Oklahoma Press.

Abstract

The ethnographic conservator's repertoire easily transfers to contemporary art because modern objects share many of the same problems associated with traditional works, such as identifying materials, stopping deterioration agents and selecting treatments. Two case studies illustrating conservation issues of contemporary art at the Smithsonian Institution's National Museum of African Art (NMAfA) are discussed. A sculpture and a ceramic fabricated in the last ten years exhibit efflorescence. Technical studies were conducted on both objects and valuable contextual information was derived from interviews with the artists. A corrosion inhibitor applied to an iron chain is the cause of the efflorescence on the sculpture; calcareous inclusions in the ceramic body, which resulted in lime popping, caused the deterioration in the ceramic.

Keywords

African contemporary art, ethnographic conservation, archaeological conservation, efflorescence, corrosion inhibitor, cyclohexylamine, lime popping

Common problems in archaeological and ethnographic conservation intersect with the contemporary: case studies of two African objects

Dana Moffett*, Stephanie Hornbeck and Stephen Mellor
National Museum of African Art
Smithsonian Institution
950 Independence Ave. SW
Washington, D.C. 20560, U.S.A.
Fax: +1 (202) 357-4879
E-mail: dmoffett@nmafa.si.edu

Introduction

To fulfil its mandate to collect and preserve the visual arts of Africa, the National Museum of African Art (NMAfA) began acquiring contemporary works in the early 1990s. The museum has collected works by workshops, regional schools and formally trained artists, which together represent a variety of techniques, media and influences. Modern objects share many characteristics and materials common to traditional African collections and anthropological collections in general. Moreover, new media incorporating diverse aesthetic influences further links these objects to global contemporary art. The ethnographic conservator's repertoire is readily transferable to the problems associated with modern materials.

The case studies are a sculptural panel with imagery rooted in the turbulent history of South Africa, yet fabricated from found objects in New York City, and a ceramic vessel referencing traditional Nigerian and Kenyan pottery techniques, yet executed in England with British-sourced clay. In both cases, interviews with the artists provided insight regarding materials, aesthetic decisions and context, which in the case of archaeological or ethnographic objects must be meticulously reconstructed from material evidence or associated ethnological data. Both objects were produced within the last ten years and exhibited efflorescence. Efflorescence is familiar to the ethnographic conservator and occurs as soluble and insoluble salt contamination, fatty bloom or residual fumigants. However, its appearance on objects recently manufactured indicated problematic materials choice.

Case study: Nemasetoni sculpture

The work of Rudzani Nemasetoni, a South African artist living in New York City, reflects his experiences growing up under apartheid. It addresses the government's use of aesthetics in official documents, such as the decorative patterns and colours in passbooks, which were the official identification document all black South African adults were required to carry. His mixed media series, consisting largely of found objects and called *Urban Testaments I–IV* (NMAfA 95-13-7 to 10), incorporates reproductions of the pages, stamps and signatures in his father's passbook. *Urban Testaments IV* is comprised of an etched copper plate rendering of a passbook stamp and a window frame mounted onto a wooden panel covered in iron sheeting (Figure 1). Rusted chains, window pulleys and iron hardware representing the Soweto urban environment are embedded across the piece using pigmented plaster.

Three years after acquisition, *Urban Testaments IV* was brought into the conservation lab because several small pieces of plaster had fallen off while the object was in storage. Closer examination showed extensive deterioration of the plaster. In many areas, small flakes of plaster were lifting or popping off the iron surface of the larger chains (Figure 2). Under magnification, white feathery crystals were apparent beneath the lifting plaster. On the underside of many plaster flakes, a small amount of iron was detached from the chains by the force of growing

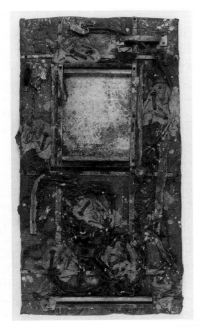

Figure 1. Urban Testaments IV. *1995. Rudzani Nemasetoni (born 1962, South Africa). Iron, wood, found objects, plaster, copper, pigment. H × W × D: 98.5 × 52 × 7 cm (38 3/4 × 20 1/2 × 2 3/4 in.) Museum purchase 95-13-10. Photograph by Franko Khoury, National Museum of African Art, Smithsonian Institution.*

*Author to whom correspondence should be addressed

Figure 2. Detail. Plaster lifting from iron chains. Some fragments retained by artist's spray-mount adhesive. Urban Testaments IV. *1995. Rudzani Nemasetoni. Museum purchase 95-13-10. Photograph by Dana Moffett, NMAfA Conservation Archives.*

crystals. Fortuitously, many lifting flakes were held on by dark brown spray-mount adhesive applied to the surface by the artist.

It was conjectured that a migration of salts contaminating the iron or plaster deterioration was the cause of the efflorescence. Microchemical testing of the plaster was positive for carbonates (this was the nitric acid test) and negative for both chlorides (the silver nitrate test) and sulfates (the barium chloride test). The crystals tested strongly positive for chlorides and negative for carbonates and sulfates. These results suggested the crystal growth was a consequence of chloride contamination of the iron and not a by-product of plaster components.

A crystal sample sent to the Smithsonian Center for Materials Research and Education (SCMRE) was subjected to scanning electron microscopy with energy dispersive spectroscopy (SEM/EDS) to determine major and minor elements present; subsequent X-ray diffraction (XRD) analysis determined the compound's crystalline structure. Elemental analysis indicated major amounts of chloride; almost all lines in the XRD pattern indicated the organic compound, cyclohexylamine hydrochloride (Feather and Hopwood 1998). The presence of this compound was confirmed by gas chromatography (Feather and Hopwood 1998).

Cyclohexylamine is a strong base and a water soluble, flammable liquid. It is most commonly used as an anti-corrosive in steam humidification and water boiler systems. In these condensate systems, the thermal breakdown of naturally occurring carbonates in the feed water produces carbonic acid, a major corrosive agent. The low resultant pH exacerbates corrosion of ferrous metals within the system. To retard corrosion by neutralizing the acid, anti-corrosives such as amines are added. The liquid amine is supplied to the system, vaporized and carried throughout the piping with the steam.

A similar compound, cyclohexylamine carbonate, has been used in the vapour phase as a corrosion inhibitor for museum collections, farm machinery and military equipment (Langwell 1966, Sharma 1989). Paper conservators used this chemical for vapour phase deacidification but the practice was terminated due to reports of the paper yellowing when aged (Ruggles 1971).

Cyclohexylamine hydrochloride crystals were previously identified on collection objects at the Glenbow Museum in Calgary, Alberta, Canada, where the steam humidification system used cyclohexylamine as an anti-corrosive (Dumka 2001). The objects in question were originally used for pickling and contained residual chlorides and acids, thus accounting for the reaction with ambient amines to form crystals (Dumka 2001). Because the HVAC system at NMAfA does not use volatile amines, the source of the cyclohexylamine hydrochloride crystals on *Urban Testament IV* remained a mystery. While chemical suppliers knew of no industrial application, it was conceivable that an individual chain manufacturer or previous owner attempted to prevent corrosion by dipping the chain into liquid cyclohexylamine (Anjard 2001, Corbett 2001).

Correspondence with the artist revealed that he did not add corrosion inhibitor to any of the metal components of the piece. He did collect the chains from a marine environment and they had been used for mooring boats (Nemasetoni 1998). Furthermore, cyclohexylamine is water-soluble and usually used in the vapour phase to neutralize acidic gases; therefore, it seemed curious that it would remain on chains exposed to the elements and to seawater. According to Corbett, cyclohexylamine does form a protective barrier layer on the iron surface that remains contiguous in an environment of pH 8.5 (Knaack and Brooks 1973, Corbett 2001). The exact mechanism for barrier formation and retention is unclear. Presumably it results from adsorption of protective ions onto the metal's surface and from formation of a protective molecular film. If this protective layer was retained on the chains, when the carbonate plaster was introduced, the pH most likely increased dramatically thus breaking down the cyclohexylamine-iron barrier, yielding available cyclohexylamine for crystal formation (Corbett 2001). Undoubtedly, the marine environment where the chains were collected provided chlorides in the iron lattice for the hydrochloride compound formation. A specific source for the acidic component for the catalytic formation of cyclohexylamine hydrochloride is less apparent, but the reaction environment could have been rendered acidic by seawater or atmospheric CO_2.

Figure 3. Untitled 1. *1994. Magdalene Anyango N. Odundo, (born 1950, Kenya). Ceramic. H × W × D: 47.5 × 42.8 × 42.8 cm (18 11/16 × 16 7/8 × 16 7/8 in.). Museum purchase 95-8-1. Photograph by Franko Khoury, National Museum of African Art, Smithsonian Institution.*

Figure 4. Photomicrograph (12′) of minute white accretions on lip of vessel. Untitled 1. *1994. Magdalene Anyango N. Odundo. Museum purchase 95-8-1. Photograph by Stephanie Hornbeck, NMAfA Conservation Archives.*

Figure 5. Photomicrograph (64′) of minute white accretion and spalled slip on neck of vessel. Untitled 1. *1994. Magdalene Anyango N. Odundo. Museum purchase 95-8-1. Photograph by Stephanie Hornbeck, NMAfA Conservation Archives.*

After consultation with the artist, the conservation treatment was to reattach larger detached and partially detached fragments; minute losses were not restored. Crystals were brushed away carefully to avoid transferring them to other areas on the object. An isolating layer of 20% Acryloid B-72 in acetone was applied to metal surfaces exposed by the damage. Detached and lifting flakes were reattached using a more viscous solution of the same resin. Areas of large loss were isolated with a layer of B-72 before being reconstructed with putty made from B-72 and glass microballoons. To date, no additional crystal growth has been noted.

Case study: Odundo ceramic

The deep orange ceramic *Untitled I* (NMAfA 95-8-1, Figure 3) was fabricated in 1994 by Magdalene Odundo, a Kenyan-born artist residing in England. Odundo hand-builds her ceramic vessels using a method she developed and personalized from study in England, Nigeria and Kenya. Her repertoire focuses on a vessel form with variations occurring on the neck and mouth and on additive elements such as loops, spikes, or nodules (Berns 1995). First trained as a potter in England, Odundo's subsequent travels to Africa and America's Southwest influenced her style. Her work is not categorically African and, interestingly, she is considered a proponent of Britain's studio pottery movement.

Odundo vessels are built by coiling, using a gourd or coconut shell scraper to achieve the curved profile (Berns 1995). After a period of trial and error the artist chose a clay that is a blend of 75% Etrurian marl, a red clay from Stoke-on-Trent, England, and 25% Brick, a yellow clay from southern England (Berns 1995). At the leather-hard stage, vessels are burnished with a pebble or spoon, slipped and then polished. The slip is applied by pouring it in the inside and then dipping the vessel to coat the outside.

Odundo calls the slip *terra sigillata*, producing it by deflocculating and levigating the same clay used for the body to yield a dilute suspension. Ultimately, the pots have a very smooth, glossy surface. Formally speaking, the ancient technique of *terra sigillata* uses an illite–iron clay slip to achieve the surfaces familiar in the Greek black and red figure vases of the 6th century BC; its dissemination continued with Etruscan and Roman lustreware production (Bimson 1956). Contemporary potters using the slip find recipes readily available in books, journals, ceramic magazines and online discussion groups. It is unclear if these slips are truly *terra sigillata* or if the term is being used to apply more broadly to slips made from the same clay as the ceramic body. Odundo's first firing in a gas kiln under oxidizing conditions produces ceramics that have an even, deep orange colour. Some of the wares are then packed with wood chips and shavings and submitted to a second, or to multiple, strongly reducing firing(s) to yield a lustrous black surface, with occasional mottled firing blooms or a metallic sheen (Berns 1995, Odundo 2001).

In 1995, conservators noted tiny white accretions (Figure 4) on the vessel's surface. Found in discrete spots over the entire vessel, these salts caused minute spalling of the slip layer (Figure 5). They interrupted the flawless, smooth, monochromatic orange surface and were visible from two metres distance. Of the three NMAfA Odundo ceramics, only *Untitled I,* an oxidation ware, exhibits this condition; the other two are reduction wares. Odundo's orange vessels in other public and private American collections show this efflorescence. However, no known analysis has been done. It was conjectured that the accretions pertained to a temper or flux and research indicated that contemporary potters used Calgon™, sodium hexametaphosphate, as a defloculant for *terra sigillata* slips.

Qualitative microchemical testing was not possible due to small sample size (less than 0.5mm in diameter). Two samples were analyzed with SEM-EDS and XRD at the Conservation Department, Arthur M. Sackler Gallery/Freer Gallery of Art, Smithsonian Institution. Analysis of both samples was identical: a mixture whose principal constituent was Portlandite, $Ca(OH)_2$ (Douglas 2001). Elemental analysis corroborated the presence of calcium, carbon and oxygen as major constituents and revealed the presence of trace amounts of chloride (Douglas 2001).

The Portlandite derived from calcite ($CaCO_3$) inclusions that were calcined to lime (CaO) during the firing process. Upon cooling, water was absorbed to yield

Portlandite. The Portlandite molecule is larger than the calcite molecule and unless actions are taken to mitigate it (described below), its presence results in lime popping, also known as lime blowing or lime spalling, within specific firing temperature ranges. Affected ceramics can explode, disintegrate or spall. The decomposition of calcium carbonate occurs at approximately 870°C; thus, lime popping results on ceramics fired under oxidizing temperatures of 850°C to 1000°C. Because the effects of lime popping are due to water absorption, the time frame for occurrence is variable, appearing as soon as the fired ceramic cools or several weeks or months later.

Clay inclusions and Odundo's preferred oxidizing firing temperature combined to make *Untitled I* susceptible to lime popping. Calcium carbonate may be present in calcareous clay or added as a shell or limestone temper. In *Untitled I*, it was a natural inclusion in the marl clay used to build the vessel. Odundo's oxidized vessels are fired once to cone 09-07 (930°C to 975°C), well within the temperature range where calcium oxide forms. In contrast, the vessels chosen for reduction firing are fired to cone 014-012 (795°C to 840°C) (Odundo 2001). Upon inquiry, Odundo said she knows her vessels exhibit lime popping because of the 'mined secondary deposit marl' that she uses (Odundo 2001).

Firing ceramics in a different temperature range, below 850°C (e.g. Odundo's reduction wares) or above 1000°C, would avoid lime popping. At temperatures above 1000°C, the calcium in the clay becomes part of the liquid phase with sintering and vitrification. New calcium compounds, silicates or ferrosilicates, are formed and as a consequence, rehydration cannot occur (Rice 1997). Firing in a reducing atmosphere yields similar effects, even at lower temperatures, because calcareous components are melted, thereby avoiding the formation of lime (Rice 1997). In fact, Odundo experimented with firing at higher oxidizing temperatures but was unsatisfied with the results above 1000°C, when 'the clay fires into a brick red, vitrifies and gets a brown-red'; the firing temperatures she uses are 'a deliberate choice to get desired colour [that is] soft, like traditional work' (Odundo 2001). Odundo has accepted lime popping on her orange vessels as a side effect of the clay she uses and the oxidizing temperature range that produces the desired coloration (Odundo 2001).

Archaeological literature demonstrates that lime popping and mitigation methods have been known to potters (e.g. pre-historic Native American and present-day Melanesian) working with calcareous clays and tempers for centuries (Stimmel 1982). Depending upon calcite content, additions of as little as 0.5% sodium chloride will inhibit lime popping. The salt acts as a flux either by promoting a reaction between calcite and iron to form stable compounds below 900°C to 1000°C or by lowering the onset of vitrification so the calcite is sealed off from contact with water vapour. The formation of Na_2CO_3, provided by an ionic exchange of reciprocal salt pairs $CaCO_3$–$NaCl$ and $CaCl_2$–Na_2CO_3, results in larger pore formation, which allows room for the re-assimilation of water, thereby avoiding the problem of spalling (Stimmel 1982). The detected trace amounts of chlorides in the samples removed from *Untitled I* appear to be an accidental addition that may pertain to the clay or water used. Nevertheless, the presence of sodium chloride may have mitigated the lime popping; indeed, compared to affected archaeological wares, the problems on *Untitled I* are minor.

Several important factors influenced a decision not to treat the object. Since its arrival at NMAfA, the problem has not worsened and due to its present stable museum environment, further damage is not anticipated. As Portlandite is an insoluble salt, the soaking and poulticing methods used for soluble salts were not appropriate solutions. Because the salts present are actually a mixture, the stable humidity range is broader than that for a single salt (Price 1994); consequently, storing the ceramic at an appropriate humidity level is impractical. Mechanical removal of the salts could be undertaken; however, the slip has already spalled where the salts have crystallized, so aesthetic improvements would be insignificant. Similarly, inpainting the tiny spots would not likely result in satisfying aesthetic improvement. Also significant, Odundo regards the spalling as an acceptable consequence of her manufacturing technique. As is frequently the case with ethnographic and modern materials, non-intervention appears to be the best solution at present.

Conclusion

The approach by ethnographic conservators to traditional non-Western objects (identifying materials, deterioration processes and treatment options) is not unlike that for contemporary objects. The technical studies carried out on the efflorescence exhibited on Rudzani Nemasetoni's *Urban Testaments IV* and Magdalene Odundo's *Untitled 1* demonstrated that these contemporary objects present familiar deterioration and inherent vice problems, similar to those of many ethnographic and archaeological objects. Understanding the causes of these two instances of efflorescence, the application of a corrosion inhibitor and rehydrated calcareous inclusions, was necessary in order to select appropriate treatment protocols. The archaeological and ethnographic literature was drawn upon for reference.

The conservators' investigations were significantly enriched by interviews with the artists. These elicited valuable information for determining the mechanisms involved in the efflorescences. Furthermore, as the artists described the materials and techniques of art production, personal choices became clear. As Odundo desires a specific coloration and Nemasetoni elects to work with found objects, inherent vice is an acceptable consequence to them. In addition to providing this kind of information, living artists may wish to advise on the treatment of their objects as was the case of *Urban Testaments IV*. Ultimately, because of the nature of the efflorescence, each reaction apparently was completed with no further damage anticipated, so these objects received minimal intervention and little interference with their current aesthetic appearance.

Acknowledgements

We appreciate the useful information and insight into their respective working methods generously provided by artists Rudzani Nemasetoni and Magdalene Odundo. We are grateful to Walter Hopwood, an organic chemist, and Melanie Feather, Scientific Support Coordinator, Smithsonian Center for Materials Research and Education, as well as Janet Douglas, a conservation scientist with the Conservation Department of the Arthur M. Sackler Gallery/Freer Gallery of Art, Smithsonian Institution, for technical analyses undertaken on these objects. We are indebted to Richard Corbett of Corrosion Testing Laboratories, Inc., Newark, Delaware, for interpreting the behaviour of cyclohexylamine on iron surfaces.

References

Anjard, C, 2001, Personal communication, York, Pennsylvania, North Metal and Chemical Company.

Berns, M C, 1995, *Ceramic gestures: new vessels by Magdalene Odundo*, Santa Barbara, University Art Museum, University of California.

Bimson, M, 1956, 'The technique of Greek black and *terra sigillata* red' *The antiquaries journal* 36, 200–205.

Corbett, R, 2001, Personal communication, Newark, Delaware, Corrosion Testing Laboratories, Inc.

Douglas, J, 2001, Personal communication, Washington, D.C., Conservation Department, Arthur M. Sackler Gallery/Freer Gallery of Art, Smithsonian Institution.

Dumka, H, 2001, 'Amines in steam humidification systems', February 15, 2001, Conservation distList: <http://palimpsest.stanford.edu/byform/mailinglists/cd1/1997/0513.html>.

Feather, M and Hopwood, W, 1998, *Smithsonian Center for Materials Research and Education Report* 5658, April 23, 1998. Washington: SCMRE.

Knaack, D F and Brooks, D, 1973, 'Inhibitors for temporary protection' in Nathan, C C (ed.) *Corrosion inhibitors*, Houston, Texas, National Association of Corrosion Engineers, 220–227.

Langwell, W H, 1966, 'The vapour phase deacidification of books and documents' *Journal of the society of archivists* 3(3), 137, London Society of Archivists.

Maniatis, Y, Simopoulos, A and Kostikas, A, 1981, 'Mössbauer study of the effect of calcium content on iron oxide transformations in fired clays' *Journal of the American Ceramic Society* 64, 263–269.

Maniatis, Y, Simopoulos, A and Kostikas, A, 1983, 'Effect of reducing atmosphere on minerals and iron oxides developed in fired clays: the role of Ca' *Journal of the American Ceramic Society* 66, 773–781.

Nemasetoni, R, 1998, Personal communication, New York, New York.

Odundo, M, 2001, Personal communication, Farnham, England.

Paller, J, 2001, Personal communication, Newark, Delaware, Corrosion Testing Laboratories, Inc.

Price, C and Brimblecombe, P, 1994, 'Preventing salt damage in porous materials' in Roy, A and Smith, P (eds.), *Preventive conservation: practice, theory, and research*, IIC, Preprints of the contributions to the Ottawa congress, September 12–16, 1994, 90–93.

Rice, P, 1987, *Pottery analysis: a sourcebook*, Chicago, The University of Chicago Press.

Ruggles, M, 1971, 'Practical application of deacidification treatment of works of art on paper' *Bulletin of the American Group - International Institute for Conservation* 11(2), 76–84.

Sharma, V C, 1989, 'Corrosion inhibitors in conservation' in Agrawal, O P (ed.), *Conservation of metals in humid climates: proceedings of the Asian regional seminar*, December 7–12, 1987, Rome: ICCROM, 37–40.

Stimmell, C, Heimann, R B and Hancock, R G V, 1982, 'Indian pottery from the Mississippi Valley: coping with bad raw materials' in Olin, J S and Franklin, A D, (eds.), *Archaeological ceramics*, Washington, DC, Smithsonian Institution Press, 219–228.

Resumen

Hablar de colecciones etnográficas y antropológicas, de culturas materiales, es hablar de definiciones de las diversidades, significados, conceptos; lo que de modo general crea polémica. La propuesta de este artículo, es indagar y reflexionar sobre los conceptos de conservación de los objetos que forman estas colecciones; hacer una relectura de sus valores. Empezar a ver más allá de los objetos individuales, incluso más allá de los objetos mismos.

Palabras claves

colecciones, culturas materiales, valor reflejar, plumaria, técnicas, conservación

Renovación del enfoque de las tradiciones culturales del pasado y presente

Monica Adriane Paixão
Conservadora a contrato
MME – Musei Vaticani
Estato, Cittá del Vaticano
Tel: 39 06 580 3263
E-mail: mapp@katamail.com

Introducción

Trabajando desde algunos años en conservación y/o restauración de artefactos plumarios sudamericanos para museos italianos, fui sorprendida al darme cuenta – no solo de la gran cantidad de artefactos indígenas en las colecciones, sino también empecé a descubrir una 'nueva cultura'.

Actualmente, trabajando para los Museos Vaticanos – Museo Misionario Etnológico, con artefactos plumarios (que presento en este artículo), percibí que durante el período que trabajé en Brasil y en otros países de América Latina, yo conservaba colecciones de la 'cultura material colonial', como por ejemplo: tapicerías francesas, indumentos militares portugueses y varios otros objetos de procedencia europea. El valor de estos objetos está orientado por una identidad cultural ocidentalizada, en una sociedad en que es más probable ver una gran cantidad de personas en una exposición en el Museo de Bellas Artes, que en el Museo de los Indios.

A despecho de los esfuerzos llevados a cabo por los Museos etnográficos y arqueológicos para llamar la atención del público, éste generalmente pasa cuando hay un gran evento, como exposiciones específicas, publicaciones de libros o ciertos programas educativos de modo general orientados hacia niños. Además, la mayoría del público interesado en estas colecciones son personas o profesionales del sector.

Re-evaluando estos conceptos de valores y estimulada por mi experiencia personal y profesional, empecé a reflexionar sobre las colecciones etnográficas des-construyendo y enfocando los artefactos con otros ojos. Mirándolos más allá de ellos mismos... Y desde entonces tengo desarrollado un profundo interés por las culturas materiales, su concepción técnica y estética, por su significado cultural.

Colecciones etnográficas en Europa

En general de todas las manufacturas indígenas, las de 'arte plumario', fueron las que más impresionaron a los europeos que llegaron a Sudamérica en la época del descubrimiento. Durante quinientos años los productos de la cultura material de ese continente fueron transferidos para Europa, siendo muy difícil tener cuenta de la dimensión exacta de ese patrimonio, por el hecho que una cantidad significativa de los objetos ni siquiera están catalogados ni organizados.

Hoy en día, podemos encontrar miles de objetos indígenas que hacen parte de los acervos de museos etnográficos en muchas ciudades de varios países europeos como: Alemania, Noruega, Suecia, Dinamarca, Austria, Suiza, Francia, Inglaterra, Portugal, España e Italia (Freire 1998). Solo en Italia las colecciones de objetos etnográficos brasileños son conservadas – además de los Museos Vaticanos, en el Museo Nacional Prehistórico - Etnográfico di Roma – Luigi Pigorini, en el Museo de Antropología y Etnología de Firenze, en los Museos Cívicos y Universitarios de Turín, Novara, Génova, Modena, Reggio Emilia, Rimini, y en algunas colecciones misioneras de Turín, de Rubano (Padua) y de Asís (Petrucci 1983).

Según un examen realizado de colecciones etnográficas brasileñas dispersas en varias instituciones, el registro aproximado llega a doscientos. El número de

artefactos insuficientemente documentados en museos de todo el mundo, es aproximadamente 4.5 millones (Freire 1998). Con base en estos datos, y tomando conciencia de la dispersión de gran parte de los objetos de culturas materiales hechos en el pasado, queda la pregunta: ¿Quién tiene acceso a estos objetos? ¿Cuál es la función del conservador de frente a estos datos?

El carácter dinámico de las culturas materiales

Numerosas culturas tradicionales están desapareciendo, o se han modificado a través del contacto con la tecnología y valores modernos. Todo proceso cultural con configuración dinámica está sujeto a transformación; aún hoy ciertas culturas están permanentemente recreando su tradición, introduciendo nuevos sentidos y nuevos símbolos. Por otro lado, también sufren del peligro de total descaracterización no solo por el hecho que la materia prima está desapareciendo, sino también por el turismo poco exigente, donde es más importante la cantidad que la calidad.

Artefactos plumarios, cestería y cerámica, hoy son substituidos por valija (de la peor calidad), latas, plásticos y otros detritos de la sociedad industrial. De frente de la velocidad dinámica de la actualidad, nuevas situaciones históricas no solo propician, pero muchas veces exigen la formulación de nuevos significados. ' Así cada cultura en particular se mantiene en esa tensión provocada por la articulación entre tradición y innovación' (Vidal 1992).

El arte Plumaria técnicas y conceptos: Artefacto Tucano y Manto Nazca/Huari

Uno de mis más recientes trabajos para los Museos Vaticanos, era la conservación de dos objetos plumarios bastante significativos, justo por ser de culturas que ya no existen o que están dentro del triste cuadro de cambiamiento. Los objetos son un brazalete de la cultura brasileña Tukano-Waikino usado en los ritos de iniciación y un manto de la cultura precolombina Nazca/Huari.

De modo general entre los grupos tribales brasileños, la materia prima utilizada en la confección de los artefactos es básicamente la misma: fibras vegetales, pelos de animales, maderas y plumas. Sin embargo, muchas de esas culturas desarrollaron estilos propios caracterizados por atributos especiales, como forma, procedimiento técnico, materiales y combinación de colores, que en gran parte de las veces, permite identificar su proveniencia con precisión.

De los pueblos que practican el arte plumaria, sin embargo, ejercen su creatividad y capacidad inventiva mediante el desarrollo de técnicas complejas, especializadas en la confección de sus artefactos. Entre ellos están las culturas peruanas que desarrollaron una de las técnicas más sencillas y sofisticadas en la composición de la arte plumaria del pasado.

Plumaria Tukano-Waikino

Los Tukanos pertenecen a una familia lingüística distinta y comprenden diversos grupos indígenas. Todos ellos habitan en la región del Rio Uapés y sus afluentes, en el Estado de Amazonas de Brasil. Su arte plumaria es hecha y utilizada por los hombres, sobre el cuerpo (altura del codo) como ornamentos rituales de iniciación, donde dentro de su organización social tiene toda una representación y simbolismos de los cuales solo ellos mismos en su contexto conocen el significado.

La confección de artefactos de ese pueblo es fundamentada en la forma y textura de las plumas. Es difícil conseguir la materia prima, así que los Tukanos mantienen variadas especies de pájaros en cautiverio. Para almacenarlas, las plumas son unidas por fibra de palmera y guardadas en una caja rectangular hecha de tallo de Miriti (*Palmae-Mauritia setigera*).

A pesar de la gran diversidad de matices cromáticos, las combinaciones de colores son poco variables. Se basan en el rojo, negro, amarillo y blanco, con una preferencia por la combinación de rojo y amarillo. Las dos últimas son las más utilizadas para los artefactos de gran importancia. También practican la 'Tapirage', que es el proceso de sacar las plumas de los pájaros vivos, para lograr obtener plumas amarillo-naranja. Para eso arrancan las plumas verdes del papagayo y les frotan

Figura 1. Diseño del brazalete, pormenor fijación de la plumas a los hilos. Dibujo de Hamilton Botelho Malhano, sacado del libro Diccionario do Artesanato Indígena.

Figura 2. Diseño de una de las etapas de confección del brazalete. Dibujo de Hamilton Botelho Malhano, sacado del libro Dicionário do Artesanato Indígena.

Figura 3. Diseño de la técnica de fijación de las plumas entre ellas y al tejido. Dibujo y elaboración Monica Paixão, segun el Dicionário do Artesanato Indígena.

sobre la piel la secreción lechosa de una rana pequeña (*Rana tinctoria*) y al crecer las plumas aparecen con el color deseado (Velthen 1982).

Las técnicas plumarias tradicionales de los Tukanos son diversas. En el caso del brazalete la técnica utilizada es la técnica del amarre; las plumas se amarran horizontalmente sobre cordeles con hilos delgados, las plumas se fijan ya sea unas a otras, o a semillas. El brazalete es un círculo hecho por un envoltorio de cordeles de pelo de *jupara*, teniendo como pendiente cordeles más delgados del mismo material concluidos con manojos de plumas (Ribeiro 1988) (véase Figuras 1 y 2).

Manto Nazca/Huari

Hablar de estas culturas no es muy simple por el hecho que ya desaparecieron y que sus períodos de transición son bastante complejos. El Manto que conservé se encaja en la fase 9 – Horizonte Temprano, es decir hacia 700 y 800 años de nuestra era, a la llegada a la costa sureña del Perú de la influencia serrana huari se manifiesta en la textilería en lo que se denomina Nazca–Transición (Lavalle y García 1988).

En los años 1960-70 el arqueólogo Eloy L. Málaga, encontró en una excavación de la zona de Andaray, Condesuyos (Valle de Ocoña), Departamento de Arequipa, 14 mantos con decoración plumaria semejantes al que se encuentra actualmente en las colecciones del Museo Misionario Etnográfico - Museos Vaticanos.

Al referirse al arte plumaria peruana, es imposible no hacer una analogía con los textiles: las cronistas españoles han dejado extensivos datos sobre la importancia del tejido en la vida del antiguo Perú. En estas crónicas se destaca claramente como el tejido desempeñaba un papel privilegiado dentro del ámbito religioso, social, político, militar. Además, a causa de su asociación con la magia, misticismo y mitología, era objeto de una gran reverencia (Lavalle 1984). De este modo, el arte plumaria puede ser considerado en el mismo nivel de los textiles, principalmente porque la mayor parte de los objetos ornados con plumas, eran utilizados como adornos ceremoniales.

El tejido de base del manto es un tejido plano que consiste en el entrelazar elementos de urdimbre y trama en ángulo recto. Las plumas son fijadas al tejido doblando el calamo en forma de gancho y anudando a un primer hilo de algodón; un segundo hilo es anudado al centro para consolidar la posición (véase Figura 3). Las plumas utilizadas eran de *guacamayo* (*Ara ararauna*), pájaro de la región amazónica que tiene una gran variedad de color en su plumaje. Es interesante subrayar que el gran desarrollo del arte plumaria era en la zona costera del Perú, cuando los pájaros más apreciados no existían en esta región sino en la parte de la Amazonia, de la otra parte de la cordillera, donde se supone que los tenían en cautiverio.

La conservación de objetos etnográficos: un enfoque personal

Con el pasar de los años todas las veces que empecé a conservar un objeto, fui tomando conciencia que yo era responsable de una parte del pasado, de vestigios materiales de culturas lejanas. Considerando que los criterios para conservación de colecciones etnográficas son muy distintos de colecciones de otra naturaleza, como por ejemplo colecciones artísticas; muchas veces me presentaran ciertos conflictos en relación a la visión tradicional de la cultura, en función al uso y propósito del objeto. Digo eso porque los cambiamientos conceptuales están ocurriendo de forma muy acelerada. Donde el conservador y/o restaurador se tiene que adaptar rápidamente a los cambios de conceptos del pasado al presente, y muchos de los conceptos primordiales, principalmente éticos son olvidados en función del uso indiscriminado de nuevos productos y tecnologías.

No es que no creo en la necesidad de cambios, en nuevas tecnologías, pero en relación los objetos de culturas materiales los cambios podrían ser más graduales, orientados sobretodo por criterios de conservación y/o conservación preventiva. Tal vez conservar los objetos con un ritmo gradual sea una cierta forma de compensación, una forma de actuar más respetable en relación a estas culturas. Reflexionando sobre todo eso, tome la decisión de hacer el tratamiento conservativo en estos objetos, a través de la mínima intervención.

Figura 4. Diseño de la caja para almacenaje del brazalete. Dibujo Monica Paixão.

Tratamiento de conservación

Estos objetos por muchos años estuvieran como que almacenados en sus vitrinas; además el museo está cerrado al público pues actualmente está desarrollando un proyecto de reorganización de la exhibición y del sistema de conservación de las colecciones. En términos de estado de conservación no puedo decir que era uno de los mejores; no solo porque estaban expuestos de forma inadecuada, sino también por la infección de insectos en las colecciones.

Antes de empezar a intervenir en los objetos, fueran hechas una serie de análisis por el laboratorio de investigación científico de los Museos Vaticano: tipos de fibras, hongos y insectos. Donde se decidió que la desinfección debería ser hecha por el proceso de privación de oxígeno. Como eso proceso tiene un tiempo de duración (de 20 a 25 días), en este período fue posible hacer una investigación más acentuada de la proveniencia de los objetos. Los principales factores de degradación del brazalete y manto fueran: cambios climáticos muy acentuados, el ataque de insectos y manipulación inadecuada.

Brazalete Tukano

- Confección: hilos de fibra vegetal y pelo de jupara o cuchumbí (*Potos flaivus*).
- Plumas de: guacamayo bandera (*Ara macao*), japu (*Ostinops* sp.), tucán (*Ramphastos* sp.), parte de la cola.
- Carozo de tucumã (*palmea*).
- Cuantidad de hilos = 17 hilos formados por dos cables, con torsión en S.
- Medida: diam. 9 cm, longitud máx. de los hilos es de 41 cm.

Además de los factores arriba citados, el objeto presentaba excrementos de insectos dentro de los cordeles de pelo, de forma se mantuvieran unidos, casi como collados.

También en algunas partes de los cordeles se perdieran los pelos y quedaran solo las fibras vegetales. La plumas estaban comidas y muy frágiles en la región de los barbes y rachis.

El tratamiento realizado fue una limpieza profunda con brocha y micro aspiración y la creación de una caja donde no solo puede ser utilizada para almacenaje como también para exposición (véase Figura 4).

Manto Nazca/Huari

Confección: compuesto de una base de tejido de algodón natural, adornado con plumas de guacamayo formando 4 rectángulos de colores azul y amarillo. En la parte superior una banda de lana fue utilizada como un remate. Las costuras de fijación de las plumas eran todas originales. Las plumas son de más de una dimensión, todas en la posición vertical. Medida: 290 cm x 70 cm.

El manto se presentaba con muchos excrementos y huevos de insectos principalmente en la región de las plumas. En estas áreas ya casi no existían más plumas, solamente el tejido de base y en algunas otras, el tejido se fue. Las plumas por su vez se presentaban muy frágiles, con muchos calamos quebrados y barbe divididos, sobretodo las plumas azules por que son las más grandes. En la parte del tejido, había varias manchas de color marrón en tonos diversos, siendo que el laboratorio ánalisis las identifico como hongos. El manto también sufrió varias distorsiones por permanecer colgado de forma inadecuada por mucho tiempo.

La primera intervención hecho fue la limpieza meticulosa dividida por áreas, tanto delante como en el revés, con la ayuda de brocha y micro aspiración. Para eliminar los hongos en el revé fue utilizado etanol (solución hidroalcohólica a 70% en alcohol) y para limpiar otros tipos de manchas fue utilizado saliva sintética. El las pequeñas áreas donde no existía más el tejido yo utilice suporte parciales de tejido de algodón.

Teniendo cuenta de la fragilidad de las plumas y en vista de la necesidad de fijarlas, me pareció que el mejor seria la crepeline y hilos de seda, por dos motivos: primero que no era tan agresivo como ciertos productos y segundo por algunas características propias del material (compatibilidad, flexibilidad, transparencia) y el aspecto estético, pues compone muy bien las áreas donde no existen más las plumas. Por lo que tuve que teñir la crepeline del mismo color de las plumas, hecho

con colorantes direto. Por fin fue idealizada y construida una caja, un suporte, de forma que el manto puede quedar almacenado y/o expuesto.

Conclusión

Después de hacer ese enfoque sobre los objetos de culturas materiales muchas veces olvidadas no solo en sus vitrinas sino también desamparadas en muchos museos. Personalmente creo que la mínima intervención es un proceso gradual. Los soportes de los objetos bien pensados traen más beneficios que una intervención de restauración. La adaptación de los diseños de las cajas utilizadas por las culturas creadoras de los objetos ofrece muchas posibilidades para el almacenaje de los objetos. Es importante explorar esta alternativa en nuestro trabajo. Espero que a través de mi trabajo de conservación, este actuando 'políticamente correctamente', en función a estés pueblos. Tenemos mucho que aprender con ellos, y como ya sucede en otros países, empezar a formarlos en la conservación de sus propios artefactos.

Bibliografía

Dorta, S F, 2000, *A Arte Plumária Indígena Brasileira*, ed. USP, MAE, São Paulo.

Freire, J B, 1998, *Um Olhar Sobre a Cultura Brasileira. O Patrimônio Cultural Indígena*. Ministério da Cultura (www.minc.gov.br).

Guillemard, D, 1993. 'La conservation de la plume', *Conservation-Restauration des Biens Culturels* n° 5, 36–40.

Lavalle, J A y García, J A G, 1988, *Arte Textil del Peru*, Imp. Santiago Valverde S.A., Lima-Peru.

Florian, M L E, Kronkright, D P y Norton, R E, 1997, *The Conservation of Artifacts Made from Plants Material*, 3° edición, The Getty Conservation Institute.

Petrucci, V, 1983, Le Collezione Etnografiche Brasiliane in Italia, *Indios del Brasile*, 51–57, Roma, Italia.

Petersen, K S y Larsen, A S, *Cleaning of early feather garments from South American and Hawaii*, Copenhagen, The National Museum of Denmark, Conservation Department.

Ribeiro, B G, 1988, *Dicionário do Artesanato Indígena*, Ed. Universidade de São Paulo, Brasil.

Velthen, L H, 1982, *Plumária Tukano, Catálogo de Exposição Arte Plumária do Brasil*, 41–43, MEC, Brasília, Brasil.

Vidal, L, 1992, *Grafismo Indígena, Estudos de Antropologia Estética*, Edusp - Editora da Universidade de São Paulo, Brasil.

Materiales

Saliva Sintética-Triammoniocitrato
Klucell G
Cartone sin acido, Schoellrs Hammer
Bresciani S.R.L
Via Socrate 713 – 20128 Milano
Tel/Fax: 39 02 2700 2121

Cartone Vulcano
Carta Industria Mantovana
Via Panizza, 2 - Mantova
Tel: 0376/370611
Fax: 0376/372032

Ethanol 96% reinst - Merck
Importado da Braccos.p.a
Lic. U.T.I.F Min.36

Oxygen Absorber – Ageless
Save Art
Via Molajani,68
00157 Roma, Italia
Tel: 06 4362175

Tejidos de algodón, lino, crepeline y hilos de seda
Fornecidos por los Museos Vaticano

Into the Unknown Amazon . . .

Abstract

In October 2001, an innovative six-month ethnographic and archaeological exhibition opened at the British Museum. Preparations took conservators on a journey into the unknown, across continents and into related professional areas, to select and prepare objects for display. This paper will discuss how the exhibition came to fruition and the remarkable collaboration between people from dissimilar backgrounds, some with little exhibition experience: field archaeologists, ethnographers, business people and conservators with very different areas of knowledge and often without a common language.

The involvement of the British Museum's conservators at the earliest stages in planning was unusual, as the majority of objects being lent were from museums in Brazil and Europe. The benefits of early conservation input will be discussed, both in terms of the exhibition and of the conservators involved. This paper will demonstrate that conservators can make a unique contribution by using their specialist skills.

Keywords

collaboration, workshop, ceramics, toxicity

Janet Quinton* and Barbara Wills
Department of Conservation
The British Museum
Great Russell Street
London WC1B 3DG, United Kingdom
Fax: +44 (0)20 7323 8636
E-mail: jquinton@thebritishmuseum.ac.uk

Introduction

The exhibition

In the year 2000, Brazil officially celebrated 500 years of European contact. As part of this celebration, exhibitions were planned for selected museums in Europe and North America to accompany the many and varied events which had formed part of the national celebrations of Brazilian art and culture. The British Museum was approached to host one of these exhibitions.

The emphasis of the exhibition was, to quote the original design brief: 'To address the antiquity and complexity of the tropical forest civilization in the Amazon basin and bring to life the history of human occupation in the region. By focusing on archaeology, the exhibition aimed at a radical rethink of the relative simplicity of tropical forest societies.' From the European perspective, the archaeology of this area is largely unknown, whereas the ethnography of the Amazon has been explored quite extensively.

The curators set an ambitious agenda to select objects from collections in Brazil and throughout Europe. Two years is a relatively short time in which to plan an exhibition, a book, a conference and associated events. Time was short, the distances involved were sizeable and the logistics complicated. The curators felt that involving conservators at an early stage would help the project, when choosing objects, planning conservation, getting display conditions right and facilitating good relationships with the lending museums and institutions.

Background

Many of the lending museums in Brazil were small, and without specialized conservation resources. As the condition of the objects was crucial in making display choices, two conservators (the authors) were involved at the selection stage. As Amazonian ceramics were unfamiliar (there is very little published on the subject) and their condition largely unknown, a ceramics conservation specialist (Janet Quinton) was invited to join the first trip in February 2000 to visit collections in São Paulo, Rio de Janeiro and the principal settlements along the middle and lower Amazon River. An organic conservation specialist (Barbara Wills) joined the group for a subsequent trip in July 2000 to São Paulo, where much of the organic material was on display and a good choice could be made from the available objects.

Conservation pre-planning

Conservation pre-planning for these trips involved anticipating problems that might occur and devising a method of making the information accessible once back in London. Two different forms were designed by The British Museum conservators, by which information could be recorded as each object was examined. For the ceramic objects, information such as friability of surfaces, presence of hairline cracks or stability of old restoration was noted and estimates were made of time

*Author to whom correspondence should be addressed

needed to stabilize the objects and bring them to condition suitable for exhibition. A tick-box form was designed, with space for more detailed notes and a sketch where necessary to facilitate the reporting process. A camera was also taken to allow for quick working pictures to show detail and as an aid to identification.

A questionnaire relating to organic material was designed by Wills and sent in advance to all the possible lending museums. Preparations had to be made in good time in order to transport, store and display the objects safely, in accordance with the wishes of the lending museums. If conservation work was deemed necessary, who would undertake it and to what level? The museums were asked to evaluate the condition of their organic objects and to consider whether the appropriate conservation expertise was available locally.

Fernando Chaves (a freelance photographer) had warned of the possible contamination of artefacts with pesticides. He had become unwell after handling objects while photographing them. The questionnaire asked each museum and institution about the history of pesticide treatments. Had staff experienced any health problems? Were objects inherently toxic (e.g. curare-tipped darts)? Information on the ambient environmental conditions was also requested. The possibility of freezing the lent objects for pest control purposes on arrival at the British Museum was broached. Finally, the museums were asked if there were any reasons for not lending objects to The British Museum.

First contact

After the initial planning and formal approval by the British Museum Exhibition Forum, the curators and conservators from the British Museum and Brazil met for the first time in February 2000. The British Museum staff (Dr Colin McEwan, who is the curator of Latin American collections, and Janet Quinton) met in São Paulo with co-curators from Brazil (Dr Eduardo Neves from the University of São Paulo and Dr Cristiana Barreto from BrazilConnects). The four formed the curatorial team. The first visit was to Museu Nacional, Rio de Janeiro, followed by a visit to the Museu do Indio, where the team met Lucia Bastos, the conservator. Gedley Braga, conservator, showed the team the museum, the stores and the conservation facilities of the Museu de Arqueologia e Etnologia (MAE) in São Paulo.

The Museu Paraense Emílio Goeldi is in Belém at the mouth of the Amazon. Dra Vera Guapindaia, the curator, showed us the displays and the large stores, which included the workroom where objects are restored. Further west, in Santarem, the team was welcomed to the Museu Municipal de Santarém. The project was seen to be sufficiently important to be met by the local dignitaries with the local press and television reporters in attendance. In Manaus the Museu do Homem do Norte was visited, as was the excavation run by Eduardo Neves, where the team was able to see ceramic sherds *in situ*.

The conservator's contribution

It takes time and proximity to develop mutual trust, both within the core group, and between people separated by distance and language. Within the core team, the curators learned what the conservator could contribute because each worked alongside the other. For example, when the conservator tapped each ceramic piece with a knuckle, it had to be explained that the sound revealed the presence of unseen hairline cracks. The problem of hairline cracks itself also required explanation; a vessel that looks intact, and which may be safe if handling and transport is avoided, could be badly damaged if it is lent. An obscured surface might be safely revealed, using simple (to us) dry cleaning methods such as a putty rubber rolled over a small area (where the surfaces were stable).

The developing familiarity and understanding of what a conservator could offer led to a greater exchange of information. Typically, the curators discussed which objects they thought would be suitable for the exhibition and made notes. The vessels were then examined from a conservation point of view to decide what treatment would be needed, and observations were noted on the forms. Some objects were obviously in need of major conservation, having been over-restored in the past. Others required less intervention; a more aesthetic conservation

process, like surface cleaning, was appropriate. Thus the greatest help given at this stage of the project was aiding curator choice. Where the conservation of an object was too complex or time-consuming, alternatives could be selected.

As with every institution, the British Museum has a 'house style' in terms of exhibition and display. There is an expectation of how clean an object should be, how far restoration should go and so forth. While these standards were maintained, there was a compromise necessary in relation to the time available for conservation. These standards, in relation to the *Unknown Amazon* exhibition, had to be explained and this viewpoint discussed with the staff in the museums visited.

A uniform approach to the conservation done by different loaning institutions, with some reference to the British Museum's style of display, would give a cohesive appearance to the displays. For example, the style of retouching on old ceramics restorations needed to be coherent. From this, the curators took the initiative to propose that the British Museum should organize a short, collaborative, workshop in practical conservation of archaeological ceramics. The purpose was to share information and to bring objects conserved in Brazil to a standard suitable for the British Museum exhibition.

Second contact

A second trip to São Paulo was made in July 2000 to run the workshop and to select organic material objects for the British Museum exhibition. The Brazil 500 exhibition in the Pavilhao Lucas Nogueira Garcez (OCA) at Parque do Ibirapuera displayed an unprecedented range of ethnographic and archaeological material from Brazil and Europe. Along with the collections at MAE, there was much to choose from. An organics conservator (Wills) accompanied the team to help in the curatorial choices, and to consider and discuss conservation treatments should these be necessary. The 'possible' objects were systematically examined and reports written, using the forms devised earlier. The questionnaire results were assimilated and discussed with a curatorial member of the team so that the implications of the results were understood. Some early conservation decisions could be made. For example, the masks from Coimbra in Portugal were considered too vulnerable to travel again.

Subsequent to the Brazil visit, the organics conservator had visited the Museum Für Volkerkünde in Vienna. The objects to be borrowed from this institution were in remarkably good condition considering their age (collected in the first half of the 19th century), but they required some conservation cleaning of the featherwork and other minor interventions. The Department of Conservation at The British Museum had agreed to undertake necessary work on the Viennese objects, as the scope for treatment in Vienna was limited.

There was an opportunity to further refine choices of objects. For example, of two ritual ant-gloves, only one was in sufficiently good condition for travel and display. The conservation of all objects being lent by museums in Brazil, with the exception of four (two organic and two ceramic objects, conserved by arrangement at the British Museum) was to be carried out under the auspices of Gedley Braga in Brazil.

The workshop

The conservators who were to be involved with the objects in Brazil for the *Unknown Amazon* exhibition came together for the workshop and to agree a common approach to the conservation of the ceramics. They were joined by a conservator from Centro de Conservacao e Restauracao de Bens Culturais Movels in Belo Horizonte, the training centre for conservation in Brazil.

The purpose was not to dictate methodology, but to offer advice and to pass on current conservation thinking on ethics, materials and techniques used in the U.K. and the United States. The availability of some conservation materials in Brazil was limited. To widen the choices, a range of materials was sent from England for use at the workshop.

However, it was recognized that some materials might not perform well under varied conditions in the different workshops across Brazil. The environment in

Belém, for example, is much more extreme than in São Paulo, and certainly more hot and humid than in London. It was hoped that the workshop would offer some solutions or alternative approaches to help solve these problems. At the end of the week the surplus materials were divided among the museums represented. The Brazilian conservators could now test them under local working and environmental conditions.

During the weeklong workshop, slides of processes and techniques were shown in the mornings, followed by practical sessions in the afternoon. Initially, the range of treatments was to include cleaning, sticking, filling, retouching and consolidation, which were considered to be most relevant in preparing the pots for the *Unknown Amazon* exhibition. However, due to the wide range of skills of the participants, consolidation was omitted, as it would have required more time than was available to explain fully. Retouching also became a topic for discussion rather than a practical exercise.

The workshop was undertaken in the conservation room at MAE with the kind permission of the museum authorities. The exhibition sponsors agreed to fund the entire project. This was a farsighted and generous act of faith on their part as, although it was recognized as a vital addition for this exhibition, it is generally difficult to get sponsorship for conservation.

Ethical discussions and observations

As the week progressed, the participants in the workshop became more relaxed, involved and communicative. One of the benefits was the discussion of ideas and viewpoints, which occasionally led to heated exchanges. The British Museum has a well-defined approach to the conservation and repair of organic objects. Where repairs are necessary, for example, these are generally done with a material that is different from the original. This is an ethical as well as a practical choice, because it eliminates the possibility of confusion in the future. It was interesting, therefore to come across an opposite view; choosing the *original* plant material or pigment to effect repairs. The context is different; in Brazil the curator or conservator concerned was in contact with the indigenous people, understood the use of the materials and therefore felt able to apply these appropriately.

Some participants felt that The British Museum standard on retouching filled areas in ceramic objects was too close to the original ceramic colour. It was pointed out that, usually, if the appearance is close, the texture is not. If the outside is close, the inside is not, but these differences can sometimes deceive the eye at a distance. The idea is not to draw the eye to the restoration, but for it to be detectable on close inspection.

Another discussion was on the subject of painting on to original surfaces to replace lost decoration. This is often a matter of curatorial request, but from a conservation point of view, over-painting is to be avoided, although it did come up in connection with this exhibition. The role and responsibility of a conservator to influence curators and designers was explored. Curators, museum authorities and designers can benefit from conservation input to help make considered and well-informed aesthetic and other judgments. At what point can a conservator say no?

Viewing the collections in so many museums drew attention to the similarities and the differences in institutions. For example, many of the museums we visited were, like The British Museum, housed in inappropriate buildings with all the attendant problems. One marked difference is in funding, which in turn influences the conservation priorities. The emphasis at the British Museum is on exhibitions, so the conservation programme is predominantly exhibition-led and, therefore, conservation tends to be active. In Brazil, the emphasis appears to be on passive conservation, in that the reserve collection store areas received the major conservation attention and funding.

Design of the *Unknown Amazon* exhibition

Our early inclusion in the project meant that conservation issues informed the design of the exhibition. The exhibition designers had worked with The British Museum's Amazon collections before and so appreciated the implications of such

an exhibition, in that they understood the nature of the material being displayed and they accepted the restrictions imposed for the protection of the organic material.

The main conservation considerations were ensuring the dust levels in the exhibition would be acceptably low after recent millennium building works, covering the floors and carpets during installation, keeping the lights low to protect sensitive objects and making sure the storeroom conditions were appropriate and fairly constant.

For this exhibition, the gallery conditions were set at RH of 55% +/-5%, 20°C +/-2°C and 70 lux for light levels for the most sensitive organic objects (such as baskets with pigments and some feathers) with the absence of UV light. All the mounting and case materials had been tested by the Conservation Research Section and passed as suitable for exhibition purposes. Although a risk assessment had been done for handling objects with possible insecticide residues, protective gear was available, but getting people to wear it was another matter!

To keep environmental conditions constant and to eliminate potential health hazards from objects, no organic objects were to be on open display at the British Museum, with the exception of a large wooden drum. Open display of ceramics caused further concern for the lenders. In the final design the public could reach out and touch the large pots. However, after pressure was applied through the conservators and couriers from the lending institutions, a barrier was incorporated into the design. With reasoned argument all these problems were sorted out, and on October 25, 2001, the *Unknown Amazon* opened to the public for a six-month run.

Conclusion

Conservators from many institutions contributed to the exhibition by being included in discussions at a very early stage on object selection, exhibition design, artefact toxicity concerns, practical conservation treatments and availability of conservation materials. Relationships with fellow museum professionals were developed through organizing the ceramics workshop and other activities, and this aided considerably in the setting up of the exhibition. It meant that when the inevitable problems arose, these could be sorted out relatively painlessly because we knew and understood each other.

It has been a privilege to meet people and see collections in Brazil (and elsewhere) that we might never otherwise have encountered. We have been given unprecedented access to Brazilian stores and reserve collections, accompanied by their curators and conservators.

We were able to see first hand what problems they face, some very different to those of us accustomed to British conditions, although many of the problems, comfortingly enough, were very much the same. For example, the housing of a museum in inappropriate old buildings, with all the associated problems, was a shared difficulty. The exhibition has allowed us to work closely with Gedley Braga and, at a distance, with other conservators in Europe as questions arose in connection with objects coming from there.

We hope, in the future, to build on the links we have already made. There is a gap in conservation training in Brazil, with some specialist areas unavailable. However, as Brazil has such a wide variation of climate and environment, it would be wise to widen research into appropriate conservation materials and techniques for use over there, as well as to provide training in specialist areas of conservation. It is very much a two-way process; we learn and we teach. By maintaining contact, it is hoped that all the conservators who have been involved with the *Unknown Amazon*, from Europe and Brazil, will be able to continue to build on the relationships formed and find research projects they can collaborate on to aid in the conservation of the ethnographic collections in their care.

Acknowledgements

The authors would like to thank all the many conservators and curators who made us so welcome during our visits to their museums, with particular thanks to Gedley Braga and his colleagues at MAE. They extended the hand of

friendship and fellowship, which made the project so much more enjoyable. Special thanks go to Colin McEwan, Cristiana Barreto and Eduardo Neves for creating such an exceptional exhibition, and to BrazilConnects, the exhibition sponsors, for their generosity in supporting the workshop. Thanks also to Sandra Smith for her editing skills and her encouragement during the planning of this paper and to Andrew Oddy for supporting our involvement in this project.

Reference

McEwan, C, Barreto, C and Neves, E (eds.), 2001, *Unknown Amazon*, London, British Museum Press.

Abstract

The conservation profession continues to debate recommended limits for environmental controls within museums. As bark paintings are considered susceptible to fluctuating environments, this study investigated the extent of movement of bark paintings from the collections of the National Gallery of Australia and National Museum of Australia over a relative humidity range likely to be encountered within museums. Forty-eight bark paintings were monitored in five storage environments for up to one year. Planar distortion of the tangential width was measured against relative humidity (RH) and temperature (T). Twenty-five percent of the bark paintings stored in a fluctuating environment (35%–63% RH) showed more than 20 mm of planar distortion. Movement was rapid and reproducible. Extent of movement should be incorporated into designs for display, transport and storage to limit damage.

Keywords

Australian Aboriginal art, inner bark, bark painting, storage, dimensional change, relative humidity, environmental control

Real-time monitoring of dimensional change in Australian Aboriginal bark paintings during storage

Nicola Smith* and Kylie Roth
University of Canberra
c/o National Museum of Australia
GPO Box 1901, Canberra ACT 2601, Australia
Fax: +61 2 6208 5299
E-mail: nicki.smith@nga.gov.au, kylie.roth@nga.gov.au

Introduction

Australian Aboriginal bark paintings have been collected since the 1880s. At the time of initial European contact, painting on bark was widespread across Australia, including in the Kimberley Region, Arnhem Land, New South Wales, Victoria and Tasmania (Groger-Wurm 1973). Today the major production area for bark paintings is Arnhem Land, a tropical region in the Northern Territory. The bark is collected at the end of the wet season, when it is easily removed from the tree due to the reactivation of the cambium at the beginning of the growth period. The radially expanded cells are thinner and softer, allowing the bark to be separated from the tree at the cambium, which is the interface between the wood (xylem) and inner bark (phloem) (Wenzl 1970).

Today, most paintings are done on the bark of the *Eucalyptus tetrodonta,* commonly known as Darwin Stringybark. This tree occurs prolifically across Arnhem Land (Boland et al. 1984). Once a section of bark is removed from the tree, the majority of the outer bark (rhytidome) is stripped off prior to flattening. The remaining inner bark is then flattened for painting by placing the bark over a fire until its curl relaxes, and then under weights until it is dry enough to paint. Bark can also be flattened using weight alone. The preparation of the surface for painting will also generally involve the removal of the vascular cambium and the primary or protophloem. The paint layer is then applied to the inner bark.

The hygroscopic and anisotropic nature of bark makes it susceptible to dimensional change in response to environmental fluctuations. A greater understanding of the influence that relative humidity (RH) has on the movement of bark will assist in the effective management of these collections. Repetitive and/or excessive movement of the bark may contribute to paint layer damage as well as damage to the substrate itself. Rigid display mechanisms can also restrict bark movement, creating potentially damaging tension. Erhardt et al. (1995) investigated the extent of allowable movement of wood with changing relative humidity and found that between 31%–63% RH was acceptable but beyond this irreversible deformation occurred.

This study aimed to document the extent of dimensional change of bark paintings with varying relative humidity in real time using collections from the National Gallery of Australia and the National Museum of Australia. The bark paintings were monitored at several sites in various real storage conditions.

Response of bark to environmental fluctuation

Bark, as with wood, consists of cellulose, hemicellulose and lignin, with a variety of extractives, although bark has been found to contain more extractives (Fengel and Wegener 1984). Bark cells extend outwards from the cambium, while wood forms on the inner side. This results in different growth pressures being applied to the cells as they age. The bark cells undergo pressurized tangential elongation that contributes to its more irregular structure. This irregular structure of bark results in it having less mechanical strength and anisotropy than wood (Fengel and Wegener 1984).

*Author to whom correspondence should be addressed

Figure 1: Experimental set up showing longitudinal and tangential directions

Due to its commercial value and history of use, extensive research has been carried out on the response of wood to environmental fluctuations. Comparatively little information is available about bark. Structural and chemical differences between wood and bark make it impossible to translate mechanical characteristics directly (Fengel and Wegener 1984), and what work has been done on bark may not necessarily be applicable due to species variation.

The bark used in the production of Australian Aboriginal bark paintings follows the concentric growth of the tree, and the closest comparative cut of wood is the tangential longitudinal section. Research on the dimensional instability of wood indicates that tangential shrinkage is the greatest dimensional change, with an average of 8% shrinkage from the fibre saturation point to oven-dry conditions. Longitudinal shrinkage is often considered negligible while radial shrinkage is approximately half that of tangential (Hoadley 1998). Bark also undergoes dimensional change in the tangential, radial and longitudinal directions, and uneven tensions induced by these changes can contribute to warp. Hoadley (1998) has defined the types of warp as follows:

- cup (deviation from flatness across width)
- bow (deviation from lengthwise flatness)
- crook (departure from end-to-end straightness along edge)
- twist (four corners of flat face do not lie in the same plane).

It is common for an individual bark painting to exhibit from one to all of the above types of warp leading to planar distortion. One common explanation for cupping is that the bark reverts to its original shape on the tree. This is supported by Page (1997), who found that high relative humidity and temperature both increased creep memory behaviour in *Eucalyptus tetrodonta*.

Method

Forty-eight bark paintings representing areas of production across Arnhem Land and various ages were selected. An average size (approximately 600 × 400 × 5 mm) was aimed for but as actual collection material was used it was not possible to maintain consistency in bark size. Three larger barks (e.g. 1235 × 600 × 7 mm) were included to investigate the influence of size on movement. All bark paintings were free of restraints applied by artists and did not have restraints such as storage or display devices. Each bark was placed on a flat rigid support and a Perspex end board was fixed to the support against an end grain of the bark. The end grain was selected for monitoring, as in wood it has been shown to pick up moisture 10 to 15 times faster than do side-grain surfaces (Hoadley 1978).

The end-grain width of each bark painting was recorded manually by tracing the outline on Mylar® sheets attached to the Perspex end boards (see Figure 1). Each outline was carefully traced at eye level in an attempt to minimize parallax error. Recording error was estimated at ± 1 mm, which was considered acceptable compared to the gross amount of movement being monitored. The position of the end-grain width was traced weekly and the corresponding RH and temperature (T) were recorded. A Vaisala HM34 Humidity and Temperature Meter was used to record RH and T. The Vaisala was calibrated against saturated salt solutions providing RH readings of ± 2% and T readings of ± 0.3°C.

Storage conditions were monitored over various lengths of time as outlined in Table 1. Monitoring over one year aimed to show the effect of seasonal variation.

During the height of seasonal variation (i.e. mid-summer, mid-winter, mid-spring and mid-autumn), when daily fluctuations are considered to be most extreme, the tangential width of one bark painting was visually recorded every hour over a 24-hour period using time-lapse photography. Monitoring over one day aimed to show the effect of daily fluctuations.

Simple methods of recording bark movement were employed. Although the manual method has inherent error, such as parallax, it was low cost, quick to set up, used available equipment and caused minimal disruption to storage areas. This basic technique provided an immediate visual indicator of movement that could easily be correlated with relative humidity.

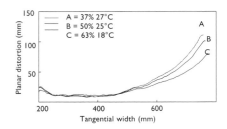

Figure 2: Profile of movement with changing relative humidity and temperature

Table 1: Description of storage areas and length of time for monitoring bark paintings

Storage area	Environmental description	Recorded environmental range		Length of time monitored
1	Fluctuating, uncontrolled	35–63%	11–31°C	1 year
2	Stable, controlled	50–57%	19–22°C	1 year
3	Fluctuating, controlled	50–54%	22–24°C	10 weeks
4	Stable, controlled	48–51%	20.5–23.5°C	8 weeks
5	Stable, controlled	49–52%	21–22.5°C	8 weeks

Table 2: Distribution of planar distortion for monitored bark paintings

Storage area	Number of barks showing extent of planar distortion					
	≤2mm	3–5mm	6–10mm	11–15mm	16–20mm	>20mm
1 (35–63% RH)		1	2	2, 2*		1, 1*
2 (50–57% RH)	3	2	3	1*		
3 (50–54% RH)	5	5				
4 (48–51% RH)	10					
5 (49–52% RH)	10					

*Refers to larger barks

Results and discussion

The traces of tangential width were compared to produce a map of the planar distortion that each bark underwent with changing RH and T conditions (see Figure 2). Profiles from one bark painting are recorded in Figure 2, showing the extreme conditions of 37% RH and 27°C against 63% RH and 18°C. The position at 50% RH and 25°C is included as a reference value. Although the RH range is 50±13% RH, the extent of movement from the 50% profile is not symmetrical. This implies the temperature range may have some influence.

Tracing across the tangential width showed which areas underwent the most cupping. Generally the end points underwent the greatest movement. From each trace of tangential width, the point that moved the most was selected and measured to produce the extent of relative planar distortion. Results of maximum planar distortion for all the monitored barks are grouped and presented in Table 2. Extent of planar distortion is at a minimum in storage areas 4 and 5, where environmental controls maintained an almost constant RH and T. The greatest extent of movement was recorded in storage area 1, as expected for an uncontrolled environment.

There seems to be no satisfactory indicator of which bark will undergo greater planar distortion than the others. Each bark appears to react in an individual manner. This may relate to the bark's structure, the region from which the bark is harvested, the technique of production used or some combination of these. The size of the bark painting also does not appear to have a consistent influence on this movement. The largest bark (1235 × 600 × 7 mm) in storage area 2 underwent considerably more movement than any other bark, with 11.5 mm of movement for a 7% RH range. However, other large barks (e.g. 1285 × 680 × 5 mm) in storage area 1 showed a similar level of movement, between 11 and 15 mm, for a 30% RH range. Further work investigating possible contributing factors, such as size, regional influence and production technique, is required.

Figure 3 shows the dimensional change for the bark painting that exhibited the most movement from storage area 1 and therefore represents the worst-case scenario. Maximum planar distortion (triangles) and maximum tangential width (dots) are plotted against RH. Fifty percent RH is used as a reference; therefore, cupping due to a decrease in RH produces movement in the positive direction. Relaxation from an increase in RH produces movement in the negative direction. Overall there appears to be a negative linear relationship for planar distortion with increasing RH, whereas tangential width appears to increase linearly with an increase in RH.

The example in Figure 3 shows that an increase in RH from 35% to 63% produced an equivalent decrease in planar distortion of 24 mm and a corresponding increase in tangential width of 16.5 mm. The line-of-best-fit for the planar distortion data has a slope of –0.93 (correlation coefficient, r=–0.92) and for the

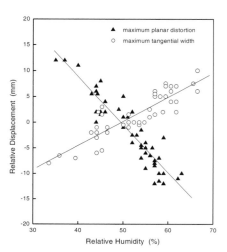

Figure 3: Maximum dimensional change with relative humidity

tangential width data has a slope of 0.55 (r=0.87). This change in width is due primarily to planar distortion but will also include some dimensional change from the tangential swelling or shrinkage of the bark. Further work is being done on the dimensional change of bark with relative humidity in the longitudinal, radial and tangential directions.

All other bark paintings in storage area 1 showed less planar distortion over the same RH range. This extent of movement for the worst-case example has implications for the design of display, transport and storage devices. It may be necessary to include movement tolerances into designs when stable environments cannot be guaranteed.

These results also indicate that the rate of change of movement is constant over this range of RH. There is no apparent range of RH that produces less movement from 35% to 63%. This is in contrast to the tangential swelling data for wood, which indicates there is less dimensional change within the 40% to 60% RH range, and a rapid increase in dimensional change beyond these parameters (Richard et al. 1998).

The scatter of data in Figure 3 indicates that the bark may not have achieved equilibrium in the fluctuating environment. Twenty-four-hour time-lapse photography showed that it is possible for a bark painting to undergo rapid dimensional change over a short timeframe following the daily cycle of RH and T. The same bark painting represented in Figure 3 showed a maximum movement of 6.5 mm with a gradual change in RH of 10% over a period of six hours. Parallel research being conducted by the authors indicates that there can be an immediate change in weight with fluctuating RH. Bark samples at ambient conditions introduced into a high-RH environment (70%) increased in weight after approximately 10 minutes, while samples placed into a dry environment (30%) decreased in weight immediately.

The effect of temperature may also increase the scatter of data. For the 35% to 63% RH range shown in Figure 3, the temperature ranged from 11°C to 31°C. Previous research on the effect of temperature on the desorption isotherm of wood indicates that at 30% RH an increase in temperature from 20°C to 30°C would correspond to a 2% decrease in RH at constant temperature (Stamm 1970). Further work using facsimile bark paintings is being carried out on the dimensional change of sample barks using the fixed conditions of an environmental chamber. These results will be correlated with this real-time study.

Hysteresis between adsorption and desorption is assumed to be negligible as the aged barks should have reached an average moisture content. Over time, the curves for adsorption and desorption of wood tend to converge (Hoadley 1998). It is expected that the curves for bark will exhibit similar behaviour.

The paint layer will provide a physical barrier to moisture sorption. Work on wooden panel paintings has shown cupping occurs away from the paint layer due to preferential adsorption. The exposed wood on the reverse adsorbs moisture and becomes softer but cannot expand due the restraining effect of the drier, stronger wood, causing compression set. When RH drops the reverse side shrinks proportionally, causing cupping (Hoadley 1998). In this study, the cupping of the bark in its attempt to return to its original curvature opposes the effect of unequal absorption from the paint layer. It appears the cupping effect overrides the effect of unequal absorption. Also, many bark paintings have restraints applied by the artist. These will restrict movement with changing relative humidity, potentially causing damage. Restraint applied by display devices could have a similar effect.

The simple measurement techniques and the use of real storage areas with fluctuating conditions limit the accuracy of the data for the corresponding RH. Despite these limitations, the dimensional results appear to be reproducible for similar conditions over the period of monitoring. Such reproducibility implies elastic deformation of the bark substrate. This appears to correspond with Erhardt's (1995) safe limit of 31% to 68% RH for tangentially cut wood equilibrated to 50% RH. However, a survey of the 395 bark paintings housed in storage area 1 (where RH ranged from 35% to 63%) showed only 47% had the support layer in good condition and only 30% had the paint layer in good condition. (Good condition indicates the bark painting is stable with no active damage.) Further work needs to be done on what extent, or repetition, of movement will cause damage to the paint layer or the substrate of a bark painting.

Conclusion

This study was conducted to gather more information on the dimensional change of bark paintings when subjected to a variety of typical museum storage environments, ranging from tightly controlled to uncontrolled environments. Conservators are concerned with dimensional change because it can result in warping and cracking of the bark substrate, and can exacerbate paint loss.

Results from this study indicate that planar distortion of bark can be considerable and rapid over a range of RH. The largest recorded planar distortion of a bark painting for a 35% to 63% RH range was 24 mm. While not all bark paintings will experience these extremes of movement, this study shows the significance of considering bark substrate movement when designing bark painting display, transport and storage units. These systems should be flexible as restriction of movement in fluctuating humidity could lead to compression set, resulting in permanent shrinkage and/or cracking.

The simple, low-cost monitoring technique adopted in this study can be employed by conservators to gain an indication of the extent of movement a bark painting will undergo over a range of conditions. If extremes of RH and T for display, transport and storage can be predicted, by placing the bark painting in a similar environment, the extent of movement can be estimated and designs modified accordingly. Alternatively, extent of movement could be used to promote placement of bark paintings in as stable conditions as possible.

Acknowledgements

We would like to thank the Australian Research Council for providing funding under the SPIRT Grant scheme, the staff of the National Museum of Australia, in particular Anne I'Ons, Mark Henderson and Ellie McFadyen, the staff of the National Gallery of Australia, in particular Gloria Morales and Janet Hughes, and Dudley Creagh and Vincent Otieno-Alego of the University of Canberra.

References

Boland, D J, Chippendale, G M, Brooker, M I H, Hall, N, Hyland, B P M, Johnston, R D, Kleinig, D A, and Turner, J D, 1984, *Forest Trees of Australia*, 4th ed., Nelson Wadsworth, Melbourne, CSIRO.

Erhardt, D, Mecklenburg, M F, Tumosa, C S, and McCormick-Goodhart, M, 1995, 'Determination of allowable RH Fluctuations' *WAAC Newsletter* 17(1), 19–23.

Fengel, D, and Wegener, G, 1984, *Wood: Chemistry, Ultrastructure, Reactions*, New York, Walter de Gruyter.

Groger-Wurm, H M, 1973, 'Australian Aboriginal bark paintings and their mythological interpretation, Vol 1. Eastern Arnhem Land', *Australian Aboriginal Studies No. 30*, Canberra, Australian Institute of Aboriginal Studies, 1–5.

Hoadley, R B, 1978, 'The dimensional response of wood to variation in relative humidity' in *Conservation of wood in painting and the decorative arts* (preprints of the contributions to the Oxford congress, September 17–23, 1978), London, International Institute for Conservation of Historic and Artistic Works, 1–6.

Hoadley, R B, 1998, 'Chemical and physical properties of wood' *The structural conservation of panel paintings: proceedings of a symposium at the J. Paul Getty Museum, April 24–28, 1995*, Los Angeles, Getty Conservation Institute, 2–20.

Page, E, 1997, unpublished research project report, *Memory of shape/creep recovery behaviour in Australian Aboriginal bark paintings and western red cedar*.

Richard, M, Mecklenburgh, M F, and Tumosa, C S, 1998, 'Technical Considerations for the Transport of Panel Paintings' in *The structural conservation of panel paintings: proceedings of a symposium at the J. Paul Getty Museum, April 24–28, 1995*, Los Angeles, Getty Conservation Institute, 525–556.

Stamm, A J, 1970, 'Wood deterioration and its prevention' in *New York Conference on Conservation of Stone and Wooden objects*, Vol 2, IIC, 1–11.

Wenzl, H F J, 1970, *The chemical technology of wood*, New York, Academic Press.

Abstract

As part of a collaborative study of the conservation of Amazonian featherwork artefacts, this paper presents the results of a fading study as well as an investigation to assess the efficacy of cleaning macaw feathers using a Nd:YAG laser. After exposure of red macaw feather samples for 10 Mlux hours, the CIE94 colour change was calculated to be 2.07 ± 0.17 units, which places macaw featherwork into the upper end (lower sensitivity) of the sensitive category in terms of Victoria and Albert Museum (V&A) lighting policy. Using the data for noticeable changes, the sample would fall into ISO light fastness rating 4. Using the blue wool data, the sample is less fugitive than Blue Wool 5, approximating the expected fading rate for Blue Wool 6, and would correspond to ISO rating 6. Initial laser cleaning successfully removed most of the artificially applied soiling from feather samples without apparent surface disruption or colour change.

Keywords

ethnographic conservation, Amazonian featherwork, museum display, lightfastness, laser cleaning, colour measurement

A collaborative examination of the colourfastness of Amazonian featherwork: assessing the effects of exposure to light and laser radiation

M. R. Solajic★
Conservation Science Section, National Museums and Galleries on Merseyside
Whitechapel, Liverpool, L1 6HZ United Kingdom
E-mail: msolajic@sympatico.ca

Boris Pretzel
Victoria and Albert Museum
London, United Kingdom

M. Cooper
National Museums and Galleries on Merseyside
Liverpool, United Kingdom

J.H. Townsend
Tate Gallery
London, United Kingdom

T. Seddon, J. Ruppel, J. Ostapkowicz, T. Parker
National Museums and Galleries on Merseyside
Liverpool, United Kingdom

Background

At the ICOM Committee for Conservation Meeting in Dresden, Horie (1990) presented a method for studying the fading of feathers by light and gave informative results regarding blue and green budgerigar feathers. Ten years later there seemed to have been no further experimental data put forward on the colour stability of this material. We are still guessing acceptable light levels and duration of exposure for the display of most feathered artefacts. As Horie pointed out, low light levels and short exposure periods may fail to significantly limit fading and the replacement of feathered items on display at regular intervals could simply result in the tragic reduction of an entire collection to an 'incorrect drabness'.

An opportunity to further address this gap in conservation knowledge was taken when, in May 2000, rare and colourful ornamental featherwork from the Amazon region was selected for display in new permanent ethnographic galleries planned for Liverpool Museum. There was no published data available that could indicate actual fading rates and acceptable exposure levels for this South American material. An investigation of the colour systems and fading rates of the particular feathers in question was considered necessary in order to reach a reliable, credible and quantifiable rationale for a display strategy.

Preliminary fading tests performed on a set of feather samples, followed by visual observations and colorimetric measurements, indicated that yellow and orange-red coloration may be susceptible to light-induced damage and may need special care or monitoring. It was also apparent that this type of colour assessment is not suitable for a detailed investigation of the feathers in the Liverpool Museum collection because of the feather's structure, optical properties and colouration. Pigmentation in the feathers under investigation was not uniform across the surface of the feather; colour varied in shade from dark to light. There was colour variation between and within feathers.

Therefore, a search for an instrumental technique suitable for the feathers was carried out. Several new technical developments related to determination of lightfastness of painted and dyed museum objects have recently been reported (Michalski 1997, Pretzel 2000, Whitmore et al. 2000). In this research we

★Author to whom correspondence should be sent. Please direct all future correspondence to the following address: Dr. Maja R. Solajic, Chemist/Conservation Scientist, 1931–200 Clearview Avenue, Ottawa, Ontario K1Z 8M2, Canada, E-mail: msolajic@sympatico.ca

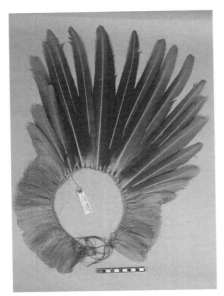

Figure 1. Amazonian feather object, Acc. No. 56.25.877 Liverpool Museum (printed with kind permission of the Director and Board of Trustees of NMGM)

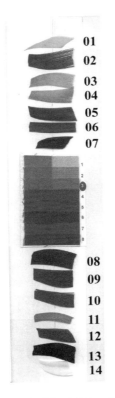

Figure 2. Detail of the "Colour fastness test binder". Feather samples (S# 01-14) and BWSs (1-8) were exposed for 6 months in the light box; shielded (left) and exposed (right) halves.

investigate the potential of a new colour measurement technique developed by Pretzel (2000) at the Victoria and Albert Museum. We focused on the examination of orange-red pigmentary colorants, which were identified, for example, in the scarlet macaw feathers of the Amazonian waistband (Figure 1).[1]

Consideration of the treatment needs of the Amazonian material also highlighted the need to identify an effective and non-disruptive means of cleaning feathers. Previous approaches have limitations or have demonstrated potential to result in structural damage on a microscopic if not macroscopic level. The control offered by, and the non-contact nature of, laser cleaning suggested that it might be a suitable technique (Cooper 1998). Only a small amount of published literature exists on the laser cleaning of feathers (Pacaud 2000, Solajic 2002). Our recent study has already shown the technique to be extremely promising. However, a more detailed investigation, described here, was necessary to evaluate the risk of possible discolouration caused by laser radiation.

Selection of objects and reference feather samples

In this study seven Amazonian featherwork objects were chosen to represent examples of 19th-century South American material. The ornaments and headdresses under investigation were acquired from two sources. Documentation, where available, suggests a northern Brazil provenance for five artefacts, while two objects were acquired in Guyana. Initial characterization of the feathers and their colour systems in the objects indicated pigmentary, structural and mixed colorants in different feather species including the blue and yellow macaw, scarlet macaw, toucan and others.

A related reference feather collection, comprising feathers from old bird skins and feathers recently moulted from living birds, has been compiled. The full colour range, including black, white, yellow, red, blue and green, was represented (Table 1).

All tests were performed on the related feather species ('model' feathers) collected from the 19th-century natural history collection of the National Museums and Galleries on Merseyside (NMGM), from living birds or from both. A detailed study was carried out on a red tail feather from a scarlet macaw.[2]

Experimental procedure

Fading in a light box

Fourteen feather samples were exposed for 24 weeks in the Mark I light ageing box designed and used by the Tate Gallery, described and illustrated elsewhere (Bacci et al.1999). This provided an illuminance of 13,000 lux with UV wavelengths below 400 nm filtered out, at 28°C to 30°C and an RH of between 27% and 30%. This is equivalent to approximately 100 years of continuous UV free exposure to 50 lux in a gallery with typical opening hours, if reciprocity holds (Saunders and Kirby 1996). ISO Blue Wool Standards 1-8 (BWSs) were exposed with the feather samples and assessed similarly (Figure 2).

Surface colour of the feathers was measured with a Minolta CR-221 tristimulus colorimeter with a 3mm diameter measuring head and 45°/0° geometry, using CIELAB 1976 chromaticity coordinates. The (almost opaque) feathers were measured over the cream-coloured card sample holder, with three measurements taken along the length of their barbs, with minimal compression, then averaged.

Light fading equipment

Light fading equipment used at the V&A consists of a Hitachi UV-Vis-NIR spectrometer with fibre optic links to an external integrating head for measuring reflectance and a Schott projector fibre optic illumination system, which provides the fading illumination (Pretzel 2000 and 2001a). A 150W tungsten halogen lamp is used in the projector and the illuminant is UV filtered using an Optivex filter. The illumination intensity is logged throughout the experiment using a Hanwell Luxbug with suitable filters. The relationship of the logged illumination levels to illumination levels incident on the sample is determined using a specially adapted

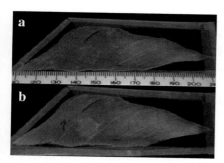

Figure 3. Scarlet Macaw feather samples a) before and b) after soiling and laser cleaning.

Table 1 List of feather samples

S#	Specification ID	Abbrev.	Source	Colour	Notes
1	Scarlet Macaw	SM	NMGM	Yellow	
2	Blue & Yellow Macaw	BYM	Knowsley Safari Park	Yellow/green	yellow on front blue on reverse
3	Scarlet Macaw	SM	NMGM	Red/pink	
4	Scarlet Macaw	SM	NMGM	Red/orange	
5	Green Winged Macaw	GWM	Knowsley Safari Park	Red/l.burgundy	
6	Scarlet Macaw	SM	Knowsley Safari Park	Red/d.burgundy	red on front blue on reverse
7	Hyacinth Macaw	HM	NMGM	Blue/dark	blue on front black on reverse
8	Blue & Yellow Macaw	BYM	Knowsley Safari Park	Blue/dark	blue on front yellow on reverse
9	Blue & Yellow Macaw	BYM	Knowsley Safari Park	Blue/medium	
10	Scarlet Macaw	SM	Knowsley Safari Park	Blue/green	blue on front red on reverse
11	Green Winged Macaw	GWM	Knowsley Safari Park	Blue/grey	blue on front red on reverse
12	Green Winged Macaw	GWM	Knowsley Safari Park	Green	green on front red on reverse
13	Red Billed Toucan	RBT	NMGM	Black	
14	White & Black Hawk Eagle	WBkHE	NMGM	White	

Megatron DL3 light meter, with an 8mm aperture light cell without cosine correction.

The feather sample was supported on a commercial white ceramic tile as a substrate. Reference white and black spectra were recorded using calibrated reference standards supplied by Labsphere. Reflectance measurements used a sample area of 10mm diameter and the illumination area corresponds to approximately 12mm diameter. Experiments were conducted at ambient temperature (Table 2). The sample was heated to less than 2 °C above ambient during exposure. Recorded spectra are corrected for dark reflectance and for white reflectance using an adaptation of the standard correction formula for spectra recorded using an integrating sphere (Clarke and Compton 1986).

Laser cleaning and colour measurement equipment

Laser cleaning tests were carried out using a Q-switched Nd:YAG laser cleaning system (Lynton Lasers R2). Such a system emits laser radiation at a wavelength of 1.06 mm, in pulses of 5ns to 10 ns duration. Delivery of the laser beam is via a single optical fibre. Cleaning tests were undertaken by hand, at a repetition rate of 4.4 pulses per second at a fluence of $0.9 \pm 0.2\,\mathrm{Jcm^{-2}}$ (pulse energy and working distance were fixed for each test). This was considered to be a 'medium clean', thereby removing sufficient dirt whilst minimizing the risk of damage to feathers. Cleaning was stopped once as much dirt as possible had been removed. This was determined visually and meant that the cleaned surface was exposed to some pulses directly.

For cleaning tests, feather sections were artificially soiled by gently brushing approximately 2 mg of museum dust into their surface. Dust was collected from shelves in one of the stores of the museum, where the Amazonian feather objects had been stored in boxes for nearly four decades. Energy dispersive X-ray analysis (EDX) and SEM showed that the dirt included significant amounts of carbon, calcium sulphate, silica and aluminum silicates (clays). Particle size ranged from approximately 1 mm to 100 mm.

The results of the cleaning have been evaluated using optical microscopy (OM), scanning electron microscopy (SEM) and UV-Vis-NIR spectrophotometry. Feather samples were placed in Melinex type 516 envelopes with 12 mm positioning holes punched through the envelope prior to inserting the sample (Figure 3). All spectra were recorded at the V&A using a Hitachi U4000 spectrophotometer employing a 0/d spinc geometry (CIE 1986) with a barium sulfate coated internal integrating sphere and Spectralon reference white reflectance plates. Spectra, taken between 250 nm and 2500 nm, were smoothed using a 15 point Savitzky-Golay algorithm.

Table 2 Summary of climate during measurements

	test A		test B	
	T, °C	RH, %	T, °C	RH, %
Average			27.1	39
Max	29.9	43	29.5	49
Min	23.4	24	22.7	35
Range	6.5	19	6.8	14
1st quartile	26.6	28	26.6	37
2nd quartile	27.3	30	27.3	39
3rd quartile	28	33	28.4	42

Each of the areas on the front of the samples (areas 1–3) was measured in transmission and reflectance whereas the areas on the back of the samples (4–6) were measured in transmission only (Pretzel 2001b). The colour difference between the original and soiled and original and laser cleaned samples was calculated from the spectra as the CIE94 colour difference (CIE 1995). The total exposure was just over 10 Mlux hours. All measurements were performed at ambient temperature (Table 2).

Results and discussion

Colour fastness of Amazonian feathers

Visual and colorimetric assessment after light accelerated aging in the fading box showed that thirteen of the feathers had a lightfastness better than BWS3, and that one (No. 2 BYM yellow/green) was compressed on measuring, which gave a misleadingly bad impression of its colour change on ageing. Standard deviations for ISO Blue Wool Standards 1-6 (BWSs) were much smaller than for the feathers. Saunders and Kirby (2001), for comparison, found standard deviations of ± 0.9 for the BWSs, and ± 1.7 for hand-dyed silk, under similar conditions of measurement with 10 readings.

As expected, the feathers gave a greater spread in readings than BWSs, since their structure is less compact than the weave of BWSs. Feathers are made of translucent, hollow fibres and measuring their colour is not entirely straightforward. The measured colour depends on the material chosen for the substrate and on the relative orientation of the feather. Results obtained are valid only for the combination of orientation and supporting substrate chosen. Also, the feathers used here have very different colours on the front and back. Thus they tended to have a greater spread of readings giving a greater measured colour difference than their appearance would suggest. In addition, relocation of the sample fading area between exposure and measurement cycles introduced uncertainty in the assessment of the colour change.

To overcome the above mentioned difficulties, we decided to assess the colour change using light fading equipment developed at V&A. Measured changes in the reflectance spectra of the red macaw feather sample were predominantly in two areas centred at 385 nm and 550 nm respectively, as shown in the spectra recorded for the wavelength range 300 nm to 900 nm (Figure 4). The changes at these wavelengths correspond to 1.8% and 2.6% absolute reflectance, respectively. These changes are small to moderate in size given the extent of exposure.

The measured data are presented in the graph, which shows the CIE94 colour difference, DE*94, and associated changes in CIE lightness, DL^\star_{ab}, chroma, DC^\star_{ab}, and hue, DH^\star_{ab} (see Figure 5). The CIE94 data are plotted against the left ordinate and bottom abscissa scale (left to right). The lightness, chroma and hue data are plotted against the right ordinate and top abscissa (right to left). Error bars

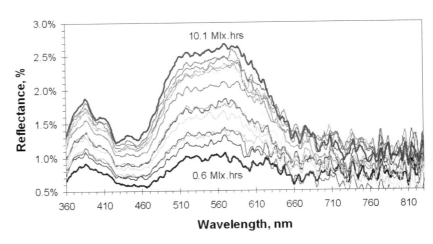

Figure 4. Changes in spectral reflectance over visible wavelengths with increasing exposure starting at 0.6 Mlx.hrs and finishing at 10.1 Mlx.hrs.

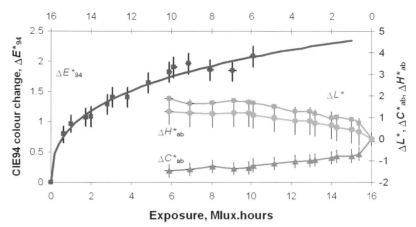

Figure 5. CIE94 colour change and changes in lightness, chroma and hue, as a function of exposure for a Macaw feather sample. Vertical error bars represent measurement uncertainty derived directly from the precision of reflectance spectra.

are calculated from the uncertainties associated with corresponding tristimulus values. The exposure scale is in megalux hours: 1E + 06lux hours is equivalent to approximately 5.5 years exposure for 10 hours per day at 50 lux, 9E+ 06 lux hours corresponds to 50 years exposure under these conditions. The CIE94 colour change after 10 Mlux hours is calculated to be 2.07 ± 0.17 units.

Laser cleaning efficacy

Initial laser cleaning successfully removed at least 95%, if not all, of the artificially applied soiling from the feather sample without apparent surface disruption. This is clearly shown in electron micrographs of soiled and laser cleaned feather surfaces (Figure 6). No discoloration was apparent to the naked eye.

Transmission spectra of the feather samples do not show any detrimental effect to be associated with laser cleaning. All transmittances dropped to significantly lower values on soiling and reapproached their original values following laser cleaning, showing that the laser cleaning is effective at removing the soiling and does not appear to introduce any changes in the bulk of the sample. Not all of the soiling was removed by the cleaning and differences between original and laser cleaned samples peaked at 6%T between 350 nm and 620 nm (Figure 7).

The CIE94 colour differences for soiled samples measured in transmission varied between 9.5 ± 0.4 and 15.4 ± 0.4, dropping to between 1.7 ± 0.4 and 4.5 ± 0.3 following cleaning (see Table 3). The CIE94 colour differences for soiled samples measured in reflectance were between 16.6 ± 0.9 and 20.8 ± 0.3, dropping to between 1.8 ± 0.8 and 5.7 ± 0.3 following cleaning (see Table 3).

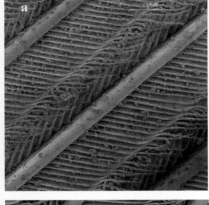

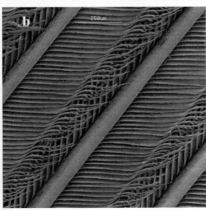

Figure 6. Electron micrographs of a Scarlet Macaw feather a) artificially soiled, b) after cleaning at 0.9 Jcm⁻².

Figure 7. Transmission spectra for a Scarlet Macaw feather sample as received, soiled and finally after cleaning. Line thickness represents measurement uncertainty.

Table 3 CIE94 (ΔE^{\star}_{94}) colour differences for each sample as a result of soiling and subsequent laser cleaning. Uncertainties are calculated directly from spectral precision estimates.

Sample	State	Transmission ΔE^{*}_{94}	Reflectance ΔE^{*}_{94}
Feather 1	Soiled	10.0 ± 0.3	16.6 ± 0.9
	Cleaned	3.2 ± 0.3	1.8 ± 0.8
Feather 2	Soiled	9.5 ± 0.4	20.8 ± 0.3
	Cleaned	4.0 ± 0.3	5.7 ± 0.3
Feather 3	Soiled	13.8 ± 0.4	17.9 ± 0.5
	Cleaned	1.7 ± 0.4	2.9 ± 0.5
Feather 4	Soiled	10.8 ± 0.3	
	Cleaned	2.7 ± 0.3	
Feather 5	Soiled	11.6 ± 0.4	
	Cleaned	4.5 ± 0.3	
Feather 6	Soiled	15.4 ± 0.4	
	Cleaned	2.3 ± 0.4	

Figure 8. Reflectance spectra for a Scarlet Macaw feather sample as received, soiled and finally after cleaning. Line thickness represents measurement uncertainty.

Conclusions

The procedure using light fading equipment allowed fading to be determined without repositioning the feather samples, thus eliminating a major source of error common to other measurement techniques currently in use. After exposure of red feather samples from the scarlet macaw for 10 Mlux hours, the CIE94 colour change was calculated to be 2.07 ± 0.17 units. Using the data for noticeable changes (corresponding to grey-scale 4, DE^{\star}_{94} = 1.7 (BS 1978) published by Michalski in 1990), the sample would fall into ISO light fastness rating 4. Using the blue wool data published by Bullock and Saunders (1999), the sample is less fugitive than Blue Wool 5, approximating the expected fading rate for Blue Wool 6 and would correspond to ISO rating 6. The red pigmentary colour in scarlet macaw feathers falls into the upper end (lower sensitivity) of the sensitive category, in terms of the V&A lighting policy proposed by Derbyshire and Ashley-Smith (1999).

OM and SEM revealed that laser cleaning at 0.9 Jcm^{-2} was successful in removing artificially applied soiling from a red feather from a scarlet macaw, without apparent disruption to its structure. Reflectance spectrophotometry showed that laser cleaning was effective in restoring the reflectances of the feather samples close to their original value. However, in the UV and IR regions of the spectrum, the reflectances after laser cleaning were greater than initial values, indicating that the cleaning process did more than just remove the artificially applied soiling (see Figure 8). The differences were small compared to the reduction in reflectance after soiling and further work is required to determine if they constitute deterioration or simply removal of contaminants on the surface of the barbs due to handling. Transmission spectra of the feather samples do not show any detrimental effect to be associated with laser cleaning.

Present findings allow a proper evaluation of fading and laser cleaning techniques leading to development of new treatment and display protocols for colourful featherwork in museum collections. Laser technology could offer the potential to remove extraneous material while avoiding manipulation of the delicate feather structure and leaving associated materials (textiles, basketry, etc.) untouched.

Acknowledgements

One of the authors, Martin Cooper is extremely grateful to the Headley Trust for financial assistance during the course of this work.

Notes

1 Waistband or headband, collected before 1879; Amazonia, northern Brazil; dimensions: Length (stretched out, without string): 580 mm; Width: 408 mm; max. length of feathers: c. 430 mm.
2 The bird was collected from the Amazon region, sometime before 1850 and now forms part of NMGM's natural history collection.

References

Bacci, M, Piccolo, M, Porcinai, S and Radicati, B, 1999, 'Indoor environmental monitoring of colour changes of tempera-painted dosimeters' in J Bridgland (ed.), *Preprints of the 12th Triennial Meeting of the ICOM Conservation Committee*, Lyon, International Council of Museums, 3–7.

Bullock, L and Saunders, D, 1999, 'Measurement of cumulative exposure using Blue Wool standards' in J Bridgland (ed.), *Preprints of the 12th Triennial Meeting of the ICOM Conservation Committee*, Lyon, International Council of Museums, 22–26.

Clarke, F J J and Compton, J A, 1986, 'Correction methods for integrating sphere measurement of hemispherical reflectance' *Colour Research and Applications* 11 (4), 253–262.

CIE 1995, *Industrial colour-difference evaluation*, CIE publication 116-1995, Vienna, Austria, Commission Internationale de l'Éclairage.

CIE 1986, *Colorimetry*, 2nd edition. CIE publication 15.2, Vienna, Austria, Commission Internationale de l'Éclairage.

Cooper M.I. (ed.), 1998, *Laser cleaning in conservation: an introduction*, Oxford: Butterworth-Heinemann.

Derbyshire, A, and Ashley-Smith, J, 1999, 'A proposed practical lighting policy for works of art on paper at the V&A' in J Bridgland, *Preprints of the 12th Triennial Meeting of the ICOM Conservation Committee*, Lyon, International Council of Museums, 38–41.

Horie, C V, 1990, 'Fading of feathers by light' in K Grimstad (ed.), *Preprints of the 9th Triennial Meeting of the ICOM Conservation Committee*, Paris, International Council of Museums,, 431–435.

Michalski, S, 1990, 'Time's effects on paintings' in Ramsay-Jolicoeur, B and Wainwright, I (eds.), *Shared Responsibility: Proceedings of a Seminar for Curators and Conservators*, Ottawa, National Gallery of Canada, 39–53.

Michalski, S, 1997, 'The lighting decision' in Canadian Conservation Institute (ed.) *Preprints of Textile Symposium 97. Fabric of an Exhibition, An Interdisciplinary Approach*, Ottawa, Canadian Heritage, 97–104.

Pacaud, G and Lemaire, J, 2000, 'Le nettoyage au laser: d'un jaunissement observable sur des plumes blanches ayant subi un traitment par laser yag de desincrustation' *La lettre de l'OCIM*, no 67, 21–32.

Pretzel, B, 2000, 'Determination of colour fastness of the Bullerswood carpet' in R Ashok.(ed.), *Tradition and Innovation: Progress and prospects, Advances in Conservation. Preprints of the contributions to Melbourne Congress*, London, International Institute for Conservation of Historic and Artistic Works, 150–154.

Pretzel, B, 2001a, 'Macaw feathers: light sensitivity and fading rates' Science Section Report No. 01/65/BCP, London, V&A Museum, 1–10.

Pretzel, B, 2001b, 'Laser cleaning of Macaw feathers' *Science Section Report* No. 01/100/BCP, London, V&A Museum, 1–14.

Saunders, D and Kirby, J, 1996, 'Light-Induced Damage: Investigating the Reciprocity Principle' in J Bridgland (ed.), *Preprints of the 11th Triennial Meeting of the ICOM Conservation Committee*, Edinburgh, International Council of Museums,, 87–90.

Saunders, D and Kirby, J, 2001, 'A comparison of light–accelerated ageing regimes in some galleries and museums' *The Conservator* 25

Solajic, M R, Cooper, M, Seddon, T, Ruppel, J, Ostapkowicz, J and Parker, T, 2002, 'Colourful feathers: multidisciplinary investigation of the Amazonian featherwork from the ethnographic collection at NMGM: initial results' in M Wright (ed.), *The Conservation of Fur, Feather and Skin*, Archetype Publ.

Whitmore, P M, Bailie, C, Conors, S A, 2000, 'Micro-fading tests to predict the result of exhibition: progress and prospects' in R Ashok (ed.), *Tradition and Innovation: Progress and prospects, Advances in Conservation. Preprints of the contributions to Melbourne congress*, London, International Institute for Conservation of Historic and Artistic works, 150–154.

Wet organic and archaeological materials

Matériaux organiques et archéologiques gorgés d'eau

Materiales orgánicos arqueológicos húmedos

Wet organic and archaeological materials

Coordinator: Per Hoffmann
Assistant Coordinators: Cliff Cook, James Spriggs

The work of the Wet Organic and Archaeological Materials (WOAM) Working Group has centred on its 8th Triennial Interim Meeting in Stockholm, Sweden, 10-15 June 2001, and on the production of the proceedings in book form, as usual. Forty-two papers were presented, with topics ranging from underwater archaeology to treatment methods, case studies and sophisticated analyses of wet organic materials and their degradation. The importance of the WOAM interim meetings is that they not only attract conservators, but also archaeologists, geo-scientists, chemists, physicists, heritage managers and microbiologists who work in fields connected with ours and who enrich the scope of our views and knowledge.

The Stockholm Proceedings comprise the following:

Leif Malmberg, 'The geodetic surveying system of the 17th-century ship *Vasa*'
Tom Sandström, 'Salt precipitation on *Vasa* timbers'
Magnus Sandström, 'Research into the salt precipitation problem'
Gilles Chaumat, 'PEG treatment using an atomization process'
Maria Mertzani, 'Lifting and conservation of organic objects from Cova des Cerrix, Menorca'
Alfred Terfve, 'Happiness is a 20-m upside-down cog at Doel, Belgium'
Fumitake Masuzawa, 'Conservation of a placenta container from a 17th-century burial site'
Christian Degrigny and Khoi Tran, 'Conservation of 17th-century waterlogged composite rifles',
Roar Saeterhaug, 'Conservation of Roman structural timbers using the PEG two-step method'
James Spriggs, 'Re-display of Viking house timbers in Jorvik'
Mike Corfield, 'Seahenge, from the beach to where?'
Andreas Olsson, 'Future cultural heritage management under water'
Thomas Bergstrand, '*In situ* preservation and re-burial of ship remains'
Inger Nyström, 'Preventive conservation of archaeological objects'
David Hogan, 'Protocol for the re-burial of organic archaeological remains'
David Gregory, 'Environmental monitoring and the deterioration of wooden artefacts in Nydam Mose, Denmark'
Per Hoffmann, 'The conservation of the Bremen cog'
Tanja Alström, 'Micro-sensors for measuring environmental parameters in wetlands'
Thomas Nilsson, 'Exploring the use of anoxic water for storing wooden artefacts'
Yohsei Kohdzuma, 'Conservation of wet wood with supercritical CO_2'
András Morgós, 'Improvement of the Lactitol® conservation method'
Charlotte Björdal, 'Decomposition of waterlogged wood'
Ann Christine Helms, 'Identification of micro-organisms from degraded wood by DNA-analysis'
Vicki Richards, 'Pyrolysis gas chromatography mass spectrometry to study wood degradation'
Ian Godfrey; 'Analysis of acid affected *Batavia* timbers'
Anthony Crawshaw, 'Simple approach to determine total iron in wet wood'
Howard Wellmann, 'Cleaning up a treatment gone wrong'
Clifford Cook, 'Archaeological conservation laboratory design'

Ulrich Schnell, 'Dynamic SEM analysis of freeze-drying processes for waterlogged wood'

Kristiane Straetkvern, 'Freezing properties of aqueous PEG solutions'

Gilles Chaumat, 'Optimization of PEG concentrations in waterlogged wood for freeze-drying'

Anastasia Pournou, 'Conservation methods for waterlogged hazelnuts'

Maria Mertzani, 'Analysis of and conservation proposal for an archaeological sponge'

Ian Godfrey, 'Iron removal from ivory and bone from shipwrecks'

Ida Hovmand, 'Mineral content of waterlogged archaeological leather'

Charles Moore, 'Reassembly of a 16th-century Basque chalupa'

András Morgós, 'Conservation of waterlogged lacquerware using Lactitol®'

Louise Mumford, 'Conservation of a waterlogged 9th-century embroidered textile'

Emily Williams, 'Treatment of waterlogged tortoise shell'

Vanessa Roth and Anu Norola, 'The diploma course in marine archaeological conservation at Evtech Institute of Art and Design in Vantaa, Finland'.

The proceedings also contain the discussions after the presentations, and are available from the Coordinator or Assistant Coordinators.

Per Hoffmann

The Lactitol® conservation of wet polychrome wooden objects found in a 15th-century Aztec archaeological site in Mexico

Alejandra Alonso-Olvera★
Coordinación Nacional de Restauración del Patrimonio Cultural INAH
Xicoténcatl y General Anaya s/n
San Diego Churubusco 04010, México D. F. México
E-mail: alonsoale@iobox.com

Setsuo Imazu
Kashihara Archaeological Institute
Nara, Japan

Demetrio Mendoza-Anaya
Instituto Nacional de Investigaciones Nucleares
Estado de México, México

András Morgos
Hungarian National Museum
Budapest, Hungary

Ma. Teresa Tzompantzi-Reyes
Universidad Nicolaita
Morelia, Michoacán, México

Abstract

A collection of organic artefacts was found inside a stone container deposited as an offering in the archaeological site of Templo Mayor, Mexico. The wooden artefacts are small painted masks and false vessels. Some routine analyses were carried out to obtain information about the wood and paint. The deterioration level of the artefacts was determined to be intermediate to low; the conservators selected the Lactitol® treatment proposed by Morgós and Imazu (1996) to assure dimensional stability and the preservation of chromatic qualities. The initial concentration was 5% and was mixed with a biocide to prevent new biological activity. The concentration of artificial sugar was gradually increased in 5% increments at room temperature until it reached 55%. Later, the temperature was raised to 70°C to achieve a concentration of 80%. The total procedure took eight months for the whole collection. After consolidation, the objects dried at room conditions. Later, the objects were cleaned to eliminate surface deposits.

Keywords

archaeological wood, consolidation of wood, Aztec artefacts, wooden polychrome objects, Lactitol treatment

Figure 1. Collection of wooden artefacts from offering 102 of the Templo Mayor Archaeological Site. Physical properties of each artefact are listed in Table 1.

Introduction

In February 1999, a collection of archaeological organic artefacts was found inside a stone container deposited in the main pre-Columbian building of the archaeological site of Templo Mayor (the great temple of the Aztecs). The site was a political and religious centre in Mexico during the 15th century. The stone box held an offering composed of small and medium-sized wooden artefacts, among others. The wooden artefacts are small masks and false vessels decorated with blue and black painted motives (see Figure 1).

The conservation team from the Site Museum was involved in the extraction work, applying 'first aid' procedures when the offering was found. The environmental conditions of the archaeological context were measured before the objects were retrieved. The offering was located six meters below the present ground level and the environment was stable, although the artefacts were wet because of the high water table, which had permeated the porous materials that had been in a container for 500 years. The temperature and relative humidity were measured during excavation so that they could be reproduced as closely as possible in the laboratory while the conservation procedure took place.

A few days after the extraction, the wooden artefacts arrived in the conservation laboratory at the Coordinación Nacional de Restauración del Patrimonio Cultural. Immediately, they were placed in a water bath to prevent biological attack. Some routine analyses were carried out to learn about the nature of the wood and the paint layer, and to see how wet the objects were.

Materials, methods and preliminary results

Cross-sections were taken to identify the species and to determine density, water content and fungal attack. Observations of wooden cross-sections were made under a light microscope (LM) and a scanning electron microscope (SEM Jeol JSM-5900 LV with an Oxford X-Ray Detector). The cross-sections were taken with a razor blade and mounted directly on double-sided aluminium tape, to be used under a low-vacuum system at 20 kV SEM. The species were identified as *Pinus veitchii* Roezl, *Pinus bonapartea* Roezl, *Pinus loudoniana* Gord and *Populus simaroe*; both softwoods and a hardwood are combined in the assemblage of artefacts (see

★Author to whom correspondence should be addressed

1 *2*

3

4

5

6

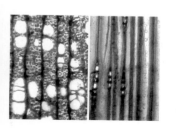

7

8

Figure 2). Density parameters of between 0.1 and 0.7 g/cm³ were obtained using the following formula:

$$\text{density} = \frac{\text{weight of dried wood}}{(\text{weight of wet wood} - \text{weight of dried wood}) + \text{weight of dried wood}/1.53}$$

The moisture content varied from 100% to 600%. The samples were dried in an oven at 105°C for 48 hours. A digital balance was used to measure the weight of the samples, before and after drying. The water content was calculated from the weight difference before and after drying as a percentage of the dry weight, according to the method used by Imazu, Morgós and Sakai (1999). Moisture content, density, dimensions and types of wood can be seen in Table 1.

The deterioration of the wooden tissue varied in each artefact. The best condition was found in objects with lower moisture content and denser wood. The cell tissue was well preserved in most artefacts. Little damage or breakdown was detected on cell walls, although some distortion and delamination was evident during microscope observations. Hyphae structures were revealed in the cell tissue of many artefacts. Because of pre-excavation damage, *macro* and *micromicetes* were discovered penetrating fibres and radial cell walls (see Figure 3).

Because of its relevance and good condition, the blue paint was analyzed and identified as Maya blue, an artificial pigment created and used in Middle America, mainly composed of indigo dye (from the *Indigophera suffrutticosa* plant leaf) and palygorskite, both forming a complex composite material. The pigment is highly resistant to solvents and acid agents (Reyes-Valerio 1993; Kleber et al. 1967). The black was identified as carbon black.

Considering the intermediate or low deterioration level of the artefacts, the main concern of the conservators was to select a consolidation procedure that could assure the dimensional stability of degraded wooden tissue and the preservation of chromatic qualities of the surface. Since such common wood consolidants as polyethylene glycols can modify surface appearances, they were excluded from the scope of this work. For the initial tests, the authors used the sugar alcohol method proposed by Morgós and Imazu (1996). The Lactitol® method has advantages because biological attack can be avoided at low concentrations during impregnation or later during storage. In addition, physical stability under high air humidity can be easily achieved because of the low hygroscopicity of the product (Morgós and Imazu 1999).

Table 1. *Moisture content, density (g/cm³), dimensions values and species of the eight artefacts of Templo Mayor*

Type of artefact	Moisture Content	Density	Dimensions	Type of wood
Artefact 1: mask	95%	0.793	15.16 × 13.41cm	Softwood (pine)
Artefact 2: vessel	-	-	8.92 × 9.13 cm	Softwood (pine), hardwood (poplar in laterals)
Artefact 3: mask	-	-	5.65 × 4.17 cm	Hardwood (poplar), softwood (nose)
Artefact 4: vessel	328%	0.357	8.31 × 6.08 cm	Hardwood (poplar), softwood (pine in laterals)
Artefact 5: mask	614%	0.218	6.07 × 5.40 cm	Hardwood (poplar), softwood (nose)
Artefact 6: vessel	400%	0.315	5.93 × 7.29 cm	Softwood (pine)
Artefact 7: vessel	233%	0.125	3.26 × 6.28 cm	Softwood (pine), hardwood (poplar in laterals)
Artefact 8: vessel	233%	0.461	9.17 × 2.43 cm	Softwood (pine), hardwood (poplar in laterals)

Figure 2. *Some cross-sections from the artefacts. View of the wooden tissue of hardwood and softwoods used to construct the objects. 1) Radial cross-section of artefact 1, 60′; 2) Tangential cross-section of artefact 2, 60′; 3) Transveral cross-section of artefact 3, 60′; 4) Transversal cross-section of artefact 4, 60′; 5) Tangential and transversal cross-sections of artefact 5, 60′; 6) Tangential and transversal cross-sections of artefact 6, 60′; 7) Transversal and tangential cross-sections of artefact 7, 60′; 8) Transversal cross-section of artefact 8, 60′.*

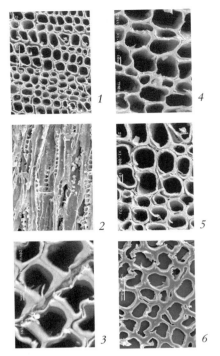

Figure 3. Cell damage observed on wooden tissue. 1) Transversal cross-section of artefact 1 (SEM); 2) Tangential cross-section of artefact 3 (SEM): some spore bags can be seen attached to cell walls; 3) Transversal cross-section of artefact 5 (SEM): de-lamination and break down in cell walls can be observed; 4) Transversal cross-section of artefact 6 (SEM); 5) Transversal cross-section of artefact 7 (SEM); 6) Transversal cross-section of artefact 8 (SEM).

Impregnation test and consolidation process

A preliminary test was made with a small fragment of archaeological wood already separated from one of the artefacts. It was originally covered with blue and black pigment. Therefore, it was chosen as a representative item. The consolidation process of the item began with a solution in a 5% concentration, which was mixed with a biocide to prevent new biological activity. Isothiazolones (Kathon® 1.5 LX) were used, since they have proven to be the most effective biocide for sugar solutions and because they are available in Mexico at a very acceptable cost. The concentration of the monohydrate Lactitol® was gradually increased in 5% increments as the weight of the impregnated wood increased. The procedure was done at room temperature until a 55% concentration was achieved. Since the Lactitol® solubility cannot be higher than 55% at room temperature, in order to reach 90% solubility the temperature was raised to 70°C. To succeed in getting the right temperature, a special heating chamber was constructed in the laboratory to place the objects in the consolidation bath, keeping it constantly warm. The device was a box, measuring $0.60 \times 0.90 \times 0.50$ m³ and made of plywood sheets attached to a steel frame. Four Hi-Lite® Infrared 250-watt bulbs were placed on top of the box interior to raise the temperature, which was controlled automatically with a common Robertshaw® thermostat (see Figure 4).

The procedure for testing the fragment took four months, although the final procedure applied to the whole collection took twice as long. After the consolidation treatment, the wood was dried at room conditions (24°C and 65% RH). Later, the object was cleaned to eliminate consolidant deposits on the surface. The cleaning was done under a light microscope to prevent paint losses. A thin layer of the consolidant remained on the surface, making the painting layer appear darker. As soon as the cleaning was carried out with a cotton swab and ethanol, the blue and black pigments emerged almost unaltered. Cross-sections were taken from the consolidated object in order to establish the extent of crystallized substance in the cell structure (see Figure 5).

The consolidation process was carried out in small, lidded glass containers. Each artefact was immersed in the Lactitol® solution. The initial concentration of the Lactitol® was 5% and had been previously mixed with Kathon® 1.5 LX. To prepare the initial concentration, 802.75 ml of distilled water was mixed with 147.25 ml of Kathon® 1.5 LX, which resulted in 950 ml of initial water volume. Then, 50 g of Lactitol® were initially added to the 950 ml of water and biocide to obtain 1 l of solution (see Table 2). The concentration was increased every 10 or 15 days, according to the artefact's weight modification (see Table 3).

Temperature was raised from 24°C to 50°C to improve the solubility of consolidant, once the consolidant reached a concentration of 45%, and to avoid crystallisation on further steps. When the solution reached a concentration of 55%, it turned to a darker colour and thicker consistency, so it was necessary to elevate the temperature to 60°C to keep the solute dissolved. The impregnation time had to be decreased as the temperature was increased from 70°C to 90°C, mainly because the solution became extremely dense and the evaporation was difficult to manage. With the higher temperatures, the containers had to be opened twice a day, or more, to let the water vapour escape.

Figure 4. The heating chamber (top: closed, bottom: opened) constructed in the workshop of conservation of archaeological materials in Mexico.

Figure 5. Appearance of wooden tissue impregnated with Lactitol: 1) Transversal cross-section with Lactitol crystals (SEM); 2) Tangential cross-section: Lactitol can be seen in the interior of lumens and cell walls (SEM); 3) Transversal cross-section: the cell walls look thicker because of the Lactitol impregnation (SEM).

Table 2. Consolidation treatment time scheduled, amounts of Lactitol® added to the original solution to increase concentration and temperature raising

Date	Amount of Lactitol (g) added to solution	Total amount of Lactitol (g)	Water volume (ml)	Solution volume (ml)	Concentration increases	Temperature
12.10.2000	50		950	1000	5%	24°C
17.11.2000	55	105	950	1055	10%	24°C
30.11.2000	65	170	950	1120	15%	24°C
19.12.2000	80	250	950	1200	20%	24°C
18.01.2001	75	325	950	1275	30%	24°C
15.02.2001	85	410	950	1360	40%	24°C
15.03.2001	100	510	950	1460	45%	45°–60°C
16.04.2001	130	640	950	1589	50%	45°–60°C
15.05.2001	145	785	950	1735	55%	60°C
28.05.2001	180	965	950	1915	60%	70°C
08.06.2001	480	1445	950	2395	65%	70°–90°C
18.06.2001	900	2345	950	3295	71%	70°–90°C
29.06.2001	2300	5495	950	5495	82%	90–110°C

Table 3. Record of weight modification of each artefact during consolidation procedure (weight in grams)

Date/No. of artefact	Artefact 1	Artefact 2	Artefact 3	Artefact 4	Artefact 5	Artefact 6	Artefact 7	Artefact 8
18.01.01	324.4	54.7	21.09	32.83	25.96	12.30	30.39	29.25
15.02.01	342.5	56.7	22.04	34.49	27.58	13.19	31.42	29.27
15.03.01	349.19	63.4	22.51	35.10	28.27	13.51	32.18	29.71
16.04.01	352.59	64.3	23.2	36.2	29.1	14.45	33.10	30.70
16.05.01	357.59	66.8	24.9	38.3	30.9	15.30	35.00	32.00
16.06.01	387.40	69.39	26.6	40.9	33.3	16.01	35.90	35.70

Once the 80% concentration was reached, the objects were taken away from the consolidation bath and they were cleaned immediately under hot water to remove dense consolidant deposits on the surface. After this easy and fast cleaning procedure, the objects were placed in partially closed containers at room temperature (24°C and RH 70%). Several days later some whitish and small crystals appeared on the wood surface; these were removed with warm water and a cotton swab. Consolidant deposits placed on the surface were removed with ethanol or hot water and a cotton swab. As soon as the cleaning was completed, the unattached fragments were re-attached with natural bone glue at 10% concentration.

Discussion and conclusions

One of the main aspects of this experience was that conservators had the opportunity to participate directly in the excavation process and extraction, which is not common in Mexican archaeological conservation. They proposed and performed the preventive procedures on-site and afterward they took control of the environmental conditions in the laboratory and during the conservation treatments.

The Mexican team also established direct communication with specialists who have tested the chosen conservation method. These specialists gave direct technical assistance, clarified questions and suggested unpublished alternatives, all of which were very valuable, since the method was being practiced for the first time.

The treatment was carried out on the whole collection of artefacts according to the previous results obtained in the test sample, since neither a high budget nor sophisticated equipment are needed to perform it. The consolidant and biocide were easily obtained and it cost just US$130 to buy 25 kg of Lactitol®, while 25 l of Kathon® cost $90.

The dimensional stability was calculated through the Antishrinkage Efficiency Parameter (ASE). High values of ASE (from 77% to 85%) were obtained with decayed wooden tissue.

The procedure was easy to apply until the temperature had to be risen. The control of the heating system through a manual thermostat was not very accurate, so the temperature fluctuated from 10°C to 15°C from day to day. This temperature changed risked producing partial crystallisation of the solution. The evaporation rate of the solution was not possible to calculate and the conservators

suppose that the concentration of the consolidant at higher temperatures was higher than the one reported on Table 2. When a concentration of 70% was reached, the modification of weight was almost imperceptible, so in the final steps, the impregnation time was set arbitrarily.

Increasing the temperature made it possible to reduce the consolidation time so that the whole process took eight months for these small objects. Treatment can be done on objects with insoluble painted layers and, later, final deposits can be easily removed with hot water and ethanol. Nevertheless, in some cases the paint layer separated from its support because consolidation substance was deposited between the paint and the wooden surface. A very detailed fixation had to be done during the cleaning, melting the consolidant with heat and removing the excess of the substance in the surface. However, conservators noticed that in this case, the heating produced some paint losses during consolidation, although the painting was not soluble on the solution. Finally, no major changes were detected, either in colour qualities or in the wood surface appearance. The final colour of the wood and painting are natural and consolidant deposits can be removed almost completely from the surface.

The method successfully preserved the physical properties of the wood, particularly as the consolidation process went on. Weight and density were improved and the consolidant provided enough strength to the original material to be handled without any damage. The consistency of the objects today is similar to that of normal wood of the same species in a dry and sound condition. Very thin and small cracks were produced in the wooden surface during the drying process, but this was not considered to be representative damage in the wood. The wood surface has an attractive colour and appearance, and the objects are ready to be exposed under controlled museum conditions.

In the future, changes in appearance and any physical modification should be monitored accurately over a long period. It is proposed by the authors that a six-month record should be kept over a two-year period to detect any changes and to confirm that the method is suitable in similar cases.

The special heating device was built with very low-cost materials. The total investment was calculated at US$300, including containers and substances. Additional experiments must be done to test several digital heating controls to improve efficiency and avoid cooling. The authors can recommend placing small objects in independent containers, which facilitates the concentration increases. The procedure is safe for the conservators, requires no special security measures and is a very easy and cheap alternative for laboratories with a low budget and basic facilities, as is the case in many countries of Latin America.

Acknowledgements

Alejandra Alonso-Olvera wants to thank Mr. Julio Chan, who helped with the design and construction of the heating chamber; Magdalena Morales, who acquired the budget for this project, and conservators Valeria García and Patricia Meehan, who kindly monitored substance temperature during the conservation process. Thanks to M. Sc. Carolusa González for checking over the English version of this work, and G. D. Sergio Gaytan for working on the images of this article.

References

Imazu, S, and Morgos, A, 1999, 'Lactitol Conservation of a 6 m Long Waterlogged Timber Coffin' in Bonnot-Diconne, C, Hiron, X, Khoi Tran, Q, and Hoffmann, P (eds.) proceedings of the 7th ICOM-CC Working Group on Wet Organic Archaeological Materials Conference, Grenoble, Arc-Nucléart and Deutsches Schiffahrtsmuseum, 210–213.

Imazu, S, and Morgos, A, 1996, 'Conservation of Waterlogged Wood Using Sugar Alcohol and Comparison the Effectiveness of Lactitol, Sucrose and PEG # 4000 Treatment' in Hoffmann, P, Grant, T, Spriggs, J A, Daley, T (eds.), York, International Council of Museums, 235–254. [AMY: the publication is missing here]

Kleber, R L, Masschelein-Kleiner and Thissen, J, 1967, 'Etude et Identification du Bleu Maya' in Studies in Conservation 12(12). [AUTHOR: missing initial for Mass-etc].

Morgos, A, 1999, 'Part II Conservation of Large Waterlogged Archaeological Finds –Sucrose, Lactitol Treatments' in Babinski, L (ed.), Archaeological Wood Research and Conservation, State Archaeological Museum in Warsaw (Museum at Biskupin), 149–166.

Reyes-Valerio, C, 1993, 'De Bonampak al Templo Mayor' *El azul maya en Mesoamérica*, México, Siglo XXI Editores, Agro-Asemex, 123–134.

Sakai, H, Imazu, S and Morgos, A, 1996, 'Protection of Waterlogged Wooden Objects Kept in Water Against Decay' in Hoffmann, P, Grant, T, Spriggs, J A, Daley, T (eds.), York, International Council of Museums, 1–21.

Materials

Lactitol ®, (4-0(ß-D-galactopyranosyl)-D-glucitol), Lactitol Monohydrate Crystalline, manufactured by Cultor Food Science Inc., Ardsley, New York, distributed in Mexico by Cultor Food Science México (25 kg = US$100).

Kathon ® LX 1.5, 5-Cloro-2-metil-4-izotiazolin-3-ona-2-metil-4-izotiazolin-3-ona 1.5%, manufactured by Rohm and Haas Mexico, distributed in Mexico by Chemical Central Mexico (1 kg = US$6).

Abstract

The Bremen Cog from AD 1380 is one of the world's largest ship finds. It is 23.27 m long, 7.62 m wide, and 7.02 m high to the top of the capstan on the castle deck. Its conservation took 19 years. A specially developed two-step PEG-treatment was employed to an extraordinary scale; the conservation tank held 800 m³ PEG-solution. The stabilization of the once-waterlogged timbers is good, residual shrinkages average 2.3%, corresponding to an anti-shrinkage-efficiency (ASE) of 84%. The novel conservation method was a success, and the concept of rebuilding the ship before conservation proved to be valid.

Keywords

Bremen Cog, PEG (polyethylene glycol), two-step PEG-treatment, stabilization, waterlogged wood

The Bremen Cog Project: the conservation of a big medieval ship

Per Hoffmann
Deutsches Schiffahrtsmuseum
Hans-Scharoun-Platz 1
27568 Bremerhaven, Germany
Fax: +49 471-4820755
E-mail: hoffmann@dsm.de

Introduction

Cogs were the ships of the Hanseatic merchants from the towns along the coasts of Northern Europe. They were high and sturdy ships built to take bulk cargo: grain, herring and forest products from the Baltic to the West; cloth, weapon, household goods and, especially, salt from the West to the growing towns of the East. The cogs ruled European seas in the 12th, 13th and 14th centuries. They brought wealth and power to the coastal towns from Flanders to Novgorod. The name of the ships survived and cogs were depicted on some town seals.

But no one in our time knew what a cog really looked like until 1962, when a dredge in the Weser River in Bremen hit upon a strange wooden hull (Figure 1). Art historian Siegfried Fliedner from the town museum was called in and from several construction features he dared to identify the ship as a big medieval cog. The extremely wide clinker-laid hull planks, the straight stem and stern posts, and the castle deck all resembled the pictures on certain seals from Hanseatic towns. Fliedner decided to salvage the unique wreck (Fliedner 1964, Ellmers 1992).

The salvage

The iron nails holding the hull together had corroded away, so there was no way to lift the ship as a whole. There was neither money nor time, with winter ice threatening, to arrange an excavation in a caisson, as was done for the Viking ships in Roskilde Fiord. The cog had to be taken up timber by timber, with the help of a helmet diver groping his way in the dark brown water of the river (Figure 2).

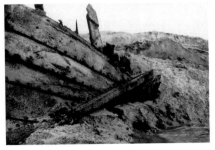

Figure 1. A strange hull in the river Weser: very wide clinker-laid planks fastened to each other with big, clenched iron nails run into straight stem posts fore and aft. These are features of a cog. (Photo: K. Schierholz, Focke-Museum)

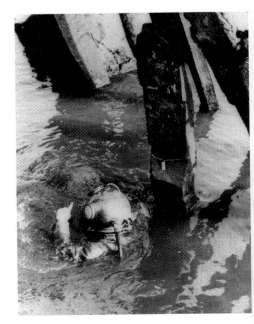

Figure 2. Feeling his way in near-zero visibility, a hard-hat diver tries to understand and describe to the archaeologists on board the barge the structure of timbers he is going to attach to the crane. (Photo: L. Kull, Bremen)

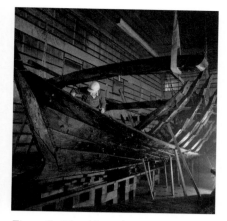

Figure 3. The 4th strake. Reconstructing the cog from waterlogged timbers called for 100% relative humidity (fog, in other words) in the cog hall and for constant spraying of the wood. Wooden dowels and treenails proved to be the best choice for assembling the wet timbers. (Photo: G. Meierdierks, DSM)

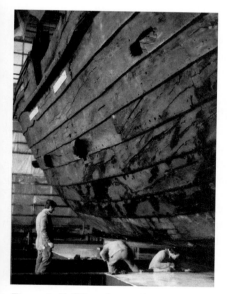

Figure 4. Building the stainless-steel conservation tank around the reconstructed cog. (Photo: P. Hoffmann, DSM)

About 2000 pieces of waterlogged wood were lifted and placed in water-filled tanks and shipped to a warehouse in the harbour. Rosemarie Pohl-Weber, Fliedner's new colleague, spent many weeks in a diving bell, searching the riverbed with probes and a metal detector for any possible pieces from the cog that were not found in the first campaign (Pohl-Weber 1969).

The reconstruction

The federal government, the government of Bremen and the town Bremerhaven established a foundation and built the Deutsches Schiffahrtsmuseum in Bremerhaven. In 1972 the ship's timbers could be transferred to the new museum. Since 1979, master shipwright Werner Lahn and a few helping hands have reconstructed the cog from the 2000 wet timbers. She is 23.27 m long, 7.62 m wide and 7.02 m high from the keel to the top of the capstan on the castle deck (Lahn 1992). A technique for glueing wet wood had to be developed (Noack 1969), and the traditional method of joining timbers with wooden dowels and nails had to be modified. Sprinklers and spraying systems kept timbers and the ship wet all the time, year after year, to avoid any drying damage prior to conservation (Figure 3).

The first conservation plan

In 1981, the largest ever conservation tank was built around the cog (Figure 4). I joined the museum at that time and inherited a conservation programme that three of my former professors from Hamburg University had proposed shortly after the cog had been found. In those days nobody had experience with the conservation of big archaeological ships. The three professors, a wood biologist, a wood physicist and a wood chemist, had consulted with colleagues in Stockholm and Copenhagen, who had just begun to conserve the VASA and the Viking ships from Roskilde Fiord.

Waterlogged archaeological wood is a strange and delicate material. When it dries, it shrinks, cracks and warps. During its long burial in a wet environment, micro-organisms, mainly bacteria, have consumed parts of the wood substance of the cell walls, or have broken them down to low molecular weight fragments. Cavities have developed and have been filled with water. The water supports the degraded cell walls and damaged cells; the wet wood does not show its weakness.

But on drying, water evaporates from the cells. Water surfaces develop in the cell lumina, and with their surface tension they pull at the cell walls. If the cell walls are degraded, they cannot withstand the tension and they collapse, along with the whole cell. The water surfaces sink deeper and deeper into the wood during the drying process, and collapse affects the whole piece of wood. To avoid heavy shrinkage, splits and warping, one has to strengthen the structure of the wet wood before it is allowed to dry.

The Hamburg wood scientists agreed with their colleagues in Stockholm and Copenhagen: polyethylene glycol (PEG), which was used to stabilize such fresh wood as veneers and gun stocks, was the choice substance also for the treatment of the ships. PEG is a colourless and water soluble artificial wax. It is chemically stable, cheap and easy to handle. When a piece of waterlogged wood is placed in a PEG-solution, PEG molecules will diffuse into the wood and substitute part of the water. When the wood is allowed to dry, the residual water evaporates and the PEG precipitates in and on the cell walls. It solidifies and reinforces the degraded wood structure against shrinkage and collapse. The question is, however, which PEG is the best and which molecular size is suitable?

High molecular weight PEG 3000 or 4000 (MW 3000 or 4000) is solid, like stearin, at room temperature, and gives a good stability to the wood. But it permeates less degraded wood only very poorly, if at all. Low molecular weight PEG 200 or 400 permeates much better. But these PEGs are hygroscopic, and wood impregnated with them tends to absorb moisture from the air; it never really dries. Apart from that, low molecular PEG is liquid at room temperature, so it cannot strengthen heavily degraded wood. Another question arose: what is the best way to impregnate a ship?

The conservators in Stockholm were going to spray the VASA with a solution of high molecular PEG, and they had installed hundreds of spraying nozzles in and

around the huge ship. But would the PEG really get into all corners and crevices of the hull structure? The planks of the Viking ships sat in heated impregnation tanks in PEG 4000. The Bremen cog had also been salvaged in pieces. But the planks were more than twice the thickness of those of the Viking ships. The Hamburg professors doubted that they could be reassembled once they were conserved and would have become less flexible. The professors suggested a compromise. PEG 1000, solid but with medium size molecules, would not be too hygroscopic. They recommended reconstructing the cog first, and then conserving the ship in an impregnation bath. The impregnation time, they estimated, would be 30 years (Noack 1969).

In 1981 my co-workers in the museum filled the tank around the cog with 800 m^3 of water, and we started to add PEG. Our budget was good for 40 tonnes per year, for a 5% increase of the concentration. The final concentration would be 60%.

In 1982 I analyzed some oak timbers from a pilot scale conservation, which Werner Lahn had started already during the reconstruction of the cog. In five years the PEG had only penetrated the outermost two to five millimetres of the wood. On drying, the planks remained greasy and looked unpleasant, and, even worse, they shrank and split considerably. I had to change the conservation.

The two-step PEG-treatment

During the next couple of years I looked closer at the stabilizing capacities of a wide range of PEGs for oakwoods of various degrees of degradation. Penetration of PEG into cell walls was investigated, as was the hygroscopicity of impregnated wood measures. In the end I could design a novel two-step PEG-treatment which would stabilize timbers of all states of preservation, even timbers made of tissue of different degrees of degradation at the same time (Hoffmann 1986). In a first bath containing low molecular PEG 200, this PEG diffuses into the wood and into the cell walls of the only slightly degraded parts of the wood. The PEG 200 replaces the water in the cell walls. When the wood dries after treatment, the PEG remains there, held absorbed by physical forces. It keeps the cell walls in a permanently swollen state, and prevents the wood from shrinking. In a second bath with high molecular PEG 3000, this PEG diffuses into the areas of highly degraded wood only. It cannot penetrate into non-degraded cell walls. But in the degraded tissue the PEG 3000 fills the cell wall remnants, and also the cell lumina to a certain degree. In this bath non-absorbed superflous PEG 200 from the heavily degraded areas diffuses out of the wood again. As a result, after the second bath the stabilized wood is not hygroscopic. Optimal PEG-concentrations are 50% for the first bath, and 70% for the second. The second bath has to be heated to 40°C to 50°C to keep the solution of PEG 3000 liquid.

The treated laboratory samples showed residual shrinkages on drying of up to 5%; without stabilization comparable samples shrunk 15% to 25%. If all wood qualities were stabilized to the same degree, presumably no tensions would build up in larger, multi-quality timbers (i.e. the tensions that normally lead to distortions and cracks).

This two-step impregnation method was the right procedure for the cog. However, it would cost substantially more than the original scheme, we would need about twice the amount of PEG and the second bath would have to be heated for several years.

The board of the museum invited the leading waterlogged-wood conservators to Bremerhaven: Kirsten Jespersen from Copenhagen, Lars Barkman from Stockholm, David Grattan from Ottawa, Detlev Noack (my professor from Hamburg) and Kurt Schietzel, Director of the Archaeological Museum in Schleswig and excavator of the Viking ship from Haithabu. The specialists examined the laboratory results, the two-step PEG-method and the new conservation scheme. They approved. The large-scale experiment began.

The conservation of the cog

During the first treatment step we added 5% PEG 200 annually to the bath. Two times a year a tanker came with 20 tonnes of liquid PEG and pumped it into the

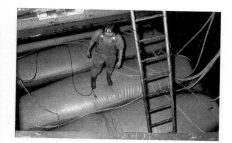

Figure 5. Filling displacement balloons in the tank with brine in a tropical climate. The PEG solution had to be kept at 40°C. (Photo: P. Hoffmann, DSM)

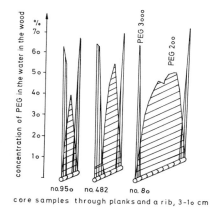

Figure 6. At the end of the second treatment step the PEG-profiles show PEG 200 in the inner parts of planks and ribs, and PEG 3000 in their surface layers.

tank. In the preceding days we had evaporated the corresponding volume of water from the tank in a large evaporator installed in the basement. In all, 320 tonnes of PEG 200 were needed for the first bath.

Visitors to the museum could watch the cog from a gallery through large windows. Floodlights hung in the water, and in a green and mysterious twilight the visitors saw dark beams and parts of the hull planking. The divers from the Mary Rose, the sunken battleship of King Henry VIII, once came to see the cog. They said it reminded them of how their ship had looked on the bottom of the sea on days with good visibility.

Two times a year we took 5 mm-thick core samples from representative timbers and analyzed them for PEG-content and PEG-distribution. The PEG profiles told us how far the timbers were from the desired degree of impregnation (Hoffmann 1989).

The cog sat in the bath for 15 years. We were limited by our annual budget and could not buy as much PEG as we would have liked. Otherwise, the impregnation with PEG 200 could have been finished in about five years.

Large volumes of conservation solutions can only be disposed of with the consent of the authorities. While the cog was still sitting in its first bath, I negotiated with the town wastewater authority about the disposal of both baths into the municipal drains. No conservator colleague wanted to take over two 800-tonne batches of PEG-solution, and having them burnt as 'special waste' would have cost us two million Deutschmarks, which we did not have. It took several years and a series of limnological and wastewater treatment investigations and of experts opinions to demonstrate that both PEG 200 and PEG 3000 are completely biodegradable in a normal wastewater treatment plant. The authorities then permitted us to pump the solutions slowly down the drains, so that the microbes in the treatment plant could adapt themselves to the PEG macromolecules. It took three months to pump off the first bath.

After 15 years we stood in the cog again. The warm dark brown wood gleamed and the cog looked beautiful. Many visitors came, including journalists from newspapers, radio and television stations, as well as numerous conservators and archaeologists. They all wanted to see the cog and to creep into her and around her in the tank.

We laid out 250 metres of warm water tubes under the ship and connected them to the central heating of the museum. The second bath had to be heated to 40°C to keep the solution of PEG 3000 liquid.

In November 1995 we began to fill the tank again. We arranged with the producers of the PEG to synthesize it on demand, to fill the 100°C melt directly into the tankers and to ship it overnight from the factory to the museum 800 km away. Here the melt, together with water from a fire hydrant, was pumped through a mixing station, and the resulting 60% solution was piped into the tank. The tankers came two days a week, and only once did a ruptured tube send a 10-m geyser of hot PEG to the ceiling of the hall. Thirteen tankers brought 270 tonnes of PEG 3000.

The days between the deliveries were devoted to work in the tank. We laid layer after layer of 5 × 1 m elastomer-coated textile balloons under the ship and into its hold, and filled them with brine. The balloons were a means of reducing the active volume in the tank in order to save on expensive PEG. The heavy 18%-saltwater solution kept the balloons submerged in the PEG solution. We installed the balloons at the same pace as the tide of PEG-solution rose (Figure 5). One hundred and sixty balloons reduced the active volume by about 50%. Eighty tonnes of salt were used to produce brine. These exciting weeks have been described in greater detail elsewhere (Hoffmann 1997).

A year later some balloons were removed, and more PEG 3000-melt was mixed into the solution to increase its concentration to the final 70%. Again we monitored the progress of the impregnation. The PEG-profiles confirmed my expectations: PEG 3000 filled the outer, more degraded portions of the timbers; nearly no PEG 200 was found there anymore. But in the less degraded inner parts of the timbers sufficient PEG 200 remained for a good stabilization (Figure 6). When no more PEG 3000 accumulated in the wood, we terminated the impregnation in March 1999. The second bath had lasted for three years.

The steelworkers from a nearby shipyard found it a rather intricate job to dismantle the tank. No pieces of steel, nor any droplets of liquid steel from their plasma torches, could be allowed to fall onto the ship in the tank. But once they had found out how to ensure that, it did not take long to cut the largest conservation tank in the world down to a heap of scrap iron (Figure 7).

Results and discussion

By Christmas 1999, the cog stood free once again in the cog hall of the museum. She looked like a ship on an arctic expedition, encrusted in white, solidified PEG-solution (Figure 8). Cleaning was tedious. But with a carefully applied steam jet, and with brushes, sponges and spatulas, we could remove the PEG without washing too much of it out of the wood surface.

Today the timbers have a nice dark brown colour. Just enough PEG has been washed out of the surfaces to render them natural looking and dry. After 600 years we still see charred patches on the planks: the medieval shipwrights heated them over a fire to make them soft and pliable, so that they could bend them in place onto the hull. We will not apply any surface treatment to the wood; it looks very attractive as it is. But we have worked over the dry timbers with a hot-air blower. We just melted the PEG in the surface, and that gave a deeper and more transparent colour to the wood.

Planks and beams of the cog have now dried for two years. Residual cross-grain shrinkage measures 2.3% on average and the longitudinal shrinkage is zero. Comparing these values to the average shrinkage of 15% of some non-treated pieces of wood from the cog, the anti-shrinkage-efficiency (ASE) of the treatment is 84%. The full-size two-step PEG-treatment has rendered the same good results as the laboratory experiments. We feel very relieved that the scaling-up of the method has not reduced its efficiency.

Only a few heavy beams have warped. They were cut from the centre of the tree. Such centre-beams, when made of fresh wood, are extremely difficult to dry without damage. This limited warping, however, has not influenced the integrity of the hull structure. It is only a slight aesthetic irritation.

Planks and beams have become hard and stiff through conservation, as the Hamburg professors had feared. The extravagant decision to rebuild the cog from the wet timbers before conservation was right. Today we realize that it was the only way the ship could have been reassembled.

Presentation

From the beginning of the project the exhibition aspect was kept in mind. A ship is most beautiful when you can see and appreciate the lines of her hull unimpeded. To avoid any outside supporting structures, the cog was rebuilt, hanging from the ceiling and suspended by a system of steel rods (Hoheisel 1969). The keel rests on a row of keel blocks, but most of the weight is taken by the ceiling (Figures 9 and 10).

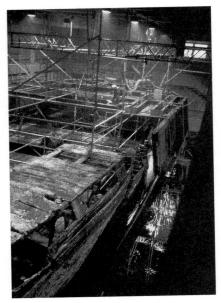

Figure 7. Turning the huge conservation tank into 130 tons of scrap iron. The starboard side of the castle deck is cleared in the foreground. (Photo: P. Hoffmann, DSM)

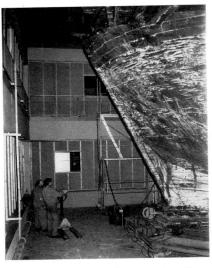

Figure 8. Due to the slow pumping-off, the concentrated PEG 3000 solution has solidified on the timbers of the hull. (Photo: E. Laska, DSM)

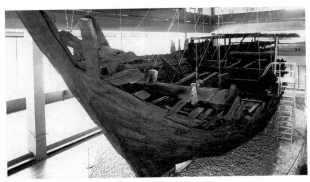

Figure 9. A view into the Cog. The port side has eroded away down to below the huge cross-beams. The asymmetric steel-rod-system transfers most of the hull's weight to the ceiling. (Photo. E. Laska, DSM)

Figure 10. The Bremen Cog as she stands in the Deutsches Schiffahrtsmuseum. (Photo: E. Laska, DSM)

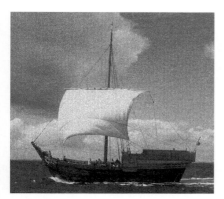

Figure 11. Werner Lahn's drawings of the Bremen Cog were the basis for the construction of several full-size replicas. Here the Hansekogge from Kiel sails in a light breeze. (Photo: U. Dahl, Flensburg)

The cog is a nearly complete ship: only the upper part of the port side has eroded away in the riverbed. Visitors standing at the foot of the stem, or at the stern, are amazed at the impact of the bulky and high hull, and at the same time delight in the elegant strakes of the enormously wide planks. Without props the cog seems to be ready to move at any moment.

Conclusion

The Bremen cog project has taken 38 years, from the salvage to the presentation of the stabilized ship in the museum. Three major decisions characterize this project, and they were all successful. First, we rebuilt the ship from its waterlogged timbers before conservation, as the planks would have become stiff and unpliable in conservation. Second, we hung the ship from the ceiling and avoided outside props to the hull to provide maximum appreciation of the lines of the ship. And third, we stablized the ship's timbers with a specially developed two-step treatment using low molecular PEG and high molecular PEG. This two-step PEG-treatment has meanwhile been adopted for the conservation of other archaeological ships, such as the Kinneret boat in Israel, the Shinan Treasure Ship in Korea and the Mary Rose. This treatment is expensive, but it serves the purpose.

References

Cohen, O, 1999, 'The Kinneret boat: conservation and exhibition' in Hoffmann, P, Bonnot-Diconne, C, Shiron, X and Tran, Q K (eds.), *Proc. 7th ICOM Group on Wet Organic Archaeological Materials Conference, Grenoble*, 182–187.

Ellmers, D, 1992, 'Introduction and Bibliography' in Lahn, W (ed.), *Die Kogge von Bremen, Bauteile und Bauablauf*, Schriften des Deutschen Schiffahrtsmuseums Bd. 30, Kabel Verlag, Hamburg.

Fliedner, S, 1964, *Die Bremer Kogge*, Nr. 2 Hefte des Focke-Museums, Bremen.

Hoffmann, P, 1986, 'On the stabilization of waterlogged oakwood with PEG II. Designing a two-step treatment for multi-quality timbers.' *Studies in Conservation* 31, 103–113.

Hoffmann, P, 1989, 'HPLC for the analysis of polyethylene glycols (PEG) in wood' in MacLeod, I D, (ed.) *Proc. ICOM Groups on Wet Organic Archeological Materials and Metals Conference, Fremantle*, 41–60.

Hoffmann, P, 1997, 'The conservation of the Bremen Cog – between the steps' in Hoffmann, P, Grant, T, Spriggs, J A and Daley, T (eds.), *Proc. 6th ICOM Group on Wet Organic Archaeological Materials Conference, York*, Bremerhaven 527–546.

Hoffmann, P, Choi, K N and Kim, Y H, 1991, 'The 14th-century Shinan ship – progress in conservation' *IJNA* 20.1, 59–64.

Hoheisel, W D, 1969, 'Die Aufstellung und Sicherung des Schiffskörpers im Haus der Kogge' in *Die Bremer Hanse-Kogge*, Monographien der Wittheit zu Bremen Nr. 8, Verlag Friedrich Röver, Bremen, 169–179.

Jones, M A and Rule, M H, 1991, 'Preserving the wreck of the Mary Rose' in Hoffmann, P (ed.), *Proc. 4th ICOM Group on Wet Organic Archaeological Materials Conference, Bremerhaven*, 25–48.

Lahn, W, 1992, *Die Kogge von Bremen, Bauteile und Bauablauf*, Schriften des Deutschen Schiffahrtsmuseums Bd. 30, Kabel Verlag Hamburg.

Noack, D, 1969, 'Zur Verfahrenstechnik der Konservierung des Holzes der Bremer Kogge' in *Die Bremer Hanse-Kogge*, Monographien der Wittheit zu Bremen, Nr. 8, Verlag Friedrich Röver, Bremen, 127–156.

Pohl-Weber, R, 1969, 'Fund und Bergung der Bremer Kogge' in *Die Bremer Hanse-Kogge*, Monographien der Wittheit zu Bremen, Nr. 8, Verlag Friedrich Röver, Bremen, 15–38.

Textiles

Textiles

Textiles

Textiles

Coordinator: Rosalia Varoli-Piazza
Assistant Coordinators: Dinah Eastop, Lynda Hillyer, Patricia Dal Pra

The Textiles Working Group (TWG) continued with the publication of its newsletter (numbers 15 and 16 for 1999–2000, total 64 pages). It was distributed by postal service (for the last time) to the 350 addresses on the TWG database, and also digitally to 50 Italian institutions, as it has been put on the Web page of the Instituto Centrale del Restauro in Rome. The newsletter was dedicated to the memory of Ágnes Tímár-Balászy, our unforgettable colleague and friend who died in 2001.

Of the topics arising from discussion at the Lyon Textiles Working Group session, five were identified for the triennium: costume; detergents; textile conservation education and professional development; conflicts between the pressures for preservation and accessibility; and carpets, DDT permanence and risks to operators. The scope of the newsletter was broadened to reflect these topics, in the form of a 'Carpet Corner' and a 'Contemporary Textiles Corner'. The Working Group submitted 10 papers on various of these subjects for the Rio Triennial Meeting, of which seven were short-listed.

Formal contact with the Costume Committee of ICOM was maintained via a joint session during the ICOM 2001 Barcelona Conference. Many colleagues participated in the General Assembly of CIETA (Centre International d'Études des Textiles Anciens) in Bern, Switzerland (1999), and in Lyon, France (2001).

The TWG's long association with the Dutch Textile Committee continued with a one-week programme concerning the conservation of textiles and education; it was organized in November 2000 by the Dutch Textile Committee, together with the Netherlands Institute for Cultural Heritage and our Working Group. In November 2001, the Netherlands Institute for Cultural Heritage organized a meeting on 'Dyes in History and Archaeology'. In May 1999, the Canadian Conservation Institute (CCI) organized a Professional Development Workshop on 'Adhesives for Textiles and Leather Conservation: Research and Application'. This intensive four-day workshop (since lengthened to five days) was ably led by Jane Down, the senior scientist responsible for the adhesives research carried out at the CCI over the last 20 years.

Members of the TWG continue to define the scope of textile conservation, both by reviewing past practice and by encouraging innovative developments. For example, Nicola Gentle surveyed 20 years of textile conservation practice in the last newsletter, and Deirdre Windsor, formerly Director and Chief Conservator of the Textile Conservation Center at the American Textile History Museum, was one of 27 Americans to win the 104th annual Rome Prize Competition awarded by the American Academy in Rome. During her six-month fellowship in Rome, Deirdre undertook a comparative study of conservation treatments for Coptic textiles and analyzed the prevailing ethics for archaeological preservation in the field.

Another important development for textile conservation is the establishment of the AHRB Research Centre for Textile Conservation and Studies, 2002–2007. The Centre is a partnership between the U.K.'s Textile Conservation Centre at the University of Southampton, the Department of Archaeological Sciences at the University of Bradford, and the School of Art History and Archaeology, University of Manchester. It will be directed by Dinah Eastop of the Textile Conservation Centre. Funding is provided by AHRB, the U.K.'s Arts and Humanities Research Board, for two post-doctoral researchers for five years, as well as research conservator posts (totalling six months for each of the five years of the award), and for publications and conferences.

All these activities, and many are not mentioned here, indicate the vitality of the Textiles Working Group and the willingness of its members to cross national and disciplinary boundaries in order to foster best practice in textile conservation.

Abstract

This paper will discuss conservation of eight large embroidered panels by Artur Bispo do Rosario. The panels were to part of the huge Rediscovery Exhibition in São Paulo to celebrate Brazil's 500th anniversary and work was carried out in Rio de Janeiro around Carnival 2000, a few weeks before the opening. The panels are extremely fragile, not only due to inadequate environmental and exhibition conditions but also to previous repairs that caused the colours to fade and the textiles to weaken and shrink, leading to distortion and tears. Time constraints meant the main challenge was to make them safe to endure exhibition and travelling. The accomplishment of the work was achieved due to proper and careful planning, outlined here.

Keywords

textile conservation, Brazilian embroidery, time constraints, planning

Caring for a Brazilian 'humming bird': an adventure in the embroidered world of Arthur Bispo do Rosario

Luciana da Silveira
Rua Belizario Tavora
467 ap 210
22245-070 Rio de Janeiro, Brazil
Fax: +55 21 2252 5619
E-mail: lucianadasilveira@hotmail.com

Teresa Cristina Toledo de Paula
Museu Paulista da Universidade de São Paulo
Caixa Postal 42.503
04218-979 São Paulo, Brazil
Fax: +55 11 6165 8038
E-mail: tcpaula@usp.br

Introduction

In the year 2000 Brazil celebrated its 500th anniversary and for this reason several events took place. One of them was a huge exhibition named 'Mostra do Redescobrimento' (The Rediscovery Exhibition) which presented thousands of artistic works owned by museums and private collections from both inside and outside Brazil. The exhibition was divided into different sections, and one of which was dedicated to 'the Art of the Unconscious'; Bispo's works were included there. This paper will concentrates on the planning and activities involved in conservation of the panels that were part of this exhibition.

Work started only few months before the opening and included a visit to the museum for an evaluation of the panels (see Figure 1). The visit made clear the fragility of the panels and the necessity of some objective conservation approaches to make them safe for display. The very short time available, the poor conservation conditions, the amount of work to be carried out and the exhibition requirements, all were considered when developing the plan of action. A team of seven was hired from from São Paulo and Rio de Janeiro and the work was carried out in Rio during weekends and Carnival.

The 'humming bird', Arthur Bispo do Rosario

Arthur Bispo do Rosario (1909–89), known all over Brazil after his death for his embroideries and other objects, spent most of his life in a hospital for the mentally ill. He used to say that the mentally ill are like humming birds, never landing and always two metres above the ground. Born in a small northeastern village of Brazil, Bispo was raised in a very religious environment. He moved to Rio de Janeiro where he started boxing and joined the navy as a mariner. This allowed him to know many different places and cultures. After being arrested several times due to his aggressive behaviour he was discharged from the navy. In 1938 he was found wandering around Rio and was placed in the first of several psychiatric hospitals, which included Colonia Juliano Moreira where he lived until his death. According to his biographers Bispo believed himself to be Jesus and to have received a message from God ordering him to rebuild the world. After the message, he decided to isolate himself and recreate the world through embroideries and objects, going for long periods without eating, sleeping or talking to anyone. Bispo used bed sheets as the ground for his embroideries. As yarn he unthreaded his own blue uniforms, which explains the blue colour forming the major tone of the panels. The main themes depicted on the panels are scenes from Bispo's daily life – the cities he knew, mostly Rio de Janeiro, the names of people and their professions, ships, hospitals, texts from the Bible and magazines available to him. Most of his works today belong to the museum located inside Colonia Juliano Moreira.

Figure 1. One of the panels on exhibition at the museum before conservation

The embroidered panels

Seven of the eight large panels are quite similar: double-sided cotton fabrics (bedsheets) embroidered with cotton threads, generally blue (usually threads from Bispo's uniforms).

The content of his work was based on his everyday life and experiences. One panel, however, was different in format and content, showing sentences copied from the Bible. All the panels hang from wooden sticks, six of them attached by small straps. Their construction is quite unique and includes different materials such as plastics, paper, metals, etc.

Conservation condition and constraints

The panels were extremely fragile, not only due to inadequate environmental and exhibition conditions but because previous repairs that caused the colours to fade and the textiles to weaken and shrink, leading to distortion and tears. The wooden sticks by which they are attached were in poor condition, infested with termites and presenting holes. The straps that hold them were very weak due to the weight of the panels and years of exhibition (see Figure 2).

Some of the wooden sticks that were infested and damaged by termites received appropriate treatment from a specialist. Such an action took into consideration the complexity of the objects and the fact that the sticks could not be removed.

Figure 2. Close up of the wooden stick and strap areas before conservation

Conservation planning

The fact that there is no formal training on textile conservation in Brazil had to be considered. Apart from the authors, the team had no areas of specialization and practice in this field. Two of team were conservators of paintings and wood, and three were being trained in the field, both in Rio de Janeiro (atelier Luciana da Silveira) and São Paulo (Teresa C T Paula, Museu Paulista, Universidade de São Paulo).

The first step was solving the very basic issue of how to deal with the large dimensions of panels that should be worked simultaneously and the other objects already being treated at the same conservation studio. The team was then divided in subgroups according to the objects' needs, for instance, while one group was surface cleaning another was treating the wooden sticks.

The main issues under consideration were the short time available before the opening of the exhibition (10 days), minimum interference (respecting Bispo's characteristics), exhibition requirements (open vertical and itinerant display), length of exhibition (originally one year), and the need to prepare and provide enough support for travelling (focusing on the double-sided structure of the panels) and to minimize future damage (reinforcing weakened areas).

The way that Bispo embroidered was very peculiar and unique, and complicated by the fact that he mended the panels several times during his life. The panels had also been through several interventions after joining the museum collection (see Figure 3). Considering these points, it was crucial to determine which interventions had been carried out by Bispo and which ones had not.

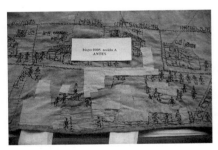

Figure 3. Close up of a previous intervention

Conservation treatment

The working space needed to be adapted to allow the various phases of treatment on the different banners to be carried out simultaneously. According to time constraints the main objective was to make them safe to endure exhibition and travelling. Since the panels were double-sided, it was decided that three would be treated whilst lying on tables and the others while hanging after being supported. Once a large wall area was available, a system was created to make object rotation possible, always considering further action (see Figure 4).

As mentioned previously, the sticks from the panels required intervention. Some presented large areas of loss (due to termite attack), meaning that they would not withstand the weight of the textiles. They first were surface cleaned using swabs wetted in distilled water. The termite galleries were cleaned by suction to remove

Figure 4. General view of the panels during different stages of treatment

Figure 5. Nylon net being sewn to the original strap and the wooden stick after treatment

Figure 6. Close up of straps after reinforcement

Figure 7. Panel after treatment at the conservation studio

Figure 8. Panel hanging inside the box before transport

the debris and the areas comprising the textile straps isolated with Melinex® prior to disinfestation. For this we used clorpirifos diluted in white spirit, considered at the time to be the mostly easily available option. The areas were filled using wooden powder with polyvinyl acetate copolymer JADE R® adhesive. After drying the areas were evened out by surface abrasion. The damaged wooden sticks were reinforced by attaching new sticks to them.

After being surface cleaned by low suction vaccum the panels were humidified vertically (since they are double-sided). Before humidification a correx was inserted between the two sides of the panels to provide support for the pinning and minimize the distortions. The humidification was carried out using both cold and hot vapours.

The next step was to support the fragile areas of the fabrics using polyester fabric, nylon net and plain weave cotton with colour matching according to the different needs. Some of the fabrics had to be imported due to the properties required (basically, semi-transparence and strength). All the hanging straps were reinforced with a strong nylon net since the entire weight of the textiles were concentrated on pulling them down (see Figure 5). The special nylon net was chosen to integrate visually with the objects and for ease of dyeing to a matching colour (see Figures 6 and 7).

The final step was to plan and prepare the travelling containers. Individual wooden boxes were ordered according to the dimesions of each panel. Special requirements such as volatile barriers and paddings were requested but were not provided by curators. To best guarantee minimal damage during travelling from Rio to São Paulo (and onwards) we padded the boxes inside with wadding covered with non-woven fabric, both polyester. The panels had to be transported vertically to avoid creases and wrinkles, because of their unique construction. Special screws were attached to the top parts of the boxes and the wooden sticks tied to them in several places (see Figure 8).

Conclusion

The accomplishment of the work was achieved due to proper and careful planning and good team work. An evaluation of the time necessary was very important as the time scale was very short and long journeys were necessary. The main objectives were achieved, although some problems with curators were verified during the conservation work. After the panels had left the conservation studio the team had no say in any further exhibition and storage plans despite guidelines provided for both the museum and curators.

Acknowledgements

The authors would like to thank the team: Claudia de Sampaio Ferraz, Ilacir Galvão dos Santos, Joelma Leão, Rafael Celidônio and Teresa Cristina Cavalcante. We thank also Marylka Mendes, Museu Paulista da Universidade de São Paulo (Fundo de Pesquisas), for the hard copies of photographs, with special thanks to Helio Nobre and José Rosael.

The authors dedicate this paper to Dinah Eastop (The Textile Conservation Centre) for her continuous support.

Abstract

This conservation project is the result of a multidisciplinary approach including contributions from the restorer, curator, art historian and chemists.

Scientific examination of a 19th-century Turkish Ghiordes rug was employed to reveal the cause and level of fibre degradation and the nature of the dirt, amongst which was found a considerable level of pesticide contamination (DDT). Laboratory tests were subsequently made to provide suggestions for cleaning and decontamination. A dry cleaning procedure was set and led to the elimination of between 70 and 80% of the pesticides and the total elimination of the fatty matters. The following wet cleaning treatment allowed the complete elimination of the DDT residues.

After cleaning, the first stage of conservation undertaken was to consolidate the original damaged structure. Thereafter, a selective compensation of losses was undertaken on a support fabric in order to minimize the interruption created by missing areas and produce a readable unity of the rug within the limits of conservation ethics.

Keywords

rug conservation and restoration, philosophy and technique, compensation of losses, ethic and aesthetic, DDT decontamination

Conservation project of an early 19th-century Turkish Ghiordes rug found to have significant pesticide (DDT) contamination: the result of a successful cooperation

Cecilia Di Nola★
Voc. Albano 46
Collelungo
05010 San Venanzo, Italy
E-mail: ceciliadinola@libero.it

C Tonin, M Bianchetto Songia, R Peila, C Vineis and R Roggero
Consiglio Nazionale delle Ricerche (CNR)
Istituto di Ricerche e Sperimentazione Laniera 'O Rivetti'
Corso G. Pella, 16
13900 Biella, Italy
E-mail: c.tonin@irl.to.cnr.it

L E Brancati
Via Ornato 5/9
10131 Torino, Italy
E- mail: luca@rict.it

Introduction

The project outlined here was undertaken on a Ghiordes prayer rug from West Anatolia dated to the first half of 19th century. The rug belongs to the Galleria Nazionale d'Arte Antica situated in Palazzo Barberini, Rome, and is to be displayed in the Museum of Decorative Art, which occupies an entire floor of the Palazzo.

Rugs and textiles produced in the workshops of the Ottoman Court of Istanbul and Bursa during the 17th and the 18th centuries were appreciated for their intricate workmanship characterized by minute decorations arranged in complex patterns. Such items and their design provided models for future production in Anatolia.

Among the many different compositions, the 'prayer scheme' is one of the most usual. It is characterized by a niche known as a 'mehrab', represented by a pointed or curved top. Many rugs of this type illustrate a close relationship in their design composition to architectural motifs, and some clearly represent sections of a mosque or a church. High ogival or cuspidate vaults supported by twisted columns and a lamp suspended from the centre of the niche, with all the surrounding decoration based on flower motifs, are frequent expressions of the 'prayer scheme'.

From early Anatolian rug types made in the 16th century, through to a production style known as 'Transylvanian' (al though still produced in Anatolia), by the beginning of the 17th century rugs had come to be characterized by their very high-quality workmanship together with a great richness of detail. Such rugs included also those from Kula and Panderma, as well as those from Ghiordes. They were greatly appreciated by experts and collectors in the first half of 19th century and today provide a fine example of Turkish production of that (19th century) period.

Detail

The Ghiordes rug of the Galleria Nazionale, the subject of this conservation project, is a fine example of such works. Following the aulic style, the central niche appears on a plain green background, the arch is stepped and the two rows of flowers are reminiscent of columns found amongst the oldest decorations of this type of rugs. The upper part shows a floral decoration, where the two strips that enclose the main background show a design known as a 'cloudband' or 'chi'. These borders consist of two strips decorated with flowers which have between them a

★Author to whom correspondence should be addressed

typical border formed from seven smaller strips alternating with red and white colours and small flowers inside (see Figures 1 and 2).

A similar rug belongs to the Museum of Applied Art in Budapest (inv. 79.153.1) and there are many others in other public collections.

Technical notes

- size: 160 x 240cm.
- warp: ivory wool 2 Z-yarns S-plied
- weft: ivory cotton, 2 runs every row of knots.
- pile: ivory coloured wool and cotton fibres mixed together, wool for the other colours
- colours: ivory, dark green, light green, light brown, dark brown, red, blue, yellow
- knot: symmetrical or Ghiordes, 1800 knots x dm².

Analyses

Materials and methods

The analytical tests performed on small samples taken from the Ghiordes rug consisted of microscopic investigation and chemical analysis of the fibres, dirt particles, dyes and substances extracted using different solvents. The results are as follows.

All the yarns from different colours of the pile comprised wool fibres except the ivory, which was either cotton and/or wool. The fibres were generally in good condition and relatively clean.

Many wool fibres showed the effects of larval attack from keratin-digesting insects and a typical fragile breakdown caused by photo-oxidation of the protein material due to exposure to sunlight, especially in fibres from the green and dark brown yarns (see Figure 3).

The warp yarns were double end-twisted (one white and one black) wool yarns; the weft was a single cotton yarn. The seams were made with double end-twisted flax yarns.

SEM (scanning electronic microscopy) examination of the dust collected by vacuum-cleaning the rugs and of the dirt that covered the fibres or was included between them revealed the presence of materials of different origins. Organic materials were classified as wool breakdown and larvae excreta. An intense absorption at 1040 cm⁻¹, typical of the cysteic acid produced by the oxidative degradation of the cystine contained in wool keratin, confirmed the weakening caused by the photo-oxidation of the fibres.

EDXS (energy dispersion X-ray spectrometry) spectra of the inorganic particles revealed the presence of substances consistent with the composition of common natural mineral dust.

GC analysis (gas chromatography) of the fibre samples revealed DDT concentration between 1.6 and 4.8 ppm (2.4 and 4.4' isomers); the average concentration was determined as 4.0 ppm of 4.4' DDT and 1.8 ppm of 2.4' DDT.

GC analysis of the dust incorporated within the fibres, collected by a vacuum cleaner, contained a concentration of 13.9 ppm of 4.4' DDT and 3.7 ppm of 2.4' DDT. These levels are very high if one considers that current European legislation provides for a limit of 0.5 ppm for the total content of organo-chlorine pesticides in textiles.

Analyses were carried out by extraction of the pesticide with dichloromethane, purification from the fatty matters by *HPLC* (high-performance liquid chromatography) and successive dissolution in iso-octane for GC quali-quantitative analysis.

PESTICIDES

The pesticides extracted from the dust were confirmed by the addition of concentrate solutions for the corresponding standard chemical (addition method).

The concentration of PCP and other organo-chlorine pesticides was not distinguishable from the ground noise in this case, and the analyses were confined to the DDT isomers only.

Figure 1. Ghiordes rug before conservation treatment

Figure 2. Ghiordes rug after conservation treatment

Figure 3. Fibres from pile, light green in colour, showing breakage due to exposure to sunlight

Organo-chlorine pesticides have been used in the past primarily as moth- and beetle-proofing agents. Most of them are contact insecticides and, because of their toxicity even to warm-blooded species, their use is now prohibited in most countries. However, these substances are still active on treated textiles. It should be noted that this practice is still in use in most of the countries connected with a carpet-weaving tradition.

Organo-chlorine pesticides are lyophilic and thus the contact with eyes and skin must be avoided. The utilization of Tyvek® overalls, protective goggles, chemical-resistant gloves and a respiratory mask for toxic dust (Class FFP3S(L), EN 149) is recommended during treatment.

Dye analyses

Identification of the colouring matters was extracted using small yarn samples obtained from the Ghiordes rug and was performed by HPLC.

- yellow was obtained from *Anthemis tinctoria*
- coral red and brick red from madder (*Rubia tinctoria*)
- light green and dark green from a blend of indigo (*Indigofera tinctoria*) and stinking chamomile (*Anthemis chia*)
- dark brown from black walnut (*Juglans nigra*)
- light brown from a blend of sumach (*Rhus coriaria*) and tannic acid
- blue from indigo
- ivory consisted of undyed cotton and wool fibres.

Cleaning and decontamination: laboratory tests

In order to set suitably safe and adequate methods for cleaning and decontamination, whilst bearuing in mind the fragility of the rug, preliminary tests were carried out on samples of a modern rug, artificially contaminated with DDT.

Test A

Test A comprised dry cleaning with tetrachloroethilene (perchloroethilene), total immersion for 20 minutes, at 20°C, 4 cycles of slight motion for 15 seconds, then rinsing with fresh tetrachloroethilene, total immersion for 25 minutes at 20°C, 2 cycles of slight motion for 15 seconds and drying with slow centrifugal in flat condition for 15 minutess with air ventilation at 40°C.

No mechanical stresses were observed as a consequence of the treatment and the presence of DDT was reduced by 70–80 %.

In order to compare the effect of dry cleaning and wet cleaning, other samples were contaminated and treated as follows:

Test B: wet cleaning

WET TRESTMENT COMPRISED

- non ionic detergent (alcohol polyetoxilate) 0.5 g/l
- CMC carboximetilcellulose 0.05 g/l
- sodium chloride 5 g/l.

The wet treatment reduced the pesticide percentage by 44%, and was both less effective and less ecological, as the pesticides were transferred into the water.

Conservation treatments

Preparation prior to cleaning procedures

In order to protect the most fragile areas before any further intervention, a blanket stitch was used to secure the perimeter of the rug. Losses and fragile areas were supported locally between two layers of polyester net. For the dry cleaning

Table 1. DDT levels

Perchloroethilene treatment	before	after
4.4' DDT	13.9	2.9
2.2' DDT	3.7	0.8

treatment (perchloroethilene), an entire further protection was added by sandwiching the whole rug in a polyester net. A loose and long running stitch was used in the warp direction to secure the net.

Cleaning and decontamination

Tests for colourfastness were carried out before any cleaning treatment. All the dyes proved to be fast in contact with the solvent.

For the perchloroethilene treatment, the rug was put horizontally in an appropriate machine. The operation was controlled manually in order to follow the indications provided by prior laboratory tests and the treatment was visually controlled through glass.

After treatment, no stress was observed in the stitches or in the rug structure. The entire net sandwich was then removed and the pile carefully vacuumed in order to analyse DDT levels. The DDT level decreased in line with the results obtained in previous laboratory tests (see Table 1).

With the aim of removing the remaining DDT residue, together with any dirt not sensitive to the solvent but soluble in a water and detergent solution, a wet cleaning treatment was then performed.

TEST FOR COLOURFASTNESS

We used here the same solution as for Test B but with 0.5 to 1g/l non-ionic detergent and the addition of de-ionized water

All the dyes proved to be fast except a light green dye. With a full concentration of detergent solution (1/gl), this dye showed instability after 30 minutes. Using a reduced amount of detergent (0.5/gl), the same dye was fast for 60 minutes, showing less instability even after this longer time. The same dye was completely stable when in water only.

The wet cleaning treatment had to be planned taking into consideration test results for colourfastness.

Complete immersion in a shallow bath, especially created to contain the rug size in flat position, at a temperature set at 20°C, was arranged. The detergent solution used was as for Test B. pH measurements were 5.5 for de-ionized water and 5.8 for detergent solution in de-ionized water.

After 30 minutess the water showed a yellow-brown colour and had a pH value of 5.3. The majority of the dirt was now diluted in the water. During this phase the rug was rolled up on a PVC tube and unrolled face down to facilitate the expulsion of foreign materials trapped in the pile. Mechanical action was provided using soft brushes on both faces of the rug.

After 40 minutes the rinsing operation was carried out, with demineralized water running continuously for 20 minutes on both faces of the rug and soft brushes to assist the process. Excess water was then blotted. The light green dye was remained fast. The rug was then laid on a net screen to give good air circulation and two ventilators assisted drying. After 20 hours, the rug was completely dry. The surface was then vacuumed and the powders analysed in order to determine the presence of any remaining DDT residue, but none was found.

Rugs and conservation: a short history

Integrative restoration practice was commonly used until the 1950s/1960s, essentially to restore utilization of the rug. As a backlash against to the many disrespectful restorative interventions of the past, the last 30 years of rug conservation has consisted of minimal intervention with no other objective beyond conservation.

Current practice consists of lining the back of the rug with a fabric support (cotton or linen, neutral or dyed) in order to secure the damaged areas. This 'lining theory' is drawn from the field of painting conservation and has been used successfully in textile conservation, although it is not adequate for all rugs.

The three-dimensional characteristic of a pile rug seems often to be in contrast with the flat appearance of the lining. Our visual perception is at first attracted by the losses, which lie back when compared to the original surface of the rug. Whilst

this practice has helped to foster respect for any existing fragments of the rug, it does not always satisfy the 'aesthetic' perception.

Another doubt concerning 'full-screen' support has to do with the continuous degradation of the molecular structure of the wool fibre. A total support obstructs its degradation which could cause ideal ambient factors for biological attacks.

The Rug Conservation Symposium, held in Washington, 30–31 January 1990, made an important contribution to the field. For the first time, rugs were considered in their complexity, analysing the interaction between designs and structure, the perception of the missing areas in pile rugs and the possibility of an integration of knowledge between conservation and restoration techniques.

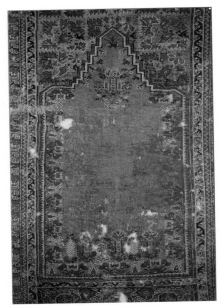

Figure 4. Detail of the central 'niche'. Several losses of different size produce a disturbing vision of the field; local support patches have been already positioned underneath

Conservation and restoration: philosophy and technique

In Italy, one of the most important experts in the field of art history and its conservation in the last century was Prof. Cesare Brandi. Brandi was the first director of the Istituto Centrale del Restauro (ICR) in Rome from 1939 to 1959. His lectures have been collected in a *Teoria del Restauro* (1963) in which he defines the philosophical fundamentals of restoration. In this particular conservation/restoration project, Brandi's work was used as a guide. Quotes extracted from this book illustrate the different phases of the restoration project.

Consolidation of the original physical consistency

> The physical consistency of any work of art must necessarily take precedence because it represents the place of the image's manifestation, it assures the transmission of the image to the future, and it therefore guarantees its reception within human consciousness. (Brandi 1977, p.6)

The end finishes and the selvages of the rug were consolidated by a blanket stitch as a preliminary method of conserving the existing periphery of the rug.

The most fragile areas and those missing were treated with local support using a 'canneté' cotton fabric (previously treated in a water-only washing machine cycle at 40°C) and cut to shape according to the dimensions of the damaged areas. The original parts of the rug which bordered on missing areas were positioned and fixed to the fabric support using a couching stitch. For the outer perimeter of support patches, a herringbone stitch was used.

These interventions restored much of the structural solidity to the rug and secured the original damaged parts from further deterioration.

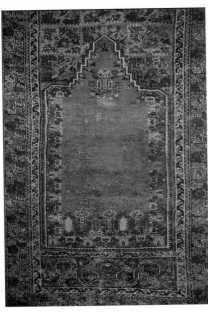

Figure 5. Same detail as in Figure 4 after selective compensation of losses by a re-knotting technique which interacts only with the support patch

The potential unity of a work of art: compensation of losses

> Our attitude towards the work of art is the respect of the integrity of what is arrived to us without compromising its future. Only at this point the question of what is left of a work of art can be examined; whether the unity of its image permits or not the reconstruction of certain lost passages, as reconstruction of that potential unity that the work of art has in consideration of its whole. (Brandi 1977, p.74)

In the Ghiordes rug, the decorative pattern of the main central border shows flowers in alternating red and white rows, especially on the left side. Several losses of different sizes interrupt the continuity of the design which frames the central field. In the 'prayer niche', the losses are emphasized by the presence of missing areas because they appear on a solid dark-green field, producing an unsatisfactory vision of the rug as a whole (see Figures 4, 5 and 6).

A selective re-knotting of some areas was made on the local fabric support. The original broken warps and wefts were left in place and secured underneath the reweaving (see Figures 5, 6 and 7).

Where it was not possible to be sure of the original pattern, any arbitrary reconstruction was avoided. In these cases only new warps and wefts were placed to compensate the loss and were fixed in place through a couching stitch, but no re-knotting was done.

The aim was to reconcile the ethical principles of conservation with the aesthetic appearance of the rug as a whole.

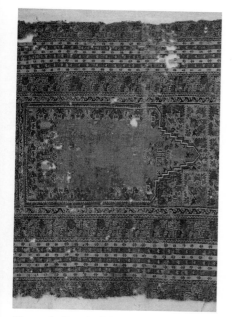

Figure 6. Detail of the central strip; the left side of the rug shows vast areas of damage and several lacunae

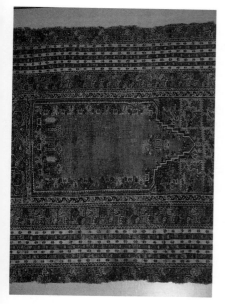

Figure 7. Same detail as in Figure 6 after consolidation and selective restoration treatments

Reversibility

> With reference to the future: every restoration should not prevent but, rather, facilitate possible future restorations. (Brandi 1977, p.18)

Every intervention is clearly recognizable on the reverse of the rug and the selective re-knotting interacts only with the local support patch.

Conclusions

Scientific investigations and analyses carried out within the preliminary stages were indispensable instruments for the formulation of eventual treatments.

SEM examination of the fibres revealed a high degree of weakening due to photo-oxidation, giving a real picture of the fibres' fragility despite their good appearance. From the dirt samples inorganic substances of mineral origin were identified and organic materials classified as breakdown of wool, larvae excreta. GC analysis on the dust vacuumed from the carpet showed the presence of a significant DDT concentration. These results gave the opportunity of setting up a specific method of decontamination and cleaning suitable for this particular rug.

A multidisciplinary viewpoint gave a more complex view of restoration and was essential in formulating a more aware approach.

Conservation and restoration treatments followed, as a guide, Brandi's *Teoria del Restauro* (1963).

The first stage of conservation had the objective of consolidating all the original damaged parts of the rug. Only then was partial and selective interventions on the main losses undertaken to achieve a comprehensive unity of a work of art within the limits of the principles of conservation ethics, but taking into consideration also the object as a whole, together with its aesthetic value.

References

Aslanapa, O, 1988, *One Thousand Years of Turkish Carpets*, Istanbul.

Batári, F, 1994, *Ottoman Turkish Carpets*, Budapest.

Bennett, I, 1977, *Rugs & Carpets of the World*, London.

Brandi, C, 1963, *Teoria del Restauro*, 1st ed., Turin, Einaudi.

Brandi, ibid., 1977 ed.

Cohen, G, 1968, *Il fascino del tappeto orientale*, Milan.

Eiland, M L and Eiland, M, III, 1998, *Oriental Rugs. A Complete Guide*, London.

Ellis, C G, 1969, 'The Ottoman prayer rugs', *Textile Museum Journal*, 2, 5–22

Eskenazi, J J, 1983, *Il tappeto orientale*, Milan.

Ettinghausen, R, Dimand, M S, Mackie, L W and Ellis, C G, 1974, *Prayer Rugs*, Washington, The Textile Museum.

The Getty Conservation Institute, 1995, *Historical and Philosophical Issues in the Conservation of Cultural Heritage*, edited by Nicholas Stanley Price, M Kirby Talley Jr and Alessandra Melucco Vaccaro, Los Angeles, The Getty Conservation Institute.

Hammers, W K, Altenhofen, I, Melliand, U and Ilkley, G B, 1985, 'Textilberichte', 8, 666–672. International Wool Secretariat (Ilkey, GB), *Wool Science Review*, no. 2, 31–43.

Hangeldian, A E, 1964, *Tappeti d'Oriente*, Milan.

Iten-Maritz, J, 1975, *Der anatolische Teppich*, Freiburg.

Sabahi, T, 1986, *Tappeti d'Oriente. Arte e tradizione*, Novara.

Textile Museum Journal 1990–1991, Carpet Conservation Symposium, January 30–31, 1990.

Tonin, C, Innocenti, R, Bianchetto, S M, Pozzo, P D and Di Nola C, 1999a, 'The problem of organo-chlorine pesticides in ancient wool rugs', abstract no. 143, Second International Congress on Science and Technology for the Safeguard of Cultural Heritage in the Mediterranean Basin, Paris.

Tonin, C, Innocenti, R, Bianchetto, S M, Pozzo, P D and Di Nola C, 1999b, 'SEM investigation of historical wool rugs: state of fibres and contaminants', 4th Multinational Congress on Electron Microscopy' Veszprem (H).

Tonin, C, Innocenti, R, Bianchetto, S M, Pozzo, P D and Di Nola C, 1999c, 'Quantitative analysis and removal of organochlorine pesticides in ancient historical artistic wool textiles', ICOC 9th International Conference on Oriental Carpets, Milan.

Wimbush, J and Ilkley, G B, 'GC method for chemical analysis of PCP in carpets', IWS Method PCP4/92.

Zipper, K, Fritzsche, C and Jourdan, U, 1990, *Tappeti orientali. Turchi-Turcomanni*, Milan.

Résumé

Depuis 1995, le Centre de conservation du Québec (CCQ) est devenu une unité autonome de service du ministère de la Culture et des Communications (MCC). Ce nouveau statut a permis au CCQ de passer des contrats avec le secteur privé, incluant des établissements et des individus. C'est dans ce contexte que l'atelier de textile du CCQ a été invité, en avril 2000, par la compagnie L'Industrielle Alliance, propriétaire de l'édifice du ministère du Revenu du Québec, construit en 1979, à proposer un traitement de conservation d'un immense textile architectural tridimensionnel. Ce contrat met en évidence l'importance du développement des partenariats, comme ce fut le cas pour la recherche scientifique, la mise au point d'un traitement de conservation et aussi la proposition d'un programme de conservation préventive. Il est entendu que la création des partenariats serait inestimable pour l'existence future des textiles architecturaux gardés dans les édifices publics à travers le Québec.

Mots-clés

conservation préventive, édifices publics, nylon, partenariats, produit ignifuge, traitement de conservation, teintures industrielles, textile architectural contemporain

L'art de la fibre de nylon : Le défi d'un textile architectural contemporain

Sharon Little
Restauratrice
Responsable – Atelier de textile
Centre de conservation du Québec
1825, rue Semple
Québec (Québec) G1N 4B7, Canada
Fax : (418) 646-5419
Courriel : sharon.little@mcc.gouv.qc.ca, Bellaluna@sympatico.ca

Introduction

Le fils des étoiles, une œuvre de textile architectural, a été créé en 1979 par Micheline Beauchemin, une artiste québécoise de réputation internationale qui bénéficiait d'une subvention du ministère des Travaux publics et de l'Approvisionnement (MTPA) du Québec pour réaliser son œuvre. *Le fils des étoiles* est installé dans le grand hall d'entrée du ministère du Revenu du Québec, dans la ville de Québec (figure 1).

De 1961 à 1980, le MPTA a été responsable de l'intégration d'œuvres d'art à l'architecture des édifices publics. Depuis 1980, c'est le ministère de la Culture et des Communications (MCC) qui est chargé d'appliquer la Politique d'intégration des arts à l'architecture et à l'environnement des bâtiments et des sites gouvernementaux et publics. Conformément à cette politique, une partie du budget de construction ou d'agrandissement d'un bâtiment ou d'un lieu public doit être réservée à la réalisation ou à l'achat d'une ou de plusieurs œuvres conçues spécialement pour ce lieu.

Une fois l'œuvre installée, son entretien est à la charge du propriétaire de l'édifice ou du lieu. Or, depuis 40 ans, la majorité des textiles architecturaux n'ont fait l'objet d'aucune intervention de conservation. Dans cette optique, le traitement et la conception d'un programme de conservation préventive pour *Le fils des étoiles* constituent une entreprise déterminante pour l'avènement d'un programme général de conservation préventive visant tous les textiles architecturaux existants et futurs.

Description technique et état du textile architectural

Le fils des étoiles est une œuvre colossale. Elle mesure approximativement 25 mètres de hauteur sur 11 mètres de largeur et son poids est de 1 361 kilos. Les 20 pièces multicolores en forme de voiles qui la constituent sont suspendues à un grand anneau fixé au plafond du bâtiment, au sixième étage. Elles se déploient de tous côtés dans l'espace central sur les six étages, entre plafond et fontaine au rez-de-chaussée (figure 2). Même si le bâtiment dispose de plusieurs ascenseurs, l'accès aux étages est également possible par un escalier mécanique installé du côté nord de

Figure 1 : Édifice du ministère du Revenu du Québec, Québec, construit en 1979. Propriétaire : Industrielle Alliance. René Caissie

Figure 2 : Vue pleine hauteur de l'installation textile dans l'espace central du bâtiment. Sharon Little

Figure 3 : Détail du filet en monofilament de nylon, provenant du textile. Jean Blanchet

Figure 4 : Détail des cordes de nylon utilisées pour suspendre le textile. Les parties blanches des fibres indiquent que les fibres n'étaient pas teintes dans la masse. Jean Blanchet

Figure 5 : Détail du textile indiquant l'accumulation de saletés atmosphériques. Sharon Little

l'espace central. L'escalier offre ainsi, pendant la montée, des points de vues différents sur l'œuvre. L'expérience visuelle est également renforcée par la présence d'aires de séjour autour de l'espace central, à chaque étage en extension vers les murs extérieurs fenêtrés nord et sud, les bureaux étant situés du côté des murs extérieurs est et ouest. La vue d'ensemble de l'installation donne vraiment l'impression que le bâtiment a été conçu en fonction de l'œuvre de l'artiste.

Chacune des 20 pièces de textile a été fabriquée en monofilament de nylon. Le monofilament est noué à intervalles réguliers comme pour un filet de pêche (figure 3). L'information technique de base, ainsi que des échantillons originaux du filet et des cordes ont été fournis par l'artiste. Le monofilament n° 12 et la corde ont été achetés au Japon et teints selon un procédé industriel à Saint-Hyacinthe, au Québec (figure 4). Un produit ignifuge a été appliqué sur le filet et les cordes après les bains de teinture. Malheureusement, l'entreprise qui a effectué le travail a, depuis, fermé ses portes et les données concernant les teintures et le produit ignifuge sont introuvables.

Le textile était sec et cassant au toucher. Il était recouvert d'une couche de poussière et de saleté (figure 5). Des débris divers étaient entremêlés dans le filet demeuré cependant quasi intact, sauf à quelques endroits. Quelques-unes des cordes fixées autour de la fontaine, ayant été en contact avec l'eau, étaient rigides et décolorées (figure 6).

Le textile lui-même était décoloré de façon inégale, ce qui a été confirmé par une comparaison avec les fibres d'origine fournies par l'artiste. Apparemment, le monofilament et la corde avaient été importés non teints pour réduire les frais de douane : les produits teints étant considérés comme des produits finis, les droits de douane sont plus élevés. La teinture des fibres après extrusion et l'application d'un produit ignifuge sont en partie la cause de la décoloration et de la rigidité des fibres. Sans ces deux opérations, la longévité des fibres et l'intégrité des coloris auraient été prolongées.

Les renseignements que nous possédions sur la finition des fibres ont été fort utiles dans la mesure où ils ont permis d'éviter une autre application de produit ignifuge. En effet, un inspecteur du service des incendies de la municipalité avait recommandé que le textile soit traité à nouveau avec un produit ignifuge et que la résistance des cordes supportant le textile soit vérifiée. Il faut préciser que le ministère du Revenu du Québec loge environ 4000 employés et que ces recommandations reflétaient une préoccupation justifiée pour la sécurité publique.

Analyses scientifiques

Peter Aspley, spécialiste du marketing technique chez DuPont Canada, a été contacté pour réaliser des analyses scientifiques des produits en nylon et contribuer à formuler une proposition de traitement de conservation. Toutes les expertises effectuées par la compagnie DuPont ont été faites gratuitement, étant donné son grand intérêt, depuis plusieurs années, pour les problèmes de conservation des moquettes en nylon. En bref, les fibres du filet et les cordes ont été fabriquées en polymère de Nylon 6-6. Le filet a perdu de 10 % à 20 % de sa résistance. Ce résultat a été obtenu par une analyse chimique du polymère, basée sur une comparaison de la viscosité relative entre les échantillons d'origine et des fibres dégradées. L'analyse physique du filet n'a pas été tentée, étant donné la présence de nœuds dans le filet. L'analyse de la corde d'origine et de la corde dégradée a indiqué respectivement une force à la rupture de 227 kilos à 50 % d'élongation et, pour la corde dégradée attachée au plafond, une force à la rupture de 181 kilos à 36 % d'élongation. Enfin, l'analyse de la viscosité relative des cordes a donné des résultats semblables à ceux obtenus pour le filet en nylon, soit une perte de résistance de 10 % à 20 %.

Traitement et programme de conservation préventive

Il a été recommandé de passer un aspirateur sur toutes les surfaces du textile, vu que la saleté n'avait pas pénétré la fibre de nylon. Les 20 pièces formant l'œuvre sont demeurées dans leur position originale.

Le fait de démonter les pièces pour un nettoyage humide (traitement souhaité par l'artiste) pourrait entraîner des risques à cause de la rigidité des fibres, de leur perte de résistance et de la mémoire positionnelle du textile.

Figure 6 : Prise d'échantillon. Détail d'une corde de fixation installée à proximité de la fontaine, montrant sa décoloration. Sharon Little

Figure 7 : Partie supérieure de l'œuvre, face à la fenêtre sud située aux troisième et quatrième étages de l'édifice du ministère du Revenu du Québec. Sharon Little

Une autre raison permet d'écarter le traitement humide sur place : le poids du polymère de nylon pourrait augmenter de 15 % au contact de l'eau. Cette augmentation de poids pourrait constituer un danger, vu que le nylon a déjà perdu de 10 % à 20 % de sa résistance totale. Après le passage de l'aspirateur, la position de toutes les extrémités des cordes devrait être vérifiée pour voir si elle est correcte, en particulier celle des cordes autour de la fontaine, dont les extrémités immergées devront être relevées.

Le nettoyage par aspirateur doit être assuré par une entreprise spécialisée à cause de l'équipement et des mesures de sécurité qu'il nécessite. Il a été recommandé de passer l'aspirateur en limitant le plus possible les mouvements du textile, vu sa fragilité. Une entreprise consultée proposait de souffler de l'air sur le textile, mais cette proposition n'a pas été retenue, compte tenu des risques de faire subir au textile des mouvements indésirables et aussi de la probabilité que la poussière se dépose ailleurs. Une restauratrice de textiles du CCQ devrait superviser le travail de nettoyage par aspirateur. Par contre, le traitement ne devrait commencer qu'après que le propriétaire aura fait évaluer le textile sur le marché pour lui permettre d'acquérir une police d'assurance adéquate avant le début des travaux. Dans le cas où le coût du traitement proposé serait supérieur à la valeur marchande du textile, il est possible que l'œuvre (et cela vaut pour toutes les autres) ne soit pas traitée.

L'application d'un produit ignifuge n'a pas été recommandée pour quatre raisons. Premièrement, les restaurateurs de textiles sont d'avis que les produits ignifuges ont tendance à accentuer la dégradation des fibres. Deuxièmement, il reste probablement assez de résidu de sel sur les fibres, provenant du processus de fixation de la teinture, pour faire office de produit ignifuge. Troisièmement, le produit ignifuge appliqué après la teinture demeure présent en quantité suffisante, ce qui constitue un argument supplémentaire contre le nettoyage humide. Enfin, le nylon 6-6 ne propage pas le feu : il fond simplement à température très élevée (point de fusion de 254 °C), ce qui réduit considérablement le danger de propagation des flammes.

Il a aussi été recommandé de réduire l'intensité lumineuse et celle des rayons ultraviolets pour limiter la décoloration et l'affaiblissement des fibres, le nylon 6-6 étant sensible à la lumière et particulièrement aux rayons ultraviolets. Heureusement, la distance qui sépare les fenêtres du textile limite son exposition directe à la lumière. Cette distance va de 10 mètres aux 4 étages supérieurs (700 lux et 300 μwatts par lumen) à 30 mètres au premier étage (200 à 300 lux et moins de 50 μwatts par lumen) (figure 7). De plus, le vitrage de teinte dorée atténue l'intensité lumineuse. Par conséquent, la principale cause de décoloration du textile et d'affaiblissement de la fibre sera désormais la lumière provenant des plafonniers fluorescents et surtout des luminaires de type projecteur dirigés sur l'œuvre (4000 lux), mais le niveau d'ultraviolets des projecteurs est de seulement 50 μwatts ou moins par lumen. Cependant, le fait que le bâtiment soit illuminé 24 heures par jour ajoute au problème constaté. Aussi, il a été recommandé de réduire l'intensité de la lumière, d'ajouter des filtres aux luminaires et d'équiper les projecteurs d'ampoules émettant des rayons diffus plutôt que concentrés. Enfin, le nombre total de projecteurs pourrait être réévalué dans le but d'éliminer ceux qui sont superflus.

Il a aussi été suggéré que l'artiste renoue les filaments cassés en utilisant ses réserves de fibre d'origine pour conserver l'authenticité du textile. L'atelier de textile du CCQ a toujours encouragé la participation des artistes au traitement de conservation de leurs œuvres. Mentionnons en passant que l'artiste, Micheline Beauchemin, a été invitée à l'atelier de restauration il y a deux ans pour rebroder son nom sur une de ses tapisseries. Une photo envoyée par le Musée du Québec, nouveau propriétaire de la tapisserie, montrait la présence de sa signature dans le coin inférieur droit de la tapisserie. On ne sait toujours pas comment la signature a pu disparaître avant que la tapisserie ne soit acquise par le Musée.

Enfin, il a été recommandé que l'Industrielle Alliance crée un programme de nettoyage par aspirateur. Ce nettoyage serait effectué périodiquement, en fonction de la quantité de poussière accumulée une fois le textile traité. Il a aussi été suggéré qu'une restauratrice de textiles du CCQ supervise les traitements futurs et les autres interventions nécessaires.

Partenariat et conservation des textiles architecturaux

Il faut insister sur l'importance de réunir des spécialistes pour décider des traitements de conservation et des interventions de conservation préventive à privilégier pour les textiles architecturaux. Un tel partenariat garantit que les multiples aspects de la conservation sont respectés, c'est-à-dire la préservation des textiles architecturaux, l'aspect financier et la sécurité du public. Le rôle de la restauratrice de textiles aux comités de subventions doit aussi être souligné. Ainsi, dans le cas qui nous intéresse, la décoloration aurait pu être réduite si les fibres avaient été teintes dans la masse, par l'ajout de pigments lors de l'extrusion des fibres. De même, l'application du produit ignifuge aurait pu être évitée si les justifications en ce sens avaient été apportées au service des incendies de la municipalité.

Ces partenariats pourraient probablement contribuer à mettre un terme au déclin que l'on observe depuis quelques années dans la sélection des œuvres textiles dans le cadre du programme du MCC visant l'intégration des arts à l'architecture et à l'environnement. Ce déclin est sans doute dû à la fragilité relative des œuvres de ce type. La présence de spécialistes garantirait le choix d'un textile adapté à l'environnement architectural. La durée de vie de chaque type de textile devrait également être prise en compte et donner lieu à l'établissement d'un plan stratégique pour sa conservation, sa reproduction ou son remplacement.

Conclusion

Un registre central pourrait être créé au ministère de la Culture et des Communications, dans lequel seraient répertoriées toutes les données relatives aux œuvres créées en vertu de la Politique d'intégration des arts à l'architecture et à l'environnement des bâtiments et des sites gouvernementaux et publics. Le registre pourrait comprendre des photographies, des renseignements techniques et scientifiques, des échantillons de matériaux, ainsi que la description des interventions nécessaires en matière de conservation et des mesures de conservation préventive pour chaque œuvre.

Des restaurateurs devraient participer aux étapes initiales de planification des bâtiments sélectionnés pour l'intégration des objets d'art. Pour chaque nouvel édifice, les types et la longévité approximative des objets pourraient être prévus. Des efforts devraient être aussi déployés pour que chaque type d'objet d'art soit représenté. Les partenariats pourraient être créés en réponse aux besoins spécifiques de chaque objet d'art architectural, de manière à assurer la longévité de l'objet, et à réduire les coûts de conservation préventive et le traitement de conservation. De toute façon, un textile adéquatement protégé et construit en respectant certaines normes techniques pourrait mettre en valeur un bâtiment public pendant un laps de temps prolongé et ce, à un coût abordable.

Chaque objet devrait avoir son programme de conservation préventive. Toutes les interventions prévues seraient consignées dans le registre central. Enfin, il est recommandé d'inviter les artistes à collaborer au traitement de leurs propres œuvres quand cela est possible.

Remerciements

L'auteure tient à exprimer sa gratitude aux personnes suivantes : Peter Aspley, spécialiste du marketing technique chez DuPont Canada à Kingston (Ontario), pour ses analyses scientifiques et son soutien technique ; Denis Drapeau, gestionnaire d'immeubles à l'Industrielle Alliance, pour sa collaboration constante ; et Jean Tétreault, spécialiste de la conservation préventive à la Division de conservation préventive de l'Institut canadien de conservation à Ottawa (Ontario), pour les renseignements fournis sur les polymères.

Références bibliographiques

BASA, L. « Trends in Public Art: Where Does Fiber Fit In? », *Fiber Arts*, janvier 1992.
DUPONT CANADA INC. « Properties of DuPont Industrial Filament Yarns », *Multifiber Bulletin X-273*, avril 1993.

DUPONT CANADA INC. « Light Resistance of Industrial Fibre Products », *Nylon Bulletin* N-96, révisé, août 1981.

DUPONT CANADA INC. « Properties of Ropes of DuPont Nylon & Dacron », *Nylon T.S.B. N-94*. octobre 1973.

DUPONT CANADA INC. « Resistance of Fibres to Aqueous Solutions of Various Salts », *Multifiber Bulletin X-46*, août 1974.

ELLIS, S., et N. KERR. « Degradation of Nylon: A Case Study », Conférence de l'Association canadienne pour la conservation et la restauration des biens culturels (ACCR), Whitehorse (Territoires du Yukon), mai 1998.

HALVORSON, B. « Flame Retardant Finishes for Textiles », *Textile Conservation Newsletter*, automne 1995, n° 29.

ROCKLIFF, D., et N. KERR. « Fire Retardant Finishes for Fiber Art: A Conservation Perspective, Preliminary Findings » ICOM-CC, 17ᵉ assemblée triennale, Copenhague, septembre 1984.

SECRÉTARIAT DE L'INTÉGRATION DES ARTS À L'ARCHITECTURE, MINISTÈRE DE LA CULTURE ET DES COMMUNICATIONS. *Guide d'application – la politique d'intégration des arts à l'architecture et à l'environnement des bâtiments et des sites gouvernementaux et publics,* Gouvernement du Québec, 2000.

Abstract

This paper describes how two different ancient Egyptian beaded items of dress, a bead net dress and a bead mask, were, during conservation, reconstructed for display in museums. The beaded dress was literally created by the conservator by rethreading beads, while an image of the beaded mask was created via digital imaging. The rationale was to give points of reference to otherwise abstract and easily misunderstood artefacts. Issues of interpretation and representation are discussed, as it is considered that the resulting reconstructions are acknowledged variants based on available evidence and inevitably subjective decisions made by the conservator. It is concluded that appropriate reconstructions are those that allow for future interpretations of the artefacts in light of changing approaches and new evidence.

Keywords

ancient Egypt, bead, reconstruction, digital imaging, interpretation

A study of material and digital transformations: the conservation of two ancient Egyptian beaded items of dress

Cordelia Rogerson
Textile Conservation Centre
University of Southampton
Winchester Campus, Park Avenue
Winchester
Hampshire SO22 8DL, United Kingdom
Fax: +44 (0)2380 597101
E-mail: C.Rogerson@soton.ac.uk

Introduction

Two ancient Egyptian beaded artefacts, a beaded dress and a beaded mask, recently underwent conservation at the Textile Conservation Centre. Both objects required conservation to enable display within museum settings. Whilst varying in size, function and appearance, the challenge in each case involved deciding how to present the incomplete artefacts to the viewing public in a coherent and comprehensible manner. The beaded dress was literally 'created' by the conservator by rethreading beads, whilst an image of the beaded mask was created via digital imaging. The interpretation and presentation of the artefacts were especially important, as both were unusual items that may have not been encountered before by museum visitors. In both cases it was the conservators, by their material and digital transformations, who were influential in determining the form in which the artefacts were presented to the public, and whose work provided additional information about the garments.

Material transformation: bead net dress

In 1923 the archaeologist Brunton uncovered a box containing faïence tubular beads and ring beads, mitra shells and two fired clay breasts in a niche of a bricked grave at the southern cemetery at Qua near Badari, Egypt (Seth-Smith and Lister 1995). These items passed into the collection that formed the Petrie Museum of Egyptian Archaeology, University College London (UC 17743). The beads, shells and breasts were dated to the fifth dynasty (c.2456–2323 BC) and were thought to be the remains of a beaded garment worn by a young female dancer (Brunton 1927, Lister 1997).

Some time between the formation of the Petrie Museum and the 1990s conservation treatment outlined below, some of the beads had been threaded together to form a rectangular panel (measuring 57 mm x 510 mm) incorporating the breasts; the remaining beads were placed loose in a box (see Figure 1). The date of and rationale for this assembly are not recorded, but was deduced to have occurred in the 1950s. When placed on a mannequin the panel obviously did not conform to known styles of bead net dresses from the fifth dynasty or a female profile.

The 1950s form of the dress (see Figure 2) was considered misleading and a project was initiated to investigate alternative assemblies of the beads, shells and breasts, in order to make a more comprehensible display of the bead net dress at the museum. The investigation was undertaken by a student conservator at the Textile Conservation Centre as part of her studies (Seth-Smith 1994), with curatorial advice supplied by Rosalind Janssen (assistant curator) and the supervision of Alison Lister (Conservator Tutor, TCC). The curator wished the dress to be displayed vertically to demonstrate its original function, as it was not a dress specifically for burial, and to reflect the objectives of the Petrie Museum, which is to 'illustrate the development of Egyptian culture, technology and daily life'.

A two-part strategy was developed. The first part involved deconstructing the 1950s panel and constructing a bead net dress that resembled more closely the

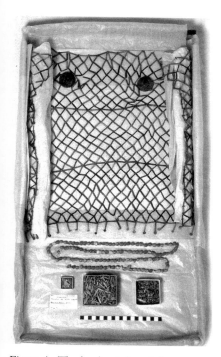

Figure 1. The bead net dress before conservation
© *Textile Conservation Centre*

Figure 2. The 1950s version of the dress
© *Textile Conservation Centre*

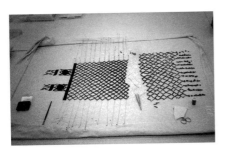

Figure 3. Threading of the 1990s dress panel in progress
© *Textile Conservation Centre*

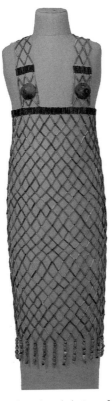

Figure 4. The selected design of the dress panel displayed on its mannequin
© *Textile Conservation Centre*

presumed original form. The second part involved the making of a display mount that would transform the flat panel of rethreaded beads into a three-dimensional presentation in the manner envisaged by the curator.

There was little physical or pictorial evidence of bead net dresses to assist generation of an appropriate design but a general impression was obtained from the information that was available. For example, there is a 4th-century bead dress from Giza reconstructed in the Museum of Fine Arts Boston (Jick 1988). Balancing the conservation and display needs of the bead net dress and responding sensitively to the available evidence meant that only the front of the dress could be reconstructed. Only those beads thought stable enough to withstand the inevitable mechanical movement and strain of display were selected for the 1990s assembly. A complete dress would also increase the potential damage to the beads in terms of handling if removed from the case or if the display orientation were altered. As there was no evidence for the reverse of bead dresses (only front-facing depictions were discovered), a complete recreation was not an option, on both practical and ethical grounds.

The chosen design consisted of a panel of a diamond-shaped network of tube beads, with the fired ceramic breasts incorporated as 'breast caps' into the extended shoulder straps and a fringe of mitra shells. Assembly was undertaken by the project supervisor, Alison Lister, in 1994 (see Figure 3).

The beadwork panel was stitched to nylon net for support. The panel was then mounted on a specially constructed three-dimensional torso to give a realistic effect of the closely fitting dress, which displaying it flat clearly would not do (see Figure 4). The mount size was determined by the assumption that all beads were present and the quantity suggested the dress would fit a child rather than an adult.

This assembly created a believable artefact from what would otherwise be an assortment of beads, shells and breasts. That is, it was recognized by both the curator and conservators involved that the resulting assembly rose from careful but still subjective decision-making. The threading was an essential interventionist act to present the artefact to the viewer, while the mount was a similarly crucial element in the transformation to create a credible display.

Digital transformation: beaded mask

The beaded mask is a small object measuring approximately 140 mm long (see Figure 5). It depicts a symmetrical stylized two-dimensional face with a long chin/beard, large eyes and nose and ears that extend above the eyes. It is constructed from faïence disc beads approximately 4 mm in diameter in non-realistic colours of turquoise, red, yellow, dark red and dark blue. The beads are threaded using what is considered to be the original linen thread in a manner that holds them closely together to construct a sheet or 'textile' of beads without gaps. The beads are arranged in pairs and lie on their sides in horizontal lines, and each line is offset to create a brick-like pattern. The linen threads are passed vertically through the beads to create an interlocking configuration.

This colourful mask is part of the collection at Leeds City Museum, UK, where it is considered to be one of the most popular items of Egyptology, although its date and provenance are uncertain. Prior to conservation the mask was soiled so that the beadwork design was obscured, adhered to cardboard with animal glue and covered with white alkaline deposits on the glaze indicating deterioration of the glaze. Furthermore, the mask was incomplete. The left half of the face, as viewed, was incomplete, missing most of the proper right eye and ear, the middle of the nose, the top edge and part of the chin/beard.

The curator wished the mask to be cleaned and presented for display. He also wished the mask to be 'completed' in an appropriate manner so that visitors could appreciate the design clearly. Both before and during treatment it became obvious that the incomplete mask was difficult to decipher visually. Indeed the conservator's (Rogerson's) initial interpretation wrongly concluded that the face was in three-quarter profile, an aspect almost unknown in ancient Egyptian imagery.

Despite extensive cleaning that dramatically improved the appearance of the mask, observers repeatedly misinterpreted the image of the face. By chance the

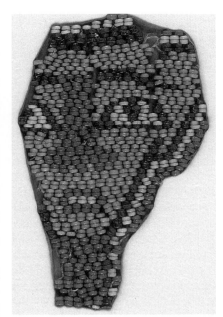

Figure 5. The bead mask after conservation, showing its incomplete appearance
© *Textile Conservation Centre*

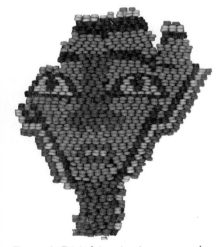

Figure 6. Digital imaging in progress; the face is built up by cloning beads from appropriate areas
© *Textile Conservation Centre*

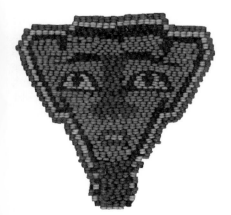

Figure 7. The final digitally altered image of the mask as presented to museum visitors
© *Textile Conservation Centre*

remaining shape of the mask resembled the shape of a human skull, i.e. the proper left ear appears to form the rounded bulge that would be the back of a skull and the two dimensional symmetrical form could not be identified easily. It became obvious that additional information would be necessary to make the mask intelligible on display.

Research quickly revealed that the mask would probably originally have formed part of a much larger object – a bead net shroud completely covering the linen wrappings of a mummy. Other more complete examples show masks incorporated into diamond net structure of tube beads (Bosse-Griffths 1978). An example in the Liverpool Museum collection (Bienkowski and Tooley 1995) showing a mask still attached to a linen wrapped head and surrounded by remnants of a bead net structure was strongly reminiscent of the Leeds example.

In order to complete the face for display various methods were explored, including coloured fabric patches attached to the mount and provision of a replica. These methods either seemed ungainly or were too time-consuming. Manipulation by digital imagery seemed a possible answer: a photograph of the entire reconstructed face could then simply be displayed next to the mask giving the necessary additional data. The advantages were that the process is non-interventionist – indeed the mask did not have to be touched at all – and the technology was available. At the Textile Conservation Centre digital image technology had recently been used to resolve the design of rug fragments (Boersma 2000). The graphic grid-like structure of the mask was perfectly suited: using units of 1 pair of beads at a time, areas could be cloned and added to the image to gradually build up the face (see Figures 6 and 7). It was anticipated that the number of beads missing could be calculated numerically and evidence from the more complete areas and similar examples would inform the reconstruction.

This apparently simple approach was more complex than expected. In some areas there was not enough of the mask remaining in its original form to be absolutely precise. Additionally, each bead mask studied was unique in some manner, e.g. a slightly different numbers of beads used in each situation, thus these could not be relied upon to give accurate evidence for this particular example. Inevitably the resulting image, like the beaded dress, involved much subjective decision-making to create what was acknowledged as just one interpretation of the evidence.

There are seemingly endless possibilities using digital imaging, especially considering the pace of swiftly advancing technology. How far should such manipulation go? The conservator rapidly discovered that the true skill of the technique is to select and restrict what is to be manipulated, altered or added rather than simply learn to drive the software. In this case the conservator chose only to add areas rather than clean up and enhance existing ones in terms of homogeneity of colour, form and alignment. A patinated appearance was felt to be more 'realistic' and believable than presenting a pristine 'image'.

The decision to reconstruct the face only and not its probable original form of a surrounding bead net shroud further demonstrated the intricacies of the technique. Presenting the face only was still exhibiting the mask considerably removed from its context – literally as a fragment of its former self. Such extensive reconstruction, however, when there was no actual physical evidence on the mask to support it (any evidence was by association only), was felt to exceed the conservator's remit. Whilst it is hoped that the reconstructed face is relatively accurate, any reconstructed shroud would have been far less so. The curator also felt less concerned by the larger issue, essentially wishing the face to be legible for museum visitors. A disadvantage with the technique is that should the digital image become separated from the mask the information is lost and the original is once again open to misinterpretation.

Discussion

The reconstruction of the bead dress created an artefact through the intervention of threading and mounting whilst the digital image of the bead mask was created in addition to the object itself without physical intervention. Despite the fact that

the physical activities of these two studies differ, the intellectual processes involved in creating the transformations were very similar.

The rationale for both cases was to assist and inform the museum visitor to gain a reasonable impression of the form and function of these unusual artefacts. The role of the conservator (in collaboration with the curators) was to be the advocate of the beaded objects with responsibility to decipher the evidence they held whilst applying evidence gained from other sources, such as pictorial images and similar objects. A high degree of subjective decision-making and personal interpretation of the evidence was inevitable in each case. For the beaded dress there was very little evidence provided by the beads themselves and few complementary sources. In the case of the mask the conservator was surprised by the number of qualitative and quantitative decisions required for digital alterations of its image. Whilst it is easy to state that any reconstruction or interventionist interpretation of an object should be appropriate, it still relies heavily on the sensitivity and skill of the conservator. When learning digital imaging techniques for the beaded mask the conservator worked with a specialist photographer (Mike Halliwell) who understood its capabilities. The photographer endeavoured to create what he considered a good image but in doing so enhanced the colour and contrast of the mask so that it bore little relation to the original. The conservator had to restrict carefully the extent of alterations.

By adding some points of reference the museum visitor may gain a richer appreciation of these otherwise abstract objects and thus the underlying principle of the reconstructions is attained. Interpretation by definition is an individual viewpoint however, and in endeavouring to make sense of the artefacts representations have been created that are inevitably one of a potential number. The results presented to the museum visitor are not the absolute truth but are acknowledged variants based on available evidence and the individual conservators' current perspectives. The exact original appearances of the dress or mask are unlikely to be established but they have been deciphered in such a way that the viewer can appreciate the overall intention, and they are readable. The final image presented is intended to inform and advise rather than to dictate. Despite striving to be historically accurate subjectivity is an inescapable element in the process. A new curator working with the bead net dress and querying the colour chosen to represent skin on the mannequin illustrates how a viewer's individual interpretation can diverge from the original intention of the conservator. The colour had been selected to reflect the skin colour of Egyptian dancers seen in wall paintings but the new curator, who had not been privy to discussions, was unaware of the reasoning and questioned its appropriateness.

Eastop (2000) has argued that objects do not represent merely a single history but contain 'multiple and competing histories' that are open to a dynamic process of varied and changing interpretations. The conservator, through making a series of inevitable choices for treatment and display, is the advocate of one history or perspective over another. This idea can be applied to the cases under discussion in relation to their transformations and presentations. In choosing to recreate the beaded dress as it had been worn and displaying it vertically on a mannequin, the curator and conservator have selected not to present it as part of funerary ritual, the context in which it was actually found. Furthermore, out of several options generated only one design was selected for threading a dress panel, one which was felt to be convincing, but one which at the same time did not permit display of other well-researched configurations. Similarly, in choosing to reconstruct only the face of the beaded mask to develop decipherable two-dimensional and symmetrical features rather than an entire funerary shroud, active choices were again made. The museum visitor thus is being presented with an image that the conservator and curator have selected to disclose with objectives defined by the purpose of display and conservation needs of the objects.

This highlights a level of trust not only between the conservator and curator who have to work within each other's areas of expertise, but also between the museum professionals and the museum visitor. The visitor can only experience what is presented in the gallery, and thus relies on the museum professional for accurate and informative encounters. The visitor expects to experience 'authentic' artefacts, a term discussed by Roberts (2001). In the examples studied the term 'authentic' can

be relevant on two levels: first the physical materials of the beads are authentic Egyptian artefacts and second, conceptually, in terms of the reconstructed forms. When combined do the physical and conceptual add up to an authentic object, especially when the conservators recognize they have created only one variant? It is a complex term to apply, and perhaps one way to address this is to clearly inform the viewer of the nature of the reconstructions, thus permitting them to question what they see. A disadvantage is that even if clearly explained the viewer may indisputably take what they see as an absolute.

Hooper-Greenhill (1997) states that a museum audience currently demands active participation rather than passive viewing and museum experiences are now three-dimensional with sights and sounds being presented in addition to the collection. She goes on to argue that the overdevelopment of and emphasis on contextualized experiences can prevent personal interpretation of real evidence, the artefacts. She states:

> that effective history teaches us that, because meanings and interpretations are endlessly rewritten, we too can seize the opportunity to make our own meaning, and find our own relevance and significance.

Overpresentation can be in opposition to the objects themselves, preventing experiences and ideas as much as trying to encourage and provide them. By creating a more complete object by means such as digital imaging, are we informing the viewer too much? Can 'virtual restoration' be considered unethical, akin to physical restoration, by raising the viewers' expectations of pristine objects so that the 'real' artefacts are disappointing? Is the conservator imposing their subjective viewpoint strongly by adding some context or are they just providing information essential to understanding the object? The answers (of course) are subjective and unique in every case. Raising the questions and documenting the debate are what is crucial.

In response to the issues discussed above it can be stated that the transformations of both objects examined are open to reinterpretation in the future in response to changing attitudes of curators, conservators and, no less, visitors. The two approaches discussed will allow for future rewritings of the objects' histories. The threading used for the beaded dress is reversible, ensuring it can be altered or completely re-made and reconfigured. This was the case when after a period of display the curator found visitors had a tendency to view the dress as an apron; further threading of beads was devised to extend the panel further around the form to give a more complete impression. Similarly the digital imaging of the bead mask can be altered at any point to change its appearance. Hence the current recreations of both objects are neither static nor definitive. Their present manifestations are grounded in the contemporary conservation approaches and ideas and their supporting documentation details the rationale and methodology. In the future it is quite possible that perceptions may change and these interpretations will appear dated in the light of new evidence and assessment, but they can then be altered.

Conclusion

It is to be expected that both of the approaches discussed above will have admirers and critics, but in transforming these uncommon artefacts in the manners described their form and function have been deciphered to allow greater appreciation. A conservator should continually reflect on past practices to procure professional development, and hence it can be argued that appropriate reconstructions and presentations of artefacts, such as the beaded objects discussed, are those that permit and even encourage future interpretations.

Acknowledgements

The author would like to thank staff at the Textile Conservation Centre for all their help and encouragement with the preparation of this text.

References

Bienkowski, P and Tooley, A, 1995, *Gifts of the Nile*, London, HMSO.

Boersma, F, 2000, 'Modern technology: an aid into the interpretation of a group of archaeological carpet/rug fragments', oral presentation at Instiuut Collectie Nederland, Focus on Textile Conservation, 13–17 November.

Bosse-Griffiths, K, 1978, 'Some Egyptian beadwork faces in the Wellcome Collection at University College, Swansea', *Journal of Egyptian Archaeology*, 64, 99–106.

Brunton, G, 1927, *Qua & Badari 1*, London, University College, British School of Archaeology in Eygpt 1923.

Eastop, D, 2000, 'Textiles as multiple and competing histories', in Brooks, M M (ed.) *Textiles Revealed. Object Lessons in Historic Textile and Costume Research*, London, Archetype Publications, 17–28.

Hooper-Greenhill, E, 1997, *Museums and the Shaping of Knowledge*, London, Routledge.

Jick, M, 1988, *Mummies and Magic: The Funerary Arts of Ancient Egypt*, edited by S D'Auria, P Lacovara and C Roehrig, Boston, Museum of Fine Arts.

Lister, A, 1997, 'Making the most of mounts: expanding the role of display mounts in the preservation and interpretation of historic textiles', in *Preprints of Fabric of an Exhibition: An Interdisciplinary Approach*, Canadian Conservation Institute Textile Symposium '97, 22–25 September, Ottawa, CCI, 143–148.

Roberts, Z, 2001, *The Influence of Perception of Authenticity on Textile Conservation*, unpublished Masters degree dissertation, Textile Conservation Centre.

Seth-Smith, A, 1994, *Investigation into the Reconstruction of a 5th Dynasty Egyptian Bead Dress*, unpublished diploma report, Textile Conservation Centre.

Seth-Smith, A and Lister, A, 1995, 'The research and reconstruction of a 5th dynasty bead net dress', in Brown, C, Macalister, F and Wright, M (eds) *Conservation in Ancient Egyptian Collections*, London, Archetype Publications, 165–172.

Abstract

A rare Korean banner, of the Choson period (c.1800), made of a single layer of silk damask, painted on both sides, was conserved for long-term, free-hanging display at the Victoria and Albert Museum, London. The brief included retaining access to the reverse face and the drape of the banner. Cross-sectional analyses of paint revealed proteinaceous media and animal glue. The colourants were characterised with X-ray fluorescence, revealing the presence of the potentially toxic compounds, arsenic oxide and orpiment. The friable paints were consolidated using isinglass (1.5% w/v) in an IMS/water mixture. Slits in the painted silk were supported with patches of silk crepeline coated with Lascaux 360/498 HV prepared (at 15% v/v) with an acetone/water mixture; the adhesive was reactivated with acetone vapour via a Gore-Tex poultice. To allow for free-hanging display, nylon net was applied to support the notched side edge, and the top edge was supported with silk lined with cotton, which formed a hanging sleeve.

Keywords

textile, Korea, painted banner, cross-section, paint consolidation, isinglass, solvent-reactivation, Gore-Tex

The conservation of a Korean painted silk banner, c. 1800: Paint analysis and support via solvent-reactivated acrylic adhesive

Mika Takami*
National Museum of the American Indian / Smithsonian Institution
Cultural Resources Center
4220 Silver Hill Road
Suitland, Maryland 20746, U.S.A.
Fax: +1-301-238-3201
E-mail: m_takami@mac.com

Dinah Eastop
The Textile Conservation Centre
University of Southampton, Winchester Campus
Park Avenue, Winchester
Hampshire SO23 8DL, United Kingdom
Fax: +44-2780-59-7137
E-mail: dde@soton.ac.uk

Introduction

The conservation of painted banners provides cross-disciplinary challenges. This paper reports on the investigation and treatment of a Korean double-sided, painted silk banner of irregular shape. The conservation treatment included paint consolidation, adhesive support and lining support for display.

The banner, dating to c. 1800 (the late Choson period), was collected in Korea c. 1920, and acquired by the Far Eastern Department, Victoria and Albert Museum (V&A), London in 1999 (FE 45 1999). The banner was selected for long-term, vertical, free-hanging display in a sealed showcase at the V&A.

The banner

The banner (see Figure 1) measures approximately 1590 x 1150mm; an armour-clad, anthropomorphic tiger is painted on both sides, beautifully coloured in red, orange yellow, green, blue, white and gold paint. The tiger image on the reverse is depicted in mirror-image, so the two tigers are in the same place on each side of the banner. Chinese characters, painted in black in calligraphic style on the fly edge, read 'military officer[1]'. The banner is made of a single layer of light-blue, silk damask woven with cloud and geometric patterns. It consists of five pieces of damask – a large, rectangular central panel, made of two pieces of silk (probably loom widths) seamed horizontally, and three notched edges – joined with hand-stitched 'French seams' in blue silk thread. Three leather ties, sewn on the left side, would have served to attach the banner to a pole. Such side pole attachments, along with notched fly edges, are a typical feature of banners used in Korean processions.

The tiger resembles one of the twelve figures of the Buddhist zodiac, commonly depicted in sculptures placed around royal tombs and temple paintings hung at religious rituals. Funeral processions in Korea are customarily led with flags (Korean Overseas Information Services 1993:165); the banner may have been used in the funeral procession of a military officer. While several military flags with a winged tiger rampant of the same period are catalogued, none feature a zodiac tiger and none has undergone a detailed technical examination.

Preliminary condition assessment

Overall the banner was in fair condition. The silk damask was sound and supple, but the banner was sharply creased at the borders, and several major fold lines ran across the painted image. The top leather tie was knotted, pulling the damask tightly and creating extensive wrinkling. The blue damask was faded overall, with

Figure 1. Korean painted silk banner (c. 1800). Victoria and Albert Museum. Front face before treatment. The identical tiger image is painted on the reverse face.

*Author to whom correspondence should be addressed

Figure 2. Detail of the damaged area below the central seam in the waist showing extensive paint loss, slits, tears and missing areas in the fabric

Figure 3. Damage of the gilt area in the belt. The cracked paint layer was cupping and flaking. Some areas lost the gilding layer only, whilst others lost the entire paint layer leaving the residue of the white ground on the fabric

Figure 4. Cross-sectional view of the gilt paint layer in the belt buckle showing the symmetrical layer sequences. The paint layers above the fabric are for the front face. The gilding layer of the reverse face had blackened (see the bottom of the cross-section)

some distinctive light-brown ring staining. Waxy deposits were present on both faces near the lower Chinese characters, causing discolouration and stiffening.

The painted image was torn and slit, making the banner very fragile, especially in an extensively damaged area below the central seam at the tiger's waist (see Figure 2). A ridge formed by the 'French seam' probably contributed to the physical stress in these areas. The fabric around the painted image was puckered, most notably around the tiger's face, where the nose and head were disfigured by fold lines, and where paint loss was noticeable.

The paint was in poor condition: cracking and flaking were evident and extensive loss was occurring, particularly in the coarsely ground paints, such as blue and green, and the gilt areas in the eyes and gold-coloured belt buckle. In the latter, the paint film was cupping and lifting (see Figure 3). The buckle on the reverse face had corroded, appearing black or exposing the underlying orange-red gilding ground.

Characterization of the paint film

Characterization of the paint film was considered vital to inform any intervention decisions. Analyses focused on binding media and layer structure, and proceeded from visual examination in situ to cross-section studies, micro-chemical analysis and X-ray microanalyses via SEM.

Details of texture, condition and some layer sequences of the paint film were characterized in the initial in situ examination using a stereo microscope. Amongst twelve different pigments observed, ten samples of 0.5–1.0mm were prepared as cross-sections. Precise layer sequences were then confirmed by examination with polarized-light microscopy and ultraviolet fluorescence (see Table 1). As expected, the multi-layered structure of the paint film extended symmetrically on both sides of the fabric (see Figure 4).

Microchemical analyses undertaken to characterize binding media started with solubility tests on eight small loose paint samples, using the reagents described by Plesters (1956:130). Results indicated that only the yellow paint contained a drying oil medium, while all other samples had a proteinaceous binding medium. Staining tests on polished cross-sections confirmed these results. The cross-sections were then examined via SEM-EDS, and the identities of colourants were inferred from their X-ray fluorescence spectra.

The following sequence of manufacture and materials was revealed. The painted image was first outlined with black Chinese paint before infilling with a white ground layer, approximately 50μm thick. Colour was laid over in a single or double layer(s) to pick out some details. Gilt areas involved a more complex layer sequence, with a gilding ground and an adhesive layer. No evidence of a sizing agent of an animal glue/alum mixture (a common size for East Asian paintings) or a varnish was found.

The pigment binding medium was characterized as proteinaceous and the gilding adhesive as animal glue. The gilding layer was found to be pure gold; the gilding ground was an iron-based pigment, possibly red ochre; the black paint was a carbon-based pigment, the white ground layer was found to include calcium carbonate, lead white and, unexpectedly, arsenic oxide; the yellow pigment was orpiment; the red pigment was mercuric sulfide (cinnabar/vermilion) and red lead. These pigments are consistent with those typically reported for East Asian paintings (Winter 1984,1989), except arsenic oxide as a white pigment.

Table 1. Layer sequences of the selected paint films

Paint sample (location)	White (sash)	Black (boot)	Yellow (waist guard)	Red (spear)	Gold (belt buckle)
Front: overpaint layer 3					× gold
Front: overpaint layer 2					× brown
Front: overpaint layer 1		× black	× yellow	× red	× red
Front: ground layer	× white	× white	× white	× white	× white
SILK FABRIC					
Reverse: ground layer	× white	× white	× white	× white	× white
Reverse: overpaint layer 1		× black	× yellow	× red	× red
Reverse: overpaint layer 2					× brown
Reverse: overpaint layer 3					× gold (blackened)

However, technically, the banner was painted in an unusual way: with no sign of sizing, painted on both sides with a white ground layer. It is clear that the banner was made to remain flexible, but a white ground layer, common in Western painting but unusual in East Asian painting, may have enabled clearer details. The use of arsenic oxide as white pigment is totally unknown to East Asian paintings,[2] except for some evidence of it being used to paint a temple or house in Japan[3]. The considerable amount of white paint used to infill the outlined images suggests that arsenic oxide was readily available and affordable and may have been used as an alternative to other white pigments. The availability may be related to trade history or to a district in which arsenic was easily obtained, e.g. from a copper vein with naturally occurring arsenic compounds. This information may assist the dating and attribution of the banner.

The results influenced both interventive and preventive conservation measures. The presence of proteinaceous media and animal glue suggested a cautious approach to the use of water and vitiated the use of heat in the treatment, because it could cause shrinkage and expansion of the paint film (Tímar-Balázsy and Eastop 1998:119–122). The presence of arsenic oxide and orpiment led to health concerns due to the toxic nature of these materials. Appropriate measures were implemented immediately to limit conservators' exposure to these materials, and handling recommendations were made.

Proposed treatment

The aim of the treatment was to facilitate the long-term preservation of the banner by making it safe and pleasing for display, whilst retaining the draping nature of the silk and access to the reverse face of the banner. To this end, close liaison was maintained with the curator and other experts at the V&A.

To help prevent further loss of paint, consolidation of the flaking and lifting paint films was proposed. To reduce the risk of damage during long-term, free-hanging display, a patch support was agreed upon for the torn painted areas; the patch being applied to the reverse face of the banner. A semi-transparent material was selected for the patch so as to minimize disturbance to the painted image on the reverse face. As a stitching technique could damage the thick, stiff paint film, an adhesive treatment was selected.

Paint consolidation

In paint consolidation, the consolidant helps to improve both adhesion between the paint and substrate, and cohesion within the paint layer. It is generally accepted in conservation that paint consolidation is practically irreversible: consolidants are therefore selected so as to permit future re-treatment rather than to ensure reversibility.

From the common means of application including brush, spatula, pipette, syringe, ultrasonic humidifier and air-pressure nebulizer, brush was selected for its ease and control in application to localized areas. An organic solvent was preferred to carry the consolidant because of the sensitivity of the proteinaceous medium to water/moisture.

Table 2. The consolidants tested

Material	Concentration (w/v %, *v/v %)	Solvent
Paraloid B-72		
(acrylic resin)	5	Acetone
Beva 371	2.5	Xylene
(ethylene-vinyl acetate copolymer)	5*	White spirit
Klucel G	3	IMS
(Hydroxypropyl cellulose)		
Isinglas		
(Gelatine, fish glue from	2.5	Water
dried swim bladder of sturgeon)	1.5	Water
	1.5	Water and IMS (1:1)
Funori		
(polysaccharide, extract from dried seaweed)	1	Water
	1	Water and IMS (1:1)

Five consolidants were evaluated[4] (see Table 2). The test showed that 1.5% w/v isinglass solution in a water/IMS mixture (1:1) had the most suitable working properties. Isinglass and the binding medium used in the paint are both proteinaceous, as is the silk substrate. This similarity of material type would confer compatibility in the whole object, making future re-treatment and care less complex.

Selection of adhesives

The areas of the banner requiring patch support had uneven surfaces resulting from the coarse and fine paint films, a ridge of the 'French seam' and the silk damask patterns. A sufficiently strong adhesion was therefore required to achieve a uniform support. Flexibility as well as minimal disturbance on the painted image was also considered essential.

Thermoplastic adhesives and starch paste were considered inappropriate due to the binding medium's sensitivity to water and heat. Cold vacuum lining was also considered impractical in this instance because of the painted surface on both sides of the banner. Solvent-reactivation, an alternative technique, was investigated. Research suggested two adhesives for testing: Klucel G® (hydroxypropyl cellulose) and Lascaux® 360HV and 498HV (butyl-methacrylate copolymer).

Reactivation of Klucel G® can be achieved with either IMS or acetone, but the use of former is reported to result in stronger bonding (Gill and Boersma 1997). Lascaux® has been used as a thermoplastic adhesive in textile conservation since the late 1980s. Experience at the Textile Conservation Centre (TCC) suggested reactivation of Lascaux® 360HV/498HV adhesive film with acetone vapour is an effective alternative.

Testing of Klucel G® and Lascaux® was undertaken with the addition of a non-aqueous solvent in the solution/emulsion to assess adhesive quality[5] (see Table 3). The solvent mixture was tested to seek strong bonding. Tests were performed on an adhesive-coated silk crepeline on a simulated surface reactivated with either acetone or IMS vapour for ten minutes in a poultice system using a Gore-Tex® barrier (see Figure 5).

Test results indicated that generally Lascaux® reactivated with acetone adhered best. The 15% v/v Lascaux® emulsion in a water/acetone mixture (1:1) showed the most suitable working properties and was selected for the treatment.

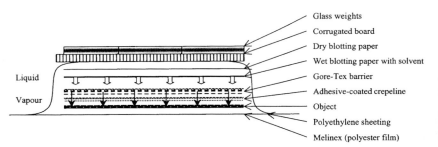

Figure 5. Diagram showing the cold poultice system for solvent reactivation using a Gore-Tex® barrier

Table 3. Sample adhesive solutions/emulsions tested and summary of testing

Adhesive	Sample solution/emulsion	Substrate	Simulated surface to adhere to	Reactivated with	Criteria for assessment
Klucel G	4% w/v in water 4% w/v in water and IMS (1:1) 4% w/v in IMS 10% w/v in water 15% w/v in water	silk crepeline	1. silk damask 2. sand paper (grade 1000)	1. IMS vapour 2. acetone vapour	weight increase surface tack appearance stiffening moiré effect peel strength
Lascaux 360HV:498HV (1:2)	10% v/v in water 10% v/v in water and acetone (1:1) 10% v/v in acetone 15% w/v in water 15% v/v in water and acetone (1:1) 20% v/v in water 25% v/v in water 30% v/v in water				

Figure 6. Application of paint consolidation to the gilt eyes with a fine sable brush (front face)

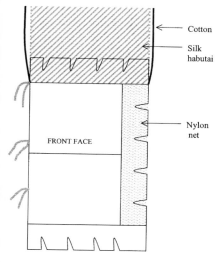

← Cotton

← Silk habutai

FRONT FACE

← Nylon net

Figure 7. Diagram showing the areas and layers of the supports applied to the reverse face

Treatment

Both faces were surface cleaned using low-powered vacuum suction and a soft brush. Loose paint flakes sitting on the surface were collected for reference use.

The knot in the top leather tie was untied. The sharp creases in the silk were eased out, surface cleaned and flattened by contact humidification. The released leather tie which appeared sharply curled was eased under glass weights for a week, and was then stitched to the edge in the same way as the other ties.

Localized humidification reduced fold lines and creasing in the banner. Humidification on the painted area was focused only on the fold lines. Tests carried out prior to treatment revealed that the dark blue paint became loose in contact with moisture. Therefore, areas of this paint were avoided, as were the gilt areas due to the risk of damaging the animal glue layer.

The waxy deposits, which the curator advised were of little evidential value, were removed with Genklene® (1,1,1-trichloroethane).

The friable paint (dark-blue, green and gilt areas) was consolidated with a 1.5% w/v solution of isinglass in a 1:1 water/IMS mixture with a fine sable brush under a stereo microscope with absorbent paper underneath (see Figure 6). As finger pressure through silicone release paper was found to lift the paint, gentle pressure was applied by rolling the wooden end of the brush over these areas while wet. No trace of isinglass was found on the filter paper underneath. Consolidated areas were allowed to dry overnight. No changes in the appearance of the paint or in the handle of the fabric were observed. The friable paint was firmly reattached to the ground. The reverse face was consolidated on the following day.

A single piece of silk crepeline, large enough to cover all the tears and slits in the waist area, was used to achieve uniformity in the strength and stiffness of the support. The light olive-green colour and shape of the crepeline patch were selected to optimise camouflage on the multi-coloured area at the waist. Black silk crepeline was used for the small black torn areas in the nose, boot and calligraphy.

The adhesive-coated patches were applied onto the reverse face of the banner. A 15% w/v emulsion of Lascaux® 360HV/498HV (1:2) in a 1:1 mixture of water and acetone was brushed on the silk crepeline. When dried, the crepeline was cut and held in place on the fabric with fingertip pressure. The adhesive was then reactivated with acetone vapour, applied via a Gore-Tex® membrane for 10 minutes (see Figure 5). While good bonding was achieved in the small black patches, the patch at the waist area, where the 'French seam' was, did not adhere well. Reactivation was extended by ten minutes, with more weight applied along the contour of the seam. The poultice was then removed and the area was weighted for a further five minutes to ensure good bonding. After the treatment, the area appeared well-supported; it did not feel tacky to the touch and remained flexible.

However, small, barely perceptible, shiny dots were found in the weave interstices of the large crepeline patch. Also, faint yellow stains were found on both sides of the Gore-Tex® used for the waist area. The area of yellow staining corresponded to the yellow waist guard, which appeared more vivid than before treatment. However, no colour bleeding in the adjacent areas or destruction in the over-painted patterns on the yellow was noted. The staining in the Gore-Tex® indicated that the colourant was carried by the acetone vapour as it evaporated and penetrated from the laminated face to the felt face of the Gore-Tex®. This undesirable result occurred despite the fact that testing prior to treatment had shown that the yellow paint was stable when tested with liquid acetone for two minutes. This effect may be related to the drying oil medium, which was identified as present only in this yellow paint film. Alternatively these results indicate that a long exposure of solvent vapour may result in an adverse effect.

A support was given to the right and top notched borders to ensure its stability during long-term free-hanging display and to provide a hanging sleeve space (see Figure 7). A fine nylon net (20 denier), dyed blue/grey, was attached to the back of the right notched border. The notched edges were held in place using fine polyester thread drawn from Stabiltex® (polyester crepeline). The top notched border was backed with medium-weight silk habutai, also dyed blue/grey, lined with undyed cotton lawn to provide additional support. The bottom edges of these two fabrics were stitched to the banner's upper 'French seam' using fine polyester thread; the notched edges were then held in place on the silk habutai with blue silk

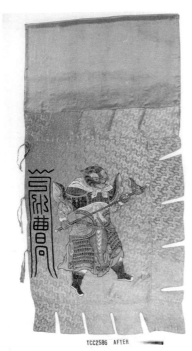

Figure 8. Korean painted silk banner after treatment

thread. These silk and cotton support fabrics were left long enough to make a pole sleeve or other later adaptation for mounting (see Figure 8).

Evaluation

The treatment increased the stability and improved the appearance of the banner. Paint loss, which occurred during handling before treatment, was much reduced after paint consolidation with isinglass. Little colour change was seen and the consolidated areas remained flexible. The use of Lascaux® adhesives, reactivated via an acetone-vapour poultice, provided a strong, even bond with flexible, matt support to an uneven painted surface. The technique of solvent reactivation, however, was shown to have limitations associated with long exposure to solvents; testing prior to treatment should replicate the duration of exposure. Overall the results indicate that such adhesive support is a valid alternative where a stitched support and/or use of water/heat are inappropriate.

Conclusion

This project demonstrates interdisciplinary collaboration between conservators, a curator and a scientist, which helped to expand cultural as well as technical information of the banner and to develop a most suitable conservation strategy.

The technical examination, the first for an East Asian painted banner, revealed some material and techniques different from East Asian paintings: no sizing, an overall ground layer and, notably, a previously unrecorded white pigment, arsenic oxide. The results provide new data on the construction and pigment history in East Asian painted banners/paintings. The presence of arsenic oxide not only highlighted possible health risks associated with handling the banner but also may inform attribution of the banner.

The case study also demonstrates the application of paint analysis using cross-sections, which is now becoming more routine in textile conservation. The findings about binding media and layer structure helped formulate criteria for selecting materials and techniques in paint consolidation and adhesive support.

This study suggests that solvent reactivation can produce strong bonding and can be a viable alternative to heat reactivation. More comprehensive research is suggested to inform the choice of solvent vapour, reactivation time and poultice systems.

Acknowledgements

The authors thank Charlotte Horlyck, Assistant Curator of Korean Art, Far Eastern Department, Lynda Hillyer, Head of Textile Conservation, Conservation Department, V&A, Nell Hoare, Director of the Textile Conservation Centre, Dr. Paul Wyeth, Lecturer in Conservation Science, and Paul Garside, PhD student, University of Southampton.

Notes

1 Translation provided by Dr. Youngsook Pak, Lecturer in Korean Art. School of Oriental and African Studies (SOAS), University of London.
2 Personal communication (Takami) with Dr. John Winter, Senior Conservation Scientist, Freer Gallery of Art and Arthur M. Sackler Gallery, Smithsonian Institution, on 29 September, 2001.
3 Personal communication (Takami) with Professor Tsuneyuki Morita, National Museum of Ethnology, Osaka, Japan, on 21 May, 2000.
4 More information on experimental design and results is available in Takami (2000).
5 The testing was carried out under constant conditions of 23–24°C and 44–48% RH. More information on experimental design and results is available in Takami (2000).

References

Gill, K and Boersma, F, 1997, 'Solvent reactivation of hydroxypropyl cellulose (Klucel G®) in textile conservation: recent developments', *The Conservator*, 21, 12–20.
Korean Overseas Information Services, 1993, *A Handbook of Korea*. Seoul: Samhwa Printing.
Plesters, J, 1956, 'Cross sections and chemical analysis of paint samples', *Studies in Conservation*, 11, 110–132.

Rogerson, C and Eastop, D, 1999, 'The application of cross-sections in the analysis of historic textiles', *The Conservator*, 23, 49–53.

Takami, M, 2000, 'The conservation of a Korean painted silk 'tiger' banner: Solvent reactivation of acrylic adhesive', Diploma Report, Textile Conservation Centre, United Kingdom.

Tímar-Balázsy, Á and Eastop, D, 1998, *Chemical Principles of Textile Conservation*, Oxford: Butterworth-Heinemann.

Winter, J, 1985, 'Some material points in the case of East Asian paintings', *The International Journal of Museum Management and Curatorship*, 4, 251–264.

Winter, J, 1989, 'Identification of some early Korean pigments', *Misul Charyo*, 43, 9–36.

Materials

Gore-Tex® (Expanded Teflon membrane laminated on polyester felt)
AP Fitzpatrick, 142 Cambridge Health Road, Bethnal Green, E1 5QJ, UK
Tel: +44 (0)207 790 0884, Fax: +44 (0)207 790 0885

Isinglass, leaf (Salkianski)
AP Fitzpatrick, 142 Cambridge Health Road, Bethnal Green, E1 5QJ, UK
Tel: +44 (0)207 790 0884, Fax: +44 (0)207 790 0885

Paraloid B 72®, Klucel G®, Lascaux® 360/498HV (adhesives)
Conservation Resources Ltd., Unit 1, Pony Road, Horsepath Industrial Estate, Cowley, Oxfordshire OX4 2RD, UK
Tel: +44 (0)1865 74 7755, Fax: +44 (0)1865 74 7035

ADDENDUM: Pigment Identification

Introduction

More detailed elemental analyses for pigment identification were undertaken on the same paint cross-sections as well as on two other samples, dark blue and green, by Dr. Paul Wyeth, Lecturer in Conservation Science, Textile Conservation Centre, University of Southampton, UK, using SEM-EDS and Raman microspectroscopy. This report describes the new evidence on the colourants revealed after the initial submission of this paper.

The analysis was carried out on the polished cross-sections using a Phillips XL 30 environmental scanning electron microscope (ESEM) operated in high-vacuum mode. Backscattered electron images (acquired at 15 kV) were compared with optical micrographs and then used to define the area for X-ray analysis (spectra were acquired at 20 kV, 100s live time). Replicate spot or selected area (10–20μm box) analyses were undertaken, as appropriate. To resolve ambiguity, Raman microspectra were also acquired of the orange-red gilding ground and the green, copper-containing pigment, courtesy of Averil Macdonald, Department of Chemistry, University of Southampton. Table A1 describes the elements identified and suggested pigments for each paint layer.

Results

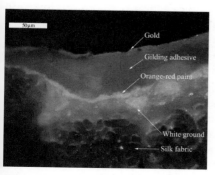

Figure A1. Incident light micrograph of the upper paint layers of the gilt-paint cross-section; the front face is uppermost

In the white paint sample, no evidence was found of arsenic oxide in this subsequent analysis; x-ray spectra of both white layers above and below the silk (high contrast particles up to 20μm across were observed in the backscattered electron image) simply revealed the presence of lead, indicating that the pigment is lead white ($2PbCO_3 \cdot Pb(OH)_2$). The orange-red gilding ground (see Figure A1) showed predominant lead peaks in its X-ray spectrum, indicative of red lead (Pb_3O_4). The white ground layer under the gilt (Figure A1) contained aluminium and silicon, suggestive of an aluminosilicate such as clay, although the relatively high silicon levels may indicate the admixture of silica. It was also found that a small amount of silicon is associated with the silk, but no complementary elements were highlighted.

The yellow paint (Figure A2) overlaid a light brown coat, which was immediately above the white ground. Spot analysis of a yellow particle (20 x 50μm) confirmed it as orpiment (As_2S_3), while the adjacent light brown layer, approximately 2μm thick, again indicated an aluminosilcate.

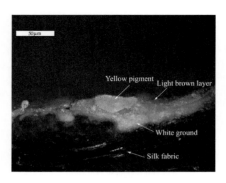

Figure A2. Incident light micrograph of the upper paint layers of the yellow-paint cross-section; the front face is uppermost

Table A1. Results of X-ray microanalytical determination of the elements in the various paint pigments. Emboldened symbols represent those elements present at the highest levels (above 5 atom % according to the standards less quantitation), while the other elements were found at levels between 1 and 5 atom %; elements are listed in order of decreasing content. Carbon and oxygen were seen at relatively high concentrations in all cases, representing contributions from the organic content of the layer, e.g. medium. The green copper-based pigment was identified as a mixture of malachite and atacamite and the orange-red pigment as red lead by Raman microspectroscopy.

Sample description (location)	Layer	Elements identified	Pigments suggested
Gilt paint (belt)	Gold	**Au**	Gold
	Brown	S	Animal glue
	Orange-red	**Pb**	Red lead
	White	**Si, Al**, K, Fe	Clay?
Yellow paint (waist guard)	Yellow	**S, As**	Orpiment
	Light brown	**Si, Al**	Clay?
	White	**Pb**	Lead white
Red paint (spear handle)	Red	**S, Hg**	Mercuric sulfide
	White	**Pb**	Lead white
Dark blue paint (belt)	Blue	**Si, As, K**, Fe, Co,	Smalt
	Black	(only **C, O**)	Carbon black
Green paint (waist guard)	Green	**Cu, Cl**	Malachite, atacamite
	White	**Cu, Cl, Pb**, Mg	Malachite and Lead white
	Light brown	**Si, Al, K**	Clay?
Black paint (boot)	Black	(only **C, O**)	Carbon black
	White	**Si, Pb**, K, Mg	Lead white and silica?
White paint (chest sash)	White	**Pb**	Lead white

The blue paint contained blue shards, 20 x 50μm, of varying hue, and similar amounts of black particles with much the same dimension. X-ray microanalysis confirmed that the blue pigment is smalt. Besides Co, the glass also appeared to have a significant iron and arsenic content (the cobalt to arsenic atomic ratio is about 1:3). These two elements may then have been introduced to the glass mixture together, for example as a mixed salt such as a cobalt arsenate $CO_3 (AsO_4)_2$. The black particles were found to contain carbon alone.

The green colorant was found to be a mixture of malachite ($CuCO_3 \cdot Cu(OH)_2$) and atacamite ($CuCl_2 \cdot 3Cu(OH)_2$). There was a lead white ground, while the light brown layer adjacent to the silk seemed to be composed of an aluminosilicate.

The white layer underneath the black pigment, identified as carbon black i.e. Chinese ink, was revealed to be lead white with a high content of silicon. Kaolin or micaceous white may have been added and perhaps silica (e.g. quartz).

Discussion

One notable feature is that, in many of the X-ray spectra, a significant amount of silicon and aluminium was detected. Clay or silica appear to have been mixed in with the white and blue paints and, in yellow and green paint samples, clay is present as a thin but distinctive layer either on the silk fabric or in-between paint layers. Clay could have been mixed with paint as filler to provide the flat surface for painting.

In preliminary analyses of the pigments, significant levels of arsenic were noted; it was suspected that very toxic arsenic oxide might be present throughout the white ground layer. Appropriate health and safety measures were immediately introduced to limit exposure, and suitable recommendations for the handling and storage of the banner were formulated. However, the subsequent detailed analysis reported here suggests that the white pigment is predominantly lead white, while the presence of arsenic is accounted for by the high content of the element in blue smalt (besides orpiment) and in this form its toxicity is less of a concern.

Abstract

This paper presents the results of collaboration between three institutions in assessing the current role of pressure mounting in textile conservation, examining techniques primarily developed in North America using this system. Preliminary results recording the microclimate of a pressure mount are reported; proposals for further research are highlighted

Keywords

pressure mount, Perspex™, Plexiglas®, minimal intervention, microclimate

The role of pressure mounting in textile conservation: recent applications of U.S. techniques

Deirdre Windsor★ (formerly at the American Textile History Museum)
Windsor Conservation
85 Pine Street
Dover, Massachusetts 02030, U.S.A.
Fax: +1 (508) 785-1974
E-mail: dwindsor@attbi.com

Lynda Hillyer
Victoria and Albert Museum
London, United Kingdom

Dinah Eastop
Textile Conservation Centre
University of Southampton
Winchester, Hampshire, United Kingdom

Introduction

Pressure mounting has been used to store and display flat textiles for at least a century. Large numbers of archaeological fragments excavated in the late 19th century have survived in collections because they were 'sandwiched' between glass on acquisition. These rudimentary mounts allowed both sides of the textile to be examined and provided protection from damage through mishandling. This method was developed primarily for museum study collections and archives. Often, the glass sheets were secured with tape around the edges or placed in standard-size frames fitted into storage units. The rigidity and non-porous surface of the glass inhibited movement of the textile and reduced its exposure to oxygen and environmental contaminants while permitting the textile to be exhibited, studied and handled (Kajitani and Phipps 1986). As conservation methodology progressed, textile conservators made critical observations of these old mounts, which were considered a basic and effective system through to the 1950s. This assessment led to revisions in the principles and techniques of pressure mount systems using modern archival materials.

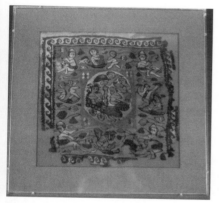

Figure 1. After treatment of tabulae fragment, Egypt, 6th century AD, stabilized in double-glazed Plexiglas® box pressure mount system.

Recent developments

Sophisticated systems of pressure mounting have been developed over the last 40 years in Europe and North America for thin, flat textiles considered too fragile for stitched supports and for which an adhesive treatment would be inappropriate or undesirable. A contemporary pressure mount is primarily a method to prepare textiles for vertical display. The technique is based on sandwiching the textile between glazing material and a padded rigid support, which acts as a minimally interventive stabilization.

Examples of types of textiles commonly preserved in this way include archaeological fragments (Figure 1), degraded silks and textiles with smooth surfaces, such as silk satins and glazed cottons. Providing support by placing the glazing material in direct contact with the face of the textile eliminates the need for stitching or mechanical intervention of such delicate surfaces. Textiles with a pile structure or heavy embellishments are not normally considered for pressure mounts as surface elements could be crushed or cause deformation to the substrate, or alternatively not permit complete contact.

Principles and materials

The two major systems of pressure mounts currently in use reflect differences in theory and technical approach between North American and European conserva-

★Author to whom correspondence should be addressed

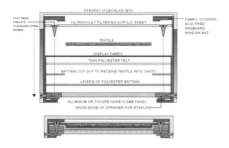

Figure 2. Diagram of layers in acrylic box pressure mount system showing cut-out to accommodate depth of textile.

tors. The principal difference is the material used for glazing and constructing the mount. Choices may be guided by historical, practical and aesthetic choices. The most definitive distinctions between North American and European practice are the use of acrylic Perspex™ (Plexiglas®) versus glass for glazing, non-woven polyester versus woven cotton padding for cushioning, and aluminium, fibreglass or archival paper-based versus wood-based rigid mounts. Variables in the principles of construction include closed systems with traditional wood or contemporary metal frames, and acrylic box-covered mounts in comparison to open systems compressed with metal or acrylic clips exposing the edges of the mount to some air movement.

Rigid mounts are constructed from a variety of archival honeycomb and solid support panel materials including basswood or poplar strainers fitted with aluminium honeycomb, Hexlite™ (fibreglass skins with an aluminium honeycomb core), Dibond™ composite panel (aluminium skins with low-density polyethylene core), Tycore™ (acid-free honeycomb paper panel), 8-ply rag board, masonite, block board or plywood. Wood-based components are generally sealed with polyurethane, although some conservators use superior grade non-resinous woods and advocate unsealed wood mounts to buffer changes in relative humidity. Rigid mounts are prepared with a variety of buffering and padding materials. The extent to which pressure mounts serve as buffers to environmental fluctuations remains widely debated.

Although pressure mounting can appear as a simple system, a high level of technical skill is required to create a successful mount. Essentially, textiles prepared for vertical display in pressure mounts are in direct contact with Perspex™ or glass in a fully or partially enclosed environment to achieve full support. These two glazing materials have distinctive physical characteristics, which affect the design and construction of the corresponding mount. Differences include rigidity, weight, surface hardness, surface compactness, static electricity, chemical state, visible light and UV transmission, thermal transmission, inherent colour, breakage and crafting possibility (Kajitani and Phipps 1986).

In North America, Perspex™ is often preferred because of its chemical stability, its light weight, its ability to deter adhesion, its UV filtering properties (also available with glass products), and the fact it will not shatter. Negative qualities include electrostatic charge and the tendency for Perspex™ to bow over a certain size. The electrostatic charge can be effectively reduced with an anti-static agent on the outer surface of an acrylic sheet or by increasing conductivity by increasing the humidity (Commoner 1998) while assembling a pressure mount to prevent attraction of fragile fibres. The tendency of acrylic sheets to bow out in a vertical position can be counteracted by the mounting technique.

The term *pressure mount* can be misleading. In a well-engineered mount, there is no direct pressure on the object. In some cases, the depth of a textile or select elements such as fringes can be accommodated in the mount by cutting out a layer or layers of padding material underneath the show fabric. This cavity can be achieved in several ways. The shape can be cut out of the polyester batting or felt layer, or from museum board adhered to the mount, or alternatively with cotton molton (domette), which is a napped woven cotton used in Western Europe. A successful mount achieves a balance of materials and secures the textile by even contact with the glazing, without causing deformation of the fibre (Figure 2).

A method to determine even pressure over the entire surface of the textile has not been established. How much pressure is enough remains empirical knowledge and is directly related to mount design. Insufficient pressure can result in slipping or buckling of the textile. Some conservators use minimal stitching of the textile when the object exceeds a certain size to supplement the contact of the glazing material. Stitching prevents slippage when vertical and often is used as a precaution so fragments are not displaced when the glazing is attached to (or removed from) the rigid mount. Stitches are carefully executed between the elements without piercing fragile degraded fibres, or fine threads are used to bridge over loose fragments from edge to edge. An alternative method to eliminate lifting of fragments or desiccated fibres is to encapsulate the textile in silk crepeline or polyester Stabiltex™ prior to glazing. Although the principles of pressure mounts are fairly straightforward, several variations in presentations of an object can be considered.

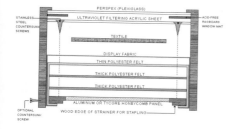

Figure 3. Diagram of pressure mount system in traditional wood frame.

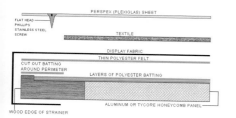

Figure 4. Detail of method to reduce compression at the edges with a 0.4 × 1 mm acrylic or wood lip around the perimeter of the mount.

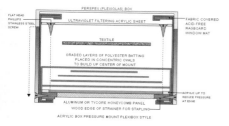

Figure 5. Diagram of large acrylic box contact/pressure mount system showing build-up of layers of padding.

Figure 6. After treatment of Boys in Blue Lowell *banner in mount with recess for pole.*

Applications

Pressure mounting small textiles in traditional or contemporary frame

Pressure mounts can be an effective way to support small textiles in frames. Traditional wood or contemporary metal frames can be used to provide support, to enclose the mount materials and to enhance overall appearance (Figure 3). The choice often depends on exhibit design criteria. For a small thin textile, a complete single or double layer of padding is often sufficient.

Pressure mounting large-scale textiles

The principles of a pressure mount technique can be applied to a large textile, but the manufacture of the mount needs to be modified to compensate for the bowing of large acrylic sheets. Perspex™ of between 4 and 6 mm thick is recommended; the rate of deflection or bowing of the Perspex™ depends on both the thickness and the span of the sheet.

The Perspex™ is attached to the strainer around the edge with evenly spaced screws, which compress the padding materials and accentuate the bowing; the larger the expanse of the acrylic the more severe the bowing. Bowing can be compensated for by building concentric layers of polyester batting underneath a full layer to ensure even contact of the textile.

The problem of compressing the padding materials along the outside edge can be alleviated by adding a raised lip of acrylic or wood around the edge of the strainer (Figure 4); the lip serves to equalize the plane of the acrylic glazing when screwed to the mount. Large pressure mounts can be put into frames or boxes (Figure 5). An alternative technique to compensate for the bowing of acrylic sheets using thermobonded and resin-bonded polyester batting has been reported (Bacchus and Lord 2000).

Textiles in historic frames

In some cases, a version of pressure mounting may be appropriate for fragile silk embroideries or samplers. If a textile is displayed in its original frame, the principles of pressure mounts can be successfully used to achieve both support and historically correct presentation. In order to incorporate archival materials and glazing, alterations (such as a build-up to increase frame depth) may be necessary. The addition of glazing can effectively isolate the textile from auxiliary materials, such as reverse-painted glass. Textiles in original frames will not allow typical fasteners, such as screws, into the mount. Systems of binding or clipping the glazing in contact with the textile can be devised to hold conservation materials in place.

Incorporating components associated with textiles in a mount

A pressure mount can be customized to incorporate both a flat fragile textile, such as a banner, and its associated pole (Figure 6). Poles may be removed to eliminate the stress of intermittent tacks or more often after splitting has occurred across the top edge of the textile, rendering them separate objects. The mount can be constructed with a recess to accommodate a three-dimensional component. This flexibility of customizing mounts can be applied to many other composite objects whose primary condition problem is best treated with minimum intervention.

Case example

An important 5th-century AD Coptic resist indigo-dyed linen textile, found in the collection of the Victoria and Albert Museum (Museum No.1103-1900), was pressure mounted in 1999 using the system shown in Figure 3. The fragment, depicting the Nativity, is a rare and vulnerable object. It was first conserved in the 1970s when it was wet-cleaned and adhered to a nylon tulle support using a thermoplastic adhesive.

Figure 7. A rare and vulnerable 5th century resist-dyed Coptic textile (850mm × 450 mm). Pressure mounting offered a flexible and minimally interventive system that has made the fragment available for study, display and loan.

By 1996, this treatment was beginning to fail and the textile could no longer be handled or moved safely without significant fibre loss. A loan request prompted a re-evaluation of the original conservation. Pressure mounting was considered after all other options had been explored, including a stitched support, a new adhesive support or encasing the textile in a protective covering. The textile's fragility was such that there was a real danger of loss. The importance of the object in the collection meant that the conservation had to aim to make the textile accessible for display, study and occasional loan to other institutions, all of which could be achieved with a pressure mounting system.

In addition, several features of the textile made it a good candidate for this technique.

- The most important feature is the *image* of the Nativity, achieved by the use of wax resist and indigo (Figure 7), there is little texture or drape to preserve. Pressure mounting accentuates image and design rather than the texture of an object.
- Any movement disturbed the weave and distorted the image of the Nativity. Every thread needed to be immobilized in order to read the design.
- The textile is thin and flat with no protruding seams or surface decoration.

Collaboration between the three authors of this paper resulted in the selection of an American system of pressure mounting using lightweight, inert and synthetic materials. The difficulties presented by the electrostatic qualities of Perspex™ in relation to a fragile and brittle textile were overcome by using the direct relationship between conductivity and relative humidity (Commoner 1998). When the Perspex™ was lowered onto the textile laid on its prepared mount, the relative humidity was raised temporarily from 50% to 66%. In this environment, each and every thread remained undisturbed as the Perspex™ was positioned.

This textile is part of a larger wall-hanging, and another fragment from the same piece exists within the collection. The exact relationship between these fragments is unknown but might be revealed through further research. Pressure mounting offered a flexible and minimally interventive system facilitating later re-arrangement of related fragments.

The role of the pressure mount

A difference of opinion exists about whether pressure mounts are a temporary method used only for display or whether they are a suitable option for both long-term storage and exhibition. McLean argues that the technique was originally designed for temporarily displaying fragile textiles. In some museums, it has become a standard approach for short-term exhibitions for which preparation time is limited. Some conservators have made a decisive choice to consider the dual role of pressure mounts in the proposed treatment plan (Guintini and Bede 1994). The size of an object or its fragility may restrict or deter conservators from disassembly; therefore pressure mounts have inadvertently become storage mounts due to practicality. The same is true for large objects that are hung on permanent exhibition. They often remain mounted because they are unwieldy and to ensure public access. Objects mounted for institutions with no specialist in textile conservation are usually stored for future exhibitions with no consideration of reversing a costly treatment.

Environmental concerns: current and future research

Pressure mounting can play a significant role in achieving less interventive treatments. However, to date, there has been no published data on the internal environment of pressure mounts for textiles. Attempts to control the microclimate created by the pressure mount have been made by integrating a moisture sensitive silica material ART-SORB® (silica gel embedded in polyethylene/polypropylene sheet) into the mount materials to buffer perceived changes in relative humidity (McLean 1986).

Figure 8. Preliminary monitoring of the microclimate within the pressure mount for the Coptic textile confirmed that the normal relation between temperature and relative humidity is not followed. The relative humidity increases with increasing temperature.

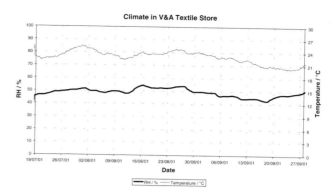

Many conservators maintain that the conservation materials used to construct and pad the rigid mount buffer changes in moisture and this belief may inform choice of mount materials. Kajitani and Phipps (1986) have used buffered acid-free paper underneath padding materials to assist in buffering changes in humidity while the Abegg-Stiftung uses unsealed seasoned wood. At the Victoria and Albert Museum, preliminary monitoring of the internal environment of the pressure mounted Coptic textile described above confirmed that within the microclimate formed in the mount the normal pattern of relation between relative humidity and temperature is not followed. In such cases, the relative humidity increases with increasing temperature (Figure 8). Hofenk de Graaff stresses the need to maintain stability of temperature for pressure mounts (personal communication, September 14, 2001). The relative buffering capacity of specific mount materials merits further investigation.

The formation of bloom or efflorescence is another concern in pressure mounting. At the Victoria and Albert Museum, a survey of 82 archaeological textiles sandwiched between glass revealed that more than half exhibited white deposits around the perimeters of the textile (Arslano lu 2001). Efflorescence has been identified as fatty acids, sodium chloride, sodium formate or long chain or saponified fatty acids. Nockert and Wadsten (1978) identified the presence of sodium formate on the inner surface of the glass cover of sealed boxes used to store archaeological textiles. It had migrated from paper used in lining the boxes.

Padfield and Erhardt (1987) investigated a transferred image on the inner surface of the glass that had been used to frame a woven silk picture. The image was found to be formed from sodium chloride (present in both object and card backboard) and occurred only in areas where the textile did not touch the glass. It is likely that local microclimates in these areas facilitated cycles of capillary action and deliquescence resulting in the deposits.

Heald, Commoner and Ballard (1992) identified myristic, palmitic and stearic fatty acids and surmise that the source of these deposits could be residual soaps left in the textile after processing or wet cleaning. Such deposits occur only on glass and are generally thought to be initiated by changes in relative humidity in local microclimates within the pressure mount. Wülfert (1999), whose findings concur with Heald et al. points out that glass has the highest coefficient for conducting heat and that sodium and calcium, (which can be present on a glass surface) in the presence of moisture, are capable of saponifying fatty acids. Until recently such deposits have only been observed on glass. However a similar effect has been noted on acrylic by van Oosten (2001), who suggests that a white crystalline appearance was caused by crazing on the acrylic surface arising from water molecules moving from card within the mount to the inner surface of the Perspex™. Further research and analysis of the internal microclimates of pressure mounts for textiles is recommended.

Conclusion

The current focus on minimal intervention has emphasised the important role of the mount in the preservation of textile artefacts (Lister 1997). The conservation process and the mounting of an object are no longer always viewed as separate operations. The pressure mount is a graphic example of the fusion of preservation and display. The mount and the artefact become, in effect, 'the object' (Lister

1997). The visual effect of this fusion is one of the most common criticisms of the pressure mount. The textile can appear 'packaged' and 'frozen' behind glass or acrylic and is translated into a fixed design. Its textural quality can be impaired by viewing through a reflective material and all sense of flexibility is lost. The reverse is no longer accessible.

Despite these drawbacks, pressure mounting remains an attractive option for display because of its versatility. Pressure mounted textiles can be framed in a variety of ways to suit a particular exhibition design. For example, a pressure-mounted textile can be placed in an acrylic box to achieve a distinctive 'clean' and 'neutral' look, as the textile remains the strongest visual element. Alternatively fabric covered mats can be changed without disturbing the conservation mounting.

The ease of reversibility for small stable textiles and the use of light synthetic materials to construct a pressure mount often makes it the method of choice for objects travelling on international or multi-venue loans. The use of Perspex™ is preferable as a glazing material for framed objects that travel on loan, as it will not shatter, thus reducing potential risks.

One of the acknowledged benefits of pressure mounting is the protection of fragile and degraded ancient textiles. In this case, the role of the mount is considered to be a tool of preventive conservation management within an actively studied collection and in this sense the mount fulfils the same role as that intended by sandwiching fragments in glass in the late 19th century.

Acknowledgements

We thank Julie Arslano lu and Richard Kibrya of the Victoria and Albert Museum's Science Section.

References

Arslano lu, J, *Proposal for the Investigation of Bloomed Glass Press-Mounted Textiles*, Science Section Internal Report No. 01/73/JMA, Victoria and Albert Museum, London.

Bacchus, H and Lord, A, 2000, 'Pressure mounting a painted regimental color using a US technique,' *UKIC Conservation News* No. 73, November, 61–64.

Commoner, L, 1998, 'Static Electricity in Textile Conservation,' *ICOM Ethnographic Newsletter* No. 18, October, 12–14.

Guintini, C and Bede, D, 1994, 'The Conservation of a Group of Paracas Mantles, La Conservation Des Textiles Anciens,' *Journée d'Études de la SFIIC*, Angers, France, October, 169–180.

Heald, S C, Commoner, L and Ballard, M, 1992, 'A study of deposits on glass in direct contact with mounted textiles,' *AIC Textiles Speciality Group*, 7–18.

Kajitani, N and Phipps, E, 1986, 'Pressure Mounting – Our fifteen years experience in interim treatment between stitch-mounting and consolidation, Textile Treatments Revisited,' Harpers Ferry Regional Textile Group Meeting in the National Museum of American History, Smithsonian Institution, Washington DC, November, 67–69.

Lister, A, 1997, 'Making the Most of Mounts: Expanding the Role of Display Mounts in the Preservation and Interpretation of Historic Textiles,' *Preprints of a Conference, Textile Symposium 97 – Fabric of an Exhibition: An Interdisciplinary Approach*, Canadian Conservation Institute, Ottawa, September, 143–148.

Nockert, M and Wadstein, T, 1978, 'Storage of archaeological textile finds in sealed boxes,' *Studies in Conservation* 23, 38–41.

McLean, C C, 1986, 'Conservation and Mounting of a Large Mughal Textile' in C C McLean and P Connell (eds.), *Textile Conservation Symposium in Honor of Pat Reeves*, February 1, 1986, Los Angeles County Museum of Art, Los Angeles, 63–67.

Oosten, T van, 2001, 'Crystals and Crazes: Specific phenomena in plastics due to micro climates' *ICOM-CC Interim Meeting – Modern Materials Working Group*, Cologne, March (unpaginated).

Padfield, T and Erhardt, D, 1987, 'The spontaneous transfer to glass of an image of Joan of Arc, Lighting and Climate Control,' *Preprints of the 8th Triennial Meeting ICOM-Committee for Conservation, Vol. III*, Sydney, Australia, September, 969–973.

Wülfert, S, 1999, Ablagerungen auf den Scutzgläsern Textiler Kunstwerke, Ehemaligentreffen der Abegg-Stiftung, Referate der Tagung, 5–6 November 1999, pp. 79–84.

Leather and related materials

Cuir et matériaux apparentés

Cuero y materiales relacionados

Cuir et matériaux apparentés
Leather and related materials

Coordonnatrice : Claire Chahine
Coordonnateur adjoint : Christopher Calnan

Nous voudrions remercier l'ensemble des 65 membres composant notre groupe qui par leur travail et leurs idées ont grandement contribué à ses activités et fait avancer le programme qui avait été établi à l'issue de la dernière réunion triennale tenue à Lyon en 1999. Ce programme comprenait des sujets d'intérêt général et d'autres, plus spécifiques. Les thèmes proposés portaient notamment sur l'évaluation et l'amélioration de traitements anciens, la fabrication de cuir plus résistant et l'étude et la conservation de divers types d'objets (comme tentures, objets composites, objets en fourrure).

Deux évènements d'importance ont eu lieu au cours des trois années qui viennent de s'écouler : la parution du deuxième numéro de notre bulletin de liaison en décembre 1999 et la tenue d'une réunion intermédiaire en Espagne en octobre 2000.

Le bulletin de liaison du groupe se veut un forum de discussions et d'informations sur des sujets généraux concernant l'étude et la conservation du cuir et des matériaux apparentés. Pour qu'une telle entreprise soit un succès, la participation de tous est souhaitée et nous voudrions ici réitérer notre invite à tous les membres d'y collaborer activement.

Notre réunion intermédiaire s'est déroulée à Vic, ville de Catalogne située au nord de Barcelone. Nous avons été accueillis à l'Université et au Museu de l'Art de la Pell qui possède une importante collection d'objets décoratifs en cuir réunis par Andres Colomer, président du groupe des Tanneries Colomer. Nous tenons tout particulièrement à remercier Félix de la Fuente, directeur du musée, et ses collaborateurs pour la parfaite organisation de cette manifestation. Le thème général des communications et des discussions portait sur le cuir en tant que matériau de revêtement de nombreux types d'objets, prestigieux ou d'usage courant, qui posent des problèmes spécifiques de conservation. Ce thème étant très large, les vingt-sept communications présentées avaient trait pour la plupart à la conservation d'objets différents. Près de cent participants, dont 60 % d'Espagnols, ont pu assister à cette conférence qui a été l'occasion pour les différents spécialistes présents de confronter leurs points de vue, ce qui a été particulièrement apprécié de nos collègues espagnols. Les participants ont eu le plaisir de pouvoir visiter l'exposition de reliures anciennes au musée épiscopal, ainsi que diverses tanneries de la ville. Ils se sont également rendus à Igualada au Museu de la Pell i Comarcal de l'Anoia.

Les thèmes de recherche qui avaient été proposés ont donné lieu à des travaux importants dont certains ont été présentés lors de la réunion intermédiaire. D'autres font l'objet de communications présentées à l'occasion de cette réunion triennale et, enfin, certains travaux ont été publiés hors du cadre de l'ICOM-CC ; notre communauté en tirera cependant un grand intérêt.

L'élaboration et la présentation d'un travail nécessitent un effort considérable, et nous voulons en remercier vivement tous les auteurs, et surtout les encourager à poursuivre leur activité dans le groupe.

Claire Chahine

We would like to thank the 65 members of the Leather Working Group, who participated actively and contributed through their work and their ideas to the achievement of the working programme established after the last Triennial Meeting in Lyon in 1999. This programme covered general and more specific topics. Themes proposed by the members included, in particular, the evaluation and improvement of old treatments, the development of archival leather, and the study and conservation of certain objects, such as wall-hangings, combinated materials and fur artefacts.

Two major events occurred during the past three years: the distribution of the second issue of our newsletter in December 1999 and the organization of an Interim Meeting in Spain in October 2000.

The newsletter of the Leather Working Group aims at being a forum for discussion and information on general subjects concerning the study and the conservation of leather and related materials. Such an attempt cannot be a success without the participation of all of us, and we encourage all members to participate in its preparation, so that the newsletter becomes more informative.

Our Interim Meeting was held in Vic, a city north of Barcelona in Catalonia, and was hosted by the University and the Museu de la Pell. This museum has an extensive collection of decorative leatherwork amassed by Andres Colomer, President of the Colomer Tanning Group. We would like especially to thank Felix de la Fuente, Director of the museum, and his collaborators, for organizing the meeting. The general theme of the talks was discussion of leather as a covering material for many kinds of objects, both prestigious and ordinary, as this is common to the conservation concerns of the Working Group. Because of this broad theme, most of the 27 presentations had to do with the conservation of various objects. Nearly a hundred participants (about 60% of them Spanish) attended the meeting, which allowed exchanges between different specialists with fruitful discussions — this was especially appreciated by our Spanish colleagues. Participants had the pleasure of visiting the old bookbinding exhibition at the Episcopal Museum, as well as various tanneries in the city. They also went to Igualada to visit the Museu de la Pell and Comarcal de L'Anoia.

The proposed research themes gave rise to important works. Some of them were presented during our Interim Meeting in Spain, others are presented during this Triennial Meeting, and some have been published outside the frame of ICOM-CC, but all are of high interest. We know how much effort goes into the preparation of a paper, and we therefore thank all the contributors for their efforts and encourage them to continue their activities in the Leather Working Group.

Claire Chahine

Abstract

The museum housed in Lunéville Castle possesses a fine representation of the meeting of King Solomon and the Queen of Sheba. It is depicted on a so-called gilt leather wall-hanging, which is painted and stamped. The recently restored hanging is one of a series of three dating from the middle of the 17th century and representing Biblical scenes. A study of the technical details documented during this work revealed information on the manufacturing process. The following paper describes the gilt leather technique according to bibliographical sources, and compares it with observations made on the Lunéville hanging. The various observations will be detailed, as well as their implications for the choice of restoration procedures. This article was written jointly by a leather conservator, a curator and an art historian specializing in interiors and gilt leather.

Keywords

gilt leather, wall-hanging, painted leather, Solomon, Queen of Sheba, Lunéville

Meeting Between Solomon and the Queen of Sheba: history, technology and dating of a gilt leather wall-hanging, or the contribution of a restoration process

Céline Bonnot-Diconne★
ARC-Nucléart, CEA/Grenoble
17, rue des Martyrs
38054 Grenoble cedex 9, France
Fax +33 4 38 78 50 89
E-mail: celine.bonnot@cea.fr
Web site: www.arc-nucleart.fr

Natalie Coural
C2RMF, Petites Ecuries du Roy
Versailles, France

Eloy Koldeweij
Rijksdienst voor de Monumentenzorg
Zeist, The Netherlands

The Queen of Sheba heard of Solomon's fame and she travelled to Jerusalem to test him with difficult questions. She brought with her a large group of attendants, as well as camels loaded with spices, jewels and a large amount of gold. When she and Solomon met, she asked him all the questions that she could think of. He answered them all; there was nothing too difficult for him to explain.... She presented to King Solomon the gifts she had brought (I Kings 10: 1–3, 10).[1]

The Departmental Museum housed in the Lunéville Castle in France possesses a fine representation of this scene (Figure 1). It is depicted on a so-called gilt leather wall-hanging, which is painted and hot-tooled. The wall-hanging consists of 15 distinct squares that are stitched together. Six of them form the central scene. Three of the sides are edged with floral, animal or figurative motifs. The border that used to run along the fourth side has been lost. This hanging measures 3.57 m wide by 2.77 m high.

For many centuries, gilt leather was an extremely expensive and luxurious type of material for a wall-hanging. This was due not only to the cost of the materials used (such as calfskin and silver leaf), but also to the equipment (such as the press, moulds and tools), labour and design. (Diderot 1776, Waterer 1971, Koldeweij 1989, 1992 and 1998, Ledertapeten 1991) Despite the high prices commanded for such fashionable wall decoration, however, probate inventories reveal that they

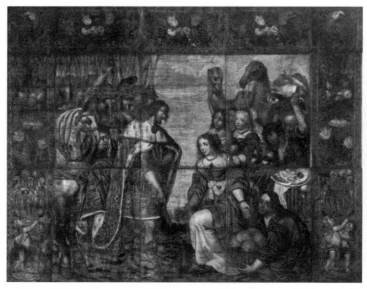

Figure 1. The Meeting of Solomon and the Queen of Sheeba *hanging (Musée Départemental du château de Lunéville, France*

★Author to whom correspondence should be addressed

existed in great quantities. It was not unusual for the wealthy to have two or three gilt leather wall-hangings in their homes.

The hanging of Lunéville is one of a series of three dating from the middle of the 17th century and representing episodes from the Old Testament: the *Meeting Between Solomon and the Queen of Sheba*, *David Victorious* (3.50 × 3 m) and *David Playing the Harp Before Saul* (3.50 × 4 m). These works entered the Lunéville museum collection relatively recently.[2] It was only in 1956 that *David Victorious* was bequeathed to the *Société des Amis du Château de Lunéville* (Friends of Lunéville Castle) by Georges Renoud-Grappin, an antique dealer from near Mâcon, France,[3] who informed us that he had acquired it two years earlier from a castle in Sancé, France, that belonged to the Malartic family.[4] The other two pieces, acquired by the museum at a public sale in Mâcon in July 1973, had been purchased at the beginning of the 1960s by Mr Platet,[5] an auctioneer in Mâcon, from Les Poccards Castle in Hurigny, France, another property belonging to the same family. According to a story related by G. Renoud-Grappin, the three pieces were bought by a member of the Malartic family when the furniture from Lunéville Castle was sold on the orders of King Louis XV after the death of his father-in-law Stanislas Leczinski (1677–1766).[6] However, the general inventory of the furniture and effects of the Royal Castle of Lunéville, dated May 16, 1764, two years before Stanislas' death, contains no mention of a gilt leather wall-hanging.[7] The only thing described is a 'leather tapestry with a red background' consisting of five pieces, probably with decorative motifs, in the Livery Room. The exact origin of these works therefore remains a mystery.

Technological information gained during the restoration process

Meeting Between Solomon and the Queen of Sheba is the only one of these three hangings that has been recently conserved. Both the structure and surface of this wall-hanging were badly damaged, partly as a result of the products used for conservation work in the past. Since 1974, several attempts have in fact been made to restore the hanging, but none have produced the desired results. In 1999, the decision was therefore taken to de-restore the object in order for it to be consolidated and exhibited once again (Bonnot-Diconne 2001).

We devoted much effort to documenting the restoration of this wall-hanging. We did so first to measure the impact of the restoration work and check that the treatment applied to the hanging would cause no harm. And second, we wanted to document the technical details that would be concealed by new restoration. Detailed study of these documents has provided much valuable information on the techniques used by the craftsmen and authors of this work.

The leather support, on which the representation of Solomon and the Queen of Sheba has been painted, is completely covered with silver leaf. This was applied with parchment glue. The analyses[8] did not reveal whether a second layer of glue was applied on the surface to protect the silver against oxidation, as was apparently sometimes the case (Havard 1909). Fougeroux de Bondaroy (1762) states that the glue was applied in two successive coats. Indeed, a stratigraphic cross-section reveals that the layer of parchment glue is very thick (about 62 microns as compared to only 2 microns for the silver). The gold varnish is placed on the silver: analyses revealed the presence of rosin and of an oil that had suffered from oxidizing hydrolysis and had partially broken down into acid groups. This type of degradation corresponds closely to that of linseed oil. It thus seems that this is indeed the usual composition found for gold varnish: rosin, sandarac, aloe and linseed oil (Fougeroux 1762, Havard 1909, Waterer 1971). Elsewhere, certain background areas of the nine panels forming the border of the wall-hanging, which are now a dirty white colour, looked as if they might have been covered with 'white varnish' made from white lead (Fougeroux 1762). However, analysis revealed that the varnish was not consistent with white lead. In contrast, it revealed the presence of hydrated calcium sulphate $SO_4Ca\ 2H_2O$ (plaster). It is likely that a plaster wash was applied to the gold varnish in these background areas in order to give an impression of depth.

The surface of the gilded parts of the hanging has been decorated using 10 different punches (Figure 2).[9] This punched decoration closely follows the lines of

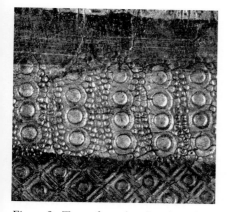

Figure 2. Type of punches (irons) used

Figure 3. Example of a leather patch used on the back of the leather

Figure 4. Example of a sewn repair on the back of the leather

Figure 5. Example of a re-used gilt leather patch on the back of the leather

Figure 6. Infrared photograph of an imprint on the fleshside of the leather

Figure 7. Infrared photograph of an imprint on the fleshside of the leather

the painting, emphasizing the details. Fougeroux de Bondaroy states that the punched motifs were created before the paint was applied. However, in this case, it is clear that the paint does not cover the indents made with the tools and the paint layer has been compressed. It would appear that the surface was tooled after the paint had been applied and not before. Furthermore, punching a decoration that has already been applied is easier and gives a more accurate result. It can indeed be observed that the punched areas are extremely localized and that the rare cases of overlapping are caused by the shape and size of the punches, which are larger than the area to be covered.[10]

According to Fougeroux de Bondaroy, stitching was the final stage after the squares had been painted. This is no doubt true for the squares that form the border: the various motifs had obviously been prepared separately and then assembled. In contrast, with regard to the six main squares, it seems unlikely that the painter completed his work before they were sewn together, as the scene is so complex. It is more likely that the paint was applied once the squares had already been assembled.[11]

Each of the 15 squares consists of two skins glued together after the leather had been trimmed. More than 70% of the squares are assembled horizontally, except for four squares in the upper frieze. While the squares forming the central scene often consist of equal proportions (four of them have a one-third to two-thirds proportion and the other two have a three-fifths to two-fifths proportion), those in the frieze are more unequal, possibly indicating that they were assembled by less skilful or meticulous craftsmen. Calf leather has been used throughout.[12]

The larger the squares, the more repairs have been made to make up for missing areas or defects in the skins and to form a smooth surface. The corners of the squares have often been finished by sticking on pared pieces of leather. The shapes and sizes have been adapted as necessary. There does not appear to be any preferred shape but the pieces are generously sized (Figure 3). Sometimes they overlap. They appear to have been squared before being assembled to form squares. In five cases, gilt leather has been reused (sometimes embossed) (Figure 4). There is even one example of a piece of gilt leather being reused on the upper edge of one of the squares, taking advantage of the gilding on the front. These pieces date from the time the wall-hanging was designed and illustrate the way in which the craftsmen worked. There are also places where the hanging was restitched at the period: a light-coloured thread was used to close a tear with a few cross-stitches (Figure 5).

The back of the leather had darkened considerably, but we noted that there were black lines on the back of all the squares forming the decorative border. This very faint design seemed to have been done with black paint (Figure 6). It was very similar to the black outlines around the painted motifs on the front of the hanging. When these lines were traced at full scale onto transparent film, various shapes became quite clear, including parrots, tulips and foliage. These shapes were similar to those on the frieze, but did not necessarily correspond to what was shown on the square in question (Figure 7). Infrared photographs were also used to document these designs. Why had these designs been made on the flesh side of the leather? In our opinion, it is possible that they are simply accidental imprints. They may have been formed when the squares were piled on top of one another, shortly after a sketch had been made and before it had completely dried. This would explain the faintness of the designs and the fact that they are not drawn with solid lines. Furthermore, it is certain that the motifs in the border squares were made with models since, when they are superimposed, they coincide perfectly. This is probably the technique referred to by Blondel (1886) and Clouzot (1925), whereby a decoration is made using carved wooden boards inked with a mixture of sandarac and soot. This hypothesis is corroborated by physico-chemical analyses of the black paint from the wall-hanging, which unambiguously reveal the presence of carbon black and an organic binder (mastic resin or dammar). We know that there is at least one other case of traces of this type on the front of an altar of Italian origin, kept in Germany.[13]

The various bibliographical sources give little information concerning the paint layer. Oil- or turpentine-based paints were used. Our analyses confirmed Fougeroux de Bondaroy's statement that the red is a madder lacquer and vermilion; the green is a copper resinate; and the white is a lead carbonate.[14]

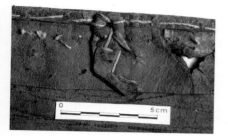

Figure 8. Leather rings for the suspension of the hanging

This type of hanging was normally suspended from leather loops that were sewn to the back of the top squares. We were able to identify this type of system on the edges of the hanging (Figure 8).[15] The hanging therefore had the means to be suspended, and this type of presentation had to be considered in order to preserve a certain historical veracity. Despite certain drawbacks, it therefore seemed preferable to back the hanging completely. Prior to doing so, all the visible marks on the back of the leather were carefully drawn and photographs taken with an infrared filter.

Historical references

It is not easy to analyze the hangings now in Lunéville from a strictly stylistic standpoint. They are traditionally attributed to the 17th-century French school. But, as will be stated below, there is every reason to believe they were made elsewhere, by second-rate artists or by craftsmen who probably copied a model distributed in the form of an engraving. Fougeroux de Bondaroy (1762) indeed states that 'highly skilled painters' are not used for this kind of work.

The Lunéville hangings can be linked to a gilt leather wall hanging in Dunster Castle in Somerset, England, and to a second hanging from Walsingham Abbey in Norfolk, England. These three hangings all have ornamental borders. Moreover, their composition, the way they have been painted and the themes are all very similar. The hanging in Dunster Castle, which is known to have hung there since the early 18th century, consists of a series of six panels showing the history of Antony and Cleopatra (Maxwell 1909, Waterer 1967 and 1971, Thornton 1978, Dodd 1979). The hanging from Walsingham Abbey, which was sold in 1916 and resold in 1939, shows the history of Esther and Ahasuerus (Cubitt 1916, Jervis 1989, Wells-Cole 1997).

The scenes on the Walsingham Abbey hanging are based on a series of engravings made by Philips Galle (1537–1612) after designs by Maarten van Heemskerk (1498–1574) from 1564. The scenes of the other two hangings were probably also copied from engravings, but these print sources have not yet been traced. Without any doubt, these hangings were all made in the second or the third quarter of the 17th century. They can be ascribed to the southern Netherlands and might have been painted by the painter Godefroid Allart (active 1647–1671). He is known to have designed and painted hangings for several gilt leather makers in Brussels, among whom were Martin Sotteau (active 1638–1647) and François Ysenbaudt (active 1671) (Duverger 1981).

This region of manufacturing is confirmed by the physical appearance of the figures, in particular the rather heavy features of the young women that recall the Antwerp school and the importance given to the still life elements in the foreground, which are very realistic.

These three hangings belong to a much larger group of gilt leather hangings, all painted with large scenes and human figures covering the full height and width of the walls. At present, 24 hangings are known, scattered across nine countries, made in several different workshops, and dating from the 16th to the 18th centuries.[16] Unfortunately, none of these hangings is documented by archival references or otherwise.

Conclusion

We feel that a systematic in-depth study of the technical aspects (such as the type of skin, stitching, gluing, repairs and punches) and further physico-chemical analyses (of the glues, varnishes, pigments and binding media) could provide important insights into the manufacturing processes and on the habits of the craftsmen behind these hangings. Indeed, in the absence of any signature or maker's stamp, it may be possible to see the mark of individual workshops in all these technical details. It would then no doubt be possible to group together certain hangings and perhaps to date them.

In any case, the restoration of this exceptional work has brought new information to light, which we documented to help provide a better understanding of the production of gilt leather in the 17th century.

Acknowledgements

The authors wish to thank Jean-Pierre Fournet and Georges Renoud-Grappin for the invaluable information they provided.

Notes

1 With regard to the theme represented here, there are many different references to the story of the Queen of Sheba up to the time of the Renaissance. (Chastel 1978, Deuber Ziegler 2001)

2 In a letter dated July 20, 1973, Abbé Choux, then curator of the Musée Lorrain in Nancy, stated that five pieces of gilt leather, *David Victorious, The Battle of Gilboa, David Playing the Harp Before Saul,* and *David Composing the Psalms* and a final piece not described, had been offered to the Musée Lorrain in Nancy in 1909 by an antique dealer named Privet of 2 rue Verrerie, Dijon (in return for 25,000 francs). It so happens that Comte de Malartic, the owner of Sancé Castle, resided in rue Jeannin, Dijon (*Annuaire des châteaux* 1906-1907).

3 Georges Renoud-Grappin told us that the work was badly damaged and had been slashed with lances by, according to him, the Cossacks in 1815.

4 The Malartic family originally came from southwestern France, in particular the Montauban area, but in September 1768, Jean Vincent Anne de Malartic (born in Montauban in 1739) married Jeanne Dorothée de Baillivy de Mérigny in Nancy.

5 The two works were auctioned on June 9, 1973 in Mâcon, going for 13,713.75 francs each (27,427.50 francs).

6 This sale was prescribed by Louis XV's Controller General of Finances in July 1766, but there was no inventory of the items sold at the time (personal information from art historian Michel Antoine).

7 Paris, Archives nationales, KK 1130, f° 64. This inventory was published in Paris by A. Jacquet in 1907 (*Le mobilier, les objets d'art des châteaux du roi Stanislas*). It should be pointed out that a misreading led to a confusion between the word *pièce* (indicating the number of leather squares forming the wall hanging) and the word *pied* (unit of measurement). In this respect, see also the correspondence of Abbé Choux, curator of the Musée Lorrain in Nancy, from 1973 to 1977 (Lunéville, accompanying file).

8 The physico-chemical analyses were performed in 1999 and 2000 by the Centre national d'évaluation de photoprotection in Clermond-Ferrand.

9 It is not embossed, but only painted and punched.

10 Tooling is generally done with a hot iron while the leather is damp (Blondel 1886).

11 The paint that can be seen nowadays covering the stitching is probably due to the hanging having been taken apart at least once in the past: after the squares had been separated, their edges were cut so that they could be stitched back together. This is confirmed by the fact that the design does not match up, as can be seen in the Queen's belt, in the ermine of Solomon's cloak and so forth.

12 Analysis performed at the Centre de recherche pour la conservation des documents graphiques, Paris, on August 31, 1987.

13 Personal letter dated December 6, 2000 from K. Meise, Cologne. It was done with iron gallic ink.

14 The colours were analyzed in 1991 by the Laboratoire de recherche des Musées de France, Paris.

15 Several other examples of similar leather loops have been preserved, on, among others, several hangings in Skokloster Castle in Sweden (Koldeweij 1998: 227).

16 The other 21 hangings are in Denmark (Gammel Estrup House), England (Knowsley House, Lancashire), France (Musée National de la Renaissance, Ecouen, two series, Musée Masséna, Nice, Hôtel Lambert, Paris private collection), Austria (Österreichisches Museum für Angewandte Kunst, Vienna), Germany (Moritzburg Castle, two series, Velen Castle, Deutsches Ledermuseum, Offenbach am Main, Deutsches Tapetenmuseum, Kassel), Italy (Banca di Roma, Rome), The Netherlands (Het Loo Palace, Apeldoorn), Spain (Palacio del Viana, Cordoba), Sweden (Royal Palace, Stockholm, Drottningholm Royal Palace, Nordiska Museet, Stockholm, Stora Sundby House). Lastly, it should be pointed out that Caen museum in France possesses several pieces of decorative border of a very similar style to that of the Lunéville piece.

References

Blondel, S, 1886, 'Les Cuirs Dorés' *La Gazette des Beaux-Arts* 34, 226–238.

Bonnot-Diconne, C, Coural, N, and Fabre, M, 2001, 'La restauration d'une tenture en cuir peint du Musée de Lunéville' *Techne* 13–14, 141–149.

Chastel, A, 1978, *Fables, formes, figures*, Paris, (1939 article republished in 1978).

Clouzot, H, 1925, 'Cuirs décorés' *Librairie des Arts Décoratifs Tome II*, Paris.

Cubitt, G, 1916, Walsingham Abbey, Norfolk, auction at the mansion, September 25–28, 1916, no. 661, Sotheby's, London, July 14, 1939, no. 116.

Deuber Ziegler, E, 2001, 'Métamorphoses de la Reine de Saba dans l'Occident chrétien du Moyen-Age', Iconographic commentary, Exhibition on the Queen of Sheba, May 18 to June 28, 2001, Musée d'Ethnographie, Geneva.

Diderot, D, and le Rond d'Alembert, J, 1776, *L'Encyclopédie, Supplément, Tome II*, Amsterdam, 735–737.

Dodd, D, 1979–1990, *Dunster Castle*, Somerset, London, 20–25.

Duverger, E, 1981, 'Godefroid Allart, een 17de eeuws Brussels patroonschilder voor de goudleermakers' *Artes Textiles* 10, 298–302.

Erlande-Brandenburg, A, and Guichard, R, 1982, 'Une expérience de restauration à la Bibliothèque Nationale' *Revue de la Bibliothèque Nationale* 4, June, Paris, 33–39.

Fougeroux de Bondaroy, M, 1762, *Arts de Travailler les Cuirs Dorés et Argentés*, Paris.

Glass, H, 1991, *Ledertapeten*, Essen.

Havard, H, 1909, *Dictionnaire de l'Ameublement et de la Décoration depuis le XIIIè s. à nos jours*, Paris, 1054–1064.

'Historique et description: la tenture de cuir peint des héros romains d'après Goltzius. Techniques utilisées' *Revue de la Bibiothèque Nationale* 2, Paris, 35.

Jervis, S, 1989, 'Leather Hangings' *Furniture History Society's Newsletter* 93, 8–9.

Koldeweij, E F, 1989, 'Some pieces of gilt leather, which have been made in the Netherlands' *Internationale Leder- und Pergamenttagung, ICOM working-group on leathercraft and related objects, Offenbach am Main, Deutsches Leder- und Schuhmuseum, May 8–12, 1989*, Offenbach am Main. 162–170.

Koldeweij, E F, 1992. 'How Spanish is "Spanish Leather"? Conservation of the Iberian and Latin American Cultural Heritage' in H W M Hodges, J S Mills, and P Smith (eds.), *Preprints of the Contributions to the Madrid Congress*, London, 84–88.

Koldeweij, E F, 1998, *Goudleer in de Republiek des Zeven Verenigde Provinciën. Nationale ontwikkelingen en de Europese context*, Amsterdam/Leiden, 5 volumes (unpublished thesis, Leiden University).

Maxwell Lyte, H C, 1909, *A history of Dunster and of the families of Mohun and Luttrel*, London, 371–375.

Thornton, P, 1978, *Seventeenth Century Interior Decoration in England, France and Holland*, London, 118, 361 note 14, pl. 105.

Waterer, J, W, 1967, 'Dunster Castle, Somerset and its painted leather hangings' *The Connoisseur* 164 (March), 142–147.

Waterer, J W, 1971. *Spanish Leather, A history of its use from 800 to 1800*, London.

Wells-Cole, A, 1997, *Art and decoration in Elizabethan and Jacobean England: The influence of continental prints, 1558-1625*, New Haven & London, 97–98, 298, pl. 127.

Conservation procedure based on methodical research to remove an alkyd varnish from a gilt leather wall-hanging

Pieter Hallebeek,★ Matthijs de Keijzer
Netherlands Institute for Cultural Heritage
Conservation Science Department
Gabriël Metsustraat 8
1071 EA Amsterdam, The Netherlands
Fax: +20 3054700
E-mail: Peter.Hallebeek@icn.nl, Matthijs.de.Keijzer@icn.nl

Nathalie Baeschlin
Kunstmuseum Bern
Bern, Switzerland

Abstract

A gilt leather wall-hanging, dated 1680 and restored in 1924, is covered with a thick, glossy varnish. A research programme was set up to study the possibility of removing the varnish. The varnish was identified as a linseed alkyd resin. Tests were performed to remove the varnish. Taking into account the large surface to be treated, the best way to remove the alkyd resin proved to be the strappo method with Scotch tape, after softening the resin. Before and after the treatments, samples were taken to study possible effects on the surface layers.

Keywords

gilt leather, 17th century, alkyd varnish, laser cleaning, air abrasive, strappo method

History

The original design is that of a room with gilt leather wall-hangings and decorative wooden interior parts in a 17th-century house at Dordrecht, The Netherlands. In 1923–1924, the wall hangings had been restored and installed in a private house. In 1989, Dr. Eloy Koldeweij rediscovered them. The owner of the house stated, in his will, that the interior had to be included in a public collection. The Simon van Gijn Museum at Dordrecht decided to build a special style room. In 2000 and 2001, the gilt leather panels were restored by the Stichting Restauratie Atelier Limburg in Maastricht and in September 2001 the style room with the restored panels was officially opened.

Dimensions, condition and construction

The wall-hangings measure 44 m^2 and are composed of rectangular leather panels. The total height is 301.5 cm. Each separate panel measures 82.5 x 66.5 cm and has a thickness of approximately 3 mm. The decoration is a traditional flower motive and the pattern is deeply embossed. The outer edges of the hanging would most likely have been nailed to the wall. The original decorative surface is in good condition considering its age and history.

Restoration in 1924

The wall-hanging was restored by a man named Mensing, a well-known restorer and manufacturer of new gilt leather at that time. The restoration is documented by means of a paper attached at the back of one of the panels. Mentioned are:

- filling in missing parts with new leather
- sewing of the panels
- treatment of the surface with a mixture of wax and lavender oil.

During the restoration the upper edges and many of the side edges of the panels were replaced with new leather, which was not so deeply embossed. The flesh side of the leather panels is covered with a thin black paper lining, to which a medium weight canvas is adhered. Mensing decided to restitch the leather panels, not using any of the original seams but making new seams, which incorporated the linings to give the new sewing additional strength. In making the new seams the panels were reduced in size.

Varnish

The total leather surface and the decorative wooden interior had been covered at some point with a transparent, colourless layer of a glossy varnish, which appears

★Author to whom correspondence should be addressed

to have been rudely applied. This coating also lies over the areas restored by Mensing and is likely to have been applied once the panels were reinstalled in their last location. The application of the varnish has given the panels an unnaturally bright appearance and has diminished the subtle differences in colour tones.

Questions

Many problems had to be solved before the panels are to be reinstalled.

- Given the condition of the seams, how will a new backing material be applied?
- How will the hangings be attached to the walls?
- How will we conserve original and restoration leather?
- How will we remove the varnish or, if this is not possible, how will we diminish the shine?
- How do we treat the original paint.

This paper deals only with the test programme set up for the removal of the varnish and the results of the tests.

Scientific examination

Microscopy before the tests

Cross-sections of samples from the surface layers taken before the tests show the following structure from bottom to top:

- metal foil: silver, 2 to 3 mm thickness (XRF)
- varnish on metal foil: mixture of colophony and drying oil (GC/MS)
- paint layer: one layer, white lead and coarse pale grains of smalt with linseed oil as binding medium (XRD and GC/MS) (the smalt at the surface is discoloured into a yellowish white tone)
- thin brownish layer: only beeswax is identified (GC/MS); although the lavender oil mentioned by Mensing is not found back, this layer is suspected to be the remainder of the 1924 conservation treatment (lavender oil is a volatile essential oil and evaporates quickly)
- red decorative stripes: one layer of cochineal with linseed oil (HPLC and GC/MS)
- green leaves: copper resinate (FTIR)
- varnish top layer: linseed alkyd resin (GC/MS), which was developed in 1927 by H. Kienle (General Electric); it came into general use quite a few years later and so this varnish cannot have been applied in 1924 but must be of later date.

Tests for the removal of the alkyd varnish

We are dealing with a layer of alkyd varnish on oil paint on a leather substrate. On the treatment of this specific problem no literature is available. One reference cited deals with the removal of an alkyd varnish from a wall-painting (Rajer 1991). This is one of the reasons why experimental methods are present in the tests. An important factor in finding a suitable method to remove the varnish is the fact that a total surface of 44 m² and an additional 10 m² of polychrome woodwork is to be treated. The effects of different tests on the original paint are studied by the evaluation of cross sections from samples taken before and after treatment.

Mechanical tests

The alkyd film is still quite elastic and flexible. Mechanical methods for removal are usually successful on hard and brittle materials (Phenix et al. 1997). One additional important factor is the strength of the bond between the varnish and the paint. The general impression is that the varnish is not attached to the paint very firmly. This is the reason for including mechanical methods in the test programme.

Methods

1. Scalpel
2. Strappo technique
3. UV Laser
4. External heat and cooling
5. Air abrasive

Chemical tests

6. Organic solvents as gel

Dummies

Dummies were made of pieces of 17th-century gilt leather, varnished with two different types of alkyd resin and artificially aged, in order to evaluate the effects of the different treatments on the original paint layers.

The varnished fragments are artificially altered with dry heat and UV radiation: alternately 11 days in a stove at 35°C, five days in a Xenotest with increasing RH (40% to 60%) at 26°C, and five days in a Suntest at constant RH (55%) and 23°C.

Results

1. Scalpel

APPLICATION
A scalpel was used to lift a loose end of the varnish. It was possible to pick up the varnish with tweezers and to remove a piece of the coating by pulling softly.

RESULT
The test with the scalpel was not successful on the dummies; the varnish was connected firmly to the paint and it was not possible to cut and lift the varnish without damaging the paint. On the actual object the result was quite different. It was possible to remove the varnish without damaging the original paint. The weak connection between varnish and paint was due to the presence of a layer consisting of a mixture of lavender oil and wax resulting from the 1924 conservation, which was not removed before application of the varnish.

2. Strappo technique (Mora et al. 1984)

APPLICATION
On the varnish a strip of thin tape (crepe band or sellotape) with a length of 30 cm was attached so that it followed the curved surface closely, especially in the deeper parts. With the rounded side of a paper knife the tape was attached to the varnish with very little pressure to get a better adhesion. At the same time the pressure loosened the connection between the varnish and the paint. It was important to find out how much pressure may be applied without damaging the original paint. When the strip was adhered to the varnish it was possible to take off the strip and varnish under a very low angle. During removal of the strip one must continuously check the attachment of the strip to the varnish.

RESULT
The test with the strappo technique was not successful on the dummies. The tests on the actual object show different results. Due to the weak connection between varnish and paint it was possible to remove the varnish with the strappo technique without damage to the original paint. After removal of the varnish the original shine of the paint was restored, the very shiny panels were duller and the dull panels had more shine. The method worked directly on the discoloured blue parts. On the green and golden parts, and at some isolated, already damaged places, the connection of the varnish to the paint was stronger. In that case the strip loosened from the varnish and the varnish stayed in place. It is advisable to soften the varnish

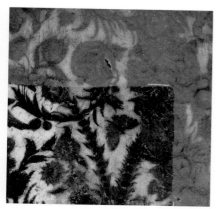

Figure 1. Partly removal of varnish with strappo (UV light, 1')

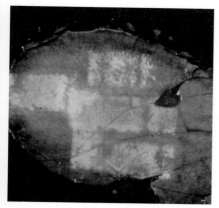

Figure 2. Removal of varnish with laser, inhomogeneous (10')

first for one minute by applying a modified Wolbers gel, originally used for cleaning pictures.

Under UV light the surface, where the varnish was removed, showed that a clean removal without damaging the paint was possible. When sufficient experience was gained, the method was rather time efficient. The technique has been tested on different places on different panels (see Figure 1).

3. Laser (Fotakis et al. 1997)

APPLICATION

The wavelength of the laser beam is 248 nm, in the UV region. The intensity of the laser beam is relatively high in order to be able to use the coupled analytical system LIBS (Laser Induced Breakdown Spectroscopy). The reflected spectrum from the ablated surface was recorded online. In this way it was possible to have a direct analysis of the inorganic compounds of the removed layer. At this moment information on organic compounds is hardly possible. In general, one pulse is able to remove 1 micron of varnish. The test spot was irradiated with the calculated number of pulses and the recorded LIB-Spectra were interpreted and attributed to different layers.

RESULT

The method has been tested on dummies and on the original material. In both cases it was possible to take away subsequent layers of different materials. In practice there are too many unsolved problems to make the method directly applicable for the removal of varnish. Perfect guidance of the laser beam was of utmost importance. The major problem was the small area treated per sequence of shots compared to the total surface of leather and the high relief, which made it very difficult to focus the laser beam continuously. Mainly for this last reason no more tests were performed. Moreover, a lot of experience in reading the spectra and comparison to reference spectra is required. The exact determination of the number of laser pulses needed to remove a layer is obligatory for a good result (see Figure 2).

4. Heating and cooling

APPLICATION

Tests were performed to raise the temperature of the surface with hot, moist air of 70% RH and 30°C, in order to influence the brittleness of the varnish. For this purpose we used also a cooling device after applying tape, so that it was not in direct contact with the painted surface. The temperature was lowered to −40°C for 10 minutes. Other, untested, possibilities include applying a cooling spray or carbon dioxide snow to reach a lower temperature.

RESULT

We did not achieve satisfactory results, either with heating or with cooling the dummies and the original leather. No changes could be observed on the varnish and no further investigations have been made in this respect. We still do not know to what degree the action can be restricted to the varnish, without influencing and changing the properties of the paint.

5. Air abrasive (Boissonas 1987, Meijer 1998)

APPLICATION

The advantage of the method is that a great number of parameters can be adapted, including the material of the particles, form and dimensions of the particles, impact angle, pressure and air–particle mixture. The first attempts attempted to completely remove the varnish. Round glass particles with different diameters were used, from 0–50 microns and from 70–90 microns. Also, we used high-pressure air without particles. The next test attempted, not to remove the layer, but to make it opaque at a pressure of 0.5 bar, a relatively high percentage of particles in the mixture, a low angle of impact and a distance of about 2 or 3 cm.

Figure 3. Removal with air abrasive, craters in varnish and paint damage (10′)

Figure 4. Removal with gel, swelling of varnish and paint (10′)

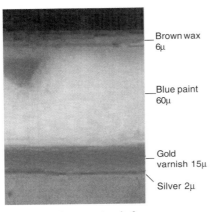

Brown wax 6μ

Blue paint 60μ

Gold varnish 15μ

Silver 2μ

*Figure 5. Cross-section **before** strappo (250′)*

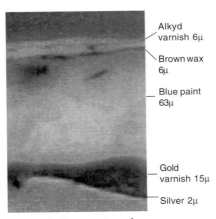

Alkyd varnish 6μ

Brown wax 6μ

Blue paint 63μ

Gold varnish 15μ

Silver 2μ

*Figure 6. Cross-section **after** strappo (250′)*

RESULT

The method has been tested on dummies and on the original material. In both cases with low pressure (roughly 1 or 2 bar) the round glass particles bounced back from the elastic varnish without any penetration. When very high pressure was applied (about 3 or 4 bar) together with a high concentration of particles, the original paint was damaged by particles that removed the varnish but still had energy left. The damage appeared in the form of crater-like holes in the paint. When particles with sharp edges were used, such as walnut shells, much less pressure was needed (about 1 or 2 bar) to penetrate the varnish, but there was still too much damage to the paint. The method can be used with less pressure (about 0.5 to 1 bar) to take the shine away. The application of particles with sharp edges instead of round particles opened the varnish layer and the optical impression changed from shiny to opaque caused by light reflection in all directions (see Figure 3).

6. Chemical methods (Hailer 1994)

During drying of the alkyd resin, oxidation and cross-linking occurs and the varnish becomes insoluble. With organic solvents it is only possible to swell the varnish. Suitable solvents for this purpose are ketones such as acetone or cyclohexanone. These solvents also act as solvents for oils, fats and resins, so they are less suitable for application on resin-oil paints.

APPLICATION

The use of a gel has been advised by R. Wolbers for the removal of alkyd varnish on oil paint (Rajer 1991)[1]. Two layers of gel are applied with a brush. First, a thin layer of gel is applied on the object to fix a sheet of Japan paper, than the second layer, with a thickness of 1.5 mm, is applied over the paper. Both layers should be applied quickly, directly after each other, within one minute. After removal of the Japan paper, the alkyd varnish is no longer transparent, but whitish in colour and swollen.

RESULT

Application of the gel on the dummies with two different alkyd varnishes showed quite different results: the alkyd varnish Talens 007 swelled considerably and shrank, resulting in a skin-like appearance. The film could easily be removed with cotton swabs. Superficial cleaning with white spirits removed the remains. The result was satisfying, except for the fact that a slight swelling of the original paint could be observed. The Flexa alkyd varnish showed a quite different behaviour. No swelling at all happened with the gel. The effect of the original gel recipe with pH of 5.5 was too strong on the actual object; the quantity ethomeen (cocamine, a surfactant) was raised, resulting in a pH of 6.5. The effect was moderate swelling of the alkyd and no swelling of the original paint, but the solvent dissolved the brownish layer of wax. We concluded that this method was too drastic (Figure 4).

Microscopy after the tests

Cross-sections of samples from the paint taken after the tests confirmed the following:

- After execution of the strappo method in all samples only the alkyd varnish was removed. The upper layer became light brown. The soft, transparent mixture of wax and lavender oil was still present (Figures 5 and 6).
- After application of the strappo method, followed by treatment with an organic solvent, the brownish layer was also removed, resulting in a large contrast between the originally light blue, but now almost white, background and the original red, green and gold varnish. Already present, the damage became more clearly visible.
- After the test with the laser beam the alkyd varnish was completely removed and the brownish layer was partially removed, resulting in a greyish bloom on the white background.

Figure 7. Part of gilt leather style room

Conclusion

During the execution of the tests it became apparent that mechanical methods were most promising. The chemical tests with gel and solvents were too difficult to control in penetrating depth. The effects of the tests on the original paint were studied by evaluating cross-sections from samples taken before and after treatment.

The test with the scalpel showed that it is possible to remove the varnish without damage to the original paint. An important drawback of the method is that it is very time consuming and is therefore not practical when there is a total surface of 44 m² of gilt leather to be treated.

The laser test performed quite well in evaporating the alkyd varnish, but in practice it was almost impossible to keep the distance to the surface (and the actual impact time) constant. This was due to the very high relief of the leather. When an automatic device is developed to keep these parameters constant, the method will work quite well.

The air abrasive test has the same drawbacks, but with the right medium the method could work quite quickly. With glass beads too much energy was needed to penetrate the alkyd resin and the round glass particles bounced back from the surface. With sharp-edged walnut shells, much less energy was required and the process was easier to control. The method could be used for diminishing the shine if the varnish is not removed.

The best way to remove the alkyd resin proved to be the strappo method with adhesive tape after softening. The method works quite quickly without any effect on the original paint. After cleaning a test part on an original panel a soft, dark layer became visible which was easily removed using solvents. In this layer the presence of wax was established and the conclusion was that it was the layer applied by Mr. Mensing and described as a mixture of wax and lavender oil. It is because of the presence of this layer that the alkyd varnish has not penetrated the original paint and the leather and is relatively easily removed with the strappo method. Parts where the varnish was attached to the paint too strongly were pre-treated with a gel to soften the varnish.

Additional restoration and conservation

Where after removal of the varnish the connection between original paint layers and leather was too weak, Mowilith DMC2 has been used to attach the loose paint. The darkened layer of wax and original varnish was not removed, in order not to enhance the strong contrast between the discoloured, almost white parts and the darkened green and golden parts. Also, the linen backing has not been removed and is acting as a consolidating layer for the degraded leather parts. The loose parts are glued to the black paper, which was applied with starch on the back of the leather during the 1924 restoration. The holes caused by iron nails, and other larger missing parts, are filled with a mixture of acid-free cotton fibres, starch and Mowilith DMC2. Bigger holes are filled with three layers of acid-free Japan paper (Kozo), in order to reach the level of the leather, and glued with starch. The fillings are painted in with gouache paint and covered with a thin layer of Paraloid B72 in order to get the same degree of reflection from the surface. The panels are individually attached to a wooden frame with Velcro and a stiff, acid-free, paper honeycomb construction is applied as backing, which is glued to the original linen with PVAc (Eukalin 3650) (Figure 7).

Acknowledgements

Thanks to Art Innovation, Almelo, for laser equipment; the ICN Training Department, Amsterdam, for air abrasive; Mr. C. de Bruyn of the Simon van Gijn Museum, Dordrecht, for coordination of the project; and the Mondriaan Foundation, Amsterdam, for financial support.

Note

1 Modified Wolbers gel: 120 ml acetone, 11 gram ethomeen (8 gr.), 30 ml benzyl alcohol, 2 gram carbopol and 50 ml demin. water. pH is 6,5-7,0.

Materials

Ethomeen, acetone, benzyl alcohol and carbopol from Aldrich-Sigma Chemie B.V. Postbox 27, 3330 AA Zwijndrecht, The Netherlands, tel: 0800-0229088, fax: 0800-0229089, e-mail: nlcustsv@eurnotes.sial.com.

Crepe band (Eurocel SICAD Spa or Sellotape)

Cooling device (-8°C, ColdHot™) from 3M Nederland BV, Industrieweg 24, 2382 NW Zoeterwoude, tel.: 071-5450451, fax: 071-5450503.

Glass beads and walnut shells from Dr. G. Kremer, Hauptstrasse 41-47, D- 88317 Aichstetten, Germany, tel.: 49-756591120, fax: 49-75651606.

Laser, UV excimer laser, Lambda Physik COMpex 205, 248 nm and LIBS detection system Oriel MS260i spectrograph, Instaspec V ICCD from Art Innovation B.V. Westermaatsweg 11, 7556 BW Hengelo, The Netherlands, tel. 31-(0)74-2501239, fax. 31-(0)74-2913707, e-mail. info@art-innovation.nl.

References

Boissonas, P B and Percival-Prescott, W, 1987, 'Removal of varnish and glue from painted surfaces using micro-friction', *Preprints of the 8th Triennial Meeting of the ICOM Committee for Conservation*, Paris, International Council of Museums, 137–144.

Fotakis, C, Zafiropulos, V, Demotrios, A, Georgiou, S, Maravelaki, N, Fostiridou, A and Doulgeridis, M, 1997, 'Laser in Art Conservation, The Interface between Science and Conservation', *British Museum Occasional Paper* 16, The British Museum, 83–90.

Hailer, U, 1994, Herstellung und Anwendung von Lösemittel-Gelen, -Pasten und -Kompressen in der Restaurierung, Diplomarbeit, Institut fur Museumskunde an der Staatlichen Akademie der Bildenden Künste, Stuttgart.

Meijer, S, 1998, Pneumatisch stralen in de Metaalconservering, Een vergelijkend onderzoek naar het effect van drie straalmiddelen: Walnootschalen, glasparels en ureum-formaldehyde, Unpublished, ICN, Training department, Metal section, ICN, Amsterdam.

Mora, P, Mora, L and Philippot, P, 1984, *Conservation of Wall Paintings ICCROM*, Butterworth, 257–261.

Phenix, A, Gottschaller, P and Burnstock, A, 1997, 'Accelerated Ageing of Polymer Dispersion Consolidants, Preprints of Consolidants and Conservation Methods', *XIV Kongress Nordisk Konservatorbund* 20-23.4.1997, NFK-N, Oslo, 99–113.

Rajer, A and Kartheiser, M, 1991, 'Art by the Acre: A Comprehensive Approach to the Removal of Aged Alkyd Resin on Murals at the Wisconsin State Capitol', *Postprints*, AIC Paintings Specialty Group, Albuquerque, New Mexico, 37–38.

Résumé

Le but de cette étude est de mettre au point une microméthode de quantification des matières grasses extractibles d'un cuir, afin de remplacer la méthode gravimétrique. Les techniques utilisées sont les chromatographies en phase liquide (CPL) et en phase gazeuse (CPG). La sélectivité des méthodes d'hydroxamation et de détection utilisées en CPL nous permet de limiter les perturbations qui pourraient être provoquées par des composés autres que les triglycérides. Toutefois, la sensibilité est moins bonne qu'en CPG, qui est par contre une méthode moins sélective. La comparaison des deux méthodes nous a donc paru intéressante. Elles ont été testées sur des huiles de pied de bœuf et de foie de morue, puis sur des cuirs moderne et ancien.

Mots-clés

cuir, graisse, extraction

Evaluation de la quantité de matières grasses extractibles d'un cuir ancien

Frédérique Juchauld★, Claire Chahine, Sylvie Thao
CRCDG
36, rue Geoffroy-Saint-Hilaire
75005 Paris, France
Fax : 01 47 07 62 95
Courriel : crcdg@mnhn.fr
Site Web : http//www.crcdg.culture.fr

Introduction

Le corroyage est une étape importante dans la fabrication du cuir, auquel il communique la souplesse nécessaire à son utilisation. Dans le passé, les lubrifiants utilisés étaient des graisses et des huiles ; ces composés constitueront le sujet de cette étude. De nos jours, les fabricants ajoutent aussi, notamment, des émulsionnants et des matières grasses synthétiques. Tous ces produits présentent la même capacité à former un film entre les fibres de collagène.

En vieillissant, les matières grasses se dégradent pour former notamment des acides gras libres, des hydrocarbures, des aldéhydes, des alcools et des polymères qui se fixent sur le collagène, perdant ainsi leur propriété lubrifiante, ou quittent la structure (repousses grasses). Lors de la restauration d'objets anciens, il est important de connaître le taux résiduel de matières lubrifiantes extractibles, car il en représente la fraction efficiente, et de ce résultat dépend la décision d'un traitement de lubrification. En effet, il peut être intéressant, surtout pour les objets « d'usage », de faire un apport régulier de nourriture afin de maintenir un certain pourcentage de lubrifiant qui assurera la bonne conservation des propriétés mécaniques, sans toutefois saturer le cuir inutilement car les lubrifiants et leurs produits de dégradation peuvent aussi engendrer des détériorations de la structure. La méthode classique de quantification des graisses, qui consiste à faire une estimation gravimétrique après extraction à l'aide d'un solvant organique, nécessite une prise d'essai importante. Nous avons donc cherché à mettre au point une méthode adaptée à de petits prélèvements.

Une méthode en CPG-SM a récemment été proposée par Van Bos *et al* (1996). Elle a été mise au point avec des préparations grasses connues et extraites d'un cuir. Cette analyse permet une évaluation qualitative et quantitative des lubrifiants extraits. Dans un but de simplification, et surtout pour mettre l'accent sur l'aspect quantitatif et pour appliquer cette analyse à toutes sortes de graisses, voire de mélanges, nous avons tenté de développer une méthode basée sur la quantification individuelle des acides gras qui, par addition, permettrait d'estimer la masse totale de matière grasse. Nous pourrions ainsi nous affranchir de l'identification préalable des lubrifiants eux-mêmes et nous ne serions pas gênés par les éventuels mélanges de matières grasses utilisées initialement ou en cours de restauration. Le résultat sera donc exprimé en pourcentage de matières grasses dans le cuir, sans identification de leur nature. Nous avons pour cela choisi d'utiliser les techniques chromatographiques en phase liquide et gazeuse, car ces méthodes permettent de travailler sur de très faibles quantités, et elles sont plus sélectives.

Matériel et méthodes

Les mises au point des méthodes ont été effectuées sur des échantillons d'huiles de pied de bœuf et de foie de morue. Les méthodes ont ensuite été appliquées aux matières extractibles d'un cuir de veau de fabrication moderne lubrifié avec un mélange de nourriture connu, et à un échantillon de reliure ancienne dont le traitement nous était inconnu.

★Auteur auquel la correspondance doit être addressée

Extraction des graisses du cuir

EXTRACTION AU SOXHLET

Nous avons adapté le mode opératoire décrit dans la norme française de quantification des matières extractibles AFNOR G52204, en diminuant la taille de l'échantillon et en remplaçant l'hexane par le cyclohexane, moins toxique.

Un échantillon de cuir d'environ 1 g découpé en petits morceaux est placé dans une cartouche d'extraction en cellulose. On procède à l'extraction au Soxhlet sous reflux de cyclohexane pendant 24 heures. Le solvant est ensuite évaporé et la masse de matière sèche est estimée par pesée. Pour la chromatographie, la prise d'essai est abaissée à 20 mg.

MACÉRATION

Nous avons repris une méthode citée par Poré (1968). Nous faisons macérer 20 mg de cuir découpé en petits morceaux dans du cyclohexane en chauffant sous agitation pendant 24 heures. La prise d'essai est ensuite séchée puis traitée pour les analyses ultérieures.

Analyse par chromatographie

MÉTHODE DE CHROMATOGRAPHIE LIQUIDE

Nous avons appliqué la méthode de dérivation mise au point par Gutnikov (1991), car elle est réputée simple et rapide. Il s'agit de transformer en acides hydroxamiques les acides gras constituant les triglycérides de la matière grasse à analyser.

Le mode opératoire de Gutnikov a été modifié afin d'améliorer la détection dans le cas des faibles concentrations ; en effet, les acides hydroxamiques présentent une absorption peu élevée en ultraviolets. Pour cette raison, nous avons diminué autant que possible la quantité de solvants ajoutés lors de la réaction. Toutefois, il ne faut pas concentrer à l'excès les solutions injectées, car des phénomènes de déformation des pics peuvent alors gêner la séparation. Les dérivations ont été effectuées en ajoutant à la prise d'essai 200 µl d'éther méthylique du tert-butanol, 75 µl de perchlorate d'hydroxylammonium 1,5 M, et 75 µl de solution de méthoxyde de sodium à 30 %. On laisse agir 2 minutes tout en agitant, puis on ajoute 200 µl de solution de méthanol et d'acide acétique glacial (v/v, 50/50), afin de stopper la réaction. La solution est ensuite filtrée avant injection.

Le système chromatographique est composé d'une pompe binaire Beckman et d'une colonne Nucléosil C18 avec des particules de 5 µm. Sa température est régulée à 40 °C. La boucle d'injection est de 20 µl. La détection s'effectue à 213 nm avec un détecteur UV à barrette de diodes.

L'éluant A est une solution tampon phosphate 20 mM ajustée à pH 3 avec de l'acide phosphorique, et mélangée à 70 % de méthanol ; on a ajouté du nitrate de sodium à la solution tampon afin de faire correspondre son absorbance à celle du méthanol. L'éluant B est du méthanol pur. Le gradient d'élution s'effectue de 15 % à 90 % de B en 45 minutes.

Les acides gras ne pouvant pas être directement transformés en acides hydroxamiques, l'étalonnage a été effectué en utilisant les esters méthyliques des acides gras. L'étalon interne est le nonadécanoate. Les esters ont été mis en solution dans du propanol avant dérivation (voir la liste des acides gras en annexe).

Notre échantillonnage en étalons n'est pas exhaustif, mais nous pouvons évaluer la structure d'un acide gras en fonction de son temps de rétention (nombre d'atomes de carbone et niveau d'insaturation). Quelques essais en chromatographie liquide couplée à la spectrométrie de masse (CPL-SM) effectués au CRCDG par Karim Dif, que nous remercions, ont montré que certains doutes relatifs à l'identification peuvent aussi être levés grâce à cette technique.

Pour pouvoir quantifier, nous avons recherché une éventuelle corrélation entre les structures des acides gras et leur « facteur de réponse ».

$$\text{Facteur de réponse} = \frac{\text{concentration de l'échantillon}}{\text{concentration de l'étalon interne}} \times \frac{\text{surface du pic de l'étalon interne}}{\text{surface du pic de l'échantillon}}$$

D'après la figure 1, nous pouvons émettre l'hypothèse que les facteurs de réponse diminuent en fonction du nombre d'insaturation. Pour une même surface de pic, la quantité sera donc d'autant plus faible que l'insaturation sera élevée. Les temps de rétention des acides gras à chaîne carbonée saturée étant connus, si nous avons des pics inconnus dans notre chromatogramme, ce sont exclusivement des acides gras insaturés. Les équations des courbes de tendance semblent être des fonctions polynomiales du premier ou du second degré. Par extrapolation, elles nous permettent d'estimer le facteur de réponse d'un acide gras non étalonné.

Dans la mesure où c'est possible, les acides gras sont calibrés avec des étalons réels, car l'erreur sur l'estimation des facteurs de réponse est relativement élevée.

Mᴇ́ᴛʜᴏᴅᴇ ᴅᴇ CPG

Les méthodes d'analyse des acides gras par CPG sont très courantes ; elles sont généralement basées sur la détection des esters méthyliques après transestérification des triglycérides de la matière grasse.

Transestérification : On ajoute 1 ml d'acide chlorhydrique méthanolique à l'échantillon de matière grasse et on chauffe pendant 1 heure à 80 °C. Après refroidissement, la réaction est stoppée avec du chlorure de sodium. Les esters sont ensuite extraits de la matrice à l'aide de l'hexane, auquel on ajoute du sulfate de sodium afin de piéger l'eau ; la solution est ensuite filtrée et injectée.

Séparation chromatographique : le chromatographe est un Hewlett Packard équipé d'une colonne CPsil 8 en « split » total. L'injecteur a été réglé à 250 °C et le détecteur à 300 °C. Après un palier de 5 minutes à 80 °C, la température suit une rampe de 80 à 300 °C à raison de 5 °C/minute, puis on effectue un palier de 20 minutes à 300 °C. La quantité injectée est de 1 µl.

Etalonnage : il a été effectué en utilisant directement des solutions d'esters méthyliques d'acides gras, préparées au laboratoire dans du propanol.

Résultats et analyse

Nos méthodes ont dans un premier temps été appliquées à deux huiles. Ces produits étant composés presque exclusivement de matière grasse, il nous paraissait plus aisé de vérifier la corrélation entre les pesées et les estimations effectuées grâce aux étalonnages de chaque acide gras.

Huile de pied de bœuf

L'huile de pied de bœuf est un lubrifiant qui a été très employé dans le passé ; il était donc particulièrement intéressant de l'étudier. L'huile que nous avons analysée présentait une répartition limitée à quelques acides gras qui ont été facilement identifiés.

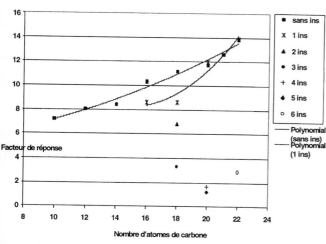

Figure 1 : Facteurs de réponse en fonction de la structure de l'acide gras

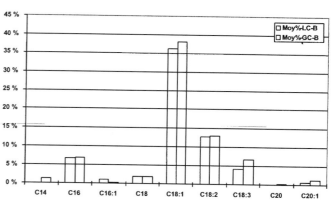

Figure 2 : Pourcentages des acides gras détectés dans l'huile de pied de bœuf, par CPL et par CPG

Dans la figure 2, nous avons réuni les deux répartitions obtenues en faisant la moyenne des pourcentages d'acides gras détectés à l'aide de chacune des deux méthodes, la CPL et la CPG, dans une série d'échantillons de masses variables.

Si nous comparons les résultats, nous constatons que les profils obtenus à l'aide des deux méthodes sont relativement semblables. C14 et C16:1 présentent quelques variations attribuables au fait que ces deux acides gras sont présents en faible quantité ; or l'erreur est toujours plus élevée aux extrémités des courbes d'étalonnage.

Le pourcentage moyen de la masse détectée par rapport à la masse pesée est d'environ 75 % en CPL et en CPG, mais cette seconde méthode a produit des variations beaucoup plus élevées.

Huile de foie de morue

Lors de l'application de la méthode de CPL à l'huile de foie de morue, nous avons rencontré quelques difficultés :

- L'identification des acides gras est plus complexe car ils sont plus variés que dans l'huile de pied de bœuf.
- Le nombre élevé de pics rend impossible l'obtention d'une résolution correcte. Une mauvaise séparation, voire la coélution, rend difficile la quantification de chaque acide gras. Comme nous l'avons exposé précédemment, nous ne pouvons pas faire une estimation globale étant donné la variation des facteurs de rétention.
- L'acide gras C22:2 pose un problème particulier car il coélue avec l'étalon interne, ce qui rend sa quantification impossible. D'autre part, quand il est présent, il augmente l'estimation de la quantité d'étalon interne, et toutes les valeurs des autres acides gras s'en trouvent diminuées.
- Du fait de la faible sensibilité des dérivés, le seuil de détection minimum est relativement vite atteint.

Dans la méthode de CPG :

- La résolution est meilleure. Les temps de rétention des acides gras saturés sont proportionnels au nombre d'atomes de carbone, mais les insaturations font légèrement varier ces temps de rétention. Contrairement à la CPL, la CPG ne permet pas d'identifier les pics sans les références.
- La meilleure séparation, comparée aux résultats obtenus en CPL, n'exclut pas les problèmes de coélutions ni de pics parasites.
- La sensibilité est supérieure à celle de la CPL, mais pour la quantification, nous n'avons pas pu établir une relation qui permettrait de lier la structure des acides gras et leur facteur de réponse.
- Nous avons des problèmes de reproductibilité qui sont peut-être dus à la multiplication des manipulations lors de l'estérification.

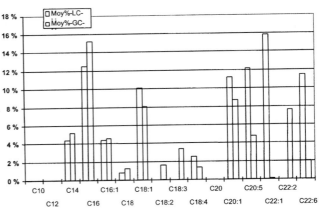

Figure 3 : Pourcentages des acides gras détectés dans l'huile de foie de morue, par CPL et par CPG

Pour pallier le problème de l'estimation des pics d'acides gras que nous n'avons pas pu étalonner, nous avons utilisé en CPL l'évaluation mathématique de leur facteur de réponse en fonction de leur structure (voir ci-dessus le paragraphe « méthode de chromatographie liquide »). En CPG, nous avons utilisé le plus petit facteur de réponse parmi ceux des étalons que nous avons étudiés. Les résultats sont indiqués dans la figure 3.

Les déficits observés pour les pics C18:2 et C18:3 en CPL sont dus à la mauvaise séparation de ces acides gras à l'aide de cette méthode. Comme nous ne pouvions pas les quantifier indépendamment, nous avons choisi de quantifier la surface totale comme s'il s'agissait d'un seul acide gras (le facteur de réponse utilisé est le plus petit parmi ceux des deux acides gras concernés). Si on associait de la même façon en CPG les pics C18:2 avec C20:5 et C18:3 avec C22 :6, on retrouverait l'équilibre des pourcentages entre la CPL et la CPG. Pour les pics C22:1 et C22:2, dont les quantités sont inversées dans chacune des méthodes, des vérifications sont en cours.

Les résultats obtenus en CPL nous permettent de recouvrer environ 85 % de la matière pesée, et 65 % en CPG, avec des problèmes de reproductibilité.

Cuir de veau moderne

Nous avons utilisé un cuir dont nous connaissions la composition du produit de nourriture (moitié huile de foie de morue, moitié émulsionnants). La mesure gravimétrique indique la présence de 3,75 % de matières grasses extractibles au cyclohexane.

Après extraction au Soxhlet, on observe, comme le montre la figure 4, des résultats communs aux deux méthodes mais aussi quelques différences. Certaines sont dues en partie aux problèmes de séparation en CPL, notamment pour les pics C18:2 et C22:6, d'autres aux problèmes d'identification en CPG, comme pour le C10 et le C22:2.

La comparaison de la répartition des acides gras analysés dans l'extrait de ce cuir et dans l'huile de foie de morue nous permet de reconnaître la présence majoritaire de cette matière grasse.

Les résultats obtenus après extraction au Soxhlet et grâce aux deux méthodes d'analyse indiquent que ce cuir contient environ 2,5 % de matière grasse, soit 70 % de la valeur estimée par gravimétrie.

Cependant, nous observons aussi une importante fluctuation des résultats. Ce problème est en partie dû à la mauvaise reproductibilité de la méthode d'extraction sur des quantités aussi petites de cuir. Nous avons donc testé une méthode d'extraction par macération. Les premiers essais ont été effectués à 40-50 °C, dans 4 ml de cyclohexane. La cohérence des résultats entre les méthodes d'extraction au Soxhlet et par macération, est vérifiée par comparaison des profils chromatographiques présentés à la figure 5.

Malgré des différences qui sont dues aux problèmes de séparation entre les acides gras C18:2 et C18:3 d'une part, et C22:6 et C20:5 d'autre part, nous pouvons

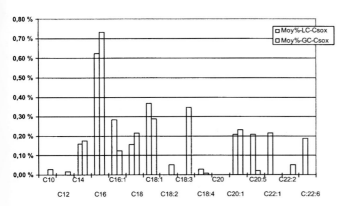

Figure 4 : Pourcentages des acides gras détectés dans l'extrait du cuir de veau moderne, par CPL et par CPG

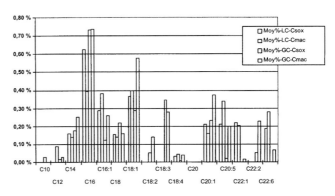

Figure 5 : Pourcentages des acides gras contenus dans les extraits du cuir de veau moderne, obtenus par extraction au Soxhlet et par macération, et analysés par CPL et par CPG

Tableau 1 : Pourcentages de matière grasse extraite du cuir de veau moderne en fonction des différents paramètres d'extraction par macération

Température	Quantité de cyclohexane	Essai n°1	Essai n°2	Essai n°3
40-50 °C	4 ml	2,95 %	2,21 %	2,56 %
40-50 °C	8 ml	3,36 %	3,33 %	
70 °C	4 ml	3,04 %	3,45 %	
70 °C	8 ml	4,11 %		

estimer que les répartitions en acides gras obtenues à l'aide des deux méthodes d'extraction sont sensiblement équivalentes.

Les pourcentages de matière grasse totale étant inférieurs aux valeurs gravimétriques, nous avons réalisé quelques essais afin d'optimiser les paramètres de la macération, notamment en faisant varier la température et la quantité de solvant.

Le tableau 1 présente les pourcentages totaux de graisse extraite du cuir en fonction des différents paramètres.

Les résultats indiquent la nécessité d'augmenter la température et la quantité de solvant.

Cuir de reliure ancienne

Le cuir de cette reliure contient 0,9 % de matières grasses, selon la méthode gravimétrique.

Les profils chromatographiques obtenus grâce aux deux méthodes présentent certaines différences : pics n'apparaissant que sur l'un ou l'autre des profils et qui ne sont sans doute que des pics parasites. Les chromatogrammes obtenus en CPL sont difficilement quantifiables car les acides gras sont très variés et en faibles quantités. Dans ce cas, le couplage CPL-SM aurait été indispensable pour identifier les acides gras. Nous nous sommes donc limités à ceux communément identifiés par la CPL et la CPG, c'est-à-dire les acides gras C12, C16, C18 et C18:1. Le principal pic est celui de l'acide palmitique, qui dépasse 40 % de la composition de la graisse extraite.

Si nous calculons nos résultats en ne considérant que ces 4 acides gras, nous obtenons des résultats qui varient entre 0,27 % et 0,34 % après extraction au Soxhlet, ce qui représente environ 30 % de la masse estimée par gravimétrie.

Des essais ont aussi été effectués sur les extraits obtenus par macération dans différentes conditions. Même après optimisation des paramètres de température et de quantité de solvant, nous n'atteignons pas des pourcentages supérieurs à 0,5 %. Dans la figure 6, nous avons regroupé l'ensemble des résultats. Les meilleurs pourcentages sont obtenus en CPL après macération.

Le cuir de reliure utilisé est très endommagé, presque pulvérulent, et l'extraction en a détruit complètement la structure. Les plus grosses particules, qui risqueraient alors d'être mises en suspension, doivent être éliminées par filtration avant

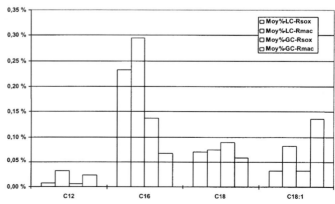

Figure 6 : Pourcentages d'acides gras contenus dans les extraits d'un cuir de reliure, obtenus par extraction au Soxhlet et par macération, et analysés par CPL et par CPG

dérivation. Des essais devront être effectués afin de vérifier l'hypothèse de la présence dans le filtrat d'éléments qui ne seraient pas des matières grasses et qui pourraient entraîner une surestimation de la masse lors de l'estimation gravimétrique.

Conclusion

Les deux méthodes chromatographiques qui ont été testées lors de cette étude offrent chacune des avantages et des inconvénients. En ce qui concerne la CPL, la dérivation est simple et rapide, et elle offre la possibilité de quantifier des pics d'acides gras non étalonnés. Mais la séparation est mauvaise et les dérivés ont une faible sensibilité. La CPG permet une meilleure séparation, ainsi qu'une bonne sensibilité ; cependant, la reproductibilité est moins satisfaisante. Le remplacement de la méthode d'extraction au Soxhlet par la macération est très prometteur du point de vue du rendement et de la facilité d'exécution.

L'application de l'une ou l'autre des méthodes nécessite encore quelques mises au point, mais nous pensons qu'elles pourraient être un excellent outil pour établir le bilan de conservation d'un cuir. Leur utilisation devra cependant être limitée à l'analyse des cuirs anciens qui n'ont été nourris qu'avec des graisses naturelles. Le domaine des cires n'a pas été abordé ici, mais pourrait être envisagé. Par ailleurs, les huiles de nourriture synthétiques n'ont pas été analysées.

Au cours de cette étude, seules quelques analyses en CPL-SM ont pu être réalisées. Elles se sont révélées indispensables afin de garantir l'identification des pics. C'est pourquoi le couplage à la masse est nécessaire, quelle que soit la méthode chromatographique retenue.

Bibliographie

FEIGL, F. *Characteristic functional groups : esters of carboxylic acids. Spot tests in organic analysis*, 7ᵉ édition, Amsterdam (Pays-Bas), Elsevier Science Publishers, 1966.

GUTNIKOV, G., et J.R. STRENG. « Rapid high-performance liquid chromatographic determination of fatty acid profiles of lipids by conversion to their hydroxamic acids », *Journal of chromatography*, 1991, n° 587, p. 292-296.

MORELLE, J. *Chimie et biochimie des lipides, volume I, Classification et structure – distribution – extraction – purification – caractérisation – composants lipidiques*, Paris, Ed. Varia, 1964.

PARA, M.H. *Etude des mécanismes de dégradation de l'huile de pied de bœuf exposée à la chaleur, à la lumière, et à la pollution*, thèse de doctorat en génie, Université Pierre et Marie Curie, Paris 6, 1985.

PORÉ, J. *La nourriture du cuir : Méthodes et principes*, Paris, Société des publications Le cuir, 1974.

SEKAR REDDY, A., M. SURESH KUMAR ET G. RAVINDRA REDDY. « A convenient method for the preparation of hydroxamic acids », *Tetrahedron letters 41*, 2000, p. 6285-6288.

VAN BOS, M., J. WOUTERS et A. OOSTVOGELS. *Quantitative and qualitative determination of extractable fat from vegetable tanned leather by GC-MS. Environment leather project. Deterioration and conservation of vegetable tanned leather*, rapport de recherche n° 6, 1996.

WOLFF, J.P. *Manuel d'analyse des corps gras*, Paris, Ed. Azoulay, 1968.

Fournisseurs

Interchrom, 213, avenue Kennedy, B.P. 1140, 03103 Montluçon, France
Merck-Eurolab, 54, rue Roger-Salengro, 94126 Fontenay-sous-Bois, France
Sigma-Aldrich, L'Isle d'Abeau Chesnes, B.P. 701, 38297 Saint-Quentin-Fallavier, France

Liste des acides gras

Classe	Nom commun	Nomenclature	Remarques
C10	Acide caprique	Acide décanoïque	
C12	Acide laurique	Acide dodécanoïque	
C14	Acide myristique	Acide tétradécanoïque	
C16	Acide palmitique	Acide hexadécanoïque	
C16:1	Acide palmitoléique	Acide 9-hexadécénoïque	
C18	Acide stéarique	Acide octadécanoïque	
C18:1	Acide oléique	Acide cis-9-octadécénoïque	
C18:2	Acide linoléique	Acide 9-12-octadécénoïque	
C18:3	Acide linolénique	Acide 9-12-15-octadécénoïque	
C18:4	Acide moroctique	Acide octadécatétraénoïque	Non étalonné
C19		Acide nonadécanoïque	

C20	Acide arachidique	Acide eicosanoïque
C20:1	Acide gadoléique	Acide cis-11-eicosénoïque
C20:4	Acide arachidonique	Acide 5-8-11-14-éicosatétraénoïque
C20:5	Acide timnodonique	Acide cis-5-8-11-14-17-eicosapentaénoïque
C21		Acide hénéicosanoïque
C22	Acide béhénique	Acide docosanoïque
C22:1	Acide érucique	Acide cis-13-docosénoïque
C22:2		Acide 13-16-docosadiénoïque
C22:5	Acide clupanodonique	Acide 7-10-13-16-19-docosapentaénoïque
C22:6		Acide 4-7-10-13-16-19-docosahexaénoïque

Abstract

The treatment of a Renaissance leather and wood ceremonial shield from a private collection in Milan provided an invaluable opportunity to study the techniques employed to construct and decorate a type of object which is little studied and essentially ignored in the principal technical sources. A series of analyses, aimed at evaluating the condition of the shield, formed the basis for the choice of methods used to stabilize the leather covering, while the treatment employed respected various modifications and additions made to the shield in an earlier restoration in accordance with the system used in displaying the collection.

Keywords

ceremonial arms, shields, 16th century, decorated leather buckler, technique, conservation

Figure 1. Leather ceremonial buckler (Milan, Bagatti-Valsecchi museum): a) external side; b) internal side. Photo ICR

The 16th-century leather ceremonial buckler in the Bagatti-Valsecchi museum in Milan: a case study

Mariabianca Paris★, Lidia Rissotto, Maria Cristina Berardi
ICR – Istituto Centrale per il Restauro
Piazza San Francesco di Paola 9
00184 Roma, Italia
Fax: + 39 064 815 704
E-mail: icr@beniculturali.it
Web site: www.icr.beniculturali.it

Introduction

In 16th-century Italy there was a vast and original output of lavishly decorated luxury armour (also known as ceremonial armour), which emphasized the power and wealth of the great lords of the era. Such armour had extremely high symbolic value, both politically and socially, but little practical use as defensive equipment. The rediscovery of ancient Rome and of classical mythology provided the inspiration for at times spectacular decoration, and the basic shapes employed were stretched to the limits by technical mannerism, embossing and working steel as if it were a precious metal (Boccia and Coelho 1967).

But armour of this type was not only made of steel. Virtuosity in the sector was also applied to leather, a structurally different material, but which was capable of being worked in imitation of the most precious metals, and which had been employed in military equipment since antiquity due to its versatility and robustness (Waterer 1981).

Today there are few surviving examples of Renaissance-era leather ceremonial armour (principally shields and headgear of various styles) in public and private collections, either in Italy or abroad. These items have received but cursory treatment in the specialist literature, whether that dedicated to arms or that more generally dealing with leatherwork. Specialist literature provides at most brief references or bare catalogue entries which do not give justice to this important line of production. Consequently, the treatment of a leather ceremonial shield from the Bagatti-Valsecchi museum in Milan provided a valuable opportunity for a technical study of this neglected type of artefact.

The buckler or round shield: general characteristics

By buckler we mean a roughly circular shield with a diameter of approximately an arm's length. Such a shield was usually convex on the outside and concave on the internal face, and might be made of a variety of materials such as steel, wood, leather and wickerwork. On the inner surface there were a series of standard fittings evolved over a long tradition of shield-making, which enabled the wearer to hold the shield (using a pad, arm-straps and handhold) or, when necessary, to carry it over the shoulder (using a baldric). Sometimes the buckler formed part of a matching set with a piece of headgear (Boccia 1982).

The example in the Bagatti-Valsecchi museum

The ceremonial shield discussed here formed part of the original furnishings of the Bagatti-Valsecchi palace in Milan. The palace, which today is a museum, was built at the end of the 19th century by two Milanese nobles, the brothers Fausto and Giuseppe Bagatti Valsecchi, who were inspired by the palazzi of the Lombard Renaissance. Maintaining a consistent approach, it was also furnished in the same taste with either original artworks or careful imitations (Pavoni 1995).

The basic details of the shield (See Figures 1a-b) are as follows:

★Author to whom correspondence should be addressed

- the inventory number is 940
- the structure is a wooden framework covered in incised, embossed and punched black leather
- the shape is roughly a spherical cap
- the dimensions are a maximum diameter of 54.6 cm and a maximum height approximately 9 cm
- the weight is 2900 g
- the provenance is Italy, probably Florence
- the date is approximately 1530–1550
- the decoration is historical-mythological scenes and plant motifs.

The historical context

There is extremely little historical information about the location and context in which these artefacts were produced. Traditionally, most embossed leather bucklers are thought to originate from Lombardy or Florence, and are usually dated to the period from 1520 to 1570 (Gall 1965). Although there is no hard documentary evidence for this assumption, it is based on similarities in style and decoration with metal armour, a field that has been more intensively studied and is hence much better understood.

L. Boccia, a great authority on historical arms, has proposed Florence as a possible source for the Bagatti-Valsecchi buckler and other similar examples. But while the production of wooden and leather shields in the 14th century is attested to by the corporate statutes of the Belt-makers' and Shield-makers' Guild (Camerani Marri 1960), we are dealing with evidence concerning a significantly earlier period, and which in any case makes no mention of decorated shields, which presumably would have required the collaboration of artisans with different specialized skills[1].

Techniques used in construction and decoration

The buckler consists of a shaped wooden framework, approximately in the form of a spherical cap, with a decorated leather covering.

The wooden frame

X-ray photographs[2] seem to indicate that the frame is made up of three layers of thin wooden strips made of poplar, glued together with opposing grains, running vertically in the external layers of strips and horizontally in the central ones. The strips are spindle-shaped so as to accommodate the convex form of the shield. Their maximum width is around 7 cm to 8 cm, while their length and shape vary according to their position. As the x-rays do not show all the join lines, we cannot tell how many strips make up each layer.

The bending and gluing of the strips were probably carried out on a form using steam or heat to permanently shape the wood (Fioravanti and Uzielli 1999).

The leather cover

The cover is made of two discs of vegetable-tanned leather, one for the interior and one for the exterior of the wooden frame. Originally, the diameter of the external cover would have been larger than it is now, and it would have had a series of radial cuts along its perimeter so it could be folded over the internal cover. However, now a strip of new leather provides the join between the two covers.

The decoration of the surface is in relief work of varying height. The techniques employed, and indeed the effects obtained, show an attempt to imitate the more valuable worked metal models.

The leather was dampened, to make it easier to shape, and then worked with the following techniques.

Incision is used to indicate the lines of the design either by intaglio work or by simply compressing the leather. The groove made by intaglio was deeper and able to be further enlarged ('opened'). It was thus used for the main lines and in

Figure 2. Leather ceremonial buckler (Milan, Ba-Va museum), detail: embossing on grained background. Photo ICR

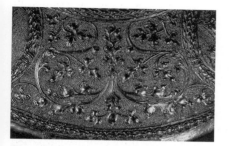

Figure 3. Leather ceremonial buckler (Milan, Ba-Va museum), detail: modelling on grained background. Photo ICR

Figure 4. Leather ceremonial buckler (Milan, Ba-Va museum), detail: small wooden pegs distributed around the figure. Photo ICR

Figure 5. Leather ceremonial buckler (Milan, Ba-Va museum), detail: nailing of the leather covering. Photo ICR

particular the external contours, thereby accentuating the difference between areas raised in relief and those that were flattened.

Embossing gives a more marked relief, generally through pressing and scraping the underside of the leather (the flesh side). This was used on the figures in the medallions and the laurel wreaths framing them (see Figure 2). In the former, the relief was kept in shape by filling it with cotton fibres[3], and in the latter cord was used, probably made of hemp.

Modelling obtains a lower relief, in general no higher than the thickness of the leather, by compressing it in certain areas so as to make adjacent areas stand out. This was applied to the plant shoots, which twine through the spaces between the medallions (see Figure 3) and was also used for finishing work on the embossed areas.

Graining, or tooling, the background with punches left a low, grain-shaped relief. This lowered the background to make the relief stand out and to vary how light reflected off the surface (see Figure 2).

The assembly of the components and finishing of the surface

The leather coverings were attached to the wooden frame both by an adhesive (probably animal glue), and small wooden pegs. The pegs have roughly the shape of a truncated cone and are distributed fairly evenly over the whole surface, but are particularly dense along the outlines of the figures and the embossed laurel wreaths (see Figure 4). They must have been placed so as to help in the stretching of the leather during assembly and to keep the coverings attached to the curved surface over time[4].

Finally the shield was tinted black using a pigmented varnish to reproduce the typical burnishing of metal armour, to give the surface a uniform appearance and to hide the numerous wooden pegs.

Previous treatments and forms of deterioration.

Prior to our work, the buckler had been subject to a thorough and radical restoration effectively aimed at making it sound enough to be used[5].

The most significant parts of this restoration involved:

- removing the entire internal leather covering from the wooden frame and partial removal of the external covering
- consolidating the wooden frame, particularly around the rim, with metal nails
- reattaching the leather covering to the strengthened frame using an animal glue (the inner covering was also nailed to the frame to help it to stay attached to the more problematic concave inside surface of the shield, see Figure 5)
- connecting the borders of the internal and external coverings with a strip of new leather
- coating the surface with a black pigmented grease to hide the nails and to give the surface a uniform appearance
- adding two new arm-straps to replace the originals which had been either lost or removed during the restoration.

Following this treatment the surface was periodically re-greased as part of standard maintenance.

When examined prior to our treatment, the wooden frame of the buckler was found to be without significant warping, and the strengthening of its component strips with nails carried out in the previous treatment was still effective.

Analyses also confirmed that the leather was in quite good condition: the fibres were stable and still showed reasonable mechanical resistance. However, environmental conditions and previous treatments had led to splitting, deformation and the serious hardening of the material. This hardening in turn had caused the progressive detachment of the covering from its wooden support. The bulk of this damage was located on the internal side, whose concave shape would have always tended to pull the cover away from the frame. It consisted in serious buckling due to strong contractions in the leather, which was so severe that most of the nails had been pulled out of the frame.

Table 1. Results of the microanalyses to evaluate the condition of the leather.

Type of tannin	condensed
Extractable tannin (OD/100 mg)	23
Monomers in tannin (%)	0.7
Ellagic acid in tannin (%)	0.2
pH (measured)	4.60
pH (calculated)	2.53
Sulphate (%)	0.71
Nitrate (%)	0.18
Sulphate as ammonium-sulphate (%)	100
Extractable lubricant (%)	1.9
Shrinkage temperature (C°)	41.2
ΔTs (C°)	4.8

The surface of the leather was also obscured by various thick layers of fatty solids which had not only trapped considerable quantities of dust and dirt but had also filled in the cavities of the modelling, blurring the lines of the design and blunting the relief-work. The excessive use of greases had probably altered the leather' moisture exchange capacities, contributing to the gradual drying out of the fibre and the consequent shrinking of the leather.

All of the nails showed obvious signs of oxidation.

Analyses

Two series of analyses were carried out, first, to assess the condition of the leather and to provide indications concerning appropriate treatment, and second, to identify the materials used to grease the leather.

Assessing the condition of the leather

Analyses were carried out at the *Institut Royal du Patrimoine Artistique* in Brussels which has experience in evaluating minimal quantities of leather samples (Wouter 1992). The results[6], listed in Table 1, show the following.

- The leather consists of hide, tanned with condensed tannin. The amount of extractable tannin is very low, probably due to cross-linking between collagen and tannin. The relative amounts of monomers and ellagic acid indicate the tannin is in fairly good condition.
- The high pH value observed results from the transformation of free sulfuric and probably nitric acids to their respective ammonium salts, which are buffering agents. The total amount of absorbed sulphate is low, especially for condensed tannin vegetable tanned leather. This means that no great acidification has taken place over the lifetime of the leather.
- The amount of extractable lubricant obtained by gravimetrical methods is low given that large amounts of this material are visibly present.
- The shrinkage temperature is average for historical leather samples[7]. A small ΔTs shows the leather fibres are all in fairly similar condition. Significantly, on contact with water no spontaneous gelatinization was observed.

In conclusion the condition of the fibre structure of the leather is that expected of a naturally aged example with no particular signs of chemical degradation, which would preclude treatment with aqueous mediums.

Identification of the substances used for greasing

Three different types of fatty materials were sampled from the surface of the leather and their methyl esters were analysed using GC/MS[8]. Results are shown in Table 2. The prevalence of saturated fatty acids indicates the presence of animal fats. However, in sample A, the higher amount of bifunctional fats probably indicates degradation brought about by contact with the metal of the nail. In the other two

Table 2. Identification and percentage values of the fatty acids present in the samples of fatty substances taken from the leather coverings.

saturated fatty acids	Sample A %	Sample B %	Sample C %
Octadioic	2.7		
Nonadioic (Azelaic)	4.3	0.4	4.2
Decadioic	0.4		
Miristic	3.9	3.1	2.2
Palmitic	62.9	59.3	56.5
Stearic	21.2	23.3	31
unsaturated fatty acids			
Oleic	4.6	13.9	6.1

Sample A: black grease taken from under the head of a nail
Sample B: colourless grease taken from inside a split in the leather covering
Sample C: colourless grease taken from the surface of the leather covering

Figure 6. Leather ceremonial buckler (Milan, Ba-Va museum), detail: mechanical removal of the grease on the surface. Photo ICR

samples, more similar in composition, the azelaic acid can be linked to the degradation of oleic acid.

It is in any case difficult to assign the identified compounds to a single fatty substance, especially given the numerous re-greasing operations carried out on the artefact.

Most attention was given to the composition of sample B as it consisted of a particle of fat, which looked relatively 'fresh'. A comparison with various commercial products seems to indicate that it would be worthwhile carrying out further analytical studies on a mixture of purified animal fats known in Italy under the product name of Stearina.

Conservation treatment

The treatment project had to take into account not only the condition of the buckler but also the conditions it would be exhibited under once it was returned to the museum, which does not have any climate control system. Further, as we were dealing with a house-as-museum, which is being maintained in its original state, the shield had to be treated so that it conformed to the display and restoration criteria established by the original owners. This meant that display cases cannot be used even for the most delicate objects, even if, like the buckler, they are particularly sensitive to changes in climatic conditions. Given these basic premises, the treatment had to take into account the fact that both the wooden frame and the leather would be continuously subject to expansion and contraction, and that, where possible, we would have to maintain the choices adopted in previous restorations and the original display system as these were held to be historically significant.

Cleaning

In order to improve chemical-physical stability of the coverings and to make the decoration more legible, it was decided to remove various materials that had been applied in previous treatments, as well as their deterioration products. Treatment in particular involved removing:

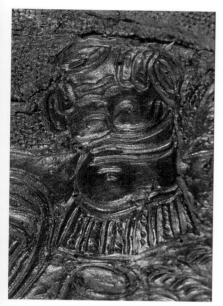

Figure 7. Leather ceremonial buckler (Milan, Ba-Va museum), detail: anchoring of the leather covering to the wooden frame with burnished staple-shaped nails. Photo ICR

- surface deposits of grease, most of which was removed mechanically using dentists' tools for the indentations (see Figure 6) and cleaning erasers (for the flat and relief surfaces); residues were thinned down by swabbing with non ionic detergent in solution (2g Arkopal N100®, 2g medium-viscosity carboxyl methyl cellulose, 996g de-ionized water) followed by rinsing with a 1:1 water/alcohol mixture using swabs
- nails in the internal covering, which had been pulled out of the wooden frame and thus were not contributing to the attachment of the cover to the frame
- corrosion products from the head of the remaining nails using fibreglass abrasive pencils.

Reduction of deformation and consolidation

Only moderately sized deformed areas were treated, mostly located near splits and losses. Treatment involved humidifying the leather (maximum duration of two hours) through Gore-Tex® membrane, followed by drying under pressure. It was decided not to treat the more extensive deformations on the shield interior, where the leather had become quite rigid, as we believe this would have induced damaging tensions in the material and produced only partially successful and temporary results.

The leather coverings, where detached, were reattached to the wooden frame by inserting thin staple-shaped nails made from burnished stainless steel wire of varying diameter (0.8 mm, 1 mm and 1.2 mm). They were mostly inserted along the borders of splits or, occasionally, in pre-existing holes, with care being taken not to force the leather to adhere to the frame (see Figure 7). A mechanical method of attachment was chosen as it seemed best suited to the characteristics of the material and the environmental conditions the object would have to face, as it

would allow movement, admittedly minimal, in the leather, thus reducing the tensions it would have to face.

Retouching and reintegration

The materials and procedures employed for fillings were also chosen to allow for the expansion and contraction of the material once it was on display, as well as being easily reversible. Splits were filled to be slightly lower than the surrounding leather, inserting the filling material into the cavities, including the spaces between the frame and the covering. The material employed was compressed Japanese paper impregnated with an adhesive mix (80:20) of hydroxyl propyl cellulose (Klucel G®) at 3% in water) and an ethylene vinyl acetate (Evacon R®). The losses, due to their limited size, were filled up to the level of the surface of the leather using an elastic fill made up of the same adhesive mixture mixed with finely powdered cellulose pulp.

Varnish paints were used to retouch the fillings and the heads of the nails, while parts of the wood support that were visible were adjusted in tone with watercolour washes.

Display

The director of the museum held it was important to maintain the spirit of the collection and keep the original wrought iron stand and wooden hanger from which the buckler was hung by its arm-straps. The structure was modified slightly to increase the number of points of contact with the shield and thus distribute its weight better and to also adjust the rotation and inclination of the object so that it was more clearly displayed.

Conclusion

Decorated leather ceremonial armour is a class of artefacts, which has only ever received marginal attention in the specialist literature. The treatment of the ceremonial buckler held by the Bagatti-Valsecchi museum of Milan not only enabled us to acquire information concerning the techniques used to build and decorate this type of artefact, it gave also rise to a number of queries leading into areas of research which have never been investigated. This in turn led the museum to organize an exhibition, which will be held before the end of 2002, and which aims to be a first and necessary approach to various themes (dealing with techniques, types, iconography, style, etc.), the occasion to bring together a variety of works, information and questions related to them, and thus finally to act as a stimulus for future studies.

Acknowledgements

The authors wish to thank Jan Wouters from IRPA (Brussels); Fabio Talarico and Maria Rita Giuliani from ICR for providing technical analyses and valuable contributions for the results evaluation; and Mark Gittins for his help in translating this report into English and preparing it for publication.

Notes

1 This subdivision of specialist labour has been noted in the case of painted wooden bucklers, for example the buckler by Giovanni Stradano with the battle of Marciano (Rome, Museo Nazionale del Palazzo di Venezia), or that by Caravaggio with the head of Medusa (Florence, Uffizi Gallery).

2 Analyses conducted by ENEA (National Agency for Research in Nuclear and Alternative Energy), Centro Ricerche Casaccia (Rome).

3 Identification of the fibres was carried out in the Biology Laboratory of the ICR by Maria Rita Giuliani.

4 A margin of doubt must remain as to whether this technique formed part of the original construction due to the extensive handling the object received over the years. It should however be noted that impressions of wooden nails have also been observed on other examples of embossed leather bucklers and an identical procedure has been documented for

the painted leather coverings in the dome of the Palacio des los Leones of the Alhambra in Granada (Bermudez Pareja 1987)

5 Evidence seems to suggest that the treatment took place at the end of the nineteenth century or, at the latest, at the beginning of the twentieth century.

6 Analyses performed on a fragment of detached leather weighing about 133 mg. Technical report by Jan Wouters, IRPA 1999 (unpublished).

7 Measurements carried out by the Laboratory of the School of Conservation in Copenhagen, by Dorte Vestergaard Poulsen.

8 Analyses carried out in the Chemistry laboratory of the ICR by Fabio Talarico.

References

Bermudez Pareja, J, 1987, *Pinturas sobre piel en la Alhambra de Granada*, Granada, Patronato de la Alhambra y Generalife, 143–144, fig.II.

Boccia, L G (ed.), 1982, *Dizionari terminologici. Armi difensive dal Medioevo all'Età Moderna*, Roma, Istituto Centrale per il Catalogo e la Documentazione.

Boccia, L. G. and Coelho, E T, 1967, *L'arte dell'armatura in Italia*, Milano, Bramante Editrice.

Camerani Marri, G (ed.), 1960, *Statuti delle Arti dei Correggiai, tavolacciai e scudai, dei vaiai e pellicciai di Firenze (1338–1386)*, Firenze, Leo Olschki Editore.

Fioravanti, M and Uzielli, L, 1999, 'Il restauro della Medusa. La struttura dello scudo', in F Cairoli (ed.), *L'anima e il volto*, exhibition catalogue, Milano, Electa.

Gall, G, 1965, *Leder im Europaischen Kunsthandwerk*, Braunschweig, Klinkhardt & Biermann.

Pavoni, R (ed.), 1995, *Museo Bagatti Valsecchi*, Guida, Milano.

Waterer, J, 1981, *Leather and the warrior*, Northampton, The Musem of Leathercraft.

Wouters, J, 1992, 'Evaluation of small leather samples following successive analytical steps' in *Proceedings of the ICOM-CC, Conservation of Leathercraft and Related Objects, Interim Symposium*, London, V&A Museum, 31–33.

Materials

Arkopal N-100, Hoechst AG, 6230 Frankfurt (Main) 80, D, Hoechst Italia Spa, P.le S. Turr 5, 20149 Milano, Italia, Tel. 02 31071, Fax 02 3311351

Evacon R, Conservation by Design Limited, Timecare Works, 5 Singer Way, Woburn Rd Ind. Estate, Kempston, Bedford MK42 7AW, United Kingdom, Tel: (01234) 853555; fax: (01234) 852 334; e-mail:info@conservation-by-design.co.uk

Gore-tex membrane, W.L. Gore & Associates, Inc., 100 Airport Road, P.O.Box 1550, Elkton, Maryland 21921, U.S.A., Tel: (301) 3924 440

Klucel G, Aqualon Co., P.O. Box 15 417, Wilmington, Delaware 19850, U.S.A., Tel: (0302) 594 7600

Paraloid B 72, Rohm and Haas Co., Philadelphia, PA 19105, U.S.A., Bresciani s.r.l., Via Ernesto Breda 142, 20126 Milano, Italia, Tel. 02 27002121; Fax 02 2576184, E-mail: bresciani@planet.it

Abstract

Identification of vegetable tannin types through spot tests are tried on reference compounds (chemicals), tannin extracts and leathers. This paper deals with and evaluates the ferric test for identification of vegetable tannins and the vanillin test for identification of condensed tannins Furthermore, a third spot test (the rhodanine spot test) is developed for identification of hydrolysable gallo tannins. The results are evaluated through visual observation and for some samples compared with HPLC. This work shows that the spot tests are useful to control the quality of new restoration leathers, but shows to be less significant applied to deteriorated leathers.

Keywords

spot test, vegetable tannins, condensed tannins and gallo tannins

Presentation and evaluation of spot tests for identification of the tannin type in vegetable tanned leather

Dorte V. Poulsen
School of Conservation
Royal Danish Academy of Fine Arts
Esplanaden 34
DK 1263-Copenhagen K. Denmark
Fax: + 45 33 74 47 77
E-mail: dvp@kons.dk or dvp@landskronagade.dk

Introduction

Spot tests are a useful tool in the work of the conservator-restorer for testing new restoration material and for testing objects prior to possible conservation/restoration procedures. Without the need of advanced and expensive equipment, information can be gained very fast, requiring only a few chemicals and a small sample of material.

Identification of the tannin type in vegetable-tanned leather is of great interest to the conservator-restorer, as the stability of vegetable-tanned leather depends upon the type of tannin. With the rhodanine test it is now possible to circle in the tannin type more precisely.

Only a few spot tests for identification of the tannin type in leather exist. The two best-known spot tests applied to vegetable-tanned leather are the ferric test (indicating vegetable tannins) and the vanillin test (indicating condensed tannins). Within this work a third spot test (rhodanine test), which can be applied for conservation purposes, has now been developed for identification of hydrolysable gallo tannins.

In this work the spot tests have mainly been performed on known tannin materials and the leather samples used have previously been thoroughly analyzed. On the basis of the results of these spot tests, this paper discusses the value of selected spot tests for identification of the tannin type in vegetable-tanned leather.

Chemistry of vegetable tannins

Vegetable tannins are extracted from plants (e.g. roots, leaves, heart wood from trees). The vegetable tannins have been defined as water-soluble phenolic compounds having molecular weights between 500 and 3000. Besides giving the usual phenolic reactions, they also have special properties such as the ability to precipitate alkaloids, gelatine and other proteins (Haslam 1989). Vegetable tannins can be divided into two main groups, the hydrolysable tannins and the condensed tannins.

Hydrolysable tannins

By reaction with mineral acid, these tannins hydrolyze and form a glucose and either ellagic acid or gallic acid. The formation of ellagic acid and gallic acid divide the hydrolysable tannins (e.g. sumac, tara) into two large groups: ellagic tannins and gallo tannins (see Figure 1).

Condensed tannins

The condensed tannins (e.g. mimosa, quebracho), known as proanthocyandins and polyflavanoids are defined as all the colourless substances isolated from plants forming anthocyanidins when heated with acid (Haslam 1989). Basically, the proanthocyanidins are formed from flavan units, or, more precisely from, flavanol units (see Figure 2).

Figure 1. Gallic acid (top); ellagic acid (bottom)

Figure 2. A flavanol unit (top). 2R Prodelphinidin detected in the heartwood of Acacia mearnsii (mimosa tannin) (right). (Hemingway 1989)

When condensed tannins react with mineral acids, they condensate and form larger molecules, the so-called tannin reds (Roux et al. 1975, Foo and Karchesy 1989, Roux 1992).

Mixed tannins

A third category of tannins has been defined as the mixed (complex) tannins. Mixed tannins contain characteristics from both hydrolysable and condensed tannins (Tang et al. 1992). Quercus (oak) and Castenea (chestnut) species have shown to belong to the mixed tannins (Porter 1992). An example is given in Figure 3.

Samples

All samples and the predetermined tannin types, listed by Tang et al. (1992) and further supported by HPLC analysis (Wouters 1993, Wouters et al. 1996) are shown in Table 1. Included in this table are the results of the spot tests.

A group of vegetable tannins has been selected, with hydrolysable (H), condensed (C) and mixed (H/C) tannins represented.

Reference compounds ((+)-catechin hydrate, ellagic acid, gallic acid monohydrate and sumac (gallo tannin)) have been tested together with tannin extracts of Chinese gall apples, myrobolan and tara. Also, new leathers sold for restoration purposes have been tested. The new leathers are vegetable tanned, but their exact tannin type is unknown.

Naturally aged leathers derive from the British long-term trial started by the British bookbinding industry in co-operation with leather and paper research associations in 1932. The purpose of the trial was to clarify the causes of leather deterioration and to develop long time durable leather. The leathers have been stored as bookbinding's at the British Library in London (B samples) and at the National Library of Wales in Aberystwyth (W samples).

Table 1. Sampels used for spot tests, tannin compounds/tannins extracts, naturally aged leathers, new leathers. The tannin type of the naturally aged leathers have been determined by HPLC (Wouters 1993, Wouters 1996). Results of the three spot tests.

Tannins	Sample codes	Tannin type	Ferric test	Vanillin test	Rhodanine test		
					Gallo	Gallic	Control
(+)-catechin hydrate		C	+	+	+	+	-
Chinese gall apples		H	+	+	+	+	-
Ellagic acid		H	+	-	+	+	-
Gallic acid monohydrate		H	+	-	+	+	-
Myrobolan		H	+	-	+	+	-
Sumac gallo tannin		H	+	-	+	+	-
Tara		H	+	+	+	+	-
Acacie	BA	H/C	+	+	+	+	-
	WA	H/C	+	+	+	+	-
Chestnut	BC	H	+	-	-	-	-
	WC	H	+	-	-	-	-
Gambier	BG	C	+	+	-	-	-
	WG	C	+	+	-	-	-
Mimosa	BM	C	+	+	+	+	-
	WM	C	+	+	-	-	-
Myrobolan	BMB	H	+	+	-	-	-
	WM	H	+	+	+	+	-
Oak	BO	C	+	-	+	+	-
	WO	C	+	+	-	-	-
	BL3	C	+	+	-	-	-
	BL4	C	+	+	-	-	-
	BL7	H	+	-	+	+	-
Quebracho	BQ	C	+	+	-	-	-
	WQ	C	+	+	-	-	-
Sumac	BS	H	+	-	+	+	-
	WS	H	+	-	+	+	-
Calf a		H	+	+	-	-	-
Calf b			+	+	-	-	-
Goat			+	+	+	-	-
Sheep			+	+	-	-	-

Figure 3. Structure of a mixed tannin isolated from Castenea crenata (chestnut) (Tang et al. 1992)

Spot tests

Ferric spot test: vegetable tannins

The ferric test is based on the principle that phenolic-based vegetable tannins react with iron–salts forming a dark black/grey reaction product. This reaction has been known for decades and is exploited in, for example, the production of iron gall ink and the dyeing of leather and textiles.

METHOD

Two samples of leather fibres are taken out. The samples are placed in each end of a glass slide. Carefully one drop of water is added to each sample, and both samples are covered with a cover glass. Right by the edge of one of the cover glasses a drop of 2% ferric chloride w/v in water is placed (ferric sulphate can replace ferric chloride). Utilizing the capillary forces, the ferric salt is soaked under the cover glass by removing the water with a piece of filter paper from the opposite side of the cover glass. When the ferric sulphate reaches the leather fibres, a dark colouring of the fibres will indicate the presence of vegetable tannins (Larsen 1990, Larsen 1996).

RESULTS AND DISCUSSION

All samples, new as well as deteriorated, showed a positive reaction towards the ferric sulphate. This supports that they are all vegetable tannins. Reactions did not always occur immediately, so a certain reaction time may be expected. This may be due to insufficient wetting of the sample.

Vanillin spot test: condensed tannins

The vanillin test indicates the presence of condensed tannins. Working the reaction between acidified vanillin (4-hydroxy-3-methoxybenzaldehyde) and condensed tannins, it yields a red reaction product. The red colour may vary from blue-red in new materials to brown-red in deteriorated materials (Larsen 1990, Larsen 1996). Basically, in reaction with acidified vanillin, flavanols produce a coloured product. They have an absorbance maximum at 500 nm (Broardhurst and Jones 1978). According to Desphande et al. (1986), the absorbance maximum varies between 480 nm and 550 nm, depending upon the carbonium ion formed. The reactions related to the vanillin assay are given in detail in Deshpande et al. (1986), together with the condensation reaction of vanillin with flavanols.

METHOD

Two samples of leather fibres are placed in each end of a glass slide. On one sample (test) one drop of 4% vanillin in 99% ethanol is added. When the vanillin is fully soaked, the surplus is removed with a piece of filter paper. Next, one drop of concentrated HCl is added to both samples (test/control). If a red colour is formed the presence of condensed tannins is indicated.

Preferably a fresh vanillin reagent should be used, as the reagent is not stable on the long term. The reagent is sensitive towards light and must be kept in the dark. It can be stored in the refrigerator for about 14 days.

RESULTS AND DISCUSSION

The following samples show a positive reaction indicating condensed tannins: acacia, gambier, mimosa, quebracho and oak (BO, WO, BL3 and BL4). This is in accordance with the predetermined tannin types (see Table 1).

The tara tannin and the Chinese gall apples, also yield a positive reaction, even though they have been predetermined to be hydrolysable tannins. Furthermore, the four new leathers with unknown tannin type prove a positive reaction indicating condensed tannins.

Rhodanine spot test: hydrolysable gallo tannins

On the basis of a quantitative analysis of gallic acid in plants described by Inoue and Hagerman (1988) a spot test for identification of gallo tannins (e.g. sumac, tara) is developed within this work.

Under basic conditions rhodanine (2-thio-4-ketothiazolidine) reacts with the vicinal hydroxyl groups of gallic acid to give a red complex with a maximum absorbency at 518 nm. To identify gallic acid it is therefore necessary to hydrolyze the gallo tannins prior to the reaction with rhodanine.

Apart from gallic acid in new gallo tannins, gallic acid is found as a breakdown product of both hydrolysable and condensed tannins (Wouters et al. 1996, Poulsen 2000). This suggests that the rhodanine test might also be valuable as an indication of deterioration of vegetable-tanned leather.

METHOD

Three small fibre samples are taken out and placed on a glass slide. One drop of 2N H_2SO_4 is added to the left sample (for testing gallo tannin), the sample is soaked for five minutes to hydrolyze. Excess of acid is carefully removed with a piece of filter paper. Next one drop of rhodanine solution (0.667% w/v in 99% ethanol) is added to both the left and middle sample (for testing gallic acid). After five minutes, surplus rhodanine reagent is removed with a piece of filter paper. Finally one drop of 0.5 N KOH is added to all three samples. The right sample is the control with only addition of base. A red colour yields a positive reaction.

It is important to stress the removal of excess of one reagent before adding a new. Besides relieving the contact between the leather fibres and the new reagent, it prevents the liquids flowing together, mixing the samples. Alternatively, the spot test can be performed in small test tubes or on separated glass slides. If the test is performed in test tubes more base must be added to the "gallo tannin" sample, as one drop of base is insufficient for creating a basic environment. Furthermore, a brown colouring of the base reference may be expected.

RESULTS AND DISCUSSION

In the interpretations of the results no discrimination has been made for the difference between a positive result identifying respectively gallo tannins and gallic acid, as no colour difference between these so far has been observed. This does not mean that the two are identical. But at the present time the red reaction products have not yet been subjected to further analysis.

The rhodanine test has been performed on glass slides and in test tubes with similar results, which is why only one set of results is presented in table 1. A positive reaction towards the rhodanine test is found in the following samples: (+)-catechin hydrate, ellagic acid, gallic acid monohydrate, sumac gallo tannin, myrobolan, tara, BA, WA, BM, BMB, WMB, BO, BL7, BS, WS and goat.

Surprisingly the BM sample shows both a positive vanillin and a rhodanine test. This indicates that the BM sample may be very deteriorated, as gallic acid has been shown to be a deterioration product of condensed tannins. The analytical results (sulphate content, B/A-value, Ts, DSC etc.) of the STEP and ENVIRONMENT leather reports (Larsen 1994, Larsen 1996) confirm that the BM sample is very degraded.

Oak can contain both hydrolyzable and condensed tannins. The results of the rhodanine reaction on the oak samples illustrate the confusion that may arise when dealing with that type of tannins, and in general with deteriorated leather. The results of the rhodanine test confirm that WO, BL3 and BL4 samples (see Table 1) belong to the condensed tannins (negative rhodanine action). Furthermore, BL7 is confirmed to be a gallotannin as it shows a positive rhodanine reaction. Also the BO sample shows a positive rhodanine test, but this sample has, just as the BM sample, shown to be very degraded (Larsen 1994, Larsen 1996).

As chestnut in the three spot tests only shows a positive ferric test (vegetable tannins), it must belong to the ellagic tannins, which is in accordance with Tang et al. (1992).

Furthermore, the new leather (goat) shows both a positive vanillin and rhodanine test. Being relatively new leather, a high degree of deterioration is probably not the cause for this. Instead the positive tests would rather indicate that the leather is tanned with both hydrolysable and condensed tannins.

The present method of hydrolysis with one drop of 2N H_2SO_4 may be insufficient, as it works at room temperature in a relative short time. According to Inoue and Hagerman (1988) the hydrolysis should be carried out in 0.2N H_2SO_4

during 24 hours. Another work of Waterman and Mole (1994) presents and evaluates a series of methods useful for quantification of vegetable tannins. Dealing with the rhodanine method, they recommend a hydrolysis using 1 M H_2SO_4 over 26 hours. Preliminary results of these methods of hydrolysis for the rhodanine test have not been successful. Further work needs to be done to establish the exact conditions for hydrolysis.

Conclusion

For examinations of new restoration leather, the presented spot tests can be very useful when identifying the tannin type. Previously, the ferric test and the vanillin spot tests have been recommended for this purpose (Larsen et al. 1996).

For conservation purposes it is recommended that leather should be tanned only with hydrolyzable tannins, as these leathers deteriorate more slowly than leathers tanned with condensed tannins (Larsen et al. 1996). With the rhodanine spot test identification of gallo tannins is now possible. Ellagic tannins may this way be identified from the method of exclusion. If the ferric test is positive and the vanillin and the rhodanine test are negative, you may have ellagic acid.

But, while performing spot tests, it is important to keep in mind that they have certain disadvantages. The spot tests will be influenced from compounds present in leather bearing a structure related to one of vegetable tannins. The ferric ion in the ferric test reacts willingly with other phenols present in leather. Presence of, for example, organic leather dyes can be problematic, as organic dyes often have chemical structures close to what is seen in vegetable tannins.

From this trial the influence of breakdown products has been shown, as breakdown products affect the rhodanine test, exemplified by the BM and BO samples.

Spot tests become less significant if deterioration of the involved tannin is increased. It can therefore be very difficult to identify the tannin type in heavily deteriorated vegetable-tanned leather. The ferric and the vanillin tests would react less willingly and the results become less significant. On the other hand, deterioration products would most likely interfere the rhodanine test, as gallic acid react and yield a positive reaction. When identifying the tannin type from spot tests it is therefore necessary to exercise great judgement.

Acknowledgements

The author would like to thank my colleagues at School of Conservation: Tine Rauff for her great help performing the spot tests, Mogens Koch for his help with the illustrations and Marie Vest for her critical reading of this paper.

Chemicals

The following chemicals have been purchased through KeboLab AS, Roskildevej 16, 2620 Albertslund, Tel: +45 43 86 87 88: Ferric(III)chloride, H_2SO_4 98%, Ethanol 99%.

The following chemicals have been purchased through Bie & Berntsen, Sandvej 17, 2610 Rødovre, Tel: +45 44 94 88 22, KOH, HCl 37%, Rhodanine, Vanillin.

References

Broardhurst, R B and Jones, W T, 1978, 'Analysis of Condensed Tannins using acidified vanillin', *J. Sci. Fd. Agric.* 29, 788–794.

Deshpande, S S, Cheryan, M and Salunke, D K, 1986, 'Tannin Analysis of food products, CRC Critical Reviews in Food Precipitation Assays', *Journal of Food Science* Vol. 24, Issue 4, 413.

Foo, L Y and Karchesy, J J, 1989, 'Chemical nature of phlobaphenes' in R W Hemingway and J J Karchesy (eds.), *Chemistry and significance of Condensed tannins*, New York, Plenum Press, 109–118.

Griffiths, D W, 1991, 'Condensed Tannins, toxic substances in crop plants', *The Royal Society of Chemistry* 180–201.

Haslam, E, 1989, *Plant polyphenols, Vegetable tannins revisited*, Cambridge University Press.

Hemingway, R W, 1989, 'Structural variations in proanthocyanidins and their derivatives' in R W Hemingway and J J Karchesy, *Chemistry and Significance of Condensed Tannins*, New York, Plenum Press, 83–108.

Inoue, K H and Hagerman, A E, 1988, 'Determination of Gallotannin with Rhodanine', *Analytical Biochemistry* 169, 363–369.

Larsen, R, 1990, 'Micro-chemical determination of vegetable tannins', *Leather Conservation News* 40, 1, 6–7.

Larsen, R, 1995, *Fundamental Aspects of the Deterioration of Vegetable Tanned Leathers*, The Royal Danish Academy of Fine Arts School of Conservation.

Larsen, R, 1996, 'General discussion' in Larsen, R. (ed) *ENVIRONMENT Leather Project, Deterioration and Conservation of Vegetable Tanned Leather*, Research Report 6, European Commission, 167–186.

Larsen, R, Vest, M and Calnan, C, 1994, 'Materials' in R Larsen (ed.), *STEP Leather Project*, Research Report 1, European Commission, 11–30.

Larsen, R, Wouters, J, Chahine, C, Brimblecombe, P and Calnan, C, 1996, 'Recommendations on the Production, Artificial Ageing, Assessment, Storage and Conservation of Vegetable Tanned Leather' in R Larsen (ed.), *ENVIRONMENT Leather Project*, Research Report 6, European Commission, 189–200.

Mole, S and Waterman, P G, 1987, 'A critical analysis of techniques for measuring tannins in ecological studies, I. Techniques for chemically defining tannins,' *Oecologia* (Berlin) 72, 137–147.

Porter, L J, 1992, 'Structure and chemical properties of the condensed tannins', in R W Hemingway and P E Laks (eds.) *Plant Polyphenols, Synthesis, Properties, Significance*, New York and London, Plenumpress, 245–258.

Poulsen, D V, 2000, 'A study of the role of tannins in the deterioration of vegetable tanned leather', School of Conservation, The Royal Danish Academy of Fine Arts, Masters thesis, unpublished.

Roux, D G, 1992, 'Reflections on the chemistry and affinities of the major commercial condensed tannins in the context of their industrial use', in R W Hemingway and P E Laks (eds.) *Plant Polyphenols, Synthesis, Properties, Significance*, New York and London, Plenumpress, 7–42.

Roux, D G, Ferreira, D, Hundt, H K L and Malan, E, 1975, 'Structure, stereochemistry and reactivity of natural condensed tannins as basis for their extend industrial application', *Applied Polymer Symposium* 28, 335–353.

Tang, H-R, Hancock, R A and Covington, A D, 1992, 'Study of the composition and structure of commercial chestnut tanning agent', in R W Hemingway and P E Laks (eds.) *Plant Polyphenols, Synthesis, Properties, Significance*, New York and London, Plenumpress, 221–243.

Waterman, P G and Mole, S, 1994, *Analysis of Phenolic Plant Metabolites. Methods in Ecology*, Oxford Blackwell Scientific Publications.

Wouters, J, 1993, 'Tannin and ion analysis of 20 historical and 2 artificially aged leathers' in R Larsen (ed.), *STEP Leather Project*, Second Progress Report, not published, 175–189.

Wouters, J, Bos, M V, Clayes, J, Oostvogels, A, 1996, 'Analysis of tannins, sulphate, moisture and ash of leather treated or produced for conservation purposes,' in R Larsen (ed.), *ENVIRONMENT Leather Project*, Research Report, European Commission, 103–112.

Natural history collections

Collections d'histoire naturelle

Colecciones de historia natural

Natural history collections

Coordinator (temporary): Christine Del Re, Milwaukee Public Museum, E-mail: delre@mpm.edu
Assistant Coordinator (temporary): Dries van Dam, Leiden Museum of Anatomy, E-mail: a.j.van_dam@lumc.nl

Natural history has formed the foundation of most of the historic museums developed in the late 19th century and early 20th century, in response to the public fascination with the natural physical and biological world. Owing to the long held perception in museological circles that these collections were stable, either in the form of taxidermied specimens or in alcohol storage media, little attention was given to the issues of decay by conservators. More recently, there has been an increasing awareness of the wider conservation issues associated with the decay of ethnographic materials and this highlighted the lack of detailed knowledge about the causes of decay of the collections of the natural environment. Most conservators dealing with the problems of decaying natural history collections are so short-staffed and starved of resources that it is difficult for them to find time to write definitive papers and to actively participate in the ICOM-CC program.

The single natural history paper presented to this Triennial Meeting has been included not only because it is a significant contribution in its own right, but also because the ICOM-CC Directory Board does not want to see this vital group fall into an inactive state. The problems of conserving natural history collections are an ever-increasing threat to the long-term survival of our shared cultural heritage. I have pleasure in commending this Working Group to you and inviting you to become an active member of it.

Ian MacLeod, member, ICOM-CC Directory Board
E-mail: ian.macleod@museum.wa.gov.au

Abstract

A pilot study of the 'petrified' forests of Lésvos Island and Kastoría and the use of a non-destructive method for identifying and measuring soluble salts contained in material found on both sites are presented here. This method is based on the application of neutral paper pulps impregnated in de-ionized water on some trunks. The study includes monitoring environmental conditions, macroscopic examination and mineralogical study of fossils. Based on climatological data, the period when frost action and temperature variations occur was determined. The results indicate that, on Lésvos Island, there is an extensive problem of deterioration due both to the crystallization of soluble salts and frost action during the winter. At the Kastoría site there is deterioration caused by frost action during the months of December to February, the crystallization of soluble salts and biological depositions.

Keywords

petrified forests, corrosion, deterioration, soluble salts crystallization, frost action

Figure 1. Map of Greece with the areas of Lésvos (1) and Kastoría (2)

Figure 2. Fossilized trunk from Lésvos

The corrosion phenomena in fossilized trees: a case study of fossil forests in Kastoría and on the island of Lésvos, Greece

V. Lampropoulos,★ G. Panagiaris
Technological Educational Institute of Athens
Department of Conservation of Antiquities and Works of Art
Ag. Spyridonos str.
12210 Egaleo, Greece
E-mail: blabro@teiath.gr, gpanag@teiath.gr

E. Velitzelos
University of Athens
Department of Geology
Sector of Historical Geology/Palaeontology
Panepistimioupoli
15784 Athens, Greece
E-mail: velitzel@geol.uoa.gr

Introduction

The fossilized forest of Lésvos (see map, Figure 1), dated to 20 million years ago, is located in the northwestern part of the island, and according to recent research it occupies half of the area defined by an imaginary line between Molyvos and Plomari. It is one of the most important natural sites in Europe (see Figure 2), and a national museum exhibit will be created soon in Sigri (Velitzelos et al. 1978, 1981a, 1981b, 1997) . The fossilized forest of the Kastoría region (see map, Figure 1) is 20 to 22 million years old and covers an extended area in the regions of Nostimo and Asproklisia. The fossilized trunks are in rather uncompacted sediments and the degree of fossilization is both partial and complete (see Figure 3). Because of the great importance of these natural features, an ongoing study aimed at their conservation, protection and publicity is needed. The deterioration affecting the fossilized forest material stems mainly from the crystallization of soluble salts, temperature variations and frost.

Soluble salts are a major factor in the deterioration of stone material and fossils (Torraca 1988, Lampropoulos 1993, Child 1994), particularly the actions of sodium chloride and sodium sulphate, which under varying temperature and humidity conditions, are crystallized in the pores of the material and thus cause mechanical stresses. The action of such soluble salts is very decisive for porous materials like fossils (Amoroso and Fasina 1983, Child 1994).

Soluble salts that enter the pores of the material are mostly chlorides and sulphates, but may also be the carbonates, nitrates and nitrites of alkalis and alkaline earths. Their provenance (Lampropoulos 1993, Child 1994), in the case of fossilized/petrified forests, may be:

- The sea, where the percentage of sodium chloride is 3.5% w/v, and in non-polluted sea water, in which the ratio of sulphate ions to chloride ions is around 0.139. For distances of about 15 km away from the sea, salts can be transported by saltspray phenomenon.
- Underground water, where soluble salts rise through capillary action from underground rock, carrying along through the soil the soluble components (particularly in silica rock but other rock as well, containing diluted salts in various concentrations; see Table 1).
- Possible contact with structural materials or mortars, i.e. cements, which are major sources of soluble sulphates, carbonates and silicate salts. In addition, contact of the fossilized material with cement, i.e. from fillings of missing parts, may cause a flow of sulphate salts into the pores of the material.

The most common soluble salts that may form efflorescences on the surface and circulate in the pores of the fossilized material (Wheeler 1993) are presented in Table 2.

★Author to whom correspondence should be addressed

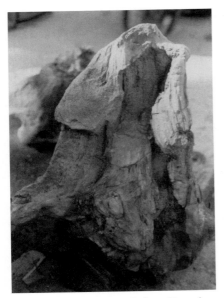

Figure 3. Fossilized trunk from Kastoría

Table 1. *List of ions of several soluble salts found in underground water*

- sodium (Na$^+$)
- potassium (K$^+$)
- magnesium (Mg^{2+})
- calcium (Ca^{2+})
- sulphates (SO$_4{}^{2-}$)
- carbonates (CO$_3{}^{2-}$)
- chlorides (Cl$^-$)
- silicates (SiO$_3{}^{2-}$)

Table 2. *The most common soluble salts that may form efflorescences*

- sylbite	KCl
- pikromerite	K$_2$Mg(SO$_4$)$_2$.6H$_2$O
- sygenite	K$_2$Ca(SO$_4$)$_2$
- glasserite	(Na,K)$_2$SO$_4$
- polyalite	K$_2$Ca$_2$Mg(SO$_4$)$_4$.2H$_2$O
- arkanite	K$_2$SO$_4$
- halite	NaCl
- nitratite	NaNO$_3$
- thermonatrite	Na$_2$CO$_3$.H$_2$O
- natrite	Na$_2$CO$_3$.10H$_2$O
- tenardite	Na$_2$SO$_4$
- mirabilite	Na$_2$SO$_4$.10H$_2$O
- nitrocalcite	Ca(NO$_3$)$_2$.4H$_2$O
- antarkticite	CaCl$_2$.6H$_2$O
- gypsum	CaSO$_4$.2H$_2$O
- bassanite	CaSO$_4$.1/2H$_2$O
- nitromagnesite	Mg(NO$_3$).6H$_2$O
- hydromagnesite	Mg$_5$(OH(CO$_3$)$_2$)$_2$.4H$_2$O
- astrakanite	MgSO$_4$.Na$_2$SO$_4$.4H$_2$O
- magnesite	MgCO$_3$
- kieserite	MgSO$_4$.H$_2$O
- neskeonite	MgCO$_3$.3H$_2$O
- epsomite	MgSO$_4$.7H$_2$O
- bissofite	MgCl$_2$.6H$_2$O
- kalikinite	KHCO$_3$
- ammonium nitrate	NH$_4$NO$_3$
- hexadrite	MgSO$_4$.6H$_2$O
- nitre	KNO$_3$

When dilution of various salts happens in the pores of a porous material, in saturation or over-saturation point conditions, these salt crystals start to form inside the pores. These crystals increase in volume, as they are supplied by continuous dilution in the capillary network, and thus impose pressure and stress on the pore walls. As this pressure and stress increases, the larger the relation will be between the existing salt concentration and its concentration of saturation, as shown in the formula:

$$P = (R \cdot T / Us) \cdot \ln(C/Cs)$$

Where:
P = crystallization pressure in Atms
R = constant of noble gases which equals 0.082 lt·atm/mole·grad
T = absolute temperature in °K
Us = molecular volume of solid salt in lt/mole
C = present concentration of the salt in moles/lt
Cs = concentration of the saturated salt moles/lt

Sodium sulphate that comes into contact with water, inside the pores of the material, at 32.4 °C is transformed from rhombohedric tenardite into monoclinic mirabilite, according to the following reaction:

$$Na_2SO_4 + 10H_2O \ (\ Na_2SO_4 \cdot 10H_2O\)$$

At this time there is a corresponding volume increase of 308%, while in the atmosphere this transformation happens at a lower temperature and the maximum of mechanical stresses and pressures occur at 20 °C (Amoroso and Fasina 1983, Lampropoulos 1993). The volume increase that follows the above-mentioned transformations produces great mechanical stresses in the pores, many times greater than the material's resistance, thus resulting in surface fractures and degradation of the material.

Chloride alkali or alkaline earth salts, due to their greater mobility in relation to sulphate and carbonates, penetrate the pores of the material where they crystallize and loosen many crystalline structures. They also cause 'digestion', i.e. the dilution of colloidal parts of clays in water, and thus facilitate the dilution of magnesium, which originates from the material.

The deposition of insoluble salts (siliceous, carbonate and sulphate salts) on the fossil's surface, besides causing aesthetic alteration of the material, also creates mechanical stresses on the conduction area by contraction/expansion, thus leading to degradation of the material.

Exposure in open air also may cause degradation of the petrographic material. Under certain conditions of temperature and humidity, soluble salts inside the pores are crystallized, thus resulting in mechanical stresses and fractures, according to the previously mentioned mechanisms (see Figure 4).

Finally, frost damage, with the increase of the volume of the water about 9.2% and from fluid to solid state and temperature variations, creates mechanical stresses in the porosity of the material.

Objective

The present paper describes the continuing search for non-destructive methods for determining the presence and crystallization of soluble salts in the petrographic material of the fossilized forests of Lésvos and Kastoría, so that a conservation strategy can be developed and a program of action established to protect this material. The development of non-destructive methods of determining the degree and parameters of degradation/deterioration of monuments of our natural heritage is considered to be of critical importance for their effective management. An extensive list of accurate identification methods of susceptible minerals has been presented (Howie 1992).

Materials and methods

The presence of soluble salts in the petrographic material of the Lésvos and Kastoría fossilized forests was determined by the application of neutral paper pulps wetted

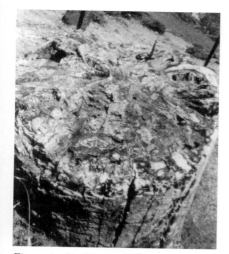

Figure 4. Cracking and alveolar corrosion due to crystallization of the soluble salts in the material of the fossilized forest

in de-ionized water in various surfaces for one hour, and by analysing the absorbed ions of chloride (Cl⁻) and sulphate (SO_4^{2-}). This was done in the Inorganic Chemical Analysis Laboratory, Food Technology Department, of the Technological Educational Institute (TEI) in Athens. Measuring the specific electrical conductivity of the obtained samples and solutions was done in the laboratory of Conservation of Ceramics/Glass-Organic Materials, Department of Conservation of Antiquities and Works of Art, at the TEI.

The above-mentioned procedure was applied to four different random samples from the area of Sigri-Lésvos and from the area of Nostimo-Kastoría (see Tables 3 and 4). In addition, climatological data of the area were gathered and diagrams of temperature and relative humidity were prepared to show the areas of soluble salt crystallization and the presence of frost (Figures 5, 6, 7 and 8).

Analysis of the fossilized material

The relatively high porosity (three samples: 19.56 mm³/gr, 19.24 mm³/gr, 26.6 mm³/gr) of the petrographic material of the fossilized forest of Lésvos (Lampropoulos et al. 1997, 1999a) favours the penetration and crystallization of soluble salts in the

Table 3. Results of chemical analysis in paper pulps from fossilized trunks of Sigri-Lésvos

I/n	Cd (is/cm²)	Cl⁻ (ppm)	SO_4^{2-} (ppm)
Sample 1	204	20,5	4,5
Sample 2	258	30,5	5,5
Sample 3	153	31,5	6
Sample 4	219	16	3,5
Sample 5	5	1	0

Table 4. Results of chemical analysis in paper pulps from fossilized trunks of Nostimo-Kastoría

I/n	Cd (is/cm²)	Cl⁻ (ppm)	SO_4^{2-} (ppm)
Sample 1	122	12,5	1,2
Sample 2	135	19,5	1,7
Sample 3	96	21	1,3
Sample 4	127	8,5	0,9
Sample 5	5	1	0

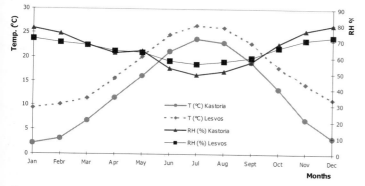

Figure 5. Diagram of mean temperature and relative humidity per month of Lésvos and Kastoría region for the period from 1955 to 1997

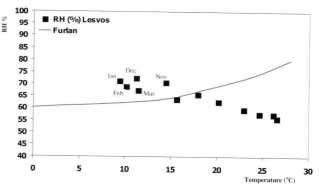

Figure 6. Furlan diagram of fossilized forest of Lésvos, and combination points between temperature and relative humidity per month during the years 1955-1997. Every point represents a different month

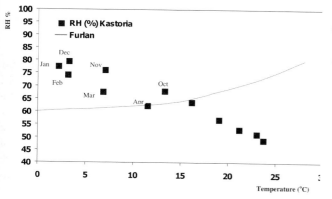

Figure 7. Furlan diagram of fossilized forest of Kastoría and combination points between temperature and relative humidity per month during the years 1955-1997. Every point represents a different month

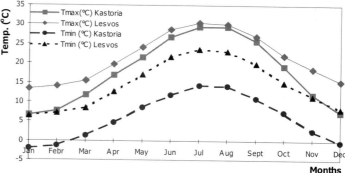

Figure 8. Diagram of average maximum and average minimum temperature per month of Lésvos and Kastoría region for the period 1955-1997

structure of the material. The same material shows, in several areas, relatively high degree of hardness (7-8 Mohs) (Lampropoulos et al. 1997, 1999a), with corresponding great sensitivity. It also consists of various different minerals, such as quartz, tridymite and cristobalite (Lampropoulos et al. 1997, 1999a), which results in discontinuities in the structure and the formation of cracks from the mechanical stresses caused by the crystallization of soluble salts.

In the case of petrified forest of Kastoría, tests were done on seven samples to determine the physico-chemical properties and analyze the structure of the material (SEM, XRD, optical microscopy, chemical analysis, water absorption, porosity and hardness). The samples consist of 95% SiO_2, which is mostly accounted for by the presence of quartz and tridymite. There are also small quantities of oxides of Fe, Al, K, Na, Ti, Ca, Mg and Mn. The porosity of the samples is between 0.85%-15.77% and their hardness is between 6-7 Mohs (Lampropoulos et al. 1999b).

The macroscopic study of the fossilized tree-trunks showed a pattern of alveolar corrosion of many parts of the surface, as well as a large number of fractures. Analyses of the four samples/solutions from Sigri-Lésvos (obtained by the application of neutral paper pulps wetted in de-ionized water on the tree-trunks of the fossilized forest) measured the specific electrical conductivity (cd) of chloride ions (Cl^-) and sulphate ions (SO_4^{2-}) and gave the results shown in Table 3.

Sample 5 (with de-ionized water) was used as a comparison with the other results of the study. From Table 3, it is clear that significant quantities of soluble chloride and sulphate salts exist on the surface and pores of the material from the fossilized forest of Lésvos. These diagrams were correlated with the V. Furlan diagram to establish the areas of crystallization of sodium sulphate for each month of the year during the period 1955-1997. Finally, the frost damage is not present, as shown in the previous diagrams. Temperature variations, which are present (shown in the previous diagrams), create mechanical stresses in the porosity of the material.

Analyses of the four samples/solutions from Nostimo in Kastoría (obtained by applying neutral paper pulps wetted in de-ionized water on the tree-trunks of the fossilized forest near to the soil) measured the specific electrical conductivity (cd) of chloride ions (Cl^-) and sulphate ions (SO_4^{2-}) and gave the results shown in Table 4.

Summary and conclusions

The action of soluble salts is obvious by the macroscopic observation of the alveolar corrosion pattern in many parts of the surface of the fossilized tree-trunks. Also, the presence of soluble salts is apparent by the presence of chloride and sulphate ions on the surface and in the pores of the fossilized forest material. Their crystallization and their actions are shown in the V. Furlan diagrams, for all months of the year during the period 1955-1997.

In the diagrams, in the case of fossilized forest of Lésvos, it is shown that during the months January, February, March, November and December, most plotted dots (combinations of temperature and relative humidity) fall over the curve and, therefore, crystallization of sodium sulphate occurs during these months in the pores of the material. And there are cracks in most of the tree-trunks in the fossilized forest of Lésvos, which are due to physical disintegration along the wood rays but also to human intervention, which multiplies the above phenomena.

The transportation of soluble salts in the material of the Lésvos fossilized forest occurs from the saltspray phenomenon. The relatively high porosity of the petrographic material from Lésvos (Lampropoulos et al. 1997, 1999a) encourages the penetration and crystallization of soluble salts in the structure material of the fossilized forest.

The same material shows, in several parts, a relatively high degree of hardness (Lampropoulos et al. 1997, 1999a) fact, which results in great sensitivity. It also consists of various different minerals (quartz, tridymite, cristobalite) (Lampropoulos et al. 1997, 1999a), the result being discontinuities in the structure and the formation of cracks from the mechanical stresses caused by crystallization of the soluble salts.

In the case of the Kastoría fossilized forest, the action of soluble salts is mainly obvious by macroscopic observation of the alveolar corrosion pattern in many parts of the surface of the tree-trunks from the fossilized forest. The presence of

soluble salts is also apparent by the presence of chloride and sulphate ions on the surface and in the pores of the material of the fossilized forest material. Their crystallization and their actions are shown in the V. Furlan diagrams, for all months each year during the period 1955-1997.

The diagrams show, for the fossilized forest of Kastoría, that during the months January, February, March, April, November and December, most plotted dots (combinations of temperature and relative humidity) fall over the curve and, therefore, crystallization of sodium sulphate occurs during these months in the pores of the material. Also, the presence of the frost damage and biological organisms was observed, mostly lichens and moss, as well as the presence of cracking possibly caused by the frost action. It is also possible that soluble salts are transferred by the capillary rising.

The relatively high porosity of the petrographic material of the Kastoría fossilized forest (Lampropoulos et al. 1999b) favours the penetration and crystallization of soluble salts in the structure of the fossilized material.

The same material shows in several areas relatively high hardness (Lampropoulos et al. 1999b), which results in a great sensitivity. And, as noted above, it also consists of various minerals, such as quartz and tridymite (Lampropoulos et al. 1999b), which results in discontinuities in the structure and the formation of cracks from the mechanical stresses caused by the crystallization of soluble salts.

Based on these results, the need for a plan for the conservation and protection of the tree-trunks of these fossilized forests is obvious and essential. It should be a plan solidly based on the detailed study of the materials and methods required for necessary interventions. Specific actions should become a priority in the general presentation policy of the fossilized forests of Lésvos and Kastoría.

Acknowledgements

The authors of this paper would like to thank Dr. S. Tzimas, chemist, of the Department of Food Technology at the TEI of Athens, and A. Vossou, I. Tsamasfyrou, D. Bika and I. Karatasios, conservators of antiquities and works of art, for their technical support in the design and application of the research procedures followed.

References

Amoroso, G G, and Fasina, V, 1983, *Stone decay and conservation*, Elsevier

Child, R E, 1994, ' Salt efflorescence and damage', *Conservation of geological collections*, Archetype publications Ltd, London, pp. 18-22.

Howie, F M, 1992, *The Care and Conservation of Geological Material*, Butterworth-Heinemann, London.

Lampropoulos, V, 1993, *Corrosion and Conservation of Stone*, Athens.

Lampropoulos, V, Panagiaris, G and Velitzelos, E, 1997, ' Deterioration aspects of petrified material from the fossilized forest of Lésvos, from frost damage and soluble salts', *Second International Symposium: Monuments of Nature and Geological Heritage*, Lésvos, Greece, June/ July, 1997.

Lampropoulos, V, Panagiaris, G and Velitzelos, E, 1999a, ' Methods used for the determination of soluble salts in the material of fossilized trees, case study of the fossilized forest on Lésvos Island', *Sixth International Conference: Non-Destructive Testing and Microanalysis for the Diagnostics and Conservation of the Cultural and Environmental Heritage*, Rome, pp. 1825-1837.

Lampropoulos, V, Panagiaris, G, Tsamasfyrou, I, Bika, D and Velitzelos, E, 1999b, ' Protection study of the material of the fossilized forest of Kastoría', *International Congress: Protecting natural sites and environmental education, Sigri-Lésvos Island*, Lésvos, Greece, September 1999.

Torraca, G, 1988, *Porous building materials*, ICCROM, Rome.

Velitzelos, E and Symeonidis, N, 1978, ' Der verkieselte Wald von Lésvos (Griechenland) ein Naturschutzebiet', *Vortag - Kurzfassung beim Arbeitskreis Paleobot. Palynol.*, pp. 17-19.

Velitzelos, E, Petrescu, I and Symeonidis, N, 1981a, ' Tertiare Pflanzenreste von der agaischen Insel Lésvos (Griechenland)', *Cour. Forsch. Inst. Senckenberg* 50: 49-50.

Velitzelos, E, Petrescu, I and Symeonidis, N, 1981b, ' Tertiare Pflanzenreste aus Agais, Die Makroflora der Insel Lésvos (Griechenland)', *Ann. Geol. Pays Hellen* 30: 500-514.

Velitzelos, E and Zouros, N, 1997, ' The Petrified forest of Lésvos – Protected Natural Monument', *Proceedings of International Symposium on Engineering Geology and the Environment*, Athens, pp. 3037-3043.

Wheeler, G S and Wypyski, M T, 1993, ' An Unusual Efflorescence on Greek Ceramics' in *Studies in Conservation* 38: 55-62

Stone

Pierre

Piedras

Abstract

The petrographic analysis of the marble is an important part of the effort to preserve a Roman sarcophagus. The studies were initiated to provide physical confirmation of the provenance and also to locate a source for analogous modern samples necessary for further tests. Isotopic ratio analysis and examination of the original marble strongly suggest that it comes from the Greek island, Thasos. Both the ancient sample and marble recently quarried from the island for comparison were found to be dolomitic, essentially granoblastic, with very limited porosity and a high degree of water repellence. The acquisition of modern samples with properties virtually identical to the ancient stone has made it possible to design a testing protocol that will determine the rate of surface loss, the effectiveness of proposed treatments and the requirements for optimum exhibition of the artefact in the future.

Keywords

marble, petrographic analysis, physical properties, porometry

The Nine Muses Roman sarcophagus at Hearst Castle: Identification of the geological provenance and characterization of the marble during the first phase of conservation

Todor Marinov
Department of Mineralogy and Petrography
University of Mines and Geology, St. Ivan Rilski
Studentski grad, Sofia 1700, Bulgaria
E-mail: tmarinov@mail.mgu.bg

Zdravko Barov★
ETHOS
PO Box 1641, Cambria, California 93428, U.S.A.
E-mail: ethos@thegrid.net

Introduction

The sarcophagus titled *Nine Muses* was purchased in 1910 by American newspaper magnate, William Randolph Hearst. Formerly in the collections of Palazzo Sciarra and Palazzo Barberini, it is considered one of the finest examples of Roman funeral sculpture (see Figure 1). The front of the white marble sarcophagus is carved in high relief, depicting Apollo and Athena flanked by the Nine Muses. Apollo's head is a portrait of the deceased (a young man) and dates the sarcophagus between AD 240 and AD 270. There is also a rare instance of surviving original painted detail on a side scene portraying Odysseus (see Figure 2).

The sarcophagus was placed in the gardens of Hearst's estate in San Simeon, California, in the early 1920s. It has remained there until the present, largely because the State of California (which now officially administers the property) acquired the San Simeon estate with the mandate that everything be preserved as it was during Hearst's tenure. Although the climate in this area is relatively mild and the air quality quite good, the Castle administration has naturally been concerned for some time that continuing to display the sarcophagus out of doors is harmful for it. One of the goals in developing an effective program to preserve the *Nine Muses* is to achieve a balance between various (seemingly competitive) requirements: the physical needs of the artefact itself, the need to honour its history and the obligation to maintain accessibility within an authentic context.

The petrographic studies were initiated to provide information regarding the physical profile of the stone, the condition of its surface and the provenance of the sarcophagus. Finding the place of origin also makes it possible to obtain suitable samples on which to perform the tests necessary for the development of optimum conservation and exhibition strategies.

Figure 1. The Nine Muses *sarcophagus, Hearst San Simeon State Historical Monument*

Figure 2. Detail of the ancient paint that remains on the side of the Nine Muses *marble sarcophagus*

★Author to whom correspondence should be addressed

Table 1. Chemical composition of the samples

Samples	Contents [%weight]												
	SiO_2	Fe_2O_3	TiO_2	Al_2O_3	MnO	CaO	MgO	Na_2O	K_2O	P_2O_5	SO_3	CO_2	Water at 105°C
Ancient, M-1	4.2	<0.05	<0.05	0.04	<0.01	30.50	19.61	<0.10	<0.10	<0.05	<0.05	46.71	0.09
Modern, M-2	6.5	<0.05	<0.05	0.05	<0.01	28.80	17.74	0.10	<0.10	<0.05	<0.05	46.74	0.03

Table 2. Mineralogical composition of the samples

Samples	Contents [weight %]								
	Dolomite	Calcite	Quartz	Muscovite	Plagioclase	Graphite	Apatite	Zircon	Titanite
Ancient, M-1	86	11	2		1			traces	
Modern, M-2	85	10	4		1			traces	

Petrographic analysis

Isotope ratio analysis was the first procedure employed in the search to identify the site from which the marble initially was quarried. A sample obtained from the underside of the sarcophagus was examined at the Center for Archaeological Sciences at the University of Georgia (Herz 2000). The isotopic results were analyzed by a least-squares program that compared the values obtained from the *Nine Muses* marble to the Classical Marble database. The results strongly indicate that the stone comes from Thasos, a northern Greek Aegean island known to have been an important marble source in ancient times (Herrmann and Barbin 1993, Kozelj and Wurch-Kozelj 1992). All subsequent petrographic and physical analysis was thus carried out on the original sample from the sarcophagus (M-1) and on a specially selected specimen from Thasos (M-2). The modern sample was chosen after examining the colour, structure and textural features of marble from three different outcrops distributed across the island's marble horizon.

Mineral composition of the marbles

Thin sections of the samples were examined with a polarizing microscope. Induced coupled plasma–atomic emission spectroscopy (ICP-AES) and X-ray phase diffraction were used for the chemical analysis. Quantitative calculation of the minerals was made according to the cation count method (Bilbija 1984).

The two marbles proved to be quite similar with regard to their mineral and chemical composition (see Table 1 and Table 2). The proportions of the minerals vary between the two marbles by only 1%. Both specimens are defined as dolomitic, essentially granoblastic (the heteroblastic element is insignificant), milk-white in colour, fine-grained, very compact, with a porcelain appearance. The whiteness of the marbles, conditioned by the presence of pure and clear carbonate minerals, can be explained by a process of 'self-purification' from admixtures, including from graphite aggregates, that took place at the time of recrystallization during metamorphism.

The mineral composition of each includes dolomite, calcite, quartz, muscovite, plagioclase and graphite. The specific components identified in the ancient marble (M-1) are as follows.

Dolomite constitutes 86% of the total. It generally presents as slightly elongated grains with curved contours, although fragments with rhombic cross-sections are also present. The cleavage is perfect. The mineral structure is dynamogenic-lamellar. The grain size varies between 0.25–0.5mm × 0.6–1.0mm, the prevailing size being 0.3–0.5mm × 0.6–0.8mm. A limited quantity of smaller (0.05–0.1mm), subisometrically shaped grains is irregularly distributed in the basic rock. In addition to polysynthetic twins, slide twins and, rarely, twist twins can be observed. The relationships between the twins (intersection and displacement) allow identi-

fication of two stages of deformation that occurred in the course of regional metamorphism. Although in certain dolomite aggregates the presence of cataclastic microcracks (two sets of mutually perpendicular cracks with cracks located diagonally to them) can be related to postmetamorphic deformations, they may also indicate the mechanical deformation that almost always accompanies recrystallization during regional metamorphism. When (as in this case) these irregular, interrupted cracks are seen with slide surfaces between individual grains or grain aggregates, the combination may be viewed as a distinguishing characteristic of those minerals (such as dolomite and calcite) that are susceptible to the mechanical stresses due to the processes of metamorphism.

Calcite is a subordinate part of the rock composition, comprising 11%. The grains are clear, mainly isometric, ranging in size from 0.3 mm to 0.6 mm. Some of them have a lamellar structure. Calcite grains are occasionally enclosed in the dolomite grains. This petrostructural relationship was formed during the course of dolomite recrystallization during metamorphism, when the partially enlarged dolomite grains enclosed the smaller ones, including calcite. It accounts for the sporadic presence of porphyroblasts and, in general, it is this largely preserved equigranular composition of the marble that determines the good physico-mechanical properties of the stone.

Quartz, muscovite, plagioclase and graphite are relatively insignificant in the composition of the marble. Quartz is encountered in the form of small grains (0.05–0.08 mm × 0.15 mm–0.3 mm), with rounded or slightly elongated contours. Muscovite is present in small scales, 0.2 mm–0.3 mm long, that are often oriented parallel to one another. Plagioclase, rarely observed, is in the form of elongated crystals, classified by its composition as labrador. Graphite occurs as fine, dust-like aggregates dispersed within the rock in so minimal a quantity that it has no effect on the colour of the marble. The trace minerals apatite, zircon and titanite are also present. No minerals subject to change after oxidation and hydration (such as sulphides and ferromagnesian silicates) were identified.

Physical properties

Investigation into the physical properties of the two marbles revealed further similarities (see Table 3). In addition to basic characterization of the stone, this area of analysis was also pursued to provide data for the sound interior marble that eventually could be compared with those obtained from surface stone for evaluation of the extent of weathering and the feasibility and type of consolidation.

Characteristics of the matrix

Density: The mass was determined by weight and the volume by the geometric method, as well as by hydrostatic weighing in fluid (kerosene). The results show that the ancient rock is very compact. The volume/density ratio is 2.73 g/cm³. The mineralogical density has an approximate value of 2.74 g/cm³. The modern sample is even more compact with equal volume and mineralogical densities of 2.79 g/cm³.

Table 3. Characteristics of the matrix

Category	Unit	Value	
		Sample from 9 Muses (M-1)	Sample from Thasos (M-2)
Density (by volume and mineralogical)	gr/cm³	2.73/2.74	2.79/2.79
Specific surface	m²/gr	0.27	0.087
Wettability		hydrophobic	hydrophobic
Porosity	%	1.2	0.87
Filtration properties	m² (md)	<1E-18 <0.001	<1E-18 <0.001
Acoustic sounding	m/sec	6400	6400

Specific surface: The specific surface of both samples is extremely low. The values were determined by numerical calculations based on the data from mercury porometry tests. The figures (0.27 m²/g and 0.087 m²/g) confirm that the marbles are highly compact and almost non-porous.

Wettability: The wettability was evaluated according to four levels of classification (A, B, C and D), where A is highly hydrophilic and D is highly water-repellent. The tested rock samples exhibit well-expressed water-repellent behaviour, similar to that of rocks containing hydrocarbon fluids such as oil or bitumen. Since the sample marbles do not contain this type of agent, we assume their water-repellent properties were acquired during long-term exposure to air containing hydrophobic agents that were adsorbed to some degree in the active centres of the rock surface. It is possible that water-repellent materials also were introduced during the various processes of the carving, such as shaping with abrasives, polishing and so on. Because of the very small size of the original sample, the marble could be only provisionally classified as having C degree of wettability.

Porosity: The porosity was determined by saturation with a wetting fluid (kerosene, chosen because of its penetrability) and saturation with a non-wetting fluid (mercury, injected at a pressure of 200 MPa). The pore volume and porosity coefficient were calculated by weighing the mass before and after saturation. The absolute volume is the sum total of the volumes of open and closed pores. The coefficient expresses the total volume of interconnected pores. Observation and tests reveal the very low porosity of the two samples, the result of highly intensive compaction accompanied by recrystallization. The concrete value for the ancient marble is 1.20%, versus 0.78% for the modern sample. Both values are typical of a rock class with extremely limited porosity. Because of the impossibility of obtaining sufficiently high saturation with the wetting agent, the porosity determined by that method (0.8% and 0.6%) is slightly lower than the results obtained by mercury injection. The latter were accepted as correct.

Filtration: The filtration properties were studied by stationary mass transfer (air phase) under conditions of stabilized inlet and outlet pressure. The permeability coefficient was calculated according to data from the volume of filtrated gas phase. The highly limited filtration properties (again the result of recrystallization and compaction) inevitably increase the error range, which is estimated at between 10% and 20%. The permeability coefficient, as determined by Darcy's Law, is less than 10^{18} m² (less than 0.001md). This classifies the stone as practically impermeable when calculated for the conditions of these tests, i.e. with an inert gas. The stone would be classified as completely impermeable by fluids with a viscosity higher than water.

Acoustic sounding: Acoustic sounding was carried out to determine the passing velocity of the longitudinal waves for integral assessment of the matrix. The tests were performed using equipment with a measuring accuracy of 0.01 microsecond. The results are typical of compact, low-porosity, high velocity media. In sample M-1, the velocity in a dry state is 4190 m/sec. The modern sample shows some acoustic anisotropy in the dry state. In one direction, the acoustic wave has a velocity of 3850 m/sec. Perpendicularly, the speed is somewhat lower, 3100 m/sec. In the state of saturation, the velocity is close to 6400 m/sec for both samples, without substantial differences regarding direction.

Characteristics of the pores

The pores were characterized by two basic methods: instrumental (mercury porometry) and microscopic (visual assessment of specially prepared thin sections.) The mercury porometry tests were performed on an apparatus with mercury injection terminal pressure of 200MPa (2000atm), which allows diagnosis of pores with a conditional radius less than 0.001 microns and up to a maximum value of 50 microns. Using the instrumental data, integral and differential (histogram) distribution curves were constructed with an assumed regular alteration interval for the pore radius logarithm (see Table 4). Important qualitative characteristics were assessed microscopically, including morphology, genetic relationship, formation mechanism, dimensions, axes ratio, regularity of presence in the area, etc. Considering these data in combination with those from

Table 4. Character of the pores

Characteristic Parameter	Sample from sarcophagus [M-1]		Recent sample from Thasos [M-2]
	Total pore volume	Closed (blind) pores	
Minimum size of conditional radius (microns)	0.01	0.01	0.006
Maximum size of conditional radius (microns)	2.5	0.4	2.5
Type of distribution of channel groups	irregular, three-modal	close to left, asymmetrical	irregular, three-modal
Predominant channel group (size and percentage)	0.25-0.4; 17%	<0.016; 56.5%	0.16-0.25; 26.7% 1-1.6; 14.6%
Radius $R_{25\%}$ (microns)	0.016	0.014	0.045
Radius $R_{50\%}$ (microns)	0.037	0.015	0.27
Radius $R_{75\%}$ (microns)	0.25	0.045	0.7
Radius $R_{90\%}$ (microns)	0.37	0.18	1.5
Degree of heterogeneity of pore sizes	15.6	3.2	15.6
Percentage of pores with radius < 0.1 micron	61.7%	77%	29.4%

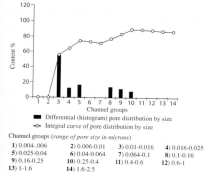

Channel groups (*range of pore size in microns*)

1) 0.004-.006　　2) 0.006-0.01　　3) 0.01-0.016　　4) 0.016-0.025
5) 0.025-0.04　　6) 0.04-0.064　　7) 0.064-0.1　　8) 0.1-0.16
9) 0.16-0.25　　10) 0.25-0.4　　11) 0.4-0.6　　12) 0.6-1
13) 1-1.6　　14) 1.6-2.5

Figure 3. M-1: Differential and integral distribution of the pores by size

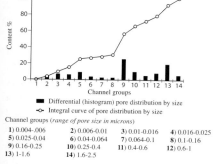

Channel groups (*range of pore size in microns*)

1) 0.004-.006　　2) 0.006-0.01　　3) 0.01-0.016　　4) 0.016-0.025
5) 0.025-0.04　　6) 0.04-0.064　　7) 0.064-0.1　　8) 0.1-0.16
9) 0.16-0.25　　10) 0.25-0.4　　11) 0.4-0.6　　12) 0.6-1
13) 1-1.6　　14) 1.6-2.5

Figure 4. M-1: Differential and integral distribution of the "blind" pores by size

Channel groups (*range of pore size in microns*)

1) 0.004-.006　　2) 0.006-0.01　　3) 0.01-0.016　　4) 0.016-0.025
5) 0.025-0.04　　6) 0.04-0.064　　7) 0.064-0.1　　8) 0.1-0.16
9) 0.16-0.25　　10) 0.25-0.4　　11) 0.4-0.6　　12) 0.6-1
13) 1-1.6　　14) 1.6-2.5

Figure 5. M-2: Differential and integral distribution of the pores by size

the instrumental injection method permits a more reliable interpretation of the porosity of the studied objects.

Qualitative: The main feature distinguished under microscope is the limited pore volume of the two marbles, the result of compaction and recrystallization. The pores are distributed unevenly and are genetically determined random residual spaces amid the building particles. They generally present as polyhedrons, with close ratios between the long and short sides. They are mainly intercrystalline in nature, with some connecting channels. The sizes of the observed pores are small, primarily within the range of 0.1 microns to 0.5 microns. Connecting channels are no more than fractions of a micron. No large pores were observed in either of the two marbles. A characteristic element is the presence of pores that are only unilaterally open (usually referred to as "blind"). These blind pores constitute 0.5% of the sarcophagus sample and are < 0.025 microns.

Quantitative: The data collected from the mercury-porometry tests permit more refined interpretation of the pores and the connecting channel structure. The sizes of the instrumentally identified voids are within the range of 0.006 microns to 2.5 microns. The smallest in the ancient sample measures 0.01 microns, whereas the minimum size recorded in the modern sample is 0.006 microns. The largest dimension for both samples is 2.5 microns. These values are typical of finely dispersed media.

The distribution of the pores in Sample M-1 has a complex character. The polymodal histogram distribution (see Figure 3 and Figure 4) is probably the result of the pores forming in several stages under varying conditions. Three relatively independent histogram sections can be discerned. The first comprises a range of up to 0.1 microns, the second, 0.1 microns to 1.0 microns and the third, >1.0 microns. This type of distribution typically has several predominant channel groups that correspond to each section. In this case, the predominant channel group of the second section (ranging between 0.25 microns and 0.40 microns) constitutes 17% of the total pore volume and is the only group of practical importance. The data for the modern sample are very similar (see Figure 5). The first section comprises pores with sizes ranging between 0.006 microns and 0.16 microns; the second, 0.016 microns to 0.6 microns; and the third, >0.6 microns. The most important channel groups are those of 0.16 microns to 0.25 microns, constituting 26.7%, and channels with sizes of 1.0 microns to 1.6 microns, constituting 14.6%.

Assessment of the heterogeneity in the pore structure was made on the basis of the ratio between the radii R75% and R25%. The pores in the two objects are highly non-homogeneous in size, having the same quantitative assessment: 15.6. Table 4 presents data on R25%, R50%, R75%, R90% as basic characteristic parameters determined by the integral porometry curve. Of interest in this case are the channels with sizes smaller than 0.1 micron, which are assumed to have the lowest non-decreasing saturation index. For the ancient sample, they constitute

62%; in the modern sample they were estimated to be 29.4%. However, the highly limited pore volume of the objects makes this result somewhat unreliable.

Capillary behaviour

A method of centrigfugation, which produces reliable and repeatable results, was applied to assess the behaviour of the samples under condition of saturation with liquid (kerosene). The optimal regime of centrifugation requires four increments of speed: 250, 500 and 1000 rpm, before reaching the final 5000 rpm, when the pressure reaches 1.2 MPa (12at). This value presupposes fluid ejection from channels 0.05 microns or larger in diameter. Of particular importance is the final non-decreasing saturation index. It was assessed both by centrifugation and on the basis of the data from the mercury porometry test. The index was found to correspond to the volume of pores having a size greater than 0.1 microns. (This volume was determined by the integral mercury porometry curve.) Due to the limited pore volume of the test samples, useful assumptions can really only be made in relation to the volumes of 'trapped' immovable liquid that create non-decreasing fluid saturation. The non-decreasing saturation index for the two objects is probably in the order of 80% to 95%.

Conclusions

As a result of stable isotope ratio analysis and the comparative assessment of petrographic and physical properties of the sarcophagus marble and a sample recently taken from Thasos Island, we can infer that the *Nine Muses* sarcophagus was carved from a marble block mined from Thasos, Greece. A high degree of similarity was established in a number of categories, including mineral composition, structural textural rock features and rock chemistry. The relatively insignificant differences can be explained if the following are taken into consideration: a) the marbles were mined by different mining methods approximately two millennia apart; b) the sarcophagus marble sample was taken from a processed (sculpted) rock block, whereas the modern was mined directly from the deposit; and c) chemical values were obtained from only one very small sample of the original rock and parametamorphic rocks, such as these, do not always have a constant composition in vertical and horizontal directions.

 This knowledge is useful from several points of view. Its art historical and archaeological worth is evident for establishing the provenance of this and similar objects, as well as furthering the study of ancient quarries, commerce routes, workshops and sculptors. It should be noted that although the stable isotope analysis and these studies indicate the sarcophagus marble comes from Thasos, there are similar marbles in the lands neighbouring present-day Greece that also are known to have been used for sculptures during the Roman Empire. A more detailed study of these formations could prove quite beneficial.

 Both the ancient and recently quarried marbles are essentially dolomitic and compact, with small pore size and low pore volume. According to the method proposed by Hirschwald (1912) and developed in Russia (Zaleskiy et al. 1941; Grigorievich 1976; Beliakov and Petrov 1977) for evaluating the durability of marbles, their mineral composition and structure classify them as weather-resistant and stable. The investigations into the pore structure and wettability of the original stone suggest that it probably will be impossible to obtain sufficiently deep infusion with consolidating agents.

 Finally, the data obtained in this study are critical for the development of an ethical and comprehensive conservation protocol. The value of identifying the source from which to obtain modern test samples that will behave virtually identically to the original cannot be overstated. These samples will be essential for determining the rate of loss of surface stone due to exposure to the elements, the effectiveness and compatibility of proposed consolidants and the suitability of reconstruction materials, without having to subject the ancient marble to unproven or generic approximations. When considered with the meteorological studies, this information is likely to provide the necessary impetus for placing the sarcophagus in a safer, climate-controlled environment.

Acknowledgements

The authors would like to thank Elena Kamburova, Georgi Bechev and Petar Stefanov at the University of Mines and Geology in Sofia; Hoyt Fields and Kirk Sturm at the Hearst San Simeon State Historical Monument; and Constance Faber of ETHOS.

References

Beliakov, B P, Petrov, V P, 1977, *Oblitsovochnij kamen I evo otsenka*, Moscow, Nauka, 140.

Bilbija, N, 1984, *Tehnicka Petrografija*, Beograd, Naucna Knjiga, 239.

Grigorievich, M B, 1976, *Evaluation of facing stone deposits during prospecting and exploration*, Moscow, Nedra, 152.

Hermann, J and Barbin, V, 1993, 'The exportation of marble from the Aliki quarries on Thasos: cathodoluminescence of samples from Turkey and Italy', *American Journal of Archaeology* 97(1), Boston, Archaeological Inst. of America, 91–104.

Herz, N, 2000, unpublished report, University of Georgia.

Hirschwald, J, 1912, *Handbuch der bautechnischen Gesteinsprufung*, Berlin, Gebrüder Borntraeger.

Kozelj, T and Wurch-Kozelj, M, 1992, 'Contrast between ancient and modern quarries of white marble in Thasos' in D Chamay, J and Zezza, F (eds.), *La conservation des monuments dans le bassin méditerranéen: actes du 2ème symposium international*, Geneva, Musee d'Art et d'Histoire, 69–87.

Kozhoukharov, D, 1994, 'Precambrian microphytofossils in the Kastro marbles from Thasos Island, Greece', *C.R.* 47(4), Sofia, Bulgarian Academy of Science, 65–68.

Papanicolau, P, 1986, *Precambrian in Younger Fold Belts*, Chichester and New York, Wiley.

Zachos, S, 1982, Geological Map of Greece [1:50,000], Thasos sheet.

Zaleskij, B V, Korsunskij, A I and Lapin V V, 1941, 'K voprosu o dolgovechnosti nekotoryh raznostey karbonatnyh porod', *Proceedings of the Institute for Geological Sciences* 84(27), Samarskoj Luki, 93–118.

Resumen

En esta investigación se realizó el análisis de la tobavolcánica de la fachada de un edificio del centro histórico en la ciudad de México, con el fin de determinar su composición, estado deconservación y procesos de alteraciones. Se realizaron análisis físicos, químicos, mineralógicos y ópticos, tales como la determinación del porcentaje de óxidos totales, microscopía óptica, difracción de rayos X y microscopía petrográfica. Los resultados obtenidos son la base para la planeación de una propuesta de conservación y restauración adecuada para este caso, así mismo puede llegar a ser utilizada como una metodología para abordar problemas similares.

Palabras claves

toba volcánica, roca ígnea, fachada, alteración, difracción RX, petrografía

Composición y alteración de la toba volcánica de la fachada de un edificio en el centro histórico de la ciudad de México

Laura Suárez Pareyón Aveleyra
Escuela Nacional de Conservación
Restauración y Museografía, INAH
Exconvento de Churubusco
Xicotencatl y General Anaya
CP 04120, México D.F., México
Fax: + 52 5-604-5163
E-mail: pareyonlaura@hotmail.com

El estado de conservación de una gran cantidad de monumentos y edificios del centro histórico de la ciudad de México, se ve gravemente afectado por la alteración que sufren los materiales pétreos que los constituyen, al enfrentarse a la acción conjunta de los agentes naturales de intemperismo; la contaminación ambiental, la cual en los últimos años ha ido en aumento y los hundimientos del terreno, característicos de esta zona.

En la actualidad es posible distinguir diferentes casos de alteración de los materiales pétreos que forman parte de construcciones arquitectónicas; esta se ha convertido en una problemática común que se debe considerar para proponer soluciones y evitar que continúen los procesos de alteración de los materiales y deterioro de la obra. Sin embargo, no es posible enfrentar el problema de manera general por lo que se decidió realizar el estudio sistemático y total de un caso particular para desarrollar una investigación metodológica que pueda servir de ejemplo para casos similares.

El objeto de estudio de esta investigación es la fachada de un edificio de uso habitacional construido a finales del siglo XIX, el cual presenta características estilísticas típicas del Porfiriato, un periodo importante en la historia de México; en la actualidad el inmueble se encuentra catalogado como monumento histórico y se localiza en un área reconocida por la UNESCO, como patrimonio de la humanidad.

Con el fin de realizar una propuesta de conservación y restauración con la que se pueda enfrentar este problema, se llevó acabo el análisis de los materiales pétreos de la fachada, para determinar la composición de la roca que la constituye, así como su estado de conservación y los procesos de alteraciones que ha sufrido.

Para poder dar respuesta a estas interrogantes se realizaron análisis físicos, químicos, mineralógicos y ópticos, recurriendo a pruebas sencillas y al uso de diferentes técnicas de análisis selectivos utilizadas por la geología y edafología, por lo que los resultados obtenidos son el producto de un trabajo multidisciplinario, que permitió comprender de manera integral la problemática.

Los análisis que se seleccionaron son los siguientes:

- Análisis físicos: color, densidad, porosidad y absorción de agua (Geotechnical Control Office 1988), con lo que se observaron claras diferencias dependiendo del estado de conservación de la piedra.
- Análisis químicos: determinación del porcentaje de óxidos totales y valor de índices de intemperismo (USDA 1994) obtenidos por fusión de la piedra, con lo que se obtuvo un resultado cuantitativo del contenido de óxidos en la muestra, con estos resultados se estableció una comparación de las ganancias y pérdidas de óxidos que ha tenido la roca conforme se ha ido alterando, con lo que se comprendió el mecanismo y grado de alteración que presenta.
- Análisis mineralógicos: difracción de rayos X, (Jackson 1966) con el que se determinó la composición de la piedra.
- Análisis ópticos: microscopia óptica y petrografía, con este último se realizó la descripción de las transformaciones que ha tenido la piedra, ligadas aun proceso de alteración.

Para llevar a cabo los análisis se realizó una toma selectiva de muestras, teniendo en cuenta el estado de conservación del material, determinado bajo un criterio visual, con lo que se obtuvieron ocho muestras de diferentes puntos de la fachada, cuatro de ellas representan a las zonas de alteración y las otras cuatro al núcleo sin alterar. Con el fin de tener un control en el momento de clasificar las muestras según su grado de alteración se siguió la clasificación de Geotechnical Control Office (1988), en la que se toman en cuenta características de la piedra como color, textura, dureza y resistencia, con lo que las muestras se pudieron clasificar como fresca, moderadamente alterada y totalmente alterada.

Con la información obtenida de los análisis realizados se sabe que la piedra que constituye la fachada corresponde a una toba ígnea de color claro con una densidad y porosidad media; formada por una matriz microcristalina con un alto contenido de sílice, la cual cementa a minerales como feldespatos y ferromagnesianos.

Las principales especies mineralógicas identificadas con el análisis de difracción de rayos X son: cuarzo, albita (silicatosódico), ortoclasa (silicato potásico) y fayalita (silicato de hierro); sin embargo se observó que la presencia de estos minerales varía según el grado de alteración de la roca, ya que los minerales menos resistentes se alteran mucho más rápido; como es el caso de la fayalita la cual no se identificó en las muestras alteradas.

La alteración que la roca presenta es producto de un conjunto de factores entre los que se encuentran su composición y origen, las condiciones medio ambientales a las que ha sido expuesta y la ubicación que tiene en la estructura de la fachada. Esta alteración es una serie de transformaciones físicas, químicas y biológicas, que cambian las propiedades originales de la roca.

Es posible identificar la acción de un intemperismo físico, sobre todo en las partes altas de la estructura, las cuales tienen una exposición directa al agua de lluvia y el sol, lo que genera cambios bruscos de temperatura y humedad que favorecen la formación de fisuras, las cuales se aprecian al observar las muestras con microscopio óptico. Así mismo es evidente un intemperismo físico-químico, por la presencia de agua de lluvia retenida en los poros del material, a lo que en los últimos años se han agregado los altos niveles de contaminantes de la ciudad de México, como el bióxido de carbono, el dióxido de azufre y el óxido de nitrógeno que modifican el pH del agua de lluvia (Bravo 1987, 1990), aumentando su acidez y causando mayor daño a la piedra.

Un primer efecto del agua y los contaminantes en la piedra de la fachada es la disolución, en un principio, de los compuestos más solubles, como las bases (sodio, potasio y magnesio); y más adelante la disolución y pérdida de parte del cementante original: la sílice. Como resultado de esta alteración la piedra presenta una dureza poco homogénea, ya que los minerales que la constituyen y sobretodo la sílice, se han movilizado y depositado en puntos diferentes, provocando la obstrucción de poros, lo que modifica sus características originales.

Este es un proceso que puede ser considerado como una cementación natural de la roca y podría ser un punto favorable para la conservación del material; sin embargo, la disolución, movimiento y deposición de la sílice no se da de manera homogénea, por lo que la piedra pierde cementante en una zona y gana en otras. Así mismo, por la composición de la piedra el agua a propiciado la degradación de minerales de hierro formando óxidos, los cuales se identificaron en la observación de láminas delgadas con microscopio petrográfico, en las que se ven los minerales de hierro originalmente negros de color amarillo y cuando la alteración es mayor se pierden dejando un hueco en el espacio que ocupaban.

Con la medición del porcentaje de óxidos totales se identificó de manera numérica la pérdida de elementos conforme la roca se va alterando y fue posible realizar un calculo de los valores del índice de intemperismo de las muestras, aplicando los resultados a formulas establecidas (USDA 1994), en las que se hace una relación entre los contenidos de bases, sílice, aluminio y hierro de las muestras (ver Tablas 1 y 2). Los resultados obtenidos permiten observar que:

- La roca considerada como fresca ha sufrido un intemperismo leve, que se manifiesta como una pérdida de bases de un 49%.
- La roca moderadamente alterada muestra un incremento de 62% en pérdida de bases y con relación a la roca fresca a perdido sílice de 58.1 a43.5. Así mismo,

Tabla 1. Porcentaje de óxidos totales

	roca fresca (M5)	roca moderadamente alterada (M8)	roca completamente alterada (M2)
SiO_2	58.1	43.5	37.1
Al_2O_3	16.3	25.5	33.2
Fe_2O_3	7.4	8.1	9.4
TiO_2	0.9	0.9	1.0
MnO	0.1	0.1	0.2
CaO	5.2	4.3	4.1
MgO	3.4	3.1	2.3
K_2O	3.0	2.5	2.1
Na_2O	3.9	2.7	1.7
P_2O_5	0.3	0.2	0.2
SO_3	0.1	0.1	0.1
perdida por ignición (H_2O)	1.2	7.5	8.1
Total	99.9	98.5	99.5

Tabla 2. Índice de óxidos totales

	intem-perismo	silice-aluminio	base-silice	silice-fierro	% pérdida de bases
roca fresca	0.62	6.4	1.05	24	49
roca moderadamente alterada	0.38	2.8	0.18	14.4	62
roca totalmente alterada	0.15	1.90	0.18	12.2	69

se observa un incremento en el hierro producto de la alteración de los minerales de 7.4 a 8.1.

- La roca totalmente alterada a perdido un 69% de sus bases y con relación a la roca fresca presenta una disminución significativa de sílice de 58.1 a 37.1 y un incremento de hierro de 7.a a 9.4.

Con estos resultados se puede establecer que el agua y los agentes contaminantes en contacto con la roca han provocado los siguientes fenómenos:

- Hidratación de ciertos minerales como las bases y los compuestos de hierro, a los que se incorporan moléculas de agua, por lo que tienen un aumento de tamaño y se favorece su descomposición.
- Hidrólisis, si la hidratación continúa los componentes de la roca se hidrolizan formando arcillas. La reacción de los iones H y OH del agua es la forma más importante de intemperismo de rocas cristalinas que afecta a los silicatos.
- Lixiviación, los minerales mas solubles de la roca, como las bases, son lavados (soluviados) por el agua y tienen un movimiento (eluviación) dentro de la roca, acumulándose (iluviación) en diferentes puntos, aun que en algunos casos pueden llegar a perderse por completo.

En el caso de la fachada, algunos materiales, bases y sílice, han tenido una gran movilidad, por una parte, minerales cementantes se han depositado en la superficie de la roca formando una costra resistente, que en un principio podría ser una protección, pero en la gran mayoría de los casos esta costra se desprende por diferencia de densidad y dureza, quedando el material sin cementante, disgregado y sin cohesión, lo que le da un aspecto pulverulento; por otra parte los minerales al hidratarse e hidrolizarse tienen un aumento de tamaño por lo que las costras de alteración tienden a hacerse convexas, lo que facilita su desprendimiento.

Conclusión

Los materiales pétreos que forman parte de monumentos y edificios se alteran de manera natural, al estar en contacto con el medio ambiente. En el caso de la ciudad de México, al igual que en toda zona urbana, la alteración de la piedra de las construcciones aumenta de manera considerable por la acción de agentes naturales de intemperismo, aunados a la contaminación ambiental, la cual en los últimos años ha ido en constante incremento.

La piedra que constituye la fachada en estudio es una toba formada por una matriz microcristalina con un alto contenido de sílice, la cual cementa a minerales

como feldespatos y ferromagnesianos. La alteración que esta presenta es producto de un conjunto de factores entre los que se encuentran su composición y origen, las condiciones medioambientales a las que ha sido expuesta y la ubicación que tiene en la fachada.

Por lo anterior es posible identificar un intemperismo físico, sobre todo en las partes altas de la estructura, en donde se distinguió una mayor formación de fisuras. También se detectó un intemperismo químico por la presencia de agua de lluvia retenida en los poros del material, a lo que se agregan los altos niveles de contaminantes. Un primer efecto del agua en el material pétreo es la disolución de sus componentes, como las bases; así mismo los carbonatos y silicatos han formado una costra resistente, que en un principio pueden proteger a la piedra, pero en muchos casos esta se desprende por diferencia de densidades y dureza, quedando el material con poca cohesión. Por otra parte, por la composición de la piedra el agua ha propiciado la degradación de minerales de hierro formando óxidos.

Esta investigación va dirigida a un caso específico, sin embargo, puede ser retomada como ejemplo para casos similares, tomando en cuenta que a lo largo de la historia la gran mayoría de las construcciones de la ciudad de México se han realizado con tobas volcánicas y se encuentran expuestas a condiciones similares.

Agradecimientos

Los análisis que se presentan en esta investigación fueron realizados en el Instituto de Geología de la Universidad Nacional Autónoma de México (UNAM) con el apoyo y asesoría del Dr. en C. Jorge E. Gama Castro, investigador del instituto; Dr. enC. Dante Morán Centeno, director del instituto. La difracción de rayos X fue realizada por la M. en C. Angélica del C. Arias H y lapetrografía por el M en C. Victor Dávila A.

Referencias

Bravo, H, 1987, Contaminación atmosférica en la ciudad de México, en *Tercer Encuentro Nacional de Conservación del Patrimonio Cultural, Sección de Contaminación Ambiental*, Centro de Ciencia de la atmósfera, UNAM.

Bravo, H, 1990, *Study of the horizontal surfur dioxide concentration on the metropolitan zone of the Mexico City*, UNAM.

Geotechnical Control Office, 1988, *Guide to rock and soil descriptions* (Geoguide 3) GCO, Hong Kong.

Jackson, M L y Sherman, G D, 1966, Chemical weathering of minerals in soils, *Adv. Aragon* 5: 219-318.

USDA SSS, 1994, Keys to soil taxonomy, 5th ed., *Soils Management Support Serv. Tech. Monograph*, Pocahontas Press, Blacksburg, Virginia.

Glass, ceramics and related materials

Verre céramique et matériaux apparentés

Cerámicas, vidrios y materiales relacionados

Glass, ceramics and related materials

Coordinator: Sandra Smith
Assistant Coordinator: Lisa Pilosi

The Glass, Ceramics and Related Materials Working Group has produced four newsletters to keep members up to date with events and to share information. The newsletter is produced in both digital and hard copy.

The Working Group held an Interim Meeting in Budapest, Hungary, on 19–22 September 2001. This fulfilled one of the triennial aims: to increase contact with conservators in Eastern Europe and share experience and knowledge. The meeting was hosted by Dr Andras Morgos, Head of Conservation, and his staff at the Budapest Historical Museum. Dr Szilvia Holo, Scientific Secretary of the Budapest Historical Museum, and Erzsebet Koczain Szentpeteri, President of ICOM Hungary, opened the meeting. It consisted of two days of talks. The first day included presentations from members of the Working Group and students who had recently completed their studies in Poland and Germany. The second day was allocated to the Hungarian and Eastern European conservators. The talks ranged from the analysis of glass, research into original technology, conservation processes, and evaluation of conservation materials.

Discussion highlighted the diversity of materials used in conservation and the different ethical approaches to cleaning and restoration. A display of adhesives and gap fillers used for glass from the late 1950s showed the natural ageing of resins such as epoxies, polyesters and acrylics. There was a tour of some of the collections of the Historical Museum and the National Museum, where the participants were welcomed by the Director.

A final dinner gave all participants an opportunity to cement friendships and develop working relationships in an informal and friendly atmosphere.

The meeting was a tremendous opportunity to share ideas and to look at the issues of re-conserving ceramic and glass objects, another priority for the triennial aims of the Working Group. Professor Gerhard Eggert from the State Academy of Art and Design invited all participants to send him samples of soluble salts to extend his project into the identification of salts formed on ceramics in storage environments. Through this collaborative work, the understanding of the causes of deterioration in ceramics will be further elucidated.

The speakers have been invited to summarize their talks, and these will be made available to Working Group members some time in the future. Lisa Pilosi, Assistant Coordinator, is developing a discussion group on the ICOM-CC Web page, which will be open to ICOM-CC Working Group members.

Sandra Smith

Resumen

Se presentan los resultados de la evaluación de la utilidad de seis técnicas de análisis científico – radiografía, microscopio petrográfico, difracción de rayos X, microscopio electrónico de barrido, microsonda electrónica y emisión de rayos X inducida por partículas – para el estudio de la técnica de manufactura de la cerámica prehispánica. Se ha determinado cómo puede abordarse este estudio, indicando la forma en que cada etapa de la técnica de manufactura puede analizarse y se ha concluido que estas técnicas de análisis científico, en especial las tres primeras, aportan información significativa que contribuye a la profesionalización del estudio material de las obras cerámicas prehispánicas. Se propone una metodología para realizar estudios con análisis científicos desde el campo de la restauración y conservación.

Palabras claves

cerámica prehispánica, análisis científico, técnica de manufactura

Una nueva metodología para estudios científicos en conservación y restauración de cerámica prehispánica

Claudia Cristiani ★
Calle y Colonia Roma 238
San Salvador, El Salvador
E-mail: claudia_cristiani@hotmail.com
Fax + 503 298-0807

Carolusa González Tirado, María Eugenia Guevara Muñoz
Escuela Nacional de Conservación
Restauración y Museografía, INAH
Exconvento de Churubusco
Xicotencatl y General Anaya
CP 04120, México D.F., México
Fax: + 52 55-5604-5163

Introducción

La técnica de manufactura o identidad técnica de un bien cultural tiene una importancia primordial para la restauración y conservación ya que, por un lado, es en sí misma parte de su integridad, su cualidad técnica – y es a través de su materia que el resto de la información tangible e intangible se hace presente – su cualidad estética e histórica; y por otro lado, no solo es causa de su alteración y deterioro, sino que es la materia la que se degrada, por lo que su estado de conservación y las medidas directas o indirectas que puedan realizarse dependen de sus características.

La mayoría de los estudios sobre técnica de manufactura de cerámica han sido realizados por especialistas de otros campos y se enfocan principalmente a la caracterización de los materiales constitutivos. Aunado a esto, muy pocos de los estudios tratan la cerámica prehispánica (Guevara y López 1996, Ontalba et al. 2000, Ortiz et al. 2000, Ruvalcaba-Sil et al. 1999); en general, son estudios sobre cerámica de alta temperatura o de otros contextos geográficos.

En este artículo se describe la evaluación de la utilidad de seis técnicas de análisis científico – radiografía, microscopio petrográfico, microscopio electrónico de barrido (MEB), microsonda electrónica (EDS), difracción de rayos X (DRX) y emisión de rayos X inducida por partículas (PIXE) – para el estudio de la técnica de manufactura de los bienes cerámicos prehispánicos desde el campo de la restauración y conservación. Esta investigación pretendió abordar desde nuestra disciplina el análisis de todas las fases de la técnica de manufactura de la cerámica prehispánica o de baja temperatura.

Estudios con técnicas de análisis científico

Debido a que la restauración-conservación de bienes culturales es una disciplina reciente, en Latinoamérica los estudios científicos en este campo, en general se realizan sin una metodología que permita aprovechar el potencial de los recursos científicos; situación que provoca la obtención de datos que rara vez pueden ser aplicados posteriormente al trabajo real que se lleva a cabo.

Con base en lo anterior y las necesidades de esta investigación se diseñó una metodología para realizar estudios con técnicas de análisis científico en el campo de la restauración y conservación, dentro de la cual se consideran ciertas condiciones y principios éticos tanto del campo que nos concierne como del campo científico con el fin de darle validez y justificación a dichos estudios. A continuación se expone esta metodología.

- Determinar cuál es el objetivo de la investigación. No se trata de realizar un análisis científico sino de utilizar este medio para resolver una interrogante que surge del trabajo de restauración y conservación de las obras; por ejemplo, la identificación de los materiales constitutivos de un objeto cerámico, objetivo

★Autor a quien dirigir la correspondencia

general del cual se pueden establecer objetivos tales como identificación de inclusiones, de material no-plástico y de la arcilla.

- Traducir el objetivo a términos científicos. Los análisis proporcionan información analítica – elementos, iones, compuestos – o estructural – morfología, comportamiento térmico – y cualitativa o cuantitativa, y es en estos términos que deben explicarse los objetivos.
- Determinar junto al científico las opciones que existen para obtener la información que se busca.
- Familiarizarse con las características de las opciones. Para evaluar las técnicas deben considerarse, primero, el tipo y calidad de información que proporciona: su sensibilidad – el límite de detección, exactamente qué elementos o compuestos identifica – su precisión – hasta que grado son reproducibles los resultados – su exactitud – qué tan cerca están los resultados que proporciona de la realidad – su área de acción – un punto, un área del objeto o muestra o todo el objeto – y finalmente, sus características de calibrado – si requiere de escoger de antemano los elementos a identificar por ejemplo.

Segundo, la disponibilidad del equipo y experiencia del operador en el uso del equipo y en el estudio de bienes culturales. La experiencia del operador resulta importante en la medida en que de ella depende la seguridad física del objeto y la validez científica de los resultados. Tercero, el tiempo que requiere llevar a cabo el análisis. Cuarto, los requerimientos de muestreo – si es invasivo o no, de qué tamaño y cuántas muestras requieren, qué tipo de preparación, si son destructivos o no destructivos. Deben considerarse y evaluarse la seguridad física del objeto, el riesgo que implica trasladar el objeto a un laboratorio, el respeto a su integridad, la validez científica de la representatividad del área que se analizará y la información que se obtendrá. Y quinto, el costo del análisis.

- Determinar si se hará el análisis y con qué técnica(s). Esta determinación debe realizarse con base en las consideraciones establecidas en el paso anterior.
- Toma y preparación de muestras o traslado del objeto al laboratorio.
- Realización de los análisis. Al finalizar este paso, se obtienen una serie de gráficas, imágenes o tablas, según sea el caso.
- Interpretación de los resultados. Resolución de las interrogantes planteadas inicialmente en el paso 1.

Procedimiento

Estudio de la técnica de manufactura de objetos cerámicos

Para poder llevar a cabo la evaluación se realizó el estudio de la técnica de manufactura de seis objetos cerámicos olmecas provenientes de San Lorenzo Tenochtitlán, Veracruz, México, con las seis técnicas mencionadas: radiografía, microscopio petrográfico, MEB, EDS, DRX y PIXE. Las condiciones y principios considerados en el paso 4 de la metodología expuesta arriba proporcionaron los parámetros con base en los cuáles se hizo la evaluación.

Se seleccionaron para el estudio seis objetos donde quedan representados cuatro tipos cerámicos diferentes – caamaño, caimán, tigrillo burdo y tigrillo – un objeto de los primeros tres tipos (Cat. números 064, 084 y 473, respectivamente) y tres objetos del tipo tigrillo (Cat. números 585, 620 y 006). Dos tipos son de pasta burda y rugosa y dos son de pasta compacta y homogénea. Dos parecían haber sido cocidos en atmósfera oxidante y dos en atmósfera reductora. Además, se contó con arcilla proveniente de San Lorenzo Tenochtitlán, que fue identificada por Guevara y López como materia prima de un objeto cerámico proveniente de dicha zona arqueológica (Guevara y López 1996), misma que fue utilizada para fabricar probetas en diferentes condiciones de cocción en un horno abierto tradicional en San Juan Teotihuacan, México, que también fueron utilizadas en este estudio (Cristiani 2001).

Para estudiar la técnica de manufactura, esta se dividió en cinco etapas: a) materiales constitutivos – arcilla, inclusiones y material no-plástico; b) preparación de la pasta – extracción de inclusiones, adición de material no-plástico y amasado;

Figura 1. Imagem radiográfica de objeto fabricado con la técnica de placas

Figura 2. Imagem radiográfica de objeto fabricado con la técnica de modelado

c) formación del objeto – técnicas de formación primaria: modelado, por rollos, por placas y moldeado; técnicas de formación secundaria: modelado, golpeado, recortado y raspado; y modificaciones superficiales: alisado, bruñido, sellado, incisiones, tallado, engobe, etc. (Rye 1981); d) secado; y e) cocción – atmósfera, temperatura máxima y duración del proceso.

Técnicas de análisis científico utilizadas en el estudio

RADIOGRAFÍA

Se utilizó un equipo de 100 KV y 30 mA con tubo de rayos X con ventana de berilio, y película Sterling 10 x12 Cronex 4 médica para rayos X. En promedio se utilizaron 50 KV, 15 MA y 8 segundos a 1 metro de distancia. Se tomaron dos imágenes de cada objeto, una del fondo y otra del frente o corte.

MICROSCOPIO PETROGRÁFICO

Se hicieron análisis petrográficos de los cuatro tipos cerámicos, de las probetas de cocción en atmósfera reductora y de la arcilla de San Lorenzo Tenochtitlan, ya se contaba con análisis petrográfico de probetas en atmósfera oxidante (Guevara y López 1996). Se utilizaron muestras en lámina delgada de un grosor de 0.03mm.

MICROSCOPIO ELECTRÓNICO DE BARRIDO (MEB) Y MICROSONDA ELECTRÓNICA (EDS)

Se llevaron a cabo en un equipo JOEL JSM-5900LV, utilizando 20 KV para cada imagen. Se tomaron imágenes MEB y realizaron análisis de EDS de la matriz arcillosa, de una o más inclusiones y de un área general donde se incluyen ambos componentes de los cuatro tipos cerámicos, de la arcilla de San Lorenzo Tenochtitlán y de las probetas de cocción. Se utilizaron las mismas muestras en lámina delgada utilizadas para la microscopía petrográfica.

DIFRACCIÓN DE RAYOS X (DRX)

Se utilizó un difractómetro Siemens D5000 y una computadora con una base de datos de 6000 gráficas estándar Siemens NIXDORF PCD-5H. Se hicieron análisis de los cuatro objetos cerámicos y de las probetas de cocción en atmósfera reductora. Ya se contaba con análisis de DRX de la arcilla de San Lorenzo Tenochtitlán y de probetas en atmósfera oxidante (Guevara y López 1996). Se utilizaron muestras en cubo de 1 cm².

EMISIÓN DE RAYOS X INDUCIDA POR PARTÍCULAS (PIXE)

Se utilizó un acelerador Pelletron con dispositivo de haz externo y ventana de salida de 8 ìm de aluminio y dos detectores, uno de Si(Li) con un colimador de 0.5 mm de diámetro para elementos mayores, y otro de germanio (LEGe) con un absorbedor de 120 ìm de aluminio para elementos traza. Se hicieron análisis de los cuatro tipos cerámicos. Se utilizaron muestras en pastilla obtenidas de 0.5 – 1 ml en volumen de polvo.

Resultados

RADIOGRAFÍA

Las imágenes radiográficas permiten observar la estructura interna macroscópica de los objetos cerámicos pero no su morfología – orientación, tamaño, cantidad y distribución de vacíos y partículas. Por lo tanto, únicamente se observan los procesos de formación primaria. En los objetos estudiados no se encontraban representadas las técnicas de rollos ni de moldeado; sin embargo, las técnicas de modelado y placas son claramente distinguibles. La Figura 1 muestra que el objeto fabricado con la técnica de placas presenta paredes muy homogéneas y compactas así como una disminución del grosor de las paredes en la parte inferior, donde fueron presionadas para unirlas con la base del objeto. La Figura 2, en cambio, muestra como el objeto fabricado con la técnica de modelado presenta una gran heterogeneidad en el grosor y densidad de sus paredes; por lo tanto, puede pensarse que las otras técnicas también serán detectadas. Así mismo, probablemente puedan detectarse los vacíos de unión entre los objetos y los elementos funcionales agregados como asas o soportes.

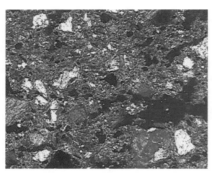

Figura 3. Imagem petrográfica de pasta cerâmica

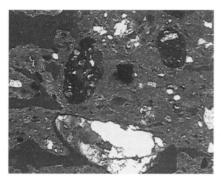

Figura 4. Imagem petrográfica de pasta cerâmica

Figura 5. Imagem MEB de uma inclusión de cuarzo rodeada de matriz arcillosa

La radiografía es la única técnica que aporta información sobre la estructura interna macroscópica de los objetos, por lo que representa un auxiliar de gran importancia para la observación visual en el análisis de las técnicas de formación. Se considera que la información que aporta, a pesar de ser sobre una sección muy limitada de la técnica de manufactura en su conjunto, justifica la realización de este análisis en la restauración y conservación de los bienes culturales cerámicos.

MICROSCOPIO PETROGRÁFICO

La microscopía petrográfica permitió en este caso realizar la identificación mineralógica de los minerales no arcillosos presentes en los objetos. La morfología general de la pasta cerámica también es claramente observable en las imágenes (Figuras 3 y 4); sin embargo, la interpretación de algunos de los datos – distribución de rangos de tamaños y formas de partículas y vacíos por ejemplo – no fue tan efectiva.

La información que aporta este análisis permite obtener datos significativos sobre la identificación de los materiales constitutivos, sobre la extracción y adición de inclusiones y material no-plástico, sobre la calidad del amasado y sobre el proceso de cocción.

A pesar de que se trata de una muestra relativamente grande, 0.8-2.5 cm, la información que se obtiene proporciona datos sobre casi todas las etapas de la técnica de manufactura, es una técnica muy versátil que permite obtener no solo la composición mineralógica sino observar la morfología y, debido a que las dimensiones utilizadas no son tan microscópicas, su interpretación y aplicación resulta considerablemente sencilla.

MICROSCOPIO ELECTRÓNICO DE BARRIDO (MEB) Y MICROSONDA ELECTRÓNICA (EDS)

Las imágenes y análisis elemental que se obtienen con esta técnica son de un área tan reducida que se pierde la posibilidad de observar la morfología general de la pasta cerámica del objeto así como de su composición general (Figura 5). Además, como la imagen es en tonos de grises y no a color, su comprensión para un ojo inexperto resulta más compleja que para las imágenes del microscopio petrográfico. Debido a que la composición es elemental y no mineral, requiere que se haga una relación química entre la composición elemental y la composición mineral del objeto, relación que se complica debido a que se trata de minerales que generalmente se encuentran alterados.

Toda la información que se obtiene puede obtenerse con el microscopio petrográfico de manera más general y por lo tanto más aplicable. Sin embargo, precisamente por ser tan específicas resultan importantes para investigaciones más puntuales como sería el caso de la composición de una capa de engobe o de una inclusión en particular.

DIFRACCIÓN DE RAYOS X (DRX)

Esta técnica permite la identificación de los minerales presentes, incluidos los minerales arcillosos. Resulta el complemento ideal de la microscopía petrográfica en cuanto permite no solo corroborar los resultados de la composición mineralógica sino la identificación de los minerales arcillosos – identificación que no se puede llevar a cabo con el microscopio petrográfico.

El tamaño de muestra que requiere no es pequeño – 0.8 ml en volumen de polvo o un cubo de 1 cm² – sin embargo, debido a que no es destructiva, puede utilizarse la misma muestra extraída para el microscopio petrográfico antes de preparar la lámina delgada.

EMISIÓN DE RAYOS X INDUCIDA POR PARTÍCULAS (PIXE)

Al igual que el EDS, con la técnica de PIXE se obtiene la composición elemental, por lo que relacionarla a la composición mineral resulta complejo. Sin embargo, como se trata de la composición elemental de toda la muestra – pastilla de 0.5-1 ml en volumen de polvo – en este caso, si se obtiene la composición elemental general de la pasta cerámica; por lo tanto, es una técnica que resulta de mucha utilidad para relacionar o diferenciar entre arcillas o tipos cerámicos.

Análisis de la técnica de manufactura de cerámica prehispánica

La identificación de los minerales presentes en la pasta cerámica sirve para determinar los materiales constitutivos de los objetos cerámicos – inclusiones, material no-plástico y minerales arcillosos. En este estudio, la identificación de la materia orgánica que pudo haber estado presente, a partir de la observación de los vacíos, no fue posible.

Para la identificación de las inclusiones eliminadas y del material no-plástico añadido, se requiere de comparar la composición mineral de los objetos con la de la arcilla que se utilizó para fabricarlos. Si no se cuenta con la arcilla original, la morfología permite realizar algunas observaciones sobre estos procesos pero no determinarlo con seguridad; por ejemplo, el tamaño promedio de los minerales puede ser indicativo de la extracción de inclusiones, y la presencia de una gran variedad de minerales puede ser indicativa de la adición de material no-plástico. La forma de los minerales, mencionada como posible indicador de su origen, no es realmente útil para la cerámica prehispánica debido a que las arcillas disponibles son sedimentarias, por lo tanto, las inclusiones presentes naturalmente ya han sufrido un proceso de alteración mecánica como parte de la formación del depósito arcilloso, y ésta no se distingue de la alteración mecánica sufrida como parte del proceso de preparación.

Con respecto al proceso de amasado, únicamente se puede deducir la calidad de dicho proceso observando la morfología de la pasta cerámica – distribución de sus partículas y vacíos y presencia de vacíos.

Debido a que no se tenían ejemplos de todos los procesos de formación en este estudio, el análisis de estos procesos requiere de mayor investigación. Sin embargo, puede decirse que los procesos de formación primaria parecen ser detectados y diferenciados claramente a partir del grosor y densidad de las paredes de los objetos.

Algunos procesos de modificación superficial, por ejemplo los engobes, pueden ser observados y estudiados a través de su morfología. La identificación de su composición resulta compleja debido al grosor de las capas; sin embargo, en este caso, las técnicas de grandes aumentos o de análisis de composición localizado pueden ser útiles.

Algunos autores mencionan que algunos procesos de modificación superficial afectan la orientación de las partículas en superficie, y que este fenómeno es observable (Rice 1987); en este estudio, sin embargo, esto no fue detectado con ninguna de las técnicas utilizadas.

Debido a que el proceso de secado no deja huellas características detectables una vez a sido cocido el objeto, no puede ser estudiado mediante técnicas de análisis científico.

Para determinar cualquiera de las características del proceso de cocción existen varias limitantes. La más importante se refiere a que los cambios químicos de los minerales provocados por temperatura – cambios que se utilizan como parámetros para determinar la temperatura máxima – no comienzan a ocurrir hasta los 650°C. Mediante la manufactura de las probetas de cocción en un horno abierto se pudo constatar que con las características de este tipo de horno, no se alcanzan temperaturas arriba de 650°C y que el control de las condiciones atmosféricas y de temperatura durante la cocción es prácticamente imposible (Cristiani 2001). Por lo tanto, las temperaturas requeridas no se alcanzan o no pueden mantenerse el tiempo suficiente para permitir que ocurran los cambios químicos de los minerales. Debido a esto, la única manera de estudiar el proceso de cocción radica en realizar probetas en diferentes condiciones de cocción y comparar su morfología y composición mineral con la del objeto.

Una excepción son los óxidos de fierro. El tipo de óxido presente – limonita, hematita – y su distribución en la pasta cerámica, si no una determinación directa del proceso de cocción, permiten realizar algunas observaciones sobre este. La presencia de limonita, un óxido de fierro hidratado, es indicativa de un deficiente proceso de cocción porque la temperatura máxima alcanzada y la duración del proceso no fueron suficientes para provocar su deshidratación. La distribución de los óxidos también puede ser indicativa del proceso de cocción ya que si se encuentran distribuidos a través de la pasta cerámica puede pensarse que ya tuvo lugar el proceso de fusión.

Conclusión

Los resultados de la investigación permiten asegurar que estas técnicas de análisis, en especial la radiografía, la microscopía petrográfica y la difracción de rayos X, no solo complementan sino que pueden esclarecer la información obtenida mediante la observación visual e investigación bibliográfica sobre la técnica de manufactura de la cerámica prehispánica, convirtiéndose así en recursos útiles y disponibles. Se considera que el uso periódico de estas tres técnicas, especialmente si se trata de colecciones y no de objetos aislados, contribuiría a la profesionalización de la restauración y conservación de bienes cerámicos prehispánicos.

La metodología diseñada para realizar estudios con técnicas de análisis científico pretende proporcionar una guía para restauradores y conservadores que facilite el aprovechamiento del potencial de estos recursos y evite los riesgos innecesarios a la integridad de los objetos.

Agradecimientos

Se agradece la colaboración de la Dra. Ann Cyphers, IIA-UNAM; Dr. Jose Luis Ruvalcaba-Sil, IIF-UNAM; Ing. Juan Carlos Cruz, IG-UNAM; Ing. Enrique Ibarra, ENCRM e Ing. Manuel Espinosa, ININ.

Referencias

Cristiani, C, 2001, 'Evaluación de técnicas de análisis para la restauración y conservación de cerámica prehispánica'. Tesis de Licenciatura, ENCRM, México.

Guevara, M y López, M, 1996, 'La restauración y su investigación: el caso de una vasija cerámica de San Lorenzo Tenochtitlan, Veracruz'. Tesis de Licenciatura, ENCRM, México.

Ontalba, S et al., 2000, 'Ion Beam Analysis of Pottery from Teotihuacan, Mexico', *Nuclear Instruments and Methods in Physics B* (161-163), 762-768.

Ortiz, E et al., 2000, 'Interdisciplinary Approach for the Analysis of Pottery from the Caxonos River Basin, Oaxaca', *Antropología y Técnica* 6 (IIA), 85-94.

Rice, P, 1987, *Pottery Analysis: A Sourcebook*, University of Chicago Press.

Ruvalcaba, J et al., 1999, 'Characterization of Pre-Hispanic Pottery from Teotihuacan, Mexico, by a combined PIXE-RBS and XRD Analysis', *Nuclear Instruments and Methods in Physics B* (150), 591-596.

Rye, O, 1981, 'Pottery Technology: Principles and Reconstruction', *Manuals on Archaeology* 4, Washington D.C., Taraxacum.

Resumen

Este trabajo se centró en el estudio y restauración de una colección compuesta de sesenta y seis objetos cerámicos procedentes de las excavaciones de San Lorenzo Tenochtitlán en Veracruz, sitio olmeca del preclásico inferior (1550-900 AC). La colección presentaba graves problemas de alteración. Con la finalidad de contribuir al conocimiento de los procesos de alteración y deterioro, aquí se analizaron las causas y los mecanismos que los generaron. Para éste objetivo fue fundamental el trabajo interdisciplinario. Como resultado del estudio fue posible definir la metodología de restauración y conservación más adecuada. En esta parte integraron reflexiones en torno a las implicaciones que algunas decisiones de intervención pueden tener en el estudio de objetos de arte prehispánico en México.

Palabras claves

San Lorenzo, olmeca, colección, objetos cerámicos, alteración, restauración, arqueología

La restauración de la cerámica olmeca de San Lorenzo Tenochtitlan, Veracruz, México: teoría y práctica

Adriana Cruz Lara Silva
Escuela de Conservación y Restauración de Occidente (ECRO)
Analco 285, CP 44450
Guadalajara, Jalisco, México

Maria Eugenia Guevara Muñoz★
Escuela Nacional de Conservación
Restauración y Museografía, INAH
Exconvento de Churubusco, Xicotencatl y General Anaya, CP 04120
México D.F., México
Fax: + 52 55-5604-5163
E-mail: maria_eugeniag@hotmail.com

Ann Cyphers
Instituto de Investigaciones Antropológicas
UNAM Ciudad Universitaria, CP 01000
México D.F., México

Introducción

San Lorenzo Tenochtitlán (SLT) es un sitio arqueológico localizado en Veracruz, México. Desde la década de 1940 a la fecha se han efectuado diversos estudios en el conocimiento de la cultura olmeca que se desarrolló durante el Preclásico Inferior (Coe y Diehl 1980).

Actualmente las investigaciones en este importante sitio se llevan a cabo dentro del Proyecto Arqueológico SLT. Entre las metas del proyecto destaca el análisis de los patrones de asentamiento antiguos (Cyphers 1997), para lo cual la conservación y restauración de los vestigios arqueológicos es de gran importancia.

La colección de cerámica se encuentra conformada por sesenta y siete objetos provenientes de diferentes áreas de excavación del sitio. El primer contacto que se tuvo con la colección, fue en 1993, a partir de varios ejemplos de cerámica caracterizados por un grave estado de alteración. Ello rompió por completo con la visión tradicional que se tenía de la cerámica arqueológica en cuanta alteración refiere, por lo que a partir de este momento y hasta 1999 se comenzó su estudio y tratamiento.

Nuestro trabajo, es un estudio pionero que proporciona los métodos y las técnicas utilizadas en la restauración de un gran corpus de cerámica antigua. Las decisiones fundamentales y la restauración de la colección conforman una base indispensable y consultable para cualquier investigador que trabaja en la zona. El trabajo realizado permitió salvar importantes objetos del paso del tiempo y conservarlo para la posteridad. Finalmente, el material cerámico restaurado amplia las bases para las inferencias culturales y las secuencias cronológicas.

La restauración de la colección dio como resultado el replanteamiento de algunos de los tratamientos tradicionales de restauración y de los criterios aplicados para cerámica arqueológica.

Enfoques teóricos

A lo largo de la historia se han generado diversas formas de entender y ejecutar la restauración. Esto tiene que ver con los distintos significados que una sociedad atribuye a los objetos producidos por ella, o por otros, en relación a sus ideas políticas, estéticas, filosóficas, religiosas o económicas. Es así, que las sociedades en diferentes épocas han establecido diversas soluciones de restauración. En México puede decirse que, la restauración, desde sus inicios hasta hoy ha sido influenciada por los criterios surgidos en Europa desde el siglo XVIII.

★Autor a quien dirigir la correspondencia

La teoría de la restauración moderna, derivada de la tradición occidental, fue elaborada a partir del concepto de obra de arte. No obstante, entre las principales limitaciones que la comunidad de restauradores ha encontrado con respecto a esta teoría es que fue elaborada sobre el concepto renacentista de obra de arte, este hecho deja fuera a gran cantidad de objetos que la sociedad actual considera importante entender y preservar, debido, a intereses de tipo artístico, histórico y antropológico. De aquí que, la teoría, se ha vinculado con el concepto de patrimonio cultural, en relación estrecha con el desarrollo de las ciencias antropológicas. Así, el campo de acción de la restauración se ha ampliado hacia un sinnúmero bienes culturales de gran interés documental, y a los cuales se les asigna un valor patrimonial relevante.

En virtud de su importancia documental, los objetos cerámicos de SLT fueron concebidos como bienes culturales. La posibilidad de conocimiento y transmisión de estos bienes está dada por la restauración, en tanto disciplina dedicada a la solución de todos aquellos aspectos que tienen que ver con su permanencia. 'Si bien los especialistas en conservación no son privilegiados oficiales responsables de elegir –ni más ni menos que otros actores sociales, que es como debe ser- si tiene el status de bien cultural, su disciplina es, ciertamente la herramienta que asegura la realización práctica de este vasto corpus' (Berducou 1996).

Van de Wetering (1996) ha resaltado la naturaleza interpretativa que caracteriza a la restauración. En concordancia con ello, el criterio para restaurar la cerámica de San Lorenzo se articuló con respecto a su interpretación desde el punto de vista de la arqueología y a partir de la adaptación de algunos principios de la teoría de Brandi (1996), así como de las aportaciones que autores como Berducou (1996) y Philippot (1959) han hecho a la teoría de la restauración.

La intervención de restauración

Contextualización y valoración

La cerámica de SLT había sido poco estudiada antes de este trabajo. Actualmente el proyecto desarrolla una nueva tipología para definir los tipos cerámicos, así como las variaciones propias a través de la caracterización de la pasta y el acabado superficial.

La colección esta constituida por objetos de uso doméstico y ritual, recuperados de las excavaciones de las áreas habitacionales, domésticas, de almacenamiento y ceremoniales, respectivamente. Las formas que se presentan son: platos, cajetes, vasos y ollas. Se trata fundamentalmente de artefactos contenedores. Al parecer estos fueron elaboradas con materiales diversos y empleando distintas técnicas de manufactura y decoración.

Se determinó que los objetos y su contexto constituyen una fuente potencial de información con respecto a los medios de subsistencia, algunas particularidades del ceremonialismo, de las distintas formas de relación con el medio y del desarrollo tecnológico de los olmecas.

Análisis del estado de conservación

Toda la materia a través del tiempo, sufre cambios o alteraciones debido a que busca establecer un equilibrio físico-químico con su entorno. En ocasiones este proceso puede verse interrumpido por eventos históricos o catastróficos, que tendrán como consecuencia el desarrollo de una nueva etapa en donde la materia tratará de encontrar un equilibrio con el nuevo medio. Estos cambios significan una transformación de la naturaleza y propiedades originales de los objetos. Desde el punto de vista de la restauración, las alteraciones se consideran como deterioro cuando implican, la pérdida total o parcial de alguno de los elementos que conforman su unidad, ya sea a través de la degradación físico-química de la materia, o bien, a través de la perdida de la información potencial que contienen. Sin embargo, no todas las alteraciones tienen un efecto negativo, en cuyo caso no pueden denominarse como deterioro, en el sentido de destrucción. Así, el restaurador se enfrenta con objetos transformados. Conociendo estos procesos, se pueden atenuar aquellas alteraciones que resulten nocivas, y preservar y aprovechar aquellas que han favorecido la conservación de los objetos en cuestión.

La colección cerámica presentaba tres tipos de alteración:

- **Perdida de cohesión**. Los objetos que mostraron este tipo de alteración fueron aquellos de pasta color naranja y ocre claro. Entre éstas destacan las que se recuperaron del área Loma del Zapote y una vasija efigie. Se cree que la alteración ocurrió por la composición mineralógica y características físico-químicas de los materiales constitutivos en relación a los procesos de manufactura, por ello se realizó el análisis de difracción de rayos X (DRX), con el que fueron caracterizados vidrio volcánico y arcillas protoilíticas. A través de los procesos de manufactura de secado y cocción, dichos materiales se alteraron. El vidrio volcánico al ser sometido a la temperatura perdió gran cantidad de agua, haciendo rígida su estructura y creando espacios vacíos. También debido a este factor las arcillas protoilíticas sufrieron un colapso en su estructura, por la pérdida de grupos hidroxilo existentes en ellas, manifestándose estos efectos como un patrón de microfisuramiento (Guevara y López 1996).

 Por otro lado se observó que las piezas de Loma del Zapote, presentaban una profusa pérdida de cohesión y por lo tanto una gran fragilidad. Es probable que este hecho este vinculado con su función ritual, en donde las vasijas fueron hechas ex profeso para ofrendar. Es decir, probablemente, dado que no estaban destinadas al uso doméstico no requirieron de materiales y técnicas que les brindaran alta resistencia. Así, aunque los materiales y las técnicas no pueden descartarse como un factor de alteración, es importante considerar que éste hecho puede tener una connotación cultural relevante.

- **Fragmentación**. Una de las causas de este efecto está relacionada con el ambiente de entierro. La presión del suelo sobre los materiales que albergó los fragmentó. A esto, puede añadirse el trabajo que el contexto pudo haber ejercido sobre los materiales cerámicos, al estar constituido por arcillas protoilíticas y montmorillonita, caracterizadas con DRX. Dependiendo de las condiciones climatológicas estos materiales absorben o pierden humedad expandiendo y contrayendo.

 En algunas vasijas la fragmentación se dio exactamente en la unión de las paredes con el fondo, sugiriendo que estas piezas fueron construidas formando las distintas partes del cuerpo independientemente, mediante placas que luego se unieron para dar forma a dicho cuerpo. Para el caso, es posible que las placas no hayan sido correctamente unidas, de ahí que la zona de unión haya quedado más débil y susceptible a fragmentarse.

- **Áreas faltantes**. Posiblemente debido a los movimientos del suelo donde estaban enterrados algunos fragmentos se perdieron. Esto dio lugar a que muchos de los objetos presentaran áreas faltantes hasta un 60%. Dicho efecto es una alteración importante debido a que resulta sumamente complejo comprender objetos cuyas formas y cualidades no pueden ser apreciadas de manera íntegra.

Tratamientos

Estabilización

Los objetos que presentaron matriz de tierra humedad fueron colocadas en cámaras cerradas para evitar así el desecamiento brusco del suelo contenido y las consiguientes alteraciones. El empleo de esta técnica es una propuesta que contribuye al manejo adecuado de objetos cerámicos con matriz de tierra húmeda y una condición frágil.

Limpieza

Se encontró que, dado que la mayor parte de las piezas de la colección provenían de excavación, presentaban restos de tierra del contexto sobre la superficie, la cual no aportaba ningún tipo de información relevante y si obstaculizaba su apreciación, indispensable para llevar a cabo un análisis tipológico completo. Las sustancias que, en cambio, si demostraron tener importancia, con respecto a la comprensión del contexto arqueológico, como cinabrio y óxido de hierro, fueron conservados.

Se determinó que el empleo de los métodos físico-químicos de limpieza, con alcohol etílico al 50% y acetona al 50%, únicamente funcionaron en las pastas más resistentes y no para limpiar la tierra depositada sobre las pastas cerámicas con gran

fragilidad, ya que se observó una disminución de su resistencia mecánica. Los métodos de eliminación mecánica mediante brocha y bisturí, brindaron mejores resultados en dichos casos.

Micro excavación

Dadas sus características de alta fragilidad muchas de las piezas tuvieron que extraerse del contexto con la tierra circundante. El proceso de micro excavación tuvo por objeto liberar a las vasijas de esta tierra, recuperar los materiales del interior y verificar la presencia de materiales que pudieran aportar información adicional sobre el contexto. En algunos casos antes de la liberación tuvieron que colocarse moldes de soporte para sostener las piezas conforme se iba efectuando la eliminación del contenido.

En la cerámica de Loma del Zapote, el bloque de tierra solo pudo eliminarse parcialmente. Las razones fueron que en primer lugar, el estado de conservación de los fragmentos cerámicos era de suma fragilidad siendo prácticamente imposible levantarlos sin afectarlos gravemente. Por otro lado, se observó que la mayoría de los fragmentos no constituía una pieza completa o alguna parte representativa de la misma. De esta manera se determinó llevar a cabo solamente una liberación parcial y consolidar el bloque, tratando que la tierra sujetara y diera resistencia a los fragmentos por el mayor tiempo posible.

Consolidación

La cerámica había perdido cohesión entre sus partículas, y por lo tanto resistencia mecánica, por lo que mediante la impregnación con Paraloid B72 (se consolidó. Esto brindó a los materiales la suficiente dureza para manipularse y conservarse.

A pesar de que la ética de la restauración establece que los tratamientos no deben cambiar las cualidades estéticas de los objetos, en algunos casos se registraron algunas variaciones en los tonos; generalmente se saturaron y oscurecieron ligeramente. La tipología en cuanto a registro de color, se basó en fragmentos no intervenidos. No obstante, era mejor una ligera variación de color a su destrucción y la perdida de información.

La ética de la restauración establece como principio la reversibilidad total de los tratamientos de restauración, para el caso de la cerámica de San Lorenzo este hecho también fue valorado, llegándose a la conclusión de que era preferible consolidar irreversiblemente a las piezas que perderlas.

Unión de fragmentos

Se decidió llevar a cabo la unión de los fragmentos en algunos casos, en orden de recuperar las formas. Muchas de las vasijas, desde la perspectiva del análisis tipológico, han sido rectificadas gracias a ésta y otras técnicas. Asimismo, puede afirmarse que este proceso les ha proporcionado estabilidad, al evitar que los cantos de los fragmentos continúen desgastándose o se pierdan. La unión se hizo con Mowithal B60H® este ha sido ampliamente utilizado para la unión de fragmentos en cerámica prehispánica en México, dando resultados adecuados en cuanto a los requerimientos de estabilidad, vida útil y capacidad adhesiva, en la mayor parte de los casos atendidos.

Reintegración formal

De acuerdo con Philippot (1959), 'la reintegración es imposible, en tanto repetición del proceso creador, de aquí que solo sea concebible, y por lo tanto plenamente justificada, si se la comprende como un acto de interpretación crítica, destinada a restablecer una unidad formal interrumpida, en la medida en que ésta queda latente en la obra mutilada, y en que la reintegración devuelve a la estructura estética la claridad de lectura que había perdido'. Muchos faltantes pueden romper de tal manera con la unidad formal de la pieza, que se dificulte su comprensión integral.

La mayoría de las piezas se encontraban incompletas. Algunas presentaban un porcentaje de faltante muy bajo, en cambio otras presentaron grandes pérdidas. En

el primer caso se consideró valida la reintegración en virtud de que, dada la forma de las piezas y el pequeño tamaño del faltante, era evidente la forma, textura y color que éste debía llevar. Al mismo tiempo este proceso dio estabilidad a las piezas y permitió su lectura. En el segundo caso, hubo piezas en donde la reintegración era imprescindible para su conservación y comprensión.

La reintegración se estableció en términos de su importancia didáctica, en virtud de que las piezas serán estudiadas y exhibidas, cumpliendo su función social actual. Para llevar a cabo esto fue consultado la tipología específica de las piezas que se pretendían reintegrar, con el objeto de documentar la intervención, procurando no alterar los datos de relevancia arqueológica. Como anota Berdocou, 'cuando un restaurador se enfrenta con un objeto muy alterado, debe buscar en él, las características que han aparecido en objetos similares, lo cual, no significa que se le imponga una forma al objeto, simplemente por su similitud con otros, pero sí hace notar que los bienes arqueológicos no siempre hablan por sí mismos, sino que deben interpretarse según su contexto' (Berdocou en Alcántara 1997).

Existían piezas con grandes faltantes que no fueron reintegrados, ya que no presentaron problemas de inestabilidad estructural y el espectador puede reconstruir por sí mismo las formas generales. Este proceso se efectuó mediante el modelado de la pasta de costilla,[1] de acuerdo a su forma.

Por último se resanaron grietas, fisuras y áreas repuestas, con la finalidad de reforzar las uniones y darle una apariencia estética. Este proceso se llevó a cabo mediante la aplicación de pasta cerámica[2] en grietas, fisuras y sobre el material de reposición. En cuanto a su grado de dureza la pasta se ajustó en cada caso, dependiendo de la resistencia que presentara el objeto en cuestión.

Reintegración cromática

Su aplicación se llevó a cabo, única y exclusivamente, sobre la intervención de restauración; resanes y reposiciones. Su objetivo también, estuvo en función del restablecimiento de la unidad de la obra, en este caso, dada por la unificación del color y del brillo.

Brandi establece que 'la reintegración debe ser fácilmente reconocible, quedando invisible desde la distancia que se observe al objeto, pero siendo fácilmente reconocible, y sin necesidad de instrumentos especiales, apenas el observador se coloque en un punto más cercano' (1990: 28). Este proceso fue evidenciado, lo más posible, principalmente en las reposiciones de gran tamaño. Se consideró que las reposiciones grandes, dado su carácter interpretativo, debían ser fácilmente reconocibles con el objeto para que se entendiera que constituyen solo una propuesta por parte del restaurador. Para ello se dejaron de un tono ligeramente más claro, con respecto al resto de la pieza. Por otra parte, fue considerado que las grietas y fisuras debían quedar perfectamente integradas, ya que de lo contrario daban la sensación de que las piezas tenían una especie de redes, de diversas formas, sobre sus superficies, lo cual definitivamente obstaculizaba y confundía al espectador.

Los materiales empleados para este proceso fueron: pigmentos minerales aglutinados con pasta, así como pinturas al barniz (pigmentos minerales mezclados con barniz dammar). La aplicación se realizó utilizando distintas técnicas. Para los faltantes grandes se empleó la técnica del manchado y para los pequeños la de puntillismo.

Conclusiones

A partir de la contextualización de la colección se determinó que su significado actual es el de documento arqueológico, lo que permitió definir, en gran medida, el criterio de intervención a seguir.

Como resultado de daños por efecto físico, exposición a condiciones ambientales extremas, materiales constitutivos inadecuados o de mala calidad y por técnicas de manufactura deficientes, los objetos cerámicos pueden presentar una pérdida de su resistencia mecánica original, la cual puede traducirse en efectos tales como: perdida de cohesión, fragmentación y áreas faltantes.

Mediante la limpieza fueron eliminados aquellos materiales que no aportaban información relevante, desde la perspectiva del conocimiento de la cultura olmeca.

La micro excavación permitió recuperar un sinnúmero de materiales que brindaron información adicional sobre el contexto.

La consolidación con Paraloid B72 (aumentó la resistencia mecánica y la estabilidad estructural de aquellos objetos que habían perdido cohesión. Se determinó que aunque este proceso es irreversible era necesario para su conservación. A través de la unión de fragmentos fue posible recuperar las formas cerámicas y al mismo tiempo contribuir con el análisis tipológico. La reintegración formal fue necesaria para que algunas de las piezas pudieran estabilizarse y comprenderse, en aras de cumplir con su función didáctica. La reintegración cromática permitió obtener una lectura integral de los objetos cerámicos y al mismo tiempo su reconocimiento como elemento moderno.

La restauración no trabaja con métodos en los que se encaja a los objetos de manera artificial y preconcebida, sino que parte de un razonamiento crítico que fundamenta y orienta en determinado sentido a sus intervenciones y es capaz de aportar información valiosa que enriquece el conocimiento sobre las culturas.

Agradecimientos

A los alumnos, profesores y especialistas que participaron en este proyecto.

Notas

1 Pasta compuesta de Mowithal B60H® alcohol etílico, acetato de etílo, fibra de vidrio. blanco de España y caolín.
2 Pasta compuesta de Mowilith 50® acetona, fibra de vidrio blanco de España y caolín.

Referencias y bibliografía

Alcantara, R, 1997, 'Un análisis crítico de la teoría de la restauración de Cesare Brandi', tesis ENCRM INAH, México.

Berducou, M, 1996, 'Introduction to Archaeological Conservation', en Price, N S (ed.), *Historical and Philosophical Issues in the Conservation of Cultural Heritage*, Los Angeles, The Getty Conservation Institute, 248-259.

Brandi, C, 1996, *Teoría de la Restauración*, Alianza Forma, México.

Buys, S, y Oakley, V, 1993, 'The Conservation and Restoration of Ceramics', Butterworth–Heinemann series in *Conservation and Museology*, London.

Coe, M y Diehl, R, 1980, *In the Land of the Olmec*, University of Texas Press, Austin.

Cyphers, A, 1997. *Población, Subsistencia y Medio Ambiente en San Lorenzo Tenochtitlán*, UNAM IIA, México.

Guevara, M y López, M, 1996, 'La restauración y su investigación: El caso de una vasija cerámica de San Lorenzo Tenochtitlán Veracruz', tesis ENCRM INAH México.

Philippot, P y Albert, 1959, 'El problema de la integración de las lagunas en la restauración de pinturas', *Bulletin del'Institut Royal du Patrimoine Artistique*, Tomo II, Bruselas, CLECRB UNESCO, México.

Van de Wetering, E, 1996, 'The Autonomy of Restoration: Ethical Considerations in Relation to Artistic Concepts', en Price, N S (ed.), *Historical and Philosophical Issues in the Conservation of Cultural Heritage*, The Getty Conservation Institute, Los Angeles, 193-199.

Abstract

This paper discusses conservation treatments on enamels on metal. It describes the physical and chemical properties, the artistic techniques and alteration products of these composite artefacts, and the specificity of their treatment is considered. Finally, historical and contemporary treatments are discussed.

Keywords

enamels, metal, treatments, history of conservation, decorative arts, archaeology

The conservation of enamels on metal: characterization and historical notes

Agnès Gall-Ortlik★
38, rue Ramey
F-75018 Paris, France
E-mail: gallortlik@yahoo.fr

Béatrice Beillard
15, avenue Marguerite
F-78220 Viroflay, France
E-mail: b.beillard@wanadoo.fr

Introduction

The conservation of enamels on metal has its own speciality in the field of conservation of works of art. Enamels on metal combine two unlike materials, with different physical and chemical properties, on the same artefact. This composite nature affects the choice of conservation treatment, because treatments for metal and for glass are different and frequently incompatible. To determine the ideal treatment, a compromise must be made and this, in turn, can make conservation treatments more complex.

When treating an enamel on metal, it is important to know the distinct physical and chemical properties of glass and metal, to identify the techniques by which the object was made and to define and characterize the deterioration of each material. A treatment can then be selected that follows, as closely as possible, those currently used in the conservation of glass or metal.

The main physical and chemical characteristics of enamels on metal are noted, but further detail is available in Carpenter (1983, 1984 and 1986). The deterioration of enamels results from the difference in properties between the glass and the metal: glass is brittle and metal ductile; glass is a poor conductor and metal is a good one; both glass and metal are sensitive to water and metals are more readily attacked by acids, but glass is instead very sensitive to alkaline solutions.

There are different ways of enamelling a metallic support. The literature on the subject is extensive. This paper will list the principal techniques. More information can be found in *The Dictionary of Enamelling* (Speel 1997). The main techniques practised are basse-taille enamel, champlevé enamel, cloisonné enamel, émail de plique or plique-à-jour enamel, painted enamel and enamel photography.

Common problems seen on enamels and their origin

The deterioration of enamels occurs through mechanical and chemical processes. The more common problems include folding, breaks, detachment or loss of the metal, and corrosion. Glass can be cracked, broken, flaked, lost, crizzled, sweated, effloresced, weathered, iridescent and pitted. The causes of the deterioration are diverse. Burial in humid, acid or alkaline soils causes metal and glass to corrode and become covered with weathering or corrosion crusts.

Deterioration can be linked to the manufacturing process. For example, if the metal sheet is thin, breakage of the plate is likely to occur with loss of metal and glass elements. When enamel and metal have widely different expansion coefficients, or when a metal object is enamelled only on one side, cracking and loss can occur. When glass has an unstable composition, decay of the glass and cohesion problems between the two materials occurs.

Poor handling can lead to breakage of the object. Furthermore, if the object is kept in unsuitable storage and is not cleaned, or is cleaned with improper products, corrosion may appear. Inappropriate conservation or restoration treatments can also be a source of damage.

★Author to whom correspondence should be addressed

Historical treatments

Even thought they have a reputation for resisting 'the ravages of time' (Millenet 1917), enamels deteriorate easily. The treatments applied to restore this damage have been numerous. The study of objects and of the limited literature available shows that enamel repair has been practised for a long time. Traditionally, the craftsmen themselves carried out repair. In the 17th century, this often involved re-enamelling, and the King John Cup is an example of this practice (Speel 1998). At the end of the 18th and during the 19th century, with the spread of decorative art collections, the task of repair was assumed by a new kind of specialist, the 'artiste-réparateur' (Thiaucourt 1868). The aim of the treatments was to restore the enamels to their original appearance, but doing so often caused irreparable damage by destroying the integrity of the object. Surface cleaning, corrosion removal, consolidation or protection of glass, repair of breaks, filling of glass losses and inpainting and varnishing are all recorded in the historic literature.

A variety of substances have been used for surface cleaning. Some of the products historically recommended to remove dirt and grease on glass and metal include 'window spray' (Cosgrove 1974), soap and warm water (Cosgrove 1974, Mills 1964, Savage 1967) or ammonia (Cosgrove 1974, Mills 1964). Metallic corrosion products have been removed mechanically with scalpel blades and sandpaper (Cosgrove 1974), or they have been chemically removed, often without any isolation between glass and metal (Fekete and Hidvégi 1981). Crizzled glass, such as the Limoges enamels, which were made at the turn of the 16th century, was swabbed with distilled water or soaked in water, ethanol and then acetone to remove the alkaline efflorescence (Michaels 1964–1965). Sulfuric acid was also added to water bath during the 1960s to neutralize alkalinity (Beillard 2001). Plenderleith recommended dilute hydrofluoric acid to remove the weathered surfaces from corroded enamel that had become detached from the metal (Plenderleith 1956).

The common way to repair a torn plate or a metal loss was to solder and chase metallic parts together (Thiaucourt 1868). This frequently resulted in damage to the enamel, often with a lost of material. For example, cups of painted enamels, broken at the junction of the leg and the cup after an impact, were usually repaired with tin solder. This often involved removing enamel from the bottom of the cup, so that the restorer could make a 'cleaner' and bigger hole in the cup's bottom to allow the reattachment of the leg. To hide the repair, the enamelled bottom was then filled with natural resins and retouched.

During the 20th century, this treatment was abandoned. In 1978 Liu advised against soldering and recommended glue or wax instead (Liu 1978). In 1994, a cellulose nitrate adhesive (HMG®) reinforced with nylon tissue was used to reconstruct archaeological copper brooches (Watts 1994). The most commonly used glass adhesives seem to have been animal glue and shellac (Fisher 1991, Mills 1964, Plenderleith 1956). But these could be the source of mould growth or metal corrosion and damage did occur to the glass when the plate was heated for repair with shellac. In 1952, shellac was still being used for the treatment of a cloisonné and painted enamel on silver (Steingräber 1952). Canada balsam is also mentioned as adhesive in 1967 (Savage 1967). Polyvinyl acetate products appeared in the 1980s and were later rejected because of poor ageing characteristics (Dove 1981, Henau et al. 1982-1983, Down et al. 1996).

The losses of glass have been filled with a variety of materials. An ancient method of filling glass used by the Chinese on their cloisonné enamels was natural wax (Liu 1978). Re-enamelling has been commonly practised until the 20th century. Richter made a very interesting study on this technique, which is usually hard to identify (Richter 1994). After firing, the historic enamel object was treated like a newly made enamel piece: the copper oxidation was removed with sulfuric acid or with alum and the enamel protuberances were sanded. Pájer (1985) recommends this technique after having applied lower fusing point enamels. 'Cold' gap-fillings or decoration in relief were carried out with materials like shellac, gum arabic, colophony or animal glue mixed with whiting agents such as Spanish white or gypsum (Fernandez-Bolanos and Herraez 1992, Michaels 1964-1965, Thiaucourt 1868). These treatments often led to the abrasion of the glass surface around the areas of loss.

Retouching of the new gap filling was often done with borrowed painting restoration techniques. Oil painting (Savage 1967, WAG LR 44.472 1944) and tempera (WAG LR 44.128 1963) were used to imitate opaque enamels. For translucent enamels, copal (Thiaucourt 1868), dammar (Michaels 1964-1965), celluloid in amyl acetate (Savage 1967, p. 40) or a polycyclohexanone resin AW-2® (WAG LR 44.128 1963) were used, sometimes coloured with dry pigments. To imitate the effect of paillons, silver or gold foil was stuck onto the metal with animal glue or gum arabic (Thiaucourt 1868). Gilding is usually restored using techniques similar to those applied on ceramic or porcelain: powdered gold, mixed with a resin, was applied to the enamel surface (Thiaucourt 1868). Ross (1934) listed some enamels showing these kinds of restorations in English collections.

But these old restoration materials were often a source of deterioration. They were removed mechanically, often using hot water (Plenderleith 1956) or a paint stripper such as Nitromors Paint Remover®, a product containing dichloromethane and methanol (Fisher 1991). Fungi were eliminated with a fungicide such as Santobrite® (Plenderleith 1956). This is no longer used as it has been found to be a carcinogen, teratogen and mutagen (Edwards 1997).

The same products were used for both the protection and consolidation of the glass and to improve its appearance. There was little differentiation between these functions.

Plenderleith recommended a dilute lacquer with no specific brand name (Plenderleith 1956). For a crazed enamelled surface, Mills advised soaking the object in the acrylic resin Bedacryl®, a material usually used to consolidate wood, fossils and leather, or in a cellulose nitrate resin of the Frigilene® type, which was used as a protection lacquer for silver (Mills 1964). Michaels uses, after the thorough cleaning of the plate, AW-2® on a crizzled enamel (Michaels 1964-65). The use of polyvinyl acetate resins begins during the 1980s with Mowilith® being the most frequently recommended brand (Dove 1981, Henau et al. 1982-1983). This was soon superseded by the acrylic resin Acryloid B-72®. Waxes such as beeswax have also been used, not only to fill the gaps, but also as a consolidant and protection layer (France-Lanord 1981). Natural wax is unstable (Clydesdale 1994) and has been replaced by microcrystalline waxes. One of the first applications dates from 1983 with the use of a Lascaux® adhesive wax 443-95 (Landgrebe 1983). Finally, there is one example of an epoxy adhesive, Hxtal-Nyl-1®, being used for consolidation (Fisher 1991). To stabilize corroded metal, the application of protection layers has been more common than stabilization with corrosion inhibitors. Cosgrove proposes 'cold enamel' or candle wax coating (Cosgrove 1974).

Contemporary treatments

Safeguarding the long-term stability of the enamelled object is seen as a priority within contemporary treatments. Soaking method and the use of alkaline and acid solutions has today been abandoned to avoid the risk of damage. Solvents for wet cleaning are locally applied with a brush or with a swab and dried with a blotter (Magee 1999). Another method for application of solvents is through gels or pealing films (Crevat 2001) mixed with water, ethanol or acetone. Water and acetone should be used in combination with ethanol, to moderate or modify their evaporation rate. Ethanol appears to be the safest solvent for both materials. All these methods are practised today to remove alkaline efflorescence on crizzled enamels and metallic corrosion from within the glass (Burgalassi, Dolcini 1987). This surface cleaning method is not completely satisfactory, as it doesn't remove all the corrosion products in the inner layers. But it remains today the safest way to durably improve the condition of the deteriorated object. Silver sulfide corrosion on silver wires in a plique-à-jour object has been removed by the local application of electrolysis with humidified blotters and a very dilute solution of calcium carbonate. The calcium carbonate is used because it, unlike other electrolytes, does not appear to react with the glass (WAG LR 44.546 1995).

Metallic corrosion is mechanically cleaned in areas where the metal is pitted with spots and on larger areas without glass. Scalpel blades or a glass bristle brush are frequently used but air abrasion is also helpful, provided that enamel is well

adhered to the metal and, in the case of a copper plate, that the cuprite layer can resist the stress of this technique. Air abrasion, using apricot shell powder, is particularly effective for enamels on iron (Gall-Ortlik 2001). Polishing of gilded or silvered areas is possible with other abrasive materials, but the abrasive should never be harder than the glass.

No satisfactory solution has yet been found for the consolidation of deteriorated glass (Smith 1999). Today a preventive conservation approach is preferable to actively treating them with resins and cleaning agents. Recent research has tested materials, such as acrylic resins (Plastogen G®, Paraloid® B-72), microcrystalline waxes (Tecerowachs® 30445 and 30222) and epoxy resin (Hxtal-Nyl-1®). This research has compared these materials to a new product, a heteropolysiloxane, so-called Ormocer® (ORganically MOdified CERamic), an inorganic-organic co-polymer (Müller et al. 2000, Richter 2000) for their effectiveness on enamels. There are different varieties of Ormocer® and some have been used as protection coating for outdoor bronze (Pilz et al. 1997).

Archaeological enamels often require stabilization treatments for the metallic components. Copper is usually stabilized with the application of benzotriazole (Dove 1981, Parrott, 1984). The protection of metal can be achieved by applying a coating of Acryloid® B-72 or microcristalline wax as Renaissance® (Crevat 2001, WAG LR 44.564 1991). Coating of deteriorated glass is not recommended as the film could enclose water and promote further weathering or crizzling of the surface.

To imitate opaque enamels, polyester resin (Grant 1998) or microcrystalline waxes Cosmolloid® 80H and Multiwax® W-445 are currently used (WAG LR 44.22 1999). The polyesters are usually retouched in surface whilst the waxes are mixed with pigments. The effect of translucent enamel is achieved with polyester or acrylic resins such as Acryloid® B-67 or B-66 in petroleum solvents (WAG LR 44.418 1996). These can be pigmented or painted with acrylic or Maimeri Restauro® paints.

Storage

Good environmental conditions are essential to preserve enamels on metal, especially when glass is crizzled or weathered or when the metal shows active corrosion. Relative humidity (RH) recommendations range from 60% to 42% (Michaels 1964-1965, Schott 1995). Determining the exact relative humidity range is still a subject of discussion. Unstable metals should be kept under 45% relative humidity (Thomson 1986). But crizzled enamels at less than 42% relative humidity will crack and become opaque and will weep at more than 47% relative humidity (Dreyman-Weisser 2000). A relative humidity of 45% is thus a good compromise that allows the glass surface to remain visually intact. Avoiding variations of humidity whilst maintaining a temperature around 18°C to 20°C remains perhaps the most important factor. The object should be stored in a box made with non-acid materials rather than being wrapped in tissue or film. Plates on display should be vertical to avoid dust build-up on the surface, provided that there are no loose glass flakes. During handling, plastic gloves must always be worn to avoid fingerprinting. Cotton gloves are to be avoided since they can leave fibres behind and snag or dislodge loose pieces of glass on the surface.

Conclusion

The study of literature and of objects has shown that enamels on metal have been repaired for a long time. Ancient restorations were intended to make the enamels look more attractive but they often damaged the original material by using techniques and products not adapted to enamels on metal. Surface coatings such as wax, varnish or consolidant have been sources of deterioration rather than preventive, or improving, treatments. Today, treatments tend to be less interventionist and to respect the material and aesthetic integrity of the objects. Conservators appreciate that glass and metal conservation treatments can't be systematically applied to enamels but have to be adapted. Several topics such as the cleaning

and consolidation of crizzled enamel or the cleaning of corroded plates under enamel today need further research to find satisfactory solutions.

References

Beillard, B, 2001, 'Dérestauration d'une série de plaques attribuées au Pseudo-Monvaerni et conservées au musée du Louvre,' *Coré* 10, 26–30.

Burgalassi, G and Dolcini, L, 1987, 'Il restauro degli smalti: la soluzione di un caso,' *OPD Restauro* II, 107–110.

Carpenter, W W, 1983, 'Primary Properties of Glass, Part 1: Fusibility and Fluidity' *Glass on Metal* 2(2), 16–19.

Carpenter, W W, 1983, 'Primary Properties of Enamel, Part 2: Thermal Expansion and Contraction Including Stresses and Strains,' *Glass on Metal*, 2(3), 28–32.

Carpenter, W W, 1983, 'Primary Properties of Enamel, Part 3: Resistance to Environment,' *Glass on Metal* 2(4), 39–42.

Carpenter, W W, 1984, 'Physical and Mechanical Properties of Enamel and Enamel Coatings,' *Glass on Metal* 3(4), 41–44.

Carpenter, W W, 1984, 'Physical and Mechanical Properties of Enamel and Enamel Coatings, Part 2,' *Glass on Metal* 3(4), 41–44.

Carpenter, W W, 1986, 'Metals Suitable for Enameling,' *Glass on Metal* 5(6), 81–99.

Clydesdale, A, 1994, 'Beeswax: A Survey of the Literature on its Properties and Behavior,' *SSCR Journal* 5(2), 9–12.

Cosgrove, M G, 1974, *The Enamels of China and Japan: Champlevé and Cloisonné*, New York, Dodd, Mead and Co.

Crevat, S, 2001, 'L'œuvre de Limoges: question de conservation à propos d'une exposition,' *Coré* 10, 22–25.

Dove, S, 1981, 'Conservation of Glass-Inlaid Bronzes and Lead Curses from Uley, Gloucestershire,' *The Conservator* 5, 31–35.

Down, J L, McDonald, M A, Tétrault, J, Williams, R S, 1996, 'Adhesive Testing at the Canadian Conservation Institute: An Evaluation of Selected PVAC and Acrylic Adhesives,' *Studies in Conservation* 41(1), 19–44.

Dreyman-Weisser, T, 2000, personal communication, Baltimore, Maryland, Walters Art Gallery.

Edwards, T, 'Santobrite,' ConstDistList (October 23, 1997)

Fekete, L, Hidvégi, E, 1981, 'Ekszerek, pénzek, veretek restaurálása (Restoration of Jewels, Coins and Fittings),' Múzeumi Mütárgyvédelem, 8, Budapest, Múzeumi Restaurátor – Módszertani Központ, 157–160 (in Hungarian with summaries in English).

Fernandez-Bolanos, M P, Herraez Martin, M I, 1992. 'Conservation and Restoration of the Sword of Boabdil, King of Granada', *Conservation of the Iberian and Latin American Heritage*, preprints of the IIC Madrid Congress, London, 38–40.

Fisher, P, 1991, 'The Restoration of Historical Enamels', Les arts du verre: Histoire, technique et conservation, *Journées d'Etude de la SFIIC*, Nice, 81–91.

France-Lanord, A, 1981, *4th of Nov. Condition Report*, unpublished report, Nancy, Laboratoire d'archéologie des métaux.

Gall-Ortlik, A, 2001, 'La conservation des émaux peints sur metal,' *Coré* 10, 31–35.

Grant, J, 'Repairing Cloisonné,' ConsDistList (August 17, 1998)

Henau, P de, Fontaine-Hodiamont, C, Maes, L, 1982–1983. 'Le baiser de paix émaillé de Namur: Examen technologique et traitement,' *Bulletin de l'IRPA* 19, 5–25.

Landgrebe, B, 1983, 'Technik und Geschichte des Emailmalerei,' Maltechnik Restauro 3, 187–203.

Liu, L-Y, 1978, *Chinese Enamel Ware: Its History, Authentication and Conservation*, Taipei, Cygnus Publications.

Magee, C E, 1999, 'The Treatment of a Severely Deteriorated Enamel' *ICOM-CC 12th Triennal Meeting* 2, 787–792.

Michaels, P E, 1964–1965, 'Technical Observations on Early Painted Enamel of Limoges: Their Materials, Structure, Technique and Deterioration,' *The Journal of the Walters Art Gallery*, 27(28), 21–43.

Millenet, L-E, 1917, *Manuel pratique de l'émaillage sur métaux*, Paris, Dunod (English edition, 1947, New York, Van Nostrand Company).

Mills, J M, 1964, *The Care of Antiques*, New York, Hastings House.

Müller, W, Kruschke, D, Köcher, C, Pilz, M, Römich, H, Troll, C, 2000, 'Welches Festigungsmittel eignet sich? Experimentelle Forschungen an der BAM und am ISC,' *Restauro* 6, 442–446.

Pájer, K, 1985, 'Problems of Completing Goldsmith's Enamel,' *Cinquième cours international pour restaurateurs*, Budapest, National Centre of Museums, 211–16.

Parrott, M, 1984, 'Problems in the Conservation of Enamelled Objects. From Pinheads to Hanging Bowls,' *UKIC Occasional Papers*, 7, 7.

Plenderleith, H J, 1956, *The Conservation of Antiquities and Works of Art*, London, Oxford University Press.

Pilz, M, Römich, H, 1997, *A New Conservation Treatment for Outdoor Bronze Sculptures Based on Ormocer, Metal 95*, London, James and James, 245–250.

Richter, R, 1994, 'Between Original and Imitation: Four Technical Studies in Basse-Taille Enameling and Re-enameling of the Historicism Period,' *Bulletin of the Cleveland Museum of Art* 81(7), 223–251.

Richter, R, 2000, 'Die Festigung der Emailpretiosen im Grünen Gewölbe,' *Restauro* 6, 447–453.

Ross, M C, 1934, 'Early Restorations of Medieval Enamels,' *Technical Studies* 2(3), 139–143.

Savage, G, 1967, *The Art and Antique Restorers' Handbook. A Dictionary of Materials and Processes Used in the Restoration and Preservation of All Kinds of Works of Art*, London, Rockliff Publishing Corporation (1st ed. 1954).

Schott, F, 1995, *Die Restaurierung des Metallteile des Goldenen Rössl: Das Goldene Rössl, Eine Meisterwerk des Pariser Hofkunst um 1400*, Munich, Bayerisches National Museum, 317–335.

Smith, S, 1999, 'Opacity Contrawise: the Reversibility of Deteriorated Surfaces on Vessel Glass', Reversibility: Does it Exist? *British Museum Occasional Papers* 135, 135–140.

Speel, E, 1997, *Dictionary of Enamelling. History and Techniques*, Aldershot, Ashgate.

Speel, E, 1998, 'The King John, or King's Lynn Cup,' *Glass on Metal*, 17, 4–7.

Steingräber, E, 1952, 'Das Silberemail-Reliquiar im Regensburger Domschatz und seine Restaurierung,' *Kunstchronik* 5, 204–208.

Thiaucourt, P, 1868, *L'art de restaurer les faïences, porcelaines, émaux, etc.*, Paris, Auguste Aubry.

Thomson, G, 1986, *The Museum Environment*, London, Butterworth-Heinemann.

Walters Art Gallery, Laboratory Reports 44.22 (1999), 44.128 (1940, 1963), 44.418 (1996), 44.472 (1944), 44.546 (1995), 44.564 (1991), Baltimore, Maryland.

Watts, S, 1994, *The Investigation of a Group of Enamels from Birdoswald*, Ancient Monuments Laboratory unpublished report 21/94, London, Historic Buildings and Monuments Commission for England.

Resumen

El Ajedrez de Carlomagno es un buen ejemplo de los trabajos del siglo XIV en esmalte translúcido sobre plata. Su restauración permitió documentar el sistema de construcción de un objeto único, así como realizar la analítica de sus materiales constituyentes. El estado de conservación de los esmaltes era muy variable, dependiendo de la composición química de éstos y del grado de daño mecánico por uso del objeto. Se aplicó un tratamiento sencillo, eliminando los depósitos de suciedad ambiental y sulfuración de la plata, consolidación del soporte, fijación de los esmaltes y aplicación de una capa de protección, utilizando materiales y productos ampliamente testados y conocidos.

Palabras claves

esmalte translúcido, nielo, Montpellier, hispanomusulmán, relicario, técnica construcción, alteración, restauración

Figura 1. Vista general del relicario.

Figura 2. Detalle de una antigua intervención. Alteración de los esmaltes y erosión.

Restauración de esmaltes sobre plata: El Ajedrez de Carlomagno

Isabel Herráez Martín
Instituto del Patrimonio Histórico Español
Ministerio de Educación, Cultura y Deportes
Calle Greco 4, Ciudad Universitaria
28040 Madrid, España
Fax: + 34 91 550-4444
E-mail: isabel.herraez@iphe.mcu.es

Introducción

El Ajedrez de Carlomagno se conserva en la Real Colegiata de Santa María de Roncesvalles, que situada en un paso natural de los Pirineos, fue escenario de múltiples batallas y leyendas. Su época de esplendor coincidió con el apogeo del Camino de Santiago, recogiendo múltiples encomiendas y donaciones. Entre ellas se encontraba Montpellier, lugar de procedencia del relicario, cuya encomienda mantuvo la Colegiata hasta 1364. Adquirida posteriormente por Carlos II el Malo, se conservó bajo la dinastía navarra de los Evreux hasta el año 1382. La leyenda dice que parte de las reliquias que contiene el Ajedrez las donó el propio Carlomagno, traídas desde Jerusalén, y que las restantes proceden del Arca de la Cámara Santa de Oviedo. Según Marquet de Vasselot (1897) algunas son de santos españoles, mientras que otras son de claro origen oriental o traídas desde Roma, como los fragmentos del Lignum Crucis.

Descripción general

Se trata de un tablero en madera de nogal, con medidas aproximadas de 57 cm de ancho, por 47 cm de alto, por 5 cm de profundidad; con 32 tecas excavadas que contienen diversas reliquias y 51 placas esmaltadas. Punzón de Montpellier. Los esmaltes del marco representan Profetas, Reyes y personajes del Antiguo Testamento como precursores y anuncios de la llegada del Mesías; Apóstoles, Evangelistas y el Martirio de San Esteban, considerado como el primer mártir del cristianismo. En el tablero central se representan todas las etapas históricas de la llegada del Mesías, desde su anuncio por Juan el Bautista hasta el Juicio Final con la Resurrección de los Muertos. La trasera aparece coloreada con pinceladas de bermellón y ocre (Figura 1) (Gauthier 1972, Martín Ansón 1984, González 1994).

Técnicas de construcción

Realizado con tres piezas de nogal, unidas mediante clavos de forja, reforzado posteriormente por dos fuertes costillas horizontales. Sobre el alma de madera se han rebajado 32 huecos de 65 mm de ancho, por 48 mm alto, por 40 mm de profundidad, cerrados con cuarzo. Todo el tablero se cubre con una retícula de chapa y perfiles de media caña, de plata dorada al mercurio, sujeta mediante clavos de plata, colocados simétricamente. Las chapas actúan como base y los perfiles forman los cintillos de sujeción de las 51 placas esmaltadas y cuarzos, de forma similar a un cabujón (Figura 3). Marcas de montaje. Para conseguir un encaje adecuado de los esmaltes y amortiguar golpes o vibraciones colocaron almohadillas de papel bajo éstas; reutilizado, se aprecian textos legibles con caligrafías de distintas épocas (Figura 4). El conjunto se completa con un marco en plata dorada y esmaltes, sujeto mediante clavos de plata al alma de madera.

Preparación de las placas

La técnica se conoce como de bajorrelieve o basse-taille, y puede apreciarse en la placa que representa un arzobispo o Papa, que por su reverso muestra un

Figura 3. Detalle del sistema de construcción. Chapa de plata, cintillos y cuarzos.

Figura 4. Detalle del sistema de construcción. Almohadillados de papel bajo los esmaltes.

arrepentimiento del esmaltador. Se comienza perfilando el motivo para, a continuación, rebajar los fondos como nivel más bajo del relieve. Estos se trabajan con buril, creando superficies discontinuas, llenas de ángulos y planos que darán intensidad al color, luminosidad, profundidad y perspectiva al trabajo, además de favorecer el agarre del esmalte. En la técnica de bajorrelieve, en la cual la placa apenas tiene barreras de contención entre los distintos colores, puede aglutinarse el esmalte en polvo con goma vegetal y aplicarlo con pincel. Después de fundido y frío, se pule. En el Ajedrez los fondos se han trabajado formando abanicos, losanges o flores de seis pétalos. Posteriormente se tallan y pulen los distintos planos de las figuras para carnaciones, vestiduras o atributos, perfilando los contornos con una incisión profunda a buril, que después queda rellena con esmalte. El metal utilizado en el relicario es plata, con pequeñas cantidades de oro y cobre. En zonas de carnaciones, atributos y elementos arquitectónicos se aplicó oro mediante amalgama de mercurio, actualmente muy perdido. Se utilizó esmalte azul cobalto en los fondos; rosa, morado, amarillo oro, verde claro, verde esmeralda y ocre en los figuras. Los fondos arquitectónicos se trabajaron con excavado o champlevé, y esmaltes rojo opaco y verde translúcido. Carece de contraesmalte. (Maryon 1971, Theophilus 1979, Cellini 1989)

Los esmaltes

La composición del esmalte, aunque varía de unas recetas a otras, es fundamentalmente sílice, bórax, plomo, sosa, potasa o cal; esta mezcla básica, transparente, se conoce como frita, y a ella se añaden diversos óxidos metálicos responsables del color o la opacidad. La presencia de todos estos compuestos, así como su relación proporcional con los demás, van a establecer las características físicas y químicas del esmalte, entre ellas su durabilidad. A medida que aumenta el número de elementos en la masa, se incrementa el riesgo de descomposición haciendo que el esmalte sea fácilmente atacado por agentes ambientales adversos como pH o HR inadecuados, que van a alterar la red vítrea transformando el esmalte en un producto friable y susceptible de alteración. Los esmaltes sobre plata suelen presentar numerosos daños mecánicos, como alternancia frío-calor (contracción-dilatación), erosión, golpes, o lagunas por deformación del soporte, limitándose los químicos a la desvitrificación o corrosión vítrea por factores como mezcla de la frita, balance de porcentajes, etc. ya que la plata no suele presentar problemas de corrosión metálica. El material utilizado en el relicario es, fundamentalmente, un vidrio potásico (sílico-potásico-cálcico). Los colores, obtenidos mediante la adición de óxidos metálicos y diferentes atmósferas de cocción, son azul cobalto, morado, amarillo oro, ocre (mezcla de colores), verde esmeralda y verde limón (mezcla de colores). Las distintas intensidades del color se deben al porcentaje en el que se utilizaron cada uno de los óxidos y al tallado de las placas de base. Las muestras, procedentes del marco y una placa central, se estudiaron mediante técnica SEM-EDX y microanálisis con BSE, en los Laboratorios del IPHE (Navarro Gascón 1998). En la elaboración del color azul se utilizó cobalto, y pequeñas cantidades de hierro y cobre, más trazas de manganeso; el amarillo oro con hierro y manganeso; el verde esmeralda con cobre, hierro y manganeso, con mayor contenido en sodio que el resto de los colores; el verde limón, vidrio amarillo con inclusiones de vidrio verde, con hierro y cobre; el ocre con manganeso, hierro y cobre; el morado con manganeso y el rojo opaco, con hierro, cobre y fósforo. Se han observado diferencias considerables en las muestras procedentes del marco con niveles muy superiores de potasio. Puede tratarse de una mezcla intencionada del esmaltador para conseguir una distinta frita de base, para esmaltar estas placas de mayor tamaño o ser un producto de alteración del esmalte (Newton y Davison 1987).

Las tecas

Interiormente se forraron con un tafetán de seda roja (posiblemente madera de Brasil) con orillo en verde (gualda e índigo). Este tejido, muy gastado y decolorado, podría ser una reutilización de material en el momento de construcción del relicario, ya que también aparece envolviendo algunas de las reliquias.

Detalle 1

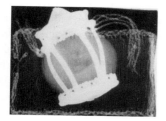

Detalle 2

Detalle 3

Figura 5. Estudio radiográfico. Película tipo 2 norma ASTM, revelado automático en 8 minutos a 30°C, 1'92 distancia foco-película, 319kV y 5mA. Tiempo de exposición 35 segundos vista general; 10 segundos detalles.

Figura 6. Apertura de las tecas. Esenciero hispanomusulmán de plata y nielo. Siglo XI.

Sobre este tejido se empotraron en los huecos cajas de plata, sin fondo. Dentro de estas tecas se depositaron las distintas reliquias, ocultas y agrupadas en bolsitas textiles o recipientes de metal, cerámica o vidrio, algunos de ellos sujetos con cera de abeja. Sobre ellos se colocó, durante una intervención no documentada, un tejido dorado (alma de seda roja y lámina de plata dorada), con decoración geométrica (ondas, zigzags, rayas, etc.) y antiguas cartelas sobre vitela. Una vez introducidas las reliquias se colocan los cristales de roca y se doblan los cintillos de plata sobre ellos, igual que se hizo con las placas esmaltadas, quedando cerradas las tecas. Su contenido no parece ajustarse a un patrón definido, aunque las primeras conservan reliquias con relación a hechos de la vida de Cristo, como por ejemplo su venta por treinta monedas, su sangre, un fragmento de la cruz o el sepulcro; a sus milagros, como la multiplicación del pan; o a su familia, como su Madre y abuela.

Después aparecen reliquias referentes a los Apóstoles como Pablo, Andrés, Bartolomé, Bernabé, Tomás, y a sus seguidores con los primeros mártires, como Esteban, reservando las últimas para los ministros de la Iglesia: diáconos, obispos, arzobispos, etc., diversos mártires, y santas o beatas en las últimas filas. Al retirar el marco del relicario quedaban abiertas algunas tecas, pudiendo estudiar su contenido; las demás sólo podían abrirse doblando las molduras de plata que sujetan los cierres de cuarzo. Este procedimiento suponía una grave agresión a la obra, decidiendo limitar la apertura y documentar los contenidos mediante RX. El estudio radiográfico, realizado en los Laboratorios del IPHE, nos permitió ver detalles ocultos del sistema de construcción, y el contenido de algunas tecas con recipientes y objetos indeterminados (Gabaldón y Antelo 1998) (Figura 5). En las tecas abiertas se localizaron, entre otros objetos, un frasquito de cristal de roca y plata dorada, un esenciero de plata y nielo, hispanomusulmán siglos XI–XII y una bolsita realizada con un fragmento de tejido hispanomusulmán del siglo XIII. El esenciero se analizó en los Laboratorios del IPHE, mediante SEM-EDX identificándose el nielado como una mezcla de azufre, plata, plomo y cobre. La presencia generalizada del mercurio está asociada a la superficie de plata, pudiendo guardar relación con un dorado posterior de la pieza (Theophilus 1979, Cellini 1989, Oddy 1983, Navarro Gascón 1998) (Figura 6). El ligamento del fragmento textil fue estudiado por Dª Pilar Borrego (Figuras 7 y 8). Técnica de tapiz, lousine, presenta urdimbre doble de seda, torsión Z, en azul (índigo) y blanco o cruda (ab.aa.aa.ab.aa.aa.ab.). La densidad de la urdimbre es de 52/56 hilos/cm aprox. La trama con un entorchado de oro sobre piel y alma de seda amarilla, ambos con torsión Z. La seda de color natural, rojo (kermes y granza), azul (índigo), salmón (posiblemente madera de Brasil), negro o pardo (ácido elágico), verde (gualda e índigo) y verde claro o amarillo (gualda). Ligera torsión S. Densidad 60/68 hilos/cm aprox. (Bernis 1956). Los análisis de caracterización de materiales se realizaron en los Laboratorios del IPHE mediante microscopía óptica, SEM-EDEX, GC, HPLC y FTIR (Gayo 1998, Gayo y Martín de Hijas 1999)

Alteraciones generales

Aunque siempre se describe como relicario es muy probable que fuera utilizado como altar portátil. Esta hipótesis explicaría la localización de mayores daños en la mitad inferior, con esmaltes perdidos por desgaste y erosión de las placas, fracturas de los cuarzos y ligero hundimiento del centro del tablero (Faltermeier 1987). El uso y transporte incrementaría la alteración, provocando un deterioro más rápido, que obligaría a reparaciones continuas para que el objeto presentara un aspecto digno durante su utilización: añadido de piezas de madera, apertura de las tecas, cambio de telas, soldadura, etc. Las tecas se abrieron doblando la chapa de plata, lo cual ha provocado el agriado del metal, con pérdida de la maleabilidad de la plata, aparición de fisuras, grietas y pérdidas de materia, además de erosiones, muescas y deformaciones.

Acumulación de cera, grasa y gran cantidad de contaminantes ambientales, antiguo ataque biológico (xilófagos y derméstidos) y una sulfuración severa de la plata, que impide apreciar el aspecto dorado original del conjunto. Pérdidas de clavos de plata y del dorado. Fractura del marco con pérdida de materia. La resistencia mecánica del grueso tablero de nogal está gravemente disminuida por

Figura 7. Apertura de las tecas. Tejido hispanomusulmán, técnica de tapiz en seda y oro. Siglo XIII.

Figura 8. Estudio del ligamento textil.

los 32 huecos de las tecas, los numerosos clavos que la atraviesan, y por el peso de los cuarzos, marco, rejilla de plata y placas esmaltadas.

Posiblemente estas fueran las causas de la aparición, muy temprana, de las fracturas del alma y deformación del tablero. En cuanto a los esmaltes, pueden apreciarse cambios de color y transparencia, con numerosas pérdidas de materia, total o puntual, por golpes, astillados o desgaste. Observados al microscopio electrónico presentan tipos y grados de alteración diferentes así, el azul cobalto presenta craquelado pequeño pero generalizado con micropicado superficial; y el marrón u ocre presenta un craquelado denso acompañado de micropicado. A simple vista el más alterado es el morado, con cambios de color, manchas opacas, picados y aspecto friable (Figuras 2, 6 y 7) (Newton y Davison 1987).

Tratamiento

El tratamiento del relicario comenzó con la limpieza de los esmaltes mediante alcohol etílico (PRS) y agua desmineralizada (1/1), o sólo etanol, seguido de una fijación previa, aplicando una resina acrílica en disolución (Paraloid B72 al 1% en xileno). Una vez estabilizados los esmaltes se procedió al levantamiento del marco mediante la retirada de los clavos de sujeción y a su limpieza con etanol. La fractura y pérdida de materia en el marco se solucionó aplicando como refuerzo un tejido de poliéster y chapa de plata, adheridas con resina epoxy (Araldit), entonando la unión con pan de oro fino. La soldadura antigua se rebajó a punta de bisturí, puliéndola con brocas de goma. El alma de madera se aspiró para retirar los restos de contaminantes ambientales y biológicos, eliminando las intervenciones previas alteradas; reintegrando con una resina epoxy (Araldit madera), utilizada también para rellenar las galerías dejadas por los xilófagos y perforaciones de los clavos de plata. La retícula de plata dorada sujeta al alma de madera se limpió con alcohol etílico, o lápiz de fibra de vidrio puntualmente, reforzando las zonas de fracturas o fisuras de los cintillos con resina epoxy (Araldit), entonada con oro fino en polvo. Las tecas abiertas al retirar el marco, se vaciaron, aspirando bajo tul para eliminar los restos de suciedad y ataque biológico. No se intervino sobre los contenedores o las reliquias, con excepción de las tres citadas anteriormente. El fragmento hispano musulmán se desmontó para estudio, lavado con agua desmineralizada, aplicación de soporte en seda natural teñida, y cosido con hilo de seda a una bolsa nueva de batista de algodón. Los recipientes de cristal de roca y plata nielada se limpiaron con etanol, igual que la suciedad acumulada sobre los cuarzos de cierre. La trasera de madera pintada se limpió con xileno seguida por consolidación de resina acrílica (Paraloid B72 al 5% en xileno) reintegrando la fractura con una primera capa aislante interna de polietileno, resina epoxy (Araldit madera) y estuco acrílico. Entonado de color con la resina acrílica citada, cargada con tierras naturales. Una vez tratado el conjunto del tablero se colocó el marco, previo enderezado de los clavos de plata, y realización de taladros en el alma de madera para facilitar el clavado y evitar golpes y vibraciones. Terminando con el desengrasado del conjunto con alcohol etílico y aplicación de varias capas de resina acrílica como protección final (Paraloid B72 al 1% en xileno) (Henau 1982, Faranda 1991, Leonhard 1991).

Recomendaciones de conservación preventiva

Las manos depositan sobre la superficie sudor, grasa, sales minerales, bacterias, etc., que favorecen los procesos de corrosión y la adherencia de suciedad, siendo necesario manipular el objeto con guantes de PE. No son adecuados los de piel o látex, polímero natural que contiene azufre, principal fuente de alteración de los objetos de plata (sulfuración), ni los de algodón ya que son permeables a la exudación de las manos. Exposición en vitrina, para evitar daños mecánicos y depósito de contaminantes ambientales; en plano para evitar todo el peso sobre el borde inferior, ya que se producen deformaciones que afectan a las placas. No son recomendables apoyos de excesiva dureza que erosionan el metal y remueven parcialmente la capa de protección aplicada. Es importante contar con unas condiciones ambientales estables, sin fluctuaciones. Los diferentes coeficientes de dilatación de la plata y el esmalte hacen muy peligrosos los cambios de temperatura,

ya que provocan fracturas y exfoliaciones. De igual manera los cambios en la HR causan la contracción o dilatación de los materiales orgánicos (p e: alma de madera) provocando tensiones que deforman las chapas metálicas y hacen saltar los esmaltes, además, una HR inadecuada favorece la desvitrificación. La luz es un factor de alteración que debe tenerse en cuenta no sólo por la oxidación y decoloración que provoca en los materiales orgánicos (vitelas, textiles, etc.), sino también por ser un potente catalizador de reacciones químicas. La plata en su color o la dorada que, en principio, no deben verse afectadas lo son al favorecerse la alteración y envejecimiento de las capas de protección aplicadas. Una vez alteradas éstas, los procesos de sulfuración del metal se aceleran. Por estas causas los niveles adecuados de iluminación son los más bajos que puedan conseguirse en la instalación y encendidos durante el menor tiempo posible, salvando las necesidades del confort visual de los visitantes. La fuente lumínica debería tener un buen rendimiento de color, algo fundamental en un objeto con los efectos cromáticos del Ajedrez, sin emisión de UV e IR.

Agradecimientos

Real Colegiata de Santa María de Roncesvalles (Navarra) y D. Carlos Idoate Ezquieta de la Institución Príncipe de Viana; Araceli Gabaldón y Tomás Antelo por el estudio radiográfico; Lola Gayo y Carmen Martín de Hijas por los trabajos de identificación de las fibras textiles, colorantes y estratigrafías en el Laboratorio de Química del IPHE; José V. Navarro Gascón del Laboratorio de Geología por el estudio de los esmaltes y metales; Pilar Borrego por el estudio del ligamento textil y Camino Represa por el lavado del fragmento; Eduardo Seco y José Puig por la fotografía; Carmen Rueda por la transcripción de las cartelas; Ana Gutiérrez del Archivo Ruiz Vernacci por la búsqueda de antiguos documentos gráficos y a Mª Jesús Sánchez por su Informe Histórico.

Referencias

Bernis, C, 1956, 'Tapicería hispano musulmana (siglos XIII-XIV)', *Archivo Español de Arte*, CSIC, Madrid, Tomo XXIX, 95- 115.

Cellini, B, 1989, *Tratados de orfebrería, escultura, dibujo y arquitectura*. Akal. Madrid, 23-148.

Faltermeier, K, 1987, *Why does rock crystal explode? Conservation of a rock crystal bowl*, University of London, Institute of Archaeology, Summer School Press, 365- 366.

Faranda, F, 1991, *Il restauro di due reliquiari, con smalti traslucidi, del XIV secolo conservati nella Cattedrale di Forlì*, Kermes, A 4, vol.10, 16-24.

Gabaldón, A y Antelo, T, 1998, *Informe interno IPHE*, Estudio radiográfico.

García Gainza et al.,1992, *Catálogo Monumental de Navarra*, IV, Merindad de Sangüesa, Jaurrieta-Yesa, Gobierno de Navarra, Arzobispado de Pamplona, Universidad de Navarra, 315-352.

Gauthier, M, 1972, *Emaux du moyen âge*, Office du Livre.

Gayo, L, 1998, *Informe IPHE pigmentos y aglutinantes*.

Gayo, L y Martín de Hijas, C, 1999, *Informe IPHE colorantes, fibras, láminas y entorchados*.

González, V, 1994, *Emaux d'al-Andalus et du Maghreb*, Edisud.

Henau, P et al., 1982-83, 'Le baiser de paix émaillé de Namur, Examen technologique et traitment', *Bulletin de l'Institut royal de Patrimonie artistique*, t. XIX, 5-25.

Leonhard Schott, F, 1991, 'Ein mittelalterliches Emailkästchen aus dem Regensburger Domschatz. Probleme der Konservierung von transluzidem GlasfluB auf Silber', *Restauro* 5, 301-308.

Marquet de Vasselot, J J, 1897, 'Le trésor de l'abbaye de Roncevaux', *Gazette des Beaux Arts* 3, T II, 322-332.

Martín Ansón, M L, 1984, *Esmaltes en España*, ed. nacional, Madrid.

Maryon, H, 1971, *Metalwork and Enamelling*, Dover Publications, New York.

Navarro Gascón, J V, 1998, *Informe IPHE esmaltes, metales y nielado*.

Newton, R y Davison, S, 1987, *Conservation of Glass*, Butterworths, University Press, Cambridge.

Oddy, W A et al., 1983, 'The composition of niello decoration on gold, silver and bronze in the antique and mediaeval periods', *Studies in Conservation* 28, 29-35.

Sánchez Beltrán, M J, 1998, *Informe interno IPHE*.

Theophilus, 1979, On divers arts, Book 3, *The art of metalworker*, 75-158, Dover Publications, New York.

Metals

Métal

Metales

Métal
Metals

Coordonnateur : William Mourey

Le groupe de travail « Métal » est sans doute l'un des plus actifs au sein de l'ICOM CC. Les trois dernières réunions intermédiaires de 1995 (Semur en Auxois), 1998 (Draguignan) et 2001 (Santiago du Chili) ont produit à elles seules plus de 170 articles liés à la conservation, l'analyse, la restauration et la formation dans le domaine du métal. Cette activité ne nuit pas à la présentation d'articles lors des réunions triennales puisque cette année 12 articles ou posters ont été soumis à l'évaluation pour Rio.

Le nombre de membres affiliés à ce groupe de travail est en constante augmentation (actuellement plus de 350).

Le programme de travail décidé lors de la réunion de Lyon s'établit de la façon suivante :

- conservation préventive et curative et limites de l'une et de l'autre
- conservation sur site et dans les aires de stockage
- protection cathodique, inhibition en phase vapeur, stockages en atmosphères modifiées
- recherches sur le plasma, les techniques de déchloruration, les stabilisations chimiques et les méthodes nouvelles
- la notion d'épiderme.

Programme réalisé (articles présentés lors de la réunion intermédiaire de Santiago du Chili en avril 2001 et articles pré-sélectionnés pour Rio 2002) :

- conservation préventive et curative et limites de l'une et de l'autre : 14 articles
- conservation sur site et dans les aires de stockage : 7 articles
- protection cathodique, inhibition en phase vapeur, stockages en atmosphères modifiées : 4 articles
- recherches sur le plasma, les techniques de déchloruration, les stabilisations chimiques et les méthodes nouvelles : 9 articles
- la notion d'épiderme : 3 articles.

Programme non présenté comme prioritaire mais ayant intéressé les membres du groupe de travail :

- analyses : 15 articles
- divers : 4 articles.

Soit un total de 56 articles publiés par le groupe de travail au cours de la période de 1999-2002.

Parmi ces articles, il faut noter une tendance au développement des recherches dans le domaine de l'analyse et une tendance à la baisse des « études de cas », d'autant plus que celles-ci, lorsqu'elles existent, sont le plus souvent couplées à des recherches analytiques.

Les méthodes nouvelles sont peu représentées alors que la conservation préventive se développe, comme dans les autres domaines de la conservation.

A ces articles, il faut ajouter les efforts particuliers de certains membres du groupe de travail pour faire connaître et diffuser les recherches en cours, en particulier le Bulletin d'information sur la Recherche Appliquée à la conservation Restauration du métal (BRAR) qui en est à sa septième édition et la création du groupe de recherche Chimart.

Au cours de ces trois années, le coordonnateur a réalisé l'annuaire des membres du groupe de travail. Cet annuaire doit être un instrument de travail et d'échange. Régulièrement mis à jour, il intègre, quand elles existent, les adresses électroniques des membres. Il est classé par pays et permet ainsi à des personnes qui auraient pu se sentir isolées de s'intégrer à un niveau national et international. Autre élément structurant : la mise en place de groupes de travail « Métal » au niveau national, comme en Espagne, ou régional, comme en Amérique Latine.

Trois bulletins auront été réalisés, soit une par année. Rédigés dans les trois langues officielles de l'ICOM, elles ont été envoyés à l'ensemble des 350 membres, soit par courrier électronique soit par la poste.

William Mourey

────────────────

The Metals Working Group is one of the most active in the ICOM-CC. Alone, the past three Interim Meetings (1995 in Semur en Auxois, 1998 in Draguignan, France, and 2001 in Santiago, Chile) produced 170 articles related to metal arts conservation, analysis, restoration and training. This activity in no way hampered the delivery of articles for the Triennial Meeting, with 12 articles and posters submitted this year for evaluation for Rio de Janeiro. Also, the number of members associated with our Working Group is growing steadily (more than 350 at present).

The project plan, adopted during the Lyon conference, is:

* preventative and curative conservation and the limits of each
* on-site and warehouse-based conservation
* cathodic protection, vapour phase inhibition, storage in transformed atmospheres
* research on plasma, dechlorination techniques, chemical stabilization, and new methods
* coating concepts.

Agenda (articles presented during the Santiago, Chile, meeting, April 2001, and the articles pre-selected for Rio 2002) include:

* preventative and curative conservation and the limits of each (14 articles)
* on-site and warehouse-based conservation (7 articles)
* cathodic protection, vapour phase inhibition, storage in transformed atmospheres (4 articles)
* research on plasma, dechlorination techniques, chemical stabilization, and new methods (9 articles)
* coating concept (3 articles).

Non-priority program of interest to Working Group members:

* analyses (15 articles)
* various (4 articles).

In all, the Metals Working Group published a total of 56 articles during 1999-2002. Among these, note a trend toward the development of analytical research and a decrease in the number of case studies. This trend is even more apparent since, when articles do pertain to case studies, they are usually combined with analytical research. There seems little evidence of new methods, although preventative conservation is developing, as in other conservation areas.

In addition to these articles, note the special efforts of certain Working Group members to publicize and disseminate current research, particularly through BRAR (*Bulletin d'information sur la Recherche Appliquée à la conservation Restauration du métal* / Bulletin of Applied Research in Metal Conservation and Restoration, now in its seventh edition) and the creation of the *Chimart* research group.

Also during the past three years, the Coordinator published a directory o members, a tool to promote collaboration and discussion. This publication i updated regularly and includes members' email addresses when available. It i organized by country and enables potentially isolated people to get involved ir national and international activities. Another building block has been the establish-ment of more metal arts working groups at national (Spain) and regional (Latir America) levels.

We have published three bulletins, one per year. These are issued in the three official languages of ICOM and sent to all 350 members, either by e-mail or regular post.

William Mourey

Résumé

Une méthodologie originale a été appliquée pour comprendre le rôle de l'humidité et des polluants de l'air des musées dans les mécanismes de corrosion de sceaux en plomb (bulles) et pour améliorer leur conservation. Elle comporte trois volets :

- Elaboration de techniques d'analyse non destructives pour étudier une collection de bulles détachées de leur parchemin (composition élémentaire des alliages, analyse structurale des zones de surface, épaisseur des patines et nature des produits de corrosion).
- Utilisation de coupons pour évaluer l'action globale de l'environnement sur la cinétique d'altération du plomb dans les divers magasins (changements d'aspect, gain de masse, composition chimique et structure des films de corrosion).
- Etude du rôle de l'humidité relative dans les réactions de carbonatation du plomb dans l'air (mesures climatiques dans les magasins et exposition de coupons en atmosphères contrôlées), analyse des polluants émis par les matériaux en contact avec des bulles en plomb ou se trouvant à proximité.

Mots-clés

air intérieur, analyse non destructive, acides carboxyliques, conservation préventive, corrosion atmosphérique, humidité relative, plomb, soufre

Evaluation de la corrosion du plomb aux archives nationales de France

M. Dubus★, M. Aucouturier, S. Colinart, J.-C. Dran, M. Gunn, R. May, B. Moignard, J. Salomon, P. Walter
Centre de Recherche et de Restauration des Musées de France
UMR 171 du CNRS
6, rue des Pyramides
75041 Paris cedex 01, France
Courriel : michel.dubus@culture.fr

I. Colson
Centre historique des Archives nationales
Paris, France

A.-M. Laurent
Laboratoire d'hygiène de la ville de Paris
Paris, France

M. Leroy
Centre de Recherche sur la Conservation des Documents Graphiques
Paris, France

Introduction

Les sceaux en plomb (bulles) étudiés ici sont conservés depuis 1865 au premier étage du dépôt Napoléon III des Archives nationales à Paris. Ce magasin, dont les planchers et les étagères sont en chêne, n'est ni chauffé ni isolé thermiquement. Les parchemins bullés sont conditionnés sans calage dans des chemises étiquetées, récentes ou anciennes (acides), et placés dans des boîtes d'archives modernes. Les rares manipulations provoquent une abrasion des reliefs des bulles et une fatigue mécanique des lacs qui peut entraîner leur rupture ; les bulles détachées sont conservées dans des tiroirs en chêne et contre-plaqué dont le fond est garni de carton à base de pâte mécanique (acide), ou de mousse de polyéthylène. Certains tiroirs contiennent des collections de moulages en soufre (Fleetwood, 1928).

Vers 1980, la comparaison de bulles détachées avec leurs empreintes moulées 100 ans plus tôt montrait qu'elles s'étaient altérées, alors qu'aujourd'hui la comparaison des mêmes bulles avec des photographies prises en 1989 ne montre pas d'évolution significative. La composition chimique des bulles, dont dépend leur résistance à la corrosion, le climat du dépôt Napoléon III et la qualité des emballages ont-ils causé cette dégradation?

Pour répondre à ces questions, nous avons élaboré des techniques d'analyse non destructives permettant de connaître la composition élémentaire des alliages, la structure, l'épaisseur et la nature des composés à la surface des bulles.

Durant deux ans, nous avons exposé des témoins métalliques avec les œuvres, observé leurs changements d'aspect et de poids, analysé la composition chimique, la structure et la cinétique de croissance de la couche corrodée, pour évaluer l'action globale de leur environnement immédiat sur le plomb.

Enfin, nous avons tenté de montrer l'effet de l'environnement, d'une part en étudiant, en chambre climatique, l'influence de l'humidité relative sur les réactions de carbonatation du plomb et, d'autre part, en caractérisant les composés organiques volatils émis par les matériaux d'emballage.

Techniques

Techniques d'analyse non destructives

Depuis plusieurs années, des techniques non destructives sont mises au point avec l'accélérateur AGLAE, permettant d'analyser la surface des œuvres sans prélèvement et à pression atmosphérique. Un faisceau de particules extrait dans l'air à travers une mince fenêtre de Si_3N_4 est utilisé pour l'analyse élémentaire par fluorescence

★Auteur auquel la correspondance doit être adressée

1 a) Dispositif expérimental
1) Ligne de faisceau 2) Fenêtre Si₃N₄
3) Anode Ge 4) Filtre C 5) Faisceau de
protons 6) Cible 7) Collimateur Mo
8) Détecteur Si(Li) refroidi par effet
Peltier. Le filtre de carbone arrête les
particules, mais pas les rayons X émis par
l'anode.

1 b) Spectre PIXE du sceau de Léon XIII.
Le détecteur basse énergie ne permet pas de
détecter distinctement le fer, le cuivre ni le
calcium, à cause du bruit de fond créé par
le plomb.

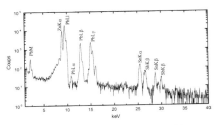

1 c) Le filtre de zinc placé sur le détecteur
haute énergie permet d'éliminer la raie
PbL» et de réduire le bruit de fond d'un
facteur 10.

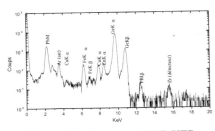

1 d) Spectre X obtenu par PIXE-XFR.
Une réaction nucléaire avec le silicium de la
fenêtre d'extraction du faisceau provoque
l'émission de rayons (qui excitent les raies
L du plomb et K» du collimateur en
zirconium. Le bruit de fond est réduit
d'un facteur 100 par rapport au spectre
1b).

X (Particle-Induced X-ray Emission) et la spectrométrie de rétrodiffusion par particules chargées (Rutherford Backscattering Spectrometry [RBS]).

L'analyse PIXE des éléments en traces plus légers que le plomb (de Ca à Zn) étant empêchée par le bruit de fond du plomb et détériorée par le rayonnement de freinage, un dispositif a été mis au point (Bertrand et al., 2001) : une cible intermédiaire de germanium est excitée par un faisceau de protons pour produire un rayonnement X d'une énergie d'environ10 keV qui, à son tour, sert de source d'excitation des éléments de numéro atomique plus petit que le germanium comme le fer, le cuivre et le calcium. Les raies XL du plomb (12 keV) ne sont pas excitées et le rapport signal sur bruit est amélioré d'un facteur 10 (figure 1).

Le faisceau extrait permet aussi de réaliser des mesures par RBS avec une résolution en énergie de quelques dizaines de keV. Cette technique donne indirectement des informations sur les profils de concentration d'éléments légers incorporés dans une matrice constituée d'éléments lourds, à travers leur déficit relatif. La mesure de l'épaisseur de la couche altérée dépend de la masse spécifique du matériau (Dubus et al., 1999).

Analyse sur prélèvement

Les analyses par spectrométrie infrarouge à transformée de Fourier (IR–TF) sont faites sur un spectromètre Perkin-Elmer Spectrum 2000 équipé d'une séparatrice en iodure de césium qui permet de travailler dans la gamme de 6500 cm⁻¹ à 450 cm⁻¹. Les prélèvements sont étudiés par micropastillage de 2 mm avec du bromure de potassium (KBr). Des produits de référence (carbonate, oxyde acétate et formiate de plomb), sont mélangés dans différentes proportions pour vérifier leur contribution au spectre final selon la méthode proposée par Tranter (1976).

Tableau 1. Chronologie des bulles étudiées

	Philippe II Auguste 1180-1223		
	Louis VIII le Lion 1223-1226	Honorius III 1216-1227	
Les Capétiens 987-1328		Grégoire IX 1227-1241	
		Innocent IV 1243-1254	
	Saint Louis IX 1226-1270	Alexandre IV 1254–1261	
		Urbain IV 1261–1264	
		Clément IV 1265–1268	
	Philippe III le Hardi 1270–1285	Nicolas III 1277–1280	
		Martin IV 1281–1285	
	Philippe IV le Bel 1285–1314	Clément V 1305–1314	Papauté délocalisée à Avignon 1309–1417
	Louis X le Hutin 1314–1316		
	Philippe V le Long 1316–1322		
	Charles IV le Bel 1322–1328		
Les Valois 1328–1589	Philippe VI 1328–1350	Jean XXII 1316–1334	
Présidents de la République Française	Mac-Mahon 1873–1879		
	Jules Grévy 1879–1887	Léon XIII 1878–1903	
	Sadi Carnot 1887–1894		
	Jean Casimir-Perier 1894–1895		
	Félix Faure 1895–1899		
	Emile Loubet 1899–1906		

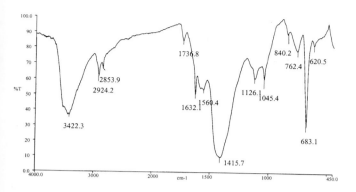

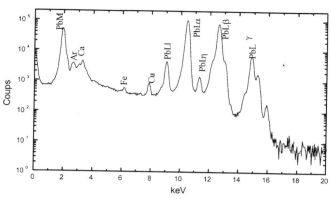

2 a) Spectre d'absorption IR-TF de la surface noire du sceau de Léon XIII. Les surfaces noires contiennent majoritairement des carbonates (entre 1400 et 1420 cm⁻¹), des produits organiques (vers 2950 cm⁻¹) ; elles sont très hydratées (vers 3450 cm⁻¹) et contiennent en plus petite proportion des acides carboxyliques (1740 cm⁻¹) et des carboxylates de plomb (entre 1540 et 1560 cm⁻¹).

2 b) Spectre IR-TF des produits de corrosion blancs du sceau d'Alexandre IV (Y19). La bande fine et forte vers 680 cm⁻¹ est caractéristique de la liaison Pb-O.

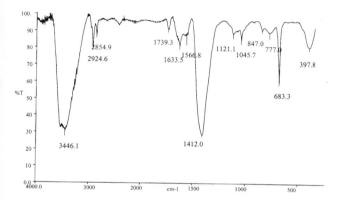

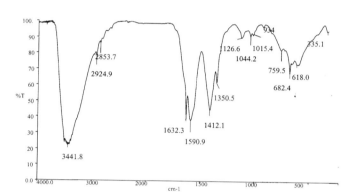

2 c) Spectre IR-TF d'un coupon vert (n° 12). Les bandes principales du carbonate de plomb sont situées à 683, 847 et 1412 cm⁻¹. La matière organique est caractérisée par les bandes à 1565, 1634, 2855 et 2925 cm⁻¹.

2 d) Spectre IR-TF d'un coupon noir (n° 6). Le pic à 760 cm⁻¹ est celui du formiate de plomb. Ceux à 618, 934 et 1351 sont caractéristiques de l'acétate de plomb. Les composés organiques qui ont réagi avec le plomb ont des bandes fortes à 1591 et à 1632 cm⁻¹.

L'analyse des acides organiques de l'air est effectuée avec un débit d'échantillonnage de 50 ml.mn⁻¹ pendant 62 h au travers de filtres en fibre de verre imprégnés d'une solution de potasse. Après élution des filtres par de l'eau déminéralisée, l'analyse est réalisée par électrophorèse capillaire en mode de détection UV inverse. Les résultats sont exprimés en microgrammes par mètre cube d'air (µg.m⁻³). Le débit d'échantillonnage pour l'analyse quantitative des aldéhydes est de 50 ml.mn⁻¹ pendant 21 h ; l'analyse est conforme à la norme AFNOR NF X 43-264. Les résultats sont exprimés en microgrammes par mètre cube d'air prélevé (µg.m⁻³).

Caractérisation

Le diffractomètre du laboratoire est équipé d'un miroir multicouches en sortie de tube et de fentes de Soller de 230 mm à divergence horizontale devant le détecteur; en incidence contrôlée ($0,1° \le \alpha \le 3°$), ce dispositif améliore le rapport signal sur bruit et la résolution d'un facteur 15 par rapport à la configuration classique. La profondeur examinée diminuant avec l'angle d'incidence des rayons X, il est possible d'identifier les composés formés à la surface d'échantillons sur une profondeur de quelques dizaines de nanomètres (nm) seulement, sans interaction avec le substrat.

Résultats

Bulles

Sur 16 bulles analysées (tableau 1), celle de Léon XIII est la mieux conservée : les reliefs et le fond en creux sont noirs, avec un éclat métallique. Les bulles de Renaud

II de Forez et de Jean XXII sont en bon état, les reliefs sont gris et brillants, le fond noir. Onze bulles sont corrodées, les reliefs pulvérulents et gris, le fond noir. Les bulles de Grégoire IX et Honorius III ont un fond beige. Les bulles noires et brillantes qui semblent bien conservées sont, à l'échelle microscopique, fissurées et corrodées ponctuellement comme le décrit Harch (1993). Les reliefs sont souvent corrodés, blancs et pulvérulents. Certaines portent des traces rouges et jaunes de composition inconnue.

Ces bulles sont constituées de plomb contenant des traces de cuivre, d'antimoine et presque toujours de fer (figure 1). Quatre bulles contiennent aussi de l'étain, associé à du zinc dans la bulle d'Honorius III. La bulle de Renaud II de Forez, bien conservée, contient du zinc. Seules deux bulles de Grégoire IX ne contiennent pas d'antimoine. L'étain et l'antimoine pourraient avoir été ajoutés pour abaisser le point de fusion du plomb et augmenter sa dureté ; l'étain est réputé augmenter la résistance à la corrosion (Tennent *et al.*, 1993 ; Lee *et al.*, 1996) et l'antimoine la résistance mécanique de l'alliage. Les inclusions comme le cuivre peuvent amorcer des piles locales (Degrigny *et al.*, 1996). Du calcium a été décelé sur toutes les bulles ; nous avons vérifié au microscope électronique à balayage qu'il s'agissait de poussière provenant probablement de l'air ambiant.

Que les surfaces soient noires ou blanches, les composés analysés par infrarouge contiennent majoritairement des carbonates (1400-1420 cm^{-1}) et de la matière organique. La matière organique est caractérisée par des acides carboxyliques, correspondant très probablement à des acides gras (1630, 1740 et 2950 cm^{-1}) et à des carboxylates de plomb (1540 et 1560 cm^{-1}) qui sont très hydratés (bande à 2950 cm^{-1}). Ces composés pourraient provenir de la dégradation des matériaux d'emballage. Des traces jaunes et certaines des traces rouges observées sur les bulles sont constituées de cire d'abeille, naturelle ou colorée en rouge, qui provient probablement du frottement des bulles contre d'autres sceaux en cire.

Sur 30 bulles caractérisées par diffraction X, les composés identifiés sont constitués d'un mélange complexe d'oxydes [litharge (PbO tétragonal), massicot (PbO orthorombique), minium (Pb$_3$O$_4$)], parfois d'acétates (Pb(CH$_3$CO$_2$)$_2$ hydratés (Pb(CH$_3$CO$_2$)$_2$, 3H$_2$O), toujours de carbonates basiques [hydrocérusite (2PbCO$_3$, Pb(OH)$_2$) et plumbonacrite (6PbCO$_3$, 3Pb(OH)$_2$, PbO)] ; ces derniers ont été observés par Olby (1965) et Tétreault (1998). Certaines traces rouge orangé sont des concentrations ponctuelles d'oxydes comme la litharge et le minium (figure 3).

Coupons

Vingt-huit coupons de plomb laminé de 1 mm d'épaisseur et 25 mm de côté (pureté 99,9 %) ont été nettoyés électrochimiquement au laboratoire Arc'Antique et exposés durant 2 ans dans différents locaux des Archives[1].

ASPECT

Les coupons de plomb vieillissent différemment selon les matériaux utilisés pour la conservation des bulles et les conditions climatiques : certains conservent un éclat métallique, d'autres deviennent irisés, colorés, mats. Ces différences s'accentuent avec le temps. Partout les composés analysés par infrarouge contiennent des carbonates de plomb plus ou moins hydratés (hydrocérusite, plumbonacrite) et des traces de matière organique (figure 2). Dans les chemises acides, le plomb prend une teinte verdâtre et se carbonate. Dans les tiroirs, le plomb devient gris violacé et la couche corrodée contient, en plus, des acétates et des formiates de plomb à des degrés d'hydratation différents.

CINÉTIQUE

Chaque mois durant les trois premiers mois d'exposition, les coupons ont été analysés par RBS pour obtenir des informations sur l'épaisseur et la structure de la couche corrodée. Après trois mois, la surface métallique est altérée sur une épaisseur de l'ordre de 1000 à 1500.10^{15} atomes/cm^2 (300 à 500 µg/cm^2), soit par diffusion progressive des éléments légers (carbone, oxygène et hydrogène) de la surface vers l'intérieur du métal, soit par formation d'une croûte corrodée (figure 4).

La prise de masse augmente plus ou moins vite selon les matériaux en contact avec le plomb. Elle évolue selon le modèle en trois phases (initiation, entretien et

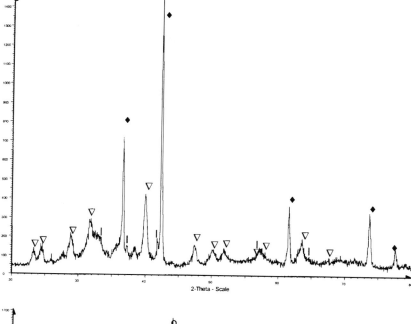

3 a) Surface noire du Sceau de Léon.
◆ = plomb, ▽ = hydrocérusite
$2PbCO_3$, $Pb(OH)_2$, 1 = litharge PbO

3 b) comparaison de coupons noir et vert.
◆ = plomb, • = galène PbS, ▽ =
hydrocérusite $2PbCO_3$, $Pb(OH)_2$, o =
plumboncrite ($6PbCO_3$, $3Pb(OH)_2$, PbO,
∀ = cérusite PbCO

noir (n°8)

vert (n°12)

3 c) diffractogrammes obtenus sur des
coupons exposés à une humidité de 30%
durant, 3, 6, 14 et 30 jours. ◆ = plomb,
▽ = oxyde de plomb hydraté $(PbP)_3$,
H_2O. 1 = litharge PbO. Le pic à 0, 295
nm est inexpliqué

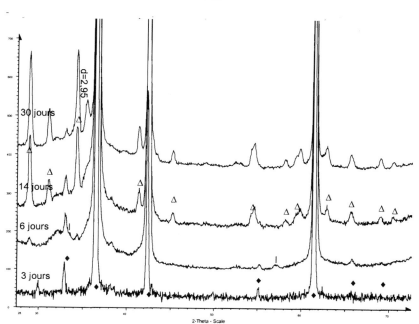

d=2,95

30 jours

14 jours

6 jours

3 jours

Spectres protons de deux sceaux comparés à une référence de plomb.

Figure 4. RBS.

Spectres alpha d'un coupon exposé dans les magasins.

équilibre) décrit par Tétreault (1998), (figure 5a). La première phase se déroule à une vitesse constante, plus lente que la seconde. Quand l'environnement est mauvais, les phases 1 et 2 sont confondues (figure 5b). Des reprises de corrosion sont parfois observées (figure 5c).

Action du soufre

Deux coupons stockés à proximité des moulages en soufre se sont recouverts d'un mélange de carbonates et de galène PbS (figure 3). Deux mécanismes pourraient être proposés pour expliquer ce phénomène :

1) Sulfuration du carbonate de plomb (la céruse a le défaut de noircir quand on l'expose à une atmosphère contenant des « vapeurs de soufre », en formant du sulfure de plomb PbS), (Faivre, 1963).
 $3Pb + 3/2O_2 \rightarrow 3PbO$
 $3PbO + 2CO_2 + H_2O \rightarrow Pb_3(CO_3)_2(OH)_2$
 $Pb_3(CO_3)_2(OH)_2 + 3S_{2-} + 6H^+ \rightarrow 3PbS + 2CO_2 + 4H_2O$
2) Sulfuration du plomb métallique.
 $Pb + (2H^+, S^{2-}) \rightarrow PbS + H_2\uparrow$

Compte tenu de l'enthalpie libre standard de formation de la céruse (-1710 kJ/mole) (Faivre, 1963) et de celle de la galène (-38 kJ/mole), (Turgoose, 1995), seule la deuxième hypothèse est thermodynamiquement possible. Dans tous les cas, la sulfuration n'a pu se produire qu'en présence de H_2S ou de sulfure de carbonyle (COS) par transport gazeux à travers la phase liquide déposée à la surface du plomb (Graedel, 1994 ; Black *et al.*, 1999).

Qualité de l'air

HUMIDITÉ RELATIVE

Dans le dépôt Napoléon III, l'amplitude des fluctuations journalières est de l'ordre de 5 à 10 % en été et va jusqu'à 15 % en hiver ; de novembre à avril, l'humidité relative se situe entre 65 et 80 %, les six autres mois, elle atteint le maximum admis pour les archives (entre 50 et 60 %). Les températures varient de 5 à 10 °C de novembre à mars et de 15 à 25 °C pour le reste de l'année. Les mesures climatiques effectuées de novembre 1998 à janvier 2000 au Service des sceaux montrent des fluctuations journalières de 5 à 25 % et des variations saisonnières de 10 %.

Au vu de ces variations, nous avons décidé d'examiner l'effet de l'humidité relative sur la cinétique d'oxydation et de carbonatation du plomb. Trente-deux coupons ont été nettoyés à l'acide nitrique (68 %), rincés dans trois bains d'eau distillée, et exposés à de l'air comprimé contenant 0,2 % de dioxyde de carbone

Figure 5. Prise de masse
a) Modèle de prise de masse des coupons de plomb en fonction du temps.
1 : Initiation de la réaction
2) Entretien du système de corrosion
3) « Equilibre » avec l'environnement
Quand les conditions sont mauvaises, les phases 1 et 2 sont confondues.
Reprise de la corrosion

Tableau 2. Concentrations en aldéhydes et en acides acétique et formique mesurées dans les magasins au contact de différents matériaux (µg.m⁻³).

localisation	formaldéhyde	acétaldéhyde	acide formique	acide acétique
Service des sceaux, salle 1, air ambiant, sur étagère bois	25	14	67	<30
Service des sceaux, salle 1, tiroir, fond en mousse de polyéthylène	137	16	106	282
Service des sceaux, salle 2, air ambiant, sur étagère bois	24	12	94	60
Service des sceaux, salle 2, tiroir en chêne, fond en carton acide	166	18	155	1032
Magasin 3, air ambiant, sur étagère en bois	13	14	161	69
Magasin 3, carton avec chemises anciennes (acides)	8	15	71	41
Magasin 4, air ambiant, sur étagère en bois	14	14	163	266
Magasin 4, dans carton, avec chemises récentes	13	14	99	<30

(CO_2) filtré sur du charbon actif et du coton, à une température constante de 23 °C et à des humidités relatives de 20, 30, 40 et 50 %[1]. Pour chaque taux d'humidité relative, deux coupons ont été examinés par diffraction X et au microscope électronique à balayage (MEB) après 3, 7, 14 et 30 jours (Dubus *et al.*, 2000).

A une humidité relative de 20 %, le plomb se recouvre d'une monocouche d'eau (Graedel, 1994 ; Leygraf, 1995) et s'oxyde pour former de la litharge sur une épaisseur de quelques nm. Cet oxyde se dissout facilement en atmosphère ambiante (Graedel, 1994) pour se transformer au contact du CO_2 en oxycarbonate de plomb ($2PbCO_3$, PbO) et former une couche réputée imperméable et protectrice, parfois appelée « patine » (Black, 1999).

A 30 % d'humidité relative, le plomb se transforme en oxyde de plomb hydraté [($PbO)_3$, H_2O] après 6 jours (figures 3 et 6), en hydroxyde oxyde de plomb [$Pb_5 O_3 (OH)_4$] après 14 jours, puis en oxycarbonate de plomb au bout de 30 jours.

A 40 % d'humidité relative (ce qui correspond à 1,5 ou 2 monocouches d'eau), de la litharge se forme dès le troisième jour, puis la formation d'oxyde hydraté et d'hydroxyde ($Pb(OH)_2$ est favorisée.

A 50 % d'humidité relative, il se forme dès le troisième jour un mélange de litharge et d'oxycarbonate de plomb, mélange qui n'évoluera plus par la suite et qui peut être considéré comme stable. Ce seuil de 50 % dit « humidité relative critique » correspond à 3 monocouches d'eau : au-dessus de cette limite, la corrosion est comparable à une corrosion en milieu liquide (Vernon, 1931).

POLLUANTS

Des acétates de plomb ayant été caractérisés sur les produits de corrosion, à la fois sur les bulles et les coupons, et sachant que le plomb est très réactif aux vapeurs d'acide acétique (Graedel, 1994 ; Turgoose, 1995 ; Degrigny *et al.*, 1996), l'analyse de l'air a porté sur les acides acétique et formique et les aldéhydes, dont le formaldéhyde.

Dans les magasins, les concentrations en formaldéhyde et acétaldéhyde ne dépassent pas 15 µg.m⁻³ par substance (tableau 2). Les concentrations d'acides formique et acétique sont nettement plus élevées dans l'air ambiant échantillonné sur les étagères qu'à l'intérieur des boîtes d'archivage, qu'elles contiennent des chemises anciennes (acides) ou récentes.

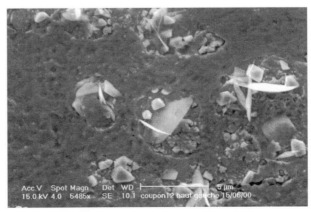

Figure 6. MEB. Croissance de cristallites octaédriques de 0,5 à 2,5 µm et de feuillets de 4 à 5 µm à la surface d'un coupon exposé durant 6 jours à une humidité relative de 30 %.

Au Service des sceaux, le formaldéhyde et les acides organiques sont plus concentrés dans les tiroirs en chêne que dans l'air ambiant. La teneur en acide acétique est particulièrement importante dans certains tiroirs, de l'ordre de 1 mg.m^{-3}. Ces valeurs sont très élevées comparativement aux recommandations de Tétreault (1998), qui estime que la concentration totale en polluants ne devrait pas excéder 0,1 mg.m^{-3} dans les musées.

Conclusions

Ces études ont bénéficié de la mise au point récente de techniques non destructives d'analyse par fluorescence X, très prometteuses pour la détection d'éléments légers mineurs ou en traces dans une matrice constituée d'éléments lourds, et d'analyses structurales de surface qui donnent des informations complémentaires entre elles : sous la forme de profils de concentration, la spectrométrie de rétrodiffusion des particules chargées montre un appauvrissement de la surface en plomb corrélé à une incorporation d'éléments légers, carbone et oxygène. La diffraction des rayons X permet de différencier les carbonates selon leur degré d'hydratation et de détecter les sulfures de plomb. Les acétates et les formiates de plomb en trop faible quantité pour être détectés par diffraction des rayons X sont identifiés par infrarouge à transformée de Fourier.

L'utilisation de coupons témoins présente de nombreux avantages car elle autorise les prélèvements, l'emploi de techniques d'analyse destructives, parfois sous vide, et les études paramétriques au laboratoire. L'étude de la réactivité d'un métal pur dans un environnement permet de s'affranchir du passé des œuvres et de reconstituer les mécanismes de corrosion. Cette méthode d'évaluation visuelle peu coûteuse est facile à utiliser par les responsables de collections regroupant des objets en plomb.

Les résultats obtenus à l'aide de cette méthode montrent que la corrosion est différente selon l'environnement : dans l'air ambiant des réserves, les éléments légers diffusent de la surface vers l'intérieur du métal et forment des carbonates plus ou moins hydratés. Dans les meubles en chêne, il se forme rapidement une croûte constituée d'acétate, de formiate, et de carbonates de plomb. Les collections peuvent également réagir entre elles, comme le montre l'exemple de la sulfuration du plomb conservé avec des moulages en soufre.

L'humidité relative joue un rôle décisif dans les réactions d'oxydation et de carbonatation du plomb : la phase aqueuse qui se forme à la surface du métal en dessous du seuil critique de 50 % d'humidité relative agit comme un solvant des constituants gazeux de l'atmosphère qui accélère la carbonatation du plomb. Au delà de ce seuil, la corrosion est de type électrochimique.

Les analyses d'air montrent que le mobilier en bois émet des composés acides longtemps après sa fabrication. Les concentrations d'acide acétique et formique sont nettement plus élevées dans l'air ambiant des réserves que dans les boîtes d'archivage, et elles peuvent atteindre dans certains cas des concentrations de l'ordre du mg.m^{-3}, valeurs trop importantes pour la bonne conservation des bulles. Il est possible de réduire ces émissions en remplaçant les emballages acides et en piégeant les composés organiques acides par des capsules de charbon actif dépoussiéré.

Remerciements

Merci à J.-L. Boutaine, chef du département de Prévention du C2RMF, pour son soutien tout au long de cette étude, à O. Guillon (photographe), à D. Levaillant (documentaliste), et à P. Martinetto (allocataire de recherche). Merci à M.-C. Delmas, chef du Service des sceaux aux Archives nationales, pour sa confiance, à C. Degrigny (laboratoire Arc'Antique) pour son aide, à C. Bonnet, à B. Boulet (Université Paris 6), à J.-B. Madec (Université Paris 11), à D. Ngy, à S. Monpain (Université Paris 12) et à M. Vilmay (ENSCPB Paris) pour leur enthousiasme.

Renvois

1 Lead foil purity 99.9%. Goodfellow, Ermine Business Park, Huntingdon PE29 6WR
 Angleterre, Tél. : (513) 983-1100.

Références bibliographiques

BERTRAND, L., J.-C. DRAN, B. MOIGNARD, J. SALOMON et P. WALTER.
 *Développement expérimental d'une ligne PIXE-XRF – Application au dosage d'éléments métalliques
 fixés dans des tissus biologiques d'intérêt archéologique*, Rayons X et matière, Strasbourg, 2001, à
 paraître.

BLACK, L., et G.C. ALLEN. « Nature of lead patination », *Br. Corros. J.*, 1999, vol. 34, n° 3.

DEGRIGNY, C., R. LE GALL ET E. GUILMINOT. « Faciès de corrosion développés sur
 des poids en plomb du musée du CNAM de Paris », 11ᵉ réunion triennale ICOM-CC,
 Edimbourg, 1996.

DUBUS, M., I. COLSON, E. IOANNNIDOU, B. MOIGNARD, J. SALOMON, P.
 WALTER et J.-C. DRAN. « Elemental and structural analysis of corroded lead seals from
 the XIIIth. to XVth. centuries: preliminary study », 6ᵉ congrès international sur les essais et
 les microanalyses non destructives pour la détermination de l'état et la conservation d'objets
 du patrimoine culturel, AiPnD, Rome, 1999.

DUBUS, M., J.-C. DRAN, M. GUNN, A.-M. LAURENT, M. LEROY, J. SALOMON et
 P. WALTER. « La conservation des sceaux en plomb aux Archives nationales de France »,
 4ᵉ Conférence de la Commission européenne, intitulée *La recherche pour la protection, la
 conservation et la mise en valeur du patrimoine culturel*, Strasbourg, 2000.

FAIVRE, R., et R. WEISS. « Plomb », *Nouveau traité de chimie minérale*, Paris, 1963, vol. 8,
 n° 3.

FLEETWOOD, H. « Moulage et conservation des sceaux du Moyen Âge », *Meddelanden fran
 svenska Riksarkivet*, Stockholm, 1928, vol. I, n° 59.

GRAEDEL, T. E. « Chemical mechanisms for the atmospheric corrosion of lead », *J. Electrochem.
 Soc.*, 1994, vol. 141, n° 4.

HARCH, A., L. ROBBIOLA, C. FIAUD et M. H. SANTROT. « Caractérisation des
 principaux types d'altération des objets anciens en plomb », 7ᵉ rencontre annuelle du groupe
 de travail ICOM-SFIIC métal, Draguignan, 1993.

LEE, L. R., et D. THICKETT. *Selection of materials for the storage or display of museum objects*, rapport
 occasionnel n° 111, British Museum, 1996.

LEYGRAF, C. « Atmospheric corrosion », *Corrosion mechanisms in theory and practice*, Marcus &
 Oudar, 1995.

OLBY, J. K. « The basic lead carbonates », *J. Inorg. Chem.*, 1966, vol. 28.

TENNENT, N., J. TATE et L. CANNON. The corrosion of lead artifacts in wooden storage
 cabinets », *SSCR Journal*, 1993, vol. 4, n° 1.

TÉTREAULT, J., J. SIROIS et E. STAMATOPOULOU. « Studies of lead corrosion in acetic
 environments », *Studies in conservation*, 1998, vol. 43, n° 1.

TRANTER, G. C. « Patination of lead : an infra-red spectroscopic study », *Br. Corros. J.*, 1976,
 vol. II, n° 4.

TURGOOSE, S. *The corrosion of lead and tin: before and after excavation*, rapport occasionnel n°
 3, UKIC, 1995.

VERNON « A laboratory study of the atmospheric corrosion of metals », *Trans. Faraday Soc.*
 1931, vol. 27.

Abstract

Neglecting corrosion, Oddy and later Holze interpreted golden chalcopyrite layers on Roman bronzes as cases of intentional pseudogilding and referred to recipes in the Papyrus Leiden X and the Mappae Clavicula. But these are far from clear and no other applicable methods seem to be described in the (al)chemical literature. Because such layers are formed under definite reducing conditions by the action of sulphate reducing bacteria, corrosion seems more likely, although a scientific distinction might be impossible.

Keywords

(pseudo-)gilding, chalcopyrite, bronze corrosion, patina(tion), Papyrus Leiden X, Mappae Clavicula

'All that glitters is not pseudogold': a study in pseudo-pseudogilding

Gerhard Eggert★
State Academy of Art and Design
Am Weißenhof 1, D-70191 Stuttgart, Germany
Fax: +49 711 28440 225
E-mail: gerhard.eggert@abk-stuttgart.de

Hartmut Kutzke
Mineralogical-Petrological Institute and Museum
University of Bonn
Bonn, Germany

Introduction

'Was this layer on a metal object formed by natural corrosion or ancient artificial patination?' Metal conservators have often to deal with such questions. They need to know whether a layer may be removed (since it is a corrosion layer obscuring details of the topography of the surface) or not (since it is intentional patination). In the case of golden or black sulphide patina on copper alloys ('bronzes') this question can be extremely difficult to answer.

Holze (1997) analyzed three Roman bronze coins ('follis'), which have been described by V. Zedelius as 'coated with brass'. An SEM-EDX of golden-looking spots proved the presence of Cu, Fe and S as main elements. He assumed the presence of chalcopyrite ($CuFeS_2$), which indeed can have a highly reflecting yellow colour, like brass. In his opinion, the high iron content 'can neither be attributed to water or soil logging nor special corrosion'. His interpretation was based on articles by Oddy (1981) and Oddy and Meeks (1981), who coined the term pseudogilding**. They interpreted a Roman bust with a golden-looking chalcopyrite outer surface layer as a case of *pseudogilding*. The brass bust has been tinned and carried some small 'blobs' of a lead/tin alloy 'presumably to secure the chalcopyrite in position'. They referred to recipes in the Papyrus Leiden X and the Mappae Clavicula without discussing corrosion.

The aim of our study was to clarify:

- whether indeed chalcopyrite was formed on the bronze coins
- whether such layers can be caused by corrosion
- whether there are working recipes in the (al)chemical literature to form a chalcopyrite layer on bronzes
- whether there are possibilities for a scientific distinction between pseudogilding and corrosion.

Corrosion

Two of Holze's coins came from a hoard of bronze coins excavated in 1894 from the Moselle river bed in Coblence. We were able to investigate two other coins from this find in the Rheinisches Landesmuseum Bonn (Inv. 9599, Theodosius I; inv. 9528/4, Divus Claudius; see Figures 1, 2 and 3), doing so non-destructively by in situ powder diffraction (non-golden parts of the patina were covered with platinum sheet) to determine crystalline phases, as there are several golden minerals in the Cu–Fe–S-system (Duncan and Ganiaris 1987, Table 3). Chalcopyrite could indeed be identified as Holze suggested.

Figure 1. The investigated Roman bronze coins from the Moselle. Photo: Hartmut Kutzke

Figure 2. Microscopic detail of the chalcopyrite layer, bar = 0.1 mm, RLMB inv. 9528/4. Photo Hartmut Kutzke

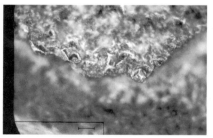

Figure 3. Microscopic detail of the chalcopyrite layer, bar = 0.2 mm, RLMB inv. 9528/4. Photo: Hartmut Kutzke

★Author to whom correspondence should be addressed
**Glossary:
Gilding: objects are deliberately coated with a layer of gold to imitate the appearance of gold (it looks like massive gold, but it isn't)
Pseudogilding: a material other than gold ('pseudogold') is used for the same purpose (it looks like gilding, but it isn't)
Pseudo-pseudogilding: the coating looks like pseudogilding but was not formed intentionally (it looks like pseudogilding, but it isn't)

Nevertheless, chalcopyrite was already described as a layer on Roman bronze coins from French mineral springs in the late 19th century (McNeil and Mohr 1993). Duncan and Ganiaris (1987) found it together with other sulfides as corrosion products on bronzes and deposit on lead objects found in anaerobic waterfront sites along the Thames. There, the black, wet, cohesive soil often has a distinctive smell due to the presence of hydrogen sulfide formed by the action of sulphate reducing bacteria. Schweizer (1994) also found chalcopyrite in the 'lake patina' of finds from the lake of Neuchatel. McNeil and Mohr (1993, Figure 3) give a potential-pH (or Pourbaix-) diagram for the Cu-Fe-S-system in water. Assuming only traces of Fe and Cu ions in solution (1μmol/l) and 0.01 mol/l total S-ions there is a broad field of (reducing) potential and pH, where chalcopyrite is the thermodynamically most stable compound. Dissolved traces of iron are ubiquitous in mud and water, as is copper in the vicinity of deposited copper alloy objects.

In other words: chalcopyrite must form sooner or later in such an environment as a corrosion product! Therefore, it is only a wonder why it is relatively rarely reported. Perhaps it is often confused with the shiny metal itself. The presence of chalcopyrite on objects from such environments, then, is what is expected from thermodynamics and cannot alone prove or even suggest an intentional process.

Duncan and Ganiaris (1987) concluded, concerning Oddy's Roman bust: 'It has been established that the gold-coloured layer in this case was not deliberate (Duncan, forthcoming)'. Unfortunately, this announced publication never appeared.

Interestingly, there is also at least one case in the literature in which the presence of chalcopyrite formed during burial inside a crucible from copper metallurgy was, as Rehren (forthcoming) showed, erroneously taken as evidence for the processing of sulphide ores.

Pseudogilding

Pseudogold (the imitation of gold with other materials) was well known in classical antiquity. The Romans knew brass ('aurichalcum') which could be mistaken for gold, as Cicero mentions in an ethical discussion (Cic. off. III 92). They also coated iron objects with molten copper alloys (Ankner and Hummel 1985). A strikingly real-looking 'goldglass' could be achieved by simply mirroring transparent yellow glass with molten lead (Eggert 1991). A similar effect was achieved at least since mediaeval times by covering leafs of white metal (such as tin or silver) with transparent yellow varnish (Thornton 2000).

In the only (surviving) collection of metallurgical recipes from classical antiquity, the Papyrus Leiden X (Caley 1926, Halleux 1981) from the early 4th century, instructions for gilding and pseudogilding can be found, but the meaning of the technical terms for ingredients and the full process is often not beyond doubt. None of them can clearly be attributed to the formation of a chalcopyrite layer. Oddy and Meeks (1981) mention two of them because of the use of misy, which they understand as iron and/or copper sulphide. Nevertheless, it can also mean their oxidation products, such as sulphates (Rottländer 2000, Smith and Hawthorne 1974).

Papyrus Leiden Recipe 51: gilding of silver

'Grind misy with sandarach (Halleux 1981: realgar, but other red pigments are also possible) and cinnabar and rub the object with it' (Caley 1926).

Oddy (1981) comments: 'The use of iron sulphide, which has a similar golden colour to chalcopyrite, clearly indicates the reason for the application of the latter to the small bust'. This does not take into account that pyrite and chalcopyrite lose their golden colour on grinding and get black! Therefore, you cannot produce a gold lacquer by mixing (chalco-) pyrite powder with a binding media (in mediaeval times the word 'sandaraca' related to gum sandarach). It remains unclear what ingredients and process were used and why this process is said to make silver golden. Halleux (1981) suggests a cementation process (removal of silver from silver-gold alloys).

Papyrus Leiden Recipe 76

'Misy from the mines, 3 staters; alum from the mines, 3 staters; celandine, 1 stater; pour on these the urine from a small child; grind together until the mixture becomes viscous and immerse (the object in it)' (Caley 1926).

The recipe does not specify what kind of object should be immersed. Celandine has been used as yellow dye. Therefore the interpretation as a recipe for mordant dying of textiles (Schweppe 1992) with iron sulfate (misy?) and aluminium sulfate (alum) seems reasonable, the urine perhaps adjusting the pH.

The Mappae Clavicula (Smith and Hawthorne 1974), a mediaeval collection of recipe collections that uses earlier material, has another recipe, which is referred to by Oddy and Meeks (1981).

Mappae Clavicula Recipe 10

'Take two parts of pyrite, i.e., firestone, and 1 part of good lead and melt them together until they become like water. After this add lead in the furnace until they are well mixed. Next, take the product out and grind 3 parts of it and with it grind 1 part of good calcitis and roast them until it turns yellow. Melt some copper which you have previously cleaned and add some of the preparation to it by eye, i.e., to the best of your judgement. It will become gold.' (Smith and Hawthorne 1974).

Oddy (1981) suggests that calcitis (which may be the chalcitis mentioned in Rottländer 2000) could be copper sulphide and continues: 'Although this recipe has a decidedly alchemical flavour, it perhaps preserves the idea of imparting a golden colour to the surface of copper with a mixture of copper and iron sulphides, and significantly from the point of view of the small Roman bust, includes the use of lead'. The need of two additional hypotheses (calcitis means copper sulphide; 'melt copper' means 'heat copper') makes this recipe not very convincing for the postulation of a chalcopyrite pseudo-gilding process. Holze and we were not very successful in replicating this recipe.

If these recipes cannot be relied on, what does the more recent alchemical literature say? Despite the alchemists' desire for the transmutation of metals to gold we were unable to find recipes for chalcopyrite coating, which is astonishing if such a low-tech process existed. From the modern chemical literature (Gmelin-Institut 1965) a practical method to form chalcopyrite by the reaction of copper and iron sulphide, either by fusing or by boiling in water freshly precipitated products, does not seem impossible, but no one (including ourselves) was able to reproduce such a method so far. Successful reproduction would be a prerequisite to lend the theory, that some of these layers were intentional fabricated instead of naturally corroded, more credibility.

Scientific distinction

It can be hard to find absolute criteria to distinguish scientifically between an artificial and a natural process. The results of an intentional, rather fast, process with high concentrations of reagent (and perhaps heat) and a natural slow one in the cold with only low amounts of patinating substances can look quite the same.

Similar problems occurred in the discussion of the dense shiny black copper sulfide patina (Born 1993). In the case of the Mahdia bronzes the matter could not be resolved by scientific investigations (Eggert 1994), neither by SEM-EDX nor by sulphur isotopes measurements. But in opposite to the chalcopyrite case, Willer (1994) could find an easy recipe for patination by simply melting sulphur powder gently on the bronzes and distributing it with a brush. His patina was scientifically undistinguishable from the copper sulphide layers found on the originals. Most importantly, he could observe features that cannot be explained by corrosion, such as the black eye of a statuette. Corrosion is unlikely to stop exactly around the eye, therefore intentional polychromy is likely.

The distinction between natural or artificial patination becomes impossible if the intentional use of a natural process lasting weeks, months or years is a possibility (McNeil and Mohr 1993). A potential recipe could then be: 'If you want golden coins bury copper pennies in a foul mud and come back some time later!'

Therefore, an observation of the framboidal structure of microbial induced sulphides alone would only prove the involvement of bacteria, but not the absence of human intention. It would be interesting to have data on how fast such a patination by mud would be. McNeil and Mohr (1993) optimistically estimate an 'accessible time' of two weeks based on Cuthbert's (1962) laboratory experiments, in which black bornite (Cu_5FeS_4), not chalcopyrite, was formed.

Sufficient proof of pseudogilding would be if the pseudogold layer would show unambiguous traces of ancient wear, such as high areas that were rubbed during everyday handling. Observation of clear features of an intentional polychromy (e.g. golden letters or patterns on a copper surface) would also be conclusive. McNeil and Mohr (1993) also feel that the thickness of the layer is important, as only the thin ones might be a result of pseudogilding. If large enough samples (some mg) could be taken, sulphur isotopes could be measured. In some cases one could expect data to exclude the biogene formation of sulfides from the surroundings of the find whose isotopic composition must also be known.

In the case of the coins from Coblence we assume pseodo-gilding to be unlikely for the following reasons:

- They were found in the Moselle, which is unsuited for intentional patination (the coins were hard to reach once being thrown in the river), but well suited for anaerobic corrosion.
- Pseudogilding as 'coin forging' (Holze 1997) does not make sense for coins known by everyone to be made from bronze, not gold. Whom could you cheat today with a golden penny? An interpretation as faulty exercise pieces thrown away instead of forged coins introduces an additional hypothesis.
- A chalcopyrite layer does not improve the appearance in comparison to the shiny golden copper-tin-zinc alloy of the coins. Therefore its deliberate application simply does not make sense. In the case of the bust, the situation is different: golden chalcopyrite could change the white colour of the tinned ('pseudosilvered') object back to the original colour of the alloy, as Oddy and Meeks (1981) argue.

If on the other hand chalcopyrite-coated copper replicas of gold coins were found, this would be a strong argument for pseudogilding as intentional forgery. According to McNeil and Mohr (1993), 'At least some coins exist which have characteristics suggesting that they are pseudogilded, and a majority of these that the senior author has been able to examine had designs and flans such as passing the gilded products off as aurei would be plausible'. We strongly welcome the publication of this evidence, but stay sceptical until then.

Conclusion

Corrosion is more probable than is deliberate patination as a cause for the formation of chalcopyrite layers on Holze's coins and Oddy's bust. In any case, at the moment, there is no proof of intentional formation of such layers and they were not replicated in laboratory experiments. On the other hand, this cannot be ruled out totally. Clear recipes do not exist in the ancient literature. Scientifically, a distinction in every case may be impossible.

To be on the safe side, chalcopyrite layers should only be removed by conservators, when this is absolutely necessary. In the case of the Buiston Bowl (Clydesdale 1993) these layers obscured surface details only visible on the X-ray radiograph. Mechanical methods should then be preferred; when chemical stripping is necessary the dithiolates discussed by Hjelm-Hansen (1984) may have advantages over the reagents tested by Clydesdale (1993). Another reason for removal could be active decay of chalcopyrite, because it leads to dangerous acid decay products, but dry storage should be sufficient to prevent this.

Humanity has been described as a 'pattern-seeking animal'. As a scientist or conservator who investigates ancient production methods, one has to be aware of a possible 'own bias' to find such methods even in cases where there were none. There is a saying: 'All that glitters is not gold'. One must add, 'and not pseudogold, either'.

References

Ankner, D and Hummel, F, 1985, 'Kupferlote bzw. Verkupferungen auf Eisen', *Arbeitsblätter für Restauratoren* 18(2), Group 1, 196–206.

Born, H, 1993, 'Multi-colored antique bronze statues' in S La Niece and P Craddock (eds.), *Metal plating and patination*, Guildford, Butterworth-Heinemann, 19–29.

Caley, E R, 1926, 'The Leyden Papyrus X. An English translation with brief notes', *Journal of Chemical Education* 3(10), 1149–1166.

Clydesdale, A, 1993, 'The Buiston Bowl: Cleaning trials for chalcopyrite removal', *SSCR Journal* 4(3), 12–14.

Cuthbert, M E, 1962, 'Formation of bornite at atmospheric temperature and pressure', *Economic geology* 57, 38–41.

Duncan, S J and Ganiaris, H, 1987, 'Some sulphide corrosion products on copper alloys and lead alloys from London waterfront sites' in J Black (ed.), *Recent Advances in the Conservation and Analysis of Artifacts*, London, Summer School Press, 109–118.

Eggert, G, 1991, 'Science and source texts on glass' in G A Wagner and E Pernicka (eds.), *Archaeometry '90*, Basel, Birkhäuser, 247–253.

Eggert, G, 1994, 'Schwarzfärbung oder Korrosion?' in G Hellenkemper Salies (ed.), *Das Wrack. Der antike Schiffsfund von Mahdia*, vol. 2, Cologne, Rheinland Verlag, 1033–1039.

Gmelin-Institut (ed.), 1965, *Gmelins Handbuch der Anorganischen Chemie*, Kupfer B3, 8th rev. ed., Weinheim, Verlag Chemie, 1282–1294.

Halleux, R, 1981, *Les alchemistes grecs, vol. 1*, Paris, Ed. Les Belles Lettres.

Hjelm-Hansen, N, 1984, 'Cleaning and stabilization of sulphide corroded bronzes', *Studies in Conservation* 29, 17–20.

Holze, R, 1997, 'Ein Fall von antiker Falschmünzerei?', *Das Rheinische Landesmuseum Bonn* 3/97, 64–67.

McNeil, M B and Mohr, D W, 1993, 'Formation of copper-iron sulfide minerals during corrosion of artifacts and possible implications for pseudogilding', *Geoarchaeology* 8(1), 23–33.

Oddy, W A, 1981, 'A Roman brass head with pseudo-gilding', *Antiquaries Journal* 61(2), 349–350.

Oddy, W A and Meeks, N D, 1981, 'Pseudo-gilding: An example from the Roman Period', *MASCA Journal* 1, 211–213.

Rehren, T, Forthcoming, 'Die Kupfersulfid-Krusten der Pfyner Schmelztiegel' in G Weisgerber (ed.), *Urgeschichtliche Kupfergewinnung im Alpenraum*, Accepted for publication.

Rottländer, R C A (ed.), 2000, Plinius Secundus d. Ä. Über Glas und Metalle. St. Katharinen: Scripta Mercaturae, 199.

Schweizer, F, 1994, 'Bronze Objects from lake sites: from patina to "biography"' in D A Scott, J Podany and B B Considine (eds.), *Ancient & historic metals: conservation and scientific research*, Marina del Rey, Getty Conservation Institute, 33–50.

Schweppe, H, 1992, *Handbuch der Naturfarbstoffe*, Landsberg/Lech: ecomed, 452, 570.

Smith, C S and Hawthorne J G, 1974, 'Mappae clavicula – a little key to the world of Medieval techniques', *Transactions of the American Philosophical Society* 64(4), 3–128.

Thornton, J, 2000, 'All that glitters is not gold: Other surfaces that appear to be gilded' in Drayman-Weisser, T (ed.), *Gilded metals. History, technology and conservation*, London, Archetype, 307–317.

Willer, F, 1994, 'Fragen zur intentionellen Schwarzpatina an den Mahdiabronzen' in G Hellenkemper Salies (ed.), *Das Wrack. Der antike Schiffsfund von Mahdia, vol. 2*, Cologne, Rheinland Verlag, 1023–1031.

Abstract

Corrosion of historic metals in Antarctica is more extensive than predicted by International Standard ISO 9223, which prescribes temperatures above 0°C together with a relative humidity above 80% for corrosion to occur. Recent research by the authors found that temperatures above -10°C, together with a relative humidity above 50%, can cause corrosion in Antarctica. This implies that corrosion will occur inside most historic buildings in Antarctica, affecting not only the artefacts inside the building but, more critically, the nails that hold timber buildings together. This paper describes experimental studies to further understanding of corrosion parameters in Antarctica and its application for preservation of historic sites. The research demonstrates that corrosion is a significantly underestimated risk in cold climates and highlights the importance of understanding the fundamental causes of deterioration processes before conservation treatments are considered in unfamiliar and extreme environments.

Keywords

corrosion, Antarctica, cold climate, ISO 9223, ISO 9225, salt deposition, time of wetness

Application of corrosion data to develop conservation strategies for a historic building in Antarctica

Janet Hughes★
National Gallery of Australia
GPO Box 1150
Canberra ACT 2601, Australia
Fax +61 2 6240 6529
E-mail: janet.hughes@nga.gov.au

George King
4 Park Avenue
Sandringham VIC 3191, Australia

Wayne Ganther
CSIRO Division of Building Construction and Engineering
PO Box 56
Highett, VIC 3190 Australia

Introduction

Although corrosion has commonly been considered minimal in the supposed 'dry cold' of Antarctica, measurements of atmospheric corrosion rates (corrosivity) in coastal Antarctica have been found comparable with temperate climates (Hughes, King and O'Brien 1996).

During four field seasons Hughes has documented serious damage to metal artefacts and building components at nine historic sites on the Antarctic continent (Hughes, King and Ganther 2001). Some buildings are partially or completely filled with ice and there are frequent proposals to remove ice to allow tourist access. Removal of ice may affect the thermal and hygrometric behaviour of the building and thereby increase corrosion risks for vital structural components, particularly nails and bolts. It is vital to understand the conditions under which corrosion occurs in cold climates, to ensure that conservation treatment does not increase the rate of corrosion damage.

Recent research undertaken at the Italian Antarctic base at Terra Nova Bay (74°43'S 164°02'E) correlated air temperature, surface temperature and relative humidity with surface wetness events measured using a gold grid that records actual surface moisture conditions. This is a high-latitude coastal site and the air temperature over 34 days during the experiment exceeded 0°C for less than 1% of the time. Yet substantial corrosion was measured on specimens of both steel and zinc. The time for which RH>50% at temperatures above -10°C estimated the measured 'time of wetness' (TOW) almost perfectly (King et al. 2001).

The aim of research in this paper is to measure additional corrosion parameters at a 'warmer' coastal Antarctic site, so as to extend the correlation of environmental conditions and corrosion parameters derived from the Terra Nova Bay experiment. Identifying environmental conditions that cause corrosion will help avoid actions that may increase corrosion risks, thus assisting the development of a conservation management plan for the site.

Research methodology

Site selection

The site selected for the experimental research is Cape Denison (67°S 142°E) on the coast of Antarctica, approximately 2500 km south of Tasmania. The Australian explorer Douglas Mawson built his pioneering scientific base on this small, remote headland in 1912 and his expedition spent two years there. The largest building (the Main Hut) comprises a 'Living Hut' conjoined with a smaller 'Workshop' on the

Figure 1. Gold grid sensor

Figure 2. Equipment array used on the Main Hut for corrosion measurements

northern side. Three smaller buildings were used for scientific measurements. These buildings and associated artefacts are protected under the Antarctic Treaty.

The buildings have survived despite the extreme climate and severe winds, although problems with erosion of the exterior timber cladding, fungal growth, corrosion and meltwater have been documented (Hayman, Hughes and Lazer 1998). Recent site conservation work has included re-cladding of part of the roof and removal of ice from the Main Hut to allow repairs (AAP Foundation 1999).

Measurement of corrosion and environmental parameters

Well-known climatic factors determine corrosion rates: temperature, relative humidity, the presence and concentration of gaseous pollutants and salts, and the TOW, which is the time the metal surface is wet. Recognized standard methods and instruments were used to measure these parameters at Cape Denison, with some minor variations based on previous Antarctic experience.

Monitoring has been undertaken inside the Main Hut since 1997. Surface temperature have been taken at ten locations using thermocouples, and combined measurements were made of air temperature and relative humidity at eight interior locations with one external reference point on the northern side of the hut (Hughes Pearson, Daniel and Cole 1999). Ongoing research aims to model the internal environment of the Main Hut to predict the effects of ice removal that has been proposed by the AAP Foundation. This site shares some characteristics of other early Antarctic sites, albeit with more severe winds, so information derived from this location can be applied to conserve other Antarctic sites.

Previous Antarctic studies by the authors (Hughes, King and O'Brien 1996) have successfully used standard low-alloy copper steel coupons to measure corrosivity. This allows direct comparison with standardized measurements at hundreds of sites in different climatic zones worldwide. Wire-on-bolt measurements are another standard method for assessing corrosivity. 'ZINCORR' units measure the weight loss of zinc wire in contact with three different bolts (nylon, steel and copper) where crevice and galvanic action accelerates corrosion rates enabling estimates of site corrosivity in a short exposure time (Ganther, Cole and King 1999). For this study duplicate coupons of an unalloyed carbon ('mild') steel, and triplicate coupons of zinc were exposed for mass-loss/corrosivity measurements. A ZINCORR unit was also exposed.

Salt deposition was measured according to the standard ISO 'salt candle' method (ISO 1992b). This enables direct comparison with results from other sites. The method uses a length of cotton gauze to wick up a solution of glycerol that 'captures' salt aerosols deposited from the air, which are then washed into a collection bottle. A modification required for Antarctic conditions was to increase the glycerol solution from 20% to 40% to prevent evaporation and freezing of the solution.

One of the zinc coupons was instrumented for both surface temperature and TOW. A TOW logger with a gold grid sensor as used in the 'Wetcorr' system (Norberg 1993), which was used to measure when the metal surface was actually 'wet' (Figure 1). The logger measures the conductivity of the surface of the gold grid, which in turn is related to the thickness of the moisture film. Readings were recorded at ten-minute intervals.

Equipment design

The remote location required compact, lightweight and robust design that could be easily installed in severe Antarctic conditions. Previous attempts to measure corrosivity at Cape Denison failed when strong winds (which can exceed 300 km/hr) broke the steel armature and blew away the coupon. Sensors and coupons must also be well-sealed and packed to prevent premature corrosion and damage in transit by ship to Antarctica.

A special mounting bracket was fabricated in stainless steel to accommodate the coupon specimens, ZINCORR unit and the ISO salt candle (Figure 2). This was designed to allow attachment to the apex of the re-clad roof of the Workshop section of the Main Hut without damaging the historic timbers underneath, and to ensure that the corrosion specimens were exposed in accordance with ISO

Table 1 Corrosion parameters measured during exposure from 27.12.00 to 8.1.01 (14 days)

Parameter	Value	Comments
Grid TOW	13.2 (% of time)	Using gold grid sensor
ISO 9223 TOW (T_{air}>0(C and RH>80%)*	2.0 (% of time)	Using exterior location from environmental monitoring system.
King TOW where T_{air}>-10(C and RH>50%(hours)*	31.8 (% of time)	Using exterior location from environmental monitoring system.
Cl⁻ deposition ISO 9225 Salt Candle	5.5 (mg/m²/day)	Shorter exposure time than specified by ISO 9225.
ZINCORR (% mass loss)	Nylon 0.12	Nylon 0.9 ('normalised to 3 months)
	Iron 0.42	Iron 3.23 ('normalised to 3 months)
	Copper 0.54	Copper 4.10 ('normalised to 3 months)

* both conditions must apply simultaneously

requirements and faced geographic north, taking account of the roof angle. The bracket was approximately 50 m upwind from the nearest point of the sea.

Results

Hourly temperature and humidity data from eight interior locations and one exterior location of the Main Hut are available for the period January 1999 to January 2000. The environmental monitoring system data were used to calculate TOW according to several criteria (Table 1) for comparison with the measured TOW using the gold grid sensor.

Calculated TOW was derived using both the ISO 9223 criteria and alternative criteria based on the Antarctic corrosion studies undertaken by King et al. (2001) at 74°S (Terra Nova Bay), discussed above. The measurements of TOW at Cape Denison also allow consideration of both air and surface temperature measurements, since these can be significantly different in Antarctica during the long hours of summer daylight.

The daily salt deposition rate was 5.5 mg/m² chloride, but this was measured over an exposure period of 14 days instead of the usual 30 days, due to logistics constraints.

ZINCORR units can be exposed for any reasonable period but the mass loss values are 'normalized' to a three-month period for comparison with other results. The normalized values for Mawson's Hut show that bimetallic corrosion has occurred, as the mass loss for iron and copper is four to five times the nylon mass loss. The three-month indices represent significant levels of atmospheric corrosion (Ganther, Cole and King 1999), although the short exposure may not be representative of the summer season. The fact that bimetallic corrosion is occurring means that free moisture must be present.

As stated, exposure time at Cape Denison was limited by logistics. Although results from the ZINCORR unit and salt candle are meaningful for this period, it was considered better to leave the coupon specimens exposed for collection and analysis at a later date.

Analysis of data

Exterior corrosion parameters

Salt deposition at Cape Denison, although low, is within the range of that measured at King George Island using Mohr titration of pluviometer contents (Rosales and Fernandez 2001), the latter values varying from year to year. It should be noted that quite small levels of chloride (22mg/m²) have been reported to cause corrosion of steel under paint films (Bartlett 1993). Salts will depress the freezing point in cold climates although the absence of industrial pollutants in Antarctica and its isolation from the circulation of other air masses means that gases from sulfur and nitrogen are in low concentrations. However, the study at Terra Nova Bay demonstrated that salt deposition is not a prerequisite for corrosion in Antarctica where monitoring of the prevailing winds indicated that little if any sea-salt deposition would have occurred during the exposure.

Nonetheless, Otieno-Alego et al. (2000) found high concentrations of chloride and sulfur in corrosion products scraped from corrosivity coupons exposed at a range of locations in coastal Antarctica. The chloride levels in rust from continental sites far exceeded those for specimens from comparative temperate marine sites. Rain is rare in Antarctica, so there is minimal flushing of salts from the metal surface. Salt deposition at Cape Denison has generally been thought to be low, in

common with other sites with predominantly katabatic winds from the polar plateau, since these winds are of such predominance and high velocity that exposure to salt-bearing offshore winds is insignificant. However, Madigan (1929) documented the formation of back-eddies in air circulation at Cape Denison that are highly localized and that may significantly increase salt deposition.

Salt deposition inside a building occurs when the salt-laden air penetrates through windows, doors and gaps between the timber cladding. Scott's Hut at Cape Evans has walls comprising three layers of timber boards over the structural framework and is also insulated with seaweed stuffed between jute cloth. Mason (1999) measured salt deposition rates at four locations at Scott's Hut at Cape Evans with two external measurements (45.5, 34.2 mg/m^2.d) and two at different locations inside the hut (15.1 and 12.1 mg/m^2.d). All fall into the S1 category (3<S<60) in ISO 9223 (ISO 1992a). These were taken before the sea ice had broken out and may underestimate typical summer values. Scott's Hut appears to have been more airtight than Mawson's Hut, which has only an inner and outer layer of timber boards with tarpaper lining and wood shaving insulation. For comparison, salt deposition at Flinders, Victoria, an Australian marine site 1.3 km from the ocean, is 33 mg/m^2.d (King, Ganther and Cole 1999).

The annual average wind speed of 80 km/hr measured by Mawson's expedition at Cape Denison makes it the windiest place on earth at sea level (Madigan 1929). When Mawson's Hut was occupied it was found necessary to stuff clothing into gaps in the wall to stop fine ice particles blowing in. The desiccation of timber on the roof as well as vibration and erosion by windborne ice particles has increased the gaps in the timber and the hut has progressively filled with ice. Ice was cleared from the living area of the Main Hut in 1977, but it had largely refilled by 1981 despite also cladding the Workshop roof with lead sheeting. Vibration against nail heads wore holes through the lead and the wind partly tore it off (Hayman, Lazer and Hughes 1998).

Using the ratio of the average exterior to interior salt deposition rates measured by Mason to estimate interior salt deposition at Cape Denison gives a rate of 1.9 mg/m^2.d, but this would probably be an underestimate given the high wind speeds at Cape Denison. Combined with typical summer temperatures of marginally above freezing and RH>80% even using the underestimate provided by the ISO criteria then significant corrosion would occur on any exposed metal surface. If ice is removed it is reasonable to expect some reduction in the thermal inertia of the building and temperatures would be most likely to rise during summer, increasing the risk of corrosion damage. Removal of ice cover would increase exposure of metal surfaces to salt deposition. Most at risk are nails holding the exterior cladding. It has not been possible to obtain and test original nails although visual examination shows these to be significantly corroded particularly at the head.

Interior corrosion parameters

During January 1999 to January 2000 the interior temperature never rose above 0°C at any time except inside the apex of the roof. Interior relative humidity was also consistently high, with the majority of locations never falling below 80%, as shown in Figure 3. Being located on the Antarctic Circle, daylight varies from 24 hours of sunlight in midsummer to 24-hour darkness at midwinter. This increases the albedo effect in summer, whereby dark surfaces, for example corroded metals, become markedly warmer than the surrounding air.

Care is required for placement of sensors inside the Main Hut and in interpretation of environmental data because of the unusual conditions inside an unoccupied Antarctic building subject to cyclic melting and refreezing. Meltwater can form preferentially on metals, such as the bolts that form a thermal bridge directly linking the exterior and interior surfaces via the wall structure. Hoarfrost forms preferentially on cooled surfaces, such as walls that are shaded or are more exposed to cooling by the wind. Ice can form on the surface of sensors giving inaccurate measurements of environmental conditions. It is important to observe salt deposits or defibring of wood indicating the passage of meltwater that cause inaccurate recording.

Measurements of TOW at Cape Denison using the gold grid sensor (13.2%), is greater than that measured using the ISO 9223 criteria (2.0%) and lower than

that estimated (31.8%) using the alternative criteria devised by King et al (2001). ISO 9223 TOW does not correlate well with the observed corrosion of artefacts. Metal artefacts in Hurley's Dark Room, where meltwater occurs frequently at floor level, are completely corroded through and artefacts where sublimation of ice is thought to occur without melting, such as the staples on the magazines on the shelves in the centre of the hut, also have significant surface corrosion.

Further research required

It has not been possible to conduct corrosivity or TOW sensor measurements inside the hut, nor to measure interior salt deposition. This would require significant funding support and the commitment to provide a visit to the site for long enough to tunnel through the ice to gain access to the interior. These measurements, however, would be most worthwhile in quantifying risks at particularly sensitive locations, such as inside the wall space, where considerable melting may occur and where bolts holding the main structural timbers are located.

A group of cold climate researchers from Argentina, Australia, Norway and the U.S.A. have proposed an ongoing program of research in the Arctic and Antarctic to provide more information on the climatic conditions that allow surface wetness to form. Identified issues requiring clarification include angle of exposure of corrosivity coupons, the times of initial exposure and more detailed analysis of corrosion products. Conservators could then apply the resulting improved methodologies and standardized data to assess corrosion risks at historic sites.

Conclusions

Data derived from this project enable temperature and humidity data to be directly correlated with simultaneous measurements of corrosivity (corrosion rate), surface wetness and salt deposition. This shows that ISO 9223 does not correlate well with corrosivity measurements in Antarctica by either coupons or wire-on-bolt methods.

Atmospheric corrosivity measured outside Mawson's Hut is consistent with previous measurements at other Antarctic sites, which are comparable with rates in suburban locations in temperate regions of Australia. Corrosion risks for historic buildings in Antarctica are thus significantly underestimated by the outdated supposition that corrosion will not occur below 0°C.

Although there is discrepancy in the various measures of TOW, ISO TOW is obviously inaccurate and either grid wetness or King's alternative TOW criteria are more realistic and may be applied to estimate the risks of particular conservation proposals for Mawson's Hut. For example, the effect on temperature and RH of ice removal from Mawson's Hut can be modelled and the climatic variation can then be used to estimate TOW and thence the corrosion risk. Removal of ice will expose metal surfaces to increased contact with sea salts both inside and outside the building. At Cape Denison the measured rate of salt deposition will significantly increase corrosion of metals that are currently covered by ice if the ice is removed.

Understanding of the fundamental parameters for corrosion in cold climates enhances general understanding of conditions in many regions where low temperatures are intermittent.

Acknowledgements

The authors thank the Australian Associated Press Foundation and the Antarctic Science Advisory Committee for funding the monitoring equipment; Vinod Daniel for his technical assistance with the monitoring program; and Dr Ian Godfrey and Dr Estelle Lazer, who installed the experiment.

References

AAP Foundation 1999, 'Mawson's Huts Historic Site Draft Conservation Management Plan', www.mawsons-huts.com.au/plan.htm.
Bartlett, D J, 1993, 'Water and water soluble salts: the scourge of anticorrosive coatings', *Corrosion Australasia*, 18(2): 7–9.

Ganther, W, Cole, I and King, G, 1999, 'Characterisation of seasonal corrosivity in a range of climatic zones using zinc wire on bolt units', *Proceedings of 39th Annual Conference of Australasian Corrosion Association*, Sydney, 21–24 November, Paper 46.

Hayman, S, Hughes, J and Lazer, E, 1998, 'Report to the Australian Heritage Commission on National Estate Grant: Deterioration monitoring and tourism management at Cape Denison (Mawson's Huts), Australian Antarctic Territory', Department of Architectural and Design Science, University of Sydney.

Hughes, J, King, G and Ganther, W, 2001, 'The application of corrosion information for the conservation of historic buildings and artefacts in Antarctica', *NACE, Northern regions Conference, Shining a Light on Cold Climate Corrosion*, Fairbanks, 26–28 February 2001.

Hughes, J D, King, G A and O'Brien, D J, 1996, 'Corrosivity map of Antarctica: revelations on the nature of corrosion in the world's coldest, driest, highest and purest continent', *13th International Corrosion Conference*, Melbourne, November 1996, Australasian Corrosion Association Publication, Paper 24.

Hughes, J, Pearson, C, Daniel, V and Cole, I, 1999, 'Monitoring of environmental conditions in a severe climate: how this can assist in development of conservation strategies for historic buildings and artefacts in Antarctica' in J Bridgland (ed.), *Preprints of the 12th Triennial Meeting of the ICOM Committee for Conservation*, Lyon, International Council of Museums, 1: 57–63.

International Standards Organization, 1992a, *ISO 9223 Corrosion of metals and alloys-Corrosivity of atmospheres-Classification*, International Standards Organization, Geneva, Switzerland.

International Standards Organization, 1992b, *ISO 9225 Corrosion of metals and alloys-Corrosivity of atmospheres-Measurement of pollution*, International Standards Organization, Geneva, Switzerland.

King, G, Ganther, W and Cole, I, 1999, 'Studies at sites progressively inland from the coast to aid development of a GIS map of Australian corrosivity', *Proceedings of 39th Annual Conference of Australasian Corrosion Association*, Sydney, 21–24 November, Paper 41.

King, G, Ganther, W, Hughes, J, Grigioni, P and Pellegrini, A, 2001, 'Studies in Antarctica help to Better Define the Temperature Criterion for Atmospheric Corrosion', NACE Northern Area Western Region Conference: 'Shining a Northern Light on Corrosion', Anchorage, Alaska, February 26–28.

Madigan, C T, 1929, 'Meteorology: Tabulated and reduced records of the Cape Denison Station, Adelie Land' in *Australasian Antarctic Expedition 1911-14 Scientific Reports, Series B, Volume 4*, Sydney, Government Printer, 1–286.

Mason, G W, 1999, 'Modelling Mass Transfer inside Scott's Hut, Cape Evans, Antarctica', Unpublished Masters of Engineering thesis, Canterbury University, Christchurch, New Zealand.

Norberg, P, 1993, 'Evaluation of a new surface moisture monitoring system', *Proceedings of the 6th International Conference on Durability of Building Materials and Components*, Omiya, Japan, October 26–29, Paper 37, 637–646.

Otieno-Alego, V, King, G, Hughes, J and Gillett, R, 2000, 'Rust from the Antarctic - A Record of Pollutants in Wilderness Environments', *Proceedings of Corrosion and Prevention 2000*, Australasian Corrosion Association Inc, Auckland, New Zealand, November 19–22, Paper 010, ISSN 1442-0139.

Rosales, B and Fernandez, A, 2001, 'Parameters controlling steel and copper corrosion nucleation and propagation in Antarctica', NACE Northern Area Western Region Conference: 'Shining a Northern Light on Corrosion', Anchorage, Alaska, February 26–28.

Abstract

A series of *in situ* corrosion measurements on the wreck *City of Launceston* (1865) have confirmed that the vessel is close to collapse. If the long-term corrosion rate of 0.119±0.014 mm/year continues until 2005, the average hull plate thickness will have fallen to less than 1 mm of steel. In this condition it is unlikely that the vessel will be able to withstand the impact of the strong storms that periodically dominate the weather patterns in Port Phillip Bay. The local surface pH of the corroding metal was used to establish the most likely sites for disintegration of the hull. Corrosion data have provided evidence of the detrimental impact of weed clearing.

Keywords

conservation, corrosion, iron shipwrecks, corrosion potentials, surface pH, metal thickness, seawater

In situ corrosion monitoring of the iron shipwreck *City of Launceston* (1865)

Ian D. MacLeod
Department of Materials Conservation
Western Australian Museum
Cliff Street
Fremantle, Western Australia 6160, Australia
Fax: +61 8 94318489
E-mail: ian.macleod@museum.wa.gov.au
Web site: www.museum.wa.gov.au

Introduction

On the evening of November 19, 1865, while steaming down Port Phillip Bay, the *City of Launceston* was accidentally rammed by the steam-powered ship *Penola*, which rescued all crew and passengers. Salvage attempts in the 1860s used patented cast iron drums (Macquay devices), which used chemically generated hydrogen from the reaction of metallic zinc and sulfuric acid to provide the lift. This raised the ship a few metres, but it remains 21 m below the surface in the middle of Port Phillip Bay. Divers removed the masts and funnel for safety reasons and the wreck remained essentially intact until snagged scallop dredges damaged the stern superstructure in the 1970s. Pre-disturbance measurements in 1991 preceded a detailed examination in 1997. Measurements in 1998, 1999 and 2001 established the nature of the decay process.

Physical oceanography

The wreck lies on a flat bottom of shingle and silt, which mounds to within 2 m of the starboard and 1 m of the port side deck and fills the interior, along with shell debris. When the site is disturbed the visibility falls to zero. 'The Bay is at various times unstratified, stratified by temperature, stratified by salinity, or stratified by both temperature and salinity' (Cowdell et al. 1985). With average residence times of one year the site has a 'low energy' with an annual mean surface oxygen concentration is 5.7 ± 0.2 ppm, temperature 15.8 ± 0.6°C, pH values of the seawater were 8.0 ± 0.2 and the salinity was 34.8 ± 1.2 ‰. Bottom temperatures were 14°-16°C with stratification of one degree between water depths of 16.6 m and 19 m. Occasional currents of 0.5 knots improved visibility during *in situ* measurements. Visibility seemed to improve with repeated site visits.

Marine biology of the site

In 1865 the wreck was clearly visible from the surface but major developments in the Port of Melbourne in the 1890s, 1920s and the 1960s made the site very silty, which inhibited marine growth and increased exposure to the corrosive effects of oxygen (North 1976, La Que 1975). The extent and maturity of colonization of the wreck was significantly different at the bow and the stern, compared with the middle section of the vessel. It was the cessation of scallop dredging after the pre-disturbance survey that resulted in a marked increase in the level of colonization and not the natural cycles in turbidity that would favour biological growth in April and May (Cowdell et al. 1985). The W–SW to E–NE orientation creates a natural barrier to the flow of sediment in the bay and causes scouring at the bow and the stern. Filter feeding marine organisms have a steady supply of nutrients and are free to grow to maturity, but the sedentary organisms in the midsections are subject to periodic burial in silt.

Corrosion studies

The state of decay of an iron shipwreck can be determined through a series of measurements on the corrosion potentials, E_{corr}, the surface pH, residual metal thickness t of the hull plates, the depth of graphitization (i.e. corrosion of cast iron, d_{mm}), and its annualized value, d_g in mm/year since the ship sank. This study on the *City of Launceston* involved more than 175 sets of pH and corrosion potential measurements. Hull plate thickness was conducted with a Cygnus 1 ultrasonic metal thickness meter. The E_{corr} measurements were made using a 2 mm diameter platinum electrode and a silver/silver chloride reference electrode ($Ag/AgCl_{sea}$), which was calibrated against the Normal Hydrogen Electrode (NHE) using a pH 4 solution, saturated with quinhydrone, and corrected for the temperature of the seawater. The pH data are conservative, i.e. the reported values will tend to be less acidic than the actual values.

Poor visibility meant there were delays in getting the electrode into position and this allows penetration of normal seawater into the corroding interface. The lack of calcareous colonizing organisms meant that the concretion covering was only a few mm thick, which is not enough to facilitate the build up of a significantly different microenvironment (North 1976). The slow rate of re-colonization became apparent when, one year after taking the metal thickness measurements, the 8 cm diameter sections that had been cleaned were still discernible. Corrosion potential measurements made on large structures, such as hull plates attached to steel frames and ribs, tend to reflect the average environment but the pH of the corroding metal is generally a better indicator of the local corrosion activity in a complex site such as the *City of Launceston* (MacLeod, 1995).

Periodic burial

A thin layer of the deep-blue copper sulfide covellite (CuS) on a copper pressure vessel on the engine is consistent with it having been buried in about 15 cm to 40 cm of sediment, since the same mineralization occurred on a bronze tallow pot and the main copper steam pipe from the SS *Xantho* (1872) engine, which had been periodically buried under 40 cm of sediment. Both objects had the same E_{corr} value at -0.137 ± 0.005 volts vs. $Ag/AgCl_{sea}$. The pH was estimated to lie between 6.5 and 7.5. The sulfide ions come from the metabolites of sulfate reducing bacteria such as *desulfovibrio salixigens* (MacLeod et al. 1986, Macleod 1982).

Depth of graphitization of cast iron

During the initial survey in 1991 and during a site inspection by Terry Arnott in 1994, a series of corrosion potential measurements were made on cast iron fittings on the vessel and a set of five depths of graphitization measurements were made. Based on the assumption that the wreck has been in a relatively constant environment since it sank in 1865, the mean depth of graphitization of 15.4 ± 1.85 mm equates to a corrosion rate, or a d_g value, of 0.119 ± 0.014 mm/yr^{-1}. Using the values of the corrosion potentials (NHE) and associated d_g values of the individual cast iron objects, the following relationship describes the average corrosion environment on the *City of Launceston*:

$$log\ d_g = 3.25\ E_{corr} + 0.202 \qquad (1)$$

This linear relationship between the log of the corrosion rate and the corrosion potential has been previously described and provides a direct method for the interpretation of corrosion potential data (MacLeod 1988, 1989, 1996a, 1998). The primary rate determining step in the corrosion process is the flux of dissolved oxygen to the encrusted artefact, with E_{corr} values being more anodic, less negative, when there is an increased flux of dissolved oxygen to the marine encrusted surface of the object. The initial inspection voltage of the cast iron engine cylinder was -0.289 volts vs. $Ag/AgCl_{sea}$, which indicates that the metal is largely graphitized, which is consistent with the easy penetration of the drill bit into the internal cavities of the cylinders. The E_{corr} of the cast iron *Macquay* devices and the massive propeller

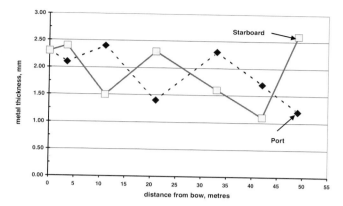

Figure 1, Metal thickness of hull plates on port and starboard sides vs. distance from the bow

were 264 mV more negative at -0.553 ± 0.004 volts and retained significant amounts of solid metal.

Effects of alloy composition on corrosion potentials

In a cast iron with 3.5 wt% of carbon, the atomic concentration is almost 16%, thus carbon will have a major effect on the electrochemical reactivity of iron. The average carbon content of wrought iron plates is between 20 and 40 times less than that found in cast iron and the corrosion potentials are up to 70 mV more negative for the same corrosion rate but only 33 mV different on the *City of Launceston*. When determining average corrosion rates for the hull plates, the voltages are corrected for the effect of the carbon content when using equation 1 to estimate the corrosion rates of the wrought iron hull plates.

Metal thickness

Reproducible measurements of metal thickness involved clearing areas typically 8 cm in diameter, owing to the roughness of the corroded plates. Eighteen surveyed locations from the bow to the stern on port and starboard sides were measured (Figure 1). There were several areas where the cleaning showed up perforated plates. The mean metal thickness was 1.98±0.47 mm after more than 130 years of corrosion but there is no systematic trend of metal thickness with distance from the bow, nor is there any direct relationship between the thickness and the present E_{corr} data. Although there is no real difference between the mean 1.9±0.5 mm thickness on the port side and 2.0±0.6 mm on the starboard side, there was a difference between the mean pH data. The higher silt mound on the portside gave lower corrosion rates, i.e. it was less acidic than the starboard side, with the mean values being pH_{port}^{97} = 6.83±0.56 and pH_{stbd}^{97} = 6.48±0.70. Two years later the same trend continued, but the lower pH values of pH_{port}^{99} 7.22±0.23 and pH_{stbd}^{99} was 7.14±0.43 are due to the incomplete re-colonization. The surface pH of the corroding metal is normally a good indicator of localized corrosion since the hydrolysis of the primary corrosion product of iron (II) chlorides produces increased acidity, viz.,

$$2\ Fe + 2\ H_2O + 2\ Cl^- \rightarrow \{FeCl_2.Fe(OH)_2\} + 2\ H^+ + 4\ e^- \quad (2)$$

Plots of the 1997 pH values from the bow to the stern (Figure 2) shows a number of points along the length of the vessel that have lower pH and these generally correlate with higher E_{corr} values, both of which indicate a higher corrosion rate. The starboard side of the *City of Launceston* has pH minima at 7 m from the bow and then at 36 m, 46 m and 52 m from the bow while the port side has pH minima at 3 m, 29 m, 46 m and 50 m from the bow.

When the pH data are plotted on the site plan there is a trend toward the port side minimum occurring several metres before a corresponding minimum on the starboard side. The mean angle of the lines joining the adjacent minima is 32° ± 9° from north, which is close to the angle at which the vessel lies with regard to

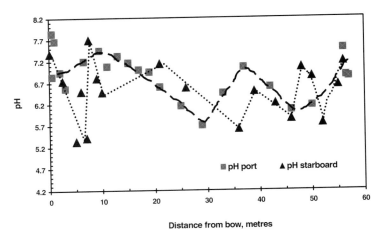

Figure 2. 1997 in-situ pH for port and starboard hull plates

the flow of the current across the site. Clearly there is a strong correlation between the localized corrosion rates and the current that brings the dissolved oxygen. Analysis of the comprehensive 1997 data indicates that the pH is dependent on the log of the thickness of the residual metal x, where x is in mm of metal. The starboard plates followed equation 3, and had a five-point correlation factor of 0.85.

$$pH^{97}_{stbd} = 4.76(0.55) + 0.89(0.27)\ x \qquad (3)$$

The port side data were more scattered with correlation coefficient of 0.62 for equation 4

$$pH^{97}_{port} = 5.90(0.44) + 0.34(0.22)\ x \qquad (4)$$

The values in parentheses are the standard deviations associated with the lines of best fit. Since the intercept and slope values of equations 3 and 4 differ by more than the sum of the errors the results appear to be significant which indicates that the starboard side is corroding at a faster rate than the port side. Given that the actual metal thickness is not greater than 2 mm, the error of ± 0.1 mm in any measurement equates to at least 5% so the correlation coefficients are not unreasonable.

Localized increases in corrosion rate (less negative E_{corr}) were coincident with two of the pH minima on the starboard side at approximately 6 m and 35 m from the bow. The fact that low pH values at 46 m and 52 m were not mirrored by elevated E_{corr} values is probably due to the hull plates being in contact with more protected parts of the wreck. A diagrammatic representation of the corrosion environment in 1997 is shown in Figure 3, which highlights the lack of uniformity

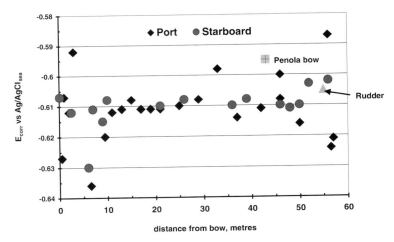

Figure 3. 1997 season of E_{corr} measurements for port and starboard hull plates

Table 1. Corrosion potentials vs. Ag/AgClsea and calculated corrosion rates for all field seasons

Date	E_{corr}^{stbd}	i_{corr}^{stbd} mm/year	E_{corr}^{port}	i_{corr}^{port} mm/year
April 1991	-0.585±0.006	0.149±0.006	-0.591±0.003	0.142±0.003
November 1997	-0.613±0.011	0.114±0.009	-0.612±0.012	0.113±0.010
November 1998	-0.596±0.026	0.134±0.023	-0.593±0.022	0.137±0.020
October 1999	-0.581±0.023	0.150±0.020	-0.583±0.011	0.147±0.011
November 2001	-0.599±0.013	0.130±0.013	-0.604±0.012	0.128±0.013

of the microenvironment. Comparison of the E_{corr}^{98} and E_{corr}^{97} values for solid metal plates showed that the mean E_{corr}^{98} value is 15 mV more anodic than in 1997, i.e. it has a 12% higher corrosion rate. Hull plates that are extensively corroded and have very little solid metal are characterized by potentials that are between 100 mV and 350 mV more anodic than the E_{corr} values of sound plates (MacLeod 1981, Pourbaix 1974). The *Penola* bow was 22 mV more anodic than the nearby hull plates (Figure 3), which is due to a mixture of the effects of increased localized turbulence and differences in alloy composition and residual stress associated with the ramming. The 32 mV elevation in the E_{corr} of the rudder is probably due to localized turbulence and the effects of non-annealed cold working.

Calculation of apparent corrosion rates

A convenient way of interpreting E_{corr} values is to use the corrosion equation, $log\ i = 3.25\ E_{corr} + 0.202$, to work out the apparent corrosion rate, after corrections for the voltage differences between wrought and cast iron. The overall situation is summarized in Table 1, where the mean E_{corr} values are tabulated, along with the corresponding estimates of actual corrosion rates for the hull plates during the five visits to the wreck site. The cessation of scallop dredging and associated improved light penetration and marine growth probably accounts for the drop in corrosion rates between 1991 and 1997. Stripping of the weed growth from the deck after the 1997 measurements, to enable the site to be fully surveyed, seemingly increased the corrosion rate by 17.5% and by a further 12% almost one year later before the rates fell to nearly 5% below the 1998 value following two years of site stabilization. The marked changes in the corrosion potentials after site stripping shows that corrosion on iron wrecks is very sensitive to removal of marine encrustations. The overall impact of conducting a detailed site survey by traditional tapes and photogrammetry on iron wrecks is major.

During the 1997 survey five of the 58 hull plates were totally corroded but this number had increased to ten out of the 56 one year later. Using the mean 1997 corrosion rates, the calculated metal loss over 132 years was 15±2 mm, which matches the mean depth of graphitization of 15.4±1.9 mm. The original plate thickness was estimated by adding the residual and lost metal values, which gave a value of 16.5±1 mm. Since the construction specifications are unknown these data indicate an original 5/8" plate (15.9 mm) was used to build the vessel.

Wreck location and localized corrosion

In moving from the bow to the stern, the starboard 1998 pH data indicate that there are zones of increased localized corrosion activity at 3m to 8 m, at 25 m, at 43 m and at 55 m from the bow. Apart from these hot spots the overall trend is towards a more uniform value of the pH, which is probably due to the lack of colonization only one year after stripping. The E_{corr} data, as the solid line in Figure 4, generally follow the trend of the pH data except between the 36-m and 52-m marks. Here the elevated voltages are reflecting the impending demise of the steel hull plates in that area.

Similar patterns of behaviour were observed for the port side, showing hot spots near the bow, at 5 m, 24 m and 36 m from the bow. Where there is a divergence of the E_{corr} data and the pH values, it is due to the loss of integrity of the hull plates. The site stabilization brought about with cessation of scallop dredging was destroyed by the 'de-weeding' operations. The re-colonization process took more than two years to begin to correct this impact (Figure 5). Without some form of

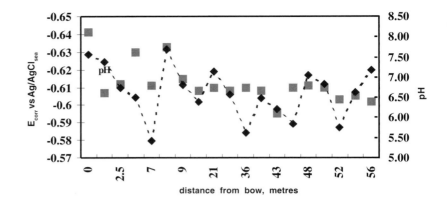

Figure 4. Starboard in-situ *values of pH and* E_{corr} *for 1998 as a function of distance from the bow*

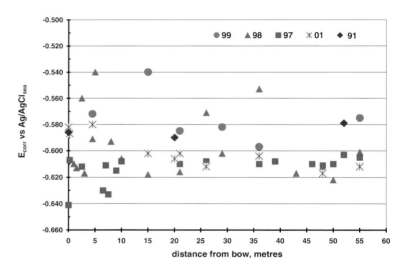

Figure 5. Starboard *corrosion potentials for hull plates from 1991–2001*

stabilization, it can be estimated that the wreck will begin to collapse from areas about 4 m to 7 m from the bow and at from 46 m to 51 m from the bow, i.e., about 5 m to 10 m from the stern. This collapse will be dependent on the timing of a major storm and can be expected to occur within the next one to three years.

Conclusion

The use of *in situ* corrosion measurements has established that the *City of Launceston* is in the final stages of its existing configuration as a complete hull. Surface pH measurements appear to be good indicators of localized corrosion rates for continuous iron and steel hulls. Corrosion potentials and associated depths of graphitization of cast iron objects provide a quantitative tool for assessing the past and present corrosion environment. When the original conditions were compared with data obtained in 1997 and 1998, they showed that the wreck was undergoing a significant deterioration, partly due to the archaeological activities of site recording. This brought on an excavation program. Subsequent monitoring in 1999 confirmed the trend towards impending collapse of the wreck. Final measurements in 2001 show the site is moving back toward its long-term corrosion rate. While silt has protected the site from major storm damage, by acting as an effective transmission medium for shock waves, it is necessary to remove some for archaeological reasons. The upper works of the vessel are also significantly decayed with several ribs, frames, the capstan and a deck plate having no solid metal. Based on best estimates of the present corrosion rate and the residual metal thickness in 1997, the wreck can be expected to collapse within the next five years.

Acknowledgements

The support of Shirley Strachan, Peter Harvey and Jenny Dickens from Heritage Victoria is gratefully acknowledged as is the work and encouragement of a number of diving buddies, especially Terry Arnott, Scott Allen and Malcolm Venturoni who performed the metal thickness measurements.

References

Cowdell, R A, Gibbs, C F, Longmore, A R and Theodoropolous, T, 1985, 'Tabulation of Port Phillip Bay Water Quality Data Between June 1980 and July 1984', Internal Report No. 98, Marine Science Laboratories, Ministry for Conservation: Fisheries and Wildlife Division, Queenscliff, Victoria, Australia.

La Que, F L, 1975, *Marine Corrosion*, New York, John Wiley and Sons.

MacLeod, I D, 1981, 'Shipwrecks and applied electrochemistry', *Journal of Electroanalytical Chemistry*, 118, 291–303.

MacLeod, I D, 1988, 'In-situ corrosion studies on iron shipwrecks and cannon: the impact of water depth and archaeological activities on corrosion rates' in W Mourey and L Robbiola (eds.), *Metal 98 Proceedings of the ICOM-CC Metals Working Group Conference*, Draguignan-Faginère, France, 1998, Mourey, London, James & James, 116–124.

MacLeod, I D, 1989, 'Electrochemistry and conservation of iron in seawater', *Chemistry in Australia*, 56(7), 227–229.

MacLeod, I D, 1992, 'Conservation management of Iron Steamships: The SS *Xantho* (1872)', *Multi-Disciplinary Engineering Transactions* GE 1, 45–51.

MacLeod, I D, 1995, 'In-situ corrosion studies on the Duart Point wreck 1994', *International Journal of Nautical Archaeology* 24(1), 53–59.

MacLeod, I D, 1996a, 'An in-situ study of the corroded hull of HMVS *Cerberus* (1926)', *Proceedings of the 13th International Corrosion Congress*, Paper 125, 1–10.

MacLeod, I D, 1996b, 'In-situ conservation of cannon and anchors on shipwreck sites' in Ashok Roy, and Perry Smith (eds.), *Conservation of Archaeological Sites and its Consequences*, London, IIC, 111–115.

MacLeod, I D, 1998, 'In-situ corrosion studies on iron and composite wrecks in South Australian waters: implications for site managers and cultural tourism', *Bulletin Australian Institute Maritime Archaeology*, 22: 81–90.

MacLeod, I D, North, N A and Beegle, C J, 1986, 'The excavation, analysis and conservation of shipwreck sites', *Preventative measures during excavation and site protection*, Rome, ICCROM, 113–132.

North, N A, 1976, 'The formation of coral concretions on marine iron', *International Journal of Underwater Archaeology and Underwater Exploration* 5, 253–258.

Pourbaix, M, 1974, 'Atlas of electrochemical equilibria in aqueous solutions', NACE, Houston, 2nd ed.

Resins: Characterization and evaluation

Résines: Caractérisation et évaluation

Resinas: Caracterización y evaluación

Resins: Characterization and evaluation

Coordinator: Klaas Jan van den Berg
Assistant Coordinator: Jens Glastrup

The Resins Working Group has been slowly growing again during the past three years and now has 25 members. Three newsletters were produced, including a questionnaire to which most members responded. This resulted in a list of research fields of interest and a list of recent publications by the members, which were also made available for a wider public on the ICOM-CC Web site.

The Working Group is a platform for exchanging information on conservation materials for researchers working in many different disciplines. This diversity of interests is also reflected by the fact that most members are involved in at least one other working group. Together with the fact that the number of submitted publications for this triennial is quite limited, this prevents us from drawing conclusions as to the development of trends or developments. Whereas in Lyon in 1999, the two papers dealt with *traditional* resins, for the present Triennial Meeting, four out of five initially accepted abstracts for full papers dealt with the characterization and evaluation of *synthetic* resins. Three of these are presented here; all are publications evaluating modern resins as varnishes/coatings on art objects.

We are aware that we have received only a limited number of papers for this session, despite the fact that there is an obvious and still growing need for information on the analysis and behaviour (characterization and evaluation) of conservation materials. We feel this can be explained to some extent by the fact that it is not widely known by conservation scientists that this working group is the platform in which work is done on both natural and synthetic conservation materials (such as coatings, adhesives, impregnation materials, etc.). The name (Resins: Characterization and Evaluation) may have become both too narrow and confusing. We will, therefore, discuss a change to the name and to the working programme at this Triennial Meeting.

Klaas Jan van den Berg

Abstract

The photochemical stability of films of urea-aldehyde resins, manufactured by BASF and sold under the trade name Laropal® A, was investigated. Due to their low molecular weight, stability and solubility in solvents of relatively low polarity, these resins can be used in many applications, for example for varnishing and retouching. The properties of two commercially available resins, Laropal® A 81 and Laropal® A 101, were compared to those of an earlier tested experimental aldehyde resin, also obtained from BASF. Films prepared from these resins were aged in a xenon-arc Weather-ometer. Films containing a hindered amine light stabilizer were also aged. The resins proved stable as demonstrated by solvent removability tests, Fourier-transform infrared spectroscopy and size exclusion chromatography. For optimum stability the addition of a stabilizer is recommended.

Keywords

low molecular weight resin, urea-aldehyde, varnish, retouching, photochemical stability, solvent removability, FTIR, SEC

An investigation of the photochemical stability of films of the urea-aldehyde resins Laropal® A 81 and Laropal® A 101

E. René de la Rie,★ Suzanne Quillen Lomax, Michael Palmer and Christopher A. Maines
National Gallery of Art
Washington, D.C. 20565, U.S.A.
Fax: (202) 842-6886
E-mail: rdelarie@csi.com

Introduction

Urea-aldehyde resins, also known as aldehyde resins, are low molecular weight resins manufactured by BASF and sold under the Laropal® A trade name. Stable synthetic low molecular weight resins are of interest to conservators because of their low intrinsic viscosity. Paints and varnishes formulated with such resins level to a greater extent than those formulated using polymeric resins. Thus, surfaces that exhibit less light scattering may be produced, providing higher gloss and more saturated colours, similar to the effects that can be obtained when using much less stable natural resins, such as dammar and mastic (de la Rie 1987, de la Rie and McGlinchey 1990, de la Rie *et al.* 2000, Berns, in press). Previous work has demonstrated the excellent stability of Regalrez® 1094 and an experimental aldehyde resin obtained from BASF (de la Rie and McGlinchey 1990 and de la Rie 1993). The current paper describes experiments carried out to investigate the photochemical stability of films of the urea-aldehyde resins Laropal® A 81 and Laropal® A 101 in comparison to that of films of the experimental aldehyde resin.

Industrially, urea-aldehyde resins are used as paint additives to improve properties such as hardness, gloss and resistance to yellowing. Because of their low viscosity, urea-aldehyde resins are also used to reduce the volatile organic content (VOC) of coatings. Urea-aldehyde resins demonstrate excellent pigment wetting and are used in the manufacture of pigment pastes.

Urea-aldehyde resins are obtained by the condensation of isobutyraldehyde (2-methylpropanal), formaldehyde and urea in an acidic environment, followed by treatment with alkali alkoxides (Freitag 1993, Freitag 1993 et al., Freitag 1996, Stange 1996). Although a theoretical structure has been published (Freitag 1993, Freitag 1996) (Figure 1), the exact composition of aldehyde resins is unknown (Kasch 1996). The oligomeric product contains cyclic amide groups and other functionalities, but residual aldehyde groups, which would be a source of chemical instability, could not be detected in a urea-aldehyde resin using nuclear magnetic resonance spectrometry (NMR) (de la Rie and McGlinchey 1990).

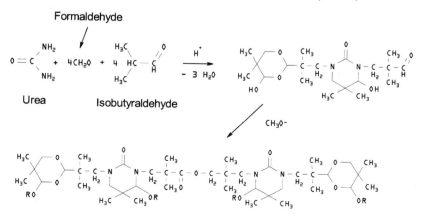

Figure 1. Scheme for formation and theoretical structure of urea-aldehyde resins

★Author to whom correspondence should be addressed

Some properties of an experimental aldehyde resin obtained from BASF for research purposes were previously reported (de la Rie and McGlinchey 1990, de la Rie 1993). This experimental product was soluble in low-aromatic hydrocarbon solvents and very stable. It was used successfully as a varnish (Leonard 1990) and experimental batches of retouching paint formulated using this resin as a binder were tested (de la Rie et al. 2000, Leonard et al. 2000). The experimental aldehyde resin has never been commercially available. The product was obtained from BASF in small quantities in three different batches in 1988, 1991 and 1996. It was obtained by purification in the laboratory of the commercial product Laropal® A LR 8786 (Kasch 1996). BASF, however, no longer manufactures Laropal® A LR 8786, and as a result the experimental aldehyde resin is no longer available.

Laropal® A 81 and Laropal® A 101 are commercially available urea-aldehyde resins, also made by BASF, which require a somewhat more polar solvent mixture than the previously tested experimental product, which is soluble in hydrocarbon solvents containing just a few percent aromatic solvent. Of the two, Laropal® A 81 requires the least polar mixture. A 20% by weight solution of the resin is soluble in 10% toluene/90% cyclohexane (by weight). A 20% solution of Laropal® A 101 is soluble in 20% toluene/80% cyclohexane (by weight). Less or more aromatics may be required depending on resin concentration, temperature and exact composition of the solvent mixture.

Newly developed retouching paints using Laropal® A 81 as the binding medium have recently been described (de la Rie et al. 2000, Leonard et al. 2000). Laropal® A 81 has also been used by some as a picture varnish. In order to further investigate the stability of Laropal® A 81 and A 101, the photochemical stability of unpigmented films of these resins was investigated in accelerated ageing experiments and compared to that of films of the 1996 batch of the experimental aldehyde resin. Films containing 2% (by weight of the resin) of the hindered amine light stabilizer (HALS) Tinuvin® 292 were also tested. Two different batches of each resin were investigated: Laropal® A 81 batches dated 2/95 and 6/97 and Laropal® A 101 batches dated 2/95 and 11/96. Changes in the films were monitored using solvent-removability tests, Fourier-transform infrared spectroscopy (FTIR) and size exclusion chromatography (SEC).

Experiment

Sample preparation

Films were prepared by casting 40% solutions by weight of the resins onto glass plates. The experimental aldehyde resin and Laropal® A 81 were dissolved in a 2:1 mixture of Shell Sol 340HT and Shell TS28. Laropal® A 101 was dissolved in toluene. The films were allowed to dry for two weeks before accelerated ageing. Film thickness averaged about 50 microns.

Accelerated ageing

An Atlas Ci65A xenon arc Weather-ometer was used fitted with a borosilicate inner and soda lime outer filter glass. This filter combination simulates daylight passing through window glass, including the ultraviolet component. The irradiance was kept at $0.90 W/m^2$ (measured and controlled at 420nm), the black panel temperature at 50°C, the dry bulb at 35°C and the wet bulb depression at 10°C (de la Rie 1988, de la Rie 1993). The films were aged for a total of 2996 hours.

Solvent removability

The varnish films were periodically tested to determine the solvent polarity necessary for removal, using solvent mixtures of cyclohexane and toluene in a regular series of increasing polarity as previously described (de la Rie 1988, de la Rie 2000). Due to the stability of the resins investigated, no mixtures of toluene and acetone were required.

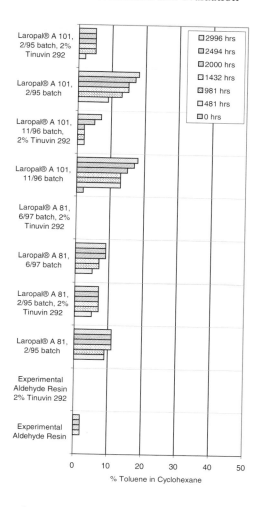

Figure 2. Solvent removability of unstabilized and stabilized urea-aldehyde resin films before and after accelerated ageing

Infrared spectroscopy

Infrared (IR) spectra of small samples taken from the resin films were measured before ageing, after 1432 hours and after 2996 hours. The spectra were recorded, either on a Bio-Rad FTS60A instrument equipped with a UMA 300A microscope or a Nicolet Nexus 670 instrument equipped with a Continuum microscope, at 4 cm^{-1} resolution. Small samples taken from the films were compressed between the windows of a Diamond Cell (Spectratech).

Size exclusion chromatography

1% by-weight resin solutions in unstabilized tetrahydrofuran (THF) were analyzed on a Perkin-Elmer (PE) liquid chromatography system consisting of a PE Series 410 LC pump, two Polymer Laboratories PL-gel 5 micron mixed-D columns (300 mm × 7.5 mm), and a Millipore 410 Differential Refractometer. The columns and the refractometer were maintained at 35°C. THF was used as the eluant (1 ml/min). The instrument was calibrated daily using five polystyrene standards with weight-average molecular weights (\overline{M}_W) ranging between 162 and 207,000. PE Nelson Turbochrom (v. 4.12) was used for data collection, and approximate values for \overline{M}_W, peak molecular weight (M_p), and number-average molecular weight (\overline{M}_N) were obtained using TurboGel Plus (v. 1.2).

Results and discussion

Solvent removability

All unaged urea-aldehyde resin films are removable using 100% cyclohexane. Upon accelerated ageing, they remain removable in solvents of low polarity (Figure 2).

The experimental aldehyde resin performs slightly better than do its commercially available counterparts. When stabilized with 2% Tinuvin® 292, it remains

removable in 100% cyclohexane after ageing for 2996 hours, and only requires 2% toluene/98% cyclohexane for removal when the resin is unstabilized.

Laropal® A 81 has slightly better removability than Laropal® A 101. Unstabilized films of Laropal® A 81 require a solvent mixture of approximately 10% toluene / 90% cyclohexane for removal after 2996 hours, compared to 18% toluene/82% cyclohexane for Laropal® A 101. Overall, there is little batch dependence observed in the removability of these resins. The unstabilized films show little difference between the two batches. Interestingly, Tinuvin® 292 stabilized one batch of Laropal® A 81 more than the other. The 6/97 batch remained removable in pure cyclohexane after 2996 hours of accelerated ageing. This effect was not observed with the different batches of Laropal® A 101.

The removability of these resins is considerably better than other materials used as clear coatings, such as the polycyclohexanone resin Laropal® K 80, which requires 9% acetone/91% toluene after less than 500 hours of accelerated ageing and 70% acetone/30% toluene after 2996 hours. The natural resins dammar and mastic also rapidly require acetone/toluene mixtures for removal when aged under the same conditions (Feller et al. 1985, de la Rie 1988).

Infrared spectroscopy

The infrared spectra of the urea-aldehyde resins are consistent with the expected functional groups, including hydroxyl, C-H, ester, tertiary amide and geminal dimethyl groups (Figures 3 and 4). The spectra of the experimental aldehyde resin, Laropal® A 81 and Laropal® A 101 are very similar. The primary hydroxyl group absorbs around 3300–3200 cm⁻¹. The experimental aldehyde resin shows the most definition in this region. Pronounced C-H stretches from the polymer backbone (methylene and C-CH₃) occur at 2960 and 2880 cm⁻¹. The ester carbonyl absorbs around 1730 cm⁻¹ while the tertiary amide absorbs at 1650 cm⁻¹. The remaining absorbances in the fingerprint region are due to the various ether and C-C stretches with the strongest being the CH₂ scissor vibration at 1485 cm⁻¹. The geminal dimethyl groups lead to the doublet absorbing near 1390 cm⁻¹, while the ether group is absorbing at 1080 cm⁻¹. There are minor variations in intensity in the fingerprint region among the three resins.

The spectra of the two batches of Laropal® A 81 used in this study differ only in the intensity of the absorbance around 1000–1100 cm⁻¹, a phenomenon that is also observed for the two batches of Laropal® A 101.

Upon ageing, the polarity of a resin can change due to the formation of species containing functional groups such as hydroxyl, ketones and carboxylic acids. The development of these functional groups can be followed using infrared spectroscopy. This is not quite as straightforward as it is with hydrocarbon resins (de la Rie 1993), because unaged urea-aldehyde resins already contain hydroxyl, ester and amide functionality.

Upon ageing, the band in the hydroxyl region in the infrared spectra of unstabilized films of the experimental aldehyde resin broadens and increases in intensity (Figure 3). The two distinct carbonyl bands have begun to merge after 1432 hours and are completely merged after 2996 hours of accelerated ageing.

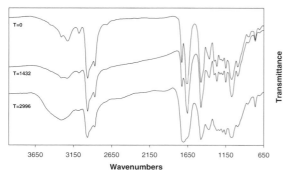

Figure 3. Infrared spectra of unstabilized films of the experimental aldehyde resin before and after accelerated ageing

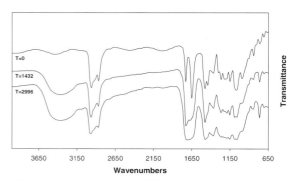

Figure 4. Infrared spectra of films of unstabilized Laropal® A 81 before and after accelerated ageing

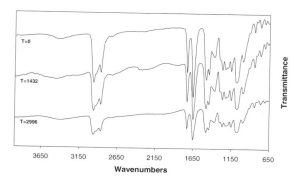

Figure 5. Infrared spectra of films of Laropal® A 81 stabilized with 2% Tinuvin® 292 before and after accelerated ageing

There are no changes in the fingerprint region. The infrared spectra of the same resin stabilized with 2% Tinuvin® 292 shows less change in the hydroxyl region. In addition, two distinct carbonyl bands are present after 1432 hours, and can still, if barely, be observed after 2996 hours.

The band in the hydroxyl region of unstabilized films of either batch of Laropal® A 81 increases in intensity and broadens in the 3100-3200 cm⁻¹ region, most likely due to formation of carboxylic acid functionality (Figure 4). Substantial increase in intensity in the carbonyl region is observed after 1432 hours, with merging of the carbonyl bands after 2996 hours. Slight changes are observed in the hydroxyl region of films of the Laropal® A 81 samples stabilized with Tinuvin® 292, but there is no evidence of oxidation in the carbonyl region, and the two bands remain distinct (Figure 5).

Unstabilized films of either batch of Laropal® A 101 show changes in the hydroxyl region upon ageing. The band increases in intensity and broadens in films of the 11/96 batch, while the 2/95 batch shows broadening only. Both batches show substantial increase in intensity in the carbonyl region by 1432 hours. The 11/96 batch also shows increased intensity in the 1200-1270 cm⁻¹ region, an area of C-O bond absorption. The infrared spectra of the 11/96 batch stabilized with 2% Tinuvin® 292 show a slight increase in intensity in the hydroxyl region without shifts in the position of the band. In addition, no change was observed in the carbonyl region. The stabilized Laropal® A 101 sample from 2/95 shows no changes in the hydroxyl or carbonyl region upon ageing.

Size exclusion chromatography

Changes in the molecular weight distribution of the resins were determined using SEC. The calculated values of peak molecular weight (M_p), weight-average molecular weight (\overline{M}_W), and number-average molecular weight (\overline{M}_N) for different batches of the same resin were well within the measurement error of molecular weight distributions for each particular resin. No measurable differences between different batches of the same resin could be detected over the 2996 hours of accelerated light ageing. However, subtle differences between batches could be seen in the shapes of the size-exclusion chromatograms.

The size-exclusion chromatogram of a fresh film of the experimental aldehyde resin shows a narrow distribution (Figure 6). Treating the envelope of peaks as a single distribution, M_p is approximately 850, and \overline{M}_W and \overline{M}_N are 1400 and 850, respectively. No differences are seen between films of the unstabilized and the stabilized experimental aldehyde resin at T=0.

The experimental aldehyde resin is very stable; there is no change in molecular weight parameters for aged stabilized and unstabilized films. The only difference between the chromatograms of the stabilized and unstabilized films is the disappearance of the small peak on the low molecular weight side of the unstabilized film between 0 and 1432 hours. The small peak remains in the chromatogram of the stabilized film after 2996 hours of ageing.

The size-exclusion chromatogram of a fresh film of Laropal® A 81 shows a broad peak consisting of several overlapping distributions that appear as features, i.e. shoulders or not completely resolved peaks, on the primary peak, similar to the features seen in the experimental aldehyde resin (Figure 7). The primary peak has an M_p of approximately 2200. There is a broad shoulder on the higher molecular

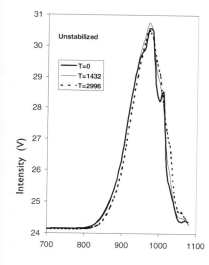

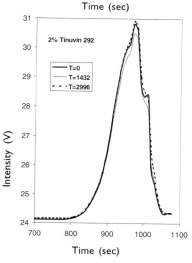

Figure 6. Size exclusion chromatograms for the experimental aldehyde resin before and after accelerated ageing

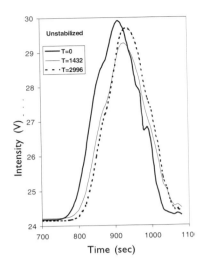

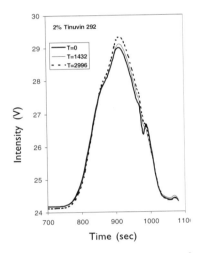

Figure 8. Size exclusion chromatogram for unstabilized and stabilized films of Laropal® A 101 before and after accelerated ageing

weight side of the primary peak, and three smaller shoulders, including one small peak, on the lower molecular weight side of the primary peak. Treating the envelope of peaks as a single distribution, an M_p of approximately 2200, and \overline{M}_W and \overline{M}_N, of 4300 and 1750, respectively, are obtained. The molecular weight of Laropal® A 81 is considerably higher than that of the experimental aldehyde resin. No differences are seen between unstabilized and stabilized Laropal® A 81 at T=0.

Upon ageing, M_p, \overline{M}_W and \overline{M}_N of unstabilized Laropal® A 81 shift to lower values. After 2996 hours, the molecular weight parameters have almost been halved; M_p, \overline{M}_W and \overline{M}_N shift to ca. 1500, 2300 and 1000, respectively. All of the features present in chromatograms of the unaged samples had smoothed considerably with the exception of a small sharp peak on the low molecular weight side of the distribution, which appeared between 1432 and 2996 hours. The small peak seen on the low molecular weight side of the chromatogram of unaged Laropal® A 81 is perhaps the progenitor of this new peak, appearing at even lower molecular weight.

The molecular weight parameters of stabilized Laropal® A 81 did not change appreciably after 2996 hours of accelerated ageing. There is a slight change in the shape of the chromatogram for the 2/95 batch; the features on the low molecular weight side of the distribution smooth considerably, including the small peak, which turns into a shoulder between 0 and 1432 hours. The 6/97 batch of stabilized Laropal® A 81 shows no such change; the features present at 0 hours are present at 2996 hours.

The size-exclusion chromatogram of a fresh film of Laropal® A 101 (T=0) shows a broad peak with features identical to fresh Laropal® A 81 (Figure 8). Treating the envelope of peaks as a single distribution, M_p, \overline{M}_W and \overline{M}_N are ca. 2100 and 3300 and 1500, respectively. No differences are seen between unstabilized and stabilized Laropal® A 101 at T=0.

Unstabilized Laropal® A 101 shifts to lower molecular weight as it is aged. After 2996 hours, M_p, \overline{M}_W and \overline{M}_N have shifted to ca. 1500, 2000 and 1000, respectively. All features present in the unaged chromatograms, smooth considerably upon ageing. The small, sharp peak seen on the low molecular weight side of aged, unstabilized Laropal® A 81 is not present in the chromatogram of aged, unstabilized Laropal® A 101.

The molecular weight parameters of stabilized Laropal® A 101 do not change appreciably upon ageing. As seen in Laropal® A 81, the features in the chromatogram smooth upon ageing. The two batches of Laropal® A 101 analyzed display the same behaviour.

The behaviour of urea–aldehyde resins upon ageing differs from that of other low molecular weight resins, including dammar, mastic, hydrocarbon resins and polycyclohexanone resins, which increase in molecular weight (de la Rie 1988, de la Rie unpublished results).

Conclusions

Unpigmented films of Laropal® A 81 and Laropal® A 101 showed good resistance to photochemical degradation. After prolonged accelerated ageing in an environment simulating daylight through window glass, including daylight's ultraviolet component, unstabilized films required solvent mixtures less polar than 20% toluene/80% cyclohexane for removal and when stabilized with 2% Tinuvin® 292, required even less polar mixtures. Infrared spectroscopy shows moderate oxidation in unstabilized films and very little oxidation in stabilized films. Size exclusion chromatography shows some change in unstabilized films, but the peak molecular weight, and molecular weight averages, \overline{M}_W and \overline{M}_N, for films stabilized with 2% Tinuvin® 292 remain unchanged. In addition, all films remain clear and colourless and do not exhibit defects such as cracking or flaking. For maximum stability of unpigmented Laropal® A 81 and Laropal® A 101 films, for example when used as varnishes, the addition of the hindered amine light stabilizer Tinuvin® 292 is recommended.

References

Berns, R S and de la Rie, E R, in press, 'A new methodology for assessing the effects of varnishes on the appearance of paintings', *Studies in Conservation*.

Feller, R L, Stolow N and Jones, E H, 1985, rev. ed, *On Picture Varnishes and their Solvents*, Washington, D.C., National Gallery of Art.

Freitag, W, 1993, 'Ketone and aldehyde resins' in Elvers, B, Hawkins, S, Russey W and Schulz, G, (eds.), *Ullmanns's Encyclopedia of Industrial Chemistry*, 5th ed., New York, VCH, 99–105.

Freitag, W, Bieleman, J, Knoef, J and Ortelt, M, 1993, 'New materials for pigment pastes' *Surface Coatings International* 3, 113–119.

Freitag, W, 1996, 'Ketone and aldehyde resins' in Stoye, D and Freitag, W (eds.), *Resins for Coatings*, New York, Hanser, 159–172.

Kasch, H, 1996, private communication, BASF Aktiengesellschaft, Ludwigshafen, Germany.

Leonard, M, 1990, 'Some observations on the use and appearance of two new synthetic resins for picture varnishes' in Mills, J S and Smith, P (eds.), *Cleaning, Retouching and Coatings*, London, International Institute for Conservation of Historic and Artistic Works, 174–176.

Leonard, M, Whitten, J, Gamblin, R and de la Rie, E R, 2000, 'Development of a new material for retouching' in Roy, A and Smith, P (eds.), *Tradition and Innovation: Advances in Conservation*, London, International Institute for Conservation of Historic and Artistic Works, 29–33.

de la Rie, E R, 1987, 'The Influence of Varnishes on the Appearance of Paintings', *Studies in Conservation* 32, 1–13.

de la Rie, E R, 1988, 'Photochemical and Thermal Degradation of Films of Dammar Resin', *Studies in Conservation* 33, 53–70.

de la Rie, E R and McGlinchey, Ch.W, 1990, 'New synthetic resins for picture varnishes' in Mills, J S and Smith, P (eds.), *Cleaning, Retouching and Coatings*, London, International Institute for Conservation of Historic and Artistic Works, 168–173.

de la Rie, E R, 1993, 'Polymer additives for synthetic low-molecular-weight varnishes' in Bridgland, J (ed.), *Preprints of the 10th Triennial Meeting of the ICOM Committee for Conservation*, Washington, D.C., International Council of Museums, 566–573.

de la Rie, E R, Quillen Lomax, S, Palmer, M, Deming Glinsman, L and Maines, C A, 2000, 'An investigation of the photochemical stability of urea-aldehyde resin retouching paints: removability tests and colour spectroscopy' in Roy, A and Smith, P (eds.), *Tradition and Innovation: Advances in Conservation*, London, International Institute for Conservation of Historic and Artistic Works, 51–59.

Stange, R, 1996, 'Butyraldehyde resin: a unique resin for lowering VOC and improving film properties' in *Proceedings of the Waterborne, Higher-Solids, and Powder Coatings Symposium*, New Orleans, University of Southern Mississippi, 354–362.

Materials

Laropal® A 81 and Laropal® A 101, BASF Corporation Coatings & Colorants Division, 4330 Chesapeake Drive, Charlotte, North Carolina 28216, U.S.A., (704) 392-4313.

Shell Sol 340HT (99.6% aliphatic hydrocarbon, 0.4% aromatic), Shell TS28 (25% aliphatic, 75% aromatic), Shell Chemical Company, PO Box 2463, Houston, Texas 77252-2463, U.S.A., (800) 872-7435.

Tinuvin® 292, Ciba Specialty Chemicals Corp., 540 White Plains Road, P.O. Box 2005 Tarrytown, New York 10591-9005, U.S.A., (914) 785-2000.

Durability of an epoxy resin employed in restoration of historical buildings

Abstract

Fibre-reinforced composites based on epoxy resins with fibres are used in such restoration, for example in the recent restoration of the Basilica di S. Francesco in Assisi, Italy. In the study presented, the epoxy resin (Epojet), which was used as matrix in the composite, was analyzed with regard to its durability under different environmental conditions. Thermal, spectroscopic and mechanical properties have been evaluated on samples aged, after curing, in different environmental conditions. The comparison between the properties of the cured resin, calculated before and after exposure to levels of humidity, temperature and water above the ordinary values, provided information on the durability of these products under severe conditions. In particular, it was found that thermal treatments lead to an increase in glass transition temperature and to a strengthening of the system, that the exposition to moisture or water reduced Tg (final glass transition temperature) and that the effects of thermohygrometric treatments are even more complex.

Keywords

epoxy resin, restoration, durability, environmental conditions

M. Frigione[*]
Dip. Ingegneria dell'Innovazione
Università di Lecce, Via per Arnesano
73100 Lecce (Italy)
Fax: (+39) 0832320341
E-mail: mariaenrica.frigione@unile.it

M. Lettieri, A.M. Mecchi
C.N.R. – Is.C.O.M.
Lecce (Italy)

U. Santamaria
Istituto Centrale per il Restauro
Roma (Italy)

Introduction

Fibre-reinforced composites based on resins are increasingly used in civil engineering restoration. Recently, they have also been employed to solve structural problems in the conservation of historic monuments. One such case was the restoration of the Basilica of St. Francesco of Assisi (Umbria, Italy). In order to secure the vaulted ceilings, in fact, fibre-reinforced composites have been employed using an epoxy resin (Epojet), either as the matrix of the composite and the adhesive to joint the composite to the vaults (Capponi et al.1999).

Starting from this experience, the ICR (Rome), the Faculty of Engineering of Lecce University and the CNR-ISCOM (Lecce) felt the need to broaden their knowledge about the durability of these materials. While the physical properties of such materials employed in the restoration and conservation have already been extensively studied by other researchers (Kotlik et al. 1983, Laurenzi Tabasso 1992, Mays and Hutchinson 1992, Riviere 1992, Selwitz 1992, Ginell et al. 1995), little is known about the durability of these materials, especially when they are subjected to critical environmental conditions (Frigione and Acierno 2000).

The first step in the study of durability of the fibre-reinforced composite has been the characterization of its matrix. In the present paper we present the first results on the curing and the aging characteristics of the epoxy resin used in the restoration of the Basilica of St. Francesco of Assisi, focusing on its durability.

The material under study is employed in indoor environments and, therefore, is mainly subject to variations in humidity and temperature and to their combinations. For this reason, in this work we took into account the effects due to these two environmental agents only, neglecting those produced by solar radiation, pollution and similar agents. To this aim, its thermal, mechanical and chemical properties were determined through different techniques (DSC, flexural tests and FTIR) before and after immersion in water, thermohygrometric cycles, exposure to different levels of humidity and temperature.

Experimental

Material

The Epojet epoxy system consists of diglycidylether of bisphenol-A and polyethylenamine – xylenediamine – nonylphenol hardener. The base resin and the hardener were mixed using the recommended ratio, i.e. resin:hardener = 4:1.

[*]Author to whom correspondence should be addressed

In order to obtain specimens to test with standard dimensions ($90 \times 10 \times 4$ mm), the mix was poured into Teflon moulds. After 26 hours the samples were removed from the moulds. All the samples were prepared and cured under controlled conditions of temperature and humidity (T = $23 \pm 2°C$ and RH = $50 \pm 5\%$).

Suppliers suggest curing times of seven days. However, the proceeding, and the completion of curing process, was monitored through thermal and spectroscopic analysis performed between one day of curing and two years.

Treatments

Samples of cured epoxy resin that have reached a constant value of Tg (final glass transition temperature), corresponding to samples cured for four months (see below), were subjected to different thermal, hygrometric, thermohygrometric treatments and to tests of water absorption/desorption. This procedure allowed us to examine the effects of these environmental agents both in isolation and in combination.

Thermal treatments: Samples of resin were kept in an oven at 50°C for different time spans, from two to 28 days. The temperature chosen for the thermal treatments was slightly lower than the Tg determined on the system cured at 23°C for four months, which is about 55°C.

Hygrometric treatments: Samples of resin were kept at constant temperature ($23°C \pm 2°C$) at three different controlled humidity levels: some samples were kept at 55% RH for 28 days; some samples at 75% RH for 28 days; other samples at 98% RH for 10 and 28 days.

Thermohygrometric treatment: Samples of resin were subjected to thermohygrometic treatments carried out in a climatic chamber (Mod. UY 600, ACS Angelantoni Climatic Systems). Two thermohygrometric treatments, consisting of 10 or 30 cycles, were performed. Each cycle was performed in accordance with the following plan:

- 2 hours at 23°C and 50% RH
- 1 hour to change the conditions
- 22 hours at 45°C and 90% RH
- 1 hour to restore initial conditions.

Water absorption/desorption: Untreated samples and samples subjected to 10 and to 30 thermohygrometric cycles were immersed in distilled water at 23°C. The samples were periodically removed from water, wiped with a dry cloth and weighed, in order to calculate the percentage water absorption. After saturation was achieved, the samples were placed in a desiccator with silica gel and weighed periodically to determine the water loss by evaporation. The weights reported are the mean of measurements performed on five samples. Before the immersion the samples were dried in oven at 48°C, until constant weight was reached (i.e. for five to seven days).

Techniques

The properties of untreated and aged samples of resin were analyzed using the following techniques:

- differential scanning calorimetry (DSC), using a DSC-7 Perkin Elmer calorimeter, performing the thermal scans between 5°C and 130°C and with a heating rate of 10°C/min, under nitrogen atmosphere
- FTIR spectroscopy, using a Nexus ThermoNicolet spectrometer, collecting the spectra in reflectance mode in the range 4000-400 cm^{-1}, with a resolution of 4 cm^{-1} and 128 scans for each measurement
- weight variations, determined using an analytical balance
- mechanical tests in three points bending, using a Lloyd LR–MK4 Dynamometer, with a crosshead rate of 2 mm/min and a support span of 60 mm, following the ASTM D 790-92 standard.

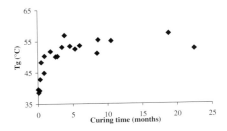

Figure 1. Glass transition temperature (Tg) values, measured on untreated samples, versus curing times

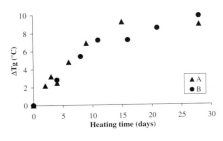

Figure 2. Variations of glass transition temperature (ΔTg) of samples kept in oven at 50°C, with respect to values calculated on untreated samples, versus heating times. A, B: samples (belonging to two different preparations) cured for 8 months and 18 months, respectively, before the thermal treatment.

All experiments were carried out on three samples at least and the results were averaged. In all experiments, the resin samples were stored in a climatized environment at 23°C ± 2°C and 50% RH, unless specified.

Results and discussion

Untreated samples

In Figure 1 the mean values of Tg are shown at different times after preparation of the resins.

The results indicate that, for the levelling off of the Tg of the resin, corresponding to the completion of the curing process, curing times higher than those suggested by suppliers are requested, i.e. four months. The Tg calculated on samples cured for seven days (≈39°C), in fact, are much lower than those found for samples cured for four months (≈55°C). The low Tg reached after few days of curing could be further decreased if water or humidity is present, as verified for samples cured at longer time (see later). The last effect is particularly worrying since the service temperature could approach and exceed the Tg of the resin, causing its change from a rigid, glass-like state to an elastomeric-like state, with a consequently dramatic decrease in mechanical and adhesive properties.

Similar FTIR spectra have been obtained by performing the analysis on untreated samples cured for different times (up to seven months).

The mechanical tests performed on samples cured for five months produced the following results: flexural modulus = 3.5 GPa, maximum flexural strength = 95.0 MPa, and strain at break = 2.7%.

Thermal effects

In Figure 2 the variations of Tg (ΔTg) of resin kept in an oven at 50°C for different times, with respect to values calculated on untreated samples, are shown.

The thermal treatment at 50°C produces an increase in Tg, higher by increasing the time of heating. The samples analyzed belong to two different preparations (A and B) and are characterized by different curing times. However, they present similar results. This is not surprising since, although after curing times of four months the Tg of the resin reaches a constant value, the resin system may not be fully cross-linked. The curing temperature (around 23°C) is about 30°C lower than the final Tg of system and any further cross-linking reaction may be slowed by kinetic restraints (Ellis 1993). Hence, if the resin is heated at a temperature higher than the ambient temperature, i.e., 50°C, but still lower than its Tg, a post-curing process takes place. In this condition the cross-linking reactions start anew and the Tg increases by increasing the post-curing time. After 28 days at 50°C the increase in Tg is about 9°C.

By comparing the FTIR spectra of untreated and treated samples (50°C for 28 days), a shift or reduction of some characteristic peaks, which indicate a higher cross-linked structure, is detected: C=C stretching band at around 1600 cm^{-1}, C-O and C-O-C stretching bands on the 1100–800 cm^{-1} wavenumber interval. The results of the infrared analysis supported the thermal results, i.e. the increased cross-linking taking place in the resin subjected to thermal treatments.

The results of mechanical tests performed on samples kept in oven at 50°C for 10 and 28 days are reported in Table 1 and compared with those found for untreated samples. It can be observed that the thermal treatment results in an increase in strength, due to the increased cross-linking; an increase in ultimate

Table 1. Thermal and mechanical characteristics measured on untreated samples and on samples subjected to thermal treatment. Tg = glass transition temperature; E = flexural modulus; σ_y = strength at yield; ε_b = strain at break. For each data set the maximum deviation is reported

Heating time (days)	Tg (°C)	E (GPa)	σ_y (MPa)	ε_b (%)
0	56.9 ± 0.4	3.48 ± 0.67	95.0 ± 19.9	2.65 ± 0.32
10	63.8 ± 0.5	2.75 ± 0.25	123.7 ± 20.6	5.58 ± 2.29
28	65.8 ± 0.5	2.83 ± 0.58	125.0 ± 20.3	6.67 ± 3.22

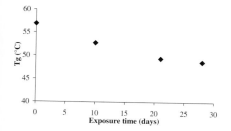

Figure 3. Glass transition temperature (Tg) values, measured on samples kept at 98% R.H., versus exposure times

strain and a decrease in flexural modulus. The decrease in flexural modulus as a consequence of post-curing process has also been reported by other researchers (Ellis 1993).

Effects of humidity

In Figure 3 the mean values of Tg of samples exposed to 98% RH are reported as a function of exposure times. The presence of humidity results in an expected decrease in Tg, increasing this effect by increasing the exposure times (Zhou and Lucas 1999b, Ivanova et al. 2000). The decrease in Tg, however, does not exceed 9°C, even for samples kept for 28 days at 98% RH. A decrease in Tg of the adhesive resin could again be particularly harmful when the service temperature approaches the Tg of the resin.

Samples exposed to lower values of RH, i.e. 55% and 75%, show almost negligible decrease of the initial Tg, even after 28 days.

Effects of thermohygrometric treatments

In Tables 2 and 3 the thermal and mechanical characteristics measured on samples subjected to thermohygrometric treatments, are reported. The thermal and mechanical tests have been performed immediately after the end of any treatment and after different times from the end of any treatment.

The simultaneous exposure of samples to a temperature of 50°C and 90% RH should produce an increase in Tg, due to the completion of cross-linking reactions, but also a reduction, due to plasticization/hydrolysis effects. The observed effect of thermohygrometric treatment is an increase in Tg lower than that expected if the two effects, thermal and hygrometric, were additive. The Tg, however, increases by repeating the measurements after one month from the end of any cycle and this tends to reduce the differences in additive effects. Later, however, the Tg of the samples remains almost constant. The result suggests that the adsorbed water partially evaporates from the resin, which is kept at a controlled humidity level, causing a new increase in Tg.

Table 2. Thermal and mechanical characteristics measured on untreated samples and on samples subjected to thermohygrometric treatment (10 cycles). Tg = glass transition temperature; E = flexural modulus; σ_y = strength at yield; ε_b = strain at break. For each data set the maximum deviation is reported

	Tg (°C)	E (GPa)	σ_y (MPa)	ε_b (%)
Before cycles	56.9 ± 0.4	3.48 ± 0.67	95.0 ± 19.9	2.65 ± 0.32
Immediately after the end of cycles	59.2 ± 0.7	3.25 ± 0.33	136.9 ± 12.2	9.08 ± 1.33
1 month from the end of cycles	61.5 ± 0.9	–	–	–
3 months from the end of cycles	60.7 ± 0.9	–	–	–
4,5 months from the end of cycles	60.3 ± 1.0	2.99 ± 0.20	108.8 ± 14.3	4.81 ± 3.63

Table 3. Thermal and mechanical characteristics measured on untreated samples and on samples subjected to thermohygrometric treatment (30 cycles). Tg = glass transition temperature; E = flexural modulus; σ_y = strength at yield; ε_b = strain at break. For each data set the maximum deviation is reported

	Tg (°C)	E (GPa)	σ_y (MPa)	ε_b (%)
Before cycles	56.9 ± 0.4	3.48 ± 0.67	95.0 ± 19.9	2.65 ± 0.32
Immediately after the end of cycles	58.0 ± 0.8	2.96 ± 0.17	123.6 ± 3.14	8.28 ± 1.83
1 month from the end of cycles	61.3 ± 0.5	–	–	–
3 months from the end of cycles	62.3 ± 0.4	–	–	–
4 months from the end of cycles	61.2 ± 0.9	2.86 ± 0.12	112.5 ± 5.37	3.85 ± 0.29

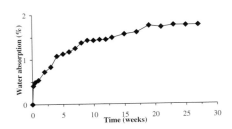

Figure 4. Water absorption versus time for untreated samples

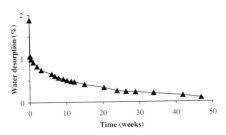

Figure 5. Water desorption versus time for untreated samples

The mechanical properties seem to be mainly influenced by the thermal treatment, being similar to those measured on samples exposed only to temperature. Further investigations are in progress to analyze the single effect of humidity on mechanical behaviour.

FTIR analysis has been performed on samples subjected to cycles, both on the surface and inside any sample (about 2 mm from the surface). The comparison between the spectra taken on surface and inside any sample showed significant differences. A peak at 936 cm^{-1}, i.e. in the region of C-O-C stretching bands, has been observed only in the spectrum performed on surface of samples. It indicates different levels of cross-linking in the two zones. Moreover, the band of hydroxyl groups is shifted to higher wavenumbers (3700 cm^{-1} instead of 3500 cm^{-1}) in the inner part of the sample. These results indicate that the thermohygrometric treatment produced different effects on the surface and inside the samples, having a higher cross-linking degree in the internal part of any sample.

A peak characteristic of the carbonyl group at 1685 cm^{-1} is observed in both spectra. The presence of carbonyl groups may indicate degradation in epoxy resins, as observed by other researchers (Xiao and Shanahan 1998). The structural changes are probably induced by interactions between water and the resin, since the carbonyl groups have not been detected on the samples cured for four months and on samples post-cured at 50°C for prolonged times.

Effects of water absorption/desorption

In Figure 4 the quantity of water absorbed over time, up to 27 weeks, for untreated samples, is reported. In Figure 5 the amounts of water subsequently evaporated over time for the same samples, are shown.

Water saturation has been reached after 23 weeks of immersion. The samples subsequently evaporated have not reached the initial weight, even after long-time desorption (i.e. 47 weeks), indicating the presence of a fraction of sorbed water that cannot be removed. This phenomenon is not unfamiliar and is reported in literature (Zhou and Lucas 1999a). The initial absorption rate is lower than the initial desorption rate. The immersion of samples in water until saturation determines a decrease in Tg of about 8°C, with the undesirable effects due to external thermal variations already mentioned. Similar results have also been found for samples subjected to different thermohygrometric treatments.

Conclusions

From an examination of results the following conclusions can be drawn.

The curing time suggested by the suppliers is not sufficient to reach the full cross-linking of the epoxy resin at room temperature (≈23°C), as the thermal and chemical analyses performed on the resin during its curing process have shown.

Exposure to temperature and water (in liquid or vapour state) affects the thermal, mechanical and chemical properties of the adhesive resin.

The exposure to a temperature higher than the ordinary ambient temperature, but still lower than the Tg of the cured system, produces the completion of the cross-linking reactions that have not taken place at room temperature, with a consequent increase in Tg. The increased cross-linking density is also confirmed by infrared spectroscopy. The influence of thermal treatment on mechanical behaviour is less appreciable on flexural modulus and it produces a strengthening of the system.

The presence of water or humid atmosphere produces a general decrease in the initial Tg of the resin samples.

The studies performed on samples subjected simultaneously to thermal and hygrometric ambient, if compared to those performed on the resins exposed to any single environmental agent, showed interesting features. The simultaneous exposure of samples to a temperature of 50°C and 90% RH should produce an increase in Tg, due to the completion of cross-linking reactions, but also a reduction, due to plasticization effects. Conversely, after any cycle treatment, an increase in Tg lower than that expected if the two effects, thermal and hygrometric, were additive, has been observed. The Tg, however, increases by repeating the measurements after one month from the end of any cycle and this tends to reduce

the differences in additive effects. This result has been explained by the partial removal of the absorbed water.

The results obtained from infrared analysis showed that the exposure to elevated humidity at elevated temperature tend to induce degradation in epoxy system.

From this study it can be concluded that thermal and spectroscopic analyses are more sensitive to structural variations of the resin induced by environmental treatments, while mechanical properties are less affected by these factors. However, the mechanical performance of the resin is of invaluable importance for the effectiveness of the fibre-reinforced composite, having the epoxy resin as matrix. For this reason, further studies are in progress to analyze in detail the relationship between mechanical properties and structural modifications of the resin, also when exposed to more severe environments.

It must be emphasized that the behaviour observed for the particular epoxy adhesive analyzed can be assumed as characteristic for any cold-curing bisphenolic epoxy based adhesive.

Finally, the results of durability studies will give invaluable information on the effectiveness of any repairing or restoration application that involves the use of epoxy resins.

References

ASTM D 790-92, Standard Test Methods for Flexural Properties of Unreinforced and Reinforced Plastics and Electrical Insulating Materials.

Capponi, G, D'Angelo, C, Santamaria, U, Massa, S, Omarini, S and Filacchioni, G, 1999, I materiali compositi fibrorinforzati per il consolidamento delle volte della Basilica Superiore di San Francesco. Verifica delle caratteristiche chimiche, chimico-fisiche, fisico-meccaniche e della durabilità. La Basilica di S, Francesco in Assisi, Quaderno n° 8, Roma: Istituto Centrale per il Restauro, 33–35.

Ellis, B, 1993, 'Chemistry and Technology of Epoxy Resins' in B Ellis (ed.), London, Blackie Academic & Professional, Chap. 3.

Frigione, M and Acierno, D, 2000, 'Adesivi per l'Edilizia: Durabilità', L'Edilizia, No, 7–8, 36–43.

Ginell, W S, Kotlik, P, Selwitz, C M and Wheeler, G S, 1995, 'Recent developments in the use of epoxy resins for stone consolidation. Materials issues in art and archaeology IV' in P B Vandiver et al. (eds.), Pittsburgh, Materials Research Society, 823–829.

Ivanova, K I, Pethrick, R A and Affrossman, S, 2000, 'Investigation of hydrothermal ageing of a filled rubber toughened epoxy resin using dynamic mechanical thermal analysis and dielectric spectroscopy', Polymer 41, 6787–6796.

Kotlik, P, Justa, P and Zelinger, J, 1983, 'The application of epoxy resins for the consolidation of porous stone', Studies in Conservation 28, 75–79.

Laurenzi Tabasso, M, 1992, 'In Construction & Rehabilitation', Colloque Europeen (Lyon, September 8–10), 13 (Complements Discussions).

Mays, G C and Hutchinson, A R, 1992, Adhesives in Civil Engineering, Cambridge University Press.

Riviere, J, 1992, 'In Construction & Rehabilitation', Colloque Europeen (Lyon, September 8-10), 7–17.

Selwitz, C, 1992, 'Epoxy resins in stone conservation', Research in Conservation, vol. 7, Los Angeles, Getty Conservation Institute.

Xiao, G Z and Shanahan, M E R, 1998, 'Irreversible effects of hygrothermal aging on DGEBA/ DDA epoxy resin', Journal of applied polymer science, Vol. 69, Issue 2, 363–369.

Zhou, J and Lucas, J P, 1999a, 'Hygrothermal effects of epoxy resin, Part I: the nature of water in epoxy', Polymer 40, 5505–5512.

Zhou, J and Lucas, J P, 1999b, 'Hygrothermal effects of epoxy resin, Part I: the nature of water in epoxy', Polymer 40, 5513-5522.

Materials

Epojet Component A (diglycidylether of bisphenol-A), Epojet Component B, (polyethylenamine – xylenediamine – nonylphenol), Mapei S.p.A., Via Cafiero, 22 - 20158 Milano, Italy, Tel: (+39)0237673.1, www.mapei.it

Possibilities for removing epoxy resins with lasers

Stefanie Scheerer,★ Meg Abraham, Odile Madden
Los Angeles County Museum of Art
5905 Wilshire Blvd.
Los Angeles, California 90036, U.S.A.
Fax: + 1 (323) 857-4754
E-mail: stefscheerer@yahoo.de, mabraham@lacma.org, omadden@earthlink.net

Abstract

Studies on the effects of Nd:YAG laser energy, at three wavelengths (1064 nm, 532 nm, and 355 nm) and Er:YAG laser energy at 2940 nm, on pure epoxy resins and epoxies with fillers were performed. The tests investigated possibilities for using lasers to remove epoxy resins from art objects. Two epoxy resins, Hxtal NYL-1 and Araldite AY103 with hardener HY991, were prepared as pure films as well as in mixtures with chalk, titanium dioxide pigment, glass microballoons and charcoal. These materials were applied to different stone, ceramic and glass substrates. The tests have shown that all tested wavelengths of laser light had effects on the epoxy resins. These effects were visible primarily as discolorations and etched surfaces. Different laser wavelengths induced different physical and chemical alterations to the epoxy resins. This is probably due to subtle changes in the cleaning mechanisms induced by exposure to longer or shorter wavelengths of light. In addition to the laser wavelength, each component, the epoxy resin and the filler, influenced the laser-induced reaction.

Keywords

laser, epoxy resin, fillers, stone, ceramic, glass, Nd:YAG, Er:YAG

Introduction

Reversibility is one of the major criteria for choosing a conservation material. Nevertheless, many conservation treatments are not easily reversed. Epoxy resins are commonly used conservation materials that can be difficult to remove from an artefact. Conservation literature cites the use of noxious solvents including dimethylformamide, chloroform and methylene chloride for removing epoxy resins (von Derschau and Unger 1998). These solvents can usually only swell epoxy resins. Mechanical treatment is necessary to further remove the softened polymers. Often these solvents must be applied for a long period of time. Soaking of the entire artefact may also be recommended.

Lasers have been used previously for the ablation of surface films such as varnish layers. Their use in conservation has been well established during the past 30 years, particularly as a cleaning tool for architectural elements. However, their application on a variety of other materials is becoming more and more common (Proceedings of the International Conference LACONA IV).

Hxtal NYL-1 and Araldite AY103 with hardener HY991, both epoxy resins that are used in conservation for glass, ceramics and stone, were selected for the study. The type of Araldite was chosen for its slightly yellow colour. It was hypothesized that yellow epoxy resins may react differently to the laser due to their tendency to absorb more light than clear films such as Hxtal NYL-1. Charcoal, titanium white, chalk and glass microballoons were selected as fillers for the tests, based on their use in epoxy systems for conservation and their different colours (Griswold and Uricheck 1998).

Samples

Hxtal NYL-1 and Araldite AY103 / HY991, both pure and in systems with fillers, were applied on marble, sandstone, granite, terracotta and glass microscope slides. The fillers were charcoal (beech charcoal, Kremer 47800), titanium white (titanium white rutile, Kremer 46200), chalk (from Champagne, Kremer 58000) and glass microballoons (409 microspheres).

To better understand whether the observed alterations of the epoxy systems are due to a reaction of the fillers or the epoxy resins, samples of unbound fillers were prepared as well. The fillers were mounted between glass slides and exposed to laser radiation through the cover glass.

Equipment

Testing was done with two different laser systems, a Nd:YAG laser and an Er:YAG laser.

The Infinity Q-switched Nd:YAG laser had a pulse duration of 3 nanoseconds and, in its current configuration, could be operated in the first harmonic (1064 nm, near infrared), second harmonic (532 nm, visible) and third harmonic (355 nm,

★Author to whom correspondence should be addressed

Figure 1. Araldite AY103 / HY991 and Hxtal NYL-1irradiated with 2940nm laser light, treated with solvents

Table 1. Colour of laser irradiated Araldite AY103 / HY991 and Hxtal NYL-1

	355 nm	532 nm	1064 nm	2940 nm
Araldite	yellow	brown	brown	dark brown
Hxtal	brown	slightly grey	slightly grey	dark brown

ultraviolet). The tests were performed with energies between 50 mJ and 100 mJ with a round spot diameter of 5 mm and a repetition rate of 3 Hz.

The Conservator®, an Er:YAG laser, emitted light in the mid–infrared range at 2940 nm. Its 200 μs pulse duration was more than 60,000 times longer than that of the Nd:YAG laser. Tests with the Er:YAG laser were done at energies between 50 and 100 mJ with a spot size of 3 mm unless otherwise noted. The laser was operated at its fastest pulse rate of 15 Hz in order to obtain maximum energy levels.

Results and discussion

Pure epoxy resin films

Laser exposure of the pure epoxy resin films showed that the Nd:YAG laser in all three different wavelengths (1064 nm, 532 nm, 355 nm) induced more noticeable reactions in the Araldite AY103 / HY991 samples than in the Hxtal NYL-1 samples. Particularly in the infrared (1064 nm) and visible (532 nm), high fluences were needed to show initial reactions in the Hxtal NYL-1 sample. However, the UV wavelength (355 nm) discoloured and ablated the Hxtal NYL-1 sample at much lower fluences. Comparable fluences in the UV on the Araldite AY103 / HY991 sample resulted in a greater degree of darkening and ablation than for Hxtal NYL-1 samples, and initial reactions started at much lower energies.

Even though varying degrees of surface etching were observed with all three wavelengths, entire removal of the epoxy resin films could not be achieved with the Nd:YAG laser.

Radiation emitted by the Er:YAG laser at 2940 nm darkened and ablated both epoxy resins. During exposure to high laser energy at 2940 nm, which developed heat in the irradiated material, both epoxy resins lowered their viscosity to a degree, and material flow occurred. Both epoxy resins discoloured to a dark brown. The Hxtal NYL-1 sample retained a lower viscosity after exposure.

Interestingly, areas of epoxy resin irradiated with 2940 nm laser light became more soluble in some organic solvents (Figure 1). The darkened material of both epoxy resins could be removed easily with cotton swabs wetted with acetone. Ethanol dissolved both epoxy resins partially. Darkened Hxtal NYL-1 was soluble in xylene. However, darkened Araldite AY103/HY991 was hardly soluble in xylene. Neither was soluble in petroleum benzine or water.

Figure 2. Hxtal NYL-1 on sandstone irradiated by different laser wavelengths with and without acetone

Residues of almost entirely ablated epoxy resin films on smooth surfaces were cleaned off with acetone. Porous surfaces, however, were more difficult substrates from which to remove the epoxy resin. Major factors for these difficulties were as follows. First, adhesion of surface films are generally stronger to surfaces with uneven topographies; second, soot that developed during laser exposure deposited itself in recessed areas of the surface; and finally, parts of the epoxy resin had penetrated into the porous surface.

Materials that have penetrated into substrates can be problematic to remove using traditional conservation methods as well as lasers. Satisfactory results of laser removal of epoxy resins from porous surfaces were only achieved in the case of Hxtal NYL-1 on sandstone, employing 2940 nm laser light at maximum energy (100 mJ with a 1 mm spot diameter) in combination with acetone (Figure 2). In all other cases, only surface films and possibly small quantities of the penetrated epoxy resin could be removed from porous surfaces, but the deeper penetrated resin remained. Stains caused by penetrated epoxy resins, other than Hxtal NYL-1 on sandstone, could not be successfully removed.

Thick epoxy resin films absorbed sufficient energy at 2940 nm that even laser sensitive substrates did not discolour beneath the material being removed. Materials that are rich in OH-bonds are known to absorb laser light at 2940 nm strongly (de Cruz et al. 2000). However, as ablation proceeded and the epoxy resin

Figure 3. Films of Araldite AY103 / HY991 and Hxtal NYL- irradiated by different laser wavelengths

film became thinner, laser energy was transmitted through the film and laser sensitive substrates underneath the film did discolour. Therefore, complete removal of epoxy resin films with 2940 nm from substrates that are sensitive to this wavelength was not possible using the laser alone. Nd:YAG laser light was transmitted through both epoxy resin films, even when thick.

The tests have shown that the Er:YAG laser achieved better results in removing these epoxy resins from any of the tested substrates, particularly when organic solvents were employed in addition. However, the Er:YAG laser seemed to develop considerably more heat to the touch than the Nd:YAG laser.

Different wavelengths of laser light induced different colours on the exposed areas of the epoxy resin films (Figure 3). Araldite AY103 / HY991 turned brown when exposed to mid-infrared (2940 nm), near infrared (1064 nm) and green (532 nm) laser light, whereas it turned bright yellow on exposure to UV (355 nm) laser light. Hxtal NYL-1, however, was only slightly affected visually by green and near infrared laser light, whereas UV and mid-infrared darkened it.

The FTIR spectra of the Hxtal NYL-1 samples after laser treatment correlated well to the visual observations. Laser light at 532 nm did not change the spectrum of the resin before and after exposure. Laser light at 2940 nm induced a slight degree of oxidation on the polymer chain, whereas UV laser light caused a much larger oxidation that affected different groups in the polymer and possibly involved some of the additives. Corresponding to the FTIR results, the 532 nm laser light did not discolour the material but rather resulted in an etched surface, which then reflected the light differently. However, areas exposed to laser light at 2940 nm and 355 nm, which FTIR results demonstrate to be oxidized, showed dark brown discolorations.

The FTIR spectra of Araldite AY103 / HY991 before and after exposure to different laser wavelengths also showed different alteration mechanisms depending on the wavelength. However, the differences could not yet be interpreted because of the complexity of the Araldite AY103 / HY991.

Epoxy resin systems with fillers

Figure 4 shows the effect of different laser wavelengths on the epoxy resins bulked with fillers.

EPOXY RESINS WITH TITANIUM WHITE

Titanium white systems with both epoxy resins discoloured to a dark grey immediately upon the first pulse of all three wavelengths of the Nd:YAG laser. The Er:YAG laser at 2940 nm did not cause any grey discolorations in the titanium white samples. Unbound titanium white powder does not discolour under the

Figure 4. Araldite AY103 / HY991 and Hxtal NYL-1 with fillers on glass irradiated by different laser wavelengths

Figure 5. Pure fillers irradiated by different laser wavelengths

Er:YAG laser, as demonstrated below. However, Er:YAG irradiated epoxy systems with titanium white showed a brown discoloration. The same discoloration was observed for unbulked epoxy resins irradiated with this wavelength.

EPOXY RESINS WITH CHARCOAL

Charcoal systems reacted more heavily in the beginning of the exposure and tended to decrease their reaction as the sample lightened in colour. All wavelengths could ablate these systems at least partially from all tested substrates. The most successful removal was achieved with the Er:YAG laser at 2940 nm in combination with acetone.

EPOXY RESINS WITH CHALK

The alterations of the Araldite AY103 / HY991 mixed with chalk were very similar to those of the pure Araldite AY103 / HY991 without filler. Hxtal NYL–1 irradiated by all wavelengths of the Nd:YAG laser reacted more when mixed with chalk than unbulked.

EPOXY RESINS WITH GLASS MICROBALLOONS

Epoxy systems with glass microballoon fillers were the least reactive of all bulked samples. As previously observed, the Araldite AY103 / HY991 with microballoons reacted similarly to the pure epoxy resins without filler. Hxtal NYL–1 reacted more strongly when mixed with microballoons than when unbulked. Ablation with the Nd:YAG laser was difficult and often only possible after long exposure time.

Epoxy systems bulked with titanium white and carbon black tended to react much more strongly than systems with chalk and glass microballoons or the pure epoxy films. Indicative of this was the fact that the former produced a loud acoustic sound wave and a large plasma plume, both of which increased upon higher laser energy. At the same fluences the degree of ablation was higher for these more reactive systems.

The tests have shown that additives to an epoxy resin can influence its behaviour upon laser radiation. For example, pure Hxtal NYL–1 transmitted almost all the laser energy at 532 nm (visible) and 1064 nm (NIR). However, when mixed with a filler, the bulked epoxy became more absorbent and exhibited reactions including discoloration and surface etching. The most sensitive component of a system seemed to determine the nature of the reaction.

Pure fillers

The effect of laser light at different wavelengths on pure fillers can be seen in Figure 5.

TITANIUM WHITE

Titanium white discoloured to a dark grey alteration product immediately upon the first pulse of all three wavelengths of the Nd:YAG laser at the lowest tested energy. Laser energy at 2940 nm did not discolour the sample even at maximum energy, which was 77 mJ behind the cover glass at a 1 mm spot diameter. The nature of the alteration product remained unclear. X-ray diffraction analysis, which was performed on an unaltered titanium white sample as well as on the grey alteration product, did not show any differences in their spectra.

CHARCOAL

Charcoal exhibited a strong colour shift to light grey early in the exposure time, while the colour change became slower at longer irradiation times. This fact was most observable by a decreasing acoustic sound wave and plasma plume.

CHALK

The chalk sample showed slight colour changes at high energy levels. Most likely these alterations are due to a rearrangement of the chalk particles, which reflected the light differently. During laser exposure a movement of the particles was observed, which increased with higher energies. Particle movement was observed on all other mounted fillers as well.

Figure 6. Terracotta and sandstone irradiated by different laser wavelengths

Figure 7. Hxtal NYL-1 and charcoal on porous and polished marble surfaces removed with 2940 nm laser light employing acetone

GLASS MICROBALLOONS

Glass microballoons did not show any signs of discoloration with any of the tested laser wavelengths. However, exposure of the microballoons was particularly difficult because the small glass spheres could not be mounted with sufficient pressure to prevent particle movement. Pulses of high laser energy immediately forced the microballoons out of the focus of the laser beam.

All samples of loose fillers were shifted between the glass slides by laser energy. The degree of particle movement corresponded with the loudness of the acoustic sound wave produced during laser exposure. This shock wave may transfer physical stress into the artefact. The lack of surface contact, 'allowing extremely fragile surfaces to be worked on' (Cooper 1998), is one of the often mentioned advantages of lasers over more traditional conservation methods. In the case of lasers, the energy is delivered as light and not as the kinetic energy of a scalpel. However, these experiments show that light energy can also place physical stress on an artefact due to the shock wave formed during the expansion of heated gasses and during plasma formation. The later often occurs regardless of the wavelength of the laser.

The substrates

It is important to note that all tests were done on modern substrates in good condition. For these tests the substrates were irradiated without epoxy resin films on their surface.

Of the substrates tested, only the marble sample exhibited surface ablation. The sample was damaged by the 355 nm and 532 nm wavelength. Glass, marble and granite did not discolour under any of the tested laser wavelengths. However, irradiated sandstone and terracotta showed discolorations.

The colours of the irradiated areas varied with different laser wavelengths (Figure 6). Sandstone discoloured upon exposure to the Nd:YAG laser to a dark grey in the near infrared, a lighter grey in the UV, and a light greyish blue in the visible. The Er:YAG laser did not discolour the sandstone. The most sensitive substrate was terracotta, which discoloured upon exposure to all of the tested wavelengths. The colours of the irradiated areas varied from a dark grey to a greyish green. However, other research groups have not observed discolorations on terracotta samples using Nd:YAG laser at 1064 nm (Cooper and Sportun 2001).

Laser sensitive substrates also discoloured upon radiation transmitted through a film of epoxy resin on their surfaces. The amount of energy transmitted through the surface film depended on the thickness of the film and on the wavelength of the laser light. This shows that the laser energy can at least partially penetrate the epoxy resin film and interact with the substrate underneath.

Conclusions

The study has shown that all tested wavelengths of laser light had the potential to induce visible alterations to epoxy resins with and without fillers. The observed alterations were primarily visible as discolorations and etched surfaces. Different laser wavelengths induced different physical and chemical alterations to the epoxy resins. A careful selection of the laser wavelength may in some cases enhance the desired results on epoxy resins, epoxy systems and the substrates.

In addition to the laser wavelength, each component of the material irradiated influenced the laser-induced reaction. Additives to the epoxies changed the behaviour of the sample upon laser radiation. It seemed that the most sensitive component determined the reaction of the irradiated system.

The colour of the material to be irradiated may influence the reaction, detected as a plasma plume, acoustic sound wave and/or ablation. Yellow films of Araldite AY103/HY991 tended to react more upon laser exposure than did clear Hxtal NYL-1 films. Dark materials that bleached during laser exposure decreased their reaction during the colour change. Correspondingly, light-coloured materials increased their reactions as darkening occurred.

Some degree of ablation was possible on all samples with all tested wavelengths. However, the energy needed was sometimes higher than the damage threshold of the substrate. All three wavelengths of the Nd:YAG laser discoloured an area of the

epoxy resin surrounding the ablated material. Therefore, selected removal of epoxy resin would be difficult to perform at a satisfactory level without discoloration of nearby areas. Laser light at 2940 nm, emitted by the Er:YAG laser, particularly in combination with organic solvents, gave the most promising results for the removal of epoxy films from all tested surfaces.

Areas where the epoxy resins had penetrated into the surface of the substrates were harder to ablate than surface films. Excess material on the surface of partially penetrated epoxy resins could usually be removed or lifted from the surface, however, the penetrated portions tended to remain in the substrate (Figure 7). Stains due to the epoxy resin's penetration could therefore not be reversed easily.

Laser energy may induce chemical reactions in epoxy resins. Long-term effects of irradiated epoxy resins to an artefact are unknown.

A factor that needs to be taken into account when considering the use of this Er:YAG laser for conservation is that, depending on the fluence, the exposure time and the character of the material irradiated, severe heat can develop on the object's surface. Heat sensitive objects may therefore not be possible candidates for laser treatment with high energy of the Er:YAG laser.

Particles of loose fillers mounted between glass slides moved during laser exposure. Consequently, we infer that there may be physical stress transferred into the artefact. If plasma formation and gas expansion are creating significant stresses, then the often mentioned advantage of lasers as a non-contact tool for extremely fragile surfaces becomes somewhat suspect.

Laser energy can penetrate through epoxy resin films at least partially and interact with the substrate. Caution must be exercised, especially if this material may potentially react negatively to laser irradiation.

Finally, when working with lasers, health and safety regulations must be followed. Eye protection must always be worn. Goggles may, depending on the wavelength they are supposed to absorb, be coloured. Coloured glasses are often considered disturbing by conservators and may decrease visual control of the cleaning process. However, they are necessary, without exceptions. Ablated materials may pose serious health risks to the conservator. Ablated materials must therefore be removed by a fume hood. If that cannot be provided, appropriate respirators must be worn by all persons involved.

Acknowledgements

Special thanks to Dr. Marco Leona, Conservation Science, LACMA; Jeffrey Maish, Eduardo Sanchez, Antiquities Conservation, J. Paul Getty Museum; Dr. David Scott, Museum Research Laboratory, Getty Conservation Institute; Adam Avila, Yosi R.-Pozeilov, Photo Documentation, LACMA; SEO Schwartz Electro Optics; National Center For Preservation Technology and Training (NCPTT); Kress Foundation; and the Andrew W. Mellon Foundation.

References

Cooper, M, 1998, *Laser Cleaning in Conservation. An Introduction*, Oxford, Butterworth-Heinemann.

Cooper, M and Sportun, S, 2001, personal communication.

de Cruz, A, Wolbarsht, M and Hauger, S, 2000, 'Laser Removal of Contaminants from Painted Surfaces', *Journal of Cultural Heritage* 1, 173–180.

Griswold, J and Uricheck, S, 1998, 'Loss Compensation Methods for Stone'. *JAIC* 37, 89–110.

'Proceedings of the International Conference LACONA IV: Lasers in the Conservation of Artworks IV, September 2001, Paris, France' in *Journal of Cultural Heritage, Supplement*, Elsevier Science, expected publication 2002.

von Derschau, D and Unger, A, 1998, 'Epoxidharz-Restaurierungen', *Zum Problem der Entfernung. Restauro* 7, 486–493.

Modern materials

Matériaux modernes

Materiales modernos

Modern materials

Coordinator: Thea van Oosten
Assistant Coordinator: Yvonne Shashoua

Five issues of the biannual *Modern Materials Newsletter* have been produced since January 2000 and have been sent to all members. The first three issues were mailed, but since nearly all members now have e-mail, the latest two were also e-mailed. Membership of the Working Group has grown from 140 to 238, but sad to say, not all are ICOM-CC members.

Several members of the Working Group participated in the book *Plastics, Collecting and Conserving*, edited by Anita Quye and Colin Williamson, and in *The Impact of Modern Paints* by Jo Crook and Tom Learner. Various members have also presented work at conferences about modern materials in London ('Reversibility: Does it Exist?') and Washington D.C. (ACS Meeting, 2000).

From March 12–14, 2001, an Interim Meeting was held in Cologne, Germany, organized in collaboration with the Fachhochschule Köln, Fachbereich Restaurierung und Konservierung von Kunst und Kulturgut. About 120 colleagues from around the world attended, and enjoyed interesting talks and had the opportunity to discuss problems and share their interest in modern materials. The history of plastics, the scientific research on modern materials, and the restoration of works of modern and contemporary art were represented. The conservation of PUR foams and case studies of pigments and paints in modern paintings were also included. University-level training in the conservation of modern art was reported from three countries: Germany, the Netherlands and Switzerland. Extended abstracts of 20 papers and two posters have been published in the preprints *Abstracts of the Interim Meeting Modern Materials Working Group* by the Fachhochschule, Cologne, Germany.

The Coordinator would like to thank Dr. Yvonne Shashoua of the National Museum of Denmark, for her assistance and support, and all members of the Working Group for their interest and enthusiasm.

Thea van Oosten

Abstract

The conservation programme developed for plastics and rubber items in collections at the National Cinema Museum in Torino is described. Constituents of set objects from classical science fiction movies have been identified using a diagnostic campaign based on pyrolysis gas chromatography mass spectrometry. Many of the plastics objects showed serious signs of degradation, soiling, loss of paint, discoloured repair materials, structural cracks and lacunae. A dramatic change of brilliant original colours was also observed. Appropriate procedure and materials were applied during restoration. Microclimate control was developed for the display cases; resulting data from one year are discussed. The entire collection, partially made of synthetic polymers, represents some of the most challenging work for conservators.

Keywords

cinema, museum, synthetic polymers, microclimate control

Analysis of materials, restoration practice, design and control of display conditions at the National Cinema Museum in Torino

Oscar Chiantore★, Dominique Scalarone
Department of IPM Chemistry
Università di Torino
Via Giuria 7
10125 Torino, Italy
Fax: +39 011 6707855
E-mail: oscar.chiantore@unito.it

Antonio Rava
Rava & C. Restauro Opere d'Arte
Torino, Italy

Marco Filippi, Anna Pellegrino
Building Physics and Indoor Environment Engineering Group
Politecnico di Torino
Torino, Italy

Donata Pesenti Campagnoni
Museo del Cinema
Torino, Italy

Introduction

The National Cinema Museum was founded in 1941 by Maria Adriana Prolo, an historian and researcher who collected films, photographs, posters, ancient apparatus for projection and shooting, and objects that document and highlight the history of cinema. The museum was officially established in 1958 in Palazzo Chiablese, an historical building of the town. In 1992 a foundation was created for its operation, and a new residence was found in a prestigious historical construction, the 167 m stone building called Mole Antonelliana, the symbol of Torino. Opened to the public on July 20, 2000, more than 500,000 visitors were counted in about one year.

The museum collections have international relevance; they include a film library with more than 7000 movies, a collection of 9000 objects, 125,000 photographic documents, 20,000 books and more than 200,000 posters and advertising material. The stimulating setting, designed by Swiss architect François Confino, involves a surface area exceeding 3000 m² with an exhibition course on five levels, exploiting the vertical structure of the Mole.

Among the objects are set materials employed in such movies as *Aliens, Gremlins, Jurassic Park, Star Wars, The Empire Strikes Back, Planet of the Apes, Robocop* and *Jaws*. At the upper level the Posters Gallery is entirely dedicated to one of the richest collections of the museum. The history of cinema is told by a fascinating journey back through time, starting with posters from the year 2000 and ending in the Golden Age of silent films.

During the extensive work to prepare the new museum setting, collections have passed through comprehensive checks and conservation procedures. Important interventions had to be planned, including characterization of the synthetic materials, restoration works and display organization for items of the large and relatively recent collection of materials coming from 'classic' science fiction movies.

Plastics and rubber items employed in the making of *Star Wars, Aliens, Planet of the Apes, Gremlins, Robocop* and *Jaws* were, after a few decades, showing aesthetic problems due to ageing and to inadequate storage. Recognition of the constituent materials was necessary to understand the origin of degradation processes and to develop correct procedures of cleaning, restoration, storage and exhibition.

★Author to whom correspondence should be addressed

Table 1. List of the analyzed samples and constituent materials.

Symbol	Sample description	Constituent materials
I	Metro Goldwyn Mayer golden sign	Alkyd resin modified with styrene and PMMA
2a	*Star Wars:* Stormtrooper's white mask	Polyvinylchloride (PVC)
2b	*Star Wars:* Darth Vader's mask	Polyethylene (PE)
2c	*Star Wars:* Chewbacca's mask, inside	Natural rubber
2d	*Star Wars:* Chewbacca's mask, hairs	Natural protein fibers
2e	*Star Wars:* C3PO's mask	PVC + plasticizer
3a	*Gremlins:* foam padding	Polyether-Polyurethane (PUR)
3b	*Gremlins:* outside flexible coating	Natural rubber + neoprene
4a	*Robocop:* armour, outside	Neoprene
4b	*Robocop:* armour, inside foam padding	Polyester-Polyurethane (PUR)
4c	*Robocop:* intermediate layer between the outside armour and the foam padding	Polyethylene (PE)
5a	*Planet of the Apes:* the ape's mask, inside	Natural rubber
5b	*Planet of the Apes:* Apes: the ape's mask, hairs	Natural protein fibers
6a	*Aliens:* looking like organic fluid on the surface of an *Aliens* egg	Polyvinylacetate (PVAc) paint
6b	*Aliens:* looking like organic foam on the alien's mask	Acrylic varnish based on co(MMA/EA)polymer
6c	*Aliens:* sticky material from the alien's chest	Natural rubber + solvent
6d	*Aliens:* sticky material from the alien's costume	Natural rubber + solvent
6e	*Aliens:* rubber material from the alien's chest	Natural rubber
6f	*Aliens:* rubber material from the alien's hand	Natural rubber
6g	*Aliens:* foam padding from the alien's tail	Polyether-Polyurethane (PUR)
7	*Jaws:* foam padding	Polyether-Polyurethane (PUR)

*Figure 1. Pyrograms of samples 2a and 2e. 1) HCl, 2) benzene, 3) naphthalene, 4) 2-ethylhexylphthalate, *) pyrolytic fragments of 2-ethylhexylphthalate*

Figure 2. Pyrograms of sample 6b. 1) isoprene, 2) EA, 3) MMA, 4) EMA, 5) isoprene dimer, 6) EA-MMA sesquimer, 7) EA sesquimer, 8) EA dimer, 9) EA-EA-MMA trimer, 10) EA-MMA-EA trimer , 11) EA trimer

Characterization of materials

All items listed in Table 1 were analyzed by pyrolysis–gas chromatography–mass spectrometry (Py-GC–MS) (Tsuge 1997, Haken 1998), sometimes supported by Fourier Transform infrared spectroscopy (FTIR). Due to their chemical structure pyrolized polymers decompose according to three main types of processes.

- Type 1. Polyethylene (PE) (samples 2b and 4c), neoprene (3b, 4a) and natural rubber (2c, 3b, 5a, 6c, 6d, 6e, 6f) undergo chain scissions consisting in random breakage of chemical bonds with production of differently sized oligomers.
- Type 2. Poly (methyl methacrylate) (PMMA) and other acrylates (6b) turn completely to monomers with an unzipping mechanism.
- Type 3. Polymers such as poly (vinyl chloride) (PVC) (2a, 2e) and poly (vinyl acetate) (PVAc) (6a) undergo side-group scission, followed by breakage of the molecular skeleton into shorter molecules.

Sample 2b, a black piece of plastic coming from Darth Vader's mask, gave the typical PE fingerprint consisting of a triple series of homologous alkanes, alkenes and dienes.

Natural rubber (2c, 3b, 5a, 6c, 6d, 6e, 6f) was recognized by identification of isoprene, the monomer, and of 4-ethenyl-1,4-dimethyl-cyclohexene and limonene, two typical cyclic dimers.

In samples 6c and 6d traces of methyl ethyl ketone were also found. In contrast to other rubber samples, these were sticky and smelly, probably as a result of previous attempts at solvent cleaning.

Sample 3b, a small, elastic, flexible and greenish film, covering the surface of the Gremlin, was found to be a blend of natural rubber and neoprene. Isoprene and chloroprene monomers, and their dimers were the main pyrolysis products.

In Figure 1, two pyrograms of PVC objects belonging to the *Star Wars* set of masks (2a, 2e) are shown. As a result of a side-group scission mechanism, PVC thermally degrades into HCl and benzene, the latter one formed by fragmentation and cyclization of the carbon skeleton. In sample 2e a considerable amount of bis(2-ethylhexyl) phthalate, a plasticizer, was detected, accounting for the different physical properties of the two objects. The stormtrooper's mask (2a) is rigid and hard while C3PO (2e) is flexible.

Pyrolytic decomposition of sample 6a to acetic acid and benzene is an example of side-group scission from a PVA paint spread on the *Aliens* egg in order to reproduce the appearance and consistence of an organic fluid.

Another type of synthetic paint, based on an acrylic poly(methyl methacrylate–ethyl acrylate) copolymer was in sample 6b, simulating a liquid on the *Aliens* rubber mask. Pyrolysis of such a copolymer produces not only monomers but also dimers and trimers (Chiantore et al. 2001), all identified by their mass spectra (Figure 2).

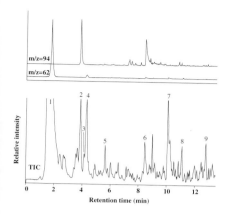

Figure 3. TIC and SIM curves of sample 2d. 1) methyl sulfide, 2) methyl disulfide, 3) 1H-pyrrole, 4) toluene, 5) 2 –methyl-1H-pyrrole, 6) phenol, 7) 4-methyl-phenol, 8) phenylacetonitrile, 9) 1H-indole

Figure 4. Gremlins. Detail of the disfiguring wrinkles and cracks before restoration (top) and the all figure during restoration (bottom)

Some of the remaining samples were analyzed by using a modification of the Py-GC-MS technique, an online derivatization known as thermally assisted hydrolysis and methylation (THM), which is based on the high temperature reaction of tetramethylammonium hydroxide (TMAH) with substances containing functional groups susceptible of hydrolysis and methylation (Challinor 1989). This approach is mostly useful in the analysis of condensation polymers (i.e. polyesters, polyamides, polyurethanes, etc.) because adequate elutions of polar compounds can be obtained with minimal sample manipulation.

By applying THM-GC-MS it was possible to recognize the golden coating of the Metro Goldwyn Mayers sign as an alkyd varnish, modified with styrene and PMMA. Alkyd resins are obtained from diols (usually glycerol or pentaerythritol), dicarboxylic acids (phthalic acid) and fatty acids. In sample 1 the methyl esters of phthalic acid and of fatty acids C_{14} and C_{16} were identified as products of the methylation reaction. Sometimes alkyd resin formulations can be complicated by adding other components, styrene and acrylates in this case, to modify physical and chemical properties, especially hardness, durability or drying rate.

The inside constituent material of most costumes and set monsters (3a, 4b, 6g, 7) is made from polyurethane foams. Polyurethanes are well recognised by FTIR (van Oosten 1999) through their specific absorption bands: NH bond stretching at around 3400 cm⁻¹, carbonyl stretching (1710-1730 cm⁻¹), C=C double bond stretching of aromatic groups (1510 and 1600 cm⁻¹), amide II band absorption resulting from the combination of bending deformation d(NH) and CN single bond stretching (1540 cm⁻¹).

With THM-GC-MS it is possible to obtain more detailed information on the chemical structures of the reagents, especially for polyester-polyurethanes. In sample 4b, for instance, hexanedioic acid methyl ester and cyclopentanone, two pyrolysis products of adipic acid, and toluenediamine, the thermal degradation product of 2,4-TDI, were identified.

Another interesting task of the project was to establish if the hairs of Chewbecca and the apes' masks were made from synthetic or natural fibers. No traces of degradation products from synthetic polymers were detected. Identification of some sulphur compounds suggested the presence of cystine, an aminoacid containing a disulphuric group. Human and animal hairs are proteinaceous. Proteins are formed by a huge number of different combination of twenty aminoacids. Those containing sulphur are cystine (Cys-Cys), methionine (Met) and cysteine (Cys), but only the first one contains a disulphuric group and cystine is one of the most important constituent of keratin, a protein present in natural hair. Figure 3 shows the total ion current (TIC) curve of sample 2d and the single ion mass (SIM) curves for m/z=62 (dimethyl sulfide, $H_3C-S-CH_3$) and m/z=94 (dimethyl disulfide, $H_3C-S-S-CH_3$). From the pyrolysis products in Figure 4 the presence of other aminoacids could be determined. 1H-pyrrole is the decarboxylation product of proline, also present in keratin. 2-methyl-1H-pyrrole is a secondary pyrolysis product of proline. Toluene and phenylacetonitrile are degradation products of phenylalanine (Chiavari 1992). Phenol and 1H-indole derive from homolysis of tyrosine and tryptophan respectively.

Restoration works

Immediate visual and photographic examination of all objects was carried out to control the presence of cracking and of discolorations due to chain scissions and crosslinking of the original components and to oxidation processes. In general the macroscopic effect of ageing was a decrease of the plastic material flexibility. In some cases, however, the plastic had become softer or sticky. Some parts of rubber items were showing severe embrittlement as a result of the oxidation reactions, with cracks at right angles to the surface of the material, and fresh substrates exposed to atmospheric oxygen.

The coating layers were cracked and appeared brittle; exposed foam had yellowed and eventually crumbled where touched. Deterioration of the foams was directly related to cracks or to missing parts on the coatings, with exposed material vulnerable to attack from external sources. Cohesion of the coating was reduced in the areas where oxidation and degradation processes had developed, making it

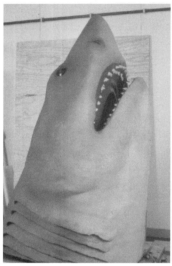

Figure 5. Jaws. *The shark before (top) and after (bottom) restoration*

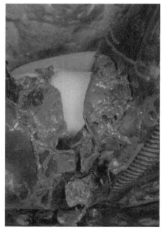

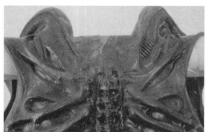

Figure 6. Aliens. *Detail of the costume before (top) and after (bottom) restoration*

particularly susceptible to mechanical stresses. The interactions between original deterioration effects and further stress damage during objects life accelerated their progressive deterioration.

The restoration work has been devoted to solving disfiguring problems like soiling, losses of paint, discoloured repair materials, structural cracks and lacunae. The most concerning features were the marks of previous repairs, plus the dramatic change of brilliant original colours to subdued greys. Removal of dirt proved to be difficult due to the extremely thin and fragile paint layer. Knowledge of the material compositions was necessary in order to choose the appropriate solvents, adhesives and repair procedures. The aim of restoration was to maintain the cinema objects as authentic 1970s objects and to restore the legibility of their design and form.

Before treatment, methods and products were tested on samples of the different types of polymers to verify the effects of impregnation, gluing, filling or retouching. Materials and application modes were designed to be reversible without changes of colour or brightness. Different products were tested as adhesives: Plextol D 498, Plextol B 500, Mowilith DMCZ and Lascaux 498 HV. Plextol B 500 was chosen because it leaves an elastic film, suitable for re-adhering the loose parts, and it has established stability characteristics (Duffy 1989).

Impainting was generally performed with pure pigments mixed with Paraloid B 72 solution, adhering well to consolidated areas. Acrylic emulsion colours were used when solvents were not compatible with the substrates. Repairing of tears and filling of losses was made with a paste of original foam crumbs mixed with Plextol B 500.

Reconstruction of the final layer, which was coloured and shaped in order to render illusory aspect to the works, was an important issue because of its protective function against photo oxidation of the internal core of the objects. The most damaged cases were found in objects made with rubber and polyurethane foams. The monstrous figure of Gremlin showed disfiguring wrinkles and cracks on the polychrome surface, exposing a yellowish foam underneath (Figure 4). Consolidation with injections of Plextol B500 was necessary before pictorial reintegration on the cracks with the acrylic resin and pigments.

The large model of Jaws (Figure 5) had to be completely cleaned from soil, dust and fingerprints, with neutral surfactant solution, Tween 20®. Small losses and cuts were repaired by filling and consolidation. A particular problem was caused by the teeth, which were almost completely missing. They were reintegrated with individually cut polyurethane forms, adhered and painted with an acrylic emulsion.

The *Aliens* costume had a series of problems, especially the need of cleaning and consolidation. The worst situation, however, was created by the sticky and leaking material present in some areas, which clearly originated from previous interventions in which patches had been glued. Consolidation and filling of the softened areas has been performed with natural rubber latex, and a lining was made with a thin rubber foil which was painted to match the original black colour of the costume (Figure 6). Similar types of interventions had to be executed on other parts, such as the fingers and the broken tail of the *Aliens* creature.

Microclimate control and exhibition conditions

Two different strategies of preventive conservation have been adopted because of the features of the heating ventilation and air conditioning (HVAC) systems and the variety of the collection materials.

On the first floor, where an air conditioning system controls both the air temperature (T) and the relative humidity (RH), pre-cinema objects are exhibited in showcases where air circulation is assured.

On the upper levels plastics and rubber items, recognized as the most sensitive objects, are exhibited in showcases where RH fluctuations are mitigated by buffering materials, while air temperature is controlled in the whole environment by a water system.

In showcases RH control is linked to air and/or moisture transfer from inside to outside the case and vice versa. Air transfer is due to stack effect (because of temperature differences) and air pressure changes. Moisture transfer from outside to inside and from inside to outside is mainly due to vapour pressure changes and

vapour diffusion through the case materials, while, inside the case, a vapour transfer can occur between air and displayed objects or between air and buffering materials. Therefore, in designing a passive system for RH control the most significant factors are:

- climate trends outside the case
- types of case joints
- types of case materials
- air circulation through the buffering material and around the display volume
- properties and amount of the buffering material.

The design procedure adopted for showcases where the most sensitive objects are exhibited was based on:

- suitable hygrothermal parameters considering the objects'sensitivities and their climatic history
- analysis of the showcase drawings with repect to the materials used, the joints and the characteristics of the housings for buffering materials
- amount and pre-conditioning of buffering materials.

Furthermore, a continuous monitoring was foreseen to assess the climate inside showcases and compare it with the climate outside. One example is the *Aliens* showcase. The recommended range for hygrothermal parameters, air temperature within 15°C and 18°C and RH within 40% and 50%, were defined in accordance with literature information (Aghemo et al. 1996; Standard UNI 10829, 1999) and restorers' directions.

Because of the objects' dimensions and the position within the exhibition way, the showcase is characterized by a triangular design, one vertical glass side and the opaque sides made of chipboard and metal (Figure 7). The room for the buffering material was positioned in the base of the showcase. In particular two drawers were introduced to insert the material and a grating introudced natural air circulation between the base and the display volume. As the presence of drawers and doors, realized on the front side to allow the maintenance of buffering materials and objects, can be cause of weakness in the showcase air tightness, specific gaskets for the rabbets of these components were adopted.

To reduce RH fluctuation inside the showcase, Art Sorb silica gel produced by Fuji Silysia Chemical Ltd. was used. As it was impossible to define the silica gel amount on the basis of a physical model (Thomson 1986) because during the design phase many factors were unknown (e.g. the number of air exchanges of the showcase still under construction or the external values of RH not yet monitored) the manufacturer's directions were followed: 4.5 kg of Art Sorb were placed in the drawers to condition a display volume of 5.3 m³. Before placing in the showcase Art Sorb was pre-conditioned at 45% equilibrium moisture content (EMC).

To check the behaviour of the system composed by the showcase, buffering material and exposed objects, a continuous monitoring of hygrothermal conditions has been carried out since the museum opened. The variation of T and RH inside and outside the showcase were recorded with stand-alone data loggers. They were programmed to record every 15 minutes, so even rapid fluctuations were considered. The recorded data were processed to obtain:

The grating dividing the basement from the display volume

Detail of the drawers and doors rubbet (expanded polyethylene gasket)

Figure 7. Aliens *showcase*

- T and RH hourly average values
- cumulated frequency of the hourly average values
- conservation risk, defined as the percentage of time for which the measured parameter lies outside the recommended range (Standard UNI 10829, 1999).

The analysis of results shows that:

- air temperature inside the display case is always higher than the recommended range for conservation because the heating system was set at a comfortable temperature for visitors (20°C)
- there are very small differences between air temperature inside and outside the showcase (up to as much as 2°C), mainly due to the light sources inside the showcase.
- in the short term the system is able to produce a good damping and time shift of relative humidity fluctuations
- in the long term the internal trends follow the seasonal trends of hygrothermal conditions outside the showcase
- during winter the system is not able to keep internal relative humidity within the acceptable range because the external values are very low.

Figure 8 shows the trends of T and RH inside and outside the showcase over a monthly and annual period, while in Figure 9 the RH cumulated frequencies and the conservation risks considering summer and winter periods are presented. On the basis of these results the curator was advised to request an improvement in the showcase features (e.g. of the air-tightness) and a regeneration of the silica gel.

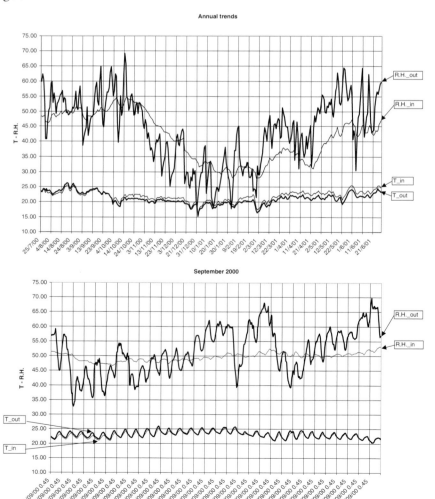

Figure 8. Annual and monthly trend of the measured hygrothermal parameters

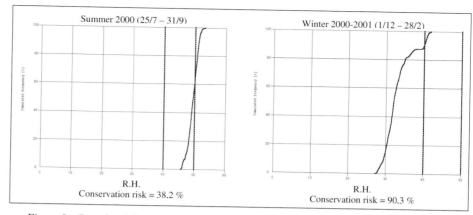

Figure 9. Cumulated frequency and conservation risk referred to the internal relative humidity

Instrumentation

Pyrolysis experiments were carried out with an integrated system composed of a CDS Pyroprobe 1000 heated filament pyrolyser (Analytical Inc., USA), a GC 5890A gas chromatograph (Hewlett Packard, USA) equipped with capillary column HP-5MS crosslinked 5% Ph Me Silicone (30 m × 0.25 mm × 0.25 mm) and a Hewlett Packard GC 5970 mass spectrometer.

Pyrolysis were performed at 600°C for 10 s. The pyrolyser interface was set at 250°C and the injector at 280°C. The GC column temperature conditions were as follows: the initial temperature of 40°C was held for 2 minutes, then increased at 10°C per minute until it reached 280°. Helium gas flow was set at 1 mL per minute. Mass spectra were recorded under electron impact ionisation at 70 eV electron energy, in the range from 40 to 800 m/z.

The air temperature and the relative humidity in the showcase were measured and recorded with "Smart Reader" – ACR stand-alone data loggers. The temperature sensor was a thermistor (range of measurement $-40 \div 70$ °C; accuracy \pm 0.2 °C) and for relative humidity a capacitive sensor was used (range of measurement $0 \div 100\%$; accuracy of \pm 3%).

Conclusions

Since plastic materials became available for many consumable objects in the 1950s and especially the 1960s, their high versatility, lightness, facility of fabrication and low costs made them valuable on movie sets. All these objects, especially when fabricated for movies, were not intended to last, their function ending at the conclusion of the movie process. Nowadays, however, many of them have become memorabilia of the history of cinema, and they are found in private collections and in museums.

The decay observed in the plastics of Cinema Museum collections is related to internal factors, such as material characteristics, and to such external factors as light, heat, relative humidity and chemical products used in previous restorations. The alterations were seen to depend on the type of materials, on their chemical compositions, and on the effects of previous uses of glues and varnishes. The whole conservation work has demonstrated that intact appearance of the objects can be achieved, and at the same time illustrates possibilities for treating polyurethane objects with protective coatings. Finally, measures for strict microclimate control were necessary to maintain conditions for preventive display.

References

Aghemo, C, Filippi, M and Prato, E, 1996, *Condizioni ambientali per la conservazione dei beni di interesse storico e artistico*, Comitato Giorgio Rota, Torino.

Challinor, J M, 1989, 'A pyrolysis-derivatisation-gas chromatography technique for the structural elucidation of some synthetic polymers' *Journal of Analytical and Applied Pyrolysis* 16, 323–333.

Chiantore, O, Scalarone, D and Learner, T J S, 2001, 'Characterization of artists' acrylic emulsion paints' *International Journal of Polymer Analysis and Characterization* (in press).

Chiavari, G and Galletti, G C, 1992, 'Pyrolysis–gas chromatography/mass spectrometry of amino acids' *Journal of Analytical and Applied Pyrolysis* 24, 123–137.

Duffy, M C, 1989, 'A study of acrylic dispersions used in the treatment of paintings' *Journal of the American Institute for Conservation* 28(2), 67–77.

Haken, J K, 1998, 'Pyrolysis gas chromatography of synthetic polymers - a bibliography' *Journal of Chromatography* A 825, 171–187.

Standard UNI 10829, 1999, Objects of historical and artistic interest. Environmental conditions for conservation. Measurements and analysis. UNI Milan, Italy.

Thomson, G, 1986, *The museum environment*, 2nd ed., Butterworth & Co., Great Britain.

Tsuge, S and Othani, H, 1997, 'Structural characterization of polymeric materials by Pyrolysis GC/MS' *Polymer Degradation and Stability* 58, 109–130.

van Oosten, T and Keune, P, 1999, 'Modern art: who cares? An interdisciplinary research project and an international symposium on the conservation of modern and contemporary art' in I J Hummelen and D Sillé (eds.) Amsterdam, Stichting Behoud Moderne Kunst/ Instituut Collectie Nederland.

Materials

Plextol® B 500, acrylic emulsion GmbH & Co. KG, Paul-Baumann-Strasse 1, 45764 Marl Germany

Paraloid B-72, Rohm and Haas, Philadelphia, Pennsylvania 19105, U.S.A.

Tween 20® (polysorbate 20), Bostick & Sullivan, Santa Fe, New Mexico 87506, U.S.A.

Art Sorb, Fuji Silysia Chemical Ltd., 121 SW Morrison Street, Suite 865, Portland, Oregon 97204, U.S.A.

Ageing studies of acrylic emulsion paints

Abstract

A selection of acrylic emulsion paints
was applied to glass slides, artificially
aged with intense light and examined
with pyrolysis-gas chromatography-
mass spectrometry, Fourier transform
infrared spectroscopy, size exclusion
chromatography, thermogravimetric
analysis and water immersion to
monitor any changes with light
exposure. The principal change
appeared to be the incremental
disappearance of surfactant from the
surface of the paint films. The
solubility in tetrahydrofuran, a high-
swelling organic solvent, was ob-
served to decrease slightly for several
paints, with an accompanying de-
crease in average molecular weight
(MW) in their soluble fractions, both
of which pointed to cross-linking
reactions. However, in some paints
no change was observed and in a few
an increase in solubility (and MW of
the soluble fraction) was noted.
Colour measurements of thermally
aged samples showed acrylic emulsion
paints to be highly resistant to
yellowing, in contrast to oil and alkyd
paints.

Keywords

acrylic emulsion paints, light ageing,
polyethylene glycol (PEG) surfactant,
cross-linking, chain scission

Tom Learner*
Tate Millbank
London SW1P 4RG, United Kingdom
Fax: +44 20 7887 8982
E-mail: tom.learner@tate.org.uk

Oscar Chiantore and Dominique Scalarone
Department of IPM Chemistry
University of Torino
via P.Giuria 7
10125 Torino, Italy
Fax: +39 11 670 7855
E-mail: chiantore@ch.unito.it, scalarone@ch.unito.it

Introduction

Since their introduction in the late 1950s, acrylic emulsion paints have been widely
used by artists and conservators. Manufacturers have always claimed these paints
exhibit high durability, resistance to yellowing and permanent flexibility, because
they are based on emulsions designed for exterior house paints, in which resistance
to light, humidity and temperature are clearly required (Hochheiser 1986). On a
visual level, it does appear that acrylic emulsion paints are less prone to cracking
or (natural) discoloration compared to oil paints of a similar age, but very little
research has been done to characterize their ageing behaviour.

Most studies have concentrated on unpigmented acrylic emulsions (or disper-
sions). De Witte et al. (1984) and Howells et al. (1984) used different ageing
methods to examine various commercial products, many of which have been used
in acrylic paint formulations. They reported that films often yellowed under dark
and warm conditions, but this was not accompanied by any change in removability
or mechanical properties. The most detailed study on the ageing of an artists'
acrylic emulsion product, by Whitmore and Colaluca (1995), was also undertaken
on an unpigmented medium. Thin films of Liquitex acrylic gloss medium were
aged naturally in the dark as well as artificially by exposure to elevated temperatures
and various sources of ultraviolet (UV) radiation. It was found that in the dark,
films acquired a slightly yellow colour, lost solubility and gained in tensile strength,
all of which were attributed to slight cross-linking of the polymer. Exposure to UV,
however, caused a loss of tensile strength and an increase in solubility, suggesting
a breakdown of the polymer by chain-scission reactions. It was noted that all of
these changes were extremely small – the tensile testing even of UV-aged samples
did not cause them to break – and it was concluded that the product certainly
exhibited high stability when exposed to ambient indoor lighting.

Most acrylic emulsion paints are bound in either a poly (ethyl acrylate-methyl
methacrylate), p(EA/MMA) copolymer or a poly (*n*-butyl acrylate-methyl meth-
acrylate), p(*n*BA/MMA) copolymer (Learner 2000). Unfortunately, the chemical
and physical differences between acrylic solutions and emulsions negate much of
the knowledge about ageing of acrylic resins (e.g. Feller et al. 1981, Melo et al.
1999, Chiantore et al. 2000). It is therefore not possible to predict the ageing of
emulsion paints from the relative stability of these copolymers alone, although it
is likely that certain trends about stability may still hold, such as the vulnerability
of tertiary hydrogen atoms to abstraction (present on the backbone of all acrylate
polymers). Unlike solutions, emulsions contain several additional components,
including surfactants, protective colloids, thickeners, anti-foam agents, biocides,
freeze-thaw agents, pH buffers and coalescing solvents (e.g. Learner 2000).
Although some of these 'additives' evaporate from the paint film on drying, the
majority are non-volatile and therefore likely to remain in the dried paint film, and
any of these may affect the ageing characteristics of the material. The influence that

*Author to whom correspondence should be addressed

a single minor constituent can have on the ageing of an emulsion system was well demonstrated by Howells et al. (1984), who showed that a 2% addition of one thickener had a remarkable yellowing effect on emulsions.

When considering emulsion paints, there are even more variables to consider, with the presence of pigments, extenders and further additives, such as wetting agents and dispersing agents. Pigments in particular may have a strong influence on ageing properties, as they have the potential to act either as catalysts for ageing reactions, for example by the adsorption of oxygen onto their surfaces, or as stabilizers, by scattering and absorbing light and/or UV radiation. As part of a long-term study of the ageing and effects of treatment on acrylic emulsion paints, thin films of commercially available paints were prepared and exposed to periods of artificial light ageing, as well as elevated temperatures. For each ageing protocol, examples of artists' paints with other binding media, including oil, alkyd and polyvinyl acetate emulsion, were included for comparison. This paper reports on preliminary observations from comparative measurements on paints before and after ageing using a variety of analytical techniques.

Experimental

Samples

Samples of acrylic emulsion paints and other artists' media for comparison were kindly provided by a number of artists' colourmen in 1995. A full list of manufacturers along with the polymers used as binding media (checked by pyrolysis–gas chromatography–mass spectrometry; see Learner 2001 for analytical details) is given in Table 1. A selection of paints was requested, usually including titanium white, cobalt blue, cadmium red, yellow ochre, mars black, phthalocyanine blue, 'azo' red and 'azo' yellow. It should be remembered that formulations alter constantly, so these copolymers may not be used in current products. Indeed, many paints containing p(EA/MMA) copolymers have been reformulated with p(nBA/MMA) emulsions. Thin films were prepared from a range of paints as 'draw downs' on cleaned microscope glass slides using a film applicator (Sheen Instruments). The wet film thickness of emulsion paints was set at 120 μm (and 60 μm for oils and alkyds), which produced dried films of between 30 and 40 μm. Samples were left to dry for five weeks prior to any ageing or analysis, for which removal from the slide was always required (except for colour measurements).

Artificial ageing

In light ageing, samples were placed in front of six daylight colour-rendering fluorescent tubes (Philips TLD 94), behind a sheet of Perspex VE (ICI) ultraviolet filter to cut out all radiation below 400 nm. Light intensity was measured as 18,000 lux at an average 25°C and 40% relative humidity (RH). Two slides of each paint were placed in the light box with a third (control) kept in the dark at ambient

Table 1. List of paint brands used in ageing tests, including the identified binding medium

Manufacturer	Range	Binding medium	Web page
Daler Rowney (U.K.)	Cryla	p(nBA/MMA)	www.daler-rowney.com
Golden (U.S.A.)	Artists' acrylic	p(EA/MMA)	www.goldenpaints.com
Grumbacher (U.S.A.)	Artists' acrylic	p(EA/MMA)	www.sanfordcorp.com
Lascaux (Switzerland)	Artists' acrylic	p(nBA/MMA)	www.lascaux.ch
LeFranc & Bourgeois (France)	Flashe	pVA/VeoVa	www.lefranc-bourgeois.com
Liquitex (U.S.A.)	Liquitex	p(EA/MMA)	www.liquitex.com
Lukas (Germany)	Lukascryl	p(EA/MMA)	www.lukas-online.com
Maimeri (Italy)	Brera	p(nBMA/styrene/ 2EHA)	www.maimeri.it
Spectrum (U.K.)	Spectracryl	p(nBA/MMA)	www.spectrumoil.com
Talens (Netherlands)	Rembrandt	p(EA/MMA)	www.talens.com
Winsor & Newton (U.K.)	Artists' acrylic	p(nBA/MMA)	www.winsornewton.com
Winsor & Newton (U..K)	Griffin	alkyd	www.winsornewton.com

Key:
p(nBA/MMA) = poly (n-butyl acrylate - methyl methacrylate) copolymer
p(EA/MMA) = poly (ethyl acrylate - methyl methacrylate) copolymer
pVA/VeoVa = poly (vinyl acetate – vinyl versatate) copolymer
p(nBMA/styrene/ 2EHA) = poly (n-butyl methacrylate – styrene – 2-ethylhexyl acrylate) terpolymer

temperature. A complete set was removed after 2688 hours (16 weeks) and a second after 5376 hours (32 weeks). Assuming reciprocity, and based on an annual museum exposure of 3000 hours at 200 lux, this correlates to approximately 90 and 180 years under museum conditions.

In thermal ageing, separate samples (all white paints) were placed in a Fisons 185 HWC environmental oven, one set of samples at 50°C and the other at 60°C (both at 55% RH). A third set was used as control and kept in the dark at ambient temperature. Once ageing was complete, the samples were all stored in the dark at ambient temperature.

Pyrolysis-gas chromatography-mass spectrometry (PyGCMS)

Samples were pyrolysed at 610°C for eight seconds in a Curie point pyrolyser (FOM-4LX system). The pyrolysis unit was mounted directly onto a HP 5890 gas chromatograph (Hewlett Packard), held at 40°C for two minutes, then ramped to 350°C at 10°C/min through an SGE BPX-5 column (25 m length; 0.22 mm inside diameter) and held for a further two minutes. The gas chromatograph was interfaced to an Incos 50 quadrupole mass spectrometer (Finnigan MAT) using electron impact at 70eV. Data were processed with Datamaster II software (Finnigan MAT).

Fourier Transform infrared spectroscopy (FTIR)/attenuated total reflection (ATR)

Transmission spectra were collected (64 scans at 4 cm⁻¹ resolution) on a 2000 series FTIR (Perkin Elmer) with a diamond cell/4X beam condenser (both Spectra Tech) accessory. ATR spectra were obtained (200 scans at 4 cm⁻¹ resolution) on a Nic-Plan FTIR microscope (Nicolet) using a Spectra-Tech ATR objective with zinc selenide crystal. Both systems were purged with dry air and data were processed with Omnic 4.1 software (Nicolet).

Size exclusion chromatography (SEC)

Molecular characterization was performed with a modular SEC system, comprising a Waters M-45 pump, a Rheodyne 7010 injection valve, a differential refractometer ERC 7510 (Erma) and PL Gel type columns (Polymer Labs, 10 μm particle diameter). Tetrahydrofuran solutions were separated from solid impurities by filtration through a 0.45 μm PTFE membrane filter. Calibration between the molecular weights 1600000 and 147 was obtained with PMMA narrow distribution standards and o-dichlororobenzene and a cubic fit for the calibration curve was used.

Thermogravimetric analysis

Thermogravimetric measurements were run on a DuPont Thermal Analyst SDT 2960, under nitrogen and air flow of 90 cm³/min and a heating rate of 10°C/min up to 800°C.

Water immersion

Samples of dry paint (approximately 5 mm²) were weighed on a C-32 Microbalance (Cahn) before and after 24 hours' immersion in deionized water. Carbon to hydrogen ratios of these water extracts were measured by dynamic flush combustion at 1600°C with an EA1108 Elemental Analyzer (Carlo Erba).

Colour change

Colour measurements were made with a Minolta CF-221 chromameter on the CIELAB 1976 colour system using illuminant C and averaging eight readings from different places over each paint film. All three coordinates were measured, but the $\Delta b\star$ value (measuring the yellow-blue scale) gave the best indication of yellowing.

Figure 1. PyGCMS of Spectacryl yellow ochre acrylic emulsion paint, from the unaged paint (upper pyrogram) and after 32 weeks' light ageing (lower pyrogram)

Results and discussion

Pyrolysis-gas chromatography-mass spectrometry (PyGCMS)

Examination by PyGCMS yielded no measurable differences after ageing. For example, Figure 1 shows pyrograms from an unaged 'Spectacryl yellow ochre' acrylic emulsion paint (Spectrum) and the same paint after 32 weeks' light ageing. The binder is a p(nBA/MMA) copolymer and the y-axis is expanded to show the smaller peaks, such as the group of four dimers/sesquimers (scans 1000–1400) and four trimers (scans 1650–2000) in detail (for full characterization of peaks, see Learner 2001). If oxidation played a significant role in ageing, it would be expected for oxidation products to become visible in the pyrogram. Since no new peaks were identified and relative areas remained unchanged, these measurements suggested that oxidation had not occurred in these acrylic copolymers. However, neither cross-linking nor chain-breaking reactions would have affected the pyrograms – the polymer is broken into small fragments on pyrolysis – so these ageing reactions could not be ruled out. It was noted that significant changes were observed in the pyrograms of oil paints after light ageing, principally the reduction in area of the octadecenoic (oleic) acid peak.

Fourier Transform infrared spectroscopy (FTIR)

Recording FTIR spectra in transmission mode also yielded no significant differences between spectra of unaged and aged paints. Figure 2 shows the spectra of 'Rembrandt naphthol red acrylic emulsion paint' (Talens) before ageing and after both periods of light ageing. The characteristic peaks of the p(EA/MMA) copolymer medium are C–H stretching at 2985 and 2955 cm^{-1}, C=O stretching at 1732 cm^{-1}, C–O stretching at 1177 and 1162 cm^{-1} and a further characteristic fingerprint region peak at 1030 cm^{-1}. Other peaks from two organic pigments (1553 cm^{-1} from PR112 and 1693 cm^{-1} from PO43) and a chalk extender (1445, 876 and 712 cm^{-1}) are also visible. Although minor changes could be identified between spectra, these were neither sequential with the amount of light exposure nor reproducible, and certainly lay within error limits. An unfortunate consequence of this mode of measurement was that sample size and thickness could not be held constant, so an appreciable variation in relative peak heights and widths was possible.

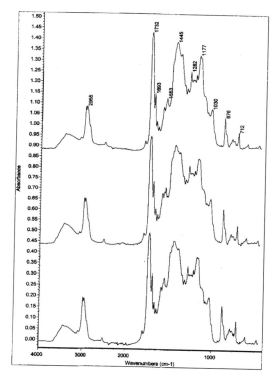

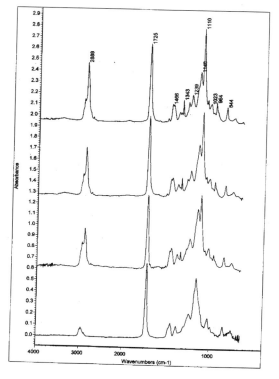

Figure 2. FTIR (diamond cell) of Rembrandt naphthol red acrylic emulsion paint, from the unaged paint (upper spectrum), after 16 weeks' (middle spectrum) and 32 weeks' light ageing (lower spectrum)

Figure 3. FTIR (μATR) spectra of Golden polymer gloss medium, from the unaged medium (upper spectrum), after 16 weeks' (second spectrum down) and 32 weeks' light ageing (third spectrum down), and from the underside of the unaged medium (lower spectrum)

However, when FTIR spectra were collected by attenuated total reflection, a significant and reproducible change with light exposure was observed. Figure 3 shows the FTIR spectra of unaged 'Polymer gloss medium' (Golden) and those after the two periods of light exposure. The sharp peaks at 2889, 1343, 1110 and 964 cm^{-1} were seen to decrease in intensity with light exposure. These peaks correspond to a polyethylene glycol (PEG) component, previously identified as a surfactant in acrylic emulsion systems (Whitmore 1996) and a class of material whose numerous ether linkages would make them prone to deterioration with light exposure. The same incremental reduction of surfactant peaks was also observed in cadmium red and titanium white (both Golden) emulsion paints, but absorbing bands from pigments/extenders made the features less obvious, so are not shown here. The lowest spectrum was taken from the underside of the emulsion film and exhibits no surfactant peaks, suggesting that it had been drawn to the film's surface with water evaporation.

Size Exclusion Chromatography (SEC)

SEC is a standard technique for determining molecular weight (MW) distribution in polymers (e.g. Chiantore and Lazzari 1996), so it was hoped this technique would detect increases (i.e. cross-linking) or decreases (i.e. chain scission) in MW. However, this is only possible in solution and unfortunately none of the acrylic emulsion paints could be dissolved completely, even in high-swelling organic solvents such as tetrahydrofuran. SEC measurements were therefore collected from the soluble fraction of these paints, in an attempt to obtain an indication of the trend towards chain-breaking or cross-linking. Figure 4 shows chromatograms from 'Lukascryl cadmium red' acrylic emulsion paint (Lukas) before and after light ageing. Since this analysis was run five years after the ageing programme, an additional run was made with a fresh sample. Two trends were apparent: first was the incremental disappearance of the low molecular weight component, previously identified as the PEG surfactant (Chiantore et al. 2001), and second was a reduction in MW in the soluble fraction. Although this suggests the soluble fraction had

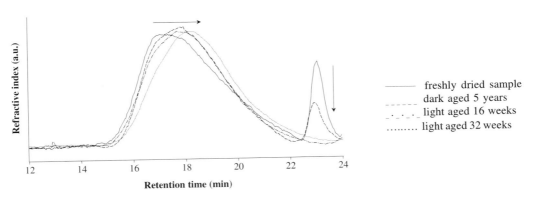

Figure 4. SEC chromatograms from Lukascryl cadmium red acrylic emulsion paint

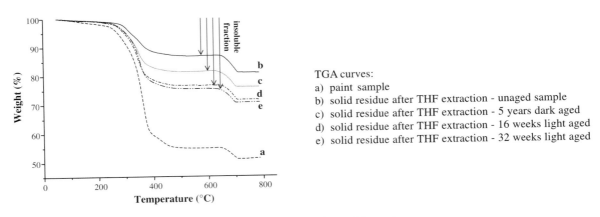

TGA curves:
a) paint sample
b) solid residue after THF extraction - unaged sample
c) solid residue after THF extraction - 5 years dark aged
d) solid residue after THF extraction - 16 weeks light aged
e) solid residue after THF extraction - 32 weeks light aged

Figure 5. TGA curves for Rembrandt titanium white acrylic emulsion paint

Table 2. List of paints examined by SEC (for MW change in soluble fraction) and TGA (for amount of insoluble material)

Brand	Main pigment	MW change in soluble fraction	Amount of insoluble material
Lukasryl	Cadmium red	Decrease	Increase
Rembrandt	Cadmium red	Decrease	Increase
Rembrandt	Azo red (PR112)	Decrease	Increase
Rembrandt	Titanium white	Decrease	Increase
Rembrandt	Azo yellow (PY3)	Decrease	Unchanged
Rembrandt	Mars black	Unchanged	Increase
Lukascryl	Cobalt blue	Unchanged	Increase
Rembrandt	Phthalo blue	Unchanged	Unchanged
Lukascryl	Titanium white	Not tested	Unchanged
Rembrandt	Cobalt blue	Increase	Decrease
Rembrandt	Yellow ochre	Increase	Decrease

undergone some chain scission reactions on ageing, the same shift in MW distribution would be obtained if the higher MW fraction had become insoluble through cross-linking. Although this MW decrease was seen in six paints tested, three remained unchanged and two showed an increase (see Table 2).

Thermogravimetric analysis (TGA)

Whereas TGA measurements on the unaged and aged paints appeared similar, differences were noticed when the technique was applied to the solid residues after extraction with solvent. Figure 5 shows the curves for 'Rembrandt titanium white' acrylic emulsion paint (Talens), with curves obtained from the solid residues after tetrahydrofuran extraction of paints after varying amounts of light ageing. As with SEC measurements, a fresh sample was compared to the original 'unaged' sample

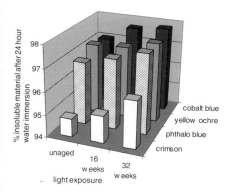

Figure 6. Weight loss in Cryla acrylic emulsion paints after 24 hours' water immersion

which had already naturally aged for five years. For each curve the major loss of weight corresponded to the volatilization of the acrylic polymer, although this area would also include organic additives, and the second smaller one around 650°C is from the loss of carbon dioxide from calcium carbonate extender. For this sample, it was seen that light exposure caused an increase in the insoluble fraction, suggesting that a degree of cross-linking had occurred in the polymer. This change was not always observed with other paints (see Table 2): half of these yielded a similar increase in insoluble fraction with light ageing, but three were unchanged and two showed a decrease. It could be seen, however, that an inverse relationship exists between the SEC and TGA measurements (i.e. when SEC measurements yielded a decrease in MW of the soluble fraction, this was accompanied by a tendency for the amount of insolubility to increase, and vice versa).

Water immersion measurements

All films yielded a decrease in dry weight after 24 hours' water immersion, ranging between 1.8% and 9.3%. This upper limit is a very significant weight loss from a dried film. Larger differences were typically observed for paints containing organic pigments, which often require larger quantities of water-soluble additives, such as wetting agents. However, the amount of material extracted was consistently reduced with light exposure. Figure 6 shows the weight loss for four Cryla (Rowney) acrylic emulsion paints for unaged and light-aged films, crimson and phthalo blue being organic pigments.

Elemental analysis was also done on the water in which the paint fragments had been immersed, to measure quantitatively the amount of organic material that had been extracted. Figure 7 shows the amount of carbon detected from these water extracts up to an hour of immersion (on an arbitrary scale). The organic extraction appeared to occur very rapidly on initial exposure to water and then level off. The quantity of carbon detected in the extracts was found to be higher from paints containing organic pigments and also decreased with light exposure.

Colour change

Colour measurements were taken on a series of white paints after thermal ageing, a commonly used method for discoloration studies. Figure 8 shows the onset of yellowing at 60°C, viewed as the change in b⋆ CIELAB (yellow-blue) value. A change of between 0.3 and 0.4 b⋆ units was measured for all acrylic emulsion paints, but this was well within the lower limit of perceptible change (often considered Δb⋆ = 1.0) and negligible compared to all other paint types, some of which exhibited a Δb⋆ = 14.0. On this scale it was not possible to differentiate between the various acrylic brands, hence the thick black band along the bottom of the graph, although it was noticed that Maimeri white emulsion paint, based on

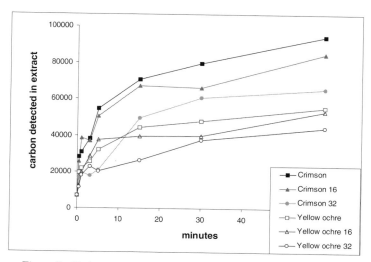

Figure 7. Carbon concentration in water extracts (arbitrary scale) after immersion of Cryla acrylic emulsion paints

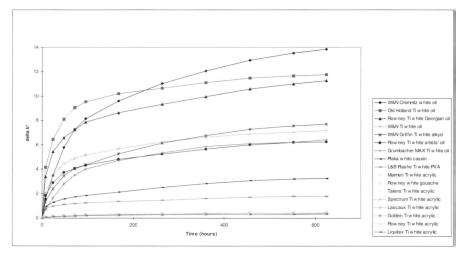

Figure 8. Change in Δb values of white paints during heat ageing at 60°C*

a styrene-acrylic copolymer, was slightly more prone to yellowing than pure acrylic emulsions. The three most yellowing paints were all based on linseed oil, compared to the other oils and alkyd paints that all contained safflower oil. The additional yellowing effect of lead white (in Cremnitz white) was also observed. The alkyd paint appeared to discolour slightly more than these less-yellowing oils. The discoloration of Plaka casein paint was probably due to a small linseed oil content and the yellowing in the Flashe PVA paint was just perceptible to the eye.

Conclusions

Although this was clearly not a comprehensive study on the ageing of acrylic emulsion paints, some interesting observations were made and several potentially useful analytical techniques were identified. The paints certainly displayed a high resistance to yellowing, especially when compared to other paint types, particularly oils and alkyds. Although an apparent stability to light ageing was also measured, the techniques used would only have been sensitive to oxidation reactions and not cross-linking or chain-breaking reactions, either of which could greatly affect mechanical properties, such as brittleness and strength.

The use of SEC to determine MW distributions before and after ageing was limited by the incomplete solubility of these paints in solvents. This partial solubility before ageing is interesting, as it indicates a significant degree of cross-linking to be already present. Although this could be the result of rapid cross-linking reactions on drying (i.e. indicative of an unstable polymer), it is possible that these emulsions are appreciably cross-linked even in the wet state. One of the advantages of emulsion formulations over solutions is that polymers of extremely high MW and/ or with cross-linked regions – which provide increased toughness and strength – can be dispersed in water, without affecting the viscosity of the medium and therefore its usefulness as a binder.

SEC could still be employed on the soluble polymer fraction and when combined with TGA measurements on the insoluble component, a general correlation was observed between an increase in insoluble material and a reduction (or no change) in the MW of the remaining soluble part. The combination of these two techniques points to a tendency for acrylic emulsion paints to cross-link with light exposure. However, there were exceptions to this, and all changes appeared small. The effect may therefore be pigment-dependent, but no definite relationship appeared in these preliminary tests. It is clear that monitoring mechanical properties would benefit this study.

The most evident change was the gradual loss of residual non-ionic surfactant from the paints' surfaces with exposure to light, as seen with micro ATR and associated measurements with its water extraction. The latter phenomenon has important ramifications for assessing changes that might occur to these paints with aqueous conservation treatments, although it is not clear how substrate-dependent is this effect.

Acknowledgements

The authors thank Joy Keeney and Herant Khanjian (both of the Getty Conservation Institute) for doing the elemental analysis and FTIR-ATR experiments, respectively.

References

Chiantore, O, and Lazzari, M, 1996, 'Characterization of acrylic resins', *International Journal of Polymer Analysis and Characterization* 2, 395–408.

Chiantore, O, Trossarelli, L, and Lazzari, M, 2000, 'Photooxidative degradation of acrylic and methacrylic polymers', *Polymer* 41, 6447–6458.

Chiantore, O, Scalarone, D, and Learner, T J S, 2001, 'Characterization of acrylic paints used as artists' materials', *Int. J. Polym. Anal. Characterization*, in press.

De Witte, E, Florquin, S, and Goessens-Landrie, M, 1984, 'Influence of the modification of dispersions on film properties' in N S Brommelle, E M Pye, P Smith, and G Thomson (eds.), *Adhesives and Consolidants,* preprints of contributions to the Paris Congress. IIC, London 32–35.

Feller, R L, Curran, M, and Bailie, C W, 1981, 'Photochemical studies of methacrylate coatings for the conservation of museum objects' in S P Pappas and F H Winslow (eds.), *Photodegradation and photostabilization of coatings*, ACS symposium series 151, American Chemical Society, Washington D.C., 183–196.

Hochheiser, S, 1986, *Rohm and Haas: History of a Chemical Company*, University of Pennsylvania Press.

Howells, R, Burnstock, A, Hedley, G, and Hackney, S, 'Polymer dispersions artificially aged' in N S Brommelle et al. (eds), op. cit., 36–43.

Learner, T J S, 2001, 'The analysis of synthetic paints by pyrolysis-gas chromatography-mass spectrometry (PyGCMS)', *Studies in Conservation* 46, in press.

Learner, T J S, 2000, 'A review of synthetic binding media in twentieth-century paints', *The Conservator* 24, 96–103.

Melo, M, Bracci, S, Camaiti, M, Chiantore, O, and Piacenti, F, 1999, 'Photodegradation of acrylic resins used in the conservation of stone', *Polymer Degradation and Stability* 66, 23–30.

Whitmore, P, and Colaluca, V, 1995, 'The natural and accelerated aging of an acrylic artists' medium', *Studies in Conservation* 40, 51–64.

Whitmore, P, Colaluca, V, and Farrell, E, 1996, 'A note on the origin of turbidity in films of an artists' acrylic paint medium', *Studies in Conservation* 41, 250–255.

Abstract

In response to the challenges of preserving the surfaces of its painted outdoor sculptures, the Object Conservation Department at the National Gallery of Art has undertaken research to compare commercial paint systems for physical and chemical durability. Specifically, black matte finishes are being studied, as they have been shown to be the most fragile and difficult to maintain among the sculptures in the collection. This paper evaluates the current condition of five matte painted outdoor sculptures at the National Gallery of Art, explores considerations for repainting, and describes ongoing comparative testing of nine commercial paint systems. This study seeks to help conservators provide informed recommendations to artists when choosing durable materials compatible with their aesthetic preferences.

Keywords

outdoor sculpture, painted sculpture, matte paint, commercial paint, alkyd, acrylic polyurethane, polyester polyurethane, polysilicone

Making better choices for painted outdoor sculpture

Abigail Mack, Angela Chang and Shelley Sturman★
National Gallery of Art
Object Conservation Department
Washington, D.C. 20565, U.S.A.
Fax: +1 (202) 842-6886
E-mail: a-mack@nga.gov, a-chang@nga.gov, s-sturman@nga.gov

Introduction

The 23 outdoor sculptures at the National Gallery of Art (NGA) in Washington, D.C., comprise a variety of materials, including patinated bronze, steel, aluminum, stone, fiberglass and concrete. A third of these works are totally or partially painted. In response to problems with the condition of several painted sculptures, the Object Conservation Department has initiated an investigation into the preservation of painted metal surfaces. Specifically, commercial black matte finishes are being studied, as they have proven to be the least stable paints among the sculptures in the collection.

This study comprises three parts. The first evaluates the condition of five sculptures with black matte painted finishes, compares the apparent durability of the paint films, and identifies factors contributing to their deterioration. The second part addresses practical and ethical considerations undertaken when choosing a matte paint for repainting outdoor sculptures. The conservator's obligation to understand and preserve the artist's intent is challenged by a need to balance the appearance chosen by the artist with the stability of the paint in an outdoor setting. Furthermore, the nature of commercial or industrial paints applied to outdoor sculpture may present maintenance difficulties for surface cleaning or loss compensation. Lastly, continuing research compares nine commercial paint systems through real and artificial ageing, physical and chemical testing, and instrumental analysis.

The use of commercial paints by artists

The technology of synthetic resins developed rapidly in the mid-20th century to support new industrial needs while curbing production costs. As alternatives to oil paints, synthetic resins developed in the 1920s offered increased versatility with polymers such as nitrocellulose-, alkyd-, poly(vinyl acetate)- and acrylic-based paints. Practical improvements included quicker drying times, inexpensive production, better handling properties, improved ageing characteristics, increased palette, better gloss retention and a variety of finishes (Crook and Learner 2000).

In the art world, the development of modern commercial paints enabled and complemented experimentation by artists working throughout the 20th century. Starting in the late 1940s artists such as the Abstract Expressionists took advantage of and experimented with the versatility of modern paints. Just as the styles and techniques of these emerging artists parted from oil painting traditions, their choice of materials embraced modernity. Unlike their adapted use on paintings, commercial coatings applied to outdoor sculpture have more closely approximated their intended use: to protect and decorate the surfaces of wood, stone and metal in an outdoor setting. Modern industrial paint systems, such as alkyd resins, acrylics, polyurethanes, epoxies and silicones, offered the qualities of toughness and increased resistance to weather, chemicals, abrasion, heat and ease of application. The palette of modern paints also offered numerous colours and finishes that ultimately affected the presentation and interpretation of outdoor sculpture. Matte,

★Author to whom correspondence should be addressed

Figure 1. Tony Smith, Moondog
(1997.137.1)

or flat, finishes, for example, comprised a critical element of many 20th-century outdoor sculptures.

A matte finish has been defined as 'a coating surface which displays no gloss when observed at any angle; a perfectly diffused reflecting surface. In practice, such perfect surfaces are extremely difficult to prepare. Hence, the term is applied to finishes which closely approach this ideal' (*Paint/Coatings Dictionary* 1978). The scattering of light necessary for a matte finish is achieved by the addition of materials such as finely divided pigments and bulking agents or by altering the pigment–volume concentration of the paint.

The works of sculptors Tony Smith (1912–1980) and Alexander Calder (1898–1976) at the National Gallery of Art are good examples of painted outdoor sculptures with matte surfaces. The matte black paint on many of Smith's sculptures from the 1960s and 1970s disguises the industrial materials and fabrication of the sculpture, while protecting the underlying metal and creating a stark visual effect. The non-reflective uniform surfaces suggest an absence of the artist's hand, while emphasizing the geometry and presence of the sculpture within an outdoor setting. When in flawless condition, surfaces such as on Smith's *Moondog* exemplify this effect (see Figure 1). By contrast, Calder's familiar painted surfaces in matte, primary colours, plus black and white, emphasize the flatness and paper cut-out quality of the sheet metal elements. From his earliest mobiles and stabiles of the early 1930s to his monumental outdoor sculpture from the 1950s to the 1970s, moving and standing elements painted with matte finishes have been an integral part of Calder's sculpture.

Matte painted outdoor sculpture at the NGA

The conservation history for painted outdoor sculpture at the NGA reflects many problems common to conservators consulted in an informal survey. An attempt to correlate factors affecting the sculptures' overall appearances helped define recurring condition and maintenance issues. Table 1 summarizes the current status of these sculptures, including their environmental settings and painting/repainting histories.

Climate and exposure

The National Gallery of Art is located in Washington, D.C. The climate can be characterized as mild with high humidity in the summer and occasional snow in winter. Notable pollutants in the region include high levels of ozone, carbon monoxide and particulate matter. In addition, the sculptures in this study are

Table 1. Painting and repainting history of matte outdoor sculptures at the NGA

Artist and Sculpture	Site	Painting History	Paint Type	Paint Brand	Performance
Alexander Calder, *Cheval Rouge*, 1974	Sculpture Garden	Most recently painted in 1998	Silicone-alkyd	Keeler & Long Poly-Silicone	Poor
Tony Smith *Moondog*, 1998-9	Sculpture Garden	Original paint applied in 1999	Alkyd	Benjamin Moore® IronClad® Low Lustre Metal & Wood Enamel *	Poor
Tony Smith *The Snake is Out*, 1992	East Building entrance	Original paint applied in 1992	Alkyd	Benjamin Moore® IronClad® Retardo*	Poor
		Most recently painted in Summer 1999	Alkyd	Benjamin Moore® IronClad® Low Lustre Metal & Wood Enamel® *	Poor
Alexander Calder *Tom's*, 1974	East Building entrance	Most recently painted in 1998	Silicone-alkyd	Keeler & Long Poly-Silicone	Fair
Tony Smith *Wandering Rocks* 1967	South side of East Building	Original paint applied in 1967†	Alkyd	Benjamin Moore® IronClad® Retardo*	Unknown
		Repainted in November 1991	Polyester polyurethane	Tnemec® Endura-Shield®	Excellent
		Most recently painted June 2001	Acrylic polyurethane pigment coat and clear top coat	Tnemec® Endura-Shield® and Endura-Clear®	Excellent

* Benjamin Moore® IronClad® Low Lustre Metal and Wood Enamel® was previously called IronClad® Retardo®.
† The repainting history of *Wandering Rocks* after 1967 and before acquisition by the NGA in 1981 is unknown.

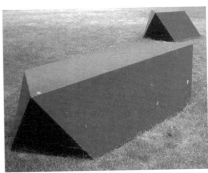

Figure 2. Many local damages to the surface of Tony Smith's Wandering Rocks *(1981.53.1) disfigure the uniform surface necessary for the correct interpretation of the sculpture*

Figure 3. Physical surface damages by lawnmowers contribute to rust formation and other irreparable problems on a good paint surface; local treatment is temporary at best for such severe damage

Figure 4. Scratches and water streaks on the paint surface of The Snake is Out *(1992.2.1) by Tony Smith; many cleaning and compensation methods were ineffective in reducing this damage*

exposed to considerable automobile exhaust. Perhaps the main source of damage is visitor contact. Approximately 700,000 patrons visit the NGA Sculpture Garden each year, and at least half of the 2,900,000 annual visitors to the NGA pass by the sculptures located just outside the entrance to the East Building.

The matte painted outdoor sculptures included in this study are installed in three general sites with varying visitation and surveillance. Those located in the Sculpture Garden benefit from the most vigilant protection, including security personnel, video surveillance, 'Do Not Touch or Climb' signs, and access limited to museum hours. Those located outside the East Building entrance do not have signs or barriers and receive the most visitors. While this area is accessible day and night, these sculptures are visible to security personnel. *Wandering Rocks* is situated in the least visible area south of the East Building next to the National Mall. This remote area is accessible by the public 24 hours a day, is monitored occasionally by security foot patrol, and lacks signs or barriers.

Condition evaluation

In addition to annual overall cleaning, weekly local cleaning and condition examinations afford NGA object conservators the opportunity to monitor changes in the condition and deterioration of various paints and coatings. For example, routine light cleaning to remove bird droppings, pollen, insect debris, dirt and handprints has shown that some matte paint surfaces abrade easily, even with soft cotton cloths. Some paint surfaces, such as on *Moondog*, appear to have become increasingly porous, absorbing oils and staining from bird droppings and human contact. Mild detergents have been ineffective in reducing these stains, and the paint surfaces have shown sensitivity to detergents and mild solvents. As a result, some fragile matte surfaces have disfiguring, untreatable stains and streaks. An accumulation of these damages undermines the pristine surface intended by the artist (see Figure 2). Attempts at retouching have been unsuccessful due to the difficulty of replicating the spray application of the matte paint. As the finishes on these sculptures age, increased sensitivities to staining and abrasion as well as difficulty with maintenance and retouching have been noted.

While the various exposure times and limited applications of paint types and brands on the NGA's sculptures do not allow for a scientific comparison of their performances as suitable coatings, several empirical observations can be drawn from their condition assessments.

- Tnemec, Endura Shield®, a polyester polyurethane paint applied to *Wandering Rocks*, demonstrated excellent durability as a protective coating. After 10 years, it was the oldest coating situated in the most vulnerable location. The semi-gloss finish of this paint was considered a compromised choice favouring durability over aesthetics. An expected and desired reduction in gloss occurred within the first year, but other changes such as fading, streaking and staining were not noted. With age, the paint maintained excellent resistance against scratching, chipping and peeling. *Wandering Rocks* was repainted in 2001 due to physical damages by lawnmowers rather than a failed paint surface (see Figure 3).
- The exterior-grade alkyd paint Benjamin Moore IronClad®Low Lustre Metal & Wood Enamel®, previously called IronClad® Retardo, on *Moondog* and *The Snake is Out*, proved to be the most fragile paint, even as the newest coatings. Recommended by the artist's estate, the paint system displayed rich saturated matte surfaces initially, but demonstrated a susceptibility to staining and abrasion within the first few weeks. Permanent water streaks and stains from human contact disfigured the surface (see Figure 4). During the removal of protective paper from the newly painted surface of *Moondog* after installation, fingernails easily scratched the surface. The paint has continued to demonstrate sensitivity to even the slightest abrasion three years later. A test panel painted with Benjamin Moore IronClad® Low Lustre Metal & Wood Enamel®, marred with various scratches, abrasions and stains, also demonstrated difficulties with loss compensation and cleaning. Experimental techniques to reduce disfiguring marks included inpainting, reforming the paint surface with solvents and

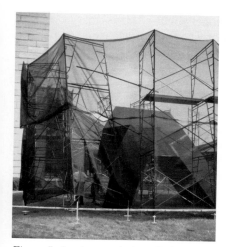

Figure 5. In situ *repainting of* The Snake is Out *on the lawn of the NGA East Building*

solvent vapors, and applying wax. Inpainting with a stipple brush produced the only modestly acceptable results. Attempts to reform the paint film resulted in a glossy surface. Surface cleaning tests with detergents, erasers and poultices showed that only a crêpe eraser was effective in reducing oils without abrading the paint surface. The paint was sensitive to mild solvents and detergents, and the surface abraded easily with cotton swabs. Results from these empirical tests on the new paint film suggested that it is unsuitable for outdoor conditions.

- Problems with the painted surface of *Tom's* demonstrated the consequences of poor surface preparation. The sculpture was painted in 1998 with Keeler & Long Poly-Silicone paint prior to loan to the NGA. With close examination, conservators demonstrated that deterioration in the form of flaking and peeling related to an uneven underlying paint layer. Another possible cause of this effect may have been inadequate corrosion removal before repainting, with a progression of corrosion disrupting the coating. The paint surface was otherwise in fair condition with moderate fading and moderate to poor scratch resistance.

- Severe fading and chalking of the red paint on *Cheval Rouge* demonstrated a poor paint formulation for outdoor sculpture. An absence of an inorganic colourant in SEM-EDS analysis suggested the use of an organic dye or pigment. In keeping with the artist's original intent, the red-orange Keeler & Long Poly-Silicone paint selected by the Calder Foundation (likely chosen for its brilliant colour and rich matte surface) showed significant fading after just a year of outdoor exposure. The surface has moderate scratch resistance, is increasingly powdery, is streaky from water stains and is prone to abrasion from soft diapers. While the colour cannot be compared with the black matte paints, the change in appearance represents a problem common to matte paint systems.

Considerations for repainting outdoor sculpture

As maintenance and retouching become unsustainable treatment options, repainting is generally accepted and necessary. While the need to repaint outdoor sculpture represents an exception to a conservator's usual responsibility to preserve an original surface, she or he may still be reluctant to repaint due to costs and the challenges of applying a modern paint system on a large scale (see Figure 5). Materials, rigging and professional painting fees can easily add up to many thousands of dollars. Even when done *in situ* by conservators or an institution's in-house painters, a lack of experience with monumental art may present additional difficulties.

Selecting a paint system for repainting presents several practical and ethical challenges. First, difficulty often exists in understanding the artist's original visual intent. This may stem from unavailability of original paints, changes in formulation, significant changes in the paint's appearance that do not allow for accurate matching, or a lack of documentation of original or subsequent paint systems. Secondly, a conservator's obligation to respect an artist's paint choice may conflict with the practicality of preserving the artist's aesthetic intent[1]. The artist or artist's estate may prescribe a specific paint system based on aesthetic criteria instead of durability. One of Calder's original paint systems, for example, an alkyd-based polysilicone from the 1960s, was likely chosen for its brilliant colours, reflectivity and texture; however, it retains an acceptable appearance for only few years. The surface condition of *Cheval Rouge* (on long-term loan from the Calder Foundation) illustrates severe problems, such as fading, chalking and irreversible staining. In this case, repainting with the same material neither conveys the artist's visual intent nor offers a sensible preservation solution for the owner or conservator. Considering these practical and ethical issues, it is clear that knowledge and experience with a variety of commercial paint systems may help the conservator select the most appropriate and durable materials for repainting and provide informed recommendations to artists or their estates when choosing materials compatible with their aesthetic preferences.

Published studies on commercial paints for outdoor sculpture are scant,[2] yet it is evident that conservators have struggled with the preservation of painted outdoor

sculpture for several decades. The experiences of NGA conservators and an informal survey of conservators responsible for matte black painted outdoor sculpture revealed the following common trends and problems with repainting.

- Documentation of original paints systems and later treatments are often inadequate. As a result, choices for new paint are often based on recommendations by other conservators or paint company representatives, rather than on testing or experience. These recommendations may include adding flattening agents or modifying the application of the prescribed commercial method in order to achieve a desired surface effect. With these adaptations, later problems may be difficult to attribute solely to the paint formula or application.
- Repainting is usually done in-house by painters or conservators. As a major treatment, repainting may present difficulties for conservators lacking experience in preparing surfaces and applying complex paint systems, while inexperience in dealing with works of art may challenge professional painters.
- Although the initial appearance after repainting may be very good, deterioration such as chalking, fading and abrading can emerge even within a year's time. With this common problem, many conservators have resorted to applying semi-gloss paints with the expectation that the surface will become matte over time. While this strategy may be a logical way to address durability problems with matte paint, it presents ethical questions when the sculpture is displayed with an incorrect finish.
- Conservators contracted to repaint a sculpture may not have the opportunity to monitor paint deterioration or maintenance problems. Knowledge that could otherwise be gained from monitoring paint condition cannot be applied to choosing future materials.

Current research

In the interest of finding more durable alternative paint systems with suitable finishes, this investigation into commercial matte paint systems consists of researching available paint systems and clear coats, selecting paints representing various paint types and brands, creating test panels, and weathering the panels in real and accelerated ageing conditions.

Consultation with technical representatives from paint companies and discussion with polymer chemists contributed to a selection of nine paint systems. These paints were originally designed for industrial, automotive, architectural, marine and signage applications, but appeared to fit the desired aesthetic and technical criteria for outdoor sculpture. Paint systems currently used on NGA sculpture were also included for comparison. Professional painters sprayed each paint type onto three sets of steel and aluminum coupons (see Table 2 and Figure 6). One set will be exposed to outdoor conditions at the NGA, another set will be retained as a control, and the last set will be subjected to accelerated ageing in the NGA's Atlas Ci65A Xenon Weather-Ometer®, calibrated to simulate outdoor exposure. A series of tests will be conducted on the controls and the coupons after accelerated and real time ageing to compare the performance of the paint films. Tests will be taken at regular intervals to compare paint performance. These include a selection of ASTM tests designed to characterize colour, gloss, hardness, abrasion, water resistance, oil resistance, acid resistance and degree of chalking.

In addition to observing how the physical and chemical characteristics of the paint films change with exposure, paint deterioration will be characterized with several instrumental techniques. These include microscopy to study cross-sections, Fourier-transform infrared spectroscopy to assess deterioration of paint components, and scanning electron microscopy-electron dispersive spectroscopy to observe changes in surface morphology and deterioration of paint system components.

Conclusions

There is a perceived difference between the durability of polyester polyurethane and the alkyds: 10 years of an acceptable finish for the former, compared to one

Figure 6. Steel and aluminum coupons painted with selected paint systems before exposure

Table 2. *Black matte paint systems currently being tested. The main paint components are listed below. Manufacturer-recommended reducers, hardeners, and activators are omitted.*

Manufacturer	Product	Product type
Akzo Nobel Coatings, Inc. [system for sign finishes]	Primer: Grip-Gard® Washprimer	Polyvinyl resin
	Pigment Coat: Grip-Gard® Acrylic Urethane Enamel (4ALU 43311 Anodic Black)	Acrylic polyurethane
	Topcoat: Grip-Gard® Clear Topcoat (Low Gloss Clear VPS-2)	Acrylic polyurethane
Benjamin Moore & Co.® [architectural system]	1st Primer*: U.S. Paint Zinc Chromate Wash Primer	Zinc chromate
	2nd Primer: U.S. Paint Awlgrip® 545 Anti-Corrosive Epoxy Primer	Epoxy
	Pigment/Top Coat: IronClad® Alkyd Low Lustre Metal & Wood Enamel (163-80 Black)	Alkyd
DuPont® [automotive system]	Primer: Corlar® 26P	Epoxy
	Pigment Coat: Imron® 333 (40M Flat Black)	Acrylic polyurethane
	Topcoat: Imron® 613P (Flat Clear)	Acrylic polyurethane
Keeler & Long/PPG [industrial system]	Primer for Steel: Kolor-Poxy White Primer (no. 3200)	Epoxy
	Primer for Aluminum: Vinyl-Butyral Wash Primer (no. 7840)	Polyvinyl resin
	Pigment/Top Coat: Megaflon® MS (UMS2301015 Black 15% gloss)	Fluoropolymer
Keeler & Long/PPG [moderate industrial system]	Primer for Steel Coupons: Kolor-Poxy Primer 3200	Epoxy
	Primer for Aluminum: 7840 Vinyl-Butyral Wash Primer	Polyvinyl resin
	Pigment/Top Coat: Poly-Silicone Enamel (0177 Black)	Silicone-alkyd
Rust-Oleum® [exterior grade system]	Primer: Primer High Performance Acrylic (5281 Gray)	Acrylic
	Pigment/Top Coat: Rust-O-Crylic® Industrial Enamel (Flat Black)	Acrylic
Sherwin-Williams® [automotive system]	1st Primer: Corrosion Shield® Vinyl Etch Primer (E2G973 Transparent Olive Green)	Polyvinyl resin
	2nd Primer: Jet Seal® Primer-Sealer (E2-A28 Gray)	Alkyd
	Pigment/Top Coat: Sunfire® Acrylic Urethane (336-1738 Black) + TIF271 Flattening Agent	Acrylic polyurethane
Tnemec® [industrial exterior grade system]	Primer: Chembuild® Series 135	Epoxy
	Pigment/ Coat: Endura-Shield® Series 75 (35GR Black)	Acrylic polyurethane
	Clear/Top Coat: Endura-Clear Series 76-763 (satin finish)	Acrylic polyurethane
U.S. Paint [marine system]	1st Primer: G9072 Zinc Chromate Wash Primer	Zinc chromate
	2nd Primer: Awlgrip® 545 Anti-Corrosive Epoxy Primer	Epoxy
	Pigment Coat: Awlgrip® (G2002 Flat Black)	Polyester polyurethane

*Benjamin Moore® IronClad® alkyd paint does not require a primer. The U.S. Paint primer system previously used for *The Snake is Out* under the Benjamin Moore® paint was applied to the test coupon for comparison.

to four years of an acceptable finish for the latter. Since the most durable paint, albeit with a compromised finish, demonstrated the best performance in the least protected site, differences in the condition of painted surfaces could not be attributed to their locations. A condition survey suggested that polyester poly- urethane paint made by Tnemec® proved to the most durable, while silicone alkyds made by Keeler & Long and alkyds made by Benjamin Moore® were less durable.

The latter, more aesthetically desirable surfaces, seemed to be the most fragile surfaces. Despite the good results from the Tnemec® polyester polyurethane, this paint is no longer available due to increased local and national pollution restrictions. These results, however, do not suggest that a specific commercial paint system is representative of the quality of other paints in that classification. Many factors, such as additives, surface preparation, application methods and curing, affect the success of paint coatings. Such factors could not be measured in this study. An ongoing systematic evaluation of various paint systems aims to address the issue of balancing durability and aesthetics for outdoor sculpture. It is hoped that this evaluation will contribute to a practical understanding of commercial paints in order to offer informed recommendations to artists, artists' estates, fabricators and museum professionals for repainting outdoor sculpture.

Acknowledgements

The authors express their sincere gratitude for the generous assistance of the following individuals from the National Gallery of Art: Robert Barnett, Denni Bult, John Clayton Hudson, Christopher Maines, Judy Ozone, Michael Palmer, Jeffrey Weiss and Stephan Wilcox. Many heartfelt thanks also to David Collens of the Storm King Art Center and to Alexander S. C. Rower of the Calder Foundation for their cooperation and contributions to this study.

This research is partially based upon work supported by a Save America's Treasures grant from the Department of Interior, National Park Service. Any opinions, findings and conclusions or recommendations expressed in this research are those of the authors and do not necessarily reflect the views of the Department of the Interior, U.S.A.

Notes

1 Essays by C. Mancusi-Ungaro and S. Sturman in 'Working with artists in order to preserve original intent' from Seminar 15 in *Modern Art: Who Cares?* offer a relevant discussion of ethics applicable to repainting outdoor sculpture. Other references pertaining to the ethics of preserving the artist's intent are listed below.
2 A review of recent publications from conferences on the conservation of modern and contemporary art (including Heuman 1995, 1999, and Hummelen and Sillé 1999) found no articles directly addressing painted sculpture and the use of industrial materials.

References

Crook, J, and Learner, T, 2000, *The impact of modern paints*, Tate Gallery Publishing Ltd., London.
Garfinkle, A M, et al., 1997, 'Art conservation and the legal obligation to preserve artistic intent', *Journal of the American Institute for Conservation* 36(2), 165–179.
Heuman, J (ed.), 1995, *From marble to chocolate: the conservation of modern sculpture*, Archetype Publications, London.
Heuman, J (ed.), 1999, *Material matters: the conservation of modern sculpture*, Tate Gallery, London.
Hummelen, I, and Sillé, D (eds.), 1999, *Modern Art: Who Cares?* Foundation for the Conservation of Modern Art and the Netherlands Institute for Cultural Heritage, Amsterdam.
Paint/Coatings Dictionary, 1978, Federation of Societies for Coatings Technology (Philadelphia) 271.
Stoner, J H, 1985, 'Ascertaining the artist's intent through discussion, documentation and careful observation', *The international journal of museum management and curatorship* 4, 87–92.
Sturman, S, Unruh, J, and Spande, H, 1996, *Maintenance of outdoor sculpture: an annotated bibliography*, National Institute for the Conservation of Cultural Property (Washington D.C.).

Abstract

Plasticized poly (vinyl chloride) (PVC) in museum collections deteriorates by migration, loss and chemical breakdown of the plasticizer, accompanied by dehydrochlorination of the polymer. The extent, rate and mechanisms of deterioration of new and deteriorated plasticized PVC were compared during and after accelerated thermal ageing in various environments. Weight loss was used to quantify total loss of plasticizer. Attenuated Total Reflection Fourier Transform Infrared (ATR-FTIR) spectroscopy was used to quantify the concentration of di (2-ethylhexyl) phthalate plasticizer (DEHP) at the surfaces of samples. Optical densitometry was used to quantify darkening of the PVC component of samples. Degradation of new and deteriorated PVC was inhibited by enclosing it in a non-adsorbent material, such as glass containing non-agitated air. Such storage inhibited migration and loss of DEHP.

Keywords

PVC, DEHP, phthalate, plasticizer, plastic, adsorbents, ATR-FTIR, degradation

Deterioration and conservation of plasticized poly (vinyl chloride) objects

Yvonne Shashoua
Department of Conservation
National Museum of Denmark
PO Box 260 Brede
DK-2800 Kongens Lyngby, Denmark
Fax: + 45 33 47 33 27
E-mail: yvonne.shashoua@natmus.dk

Introduction

Plasticized poly vinyl chloride (PVC) has been one of the most economically and technically important plastics materials since the 1950s. As a result, examples are present in many international museum collections, as clothing and footwear, furniture, electrical insulation, toys and packaging materials. Many plasticized PVC formulations are designed to function for less than 20 years. This is a short lifetime for a museum object (European Union Commission 2000).

Attempts to process pure PVC using heat and pressure result in severe degradation of the polymer (Nass 1977). Hydrogen chloride is produced and rapid discoloration of the starting material from white to yellow to brown to black is observed at processing temperatures, around 150°C. Compounding PVC involves adding sufficient modifying components to the polymer to produce a homogeneous mixture suitable for processing at the lowest price. Plasticizers are the major modifier for PVC formulations in terms of percentage weight (between 15 and 50%) and physical properties (see Table 1). They have two main functions: to assist in the processing stage by reducing the viscosity and melting temperature, and to soften the final PVC product (Wilson 1995).

Of the one million tonnes of plasticizers used annually in Europe, approximately 90% comprise phthalate esters. The largest single product used as a general purpose plasticizer worldwide is di (2-ethylhexyl) phthalate plasticizer (DEHP). It has set the standard for performance-to-price relationships since the 1950s, partly due to its documented high compatibility with PVC (Titow 1984).

Deterioration of plasticized PVC

Examination of deteriorated PVC objects and storage materials plasticized with DEHP and in the care of the National Museum of Denmark suggested that plasticizer first migrated from bulk to surfaces (Shashoua 2001). This was manifested by increased tackiness. From the surface, DEHP either evaporated slowly or hydrolyzed to crystalline phthalic acid (see Figure 1). Later, the PVC polymer component degraded to form conjugated polyene systems of increasing length that discoloured the objects. Degradation of objects was first detected within 10 to 35 years of acquisition. Although discoloration was aesthetically damaging,

Figure 1. Cockled and distorted PVC photograph pocket (top), and crystalline phthalic acid deposited on photographic positive from PVC photograph pocket (bottom)

Table 1. Typical applications for plasticized PVC formulations

DEHP (per hundred parts PVC, phr)	DEHP (% by weight based on PVC and DEHP)	application
20	16.7	vinyl flooring[1]
30	23.1	upholstery cover[2]
40	28.6	document folder[1]
50	33.3	garden water hose[3]
60	37.5	electrical cable sheath[3]
80	44.4	shoe sole[2]
100	50.0	rubber (wellington) boots[2]

[1]Wickson 1993 [2]Wilson 1995 [3]Brydson 1999

Figure 2. Microscope cover had a developed a cloudy appearance and was tacky to touch after 15 years

tackiness due to the presence of plasticizer at PVC surfaces was of greater concern from a conservation perspective.

Packaging materials adhered to tacky surfaces making storage and transport of deteriorated objects difficult. Particulates and fibres suspended in surrounding air adhered to tacky surfaces. There was also concern that handling and contact with DEHP at surfaces might pose a risk to health, mainly because of its behaviour as an œstrogen mimic (European Union Commission 2000).

For these reasons, it was decided to investigate the factors associated with migration of DEHP, and the possibilities for inhibiting its loss from new and deteriorated plasticized PVC in various storage environments.

Preparation and accelerated ageing of plasticized PVC

Model samples were prepared to represent the full range of PVC/DEHP formulations present in museum collections. In addition, two objects, also plasticized with DEHP and exhibiting deterioration, were included in the experimental work to examine the effect of the environments on non-ideal materials. Due to lack of time, accelerated thermal ageing was used instead of natural ageing. Accelerated thermal ageing in the absence of light was used because it was thought to represent the environment in a museum store.

Preparation of model sheets

Sheets were prepared from PVC plastisol by Hydro Polymers in Norway. The sheets comprised a liquid dispersion of PVC polymer, DEHP and barium/zinc laurate as the thermal inhibitor. Pigments were omitted, since they were likely to confuse perception of discoloration by the PVC component. To produce model sheets containing the range of plasticizer concentrations found in museum collections, the plastisol was diluted using DEHP, resulting in plasticizer concentrations of 33.3%, 37.5%, 44.4% and 50.0%.

The plastisols were heat pressed at 180°C for 90 seconds, achieving complete fusion between PVC and DEHP with minimal yellowing. Sheets 0.5 mm thick without solvent residues were produced and conditioned for 14 days under ambient conditions (ASTM D 2115-67). Rectangular-shaped samples weighing 1 g (approximately 50 mm × 30 mm) were cut from the sheets for inclusion in accelerated ageing experiments.

Preparation of objects

Two naturally aged PVC materials, both plasticized with DEHP, were included to evaluate the effect of various storage environments on deteriorated objects. A microscope cover in use for 15 years had developed slight opacity and a tacky outer surface (see Figure 2). Dust particles and fibres adhered to the outer surface. Samples (1 g) were cut from a side panel.

A transparent flexible PVC tube (1 cm outside diameter, 0.2 cm wall thickness) had been used to transport water for five years. Since its 'retirement' 10 years ago, it had been suspended vertically and was open at the lower end. The tube appeared yellow, and was tacky to touch. Samples 1 cm long and with a 1 cm outside diameter were taken from at least 15 cm away from the nylon connector to avoid the area with very high DEHP content.

Preparation of storage environments

Model sheets and naturally aged objects were exposed to various environments, all of which are frequently used to store materials in museums (see Table 2). Adsorbent materials were used either to modify the properties of the air inside flasks prior to ageing or to remove degradation products formed during the ageing process.

Environments were created in wide-neck Pyrex glass flasks (100 mL) fitted with heavy-duty melamine resin screw caps lined with Teflon® (polytetrafluoroethylene). The materials were selected for their very low absorption of phthalates and high chemical stability. Samples of model sheets and objects were suspended in the

Table 2. Experimental storage environments used to thermally age model sheets and objects

Environment*	Equivalent museum storage	Function	How achieved
closed	box or other container	exclude dust, buffer climate variations	sheets suspended in closed screw-cap flask
open oven	naturally ventilated storage area or display case	avoid build-up of pollutants	sheets suspended in convection oven
open glass plate	open shelf or cupboard	display	sheets on Pyrex glass plate in convection oven
activated carbon (AC)	activated carbon or activated charcoal cloth	adsorb and remove volatiles	AC placed in base of closed flask
Ageless® oxygen absorber	oxygen-free environment	inhibit oxidation pest control	one Ageless® Z sachet placed in base of each flask, before flushing with N_2
silica gel	low relative humidity (RH)	dry air	silica gel placed in base of closed flask
high relative humidity	high RH	moisten air	water (20mL) in base of closed flask
low density polyethylene (LDPE) bag	self-seal polyethylene bags	exclude dust and facilitate handling	sheet placed in LDPE bag before sealing
freezer (-20°C)	freezer for storage or pest control	inhibit deterioration	sheets suspended in closed flask in domestic chest freezer

* all environments were maintained at 70 ±1°C except for freezer

centres of flasks in order to provide equal opportunity for movement of gaseous materials around all surfaces of the sample.

Accelerated thermal ageing

Since volatile loss of plasticizers from PVC compounds is evaluated commercially at temperatures of 70°C (DIN53-405-1981, ASTM D1203 1994), this temperature was used to accelerate the thermal ageing process in this study. It was also higher than the glass transition temperature of all model formulations used. Thermal ageing was conducted using a convection oven, with the exception of the freezer (-20±1°C), for a period of 65 days.

Examination of plasticized PVC

Non-destructive examination techniques were used to identify and quantify changes in visual, chemical and structural properties of the samples during thermal ageing. Findings from weight loss, concentration of DEHP at surfaces and colour measurements are presented here.

Weight lost by model sheets

Weight loss was one of the earliest techniques used to evaluate the performance of plasticized PVC. In the 1950s, permanence of plasticizers was defined as weight loss when plasticized PVC samples were exposed to various conditions during use (Quackenbos 1954).

Model sheets and objects were weighed to four decimal place accuracy before and during ageing. Samples were removed from their ageing environment, whether it was a flask, glass plate or LDPE bag, and conditioned for five hours to ambient temperature (20–23°C) without drying their surfaces prior to weighing.

The environment in which model sheets were aged clearly influenced the extent and rate of loss of plasticizer during ageing. Table 3 shows environments rated in increasing order of plasticizer loss after ageing. Although the results presented are those for model sheet containing 33.3% DEHP by weight, the rating applied to all sheets. After 65 days, samples aged with silica gel in an open oven and on an open glass plate and enclosed in a LDPE bag continued to lose weight. Samples in other ageing environments had stopped losing weight.

Table 3. DEHP lost by model sheets containing 33.3% plasticizer after accelerated thermal ageing for 65 days

accelerated ageing environment[1]	% DEHP lost after 65 days (%)	mass DEHP lost after 65 days (g)
high relative humidity (lowest DEHP loss)	0.0	0.000
freezer	0.4	0.002
closed	0.7	0.004
Ageless® oxygen absorber	3.0	0.015
silica gel	3.6	0.019
activated carbon	3.7	0.021
open oven	5.7	0.031
open glass plate	5.9	0.032
LDPE bags (highest DEHP loss)	10.1	0.044

[1] all environments were maintained at 70°C with the exception of freezer (-20°C)

Model sheets aged in high relative humidity (RH), freezer and closed environments lost less than 1% of their original plasticizer content, while those aged in an open oven on a glass plate and in LDPE bags lost more than 5%, resulting in increased stiffness. There was very little difference between weight lost during ageing in a freezer and that lost in a closed microclimate at 70°C for the same period of time, indicating that the storage temperature was a less important factor than the opportunity for plasticizer to migrate or evaporate.

Loss from sheets hanging in an open oven, with all surfaces available for evaporation, was almost the same as that from sheets aged on open glass plates despite the fact that the surface in contact with the glass was not readily accessible by moving air to promote evaporation. However, DEHP was lost from the surface in contact with glass, observed by the presence of droplets between the underside of sheets and the glass. These droplets remained on the glass when sheets were removed for weighing.

DEHP was lost rapidly within the first 7 to 10 days of the ageing period, after which it was lost more gradually at a rate proportional to time. In closed environments and those containing activated carbon, loss of DEHP ceased after 10 days, suggesting that the concentration of DEHP vapour in the air surrounding the model sheets and the concentration at their surfaces had equilibrated. This was a good indication that the rate of loss was evaporation-controlled (Quackenbos 1954).

Mass of DEHP lost from model sheets during ageing in a closed environment (lowest loss) and an open oven (higher loss) are presented in Figure 3 for comparison. Loss of DEHP in closed environments was between 0.002 g and 0.004 g, and in environments containing activated carbon was between 0.011 and 0.013 g from a 1 g sample when evaporation ceased. These results suggest that the activated carbon adsorbed very little DEHP vapour from the model sheets prior to the concentration of plasticizer vapour in the air and on the surface of the model sheets equilibrating.

The model sheets in high RH did not lose weight, but in some cases gained it probably by adsorbing water vapour or liquid water from condensed vapour. This was explained by the fact that water vapour is an efficient plasticizer for PVC polymer (Martin and Johnson 1974). After 65 days, model sheets containing 33.3% DEHP had gained more weight (0.005 g) than those containing 50.0% plasticizer (0.0025 g).

Weight lost by objects

As for model sheets, the environment in which objects were aged influenced the extent and rate of loss of volatiles during the 65-day period of ageing. The percentage of weight lost increased in the order shown in Table 4.

Samples of the microscope cover lost more weight than did the tube samples in all environments during the same period of ageing. Percentage weight losses from both objects were lower than those from model sheets, so that the rate of loss during the experimental period was slower for objects. This was attributed to the fact that during their 15-to-20-year period of natural ageing, some plasticizer and other volatile materials had already been lost. Samples aged in an open oven on an open glass plate and in LDPE bags lost weight rapidly in the first 10 days of ageing before

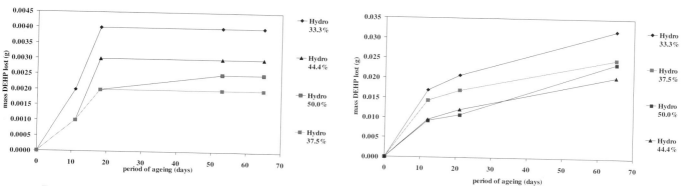

Figure 3. Comparison of mass DEHP lost from model sheets during accelerated thermal ageing in closed environments (left) and in open oven (right)

Table 4. Weight loss from objects

environment		% weight lost by tube after 65 days (%)	% weight lost by microscope cover after 65 days (%)
high relative humidity	(lowest % weight loss)	0.0	0.0
closed		0.0	0.2
freezer		0.2	0.1
Ageless oxygen absorber		0.4	0.8
silica gel		0.4	1.4
activated carbon		0.6	1.6
open oven		1.6	1.6
open glass plate		1.7	2.6
LDPE bags	(highest % weight loss)	1.9	2.8

Table 5. Influence of storage environment on loss of plasticizer from PVC

storage environment category	examples
enclosed with still, unstirred air (lowest loss of plasticizer)	freezer, closed, high relative humidity
enclosed with adsorbent materials in the same air space	Ageless oxygen absorber, silica gel, activated carbon
lightly stirred air	open oven, open glass plate
enclosed in contact with highly adsorbent material (highest loss of plasticizer)	LDPE bags

the rate of loss slowed. After the initial rapid loss, percentage weight lost was directly proportional to ageing time, a good indication of loss by evaporation.

It was concluded that percentage DEHP loss from the model plasticized PVC samples and percentage weight loss from objects increased in the order of environment types presented in Table 5.

Concentration of DEHP at surfaces of model sheets

Attenuated Total Reflection Fourier Transform Infrared (ATR–FTIR) spectroscopy was used to quantify levels of DEHP present at surfaces of all samples (Fieldson and Barbari 1993). Spectra were collected over 30 scans at a resolution of 4 cm-1 between 4000 cm-1 and 600 cm-1, using ASI DurasamplIR single reflection accessory in a Perkin-Elmer Spectrum 1000 FTIR spectrometer. The high refractive index of the diamond internal reflection element compared with that of plasticized PVC (2.4 and 1.5, respectively) allowed absorbance data to be collected from a depth approximately equal to that of the wavelength of the infrared radiation, a maximum depth of approximately two microns (Coombs 1999). Intimate contact between the diamond internal reflection element and the samples was achieved using a pre-set pressure device.

Beer's Law, which specifies that spectral absorbance is proportional to the concentrations of two components in a mixture, was applied to the spectra. Concentrations of DEHP at the model sheet and object surfaces were calculated by setting the ratio for the absorbance intensities of peaks at 2860 cm-1 (C-H stretch, due only to DEHP) against those at 1426 cm-1 (C-H stretch, due only to PVC) on raw absorbance spectra (Tabb and Koenig 1975).

Figure 4. Fitting concentration of DEHP at surfaces of objects to that of the best straight line for concentrations at surfaces of model sheets

Since the surface concentration values represented the mean of five measurements, each of which comprised 30 scans, taken at random positions on both upper and lower surfaces of aged model sheets and objects (10 measurements in total), the level of significance was determined using a t-distribution statistical test (Miller and Miller 1993). Mean concentrations of DEHP at the surfaces of aged model sheets and objects were compared with those measured for unaged samples to establish whether a minimum 95% confidence interval between the mean values existed. I not, it was concluded that there was no significant difference in the surface concentration of DEHP before and after ageing.

Ageing in an open oven on an open plate and in LDPE bags significantly reduced the surface concentration of all model sheets. This indicated that loss of DEHP in such environments occurred too rapidly for it to be replaced immediately by diffusion, indicating that diffusion had become the rate-determining step of the loss process.

Ageing in closed environments and a freezer, and with adsorbents, allowed plasticizer at the surfaces of the aged model sheets to be replaced at the same rate as it was lost, by diffusion from the bulk of the sheet. As a result, no change in surface concentration was detected; evaporation was the rate-determining step by which DEHP was lost.

Concentration of DEHP at surfaces of objects

Samples of the unaged microscope cover had a mean DEHP concentration of 1. concentration units at the surface. Fitting this value to the calibration curve obtained for unaged model sheets suggested that the surface concentration of DEHP corresponded to a bulk concentration of 46.5% (Figure 4).

Ageing in an open oven on an open plate and in LDPE bags significantly reduced the surface concentration of DEHP for the microscope cover. All other environments enabled the microscope cover to retain its original surface concentration. These results indicated the presence of two mechanisms by which DEHP was lost. The rate-determining step by which DEHP was lost during ageing in freezer and with adsorbents was evaporation. However, loss of DEHP from the surface of the microscope cover during ageing in an open oven on an open glass plate and in an LDPE bag occurred too rapidly for it to be replaced immediately by diffusion from the bulk.

Loss of DEHP from the surface of the microscope cover was compared with that lost by model sheets containing 44.4% and 50.0% DEHP by weight, since all three materials contained similar levels of plasticizer. After ageing, the extent and rate of loss of DEHP from the surface of the microscope cover were similar to that of the equivalent model sheets.

An unaged tube had a mean concentration of 1.04 concentration units at its surfaces. This value was fitted to the calibration curve obtained for unaged model sheets. It corresponded to a bulk concentration of 44.8% DEHP (see Figure 4).

Ageing in an open oven on an open plate and in LDPE bags significantly reduced the surface concentration of DEHP for the tube. After ageing in all other environments, the object retained its original surface concentration. The mechanisms by which DEHP were lost were as described previously for the microscope cover.

Loss of DEHP from the surface of the tube was compared with that lost by the model sheet containing 44.4% plasticizer by weight after ageing. In the same period, the extent and rate of loss of plasticizer from the surface of the tube was similar to that of the equivalent model sheet. For example, ageing in a LDPE bag for 65 days resulted in a reduction of 0.1 concentration units for a model sheet with 44.4% DEHP by weight; the same conditions produced a reduction of 0.3 unit for the degraded tube.

Discoloration of model sheets and objects

An electronic densitometer model Densy 301 from Barbieri was used in transmission mode to measure the optical density of model films and objects before and after ageing (Hendriks 1991). Since all colour changes were due to yellowing, a blue

Figure 5. Model sheets before (bottom row) and after 65 days accelerated ageing with activated carbon. From right to left: sheets contained 33.3%, 37.5% 44.4%, 50.0% DEHP. Edges of sheets appeared darker than the bodies.

density filter was used. The mean reading at three positions of each sample was calculated.

In general, where discoloration occurred, model sheets containing lower concentrations of DEHP exhibited greater darkening than more highly plasticized samples. Ageing in a closed environment produced no change in optical density, while ageing with activated carbon and silica gel produced unacceptable darkening. Discoloration was always visible at the edges of the sheets before it was observed at the surfaces (Figure 5).

Ageing model sheets in LDPE bags caused the bags to soften and deform and the samples to yellow (see Figure 6). Droplets of DEHP were identified on an area corresponding to that of the model sheet on the inside surface. Polyethylene is known to be a good adsorbent for phthalate plasticizers (Sears and Darby 1982).

The microscope cover and tube were already slightly discoloured due to natural ageing. It was likely that most of the thermal and photo-stabilizers included at the formulation stage were now exhausted; this was the most likely cause of the increased discoloration compared with model sheets during ageing.

Ageing in a freezer caused no change in optical density and ageing with activated carbon caused the greatest increase in optical density for both objects. One side, which had been parallel to the base of the flask and thus closest to the adsorbent materials, became darker than the upper side closest to the cap (see Figure 7). This suggested that adsorbents did not distinguish between pollutants and plasticizer vapour, and removed both from the enclosed air.

Exposure to high RH caused the model sheets and objects to become opaque (see Figure 8). However, after dehydrating under ambient conditions, little change in the original optical density was visible.

Figure 6. LDPE bags softened and crinkled after adsorbing plasticizer during use as accelerated thermal ageing environments for model sheets and objects

Figure 7. Tube before (left) and after accelerated thermal ageing with activated carbon. Note the uneven discoloration of the aged sample. The darker half was closest to the carbon during ageing. Sample dimensions: 1.5 mm diameter × 30 mm

Figure 8. Tube before (left) and after thermal ageing at high RH for 65 days. The achieved opacity was reversed on dehydrating under ambient conditions. Sample dimensions: 1.5 mm diameter × 30 mm

Conclusions

The rate and extent of deterioration of plasticized PVC and the migration of DEHP plasticizer were related. DEHP inhibited the degradation of the PVC polymer; therefore, when it evaporated the PVC became discoloured and tacky. Materials with lower levels of plasticizer were more susceptible to discoloration than more highly plasticized ones. Degradation was inhibited from both model formulations and objects by enclosing them in a non–adsorbent material, such as glass containing non-agitated air. Storage in a freezer also successfully minimized loss of plasticizer. Storage in environments where air circulated around PVC objects, including an open glass shelf, or wrapping objects in an adsorbent packaging material such as polyethylene, or with adsorbents to control air quality, resulted in high losses of DEHP.

Enclosing plasticized PVC objects, whatever their level of deterioration, is inexpensive to implement, of low practical complexity and allows public accessibility to plastics objects.

Acknowledgements

I would like to thank Mads Christian Christensen, Head of the Conservation Laboratory at the National Museum of Denmark, for his advice concerning the development and results of this project. I am grateful to Morten Ryhl-Sevendsen of the Conservation Laboratory for assistance with the photographs.

References

Brydson, J A, 1999, Plastics Materials, *Butterworth-Heinemann, Oxford, 6th ed.*

Coombs, D, 1999, 'The use of diamond as an ATR material', International Journal of Vibrational Spectroscopy 2, 3–5 (www.ijvs.com/volume2/edition2/section1.htm).

European Union Commission, 2000, Green Paper on Environmental Issues of PVC COM(2000)469FINAL (www.europa.eu.int/comm/environment/pvc/index.htm).

Fieldson, G T, and Barbari, T A, 1993, 'The use of FTIR-ATR spectroscopy to characterize penetrant diffusion in polymers', Polymer 34(6), 1146–1153.

Hendriks, K B, 1991, Fundamentals of photograph conservation: a study guide, *Lugus Publications (Canada).*

Martin, J R, and Johnson, J F, 1974, 'Poly(vinyl chloride): effect of molecular weight and vapour environment on viscoelastic and fatigue properties', Journal of Applied Polymer Science 8, 3227–3236.

Miller, J C, and Miller, J N, 1993, Statistics for analytical chemistry, *Ellis Horwood, London, 3rd ed.*

Nass, L I, 1977, Encyclopedia of PVC, *Vol 2, Marcel Dekker, New York.*

Quackenbos, H M, 1954, 'Plasticizers in vinyl chloride resins', Industrial and Engineering Chemistry 46(6), 1335–1341.

Sears, J K, and Darby, J R, 1982, The technology of plasticizers, *John Wiley and Sons, New York.*

Shashoua, Y R, 2001, Inhibiting the deterioration of plasticized poly (vinyl chloride), a museum perspective, PhD thesis, *Technical University of Denmark, Denmark.*

Tabb, D L, and Koenig, J L, 1975, 'Fourier Transform Infrared study of plasticized and unplasticized poly (vinyl chloride)', Macromolecules 8(6), 929–934.

Titow, W V, 1984, PVC Technology, *Elsevier Applied Science, London, 4th ed.*

Wickson, E J, 1993, Handbook of PVC Formulating, *Wiley-Interscience, New York.*

Wilson, A S, 1995, Plasticisers: Principles and Practice, *The Institute of Materials, London.*

Standard test procedures

ASTM D2115-67 (1980). Recommended practice for oven heat stability of poly (vinyl chloride) compositions.

ASTM D1203-94. Standard test methods for volatile loss from plastics using activated carbon methods.

DIN 53-405-1981. Testing plasticizers, determination of migration of plasticizers.

Suppliers of chemicals used in the research project

Hydro plastisol and DEHP: Technical Centre PVC, Hydro Polymers Nordic, 3907 Porsgruun Norway

Silica gel-self indicating: Merck KGaA, 64271 Darmstadt, Germany

Ageless ® oxygen absorber: Mitsubishi Gas Chemical Company Inc., Mitsubishi Building, 5 2 Marunochi 2-chome, Chiyoda-ku, Tokyo 110, Japan

Activated carbon: Prolabo, Merck eurolab, Z.I. de Vaugereau, 45250 Briare le Canal, Franc

Abstract

This case study documents the degradation of a 1960s sculpture by William Turnbull. *Transparent Tubes* is fabricated from polymethyl methacrylate (pMMA), a material commonly used by artists during the last 50 years and usually regarded as a stable material. The degradation of pMMA artworks is rarely documented. A marked difference was observed in the condition of the acrylic tube sections of the sculpture in comparison to the acrylic sheet components. The tubes had degraded while the sheet material had not. This paper highlights some of the possible contributing factors for the degradation of the pMMA and for the discrepancy in the level of degradation between the two forms of the material. The options for the future display of the sculpture are also discussed, and the conclusion reached in collaboration with the artist.

Keywords

modern sculpture, acrylics, polymethyl methacrylate, pMMA, degradation

Figure 1. William Turnbull

Transparent Tubes by William Turnbull: the degradation of a polymethyl methacrylate sculpture

Stella Willcocks
Tate Millbank
London SW1P 4RG, United Kingdom
Fax: + 44 0207 887 8082
E-mail: stella.willcocks@tate.org.uk

Introduction

This paper documents the physical and chemical degradation of a modern plastic sculpture, and the options for future display working in collaboration with the artist. *Transparent Tubes* (1968) by William Turnbull is made from polymethyl methacrylate (pMMA), which has degraded to such a level that it is no longer displayable. The degradation of plastics such as cellulose nitrate and cellulose acetate has been documented in conservation literature (Pullen and Heuman 1988), but pMMA has been regarded as a very stable material under normal conditions.

One of the group of thermoplastics known as acrylics, pMMA is also known by a series of trade names, including Perspex (ICI, U.K.), Plexiglas (Rohm and Haas, Germany and the U.S.A.) and Oroglas (Lennig Chemicals, U.K.). Acrylics have been commercially available since the early 1930s and have been used in a range of products, particularly for glazing, but also for contact lens, dentures and plastic baths. Artists such as Naum Gabo and Laszlo Moholy-Nagy began experimenting with this material in their sculptures in the 1930s, although pMMA did not become widely used by artists until the 1960s. Consequently, there are many sculptures in museum collections that either incorporate or are wholly fabricated from pMMA. Yet degradation of pMMA is rarely reported in artworks.

William Turnbull (Figure 1), born in 1922, belongs to the generation of sculptors who first made their mark in the early 1950s. However, during the 1960s the new simplified style of his sculptures associated his work with a younger group of British artists described as the New Generation, defined following the Whitechapel Gallery's sculpture exhibition of the same title. Turnbull's early works are well represented in the Tate Gallery's collection, mainly due to the large gift made by Alistair McAlpine in 1971, which included 12 sculptures by Turnbull and nearly 50 sculptures by six of the New Generation artists. These works were composed of a variety of materials, including painted steel, aluminium, fibreglass, plywood and sheets of coloured Perspex (Rolfe et al. 2000). The New Generation sculptors William Tucker and Tim Scott incorporated acrylics into a number of their sculptures in the 1960s. At present, the acrylic components of Tucker's and Scott's sculptures in the Tate collection still appear to be in sound structural condition.

Structure, condition and analysis

Transparent Tubes was presented to the Tate by the artist in 1990. The 18 identical tubes are fabricated in clear acrylic, and are comprised of a vertical tube (1770 mm high and 128 mm in diameter, with a wall thickness of 4mm) capped at the top with a disk the same diameter as the tube and a larger circular base unit (Figure 2). All 18 tubes are exhibited together as a group (Figure 3).

On acquisition, some of the plastic tubes were described as having a yellow tinge and all had a slight indentation in their circumference, usually at the mid-point in the length, only visible as a distortion of reflected light. Additionally, minor crazing was noted on two tubes and tiny droplets of viscous-looking liquid had been exuded on the inside of one tube (Figures 4 and 5). The sculpture did not come into the

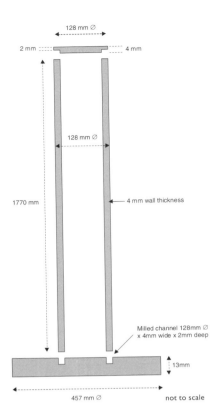

Figure 2. Plan drawing and dimensions of a single tube

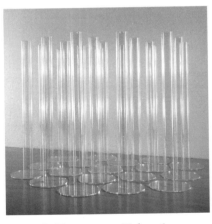

Figure 3. Transparent Tubes *(as displayed)*

Tate's collection until 22 years after it was made, and we do not know where or how it was stored during that time, but it was probably not kept in the most favorable cool and dark conditions.

By 1996, the cracking and exudation of liquid droplets had increased considerably, with droplets now apparent on two tubes, indicating an acceleration of the degradation process. However the disks of acrylic sheet, forming the integral base and caps of the tubes, did not show signs of degradation. Samples of the plastic tubes, caps and bases were taken by the conservation scientists at the Tate Gallery for analysis by pyrolysis – gas chromatography – mass spectrometry (PyGCMS). As expected, the results confirmed that the material was pMMA. At this time, the base of one of the tubes was removed for examination and analysis. Access to the interior of the tube was necessary to examine the droplets. The droplets were extremely viscous and not readily removed.

Samples of the interior of the tube and the droplets were taken. Usually, where liquid droplets appear on the surface of other types of plastics, analysis has identified these as additives, such as plasticizers (often incorporated into plastics to make them less rigid and increase their flexibility) or stabilizers (for example, UV absorbers or antioxidants, which should reduce the deterioration of the polymer). However, in analyzing the droplets on *Transparent Tubes*, no plasticizer was noted. The pyrogram from the inside of the plastic cylinder confirmed the presence of pMMA. The analysis of the liquid also yielded predominantly MMA. There was a strong smell present in the tube (probably the volatile MMA monomer), but the high viscosity of the droplets suggested there could be an oligomeric component as well. Oligomers are small groups of approximately 10–15 monomer units (Learner 1996).

Manufacture and deterioration

Methyl methacrylate is a colourless liquid and is manufactured by heating acetone cyanohydrin with methanol and sulphuric acid. As usually supplied, it contains a dissolved polymerization inhibitor, on removal of which it is readily polymerized to a glass-like polymer (Sharp 1983).

It has been suggested that this degradation effect observed in *Transparent Tubes* is a fairly straightforward case of depolymerization (Stuart 1998) in which the polymer chain breaks, leading to reactions creating degradation products consisting of relatively small molecules, including monomers. The simplest reaction of this type involves chain homolysis, which is followed by depropagation in the case of pMMA. The depropagation proceeds rapidly along the chain once the initial break has occurred, giving up to about 200 monomer units per initial scission. Monomer is the only thermal degradation product from this polymer, obtained in up to 100% yield (McNeill 1991).

On recent re-examination, all the tubes were found to have discoloured to a degree, several having yellowed significantly. Light causes photo-degradation, a significant factor in the deterioration of polymers and particularly in the yellowing and discoloration of many plastics. Light-coloured or transparent materials are more susceptible to photo-degradation than dark materials, as dark pigments restrict light from penetrating the material.

The majority of the tubes now also show signs of deterioration, including crazing and exudation of droplets associated with the areas of crazing. Cracking or crazing can appear as a result of physical degradation caused by external conditions, such as the absorption of moisture, excessive temperatures and stress. Stress can be caused by several factors, for example the anisotropic configuration caused by certain manufacturing techniques (injection moulding or extrusion), where crazing occurs along the lines of the grain. Stress also occurs when plastics have been exposed to solvents.

The emergence of droplets solely on the inside of the tube could be partly caused by the completely sealed environment. Possibly the monomer exudation is occurring on both interior and exterior surfaces of the tube, but is only condensing on the interior surface because there is no chance of evaporation in the enclosed atmosphere. However, if solvent vapours were trapped within the interior of the tubes during the bonding process, this also could have been a contributing factor in initiating the degradation.

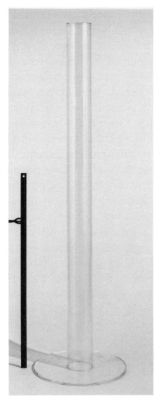

Figure 4. A single tube, showing signs of degradation in 1996

Figure 5. Detail of tube (Figure 4), showing cracks and droplets exuded on interior surface

Degradation, in the form of crazing, has been documented in acrylics used in submarine viewports, although this was only observed after several years of weathering and periodic cleaning with solvent-type cleaners (Stachiw 1982). Crazing has also been observed in Perspex glazing for display of prints. However, the high relative humidity to which the material was subjected was extreme (van Oosten 2001).

The capped ends of the tubes still remain less discoloured and show no sign of crazing or exudation. Establishing why the tubes had deteriorated while the capped ends had not suggested that this could be due to differences in the manufacturing processes of acrylic tubes and sheets.

Acrylic material can be formed by casting or extrusion. Extrusion produces noticeable 'extrusion lines' creating a faceted appearance along the length of the material, while casting results in a product virtually free of manufacturing imperfections. Cast acrylic material forms a three-dimensional network of interlocking polymer chains, producing a stronger material than extruded acrylics. Extruded material has shorter polymer chains with a linear alignment, making it weaker and more susceptible to failure. pMMA can also be injection moulded, which produces a material with similar properties to extruded material (Sale 1991). No extrusion lines are apparent on *Transparent Tubes*, indicating that the tubes were cast.

Differences in the fabrication of cast acrylic sheet and tubes

The methods of production and additives (accelerators and retardants) used in the manufacture of acrylics today are largely the same as those of 30 years ago. Acrylic sheets are produced in a mould made by attaching a gasket around the edge of two sheets of glass. A monomer/polymer mixture, with very few chains, is used with an azo catalyst and heat-cured. Heat is required to initiate the polymerization and subsequently helps to break down the catalyst within the polymer. Only a small amount of catalyst is required, approximately 0.4% by weight.

Cast acrylic tubes are produced by spin-casting (also known as rotary slush-casting). The tubes are made by spraying a slurry of monomer and catalyst into a spinning mould, usually made of stainless steel. The acrylic slurry begins curing and the mould is kept spinning until the tube reaches the required thickness. An azo catalyst can also be used for spin-casting, but larger amounts may be added (up to 10% by weight). As spin-casting tubes demands a much lower temperature during production (approximately 40–85°C), much less of the material is successfully polymerized, and an abundance of catalyst remains trapped inside, which oxidizes and degrades over time (Hill 2001).

Analysis in 1996 revealed some unidentified compounds. The pyrogram contained several peaks of lower intensity. Unfortunately, it has not been possible to identify any of these compounds yet. It is likely that they originate from materials added during the polymerization process, although it is not clear whether these materials are relevant to the depolymerization of pMMA (Learner 1996).

All the factors outlined above – principally the production temperatures, amount of catalyst and the quantity of other additives – make spin-cast tubes considerably less stable than cast sheets. Therefore, the early onset of degradation of the acrylic tubes would appear to be a consequence of the fabrication method and additives.

Display

In addition to the research and documentation, it was important to address the options for display of the sculpture, working closely with the artist to find an acceptable solution. The first option considered was to remove the disfiguring droplets from within the tubes. It was decided that this course of action was not only a short-term solution, as continued exudation would be expected, but cleaning was potentially damaging as it would require solvents or mechanical scraping. Furthermore, this would not solve the problem of the discoloration of the acrylics. Given that the process of degradation cannot be reversed, discussions between the artist, conservators and curators resulted in a decision to replicate the sculpture.

Turnbull confirmed that he had no objection to it being remade, since he himself did not make the sculpture but merely supplied a drawing to the manufacturers. Also, he intended the work to be transparent and recognized that the yellowing was irreversible. Refabrication was deemed to be an acceptable means of returning the sculpture to a displayable condition. The details and dates of refabrication will be acknowledged on the display label and in the catalogue entry for the sculpture.

Refabrication

Modifications in the design of the sculpture were considered, for example, leaving a small opening in the base to allow air exchange, but it was felt that this would lead to more problems with trapped dirt and dust in the tube. Alternatively, there was the option of not adhering the top cap in position, so that it could be removed while in storage. But since the original caps had been machined to the exact diameter of the tube after adhering and then polished *in situ*, it would not be possible to achieve a perfect fit if the two parts were machined separately. The verdict was that the original design remained the most appropriate. We hope to be able to forecast the lifespan of the new pMMA tubes through accelerated aging tests to be carried out on sample tubes made from the same batch of spin-cast tube material and capped at both ends to simulate the sealed interior.

A range of mock-up section samples were used to test bonding methods and materials for assembling the new sculpture. Two types of adhesive were considered for bonding: a solvent adhesive and a two-part acrylic adhesive. Solvent adhesives are more or less pure solvent (dichloromethane), which acts by dissolving the surfaces of the acrylic, allowing intimate fusion of the two components to be joined. The solvent adhesive tested was PK1 and the two-part acrylic adhesive was Tensol 70 (see supplier list for details). Tensol 70 is supplied as a polymer syrup and a catalyst, which hardens by polymerization at room temperature (ICI 1987). It is formulated for cementing Perspex to Perspex by forming new acrylic material to bond the components. To avoid incomplete bonds and air bubbles, excess adhesive is used, which results in a ring of adhesive around the joins.

The original tubes and caps appeared to have been bonded with solvent, since there was no evidence of excess adhesive around the seams. It is recognized that pMMA is susceptible to stress crazing and cracking when exposed to adhesives (Sale 1991), although no increase in crazing was seen adjacent to the joins on *Transparent Tubes*. Solvent adhesives have a much quicker curing time than the two-part acrylics adhesive, which should reduce the risk of crazing (Hill 2000). The solvent adhesive PK1 was selected for the refabrication, since it produced the best visual results and closely replicated the original joins.

Initially, one tube will be fabricated by Alternative Plastics (a commercial plastics company) to the specification shown in Figure 2, and working from one of the original tubes to produce an acceptable match. On confirmation that the artist, conservators and curators are all happy with the initial tube, the remaining 17 tubes will be completed.

Conclusion

One explanation for the apparent stability of acrylics in the field of fine art is that the majority of artists have been using machined and formed sheet acrylics as opposed to acrylic tubes. It is probable that the production methods and additives used in manufacturing *Transparent Tubes* have produced inherent weaknesses in the material, resulting in depolymerization.

We can also surmise that the refabricated sculpture will be susceptible to the same type of deterioration, but there is no suitable alternative material to pMMA with improved long-term stability. The refabricated sculpture will be stored and displayed in a controlled environment of 50–55% RH and 19 ± 2°C. While in storage it will remain in purpose-built packing cases to exclude the light. The exclusion of light is one of the most effective steps in reducing the degradation of many plastics.

Refabrication is a strategy that conservators instinctively dislike, since it runs counter to their training and professional practice. However, one way of viewing

the dilemma is to see a sculpture like *Transparent Tubes* as a kind of prototype, with the associated problems of any new product. By documenting and attempting to resolve these production problems in collaboration with the artist, conservators can both conserve the history of the idea and assist artists in preserving their original intention.

Acknowledgements

My thanks to the Henry Moore Foundation for its help in funding this project and to Robert Hill of Alternative Plastics Ltd for his help and expertise.

References

Hill, R, Managing Director, Alternative Plastics Ltd., personal communication.

ICI, Tensol cements for Perspex acrylic sheet, description, techniques and safety information.

Learner, T, 1996, *T05783 Turnbull Transparent Tubes*, Tate internal report of analysis.

McNeill, I C, 1991, 'Fundamental aspects of polymer conservation', *Polymers in Conservation*, Proceedings of an international conference organized by Manchester Polytechnic and Manchester Museum, Manchester, July 17–19, 1991.

Pullen, D and J Heuman, 1988, 'Cellulose acetate deterioration in the sculptures of Naum Gabo', *Modern organic materials*, SSCR Preprints of the Meeting, Edinburgh.

Rolfe, M, Morgan, L and Learner, T, 2000, 'Saving the New Generation for the next generation: traditional approaches and radical solutions in the conservation of large painted sculpture of the 1960s', *Tradition and Innovation Advances in Conservation*, Preprints of the IIC Melbourne Congress.

Sale, D, 1991, 'An evaluation of eleven adhesives for repairing poly(methyl methacrylate) objects and sculpture', *Saving the Twentieth Century: The conservation of modern materials*, Proceedings of a conference symposium, Ottawa, Canada.

Sharp, D W A (ed.), 1983, *Penguin Dictionary of Chemistry*, Harmondsworth, Middlesex, Penguin Reference Books.

Stachiw, J D, 1982, *Acrylic plastic viewports: Ocean engineering and other hyperbaric applications*, Marcel Dekker Inc.

Stuart, B, 1988, personal communication, senior lecturer, Department of chemistry, materials and forensic science, University of Technology, Sydney, Australia.

van Oosten, T B, 2001, Abstract of a talk at the Interim Meeting of the ICOM-CC Modern Materials Working Group, Köln, Germany.

Products and Suppliers

Adhesive PK1 – Thin, containing 94% (by weight) dichloromethane, 5% acetic acid and 1% other additives, Alternative Plastics, Unit 1, Buckingham Close, Bermuda Industrial Estate, Nuneaton, Warwickshire CV10 7JT, United Kingdom, Tel.: + 44 (0)2476 641210, Fax: + 44 (0)2476 326156, E-mail: sales@alternative-plastics.co.uk

Tensol cement No. 70, Cox Plastics South East, Huntsman House, Unit B, 2 Evelyn Street, London SE8 5DL, United Kingdom, Tel.: + 44 (0)207 232 4919, Fax: + 44 (0)207 232 4918

Poster session abstracts

Contents / Table des Matières / Contenido

1. Passive ventilation of enclosures and the mitigation of internally generated pollutants: the development of a simple technique for the measurement of enclosure air exchange rates
 A. Calver, L. Gibson, C. Watt

2. The Collections Centre at the Museum of Science and Industry in Manchester
 S. Cane

3. Indoor air quality specifications based on airborne pollutants and materials interactions
 J. Tétreault

4. Preventive conservation as part of the project of the construction of the Centro Cultural Eduardo León Jimenes in Santiago, Dominican Republic
 H. A. Utermöhlen

5. The fight against indoor air pollution damage
 C. Watt, L. Gibson

6. Capacitación en conservación para las bibliotecas y archivos de Chile: una estrategia a nivel nacional
 M. Krebs Kaulen, P. Mujica González

7. Microscopie Raman confocale appliquée à l'analyse des oeuvres d'art et d'archéologie
 S. Colinart, S. Pages-Camagna

8. Analysis of pigments from Mexican codices on skin
 C. Gonzalez Tirado

9. Application of graphite-assisted laser desorption/ionization mass spectrometry (MALDI-MS) to binding media analysis
 C. Herm

10. The Infrared and Raman Users Group (IRUG) and the IRUG Database
 B. Pretzel, B. Price, J. Carlson

11. Documentation et multimédia
 G. Aitken, C. Lahanier

12. Documentation et terminologie
 G. Aitken, C. Lahanier

13. A practical option for reducing vibrations in large canvas paintings
 F. Verberne-Khurshid, T. van Oosten

14. INCCA, the International Network for the Conservation of Contemporary Art
 T. Scholte, Y. Hummelen, D. Sillé,

15. Even better than saliva... about cleaning paintings!
 A. Rinuy

16. Etude comparative de quelques supports de tableaux de Vincent Van Gogh
 J-P. Rioux, E. Ravaud, C. Snyers, C. Benoit, M. Dubus

17. Quartz grounds identified in paintings by Rembrandt and his studio
 K. Groen

18. Study of some degradation processes in Peruvian artwork found in Brazil
 M. Rizzo, J. A. Carmo, H. Cortopassi Jr., J. P. S. Farah

19. Evolución del color y estrategia programada para el tratamiento de conservación de un studiolo de época renacimiento en Holanda
 J. C. Bermejo-Cejudo

20. Restauración del retablo mayor de la Iglesia de San Juan Bautista de Carbonero el Mayor, Segovia
 R. Salas Almela

21. La restauración como apoyo para confirmar una atribución
 C. Nardi, M. N. Queiroz

22. Conceptos y criterios para la conservación de un conjunto escultórico en grave estado de deterioro
 M. N. Queiroz, M. A. Sousa Jr, M. R. E. Quites

23. Conveying the faith: conservation and restoration of folkloric religious art objects
 R. Kuon

24. The influence of paper based filling enclosures containing alkaline loadings on pH-sensitive works of graphic art and photographs
 R. Damm, G. Banik,

25. Manuscript inks: Fourier Transform Infrared (FTIR) analysis with Attenuated Total Reflection (ATR) objective
 N. Ferrer, M. Carme Sistach

26. New sources of cellulose for the production of paper to be employed in conservation and restoration
 C. Landim Fritoli

27. Comparative study of natural and synthetic adhesives for strengthening the dye layer of book miniatures
 O. Perminova, T. Stepanova, I. Burtceva, A. Kamenskiy, E. Yakhnin, A. Sharikova, V. Popunova

28. Application of the Albertina poultice for removing linings from water-sensitive Japanese woodblock prints
 R. Schneller, A. Pataki, G. Banik, E. Thobois

29. Natural rubber figures in the Dutch National Museum of Ethnology: composition, condition and conservation
 M. Reuss, T. van Oosten, H. van Keulen, P. Hallebeek

30. An investigation of the early synthetic purple dye murexide ca.1853–1865
 C. Margariti

31. Analysis of restoration materials for replacement of lost fragments on broken ceramic objects
 A. Kriebel Rodríguez

32. La conservación de hierro arqueológico en México /The conservation of archaeological iron in Mexico
 P. Tapia López

33. Corrosion and conservation of copper and its alloys in the Republic of Cuba
 A. E. Cepero Acán, I. Salgado Ravelo

34. Towards more stable natural resin varnishes
 P. Dietemann, C. Sudano, M. Kälin, R. Knochenmuss, R. Zenobi

1. Passive ventilation of enclosures and the mitigation of internally generated pollutants: the development of a simple technique for the measurement of enclosure air exchange rates

Andrew Calver, Museum of London, 150 London Wall, London
EC2Y 5HN, England
E-mail:
acalver@museumoflondon.org.uk

Lorraine Gibson, Claire Watt, Department of Pure and Applied Chemistry, University of Strathclyde, 295 Cathedral Street,
Glasgow G1 1XL, Scotland
E-mail: lorraine.gibson@strath.ac.uk, claire.m.watt@strath.ac.uk

Since the Museum of London opened in 1976, it has had a policy of deliberately enhancing the natural ventilation rate of display cases using filtered ventilation ports. This is contrary to the current trend for very low air exchange rate cases, and with proposals to redevelop the galleries, this approach had to be reviewed. The primary aim of venting was to reduce the concentration of potentially damaging gases by display case construction materials and the objects themselves. A major factor governing the concentration of pollutants generated within enclosures is the air exchange rate, but no case ventilation measurements had been undertaken at the Museum of London. The first stage of the project was to identify a simple, low cost, means of measuring enclosure air change rates. Tracer gas experiments with CO_2 and N_2O loggers were undertaken and evaluated against commercially available techniques. The protoytype technique developed is simple to administer, and the equipment is readily available and can be used within existing enclosures containing objects without modification. The gas delivery method using a cream whipper is also very portable and cost effective. Air exchange rates measured on ventilated cases were found to vary between 6 and more than 30 air changes per day, but much of the air bypassed the particle filters, explaining the dust problems within cases. The technique has also been used effectively to monitor the air tightness performance of cases during gallery contruction. The next stage of the project is to measure the internal levels of key carbonyl and sulphur compounds in the same enclosures in ventilated and non-ventilated modes.

2. The Collections Centre at the Museum of Science and Industry in Manchester

Simon Cane, The Museum of Science and Industry in Manchester, Liverpool Road, Castlefield, Manchester M3 4FP, England
E-mail: s.cane@msim.org.uk, www.msim.org.uk

The Collections Centre at the Museum of Science and Industry in Manchester opened to the public on the 25 September 2001. It has been developed in response to the demand for greater access to museum collections in the UK. The project involved working with a wide range of professionals to develop a facility that provided a good environment for people *and* collections. The Museum's 19th-century railway buildings have been converted to house the Collections Centre. The poster is to be made up of a series of 10 to 15 photographs which, supported by simple explanatory labels, will depict the conversion of the museum's listed buildings and structures.

3. Indoor air quality specifications based on airborne pollutants and materials interactions

Jean Tétreault, Canadian Conservation Institute, 1030 Innes Road, Ottawa, Ontario K1A 0M5, Canada
E-mail: jean_tetreault@pch.gc.ca

For the past few decades, laboratory research and *in situ* observations on the effects of particulate and gaseous pollution on materials have contributed to a better understanding of pollutants and materials interaction through experiments replicating typical indoor environments. For heritage preservation, this improved quantification of pollutant/material interaction now provides a useful tool for risk assessment. The notion of a Lowest Observable Adverse Effect Dose (LOAED) has been developed to determine the maximum permissible pollutant level for a specific period, such as 1, 10 or 100 years. LOAEDs are determined from published papers that have measured some specific characteristic of the material over time during its exposure to the lowest level of pollutant possible. In some cases, especially with metals in the presence of carbonyl vapours, No Observable Adverse Levels (NOAELs) were determined. Contrary to the notion of doses, a material exposed to a NOAEL of a specific pollutant will not cause significant deterioration during an extended exposure period.

Knowledge of the various sensitivities of materials to airborne pollutants will help optimize indoor air quality strategies for collections in museums, galleries and archives. Decisions can be made with regard to appropriate means of control for buildings or enclosures, based on presentation needs, collection sensitivities, indoor and outdoor pollution levels, the barrier capacity of the building, the HVAC capacity, environmental parameters and, of course, available resources. This poster will summarize the LOAEDs determined from the literature for airborne pollutants for the most sensitive materials in indoor environment. The effect of the state of the materials and the environmental parameters on the LOAED and NOAEL values will be demonstrated and guidelines will be proposed to optimize preservation strategies for specific types of materials as well as mixed collections.

4. Preventive conservation as part of the project of the construction of the Centro Cultural Eduardo León Jimenes in Santiago, Dominican Republic

Hilda Abreu Utermöhlen, Conservation Consultant (Proyecto Centro Cultural Eduardo León Jimenes), Calle H 9, Los Caminos, Arroyo Hondo, Santo Domingo, Dominican Republic
E-mail: hilda@codetel.net.do

Preventive conservation, The mitigation of deterioration and damage to cultural property through the formulation and implementation of policies and procedures for the following: appropriate environmental conditions; handling and maintenance procedures for storage, exhibition, packing, transport and use; integrated pest management; emergency preparedness and response; and reformatting/duplication — American Institute for Conservation of Historic and Artistic Works (AIC)

Preventive conservation practices are recognized today as more far-reaching and cost-effective ways of preserving the integrity and value of cultural property than simply restoring individual artefacts that have already deteriorated or been damaged. The new Centro Cultural Eduardo León Jimenes (CC-ELJ) that is being built in the city of Santiago, Dominican Republic, is making every effort to integrate preventive conservation throughout the various stages of the project. Named for the founder of the generations-old corporation (Grupo León Jimenes) and family sponsoring it, this centre is scheduled to open in October 2003, in time for the 100th anniversary of the company. The CC-ELJ will be a place for the preservation of local culture and the diffusion of current cultural expressions, and will include collections of visual arts, pre-Hispanic artefacts, ethnographic objects of Dominican culture, and archives of books, maps, photographs and magnetic media.

Preventive conservation strategies of the CC-ELJ project include having a conservator on staff since the earliest planning phase, working with the architects and contractors in charge of different aspects of the construction (e.g. security and fire safety) to make them aware of critical issues to consider, integrating conservation into the exhibit process as much as possible, providing safe temporary storage for the collections, designing stable mounts for objects, practicing integrated pest management, and implementing handling and maintenance procedures. These preventive measures have been implemented by participation of the staff in lectures, training courses and exchange with foreign specialists. Including preventive conservation in such a project in the Dominican Republic is significant, as in general there has not existed a conservation tradition in museums here. Hopefully, the initiative of the Centro Cultural Eduardo León Jimenes in preventive conservation will set new standards that will be emulated by others, to the benefit of the cultural patrimony of the nation. (Poster to be presented in Spanish.)

5. The fight against indoor air pollution damage

Claire Watt, Lorraine Gibson, Department of Pure and Applied Chemistry, University of Strathclyde, 295 Cathedral Street, Glasgow G1 1XL, Scotland
E-mail: claire.m.watt@strath.ac.uk, lorraine.gibson@strath.ac.uk

The deleterious effects of indoor air pollutants, such as acetic acid, formic acid and formaldehyde, on metallic and calcareous artefacts have been recognized for many years. There is a lack of understanding, however, about the concentrations at which damage to materials will be significant. Therefore, it is difficult to define threshold, or more appropriately, 'acceptable' damage concentrations (ADCs) for carbonyl pollutants. It is also true that the atmospheric concentration is not the only parameter that needs to be regulated. Clearly, the extent of material damage will also depend on the temperature and humidity of the surrounding environment, as well as the time spent in the contaminated environment.

In an attempt to assess the effects of carbonyl pollutant concentration and humidity on a range of materials, an exposure system was developed at Strathclyde University that allows concentrations of carbonyl pollutants to be accurately controlled and monitored. The initial validation work uses passive and active sampling methods to confirm the concentration of pollutants generated inside the chamber. However, if a successful assessment is to be made, a fast and efficient method of air sampling must be developed for the target pollutants. Therefore, the first attempts at non-invasive monitoring will be presented. Further, where contaminated atmospheres are identified and carbonyl pollution concentrations are above the predetermined ADC, the concentration must be reduced to a lower innocuous level. Novel mesoporous sorbents were designed, synthesized and tested as organic acid scavengers. The new materials were based on MCM41 silicates that have sufficiently large pore sizes (2 to 5 nm) to support their application as air pollution scavengers. The surface of the materials were also modified, e.g. with basic oxides, to ensure that pollutants were chemisorbed, and thus permanently removed from the environment.

6. Capacitación en conservación para las bibliotecas y archivos de Chile: una estrategia a nivel nacional

Magdalena Krebs Kaulen, Paloma Mujica González, Tabaré 654, Recoleta, Santiago de Chile, Chile
E-mail: mkrebs@cncr.cl, pmujica@cncr.cl

La formación de profesionales para la conservación del patrimonio cultural es una de las tareas prioritarias del Centro Nacional de Conservación y Restauración de la Dirección de Bibliotecas, Archivos y Museos de Chile desde su creación en el año 1982. En conjunto con la Pontificia Universidad Católica, se inicia en 1985 un programa de formación de restauradores profesionales que incluía la conservación de materiales de archivos y bibliotecas. Desde 1987 el CNCR orienta fuertemente sus políticas de acción hacia la conservación preventiva de las colecciones, lo cual amplía la demanda por profesionales calificados para hacerse cargo de proyectos de conservación. En esta línea se desarrollan cursos de especialización para conservadores de archivos y bibliotecas de Chile y Latinoamérica entre los años 1994 y 2001 en conjunto con ICCROM.

Para la difusión de información y la capacitación en conservación preventiva en todo el país se comienza el año 1998 un proyecto cooperativo en el cual participaron diferentes instituciones nacionales. Este proyecto contó con la experiencia del proyecto CPBA de Brasil, la asesoría del CLIR y el financiamiento de la Fundación Mellon. Se recopiló información a través de un catastro de 422 archivos y bibliotecas del país, se distribuyó un set de seis publicaciones y tres videos en español y se realizaron cinco seminarios y talleres en diferentes ciudades para 101 participantes con el fin de establecer una base común para abordar proyectos futuros para todo el país. Durante estos años esta estrategia de capacitación ha representado un salto cualitativo en la formación de los conservadores y de otros profesionales vinculados a los archivos y bibliotecas y ha impulsado una red de cooperación a nivel nacional, regional e internacional.

7. Microscopie Raman confocale appliquée à l'analyse des oeuvres d'art et d'archéologie

Sylvie Colinart, Sandrine Pages-Camagna, Centre de Recherche et de Restauration des Musées de France, Département de la Recherche, UMR171 du CNRS, 6 rue des Pyramides, 75041 Paris Cedex 01, France
Courriel : sylvie.colinart@culture.fr

La microscopie Raman confocale est une technique adaptée à la micro-analyse structurale d'une large gamme de matériaux des œuvres d'art et d'archéologie. Elle permet l'identification avec ou sans prélèvement de substances inorganiques ou organiques, cristallisées ou amorphes, pour lesquelles la panoplie des analyses couramment utilisées dans les laboratoires de musée ne peut pas toujours apporter de réponse. La principale limite de cette technique est la fluorescence. Différents objets de musée (gemmes, verres, glaçures, métaux corrodés, grains de pigments ou coupes transversales de matière picturale) ont été étudiés par le C2RMF au moyen d'un microspectromètre Labram-Infinity (Jobin Yvon-Horiba) équipé de deux lasers (532 nm, 632 nm), de filtres Notch et de deux réseaux (600 et 1800 traits). Le microscope Olympus associé a une résolution latérale en analyse confocale proche de 1 μm et une profondeur de résolution d'environ 2 μm. Le principal atout de cet appareil, compact et transportable, est une sortie horizontale du faisceau laser munie d'un accessoire sur lequel les objectifs du microscope peuvent être vissés. Les objets sont placés devant le faisceau et sont alors analysés quelle que soit leur taille, la confocalité étant conservée. Palette de glaçures du XIXe siècle ou figurines en terre cuite polychromée de la Grèce hellénistique révèlent ainsi leur composition. Déjà largement utilisée par les minéralogistes, la microscopie Raman confocale, technique complémentaire de celles en analyse élémentaire (mfX, PIXE, MEB-EDS) et structurale (DRX, IRTF), devrait dans un proche futur se développer dans un grand nombre de laboratoires de musée.

8. Analysis of pigments from Mexican codices on skin

Carolusa Gonzalez Tirado, Escuela Nacional de Conservación, Exconvento de Churubusco, Xicotencatl y Gran Anaya, Coyoacan, 04120 México D.F., México
E-mail: carolusa@avantel.net

Thirty-seven samples from paint layers of seven Mexican codices on skin from the National Library of Anthropology, Mexico, were analyzed to identify the pigments. These codices have suede-like support and gypsum ground layer. Examination under stereo-microscope and polarized light microscope was carried out. EDX was used to determine the elemental composition; some samples were also analyzed by FTIR microscopy and Raman microscopy. Binders are water soluble, whites consist of gypsum, and blacks of various forms of carbon. Reds are mostly organic. Of nine samples, five are organic, three could be a low grade red ochre or a dye on clay, probably cochineal or alizarin, and one was red lead. Inorganic and organic yellows were used. Of five samples, one is yellow ochre, three are yellow or yellow-orange dyes, and one could be a low grade yellow ochre or a dye on clay, probably zacatalzalli or achiote. The blues can be silicates, blue clays or organic. Four blues were analyzed: two were tentatively identified as Maya blue; one seems to contain indigo, probably mixed with another blue pigment; and

another could be any of the blue pigments mentioned above. Five greens were analyzed: one is a copper-containing green, probably malachite, that reacted with the binder; another was tentatively identified as green earth. The others are mixtures: one contains an earth pigment, a yellow pigment and an organic blue; two appear to be a mixture of Maya blue with an organic yellow. The analyses were useful to determine the characteristics of the pigments, and a method for their identification was proposed. Non-destructive techniques were used, which allowed the samples to be saved (as is or as preparations) for reference or future analysis.

9. Application of graphite-assisted laser desorption/ionization mass spectrometry (MALDI-MS) to binding media analysis

Christoph Herm, Swiss Institute for Art Research, Zollikerstrasse 32, CH-8032 Zurich, Switzerland
E-mail: christoph.herm@sikart.ch

Graphite-assisted laser desorption/ionization mass spectrometry (MALDI-MS) has been found to be useful for the qualitative analysis of binding media. The sample is dissolved or dispersed in an organic solvent and applied to a matrix consisting of finely divided particles of graphite (or silicon). Desorption and 'soft' ionization are achieved by UV-LASER pulses. The substances are detected as sodium adducts in a time-of-flight mass spectrometer and identified by their molecular mass. MALDI-MS was applied to the study of paintings by the Swiss artist Cuno Amiet (1868-1961), who was known to have experimented with binding media starting in 1902. The following results were obtained for three paintings dating from 1913-15. (1) The majority of compounds extracted from a colorless coating were components of oil characterized as di- and triacyl glycerols composed of azelaic, palmitic and stearic acid as well as higher polymerization products. (2) A whitish bloom consisted mainly of palmitic acid. (3) One of the paintings showed ageing phenomena obviously caused by the painting technique; a brittle layer separating from the surface was found to contain oxidation products of diterpenoid resins. The paint below was hard and showed premature cracking. By means of MALDI-MS, diterpenoid resin and small amounts of diacyl glycerols were detected, whereas FT-IR spectrometry revealed mainly polysaccharides. Thus, this paint was characterized as an emulsion. It layed on top of a slow-drying oil-resin paint. MALDI-MS permits the identification of fatty acids and various di- and triacyl glycerols and higher polymerization products from oil paint, while simultaneously detecting di- and triterpenoid resins. The measurements were made possible by Professor Renato Zenobi and his working group at ETH Zurich, and were funded by the Swiss National Science Foundation (SNSF).

10. The Infrared and Raman Users Group (IRUG) and the *IRUG Database*

Boris Pretzel, Conservation Department, Victoria & Albert Museum, London SW7 2RL, England
E-mail: boris.pretzel@vam.ac.uk

Beth Price, Philadelphia Museum of Art, Box 7646, Benjamin Franklin Parkway at 26th Street, Philadelphia, Pennsylvania 19101-7646, U.S.A.

Janice Carlson, Winterthur Museum, Garden and Library, Winterthur, Delaware 19735, U.S.A.

Identifying materials using techniques such as infrared and Raman spectroscopy is fundamental to the conservation of cultural property. Whilst there are numerous commercial reference libraries, these do not cover most artists' materials and certainly do not include naturally aged organic substances. Until recently, there has not been an accurate and reliable spectral library for conservation. This has led to extensive duplication of effort in collecting reference data in institutions all over the world. The Infrared and Raman Users Group was established to promote the sharing of expertise and data between professionals working in the (not for profit) conservation field using infrared and Raman spectroscopic techniques. The *IRUG Edition 2000 Database* contains more than 1250 printed spectra and accompanying electronic records of materials encountered in the study of artistic, architectural, cultural and historic heritage, submitted by more than 50 institutions worldwide. The spectra are classified into 11 material groups. For the first time in this field, the spectra are peer reviewed and the electronic records contain all data pertinent to the spectrum. The review was conducted by an international team of 20 professionals with extensive experience in infrared spectroscopy. The newly developed electronic file format is compatible with any computer system. The poster outlines the history of the IRUG initiative and the procedure now established for the international exchange of spectroscopic information amongst participants, and demonstrates the strengths of the collection and advantages derived from contributing to it.

11. Documentation et multimédia

Geneviève Aitken et Christian Lahanier, Centre de Recherche et de Restauration des Musées de France, 6 rue des Pyramides, 75041 Paris Cedex 01, France
Courriel :
genevieve.aitken@culture.fr,
christian.lahanier@culture.fr

Le C2RMF s'est engagé, dès 1994, dans l'edition électronique de CD Rom avec la Réunion des Musées Nationaux pour diffuser des sythèses thématiques liées à des expositions. Cette forme de publication électronique a permis de diffuser les travaux de laboratoire sur un nouveau support adapté aux technologies de l'information (collection Art et Science).

- NARCISSE, glossaire électronique en huit langues (1994)
- Nicolas Poussin, analyse scientifique de 40 œuvres en quatre langues (1994)
- Les émaux limousins du Moyen-Âge, XI-XIV^{ème} siècle (1995)
- Camille Corot, 85 œuvres du musée du Louvre, analyse scientifique, trois langues (1996)
- 1648 Guerre et Paix en Europe, 400 œuvres d'art, en cinq langues (1997)
- CRISTAL-NARCISSE, réédition du CD Rom NARCISSE pour l'ICOM-CC (Lyon 1999)

Ici, les images numériques en haute définition ne sont plus seulement des illustrations du texte mais des documents de recherche permettent de naviguer dans une œuvre jusqu'aux plus infimes détails. De plus, l'interactivité permet une nouvelle écriture non linéaire mais hiérarchisée allant des idées essentielles à l'analyse du contenu. Les liens hypermédia et hypertexte permettent de croiser des informations historiques, muséologiques et matérielles.

A l'initiative des musées, trois multimédia ont été réalisés sur des œuvres nouvellement restaurées :

- Francisco Goya, à la redécouverte des Goya d'Agen (1998)
- Willem Kalf, Grande nature morte aux armures musée de Tessé, Le Mans (1999)
- l'Assomption de la Vierge l'un par Philippe de Champaigne et le second par Charles Le Brun musée Thomas Henry, Cherbourg (2000)

12. Documentation et terminologie

Geneviève Aitken et Christian Lahanier, Centre de Recherche et de Restauration des Musées de France, 6 rue des Pyramides, 75041 Paris Cedex 01, France
Courriel :
genevieve.aitken@culture.fr,
christian.lahanier@culture.fr

In the right Definition of Names lyes the first use of speech, which is the Acquisition of Science; And in wrong or no Definitions lyes the first abuse [1]

Tout concept lié à la restauration, aux techniques de fabrication, aux défauts d'un matériau ou à son vieillissement doit être associé à un terme unique, défini et traduit. Des experts ont collaboré à l'élaboration de glossaires multilingue[2] concernant les peintures de chevalet et les enluminures (programme européen NARCISSE 1990-1994), puis les peintures murales, les sculptures, la céramique et le métal (CRISTAL 1999-2000), afin de normaliser l'indexation des rapports d'études en laboratoire et celle des rapports d'intervention. L'indexation permet de sélectionner avec précision et d'accéder, en ligne, aux rapports numérisés. Institutions partenaires :

- Archives Nationales, Lisbonne
- Association Giovanni Secco Suardo, Milan
- Banques de Données des Biens Culturels Suisses, Berne
- Centre de Recherche et de Restauration des musées de France, Paris
- Collège de France, Paris
- Département de Affaires Internationales, Paris
- Service de l'Inventaire, Paris
- Service de Restauration des Biens Mobiliers, Barcelone
- Institut Royal du Patrimoine Artistique, Bruxelles
- Institut Suisse pour l'Étude de l'Art, Zurich
- Institut Central pour la Restauration, Rome
- Institut de Physique, Politecnico, Milan
- Prado, Madrid
- Brera, Milan

- Laboratoire de Recherche Rathgen, Berlin
- Région Lombarde, Milan
- Musée National des Beaux Arts, Copenhague
- Laboratoire d'Analyse pour la Conservation, Smithsonian Institution, Washington D.C.

1 'Leviathan' de Thomas Hobbes (1651) quoted by Iain Hampsher-Monk, *A History of Modern Political Thought*, Oxford, Blackwell, 1992, p.18
2 CD Rom NARCISSE, *Glossaire multilangue*, 1993, Lisboa, Arquivos Nacionais, Torre do Tombo, p.278

13. A practical option for reducing vibrations in large canvas paintings

F. Verberne-Khurshid, Rijksmuseum Twenthe, Lasondersingel 129-131, 7514 BP Enschede, The Netherlands
E-mail: fverberne@ rijksmuseum-twenthe.nl

Thea van Oosten, Netherlands Institute for Cultural Heritage, Gabriël Metsustraat 8, 1071 EA Amsterdam, The Netherlands
E-mail: thea.van.oosten@icn.nl

The long-term negative effects of vibration on paint layers on canvas have been thoroughly described and researched in the last two decades. Repeated research has shown that reducing the air space at the back of the stretcher by placing a backing board helps to restrain the canvas from vibrating. With this in mind, a practical system, with only minimal intervention on the work, was developed to further reduce the effects of vibration that occurs when handling canvas paintings. In the Rijksmuseum Twenthe's collection, the greatest problems of canvas vibration are encountered in large format paintings. A 'sandwich-construction' was developed to further diminish the air cushion between the canvas and the backing board. A polyethylene foam plate, approximately the same thickness as the stretcher, is cut to fit into the window formed by the stretcher. The inserts are mounted to a twin-walled polycarbonate sheet with nylon 6 screws. The latter can be adjusted to a position just under the surface of the foam plates.

At first the method was developed in order to deal with necessities such as internal or external transport of large paintings on canvas. In practice, the backing boards with the polyethylene foam inserts are sometimes left on the stretchers longer than originally planned. To assess whether the system is suitable as a short-term solution, and whether it could be considered for mid-term use, the precise composition of each of the different components of the sandwich was analyzed by the Netherlands Institute for Cultural Heritage's Research Department. Several other aspects were also taken into account during the research, such as the potentially damaging gaseous emissions from the materials, their ageing qualities and their possible negative interactions, as well as external factors that might influence either of these.

14. INCCA, the International Network for the Conservation of Contemporary Art

Tatja Scholte, Ysbrand Hummelen, Dionne Sillé, ICN, PO Box 76709, 1070 KA Amsterdam, The Netherlands
Email: incca@icn.nl

Since 1999, 11 international museums and other institutions of modern and contemporary art joined forces in the International Network for the Conservation of Contemporary Art (INCCA), a project undertaken to exchange professional information and to generate primary information by means of interviews with artists. The project will end in the autumn of 2002. This poster presents the results and strategies followed so far. The main objectives of the project were to develop an INCCA Web site (including professional tools, such as a literature database), to construct a reference database called the INCCA Artists' Archives and to produce a Guide to Good Practice for collecting artists' information. In view of the current backlogs in the gathering and sharing of information in the field, this project is dedicated to international collaboration, focusing mainly on interviews with artists and the accessibility of reference data via the INCCA Artists' Archives database. The aim is to develop this database into a virtual guide for informing professionals about materials and techniques used by artists, their working processes and the conservation of their works.

At the end of the first phase of the project, the main issues now are how INCCA will be continued in the future and how new members can join the network. It is INCCA's strong desire to evolve into a network for all professionals involved with the conservation of modern and contemporary art. A digital presentation as well as a poster in usual format is to be part of the session, and there will be facilities for potential new partners to apply for INCCA membership.

The organizer of INCCA is the Netherlands Institute for Cultural Heritage, and the co-organizer is the Tate. The project was funded by the European Commission, Raphael Programme, 1999.

15. Even better than saliva… about cleaning paintings!

Anne Rinuy, Laboratoire des Musées d'art et d'histoire, Case postale 3432, CH – 1211 Genève 3, Switzerland
E-mail: anne.rinuy@mah.ville-ge.ch

Experienced conservators of paintings often explain that there is nothing better than saliva to clean superficially soiled paintings. They cautiously call this treatment 'enzymatic cleaning'. Recently, our museum was preparing for an exhibition of works by the Swiss painter Pierre-Louis De la Rive (Geneva 1753-1817), works which include huge landscapes. Pierre-Antoine Héritier, one of the paintings conservators in charge of this exhibition, asked me 'couldn't you prepare artificial saliva? Otherwise, I will not survive cleaning so many square meters with my own saliva in such a short time'. After hard thinking, and numerous tests with the conservator, I prepared the 'SLUGS' (Saliva-Like Unsoiling Gainful Solution), guided by the chemical composition of saliva.[1] The composition of 'SLUGS' is:

- 0.3 % di-ammonium-hydrogeno-citrate
- 1.0 % sodium-hydrogeno-carbonate
- 2.0 % di-sodium-hydrogenophosphate
- 35 U lipase[2] for 100 ml de-ionized water

Every component is useful for removing the dirt. If they didn't, it wouldn't work as well as it does: citrates are buffers and chelating agents; hydrogeno-carbonates are buffers; phosphates, too, also act as surfactants (wetting, emulsifying agents) and calcium chelating agents; and the enzyme lipase helps to dissolve fatty dirt. The pH is 7.6-7.8 (lipase needs an alkaline pH and a temperature of 37°C). After rinsing once with water and drying, a final rinse with white spirit is recommended, if possible. Like saliva, this solution is an aqueous system: slight blanching might occur. So far, this treatment has been tested only on varnished paintings.

Paintings conservators hardly believed it—it works even *better* than saliva.

1. Wolbers, R, 2000, *Cleaning painted surfaces*, London, Archetype Publications.
2. Lipase enzyme (Fluka n° 62306), 350 mg per 100 ml

16. Etude comparative de quelques supports de tableaux de Vincent Van Gogh

Jean-Paul Rioux, Elisabeth Ravaud, Caroline Snyers, Christine Benoit et Michel Dubus, Centre de recherche et de restauration des musées de France, 6 rue des Pyramides, 75041 Paris cedex 01, France
Courriel :
jean-paul.rioux@culture.gouv.fr

Grâce à sa correspondance on sait que Van Gogh, à partir de la fin de l'année 1888, peignait sur des fragments de toile « ordinaire » préparée découpés dans des rouleaux de 2 m de large et de 10 m de long achetés par Théo chez *Tasset et Lhote*. La radiographie de 20 tableaux de l'artiste et l'analyse chimique de la préparation de 13 d'entre eux ont permis de caractériser et de comparer leurs supports. La dissymétrie du nombre de fils par cm en chaîne et en trame (12 et 17 environ), fréquente dans les tableaux peints à Arles, devient constante à de rares exceptions près à St Rémy et à Auvers. Des infiltrations ponctuelles de la préparation entre 4 fils voisins de la toile forment des zones pointillées sur la radiographie et sont une autre particularité de la toile de *Tasset*. La composition de la préparation, plus diversifiée, révèle des différences de fabrication : en plus des habituels blancs de plomb chargés avec de la craie et/ou du sulfate de baryum, l'analyse a décelé du lithopone utilisé soit comme pigment principal, soit comme additif. Parmi les préparations étudiées, ce pigment blanc apparaît pour la première fois fin 1888 (F 547). Les supports de cinq œuvres peintes à Auvers (F 756, F 764, F 783, F 754 et F 814) sont identiques : caractéristiques de la toile, épaisseur et composition des 2 couches de préparation. L'authenticité des trois premiers de ces tableaux n'a jamais été contestée contrairement aux deux derniers. L'identité des supports signifiant qu'ils sont probablement issus d'un même rouleau et que ces 5 tableaux seraient peints pendant la même période (juin 1890), apporte un fort argument en faveur de l'authenticité des deux œuvres mises en doute.

17. Quartz grounds identified in paintings by Rembrandt and his studio

Karin Groen, Netherlands Institute for Cultural Heritage, PO Box 76709, 1070 KA Amsterdam, The Netherlands
E-mail: karin.groen@icn.nl

Forty-six out of 170 grounds on canvas paintings by Rembrandt and his studio after 1640—the start of the execution of *The Night Watch*—were identified as quartz grounds. The quartz particles used measure c. 5 to 60 μm. The sharp edges of the particles indicate that the raw material (ordinary sand) was ground before use. A quartz ground appears in a cross-section under the optical microscope as a semi-transparent, yellowish to dark brown mass, with particles hardly visible due to the low refractive index of quartz and the discoloration of the medium. The cross-section was studied under an electron microscope and the elements were identified using energy dispersive X-ray analysis (SEM-EDX). EDX shows silicon

to be the main chemical element in the ground, with smaller amounts of Al, Fe, Mg, K, Ca and sometimes Na, Pb, Ti and Mn. The X-ray diffraction pattern shows up to 100% alpha-silica. The ground-up sand was mixed with a small amount of natural earth pigments and clay materials. Sometimes chalk, a little lead white or a lead dryer were present as well.

So far, no quartz grounds have been found in paintings by Dutch masters who worked in Amsterdam between 1640 and 1669 but had no studio connection with Rembrandt. The motive for the use of a new type of ground, developed in Rembrandt's studio for *The Night Watch*, could have been the extraordinary size of this painting. *The Night Watch* is painted on a canvas originally measuring about 420 x 500 cm. The examination of the grounds provided strong, additional criteria for the attribution of paintings with quartz grounds to painters who worked in Rembrandt's studio around or after 1640, including Rembrandt himself.

18. Study of some degradation processes in Peruvian artwork found in Brazil

M. Rizzo, Laboratório de Conservação e Restauração de Bens Culturais S/C, São Paulo, Brazil

J. A. Carmo, H. Cortopassi Jr., J. P. S. Farah (corresponding author), Instituto de Química, Universidade de São Paulo, São Paulo, Brazil
E-mail: jpsfarah@usp.br

A serious problem identified in 16th- and 17th-century Peruvian works of art that were brought to Brazil, often illegally in the 1950s and 1960s, is their vulnerability to contamination by micro-organisms. The salient features of these paintings, in their original condition, are the peculiar composition of the ground and the lack of original varnish. Most of these works have been treated inappropriately by conservators; interventions include wax lining and varnishing. These interventions have changed the response of these paintings to their environmental conditions. The Brazilian climate is hotter and more humid than that of Peru. These two factors have proved to be an unfortunate combination.

In order to investigate this problem, we analyzed these paintings to discover the nature of their grounds and to identify the materials added by later restorers. Methods used were FTIR and HNMR. A high level of carbohydrates was found in the brown grounds and paint layers. The medium of the painting and ground was therefore originally porous to water vapour. Degradation of more recently applied wax coatings was also identified. This has led to the bloom on the painting surface, which was ascribed to the high moisture content of the upper paint layers. The wax has acted as a moisture barrier under the extreme atmospheric conditions of temperature and humidity. This mechanism could also explain the mould growth from which these works suffer. We are currently considering putting paintings of this sort into hermetically sealed boxes with humidity controls.

19. Evolución del color y estrategia programada para el tratamiento de conservación de un *studiolo* de época renacimiento en Holanda

Juan Carlos Bermejo-Cejudo, Conservador-restaurador de escultura y policromía, SRAL *Stichting Restauratie Atelier Limburg*, Daemslunet 1C 6221, KZ Maastricht, Holanda
E-mail: juanito_bermejo@yahoo.com

El interior renacimiento conocido como *De rozinkorf* pertenece a la colección del Museo Simon van Gijn en Dordrecht (Holanda) y se construyó en 1672. Los paramentos de la habitación están recubiertos de cueros policromados. Una chimenea en madera pintada, y una alcoba son los elementos principales de la sala. Un bodegón y festones tallados decoran estos elementos. El techo presenta dos pinturas sobre lienzo divididas por una viga en madera esculpida y pintada.

Los elementos de madera están constituidas en cuatro tipos de madera diferente (resinosa, tilo, roble y madera tropical de crecimiento rápido). Para el montaje original de las piezas el artista no utilizó cola animal, sólo clavos forjados, práctica corriente en el siglo diecisiete en este tipo de trabajos. Cinco ventanas estratigráficas de correspondencia de capas de policromía, fueron realizadas para poder visualizar y evaluar el estado de la policromía original. Paralelamente se dataron también las diferentes repolicromias.

La policromía original es sobria y equilibrada. Al menos dos finas capas de carbonato de calcio y cola animal cubren la delantera de las piezas. Los planos de las pilastras están pintados en imitación de mármol: mármol blanco con venas en gris. Las molduras interiores están doradas al óleo (mixtión ocre) Los festones y los putti del arco de la alcoba aparecen policromados en gris perla, imitación de piedra. Los fondos planos del arco y el interior de las pilastras son negros 'granulado', de aspecto mate, que reproduce una superficie aterciopelada.

Los cueros presentan una policromía completamente diferente, técnicamente, a la de los elementos lígneos. Los 119 paneles de cuero están cubiertos de hoja de plata encolada con una mixtion oleosa. Para proteger la plata de la oxidación, los policromadores la recubrieron de blanco de huevo. Para imitar una superficie

dorada, utilizaron el 'barniz oro', hecho a base de colofonia. A continuación los fondos fueron pintados en azul (esmalte+blanco de plomo+aceite de lino) alterado actualmente. Después los barnices coloreados (oscurecidos fuertemente) son aplicados sobre los festones en relieve: verde (resinato de cobre) rojo (laca de garanza) y azul (esmalte).

La policromía de los cueros se consolidó parcialmente con una resina sintética Paraloid B72, la de la madera con Mowilith DMC2 diluido en agua con un fluidificante. En primer lugar un barniz alquídico brillante y oxidado sobre todas las superficies fue eliminado con dos técnicas. En los cueros utilizamos el *strappo* y en las estructuras lígneas disolventes orgánicos en un sistema gelificado. En segundo lugar, la patina artificial de las policromías de los elementos de madera se eliminó con un abrasivo impregnado en agua desmineralizada ligeramente básica. En vistas de la nueva presentación museográfica los paneles de cuero se forraron por la parte trasera con un soporte inerte para la posterior colocación en los muros con puntos de velcro.

20. Restauración del retablo mayor de la Iglesia de San Juan Bautista de Carbonero el Mayor, Segovia

Rocío Salas Almela, Restauradora de pintura del IPHE, Ministerio de Educación y Cultura, Greco 4, 28040 Madrid, España
E-mail: guo@infonegocio.com

Compuesto por 21 tablas, en él se unen, admirablemente, la influencia flamenca en la pintura y el gusto plateresco en los delicados relieves de la mazonería. Sobre él se ha intervenido, tanto desde el análisis de los materiales, con el que se ha documentado la técnica de ejecución, como desde el estudio histórico y estilístico, tan interesante en una obra de esta categoría, donde se plantean interrogantes sobre sus autores.

Los estudios han comprendido: la radiografía y reflectografía completa de las tablas y el análisis e identificación de pigmentos, aglutinantes y barnices. También se estudiaron y trataron las condiciones ambientales y ataques biológicos. Destacaremos la identificación de Carbonato Cálcico en la preparación de las pinturas que, al igual que el roble presente en las tablas, es poco frecuente en España, lo que nos ha servido para relacionar, aún más, este retablo con el ámbito flamenco. Las reflectografías realizadas han mostrado un magnífico dibujo subyacente ejecutado a pincel y ha servido para comparar con otras de pintores cercanos estilísticamente al retablo. Se ha realizado la mínima intervención necesaria, mejorando su conservación e interviniendo en la limpieza y reintegración con el máximo respeto a la obra, diferenciando los añadidos y sin eliminar elementos originales. Destacaremos la limpieza que permitió mantener el barniz original intacto, ya que se realizó con una solución acuosa de Citrato de Triamónio a un pH7.

El retablo fue desmontado debido a la carencia de estructura original y a su falta de capacidad sustentante. El nuevo montaje diseñado consistió en un novedoso sistema que combina, al mismo tiempo, la sujeción perimetral de las tablas con el anclaje del conjunto.

21. La restauración como apoyo para confirmar una atribución

Carolina Nardi, Moema N. Queiroz, CECOR-Centro de Conservação e Restauração de Bens Culturais, Universidade Federal de Minas Gerais, 30270-010 Belo Horizonte, Minas Gerais, Brazil
E-mails: nardi@brhs.com.br, monaque@dedalus.lcc.ufmg.br

Estudio comparativo y restauración de tres imágenes del siglo XVIII atribuidas al maestro de Barão de Cocais, objetivando confirmar su autoría, sistematizar y establecer parámetros para identificar otras obras de este maestro. Las imágenes de San José de Botas, San Sebastián y Santa Ana Maestra, parte integrantes del acervo del Museo Mineiro, poseen misma técnica de ejecución y policroma similar. La madera, *Cedrella* sp. y los materiales constitutivos, yeso y pegamento animal en la base de la preparación, pintura témpera y al óleo, doradura a base de agua y pasta ocre. Contaban con problemas estructurales agrabados por recientes impactos mecánicos, policroma con desgastes e intervenciones inadecuadas. La restauración englobó el tratamiento estructural y pictórico.

La restauración rescató la unidad del conjunto, auxiliando la confirmación de la atribución. La investigación documental, la clasificación y sistematización del estilo, marcaron el rumbo de los parámetros a ser utilizados para otras obras del maestro. Los análisis formal y estilístico, determinaron características y soluciones de su estilo: esculturas compactas, cabellos sobre las espaldas en puntas, ojos almendrados, labio superior saliente, con el surco naso-labial protuberante, mentón proyectado con una entrada tipo agujero, cuello corto y rollizo, dedos alargados, uñas rectangulares, ropa escotada y fruncida hasta la cintura, mantos triangulares invertidos con dobleces diagonales surcados, puños angulosos y octagonales. A través del estudio localizamos otras imágenes con las mismas características en la região de Barão de Cocais.

22. Conceptos y criterios para la conservación de un conjunto escultórico en grave estado de deterioro

Moema N. Queiroz, Mário A. Sousa Jr, Maria Regina E. Quites, CECOR, Centro de Conservação e Restauração de Bens Culturais Móveis, Universidade Federal de Minas Gerais, 30270-010 Belo Horizonte, Minas Gerais, Brasil
E-mail:
monaque@dedalus.lcc.ufmg.br (Queiroz),
masaju@dedalus.lcc.ufmg.br (Sousa),
mreq@dedalus.lcc.ufmg.br (Quites)

Estudio y tratamiento de un conjunto escultórico (siglos XVIII, XIX), con grave proceso de deterioro, parte integrante de un proyecto de conservación-restauración de 84 obras del acervo de la ciudad de Paracatu, Minas Gerais, Brasil. El acervo es de propiedad de la Mitra Diocesana de la ciudad de Paracatu. No podemos aún precisar su origen, considerando la diversidad de informaciones orales y la escasa documentación existente. Se sabe que desde la década del 1970 hasta fines de 2000, estas obras se encontraban acondicionadas inadecuadamente en la sede parroquial de la hermandad.

Las esculturas (madera dorada y policromada), se componen de bloques principales y complementarios. Se encontraban en grave proceso de deterioro, con problemas estructurales y, principalmente, pérdida casi total de la policromía, ejemplificadas en las ilustraciones anejas. Los aspectos estéticos e históricos guiaron los trabajos, considerando el contexto en que ellas se insertan. Se adoptó una 'conservación arqueológica', rescatando únicamente las informaciones contenidas a partir de los fragmentos de policromía. Se ejecutó un tratamiento estructural con la consolidación del soporte sin complementar las partes y una presentación estética en los fragmentos de policromado existentes.

El conjunto escultórico adquirió una unidad, permitiendo su lectura exenta de cualesquier otros elementos que interfieran en los originales. Su fuerza se apoya en sus partes 'ausentes', haciendo emerger otros valores que antes no eran percibidos.

23. Conveying the faith: conservation and restoration of folkloric religious art objects

Rosanna Kuon, Museo de Arte de Lima, Salamanca 265, Lima 27, Perú
E-mail: kuon@terra.com.pe

Numerous ethnographical and ethnological studies on the popular religiosity in the Central Andes region depict the vitality and richness of these expressions throughout an annual calendar of rites and holidays which, in many cases, originated as long as 450 years ago. Even contemporary religious holidays in the region are structured around the celebration of Catholic ephemeridae of saints and virgins, with an enormous amount of paraphernalia that includes music, dancing, liquors and a variety of elements, such as ephemeral architecture (altars, triumph arcs) as well as *demandas*, flags, *detentes* and *retablos*. This poster presentation is focused on the latter: small artistic wooden boxes with a popular religious meaning, called *retablos*, the antecedents of which go back to Hispanic popular religious objects such as the *Capillas Santeros* and portable altars. These small boxes were used in Andean villages as small mobile altars for the cult during colonial times. They are often painted with a profusion of brilliant flowers that refer to the celestial world, and they usually have two levels in the inner part. An image of the Eternal Father or The Trinity is usually placed in the upper part, in a clear allusion to heaven; and in the lower part may be found a representation of the Virgin, a Saint image, or a combination of religious images.

The presentation of this poster emphasizes that the conservation of these unique examples of folkloric art goes far beyond the registration of a typical procedure to preserve our heritage, or the symbolic meaning of historic moments lived by our peoples. It is, most of all, an act of rescue of a patrimony that has survived over centuries as a demonstration of the liveliness and adaptative capacity of elements of Andean culture in the context of modern religious expressions.

24. The influence of paper based filling enclosures containing alkaline loadings on pH-sensitive works of graphic art and photographs

Roland Damm, Gerhard Banik, Staatliche Akademie der bildenden Künste, Höhenstrasse 16, D-70736 Fellbach, Germany
E-mail: gerhard.banik@sabk.de

One of the major concerns of paper conservation is the appropriate storage of sensitive items. In most cases, wrapping papers are used that are loaded with 2% calcium carbonate, according to ISO 97 06. It has been observed, however, that these wrapping papers cause yellowing of albumin prints, fading of cyanotypes and discoloration of organic dyes through migration of alkaline compounds, most probably due to fluctuating climatic conditions. For our investigations, migration of alkaline loadings was enforced by an procedure in which stacks of paper (enclosed in an airtight bag of a defined volume) were treated by repeatedly fluctuating external temperatures between 35°C and 65°C. The cyclic changes in temperature are transferred almost immediately onto the entire system and induced migration of absorbed water within the paper stack. To indicate small amounts of alkaline components transferred from one sheet to another, cyanotypes were chosen. Cyanotypes are sensitive towards even a moderate alkaline environment. Indicators were placed within the stacks in such a way that each cyanotype was covered with a alkaline-loaded wrapping paper on both sides. The experiments

demonstrated clearly that through a moderate migration of absorbed moisture within a stack of paper, alkaline components can be transported by the mobile water from wrapping papers into an object. The cyanotype indicators showed little to distinguish changes in hue from blue to yellow due to hydrolysis of Prussian blue under slight alkaline conditions. Papers free of alkaline loadings did not cause any colour change in the cyanotypes under identical experimental conditions.

25. Manuscript inks: Fourier Transform Infrared (FTIR) analysis with Attenuated Total Reflection (ATR) objective

Núria Ferrer, Serveis Científicotècnics (SCT), Universitat de Barcelona, Lluís Solé i Sabarís, 1, 08028 Barcelona, Spain
E-mail: nuri@giga.sct.ub.es

M. Carme Sistach, Arxiu Corona d'Aragó (ACA), Ministerio de Cultura, Almogàvers, 77, 08018 Barcelona, Spain
E-mail: csistach@terra.es

Attenuated Total Reflection (ATR) objective with microscope was applied to IR analysis of manuscript inks. Bad spectra may result from the irregular surface of the manuscript sample because an important condition for this method is a flattened surface. An unhomogeneous thick layer of ink in the writing can be seen by optical microscopy. This irregular surface of inked paper is caused by fibres impregnated with ink and by the discontinuous sediment of ink. In order to improve the contact with the ATR objective and to obtain better spectral information, the ink was flattened with a roller before using this ATR method. Quality of spectra depends on the amount of ink placed on the surface of the sample, relative to cellulose. Black and also acidic inks keep more ink compound in the sample than brown inks, which have barely iron gall ink in its trace of writing. The condition of the ink layer spread on the surface of the paper is important for spectral quality. ATR results show repetitive bands belonging to the ink, which were close to the band of limonite. In parchment samples, it was possible to identify characteristic bands associated with basic iron oxides, probably produced when iron from the ink interacts with basic calcium carbonate in parchments. Unfortunately, the IR range of ATR objective with microscope starts at 720 cm^{-1}. This means that iron oxides, which are probably also in the ink, cannot be detected.

26. New sources of cellulose for the production of paper to be employed in conservation and restoration

Clara Landim Fritoli, Praça Ruy Barbosa 795, Apto. 36, CEP 80010-030, Curitiba-PR, Brazil
E-mail: claralandim@bol.com.br

This work analyzes the quality of fibres in handmade papers from alternative raw materials like buriti (*Mauricia vinifera*) and tucum (*Bactris lindiamara*), both native species of the Brazilian flora. The fibres of the plants researched offer superior length when compared to the short wood fibres of *Eucalyptus* spp., but shorter than the long fibres of the coniferous *Araucária* sp. and *Pinus* spp. As the tucum fibres are longer than buriti ones, they can be classified as medium or long, while buriti fibres are short or medium. Width and thickness are alike in both plants, and on the whole they yield morphologically thinner and longer fibres than conventional cellulose wood pulp. Obtaining cellulose pulp by the Kraft process, with less drastic cooking conditions, is used so that the wood will yield good characteristics of delignizing. The physical, mechanical and optical properties of the handmade paper sheets produced in laboratory from both species and the treatments have demonstrated average values compatible with wood fibres conventionally used. Between the two species, tucum fibres have shown a higher mechanical strength in all tested properties. When compared to wood fibres conventionally used, whether they are long or short, impressive results were obtained for resistance to tearing, which allows us to conclude that both species possess valuable fibres for this kind of resistance. As a general conclusion, we can state that the fibres of the two materials studied in this work, tucum and buriti, show valuable characteristics, especially with regard to tearing resistance, so they have great potential for papers that require that characteristic, such as in the conditioning of books and documents.

27. Comparative study of natural and synthetic adhesives for strengthening the dye layer of book miniatures

Olga Perminova, Tatyana Stepanova, Irina Burtceva, Arkadiy Kamenskiy, Evgeniy Yakhnin, Albina Sharikova, Valentina Popunova, Russian State Library, Vozdvizjenka 3, 101000 Moscow, Russia
E-mail: olgaperm@mtu-net.ru

The state of illuminated books has long caused alarm all over the world. Libraries have ceased to issue such items to researchers because the dye-stuffs of miniatures come off. Shortcomings are inherent in the materials used for strengthening the dye layer of miniatures (compositions of artificial polymers). Scientists of the Research Centre for the Conservation of Documents of the Russian State Library have for decades been investigating the problem of the flaking off of the dye layer in illuminated book paintings. Analyses of manuscripts and rare books in the Russian State Library have shown that most of these show damage in the book miniatures, especially among the paper documents. In 1995, researchers suggested using natural polymers similar to those that had been used by the authors of the book paintings. The Research Centre for the Conservation of Documents has been involved in such relevant research for decades, and it must be said now that a

composition has been found that fulfils a number of requirements. Modified parchment glue, i.e. its alcoholic water-soluble fraction, was examined. The examination showed the modification to have a number of benefits, including lowered viscosity and consequently heightened mobility, and better permeability of the solution, and affinity with the warp of the document and ancient binders, and the like. This poster sets out the results of the comparative study of natural and synthetic adhesives for strengthening the dye layer of book miniatures and offers recommendations for their use.

28. Application of the Albertina poultice for removing linings from water-sensitive Japanese woodblock prints

Regina Schneller, Andrea Pataki, Gerhard Banik, Staatliche Akademie der bildenden Künste, Höhenstrasse 16, D-70736 Fellbach, Germany
E-mail: gerhard.banik@sabk.de

Elisabeth Thobois, Albertina, Vienna

The Japanese woodblock print, the so-called Ukiyo-e, dates from the end of the 17th century to the mid 19th century. The printing media of Japanese woodblock prints are mostly of organic origin and are often very sensitive to water. Frequently, these prints have been relined with Japanese or Western papers by means of starch paste. The removal of the linings usually requires humidification. A possible technique for detaching relinings is the application of the so-called Albertina poultice. This enzyme poultice allows effective liquification of starch-based adhesives at low levels of humidification. The advantage of an enzymatic treatment is that starch-based adhesives are digested to low molecular water soluble products of low viscosity. Thus, the formed decomposition products are much more easily removed compared to humidified but still viscous pastes. The enzymatic intervention technique reduces the danger of tensions and stiffness caused by residual paste in the original item. The complete area of the relined print may be treated in one operation. Poultice assembling follows the description given by Schwarz (1999).[1] Even humidification of the poultice is decisive. A recommended procedure is to soak both the interleaf paper and the blotter serving as humidity reservoir in water and subsequently to remove access moisture. The enzyme carrying nonwoven is humidified by spraying. Quick assembling of the poultice is necessary to avoid early drying of the poultice. Detachment of relinings from Japanese woodblock prints was possible after 20 to 30 minutes of enzymatic action.

1 Ingrid Schwarz et al., 1999, 'The development of a ready-for-use poultice for local removal of starch paste by enzymatic action', *Restaurator* 20: 225–244.

29. Natural rubber figures in the Dutch National Museum of Ethnology: composition, condition and conservation

Margrit Reuss, National Museum of Ethnology, Steenstraat 1, 2312 BS Leiden, The Netherlands
E-mail: margrit@rmv.nl

Thea van Oosten, Henk van Keulen, Pieter Hallebeek, National Institute for Cultural Heritage (ICN), Gabriel Metsustraat 8, 1071 EA Amsterdam, The Netherlands

The National Museum of Ethnology Leiden possesses a number of objects made of natural rubber, including balls, raincoats and figurines. This research focuses on the latter: 14 figurines from South America (Surinam and Brazil) and Southeast Asia (Borneo) depicting boats, trees and people. They are currently hard, brittle and cracked, and most are broken into many pieces. Unlike rubber balls, the figurines were never intended to be elastic. Evidence for this comes from FTIR analysis identifying the material as being similar to gutta percha, a non-elastic trans-configuration of natural rubber isomers. Py-GC-MS showed that samples contained few isoprene units but a high proportion of α and β amyrin acetate, which are triterpenes as found in natural resins. EDXRF analysis detected 0.1-0.2% sulphur. Whether this occurs naturally or was added later is currently unresolved.

Presently the objects are extremely vulnerable to damage during handling. Damaged objects cannot be displayed, and some are fragmented, so they cannot even be studied properly. It is not clear whether the present, very fragile condition can be regarded as a 'final state' of deterioration or whether further decay is to be expected. Accelerated ageing is currently being conducted on a small sample to determine this. Rubber objects have previously been sealed in oxygen-depleted atmospheres to prevent further degradation. This method is unsuitable for exhibiting the objects or for allowing proper study. Other options being investigated for treatment and storage include using consolidants, external supports and anti-oxidants.

30. An investigation of the early synthetic purple dye murexide ca.1853–1865.

Christina Margariti, 16-18 Amfias Street, Gyzi, 114 75 Athens, Greece
E-mail: xchrisma@hotmail.com

The earliest human-made purple dye that predates Perkin's mauve was murexide, used from about 1853 to 1865. Very little is known about murexide or murexide-dyed textiles. The aim of this investigation was to prepare murexide and dye cloth with it. The original patents (1855, 1856, 1858, 1859) were the starting point of the experiments. Although the patents were very informative in some ways, when it came to making and using murexide, the information was inaccurate and

unclear. Murexide proved to be a very unstable dye and difficult to use. It is very sensitive to pH changes, heat and light. Mercury (II) chloride and mercury acetate are essential for dyeing cloth with murexide.

The conservation implications for a textile dyed and/or printed with murexide are the following. The textile should not be washed, since the dye is not wash fast, and it should be stored away from light and displayed for only very short periods, since the dye has poor light fastness. Because a murexide-dyed textile would almost certainly have been treated with mercury, careful attention must to be paid to health and safety measures, such as avoiding skin contact with it. The documentation implications are that a textile dyed and/or printed with murexide can be dated to between 1853 and 1865 and it is highly likely that it was produced in either England or France. Further research and experimentation on the wash and light fastness of murexide would help determine the rates and results of dye bleeding and fading. This would make the identification of murexide on any existing samples both easier and more accurate.

31. Analysis of restoration materials for replacement of lost fragments on broken ceramic objects

Anneliese Kriebel Rodríguez, Escuela Nacional de Conservación, Restauración y Museografía (ENCRyM), Ex-convento de Churubusco, Xicotencatl y Gral Anaya, Coyoacan, 04120 D.F. México
E-mail: anne_90210@hotmail.com

In the daily restoration work on ceramic objects, it is necessary to fill minor losses or to complete missing areas. By this structural stabilization process, the object will recover its aesthetic aspect, historic value and also its functional purpose. In Mexico, a variety of commercial synthetic products are used as ceramic fillers, but most have not been tested for conservation. Tests were carried out on the following products: ceramic dough (ENCRyM's recipe); Comex® pine-colour wood filler; OK-Comex® and Red Devil® plaster fillers; Poliplásticos® epoxy resin; and Poliplásticos® crystal polyester resin. Additional tests were carried out with crystal polyester and epoxy resin mixed with 23% of fumed silica gel. Three samples of equal size (2.4 x 1.5 x 0.5 cm) were made of each product for testing (24 samples total). The samples were assessed for the following: drying time, hardness, shrinkage, reversibility, and light and temperature stability. Finally, the products were applied to glazed and non-glazed ceramic and porcelain to assess the following: ease of application and handling, viscosity, cleanliness during application and shape retention upon drying. From these results, it was possible to compare the qualities of the main products used in Mexico as ceramic fillers. The conclusions of the research are presented in this poster.

32. La conservación de hierro arqueológico en México
32. The conservation of archaeological iron in Mexico

Pilar Tapia López, Escuela Nacional de Conservación, Restauración y Museografía (ENCRyM), Ex-convento de Churubusco, Xicotencatl y Gral Anaya, Coyoacan, 04120 D.F. México
E-mail: pilartap@prodigy.net.mx

Se presentan de forma general los tratamientos de restauración de objetos arqueológicos de hierro, aplicados en la ENCRyM a partir del año 1991, cuando se comenzaron a restaurar este tipo de bienes bajo métodos descritos en la bibliografía especializada, así como adaptando tratamientos usados anteriormente en la ENCRyM sobre objetos históricos. Se practica la toma de rayos X, exámenes visuales, e identificación a la gota de metales constitutivos. La presencia de cloruros es determinada por medio de la prueba del nitrato de plata y la medición por conductímetro. Para consolidar se ha aplicado cera microcristalina y el Paraloid® B72. En la limpieza se usa la limpieza mecánica, química y electrolítica. En la limpieza química se han empleado: hexametafosfato de sodio, sulfito de sodio, ácido tánico, fosfórico, cítrico y oxálico. La limpieza electrolítica se ha hecho con hidróxido de sodio como electrolito, y acero inoxidable como ánodo. Como pasivadores se han usado el ácido tánico y el hexametafosfato de sodio. Para los procesos de consolidación, capa de protección y unión de fragmentos se aplica Paraloid® B72 en diversos medios y porcentajes. La ENCRyM ha diseñado una pasta, usada comúnmente para el resane y la reposición de faltantes cuyos componentes son: Paraloid® B72, carborundum y cab-o-sil.

Se presentarán cuatro estudios de caso sobre piezas de los siglos XVII, XIX y XX, localizadas en excavaciones del Centro Histórico de la Ciudad de México. Se revisan los criterios de restauración, así como los materiales y métodos empleados en cada tipo de artefacto.

The aim of this poster is to show in a general way how the National School of Conservation, Restoration and Museography has restored archaeological objects

made in iron. Treatment of these kinds of objects started in 1991. Treatments that were found in the specialized literature were used, as well as those that had been used on historical objects. X-ray, visual examination and micro-chemical tests were used to identify the metal in each case. Silver nitrate tests and conductimetre were used for chloride measurement. Mycrocristaline wax and Paraloid® B72 were used for consolidation. Mechanical, chemical and electrolytic cleaning were used (chemical cleaning was done with sodium tripolyphosphate, sodium sulphite, tanic acid, phosphoric acid, citric acid and oxalic acid. Electrolytic cleaning was done with sodium hidroxide and stainless steel. Tanic acid and sodium tripolyphosphate was used for archaeological iron stabilization. Paraloid® B72 in different percentage and solvents were used for consolidation, surface protection and adhesion of fragments. The National School of Conservation has created a special filling paste with Paraloid® B72, carborundum and cab-o-sil.

The poster describes treatments of four different archaeological iron objects that were found in the historical centre of Mexico City. These objects are from the 17th, 19th and early 20th centuries. The materials, methods and theoretical aspects of restoration will be explained for each object.

33. Corrosion and conservation of copper and its alloys in the Republic of Cuba

Ana E. Cepero Acán, Ileana Salgado Ravelo, National Centre for Conservation, Restoration and Museology (CENCREM), CP 10100, La Habana Vieja, Cuba
E-mail: acepero@cencrem.cult.cu

The conservation of bronze monuments is of great importance at present, as the increase of environmental impacts have accelerated the decay processes of this alloy out-of-doors. In the Republic of Cuba, research is in progress to evaluate copper and its alloys as well as new protective coatings available in this humid tropical country. In part, results of our ongoing scientific research programme at various corrosion testing stations, we can state that greater copper corrosion occurs along the north coast than along the south coast of the island. In the three corrosion sites selected, when we made a correlation between the copper corrosion plates and the environmental pollution (mainly SO_2 and salinity), we observed that copper is more sensitive to attack by sulfur compounds than by chloride ions when corroding out-of-doors. Analysis of crust samples of the copper plates (DRX, IR, SEM-EDAX) showed that the composition of the corrosion products fits well as reported with the existing pollution, having more sulphates in industrial zones and more chlorides at the coast. It is remarkable that the copper corrosion values in the Cuban rural stations were similar to those reported in European coastal zones. However, the order of the atmospheric aggressiveness was different. In Europe it is industrial first and seashore second, and in Cuba seashore first and industrial second.

The aggressiveness of the Cuban climate towards bronze monuments demands more effective protective coatings. So we started testing ORMOCER systems. Evaluation of brass plate samples coated with two systems (OR5 and OR16), exposed for 18 months at two Cuban stations (corrosion agressivity C3 and C4, ISO 9223), was done according to ISO 4540-1980. The coating systems were not very effective under these climatic conditions. At present, the percentage of damaged surface is high, mainly at the rural station; the samples lost their brightness after two months, and showed pits, dark spots and some cracks. Samples at the industrial station were more resistant.

34. Towards more stable natural resin varnishes

Patrick Dietemann, Christian Sudano, Moritz Kälin, Richard Knochenmuss and Renato Zenobi, Swiss Federal Institute of Technology, ETH Hönggerberg E330, 8093 Zürich, Switzerland
E-mail: dietemann@org.chem.ethz.ch

Natural resins are widely used as varnishes on paintings. Since they oxidize and yellow considerably within a relatively short time, it would be better to have more stable and less yellowing varnishes. Earlier work by us has shown that commercial, nominally 'fresh' mastic resin is already in an advanced state of oxidation and considerably changed compared to very fresh resin. To investigate the influence of sunlight exposure during harvesting, samples of mastic resin were collected on the island of Chios, Greece, some without exposure to sunlight and some which were exposed to sunlight for several days. These different resins were artificially and naturally aged in darkness or light (with and without UV). Oxidative and yellowing processes were monitored by EPR (radical concentrations), UV–VIS spectrometry (yellowing), graphite-assisted LDI-MS and FTIR (oxidation), and GPC (polymerization). Our data reveal that radical concentrations decrease when a resin is kept in darkness, but significant amounts remain. As a result, oxidation continues in darkness. All resins harvested in darkness contain significantly less

radicals than all resins conventionally dried in the sun. Radical concentrations also build up more slowly during artificial ageing of these resins. Oxidation, although it proceeds rapidly, is therefore less pronounced. All resins collected in darkness yellow considerably less under all ageing conditions (darkness, and light with and without UV).

Index of preprint authors / Index des auteurs des prétirages / Indice de autores de trabajos completos

Abraham, M. 894
Ackroyd, P. 321, 370
Agüero, S. 51
Aitken, G. 287
Åkerlund, M. 96
Aliev, A. 615
Allart, D. 383
Alonso-Olvera, A. 712
Alquié, G. 295
Antomarchi, C. 119
Aschero, C.A. 582
Ashley-Smith, J. 3
Aucouturier, M. 851
Aze, S. 549

Bacci, G. 238
Bacci, M. 73, 238
Baeschlin, N. 770
Baldini, I. 34
Banik, G. 597
Barov, Z. 809
Beillard, B. 835
Beltinger, K. 388
Berardi, M.C. 785
Berg, H. 80
Bergh, J-E. 96
Berlowicz, B. 394
Berns, R.S. 211, 217
Berry, J. 108
Binnie, N. 328
Blades, N. 9
Bonnot-Diconne, C. 764
Boon, J.J. 73, 223, 401
Botelho, A.M. 658
Brajer, I. 153
Brancati, L.E. 730
Bret, J. 439
Brokerhof, A.W. 15
Brooks, M.M. 125
Brown, K. 597
Burnstock, A. 261
Bykova, G.Z. 593

Campagnoni, D.P. 903
Cane, S. 21
Cappitelli, F. 231
Carlyle, L. 328
Carrassón López de
 Letona, A. 490
Cassar, M. 9
Casu, G. 609
Cazenobe, I. 238
Chahine, C. 777
Chang, C.A. 920
Chiantore, O. 903, 911
Christensen, M.C. 394
Christiani, C. 823
Christofides, C. 295
Cirujano, C. 496
Civil, I. 407
Clark, J. 269
Cobo del Arco, B. 533
Coelho, B. 502
Cohen, N.S. 73, 615
Colinart, S. 540, 851
Colson, I. 851
Considine, B. 245
Conti, S. 238
Cook, G. 414
Cooper, M. 701
Cotte, P. 295
Coural, N. 764
Cruz Lara, A. 160, 829
Csillag, I. 637
Cummings, A. 231
Cyphers, A. 829

da Silveira, L. 727
Dahlstrøm, N. 80
Dardes, K. 132
David de Oliveira Castello
 Branco, H. 556
de Deyne, C. 295
de Groot, S. 464
de Joia, A. 108
de Keijzer, M. 770
de la Rie, E.R. 211, 881
de Tagle, A. 245, 352, 658
Degrand, L. 540
Del Zotto, F. 338
Derbyshire, A. 3, 597
Di Nola, C. 730
Dorge, V. 27, 245, 352
Dran, J-C. 851
Dubus, M. 851
Dufresne, J-L. 301
Dupuis, G. 419
Duval, A. 609
Dvalishvili, M. 560

Eastop, D. 747, 755
Eggert, G. 860
Elias, M. 419
Englisch, G. 388
Eshøj, B. 137
Esmeraldo, E.G. 34

Faulk, W. 27
Filippi, M. 903
Fiske, T. 166
Forstmeyer, K. 622
Foster, G.M. 615
François, S. 125
Frigione, M. 888
Frosinini, C. 609

Gall-Ortlik, A. 835
Ganther, W. 865
Geldof, M. 464
Giovannini, A. 622
Gittins, M. 560
Gómez Espinosa, T. 490
González Tirado, C. 823
Gordon, E. 346
Gradin, C. 582
Grauby, O. 549
Grimaldi Sierra, D.M. 565
Gros, D. 388
Guerra-Librero, F. 496
Guevara Muñoz, M.E. 823, 829
Guicharnaud, H. 609
Gunn, M. 851

Hackney, S. 426
Hallebeek, P. 770
Hallström, A. 96
Hanus, J. 603
Hanusová, E. 603
Haydock, P. 571
Heeren, R.M.A. 252
Helwig, K. 582
Hennessy, S. 38
Henriksen, K-M. 360
Henry, J.P. 673
Herm, C. 388
Hesterman, W. 252
Heydenreich, G. 432
Hibberd, R. 370
Higgitt, C. 455
Hillyer, L. 755
Hoffmann, P. 718
Homulos, P. 275
Honda, K. 281
Hornbeck, S. 679
Hughes, J. 38, 865

Ikeshoji, N. 281
Imai, F.H. 217
Imazu, S. 712

Johansen, K.B. 644
Johnsen, J.S. 644
Johnson, J.S. 673
Joly, M.C. 86
Jonsson, K. 96
Juchauld, F. 777

Kaminska, E. 328
Kamiuchi, T. 281
Kanai, T. 281
Kargère, L.G. 507
Keita, B.F. 119
Kennedy, N.W. 651
Keune, K. 223, 401
Khandekar, N. 245, 352
Khanjian, H. 245, 352, 658
Kibrya, R. 597
King, G. 865
Knight, B. 45
Koldeweij, E. 764
Kruppa, D. 9
Kuon, R. 51
Kuprashvili, N. 560
Kutzke, H. 860

Laguna Paúl, T. 496
Lahanier, C. 287, 295, 301
Lahoda, F. 360
Laing, A. 479
Lampropoulos, V. 801
Lanterna, G. 238
Larsson, I. 252
Laurent, A-M. 851
Lavédrine, B. 664
Learner, T. 223, 231, 911
Lehmann Banke, P. 360
Leirens, I. 513
Leroy, M. 851
Lettieri, M. 888
Lewis, P. 287
Little, S. 736
Lomax, S.Q. 881
Luhila, M. 119

Mack, A. 920
MacLeod, I.D. 571, 871
Madden, O. 894
Maekawa, S. 58
Magar, V. 176, 578
Maines, C.A. 881
Maish, J. 245
Marinov, T. 809
Martin, E. 439
Martín, I.H. 841
Martínez, J.M. 27
Martinez, K. 287
May, R. 851
Maynés, P. 172
Mazzeo, R. 137
Mecchi, A.M. 888
Mellor, S. 679
Mendoza-Anaya, D. 712
Menu, M. 419
Michalski, S. 66, 407
Miller, D. 245
Mináriková, J. 603
Mochimaru, Y. 281
Moffett, D. 679
Moignard, B. 851
Montalbano, L. 609
Moresi, C.M.D. 520
Morgan, S. 261
Morgos, A. 712
Murray, A. 407, 565

Noble, P. 401
Norris, D.H. 651

Odlyha, M. 73, 615
Onetto, M. 582
Orea, H. 176
Ortega, R. 96
Ostapkowicz, J. 701
Owen-Hughes, H. 479

Padfield, T. 80
Paixão, M.A. 685
Palmer, M. 881
Panagiaris, G. 801
Paris, M. 785
Parker, T. 701
Pataki, A. 622
Paula, T.C.T. 727
Peila, R. 730
Pellegrino, A. 903
Petetskaya, V.S. 593
Petrova, N.L. 593
Phenix, A. 321
Philpott, F. 108
Picollo, M. 238
Pillay, R. 287, 295, 301
Pincemaille, C. 183
Plahter, U. 446
Podestá, M.M. 582
Porcinai, S. 238
Poulsen, D.V. 792
Pretzel, B. 3, 701

Queiroz, M.N. 502
Quinton, J. 690
Quispitupac, E. 51
Quites, M.R.E. 502

Radicati, B. 238
Rava, A. 903
Regnault, P. 597
Ridge, J. 426
Rischel, A-G. 80
Rissotto, L. 785
Rodrigues de Carvalho, C.S. 86
Rogerson, C. 741
Roggero, R. 730
Rogozina, T.B. 593
Rolandi, D.S. 582
Rolland-Villemot, B. 187
Romain, A. 540
Romer, G.B. 172
Roth, K. 696
Ruggles, A. 328
Ruppel, J. 701

Salomon, J. 851
Santamaria, U. 888
Saunders, D. 295, 455
Saverwyns, S. 628
Sawicki, M. 524
Scalarone, D. 903, 911
Scheerer, S. 894
Schmitt, F. 295
Seddon, T. 701
Shashoua, Y. 927
Shindo, J. 287
Simonot, L. 419
Sizaire, V. 628
Smit, I. 363
Smith, G. 597
Smith, N. 696
Solajic, M.R. 701
Songia, M.B. 730
Souza, L.A.C. 556
Spencer, H. 533
Spirydowicz, K. 565

Spring, M. 455
Stable, C. 533
Staniforth, S. 479
Stein, M. 192
Stoll, A. 388
Stulik, D. 245, 352, 658
Sturman, S. 920
Suárez Pareyón, A.L. 816
Swerda, K. 198

Takami, M. 747
Takayama, C. 281
Tavares, L.L. 86
Teule, J.M. 252
Thao, S. 777
Thickett, D. 90

Thillemann, L. 153
Toledo, F. 58
Tonin, C. 730
Towle, A. 479
Townsend, J.H. 426, 701
Trampedach, K. 192
Tzompantzi-Reyes, Ma.T. 712

Ullenius, U. 252
Utermöhlen, H.A. 146

Valentin, N. 96
Vallet, J-M. 549
van den Berg, K.J. 464
van den Brink, O.F. 73, 252
Van der Sterren, N. 363

van der Weerd, J. 401
van Keulen, H. 464
Vatelot, J. 540
Vedovello, S. 560
Velitzelos, E. 801
Verberne-Khurshid, F. 309, 363
Verger, I. 119
Villers, C. 321
Vineis, C. 730
Volchkova, M.A. 593
von Waldthausen, C.C. 664

Wade, N. 321
Wadum, J. 394, 401, 473
Wainwright, I.N.M. 582
Waller, R. 102

Walter, P. 851
Watts, S. 108, 479
Wharton, G. 203
Willcocks, S. 935
Wills, B. 690
Windsor, D. 755
Withnall, R. 597
Wouters, J. 628

Yamamoto, K. 281
Young, C. 370

Zafiropulos, V. 252

Index of poster session authors / Index des auteurs des panneaux d'affichage / Indice de autores de posteres

Aitken, G. 947

Banik, G. 952, 954
Benoit, C. 949
Bermejo-Cejudo, J.C. 950
Burtceva, I. 953

Calver, A. 943
Cane, S 943
Carlson, J. 946
Carme Sistach, M. 953
Carmo, J.A. 950
Cepero Acán, A.E. 956
Colinart, S. 945
Cortopassi Jnr., H. 950

Damm, R. 952
Dietemann, P. 956
Dubus, M. 949

Farah, J.P.S. 950
Ferrer, N. 953

Gibson, L. 943, 944
Gonzalez Tirado, C. 945
Groen, K. 949

Hallebeek, P. 954
Herm, C. 946
Hummelen, Y. 948

Kälin, M. 956
Kamenskiy, A. 953
Knochenmuss, R. 956
Krebs Kaulen, M. 945
Kriebel Rodríguez, A. 955
Kuon, R. 952

Lahanier, C. 947
Landim Fritoli, C. 953

Margariti, C. 954
Mujica, P. 945

Nardi, C. 951

Pages-Camagna, S. 945
Pataki, A. 954
Perminova, O. 953
Popunova, V. 953
Pretzel, B. 946
Price, B. 946

Queiroz, M.N. 951, 952
Quites, M.R.E. 952

Ravaud, E. 949
Reuss, M. 954
Rinuy, A. 949
Rioux, J-P. 949
Rizzo, M. 950

Salas Almela, R. 951
Salgado Ravelo, I. 956
Schneller, R. 954
Scholte, T. 948
Sharikova, A. 953
Sillé, D. 948
Snyers, C. 949
Sousa Jr, M.A. 952
Stepanova, T. 953
Sudano, C. 956

Tapia López, P. 955
Tétreault, J. 943
Thobois, E. 954

Utermöhlen, H.A. 944

van Keulen, H. 954
van Oosten, T. 948, 954
Verberne-Khurshid, F. 948

Watt, C. 943, 944

Yakhnin, E. 953

Zenobi, R. 956

Index of keywords / Index des mots-clés / Indice de palabras-clave

12th century 507
15th century 414
16th century 785
17th century 770
19th-century America 198
19th-century materials 426
3D capture 301

Aboriginal rock art 571
accelerated ageing 73, 603
access 21, 269
acides carboxyliques 851
acidic paper 603
acidity/pH of paper 628
acrylic emulsion 223
acrylic emulsion paints 911
acrylic polyurethane 920
acrylics 935
adhesive 370
adsorbents 927
aesthetics 153
African contemporary art 679
agrandissement original 439
air abrasive 770
air conditioning 38
air intérieur 851
alcaloides 51
Aleijadinho 502
alkali reserve 628
alkyd 407, 920
alkyd varnish 770
alteración 816, 829, 841
aluminium spring stretcher 360
Amazonian featherwork 701
American Indian 673
análisis científico 823
analyse 540
analyse non destructive 851
ancient Egypt 741
Anobium 96
anoxic 96
Antarctica 865
antique recipes 609
Antoni Tàpies 407
aqueous gel 245, 352
archaeological conservation 679
archaeological stratigraphy 479
archaeological wood 712
archaeology 556, 582, 835
architecture 86
Argentina 582
around 1900 388
arqueología 829
Arrhenius 66
arsenic 673
artificial ageing 549
artist's materials 261
ATR-FTIR 927
atribución 502
Australian Aboriginal art 696
authenticity 153, 203
autochrome 664
Aztec artefacts 712

Baja California 578
bark painting 696
Baroque/Rococo 520
bead 741
biaxial 370
binding 593
biocida 51
biodeterioro 51
bleaching 328
Brasil 502
Brazil 394, 520
Brazilian embroidery 727
Bremen Cog 718

bronze corrosion 860
Bruegel (Pierre l'Ancien) 383
Brueghel 473
budgeting 309
building transmission 90
building works 108
buildings 9

C14 383
calibrated large size
 printing 295
canvas 321
canvas painting 432
carbon dioxide 455
carnation 419
cartoons 388
Catedral 496
caulfield 223
Centre de recherche et de
 restauration des Musées de
 France (C2RMF) 183
ceramic 894
cerámica prehispánica 823
ceramics 690
ceremonial arms 785
chain scission 911
chalcopyrite 860
Charles Rennie Mackintosh 533
checklists 309
chemical decay 66
Christ 520
church furnishings 192
CIEDE2000 3
cinema 903
cire 540
clarté 419
cleaning 198, 252, 352
climate 644
climate control 58
coating 658
cold climate 865
colección 829
collecciones 685
collaboration 132, 269, 473, 690
collection conservation 86
collections care 21
Collections Centre 21
colorimetry 211
colour 664
colour change 455
colour conservation 301
colour correction 301
colour difference 3
colour measurement 701
commercial paint 920
communication 108, 269
comparison of pH determining
 methods 628
compensation of losses 730
completion 153
condensation 80
condensed tannins and gallo
 tannins 792
condition assessment 644
Conrad Meit 513
conservación 160, 496, 502, 637,
 685
conservación preventiva 51, 146
conservation 34, 187, 533, 556,
 593, 785, 871
conservation development 176
conservation education 125
conservation ethics 203
conservation facilities 166
conservation issues 609
conservation management 309
conservation philosophies 346

conservation préventive 736, 851
conservation science 137
conservation tool 363
conservation treatment 664
consolidation 664
consolidation of wood 712
contamination 673
contemporary art 363
contemporary paintings 407
continuing professional
 development 125
continuous tension 338
copal 328
copal-based materials 426
copyright 275
corrosion 801, 865, 871
corrosion atmosphérique 851
corrosion inhibitor 679
corrosion potentials 871
couleur 419
Courtauld Institute of Art 261
couverture photographique 183
cracks 407
Cranach 432
cross-linking 911
cross-section 223, 261, 747
Cryptotermes brevis 51
cuir 777
cultural content 275
cultural relativism 203
cultural risk 673
culturally sensitive materials 673
culturas materiales 685
Curie-point pyrolyser 231
cyclohexylamine 679

damage 45
darkening 464
data processing 58
database 261, 287, 309
DDT decontamination 730
deacidification 603
decorated leather buckler 785
decorative arts 835
degradation 464, 927, 935
DEHP 927
Dendrochronologie 383
Denmark 192
detachment 176
deterioration 66, 801
diagnostic study 560
didactic materials 132
difracción RX 816
difusión 637
digital 275
digital archives 281
digital book 281
digital imaging 217, 741
digital replica 281
digital restoration 281
dimensional change 696
dimensional measurement 301
disasters 27
display 533
distance learning 125
documentation 172, 269, 309
Dominican Republic 146
driers 328
drops of blood 520
durability 888
dust 108
dyestuff 238
dynamic mechanical thermal
 analysis 615
early Renaissance 609
earth pigments 582
Eckhout 394

édifices publics 736
education 119, 132, 651
educational materials 119
efflorescence 679
emergency plan 27
emergency preparedness 27
enamels 835
environmental conditions 888
environmental control 86, 696
environmental monitoring 108
epoxy resin 888, 894
Er:YAG 894
escultura 502
esmalte translúcido 841
ESPI 370
estándar 637
état de surface 419
ethic and aesthetic 730
ethics 153
ethnographic conservation 679,
 701
experimental wall-painting 549
extraction 777

fachada 816
fading 3
Ferdinand Hodler 388
fibre optics 238
fibrous plaster 533
fillers 894
filling 622
fire damage 252
fond d'or 419
fonds documentaires 183
formative evaluation 21
frame 338
France 183
French 507
frequency 309
frontals 446
frost action 801
FTIR 658, 881
funding 166

GCMS 352
gel 245
George Eastman House 172
gilded wood 245, 524
gilding 513
gilt leather 764, 770
glass 894
glazed 80
gloss 211
Gore-Tex 747
gradient 80
graduate study 651
graisse 777
Great Temple 565

Harris matrix 479
Hawai'i 203
health hazard 673
heat disinfestation 15
heating 58
Hide Powder 622
hispanomusulmán 841
histoire de la conservation-
 restauration 183
historia de la conservación 146
historic building 58
history of conservation 146, 835
history of painting conservation
 and restoration 198
humidité relative 851
humidity 58
hydrogen peroxide 38

identification of photographs 658
image analysis 211
image recognition 287
image transfer 658
imaging FTIR 401
imaging SEM-EDX 223
imaging SIMS 223
inclusion 21
indoor air quality 38
indoor environments 73
information and
 communications
 technology 125
information technology 301
inner bark 696
inpainting 198
insect infestation 96
integrated pest management 96
Internet 9, 132
interpretation 741
investigación 637
ionomer 401
iron gall ink 597
iron shipwrecks 871
isinglass 747
ISO 9223 865
ISO 9225 865
Italian workshop practice 414

Java applet 9

Kimberley 571
Korea 747

Lactitol treatment 712
landscape 473
large scale painting 360
laser 252, 894
laser cleaning 701, 770
lead acetate 328
lead antimonate yellow 479
lead dryers 464
lead soaps 401
lead white 328, 401, 597
leafcasting 622
life expectancy 644
light ageing 911
lightening 455
lightfastness 701
lighting policy 3
lime popping 679
linear lighting 295
lining 198, 321, 370
linseed oil 328, 464
linux 287
liquid fill preparation 622
litharge 328
Louvre 183
low molecular weight resin 881
Lunéville 764
Lupinus mutabilis 51
Lyctus 96

madera 502
maghemite 582
management 275
manganese oxide layers 578
mantenimiento 496
manuscript 593
Mappae Clavicula 860
marble 245, 513, 809
mass spectrometry 223
materials 414
matte paint 920
mechanical behaviour 407
mechanical properties 603
medieval 446
mediums 328
megilp 328
metal 835
metal point drawing 609
metal thickness 871

metamerism 217
méthode non destructive 419
Mexica paintings 565
Mexico 176
México 160
microbiological infestation 560
microbiology 58
microclimate 80, 571, 755
microclimate control 903
micro-destructive sampling 628
microspectroscopy 223
Minas Gerais 520
miniature 593
minimal conservation 321
minimal intervention 755
minium 549
model 102
modelling 9, 45, 571
modern sculpture 935
moisture 455
molecular weight 211
monitoring 58, 578
Montpellier 841
mosaic gold 597
motion picture films 644
mould 622
mounting 363, 533
multi-channel visible spectrum
 imaging 217
multimedia database 281
multi-spectral imaging 217
multi-spectral scanner 295
murals 153
museography 86
museos 146
museum 9, 119, 146, 903
museum display 701
museum refurbishment 108
museums and galleries 166
mysql 287

nacionalismo 160
NAGPRA 673
national 166
Native American 673
natural ageing 73, 549
Nd:YAG 894
nielo 841
nniaxial 370
non-destructive analysis 658
non-traditional gilding 524
Norway 192
Norwegian 446
nylon 736

objetos cerámicos 829
objetos prehispánicos 160
oil medium 446
olmeca 829
open source 287
optical spectrometry 295
oral history 172
organic pigments 223
orpiment 520
outdoor sculpture 920
oxalates 582

paint analysis 533
paint consolidation 747
paint films 455
paint-based dosimeter 73
painted banner 747
painted leather 764
painted sculpture 920
painting 261, 287, 295, 363, 464
painting conservation 252, 360
painting technique 388, 446,
 464, 565
palmitate to stearate ratios 231
panel painting 141, 446
panel treatments 346
panoramic viewing 301

paper 363
paper ageing 603
Papyrus Leiden X 860
Paradise 473
parchment 593, 615, 622
partenariats 736
patina and age value 198
patina(tion) 860
patrimoine industriel 187
Pays-Bas 383
pedagogy 132
PEG (polyethylene glycol) 718
peinture 439
permanent magnets 363
Perspex™ 755
pest control 15
pesticide 673
petrified forests 801
petrografía 816
petrographic analysis 809
pH readings 603
philosophy and technique 730
photochemical stability 881
photograph conservation 172,
 651
photography 664
phthalate 927
physical properties 809
picture frame 80
pigment 419
pigment identification 217
pigment oxidation 549
pigmented colour chart 295
pigments 261, 446, 582, 609
PIXE analysis 609
planning 309, 727
plaster 245
plastic 927
plasticizer 927
plâtre 540
plattnerite 549
Plexiglas® 755
plomb 851
plumaria 685
pMMA 935
policromía 502
polished finishes 513
pollution 9, 38
polychromy 507, 513
polyester polyurethane 920
polyethylene glycol (PEG)
 surfactant 911
polymethyl methacrylate 935
polysilicone 920
porometry 809
Post 394
prediction 45
pre-Hispanic paintings 565
prehistory 556
preparatory layers 432
prepared grounds 609
Pre-Raphaelite technique 426
preservación 637
preservation 102
preservation plan 644
pressure mount 755
preventive conservation 9, 27,
 86, 102, 146, 198, 560
principal component analysis 238
process control 252
produit ignifuge 736
professional training 125
protrusions 401
provenance 394
(pseudo-)gilding 860
psychrometric chart 66
public conservation 203
PVC 407, 927
pyrolusite 582
pyrolysis 352
pyrolysis temperature 231

Queen of Sheba 764

radiographie 439
Raffaëlli Solid Colours 388
Raman microscopy 597
reconstrucción 160
reconstruction 153, 741
red lead 455, 549
reflectance spectroscopy 238
Réflectographie infra-rouge 383
reflexivity 203
refractive index 211, 426
regional 166
relative humidity 45, 66, 80, 696
relicario 841
Renaissance 513
repatriation 673
República Dominicana 146
residues 352
response 27
responsibility 166
restauración 160, 502, 829, 841
restauration 187, 439, 540
restoration 192, 524, 888
retouching 881
risk 45
risk assessment 102
risk management 102
roca ígnea 816
rock art 556, 578
rock paintings 582
rock shelter 556
Rodin 540
Rubens 473
ruby 520
rug conservation and
 restoration 730

salt deposition 865
salts 560
San Lorenzo 829
savoir-faire 187
scientists 137
sculpture 507, 540
sculpture conservation 203
seawater 871
SEC 881
semilla 51
seventeenth century 473
Sevilla 496
shields 785
siglo 18 502
siglo XX 160
silica-rich layers 578
simulation of varnish removal
 295
sixteenth century 432
solar tent 15
solarization 15
solid-state NMR spectroscopy
 615
Solomon 764
soluble salts crystallization 801
solvent removability 881
solvent vapour 664
solvent-reactivation 747
soufre 851
sources d'archives 183
spectroscopie 419
speculative restoration 192
spot test 792
stabilization 718
standardization 309
standards 38, 269, 275
starch 432
stiffness 370
stone 894
storage 363, 644, 696
strappo method 770
strengthening 622
stretcher 338
structural treatment 321
sub-Saharan Africa 119
suction table 622

suivi documentaire des restaurations 183
surface cleaning 245
surface deformations 464
surface pH 871
surface roughness 211
synthetic polymers 524, 903

tarwi 51
teamwork 108
technical examination 394
technique 414, 473, 785
técnica construcción 841
técnica de manufactura 823
técnicas 685
teintures industrielles 736
temperature 66, 80
Tenochtitlan 565
tension 370
teoría 160
terracota 496
terracotta 245
terre cuite 540

text block 593
textile 747
textile architectural contemporain 736
textile conservation 727
THM-GCMS 231
time constraints 727
time of wetness 865
tin appliqué relief 507
Tineola 96
toba volcánica 816
toile 439
toning 658
tooled edge 593
toxicity 690
training 119, 651
traitement de conservation 736
transportation 34
treatments 176, 835
tüchlein 432
two-sided painting 338
two-step PEG-treatment 718

Ulmer golschen 432
underdrawing 473
United Kingdom 166
university curricula 137
urea-aldehyde 881

valor reflejar 685
varnish 211, 881
varnish measurement 295
varnish removal 252
vegetable tannins 792
Veloxy® 96
ventilation 9, 58
vfzoom 287
vibration 108
vibration control 338
vibration damage 90

walking 90
wall paintings 153, 176, 192, 560, 565
wall-hanging 764

water infiltration 560
waterlogged wood 718
wax 198
weathering 578
Western Australia 571
wood 507
wooden polychrome objects 712
workshop 690

XIXe 540
XML 287
X-radiography 479
XRF 658
XVIe siècle 383

yellowing 328

zinc carboxylates 388